GIOTTO

GIOTTO

BY ❧ FRANCESCA FLORES D'ARCAIS

❧ TRANSLATED BY RAYMOND ROSENTHAL

ABBEVILLE PRESS PUBLISHERS ❧ NEW YORK LONDON PARIS

❧ I WOULD LIKE to thank all those who helped me with this project, and especially the following people: Davide Banzato, Giuseppe Basile, Luciano Bellosi, Giorgio Bonsanti, Mario Ciatti, Enrica Cozzi, Alfio Del Serra, Richard Harprath, Irene Hueck, Pier Luigi Leone de Castris, Margret Lisner, Mauro Lucco, Father Pasquale Magro, Father Luciano Marini, Antonio Natali, Antonio Paolucci, Father Gerhard Ruf, Anna Maria Spiazzi, Fiorella Superbi, Cornelia Süre, Jan Sureda, Anchise Tempestini, Dominique Thiébaut, and Father Francesco Trolese.

❧ I WOULD ALSO LIKE to thank the following institutions: the Istituto Tedesco di Storia dell'Arte and the Restoration Laboratory of the Opificio delle Pietre Dure, both in Florence, and the Istituto Centrale del Restauro in Rome.

—Francesca Flores d'Arcais

Front jacket: Detail of LAMENTATION, *Scrovegni Chapel, Padua. See page 189.*
Back jacket: Scrovegni Chapel, Padua. See page 138.

Unless otherwise indicated in captions, all paintings are frescoes.

For the English-language edition
EDITOR: Abigail Asher
JACKET DESIGN: Sandy Burne
TYPOGRAPHIC DESIGN: Barbara Sturman

For the original edition
EDITORIAL DIRECTOR: Federica Motta
EDITOR: Mariacristina Nasoni
TEXT EDITOR: Augusto Leoni
PICTURE RESEARCH: Katia Zucchetti
DESIGNER: Ergonarte

First edition
10 9 8 7 6 5 4 3 2 1

Library of Congress Cataloging-in-Publication Data
D'Arcais, Francesca.
 [Giotto. English]
 Giotto / by Francesca Flores d'Arcais.
 p. cm.
 Includes bibliographical references and index.
 ISBN 1-55859-774-3
 1. Giotto, 1266?–1337—Criticism and interpretation. I. Title.
ND623.G6D3313 1995
759.5—dc20 95-15262

CONTENTS

※

PREFACE

GIOTTO'S contemporaries, especially the Florentines, were quick to perceive the revolutionary significance of his pictorial language and his central position in the history of Italian painting. They immediately saw that he marked a break with the past and launched a new way of making paintings, modern in contrast to the medieval. As Dante's famous *terzina* has it: "Cimabue was thought to hold the field / In painting; but now Giotto is all the cry / And Cimabue's fame is badly dimmed." ❧ DANTE succinctly depicts how, at the very beginning of the fourteenth century, the contrast between the two artistic geniuses—Cimabue, the greatest representative of the old style of the medieval world, and Giotto, the initiator of modern painting—was so evident in Florence. ❧ THIS is the key to the reading of Dante's passage by its first commentators, who emphasized Giotto's importance, calling him "the summit" among painters. Villani (c. 1340) was one of the first to try to understand why Giotto was regarded as the best of artists. For him, Giotto was the "most sovereign master that exists in painting . . . who draws every figure and gesture in a natural fashion." Giotto brought painting back to a natural style that unites artists, scholars, and poets in their praise of him. This idea can be found in the eulogies of Giotto by Boccaccio and Petrarch; the latter actually compared him to Apelles, the mythical painter of ancient Greece. ❧ WITH the sensibility of an artist, Cennino Cennini, in his book *Il libro dell'Arte* (c. 1390), written half a century after Giotto's death, expressed more fully the freshness of Giotto's pictorial language and his fundamentally revolutionary position in the history of painting. Cennini said, "He transformed Greek art into Latin, and made it modern. . . ." ❧ THIS definition was repeated by Ghiberti, and later by Vasari too, who credits Giotto with the rebirth of painting—which had been buried during the long centuries of the Middle Ages—after some timid attempts at a revival on Cimabue's part. This rebirth went hand in hand with the rediscovery of classical values, which the Renaissance mind saw as the apex of artistic values. ❧ GIOTTO'S status as a legend was established early; and perhaps precisely for this reason the rediscovery of his artistic development has been slow in coming, starting only in the nineteenth century. To be guided by the tendency of Renaissance Florentine

criticism may be damaging, though historically completely correct; the view of Giotto as a revolutionary innovator, the person who rediscovered volume, space, and the physicality of design, indeed, all that is exquisitely "Florentine," has perhaps hindered a broader and more articulated comprehension of Giotto's complex personality and of his varied and polyhedral pictorial language. ❦ FOR though Giotto is a revolutionary figure, and as such constitutes a turning point in the development of Italian painting, he is also profoundly rooted in his time, its most acute interpreter. So if we are accustomed to read Giotto's language in a predominantly spatial and volumetric key, I believe that we must emphasize—as have such sensitive scholars as Zeri, Volpe, and above all Lisner—the innovative significance of Giotto's coloristic intuitions (first mentioned by Cennini), which make him a very modern, avant-garde artist, particularly in comparison to Sienese painters. Typical of Giotto is his groundbreaking intuition of the close relationship between light and color, particularly the innovative insight which we will encounter first in the cycle in the Scrovegni (or Arena) Chapel in Padua: that color changes in accordance with the variation of light, not just in intensity, but also in quality. And we must also re-examine, as characteristic of the Gothic world—of which this Florentine painter was one of the chief protagonists—his extremely radical approach to everyday life, as seen in his diligent curiosity about ordinary objects, animals, plants, and the clothing of his characters. One could say that he looked at reality through a new, wide-open lens, intent on a new reading of the world, and he affectionately examined it in all its aspects, from the most aristocratic and sacred to the most humble and poor, to set it before us within truthful landscapes and realistic architectonic spaces. And in this reappropriation of reality, beyond the traditional patterns, man, newly individualized, reappears as the true protagonist of painting, in the concreteness of daily life and the profundity of his emotions. This was and is the most modern and revolutionary aspect of Giotto's language, still alive and just as gripping for viewers today.

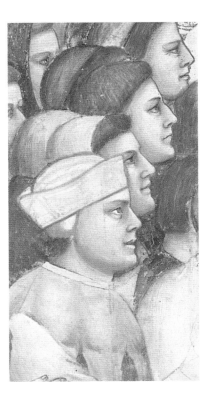

Giotto. Presumed self-portrait among the figures of the elect in the LAST JUDGMENT *(p. 142). Scrovegni Chapel, Padua.*

TRAINING

AND

EARLY

WORKS

FLORENTINE EDUCATION

G IOTTO WAS BORN AT COLLE DI VESPIGNANO IN THE VALLEY OF THE MUGELLO RIVER NORTH OF FLORENCE; HIS FATHER WAS A PEASANT NAMED BONDONE. THE DATE OF HIS BIRTH IS UNCERTAIN. IT COULD BE 1267, ACCORDING TO THE VERSES THAT PUCCI WROTE IN 1373 ON the basis of Villani's *Chronicle,* or it could be 1276, as asserted by Vasari in the first (1550) as well as the second edition (1568) of his *Lives of the Painters (Le Vite de' più eccellenti pittori).* The day and year of his death, however, are certain: he died in Florence on January 8, 1337. ❧ FOR the chronology proposed in this volume, which dates Giotto's debut as a painter around 1290 with the Old and New Testament cycles in the Upper Basilica in Assisi, the birth date suggested by Pucci would seem most acceptable, if set back by one or two years. Thus Giotto would have been about twenty years old when he appeared on the Assisi scaffolds. ❧ IN ACCORDANCE with medieval custom, the young artist was expected to enter a workshop early on, and so Giotto was already a part of the Florentine artistic community at the beginning of the 1280s. Gathering together the legends that immediately arose in Florence around the personality of the great artist, Vasari writes: "And when he reached the age of ten . . . Bondone set him to watch some sheep; which he would constantly be drawing on flat stones or on sand. . . . So one day when Cimabue was going on his affairs from Florence to Vespignano, he happened upon Giotto who . . . was drawing one of his sheep from life with a slightly pointed stone on a flat, smooth slab. . . . Cimabue halted, utterly amazed, and asked the boy if he would like to come to stay with him." ❧ IT IS easy to imagine that Giotto was an impressionable adolescent when he entered the workshop of the greatest and most famous painter that the city of Florence could then boast; indeed, in his very first works, right up to the Franciscan Cycle in Assisi, Giotto's references to the language of Cimabue are quite clear and numerous, evidence of long familiarity and a lengthy period as a disciple with the old master. A sign of this apprenticeship under Cimabue could well be the fragment of a panel (p. 11), preserved in the parish church of Borgo San Lorenzo (near Florence), with little more than the

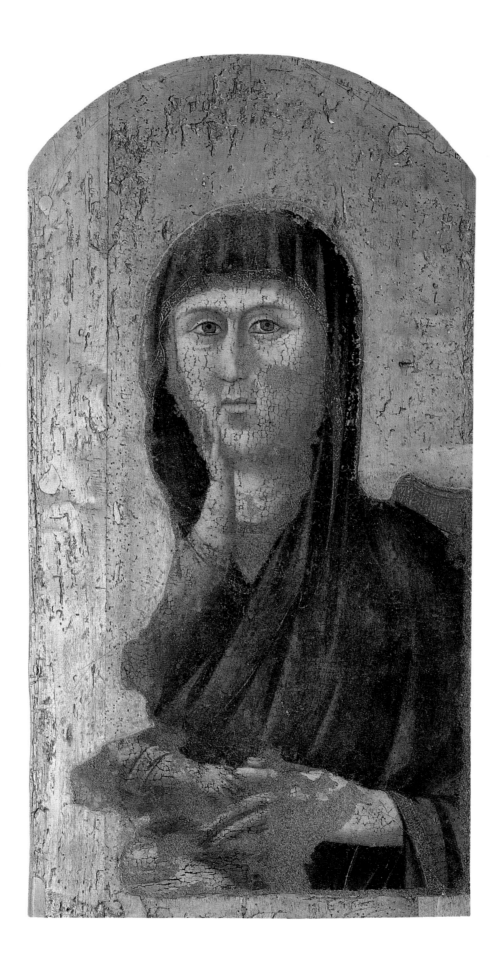

Giotto(?). MADONNA AND
CHILD. *Tempera on panel, 32⅛ ×
16⅛ in. (81.6 × 41.0 cm). Parish
church, Borgo San Lorenzo (Florence).*

face of a veiled Madonna; intensely vital, the piece was attributed to the very young Giotto in the Florentine exhibit of 1985–86 (*Capolavori e Restauri,* 1986). ❧ IN THE last decades of the thirteenth century Florence had become a lively artistic center. One could already sense the infusion of a new spirit in architecture, for example in the church of Santa Trinità (attributed, significantly, to Nicola Pisano), and in the church of Santa Maria Novella, where new Gothic motifs were reworked with a classical feeling for space, which surely made an impression on the young artist. Giotto had been similarly struck by the powerful mosaics that were then being created in the Baptistery: designed with bold, sharp contours and robustly molded limbs, these mosaics were to leave a deep imprint on his mind and imagination, so much so that he copied their version of hell in the Paduan frescoes of the Scrovegni Chapel. ❧ BUT from the start the young artist was influenced by other impulses and stimuli picked up in nearby cities. Pisa and Siena, not Florence, were at that time the Tuscan cities of greatest interest and with the most modern language. Focusing on the construction and decoration of its Gothic Duomo, Siena was then the most advanced city, in consonance with the most celebrated French centers; it claimed not only an extraordinarily poetic and refined painter, Duccio, but also—certainly more important for Giotto—the sculptural works of Nicola and Giovanni Pisano. ❧ NICOLA Pisano's workshop in Pisa had been active even before 1260 and had started the revolution that carried artistic language "from Greek into Latin." One might argue that from contact with the sculptors of the Pisano workshop Giotto drew his new proportional measure and a style of molding softened by chiaroscuro. In the youthful *Crucifix* in Santa Maria Novella, the natural plasticity that so gently shapes Christ's body and the serene beauty of his face, with its fervent emotion, seem to me to express a close formal, but also spiritual, tie with the language used by Nicola Pisano for the pulpits of Pisa and Siena.

Roman painter (and Giotto?).
PROPHET. *Santa Maria Maggiore, Rome.*

FIRST VISIT TO ROME

GIOTTO'S development cannot be explained without conjecturing that the young painter spent a long time in Rome during the years of his early training. Perhaps he accompanied Cimabue, who must have been in Rome several times, and was certainly there in 1272; or perhaps he went—why not?—with Arnolfo di Cambio, another great Florentine who settled in Rome. Cimabue and Arnolfo are the two principal poles around which the personality of their highly talented pupil revolves; and his talent is clear in the first works that scholars have attributed to him. Thus Giotto's Roman visit must be dated around 1285–88, and we can assume that he actively participated in some important pictorial enterprise in a prestigious workshop, perhaps that of Cimabue, about whose Roman experiences and production we still know too little. IN THE last decades of the thirteenth century Rome was at the height of a magnificent architectural renewal. Nicholas III (1277–80), just elected to the pontifical throne, attempted to revive the idea of Rome as seat of the papacy and thus capital of Christendom by launching a series of restorations and new constructions in the city's most important religious centers. In the Lateran complex he focused on having the frescoes of the basilica restored; he had the so-called Sancta Sanctorum chapel built and decorated with mosaics and frescoes, to house the most precious Christian relics. In the Vatican complex he had the portico of St. Peter's basilica frescoed and ordered the construction of a new palace. Perhaps the "restoration" of the old frescoes in the basilica of San Paolo was done by Pietro Cavallini, presumably during the same years in which Arnolfo executed the very modern canopy (1285) above the high altar. AFTER a brief interval of inactivity, the Roman workshops were reopened during the pontificate of Nicholas IV (1288–92), the first Franciscan pope, who resumed the work at the Lateran, commissioning the Franciscan friar Jacopo Torriti to do the mosaic in the basilica's apse (dated 1291). And to the first year of that papacy can be traced the project for a radical refurbishing of the basilica of Santa Maria Maggiore (Tomei, 1990), including the frescoes in the right transept, the mosaic in the apse by Torriti (completed in 1296), and the mosaic on the facade by Filippo Rusuti. In 1290 Arnolfo di Cambio executed the statuary group of the *Holy Crib*. THE young Giotto, not yet twenty years old, who arrived in the capital of the Christian world about 1285–86, found a very modern city,

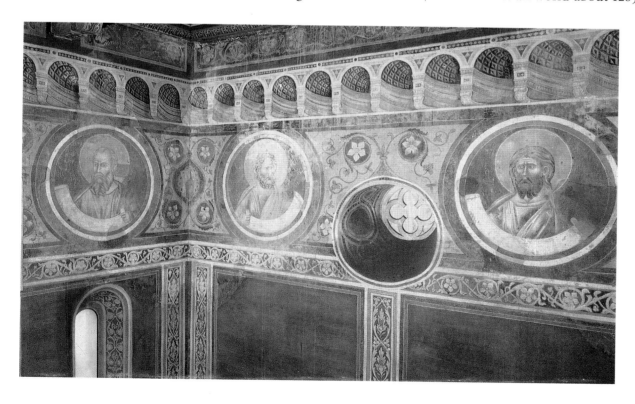

Roman painter (and Giotto?). Detail of fresco decoration with busts of prophets in medallions. Santa Maria Maggiore, Rome.

full of extraordinary buildings of a conspicuously classical flavor. The edifices were dressed in white marble and enriched by splendid polychrome inlay work by the marble cutters of the Cosmati family and by the Vassallettos, most notably in the airy cloisters of the basilicas of San Giovanni in Laterano and San Paolo, both constructed on the basis of measurements taken from buildings of the classical period. References to the ancient world and the spaciousness and monumentality of its imperial buildings, and to the serene amplitude of Paleo-Christian basilicas, made a world that so firmly took root in the imagination of the young Giotto as to become one of the most significant constants in his language. ❧ IN ROME during the last decades of the century new solutions to the problem of painted space were also being developed. The singular frescoes in the abbey of the Three Fountains attest to this, and the fragmentary decoration of the right transept in the basilica of Santa Maria Maggiore, together with, so far as we can tell from later drawings, the work on the walls encircling San Paolo and St. Peter's basilica. And the most advanced artists were probably already discussing and experimenting with new fresco techniques that painters on the Assisi scaffolds would soon use. ❧ THIS lively milieu, in which artists from the most diverse backgrounds came together, certainly stimulated the talented Giotto. And yet it does not appear that this young man, beyond his close bond with Cimabue, was particularly attracted by the Roman painters' language, derived from a sophisticated study of antiquity. More decisive was Giotto's (certainly prolonged) contact with Arnolfo di Cambio, who was undoubtedly in Rome at least since 1282. Arnolfo was a famous artist, who altered the language of Roman sculpture with the introduction of his great sculpture-architecture. He made altar canopies of clear French derivation, and tombs for popes and cardinals in which the sarcophagus was embellished with statues and other elements to make it look like a kind of articulated Gothic edifice. He stylized the plasticity of the Pisano school in monumental figures of crystalline purity and classical proportion, which the young Giotto immediately translated into painting. Giotto's figures are like huge blocks of colored stone that reproduce the clear-cut geometrical contours and the deep incisions of drapery found in the sculpture. ❧ TWO works in Rome have been attributed to Giotto's youth: the *Crucifix* from the church of Aracoeli that is now in the Palazzo Venezia (below), first attributed to Giotto by Ilaria Toesca (1966), and the frescoes in the right transept of Santa Maria Maggiore (pp. 12–13), attributed to the Florentine master by Pietro Toesca long ago (1904). If dated just to the start of the pontificate of Nicholas IV, this would testify to some activity by Giotto in Rome before his work in Assisi. Though the miser-

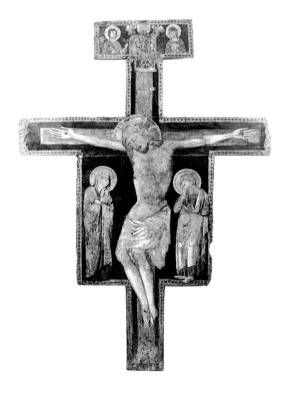

Giotto(?). CRUCIFIX *from Santa Maria in Aracoeli. Museo di Palazzo Venezia, Rome.*

able condition of the panel in the Palazzo Venezia (completely stripped of color and reduced to its bare design) reveals only some significant proportional novelties—the structure of Christ's body, the figure of St. John—much more interesting are the remains of the Santa Maria Maggiore decoration, formed by a frieze of small foreshortened arches, drawn with a strong sense of solid-ity, and busts of the prophets in medallions. Some of the faces in these medallions, while faithful to tradition, have the force of life, inscribed with an incisive and deeply expressive line, link-ing them clearly with the frescoes of the Old and New Testa-ment cycles in the third and fourth compartments in the Upper Basilica in Assisi.

THE EARLY WORKS IN THE UPPER BASILICA IN ASSISI

🎋 OF ALL the Roman monuments at the end of the thirteenth century, the most Roman was, paradoxically, the double basilica of San Francesco in Assisi, the mother church of the new order of Franciscan friars. It depended directly on the pope (rather than on a bishop or a religious order), and this explains the close con-nection with Roman figurative culture in the architectonic struc-ture and decoration of the building. It also explains why the greatest artists of the last half of the thirteenth century and the first part of the fourteenth century were called to decorate the walls of this monument. 🎋 CONSTRUCTION on the Lower and Upper basilicas began in 1228, just two years after the death of the saint, and both sections were finished in 1253; it was conse-crated by Pope Innocent IV that same year. When the decoration was completed on the nave of the Lower Basilica, which pre-served the saint's relics, with the frescoes of the Stories of Christ and the parallel Stories of St. Francis by the "Master of St. Francis," the patrons turned their attention to the Upper Basilica (below left). 🎋 IN A fundamental essay Belting (1977) has emphasized not only the unique decorative concept that informs the walls and ceilings of the entire Upper Basilica, but also the variety of artists who painted it, and the variations in the realization of its parts. The complex decoration deals with four themes: in the transept on the right are the Stories of the Apostles; in the left transept, the Apocalypse; in the choir, the Stories of the Virgin

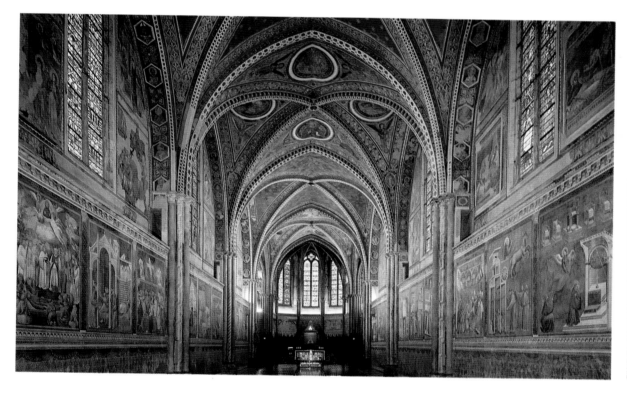

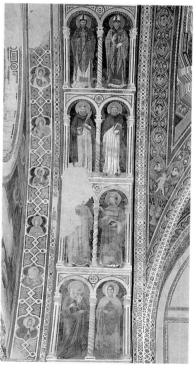

View of the nave looking toward the apse. Upper Basilica of San Francesco, Assisi.

Detail of intrados of arch of the fourth bay with pairs of saints. Upper Basilica of San Francesco, Assisi.

Mary; and on the central vault, the Evangelists. The walls of the nave are articulated in four bays and "hung" with a series of trompe l'oeil curtains at the base. Above these decorations is the band of scenes of the Franciscan Cycle (see plan on p. 373), framed by mock architectural elements. Further up, the walls step back slightly and tall stained-glass windows rise toward the vault; each window is flanked by four episodes from the Old Testament (on the left-hand wall) or the New Testament (on the right). On the cross-vaulted ceiling of the bay near the entrance are the Doctors of the Church, and in the entrance arch are the Saints. ❧ THE decoration of the Upper Basilica starts in the right transept, with the work of an artist of markedly Gothic style; certainly not Italian, he has understandably been called the "Master from beyond the Mountains." Belting (1977) and later Bellosi (1985a) have pointed out the novel emphasis on painted architecture that seems to continue and perfect the real architecture. The columns and rose windows and consoles create a complicated system of architectonic fictions, mock spaces juxtaposed to and different from the real spaces; though played out with different inventions, this treatment will be decisive in the entire Upper Basilica. ❧ BUT the first hero of the Assisi decoration is Cimabue, who succeeded the Master from beyond the Mountains and—with an extraordinary language of robust medieval violence,

qualified by a solemn classical measure—frescoed the lower part of the right transept, the whole left side, the apse, and the ceilings. Cimabue's imprint is also present in the decorative bands of the nave, which actually unify this powerful design. ❧ THIS is not the place to discuss the problem of dating the Cimabue cycle, which Belting (1977) puts at about 1280, during the pontificate of Nicholas III, while Bellosi (1985a) proposes a date early in the pontificate of Nicholas IV, the first Franciscan pope, who would therefore be responsible for commissioning the entire decoration of the Upper Basilica. Though the chronology regarding Cimabue's work at Assisi is still uncertain, almost all scholars now agree in placing the beginning of the overall decoration of the upper part of the nave in 1288, at the start of Nicholas IV's pontificate, and more precisely after May 15 of that year, when the pope issued a bull granting the right to draw on alms gathered at San Francesco and at the church of Porziuncola (near Assisi) to "decorate the Basilica." ❧ THE parallel Old and New Testament cycles, executed at the same time on the upper tier of the two facing walls of the nave, begin on the bay near the altar and continue to the facade. The chief artist in the decoration of the two bays nearest the altar is considered to be the Roman painter Jacopo Torriti, helped by a substantial group of collaborators, as Tomei demonstrated in detail in his recent monograph on the artist (1990). The

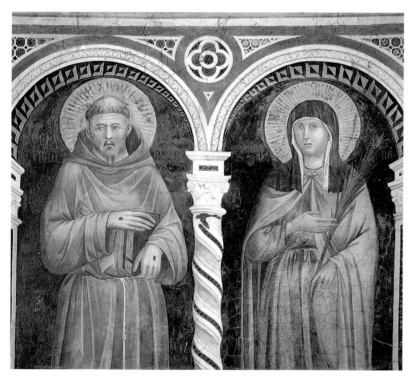

Painter of the Giotto school (Memmo di Filippuccio?). Detail of the intrados of an arch, ST. FRANCIS AND ST. CLARE. *Upper Basilica of San Francesco, Assisi.*

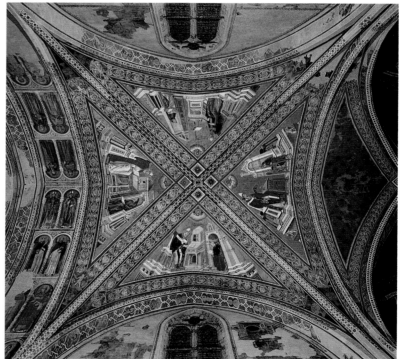

Doctors of the Church, vault of the fourth bay. Upper Basilica of San Francesco, Assisi.

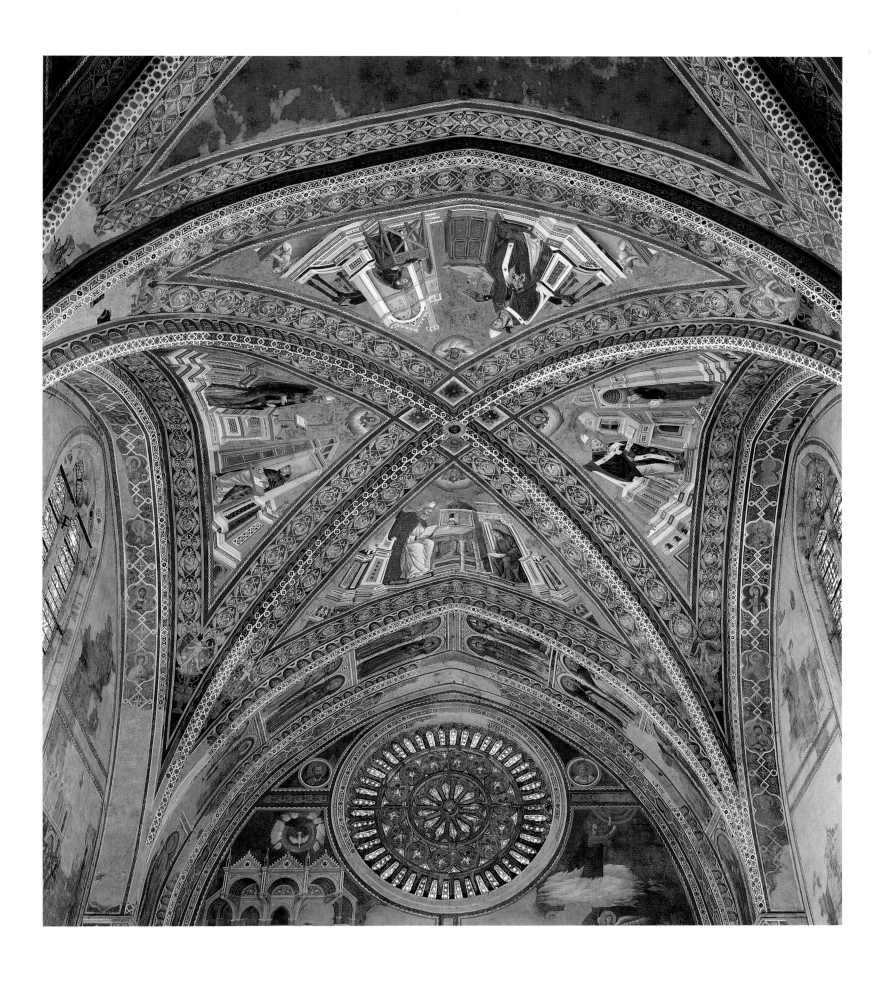

Vault of the Doctors of the Church and upper half of the entrance wall. Upper Basilica of San Francesco, Assisi.

pages 18–19: Giotto. ST. GREGORY THE GREAT, *Vault of the Doctors of the Church. Upper Basilica of San Francesco, Assisi.*

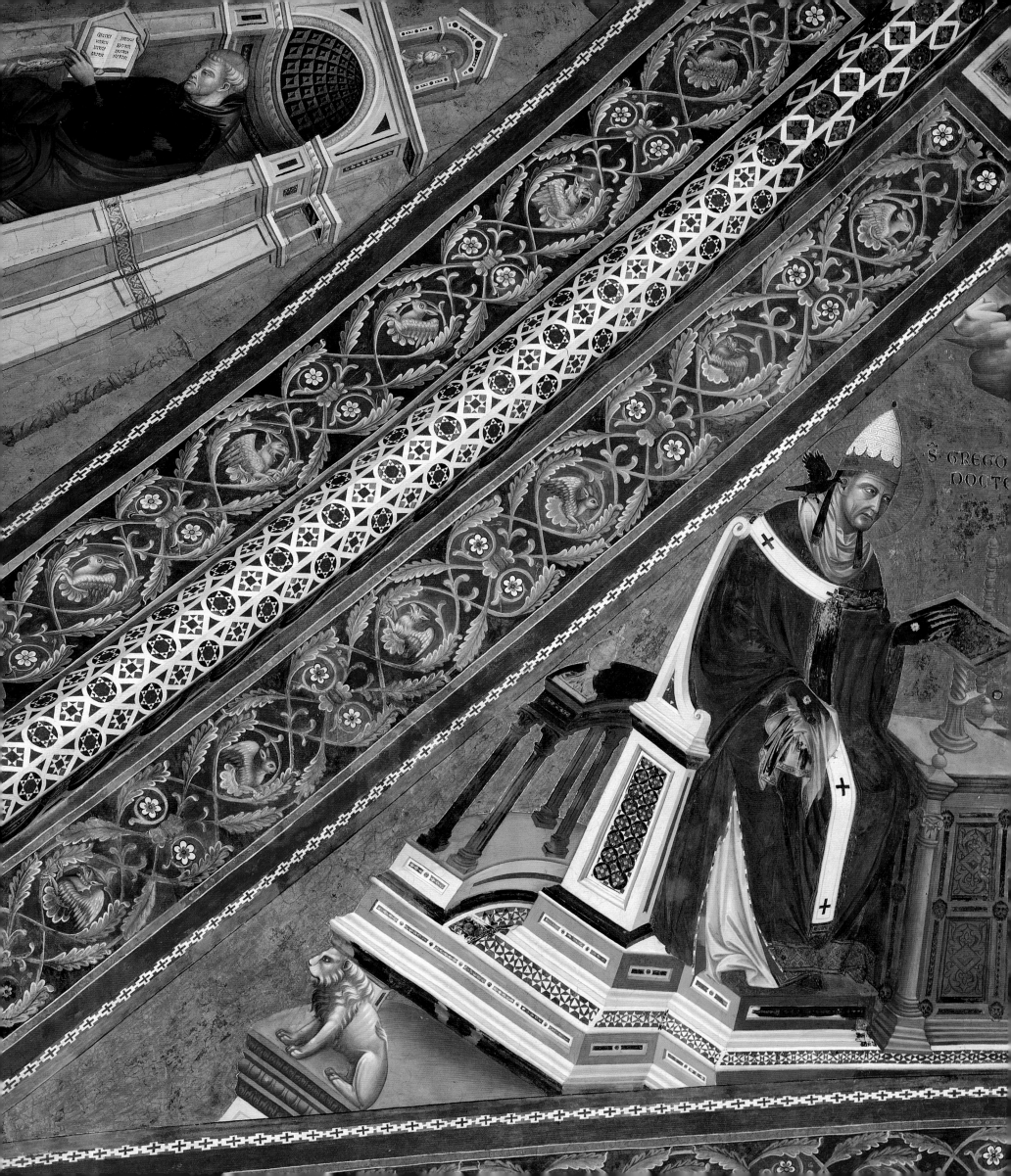

Š. GREGO
DOCTO

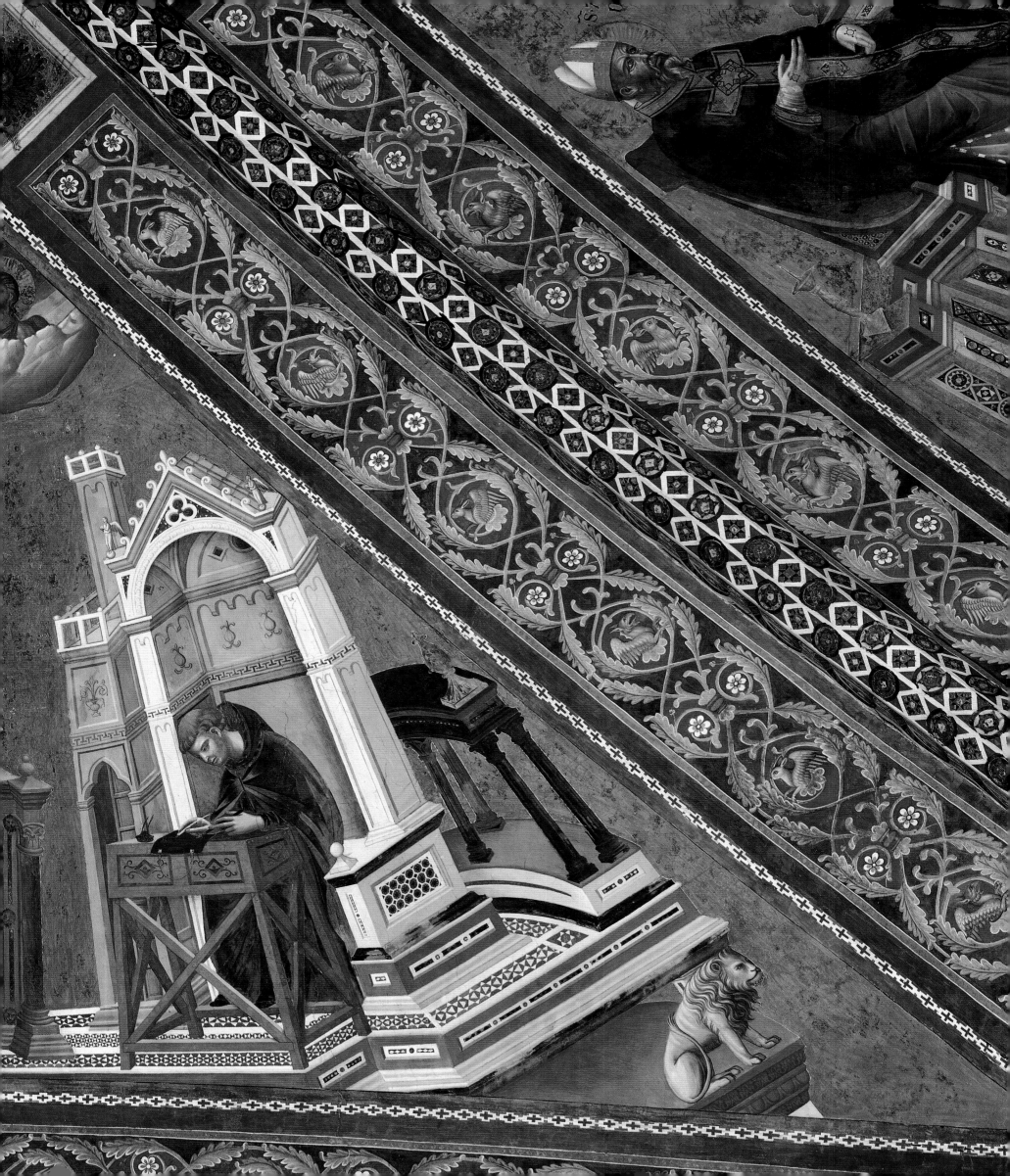

Roman painter's work in the first two bays includes the evocative Vault of the Saints, and his hand is also evident in the *Expulsion of Our Progenitors from Eden* in the upper tier of the third bay on the right. ❧ AT THIS point there is a brusque and radical change of language, as if the painter had suddenly abandoned the project. Perhaps this interruption coincides with Torriti's summons by Pope Nicholas IV to Rome, where he was commissioned to decorate the apse of the basilica of San Giovanni in Laterano (1291) and of Santa Maria Maggiore (completed in 1296). ❧ ANOTHER artist, or group of artists, arrives at the site with a profoundly different language, more modern in its compositional syntax and spatial rhythm; new characters appear with markedly expressive faces, classically proportional forms, and a plastic, robust volume that reflects the play of chiaroscuro. This new workshop or artist is responsible for the lower scenes in the third bay, as well as the Vault of the Doctors of the Church (pp. 16 right; 17), the walls of the fourth bay, and the entrance wall. These are connected to the large arch at the entrance. ❧ THIS entrance arch displays significant innovations in the compositional syntax of the basilica's decoration: it is adorned with a motif of coupled and superimposed niches, flanked by twisted white columns with colorful Cosmatesque marble inlays; pictures of the saints appear in the niches. Thus the painted architecture assumes a role of special importance in the composition, presenting the fiction of another space. ❧ ANOTHER novelty is visible in the Vault of the Doctors, where the four saints and their scribes are seated in articulated and complex Cosmatesque thrones resting on robust platforms, perfectly composed within the triangular spaces of the *vele* (sections of the ribbed vault); the complicated, very rich enclosures are crammed with steps, predellas, backrests, and armrests, all in very bright colors against the gold background. The Fathers and their accompanying friars are great and solemn, enveloped in mantles of heavy cloth with folds marked by sharp lines. ❧ WHOEVER the painter, he was very mature, rich in experience and accustomed to thinking in architectonic terms—a painter quite close in spirit to the author of the frescoes in the right transept of the church of Santa Maria Maggiore. He was certainly a Roman artist, but with a sensibility more modern than Jacopo Torriti's. ❧ THOUGH fresher than the first two bays, the *vele* of this vault have a great liturgical solemnity. Some interesting innovations can be seen, however, in the single *vela* with St. Gregory (the one that looks toward the apse; pp. 18–19): the platform that holds the throne and the scribe's high-backed chair—unlike the architecture in the other three *vele,* which appears fitted into the border—is supported by lions on consoles, thus breaking the close figurative bond between the architecture

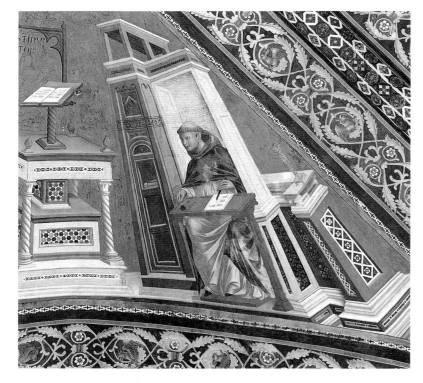

Giotto. Detail of ST. AUGUSTINE, *with scribe, Vault of the Doctors of the Church (p. 17). Upper Basilica of San Francesco, Assisi.*

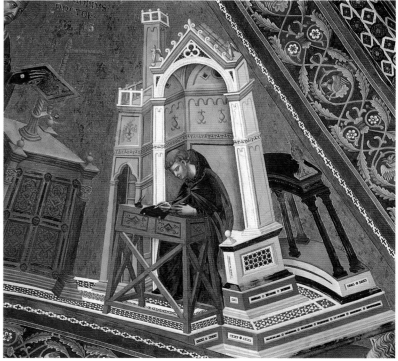

Giotto. Detail of ST. GREGORY THE GREAT, *with scribe, Vault of the Doctors of the Church (p. 17). Upper Basilica of San Francesco, Assisi.*

and the triangle of the painted field. The platform is spacious, and the diagonals are accentuated, anticipating the perspective boxes that Giotto will use from the Stories of Isaac on. The semicircular furniture fits better in the spaces next to the seats; but the most striking detail is the young friar's small table (p. 20 right), drawn in perspective with extraordinary precision, rendered in an exact calculation of elements, some bright in the light and others hidden in shadow. The figures are extremely vivid: the young friar bent over his book is indeed a real person, and his face has classical proportions. The face of the saintly Doctor, Gregory, is more deeply scored with wrinkles than those of his companions, and shows utterly new expressivity. We will encounter these faces again on the walls of the third and fourth bays; and the face of St. Gregory is identical to that of St. Francis's father in *St. Francis Renounces His Worldly Possessions,* in Giotto's Franciscan Cycle. ❧ THE walls with the stained-glass windows and the Old and New Testament cycles display further stylistic novelties. The following episodes appear: in the lower part of the third bay on the right wall are the two Stories of Isaac; on the opposite wall are the *Way of the Cross* and the *Crucifixion.* In the upper part of the fourth bay on the right wall are the remains of the *Slaying of Abel,* while in the area below are *Joseph Is Thrown into the Pit* and *Joseph Recognized by His Brothers.* Facing these, in the fourth bay on

the top tier are *Christ among the Doctors* and an almost illegible *Baptism of Christ,* while on the lower tier are the *Deposition* and a fragmentary *Resurrection of Christ.* ❧ IN ALL these badly ruined compartments, the compositions are articulated on several levels. The backgrounds lose their generic quality and are composed either of measured landscapes, for example in the *Deposition* and the *Slaying of Abel,* with rocks sloping precisely in diagonals, at once enclosing and opening up the space; or of Cosmatesque architecture, as in *Joseph Recognized by His Brothers* and *Christ among the Doctors.* The proportions of the figures are reduced, and their faces, designed on classical models, are powerfully individualized: at times they appear like expressionistic masks. The bodies, while preserving Cimabue's proportions, are enveloped in those cloth drapings, also of Cimabuesque origin, that Brandi (1983) has described as "prismatic folds," drawn with a precise line that lifts them off the background. Throughout, the characters are bound together in a kind of colloquy, underscored by gesticulation that is no longer generic, even though it may be rapidly sketched. ❧ THE new discourse continues, exploring certain themes and further refining the expressive medium, in two scenes on the entrance wall: the *Pentecost* and the *Ascension.* Of the latter there remain only the fragmentary figures of an angel, poised with assurance in the breadth of its large wings, and of Christ

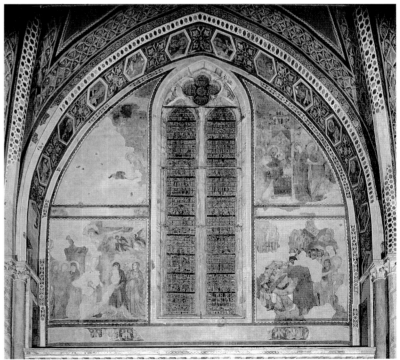

Entrance wall with busts of St. Paul and St. Peter, PENTECOST, *and* ASCENSION. *Upper Basilica of San Francesco, Assisi.*

Wall of the third bay with the New Testament Cycle. Upper Basilica of San Francesco, Assisi.

rising to heaven; but the former retains a very beautiful, ample section of a Cosmatesque church with three naves. Its decorative elements quite obviously refer to Arnolfo's style, and the church is positioned in a clear perspective; in front of it, in an enclosure, are seated the Madonna and the Apostles, most of them by now ruined and illegible. ❧ IT IS worth dwelling on the two medallions with portraits of saints Peter and Paul on the upper part of the entrance-wall decoration (p. 21 left), because they give the measure of the discrepancy between this great artist and the immediately preceding Roman painters. The medallions have a precise spatial definition, like openings in the thickness of the wall, emphasized by the play of light and shadow. St. Peter's face with its vivid intensity recalls the St. Joseph in Arnolfo's *Holy Crib;* his stole circles his neck precisely and drapes sharply over his shoulder, creating a conspicuous geometric accentuation that positions the figure spatially. Here too are a new personality and a new way of conceiving the relationship between figures and their environment: thinking in terms of space. ❧ I HAVE left for last the two beautiful Stories of Isaac, painted on the third bay of the right wall, because they constitute the highest and most mature realization of this part of the decoration (in the tier above the Franciscan Cycle) and have had, in comparison to the other episodes, a much longer and more complicated critical history. The

two scenes—*Isaac Rejects Esau* (p. 23) and *Jacob Receives the Blessing of the First-Born* (p. 25)—take place inside the same room, a proper "perspective box"—a perfect geometric and spatial re-elaboration of the "box" of the *Marriage at Cana* in the first bay. The blind patriarch Isaac reclines on a large wooden bed in the very simple room, adorned with a curtain that runs around the walls and hangs from a carefully detailed pole. The forward panels are lit up and the rear ones darker, because they are in shadow. The action is marked off by a series of graduated parallel planes. In contrast to the other stories on the opposite wall and in the next bay, here is a more measured and majestic composition: the spacious room is defined by the precision of the geometric design, and the curtain, elegant and in the fashion of the day, has a decorative significance and also serves to enclose the space more exactly by the play of light and dark. This is a very knowledgeable composition that already shows a precise relationship between the persons and the surrounding architecture. This justifies the scholars' perplexity: some are reluctant to attribute such compositions to a young artist making his debut, while others seek ties either to the other stories in the Old and New Testament cycles in the third and fourth compartments, or to the St. Francis cycle on the lower part of the walls. The figures are beautiful, with perfect features modeled along classical lines and with sober gestures. Isaac

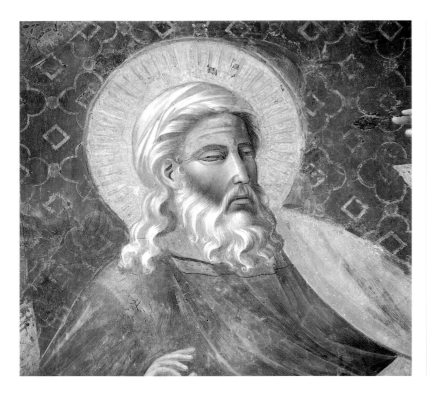

Giotto. Details of ISAAC REJECTS ESAU *(p. 23). Upper Basilica of San Francesco, Assisi.*

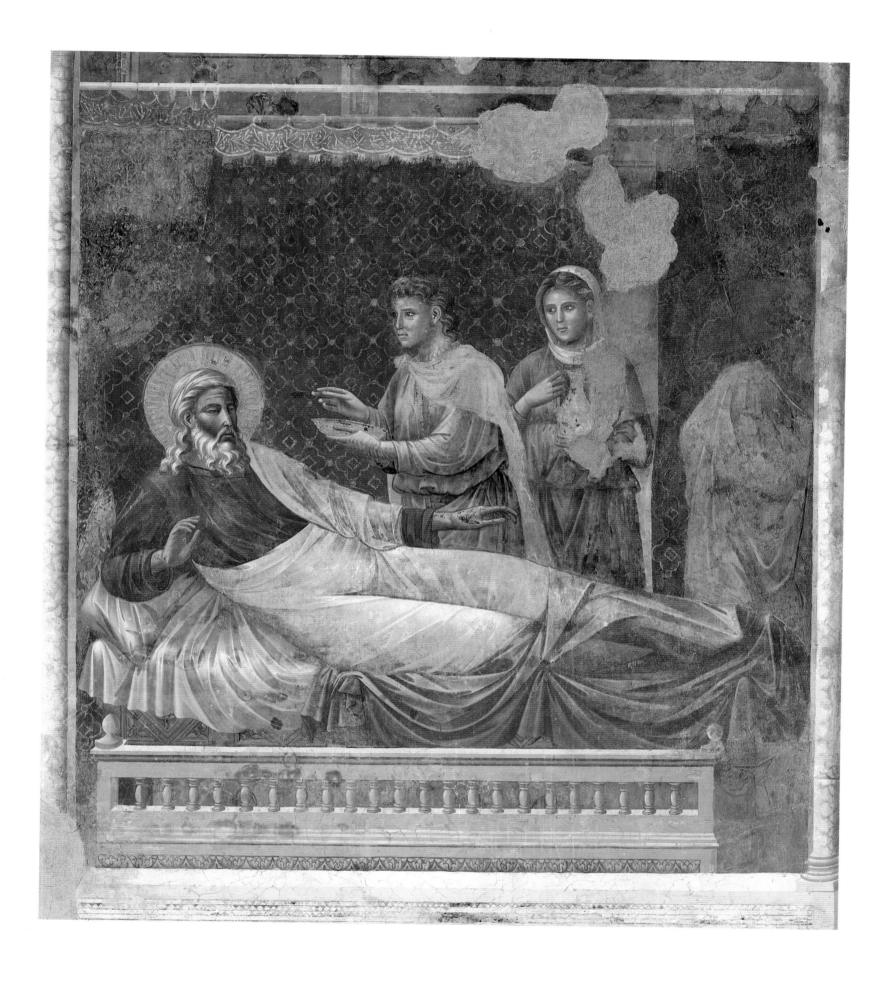

Giotto. ISAAC REJECTS ESAU.
Upper Basilica of San Francesco,
Assisi.

has the majesty of a figure on a Roman sarcophagus. And yet they are bound together by measured movements and in a barely discernible dialogue; their faces are tense and attentive. For example, in *Jacob Receives the Blessing,* Isaac touches Jacob's hand so as to recognize him, and Rebecca draws the curtain aside just a bit to watch. The completely new tone of truth is striking; and a very pronounced naturalistic attention can be seen in Jacob's face, even with his eyes half-closed due to his blindness (Romanini, 1987; p. 22 left). ❧ THE light in these compartments comes not, as one might think, from the front, but from the tall, narrow window between the two scenes: thus the episode on the left is illuminated by light coming from the right, and the other episode is lit from the opposite direction. This study in the reality of light can also be seen in other details such as Esau's curved hand, which is in shadow, while his fingertips are formed by a brushstroke of light. ❧ THIS painter uses a new and, in some aspects, revolutionary language that appears timidly in the *Way of the Cross,* in the *Crucifixion,* and in the Vault of the Doctors, and after that more and more forcefully, with a powerful, provocative urgency in the other frescoes. Evolving with great rapidity, the painter develops his own effects, as in the Stories of Isaac and in the *Deposition* (p. 28) and even more clearly in the two limpid portraits of saints Peter and Paul in the highest part of the entrance wall. By now a good number of art historians recognize this painter as Giotto making his great decorative debut. ❧ IN THEIR accurate analysis of the frescoes Tintori and Meiss (1962) have clearly shown how, starting with the third bay, the change in style on the walls corresponds to a revolutionary technical change: the fresco technique called *a giornate* (a daily application of a small area of wet plaster followed by immediate painting in pigment) was perfected here for the first time. Unlike the old method, *a pontate* (plastering as large an area as the scaffolding, or *ponte,* would permit, and then painting on the dried plaster), this permitted superior pictorial delicacy with effects quite similar to those of panel paintings. So Giotto launched this technical revolution, which was to have a great influence on Italian painting, from its first appearance on the highest scaffolds in the Upper Basilica of Assisi. ❧ THE large entrance arch does not belong to the same sensibility: the small niches, set in exact symmetry, are boring and repetitive. The figures of the saints, which Previtali (1967) assigned to the Sienese Memmo di Filippuccio, have more reduced proportions and are formed with a certain plasticity; but despite the slender elegance of line, their formulation is too thin and their sweetened faces are too repetitive to be attributed to the violent and robust language of the young Giotto. ❧ ALL scholars recognize that the painter of the frescoes of the third and

fourth bays, and especially the Stories of Isaac, was a very great artist and obviously an innovator in the context of what we know of the Roman and Florentine schools. But the identification of the artist, or artists, remains a problem. ❧ ART historians have divergent opinions on this question, and so here I can review only the most important stages of the debate, and the most significant positions of contemporary scholarship. Thode (1885) was the first to recognize Giotto's hand not only in the Upper Basilica's Franciscan Cycle but in the frescoes of the third and fourth bays, and he was followed by Zimmermann (1899) and later Toesca (1927) and Berenson (1932). This opinion is accepted by many, especially by Italian scholars. However, Coletti (1949) assigns the two compartments of the Stories of Isaac to a different personality, the so-called Isaac Master. Salvini (1952), Gnudi (1958), Previtali (1967), Bologna (1969b), Bellosi (1983), Bonsanti (1985), and Bandera Bistoletti (1989) assign to Giotto all the frescoes of the two bays and the Vault of the Doctors. I should also mention the recent opinions of Pesenti (1977), who attributes the Stories of Isaac to a painter from Arnolfo's circle, and of Romanini (1987), who assigns them to Arnolfo himself. Brandi (1983) assigns the Stories of Isaac to an unknown Roman painter and the other biblical stories to a Roman follower of Giotto. ❧ BUT to clarify this complex problem, one must first establish that the same hand created the Stories

of Isaac and the other stories in the two bays. First of all, the spatial qualities of the compositions are identical; similar, though more complex, compositions can be found in *Joseph Recognized by His Brothers* and in the *Deposition.* The handling of the drapery is the same in all the compartments, and the faces closely resemble one another. Jacob's face has the purity of profile of Joseph's brothers and of St. Gregory's acolyte. Rebecca, copied from a classical statue, is close kin to the women—also dressed in the Roman style—of the *Deposition;* and in the first of the two Isaac episodes, with sharp wrinkles on her forehead, she is actually similar to St. Gregory in the Vault of the Doctors. Furthermore, the idea of a "perspective box," which seems so new, was already present, though in a flat and not rigorous spatial form, in the *Marriage at Cana* by the Torriti workshop in the first bay; and it has a long sequel in the Franciscan stories, starting with the almost identical repetition of St. Francis's room in *St. Francis Sees a Building in a Dream,* and in the room where Pope Innocent III sleeps. ❧ THE format of *Joseph Recognized by His Brothers* anticipates the composition of the *Crib at Greccio* in the St. Francis episodes in the band below: here too is a rood-screen separating the royal palace from the city, and a door, which in the *Crib at Greccio* will be filled with people. In both, the focal point is shifted to the right: here it is the throne, while in the *Crib at Greccio* it is

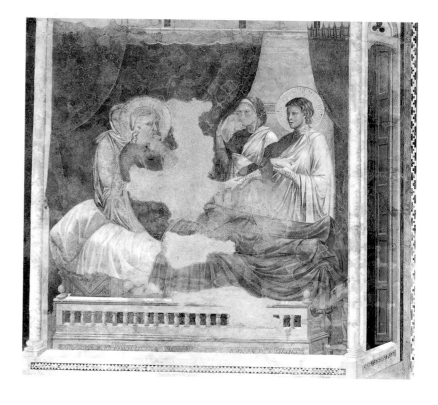

Giotto. JACOB RECEIVES THE BLESSING OF THE FIRST-BORN. *Upper Basilica of San Francesco, Assisi.* ❧ *page 26: Giotto. Detail of* DEPOSITION *(p. 28). Upper*

Basilica of San Francesco, Assisi. ❧ *page 27: Giotto. Detail of* JACOB RECEIVES THE BLESSING OF THE FIRST-BORN. *Upper Basilica of San Francesco, Assisi.*

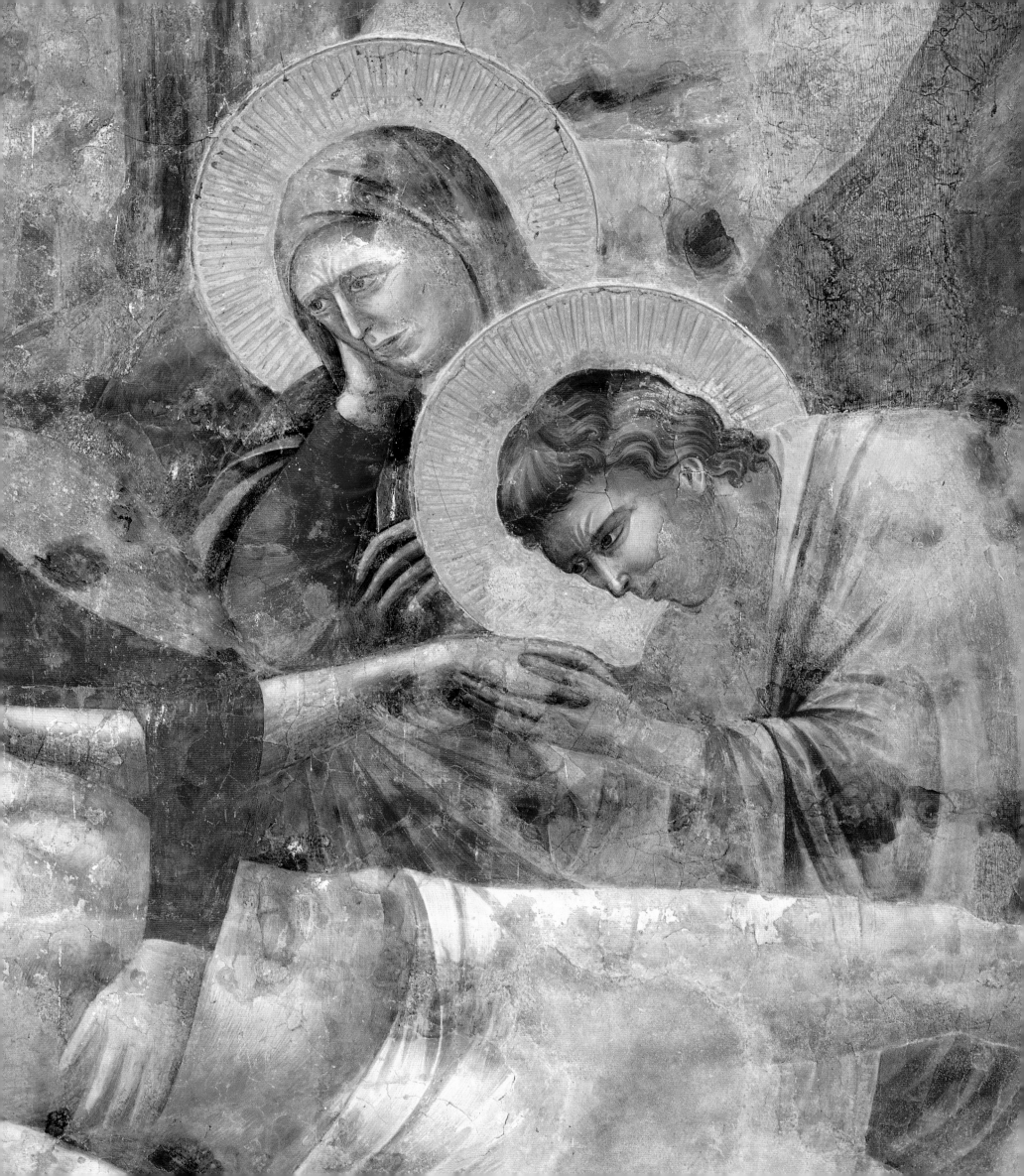

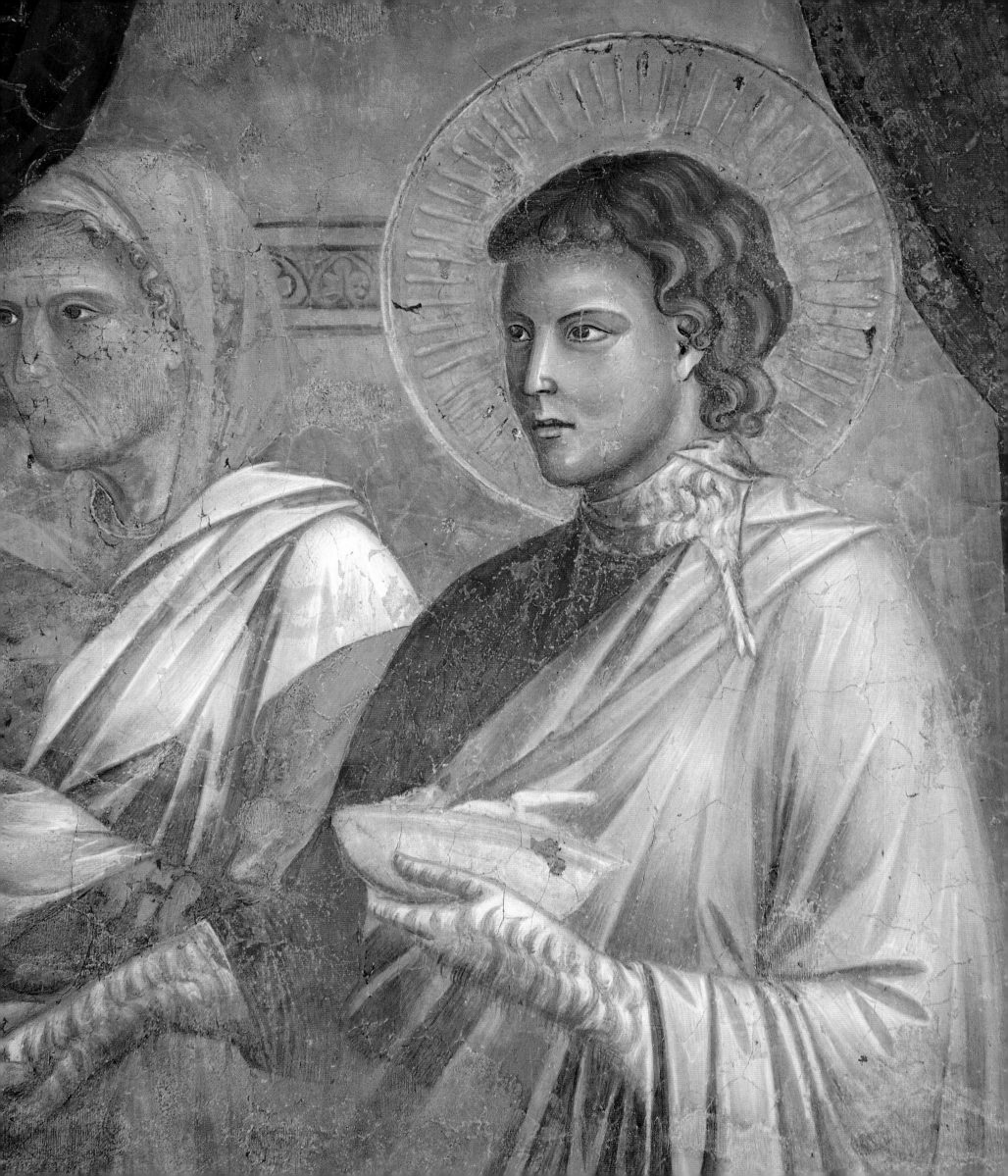

the canopy above the high altar. Beyond the screen the buildings are seen in perspective; light and dark are exactly balanced in etched clarity. In this case the people seem like paper cutouts: they are delineated with a very sharp contour that curves over their shoulders, a single decisive line from head to toe, exactly as in the later Franciscan frescoes, for example in the *Crucifix at San Damiano Speaks to St. Francis.* ❧ FURTHER comparisons among the frescoes in question and the Franciscan stories can be made: the angel in the *Ascension* is the same as the angel in the *Vision of the Thrones;* the person in profile in *Joseph Is Thrown into the Pit* is similar to the poor knight in the *Cloak Incident;* and in this episode the landscape with small trees seems simply to repeat the landscape in the *Slaying of Abel.* But one can also see in the episodes of the upper tier of the third and fourth bays precise harbingers of episodes and paintings that are unquestionably by Giotto; these leave no further room for challenging that the Florentine master did some of the frescoes in the upper areas. ❧ ONE could begin with the *Deposition* (below) where the compositional design simply anticipates the same scene in the Scrovegni Chapel in Padua: in both instances the episode is enclosed by a boulder that slopes up towards the right; also on the right are two men on their feet, one of whom has his hands clasped before him; the women are clustered on the left. The two pictures present completely similar groupings of people in a semicircle around Christ, in an effort at spatial extension. A disorderly flight of angels, reminiscent of Cimabue, crosses the sky. ❧ IN THE upper part of the fourth bay the adolescent Jesus is seated before an ample, spacious Cosmatesque building seen from the front: it is a cross-section, shown in perspective, of an arched apse with lateral naves open to the light, giving us a glimpse of the sky. In this case too it is not difficult to connect the scene with one in Padua: the *Marriage of the Virgin* there has a similar cross-section of a church. ❧ IN A further comparison with another work by Giotto, one can compare Jacob's mantle in the two Stories of Isaac with the mantle of St. John in the *Crucifix* at Santa Maria Novella: the two display identical drapery. This also proves that Giotto is the artist who worked on the third and fourth bays in the Upper Basilica at Assisi. The dating of this, Giotto's first contribution in Assisi, should be placed immediately after Torriti's departure from Assisi, that is, quite close to 1290; followed soon after by his work on the Franciscan frescoes in the lower band, which were executed without a break, at least during the first episodes of the cycle. ❧ THE attempt, most recently by Brandi (1956, 1971), to date the execution of the Vault of the Doctors, and therefore a whole part of the frescoes of the third and fourth bays, after 1298, the year in which Boniface VIII issued a bull

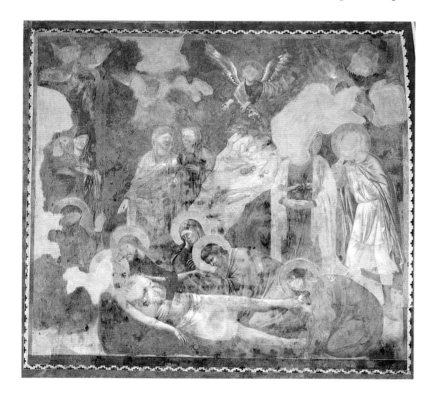

Giotto. DEPOSITION. *Upper Basilica of San Francesco, Assisi.*

regarding the cult of the Doctors, is based on an inexact interpretation of the papal document. As both Gardner (1973) and Belting (1977) have explained quite clearly, the bull simply extended the already ancient cult of the Doctors to the entire Church.

&~ THE frescoes in which I see the hand of Giotto provide proof of the young artist's debt to the painters who worked immediately before him, and allow us to clarify the course of his development. There are at least two fundamental components in his stylistic language: one is Cimabue, present in the definite contour lines, the sharp-edged drapery, the persistence of medieval proportional models, and above all in a compositional skill that creates well-balanced episodes, enclosed within precise defining limits, and in which the characters interact in a dialogue. The other is Arnolfo, who appears to be Giotto's master in the creation of an extended classical spaciousness; in architecture with Cosmatesque ornamentation; in the plastic structure of figures enclosed by geometric forms; and in the rediscovery of classical facial and clothing types. &~ GIOTTO'S relationship with his elder Pietro Cavallini, often mentioned by scholars, was not a determining factor in this period. It is quite true that Cavallini's episode of the *Nativity of Mary* in the mosaics in the church of Santa Maria in Trastevere, which could date to 1291, has some similarities with the two Stories of Isaac: the background curtain, the slender columns supporting the bed, and particularly the oval shapes of the female figures. But it is also true that the Assisi episodes are set out with much greater force and spatial clarity. Pietro Cavallini's highly refined painting, intensely concerned with the ancient world, is quite a different matter and is connected with another, very cultivated figurative tradition. &~ ONLY later, if at all, can we find Cavallini's influence on Giotto: in the *Last Judgment* in Padua, as has long been noted, and also in the classical majesty of the Badia *Polyptych* and the serene pose in the Rimini *Crucifix*. But all this occurred after Giotto's second Roman visit in 1297. &~ MORE important is to emphasize Giotto's debt to classical antiquity, a debt increased every day by his contact with the numerous ruins that could be admired in Rome in the late thirteenth century. The debt is quite visible in the shape of Giotto's faces and in the amplitude of the clothes, especially women's clothes in the Stories of Isaac and in the *Deposition*. And it is visible in his study of contemporary architecture that proposed expansive and serene spaces, also of a strong classical flavor, obtained with clear, linear elements such as white marble enriched by friezes and Cosmatesque motifs.

THE
FRANCISCAN
CYCLE
IN ASSISI

THE STORIES OF ST. FRANCIS

❧

THE LOWER, PROTRUDING PART OF THE NAVE WALLS IN THE UPPER BASILICA OF ASSISI PRESENTS A COMPLEX DECORATION, ARTICULATED WITHIN A MOCK PORTICO SUPPORTED BY TWISTED COLUMNS; HERE ARE TWENTY-EIGHT SCENES TELLING THE STORIES OF ST. FRANCIS

according to St. Bonaventure's *Legenda maior,* written between 1260 and 1263. This text took the place of the previous life of the saint and constituted the official version of the Franciscan legend. Beneath the frescoed stories, the walls are covered by a painted display of very beautiful cloths with contemporary motifs (below), which Klesse (1967) attributes to the school of Giotto. Different from bay to bay, the cloths hang like draperies, lending an aspect of sumptuous wealth to the decoration of the nave. ❧ THE scholarly literature on the Franciscan frescoes is huge, and the problems concerning their attribution and chronological placement are very complicated. In this essay, therefore, I can discuss only the most significant opinions and especially the most recent ones. ❧ THE first mention of Giotto's work at Assisi is found in Riccobaldo Ferrarese (c. 1312–13); but it is Ghiberti (c. 1450) who first points out that Giotto "painted almost the entire lower part [of the walls] in the Church of Assisi, in the order of minor

friars." In the second edition (1568) of the *Lives* Vasari speaks explicitly of the "Legend of St. Francis" (in thirty-three compartments) as Giotto's work. After this the attribution to the Florentine master was generally accepted until Witte (1821), followed a short time later by Rumohr (1827), denied Giotto the authorship of the Franciscan Cycle, pointing to the many differences between these frescoes and those in the Scrovegni Chapel in Padua. This position was taken up again later by such famous scholars as Rintelen (1912), Fischer (1956), White (1957 and 1966), Meiss (1960), and Smart (1960), but today it has fewer supporters. Giotto's paternity of the cycle is generally accepted, though opinions differ as to its date. A precise date *ante quem* is 1305, since the Torre del Popolo on the main piazza in Assisi is depicted as still incomplete in the *Man in the Street Pays Homage to St. Francis;* in 1305 the tower was raised and completed. Vasari asserts that the pictorial cycle was executed under the Franciscan superior gen-

Workshop of Giotto. Detail of decoration with trompe l'oeil drapery. Upper Basilica of San Francesco, Assisi.

eral Giovanni da Muro (1296–1304). Since then it has been considered generally datable to the close of the thirteenth century, though the date has been pushed back to the beginning of the 1290s, during the pontificate of Nicholas IV, by Murray (1953), followed by Bellosi (1983). Moreover, the latter suggests a second *ante quem* date of 1297, revealing that in the frescoes of the Hall of Notaries in the Priori Palace of Perugia, which can be dated to 1297, there are precise quotations from the Assisi paintings, which therefore must have been executed beforehand. A further bit of support for a date prior to 1297 is offered by Maddalo's study (1983), which maintains that in 1297 Giotto did the decoration of the gallery in San Giovanni in Laterano in Rome. In fact it is logical to think that the painter would have finished the Franciscan Cycle before undertaking the arduous Roman task. ❧ I ACCEPT the proposal that the entire decoration of the nave was done during the pontificate of Nicholas IV, between 1288 and 1292. The frescoes of the Franciscan Cycle must have followed the decoration of the upper parts of the walls without a break: so many are the links between the third and fourth bays and the Franciscan Cycle, especially the episodes on the right wall, that the biblical stories must have been painted before. But even from an iconographic viewpoint the Franciscan Cycle was clearly conceived together with the episodes in the upper tier, as part of a single program celebrating both the Assisi saint and the Franciscan order. This iconographic program could only have been inspired by Nicholas IV, a Franciscan himself. ❧ PREVIOUSLY the iconographic themes utilized for the decoration of churches were inspired by the Stories of the Old Testament counterposed to Stories from the New Testament, prefiguring the New in the Old; this style, derived from the first Fathers of the Church, was typical of medieval theology and preaching. In the uppermost tier of the nave in Assisi the episodes from the Old and New Testaments mirror one another. But in this case the cycle is completed, significantly, with the St. Francis stories: St. Francis was by this time considered "another Christ" *(alter Christus)*. This audacious juxtaposition had already been carried out by the Master of St. Francis in the frescoes of the Lower Basilica. ❧ SHORTLY thereafter, the new order of Franciscan friars became more important in the Church, particularly after the victory of the more worldly Conventual faction over the Spirituals. The powerful Orsini family furnished protective Franciscan cardinals; and the order also produced a pope, the friar Girolamo Masci from Lisciano, elected to the pontifical throne under the name of Nicholas IV in 1288. The new pontiff's attention to the Franciscan order, and his devotion to its greatest saints, Francis and Anthony, was manifested immediately by mosaic decorations

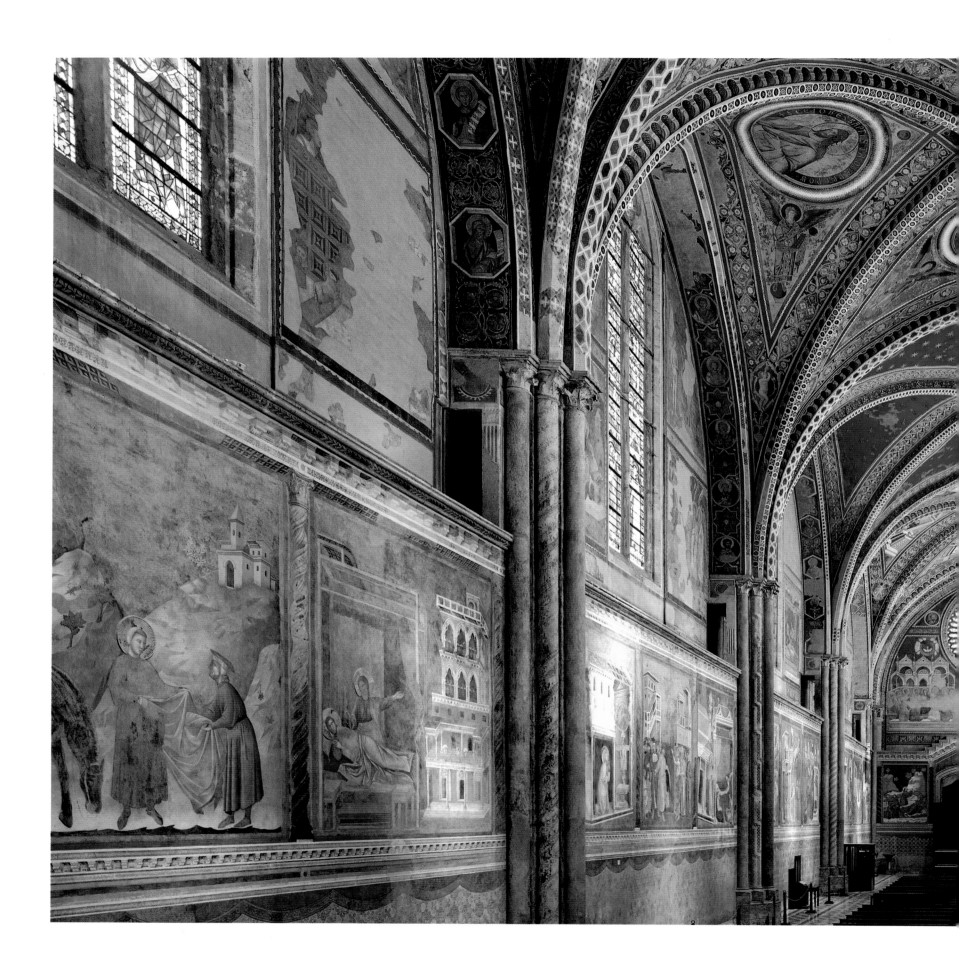

View of the nave looking toward the entry. Upper Basilica of San Francesco, Assisi.

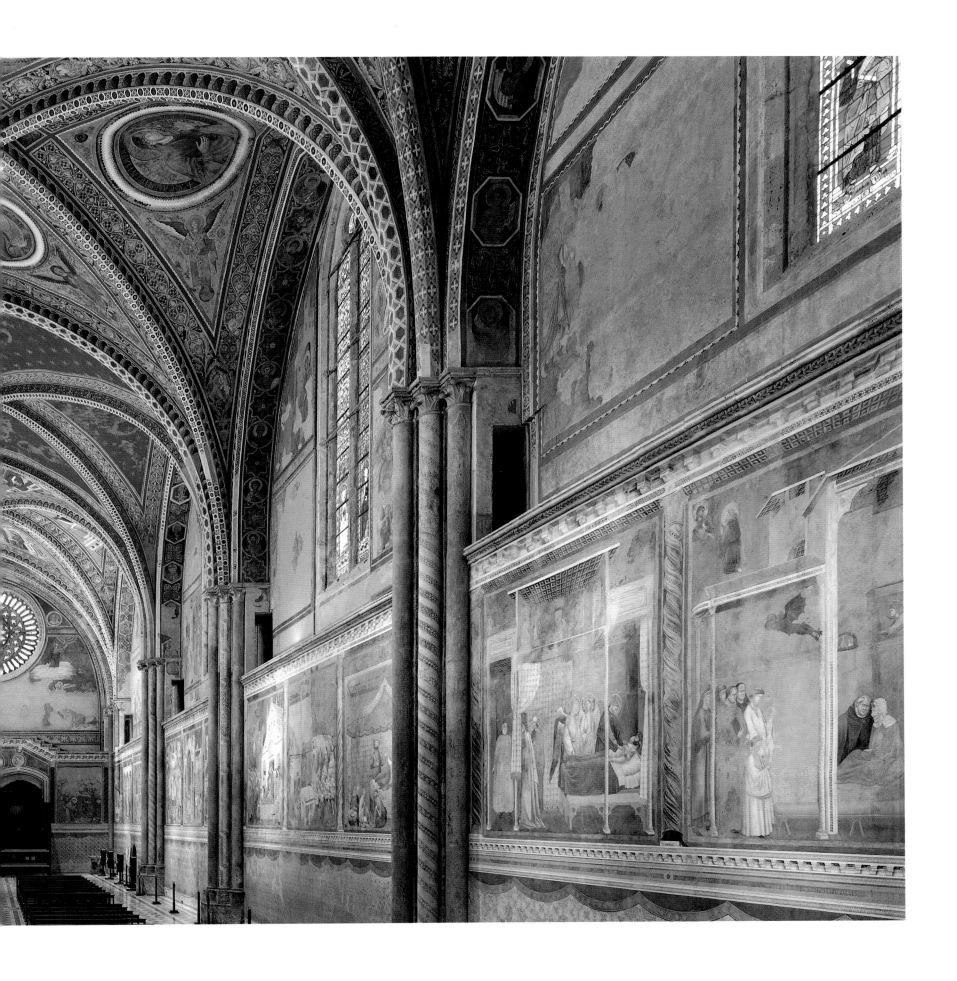

page 36: *Wall of the third bay. Upper Basilica of San Francesco, Assisi.*

page 37: *Entrance wall. Upper Basilica of San Francesco, Assisi.*

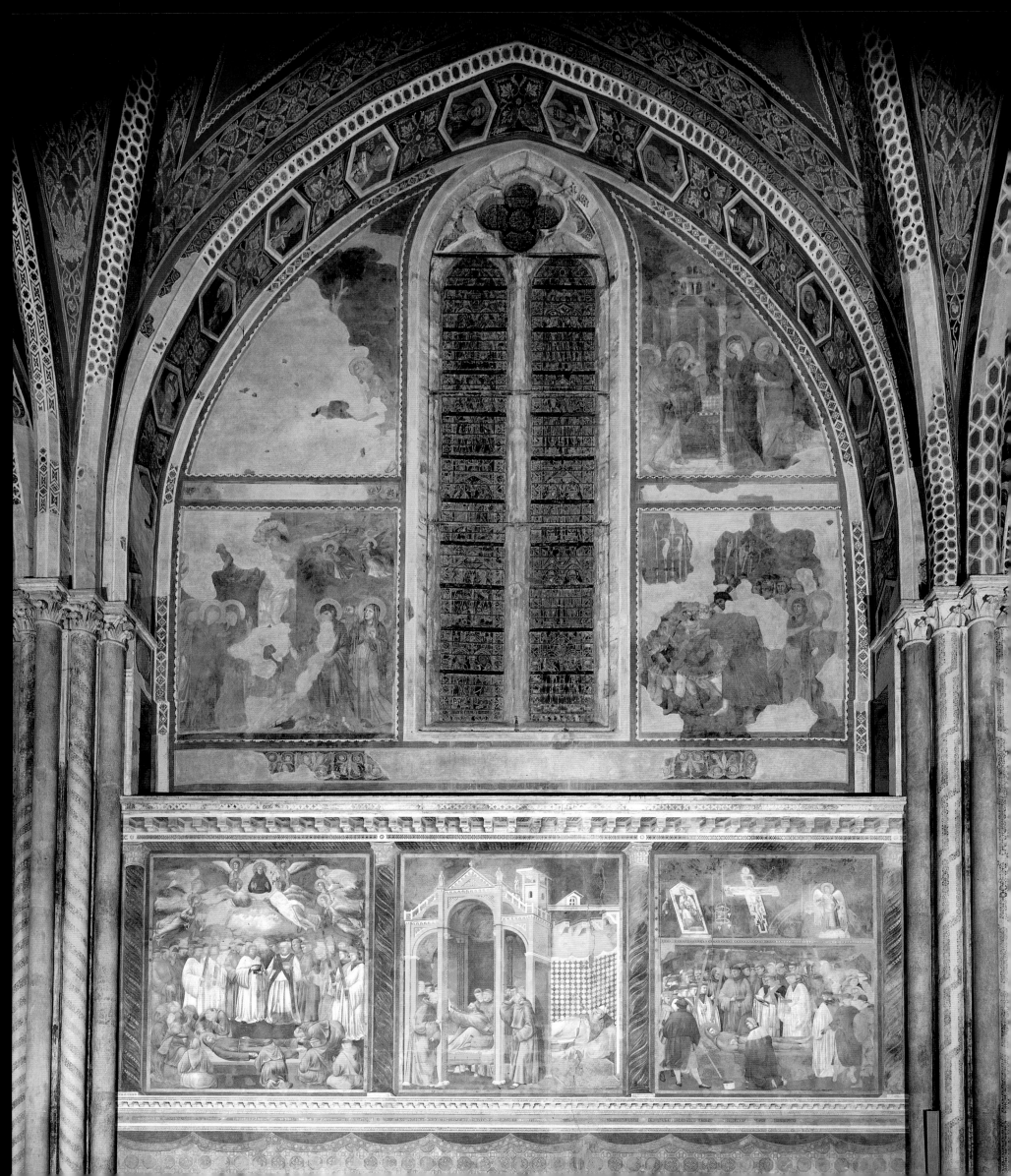

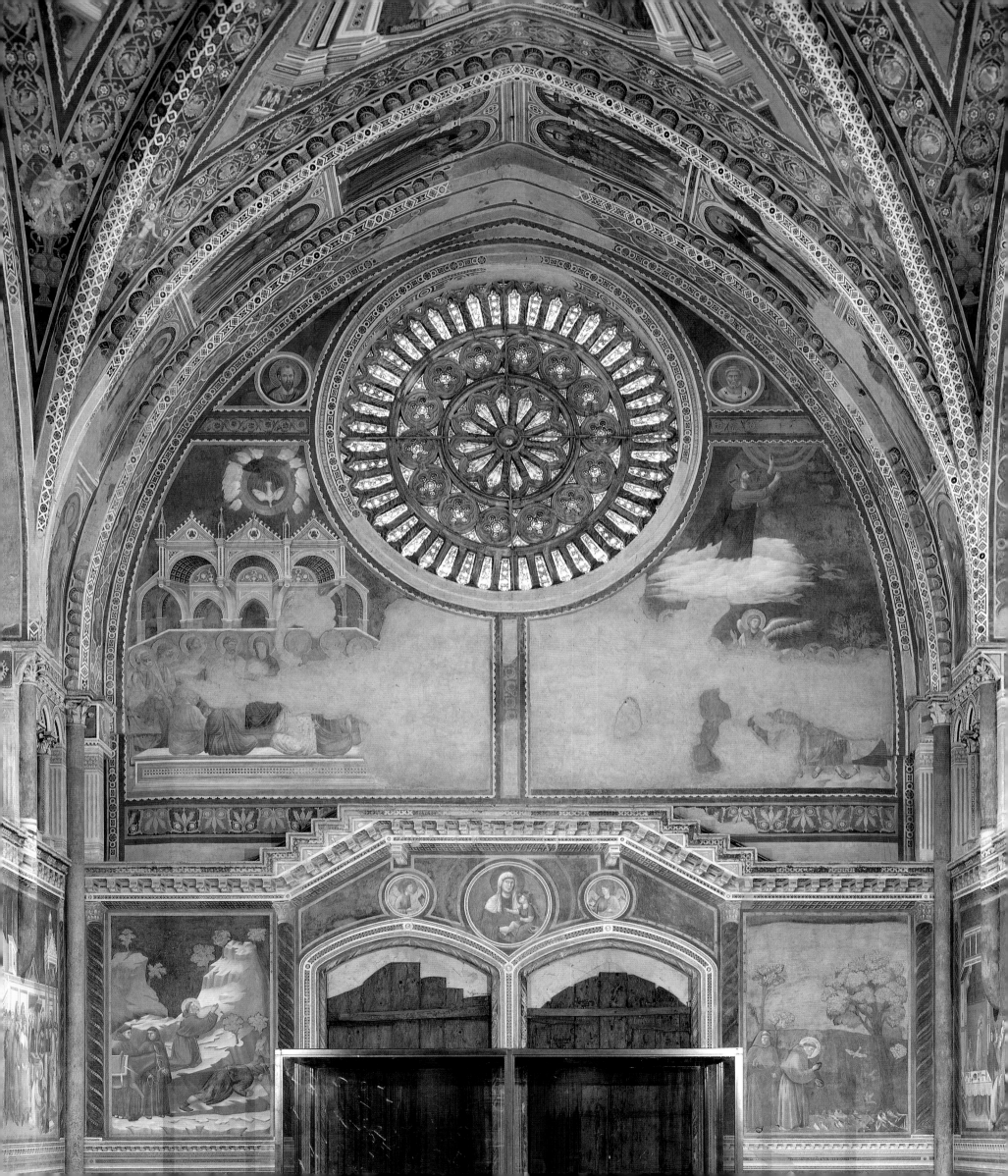

in San Giovanni in Laterano, and later in Santa Maria Maggiore, where he had the two friars portrayed alongside the Madonna, St. John the Baptist, and the apostles Peter, Paul, John the Evangelist, and Andrew. The inclusion of saints Francis and Anthony revolutionized an iconography in use for centuries, proclaiming the centrality of the Franciscan order in the life of the Church. ❧ IT IS thus reasonable to trace to this same pope the idea that the consummation of the Old and New Testament cycles can be found in the stories of St. Francis, that *alter Christus* and pillar of the official Church. The frescoes with episodes from the life of St. Francis were not necessarily finished before the death of the pope, but they had been conceived in a single program launched by the pope himself. Possibly there was some interruption in the execution of the cycle, which shows, as will be seen more clearly, some distinct phases and diverse styles. But I believe the decoration was certainly finished before 1297, the year in which Giotto returned to Rome for an important task commissioned by Pope Boniface VIII. ❧ THE Franciscan Cycle is the first great manifestation of Giotto's personality that has come to us in relatively good condition. They present absolutely new characteristics in respect to all late thirteenth-century decoration in the Florentine and Roman regions, and even in respect to the frescoes in the transept and in the upper part of the nave in the Assisi basilica.

Their very layout is revolutionary. ❧ THE walls of the nave (pp. 34–35) are articulated in a powerful rhythm of triplets. Each bay presents a complex architectonic apparatus, formed by four twisted columns with Cosmatesque motifs, which form a shallow gallery; at the back of this gallery are the sets of three compartments with the episodes. The only exception is the first bay, which has five twisted columns and four compartments. The architectonic motif, which in a certain sense repeats the tripartition of the upper area of the walls (where a tall window is flanked by scenes on each side; p. 36), appears unified in a single space, measured by the fictive coffered ceiling of the gallery in precise perspective and by the brackets of the architraves, also painted in perspective so that they diverge from the middle of each bay towards right and left. ❧ ON THE entrance wall (p. 37) the motif of twisted columns supporting an architrave with brackets in a fictive gallery also includes the doorway, in a complex play of painted architecture in dialectical relation to real architecture. With their powerful evocation of Paleo-Christian decoration, the three medallions form a tight unit with the real architecture. The medallions' images—the *Madonna with Child* and two angels, all against gold backgrounds—mimic mosaic, and thus should be read in this context, rather than as part of the narration of the St. Francis episodes. ❧ THE motif of twisted columns was typically Roman,

Giotto. Detail of ST. FRANCIS RENOUNCES HIS WORLDLY POSSESSIONS *(p. 60). Upper Basilica of San Francesco, Assisi.*

and can be found in architecture and sculptural groups; in late thirteenth-century paintings the columns would divide different compartments. This motif can be found in the frescoes in the nave of St. Peter's, restored by Cavallini; and Cavallini himself repeated the motif in the decoration of Santa Cecilia in Trastevere, which can perhaps be dated before 1293. The use of this motif confirms Giotto's presence in Rome before the work in Assisi. But Giotto did something absolutely different with the columns here: rather than using this motif to measure or to frame the scene, he invented a fictive architecture superimposed on the real architecture, creating an illusory space (White, 1957) alongside the real space. ❧ THE frescoes by the Master from beyond the Mountains and those by Cimabue, both in Assisi, launched a new spatial discourse in respect to the preceding medieval tradition (Belting, 1977; Bellosi, 1983), based on the illusion of painted architecture; in Giotto's frescoes the technique acquires a completely new robustness and clarity. Within the clear formula of the tripartition of the wall, the composition of each single compartment proposes new and daring solutions to the spatial problem with equal clarity. And though the episodes may not show a homogeneity of solutions, as would be achieved in Padua, it is still possible to sense a continuous spatial experimentation, which produces sublime results in some cases, and more inorganic and imprecise compositions in others. ❧ THE space is ample and is defined precisely by the articulation of the background architecture or by the diagonal descent of the mountainous landscapes. Architecture and settings are studied and rendered with careful lines measured geometrically, in an embryonic—sometimes perfect—perspective. In comparison to the scenes in the area above, color plays an important role in the composition; note the (ever more sober) tints of the palaces, houses, and cities. Furthermore, these buildings are always based on real models, rather than on traditional pictorial typologies. ❧ THE effective relationship between environment and protagonists is new also: a kind of visual echo happens between the settings and the protagonists of the scenes. This is the case in *St. Francis Renounces His Worldly Possessions* (opposite) where the two groups seem to be heaped against the two architectural wings; in the *Miracle of the Spring* (below) where the people fit themselves into—indeed almost seem to be reclining on—the rocks; and in the *Stigmata,* where the pyramidal block of the saint in ecstasy is made gigantic by the mountain looming behind him. In other cases the relationship is realized in a more precise proportional measure between the architecture and the persons. ❧ "PERSPECTIVE BOXES" quite frequently appear, re-working with greater elegance the two rooms of the Stories of Isaac: the small room where Francis sleeps in

Giotto. Detail of MIRACLE OF THE SPRING *(p. 72). Upper Basilica of San Francesco, Assisi.*

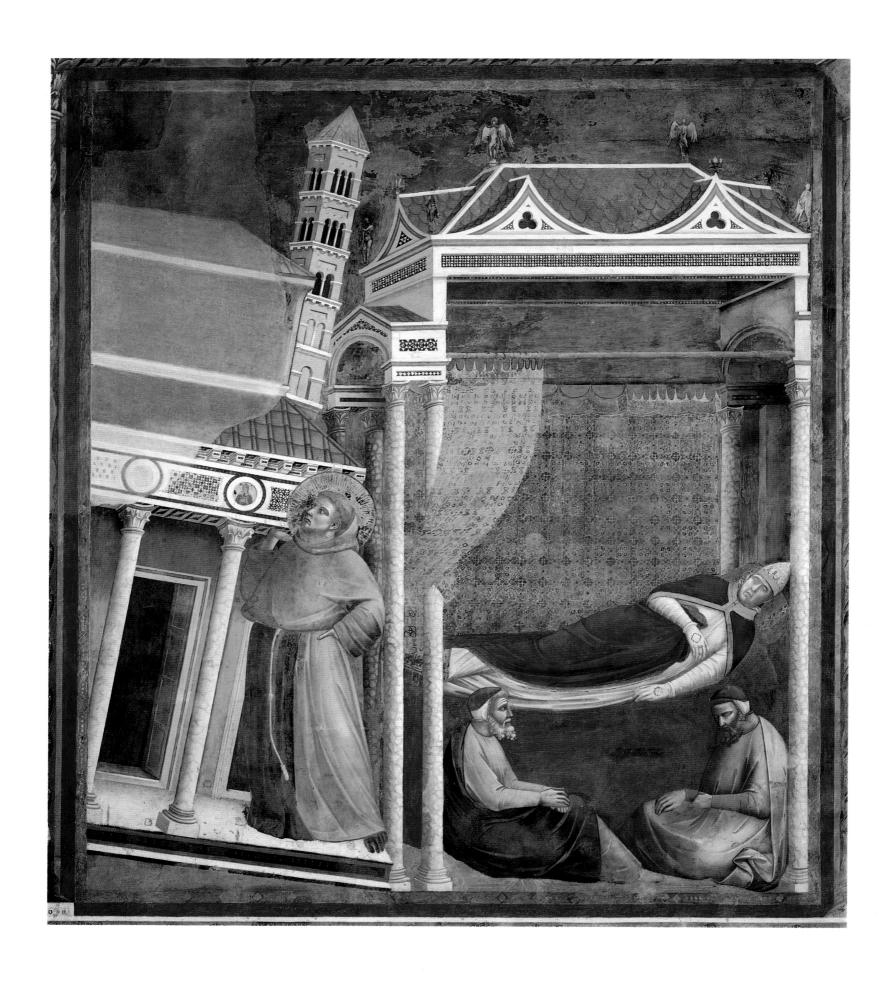

Giotto. DREAM OF INNOCENT III.
Upper Basilica of San Francesco,
Assisi.

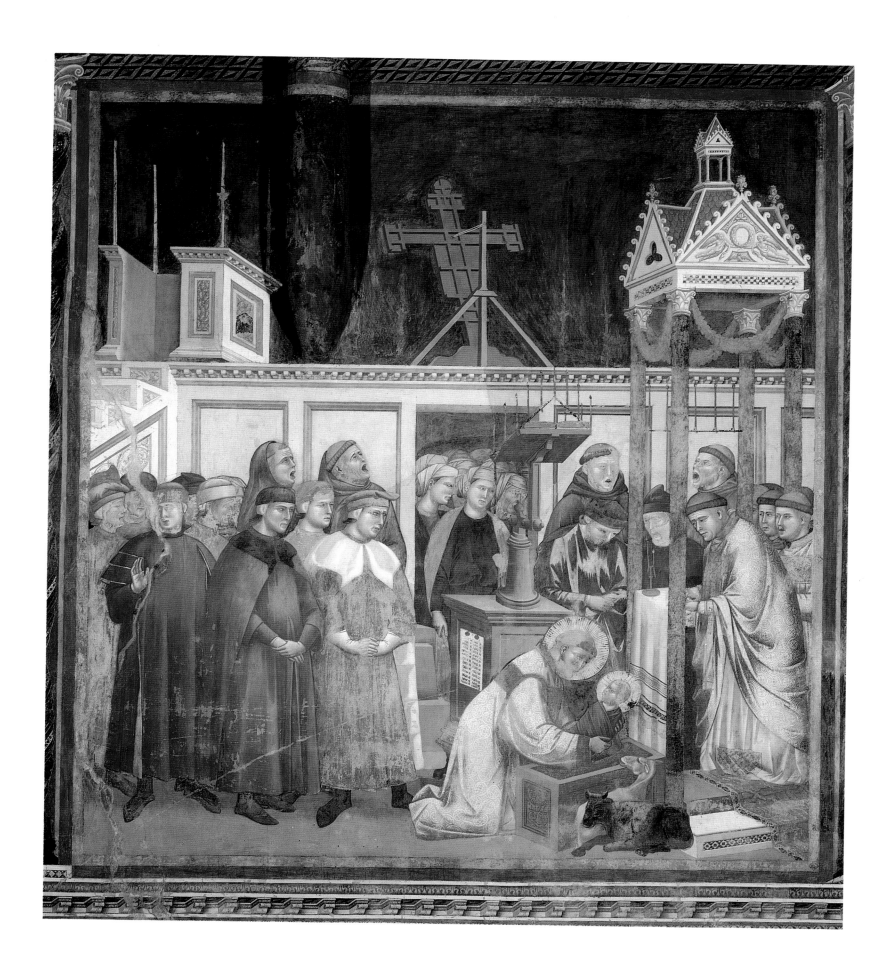

Giotto. CRIB AT GRECCIO. *Upper
Basilica of San Francesco, Assisi.*

St. Francis Sees a Building in a Dream and the more elaborate edifice of the *Dream of Innocent III* (p. 40) copied exactly, down to the motif of the curtain, hung on a pole, that reflects more light in the front. And this one element must suffice to attribute to Giotto the two famous pictures of the upper tier—must suffice, that is, until one comes to the extremely daring and revolutionary scenes where the architecture that occupies the entire scene almost becomes the protagonist. This is the case with the cross-section of the church in the *Crucifix at San Damiano Speaks to St. Francis;* and even the episodes clearly postulated in a perspective sense, such as the *Crib at Greccio* (p. 41), the *Franciscan Rule Approved,* and *St. Francis Preaches before Honorius III* (below right), all constitute crucial elements in the pictorial elaboration of painted space in the thirteenth and fourteenth centuries. The geometric precision of the design is matched by the precise study of light: light unifies the compositions with an exact play of bright and dark, of objects in light and objects in shadow, much more effectively than in the frescoes of the upper tier. This is a knowledge of real light; it is as if a shaft of light comes from the facade, grazing across and creating the robust volume of the figures. ❧ PUT in terms of the precise study of the incidence of real light, Giotto's chiaroscuro, in the Franciscan Cycle even more than in the Old and New Testament cycles, shows a phase of very personal and complex development beyond Piero Cavallini's work and that of other Roman painters, including the still anonymous master who did the frescoes from the church of Sant'Agnese, preserved today in the Pinacoteca Vaticana. For Giotto's chiaroscuro creates a sharp and incisive design, capable of powerfully individuating form, whether it be architectonic or human. The result is an utterly unprecedented series of figures, revolutionary in the context of the painting of the last part of the thirteenth century: figures constructed with sturdy vigor, resembling painted statues, enclosed in a geometric form marked off by a continuous sharp contour; figures that tower gigantically in the composition, while staying within the proportional module and in balanced relation with the setting. ❧ THE Franciscan Cycle is an extraordinary new work also because of its fresh conception of history as the depiction of events happening in a certain place at a concrete time, a conception quite distant from the generic, formal approach of previous pictorial representations. There was already a long Franciscan iconographic tradition—besides the episodes in the Lower Basilica there were many panels with depictions of St. Francis and of some of the popular legends of his life—that presented the saint in a highly stylized formula, in a generic space, proportioned larger than other men; his image was still loaded with sacramental significance. ❧ FOR Giotto,

Giotto. Detail of MAN IN THE STREET PAYS HOMAGE TO ST. FRANCIS *(p. 56). Upper Basilica of San Francesco, Assisi.*

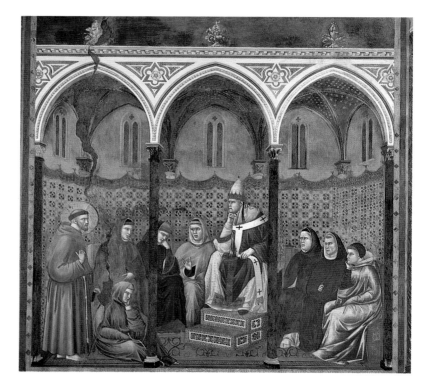

Giotto. ST. FRANCIS PREACHES BEFORE HONORIUS III. *Upper Basilica of San Francesco, Assisi.*

page 43: Giotto. Detail of ST. FRANCIS PREACHES BEFORE HONORIUS III. *Upper Basilica of San Francesco, Assisi.*

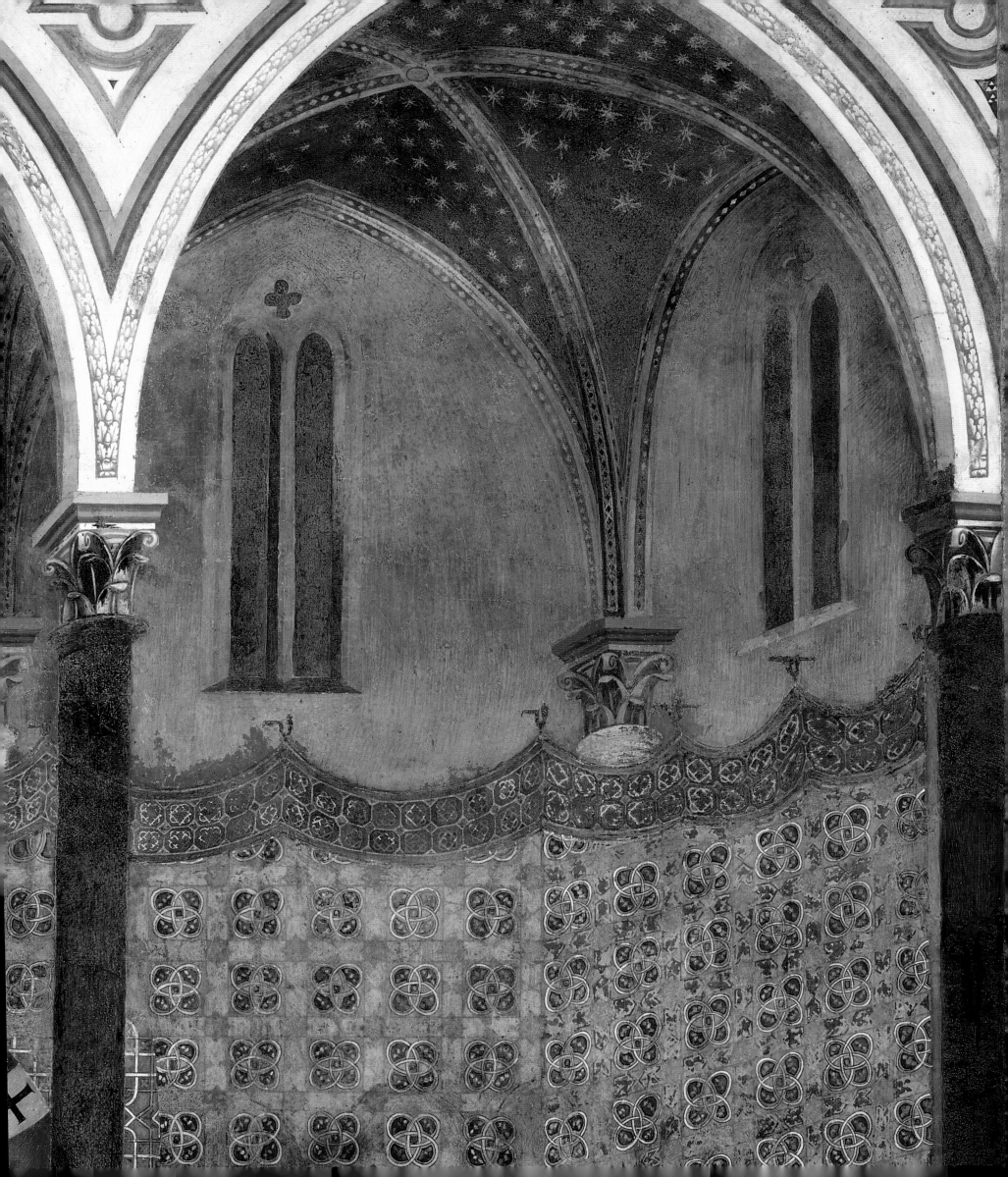

Francis is a human being, no different from others, and his legend becomes history, steeped in the reality of everyday life and in the concreteness of a city, a landscape, a real known world. This is a figurative revolution of extraordinary scope, but it is also an ideological revolution, since it starts a process of secularization of the sacred and of actualization of events that is absolutely different from, indeed opposed to, the medieval tradition, and will characterize painting in particular throughout the fourteenth century and afterwards. ❧ THUS the representation of sacred art begins, here on the walls of the Upper Basilica in Assisi, to carry a different connotation: secular, profane, modern. The architectonic backgrounds begin to present real buildings, some with a highly allusive value. For example, Giotto includes the piazza of Assisi with the Temple of Minerva and the Torre del Popolo, the city of Arezzo, and, most important, Rome. Rome and the most significant Roman edifices are the principal protagonists of these stories: not only are Cosmatesque motifs often repeated but particular monuments are used to set the depicted event exactly in a concretely historical moment and place, as for example, San Giovanni in Laterano in the *Dream of Innocent III*. The characters too are dressed in the style of the period, often with the proper insignia of their rank. ❧ BUT what especially marks this cycle as different even from the Old and New Testa-

ment cycles, where we perhaps saw Giotto's first appearance, is the indelible characterization of each individual, as they become actors in this majestic history: persons with strongly expressive faces, pristine portraits endowed with spontaneous and effective gestures. Having lost the abstract beauty of their features, with the classical measurements that still characterize the Stories of Isaac, the faces are now those of the men and women Giotto saw in the streets of Assisi: the pope intent on his sermon, Francis's father blazing with anger, the many friars with faces filled with curiosity. Powerfully individualized, the subjects of these stories are closely linked one to another, as can be seen from their looks and gestures. They are in colloquy. This is but another of the extraordinary innovations that Giotto proposes, developing the embryonic intuitions of the episodes on the highest tier, such as the *Deposition*. ❧ HAND in hand with the trenchant characterization of people goes the attention to reality in its natural, everyday aspects. Thus household objects are acutely analyzed, beginning with the fabric hangings, displayed in profusion but each quite distinct, whether an ordinary home curtain or sumptuous draperies for the papal interiors (each of them different; p. 43), or even a carpet, as in *St. Francis Preaches before Honorius III*. The crockery then in use is also faithfully portrayed, such as that depicted on the table in the *Death of the Knight of Celano*. And

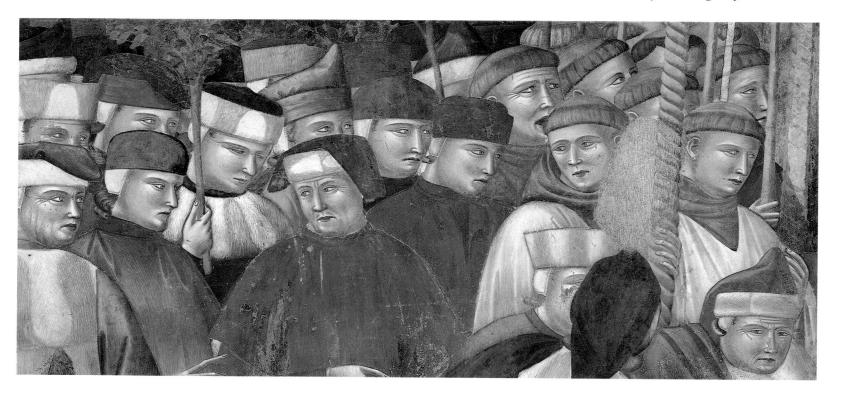

Giotto and assistants. Detail of
POOR CLARES MOURN THE
DEATH OF ST. FRANCIS *(p. 82).*
Upper Basilica of San Francesco,
Assisi.

nature too is observed, one could say, with love: the illumination of the rocks; the trees alive in the branches' flickering play of light and shadow; the small bushes and flowers, still quite few in this cycle, which are derived from tradition but as accurately portrayed as in an herbarium. And the animals: one need only think of the donkey in the *Miracle of the Spring,* who is an essential part of the story, and of the vitality of the birds in *St. Francis Preaches to the Birds.* ❧ THE cycle begins on the left wall, running from the transept to the facade, and it seems to indicate that the narration of the stories proceeds in the same order as the execution of the frescoes, from the altar towards the facade, as had been done on the upper tier of the walls; but in fact it appears that lower down the work proceeded first on the right wall and then on the left. One can see a continuous maturation in terms of the problem of space, from the first episodes to the last, and one might suspect one or more interruptions during the course of the painting. The *Crib at Greccio,* for example, is composed with complex spatial daring and a series of absolutely fresh discoveries, as if there had been a hiatus after the preceding episode. A closer examination of the Franciscan frescoes reveals the significance and novelty of the individual scenes. ❧ THE first episode, the *Man in the Street Pays Homage to St. Francis* (p. 56), is an illustration of the words of the *Legend,* "when a simple man of Assisi spread his clothes

before the blessed Francis and rendered homage." According to scholars, this episode, which displays a mature composition, belongs to the final phase of the decoration; perhaps it was a repainting or correction of the scene, or perhaps it had to be painted later. Here in the opening of the cycle there is a conscious effort to establish a quite specific, well-known place: the Piazza Maggiore in Assisi, where a prominent feature is the facade of a church carved out of the Temple of Minerva; to the left are the Palazzo and the Torre del Popolo as they looked until 1305. ❧ THIS architecture forms the background against which the protagonists are separated into two groups, as in a religious drama. The edifices are drawn in perfect perspective: the church porch is precisely measured in the tiles of the pavement and the coffers of the ceiling, which diverge at the center; a precise ray of light comes from the facade to illuminate the elements of the architectonic structure, leaving the hidden part in shadow; perspective also rules the steps, the grates on the windows at the end of the portico, and even the beautiful small rose window. Equally perfect is the drawing in perspective of the Palazzo del Popolo and the angle of light on it. The precision of the design and the play of light and dark are admirable in the bell tower—a true Cubist exercise; in the opening of the windows with their bright frames, the overhanging roof; and the drapery hung from a small

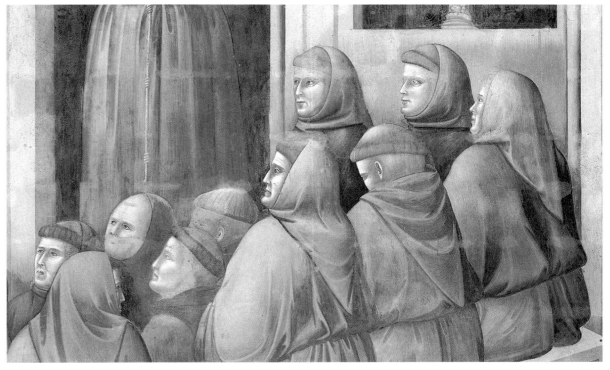

Giotto. Detail of ST. FRANCIS PREACHES BEFORE HONORIUS III *(p. 42 right). Upper Basilica of San Francesco, Assisi.*

Giotto. Detail of ST. FRANCIS APPEARS TO THE CHAPTER AT ARLES *(p. 76). Upper Basilica of San Francesco, Assisi.*

page 46: Giotto. Detail of ST. FRANCIS APPEARS TO THE CHAPTER AT ARLES *(p. 76). Upper Basilica of San Francesco, Assisi.*

page 47: Giotto. Detail of FRANCISCAN RULE APPROVED *(p. 61). Upper Basilica of San Francesco, Assisi.*

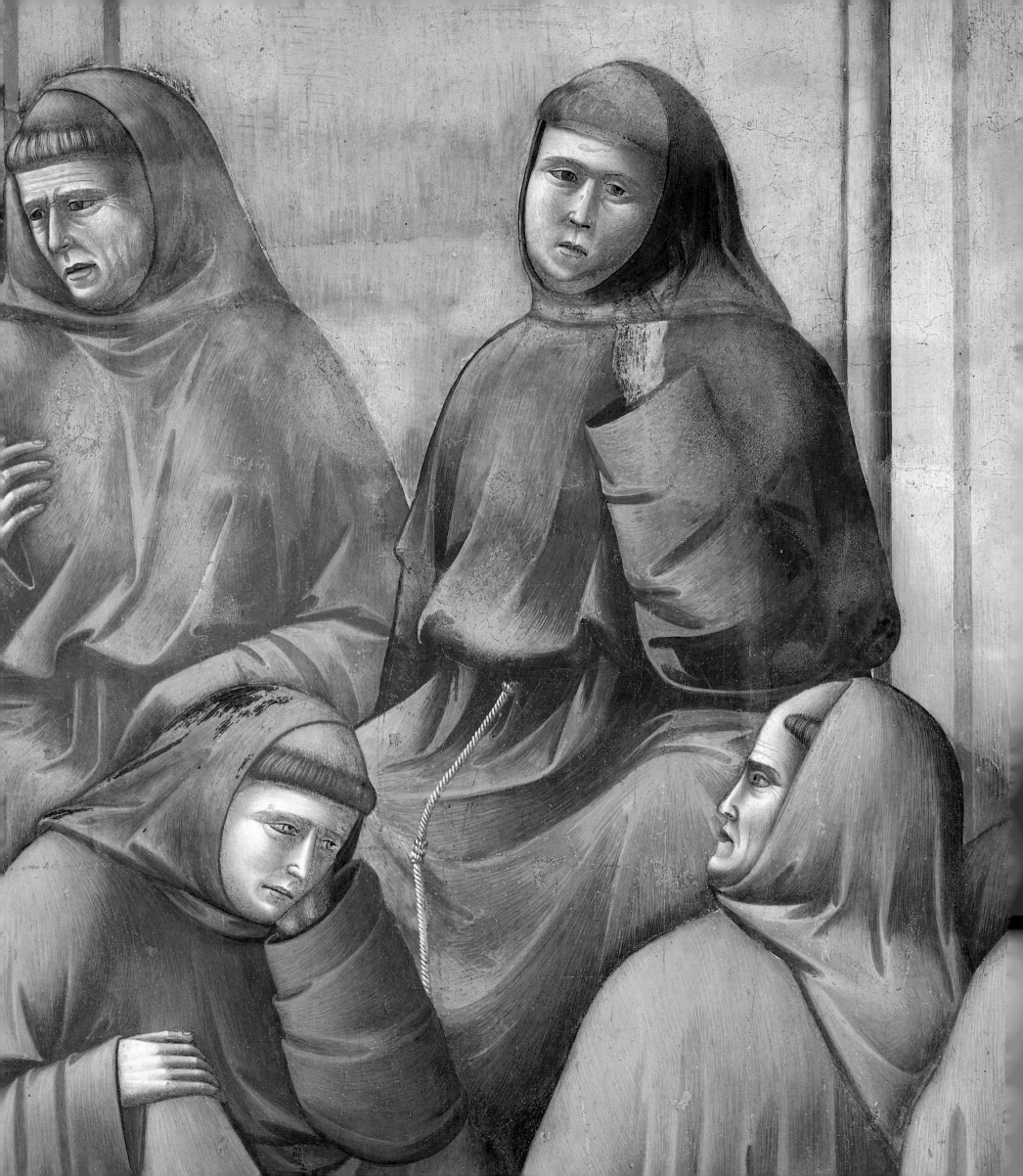

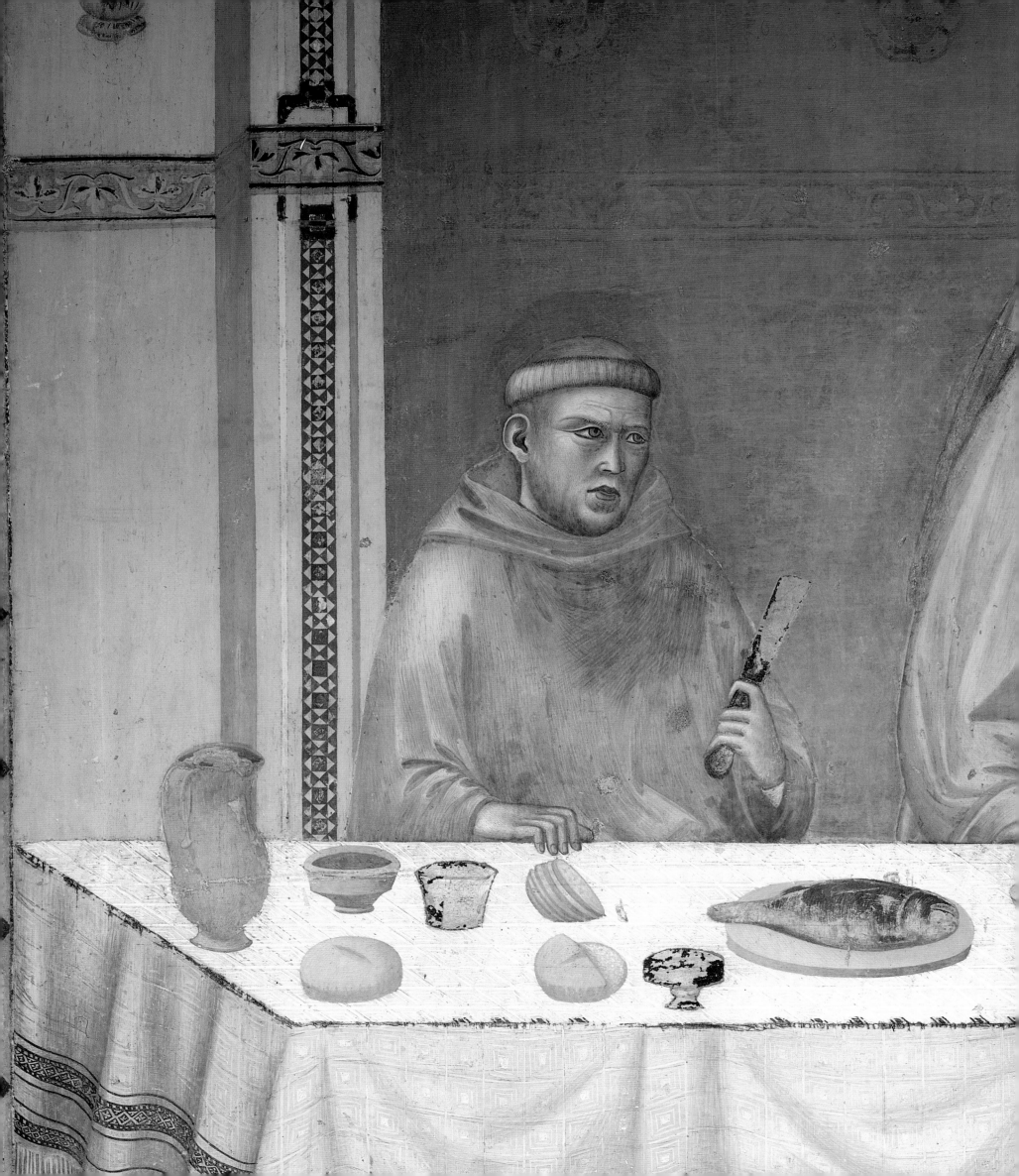

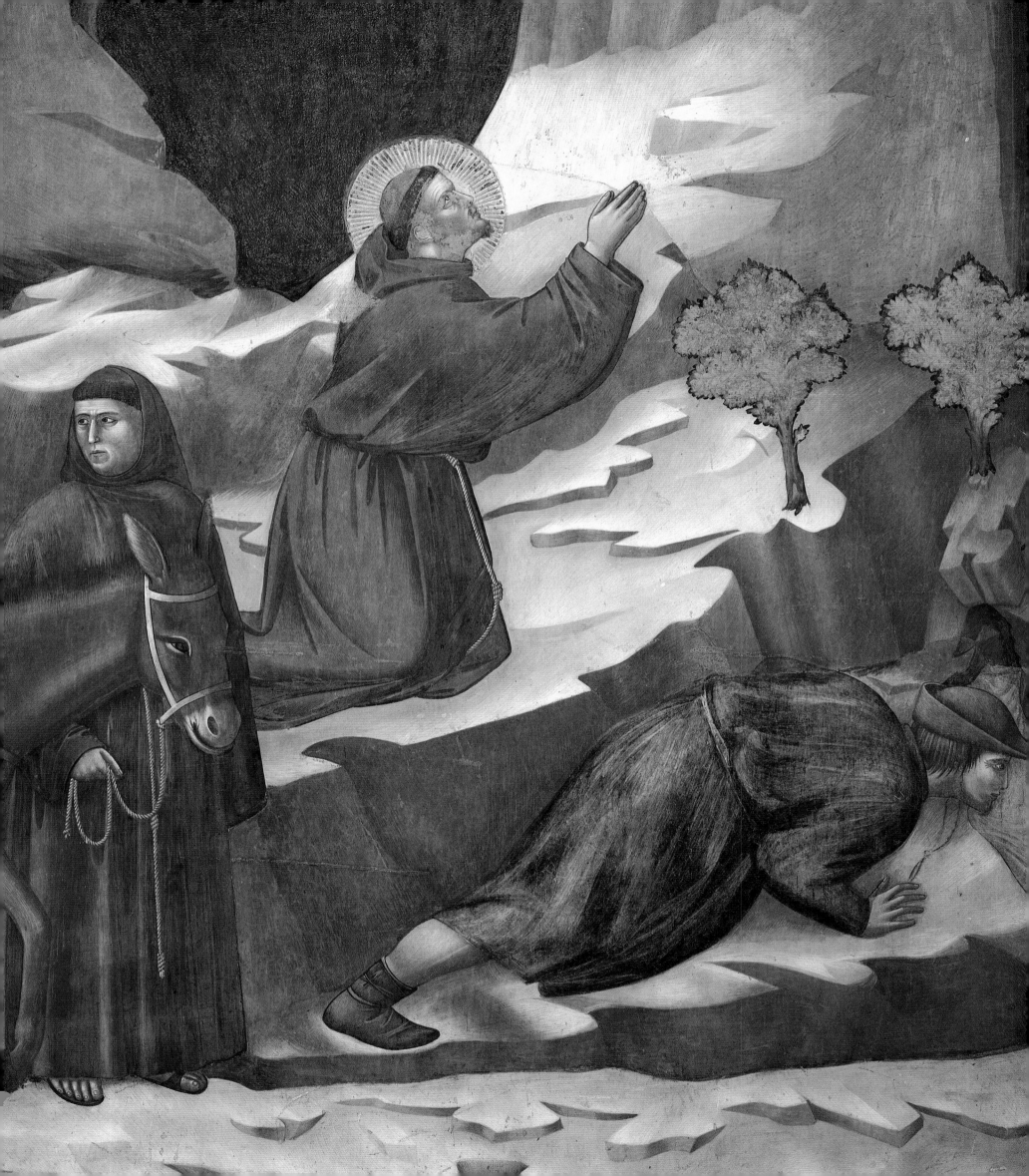

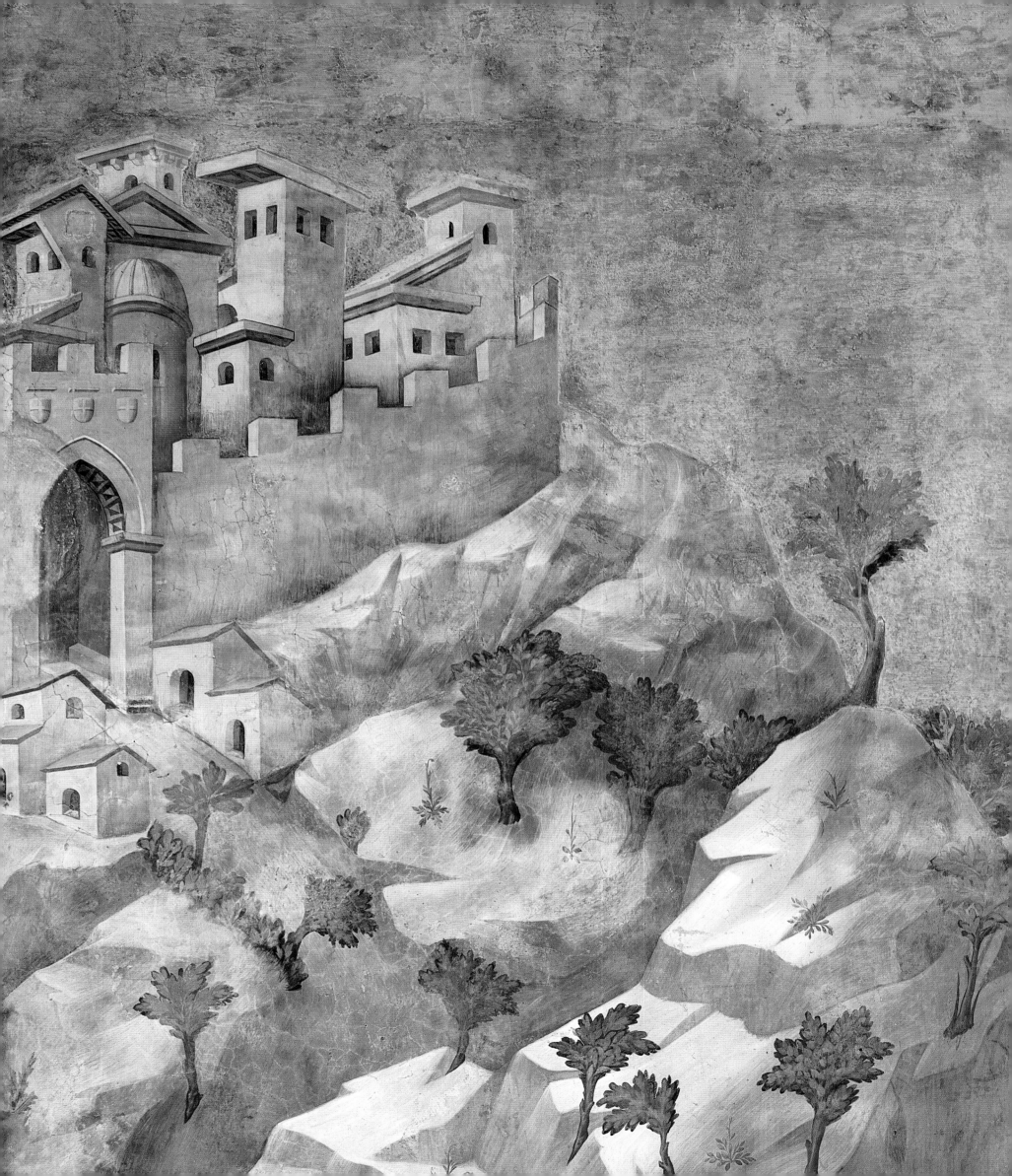

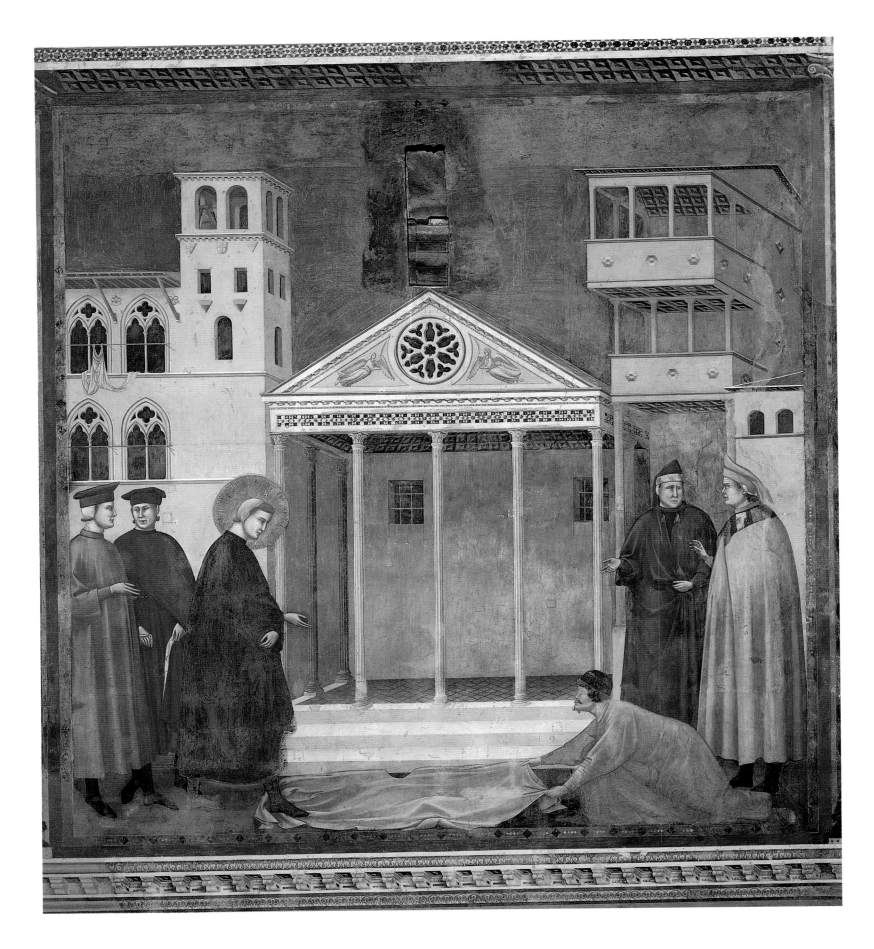

projecting rod. ❧ THE persons in the scene are real and vivid, dressed in the costumes of the period, captured in completely everyday gestures and also observed in the peculiarity and individuality of their physiognomy, bound together in a lively and attentive conversation. The figures are constructed with powerful plasticity, enveloped in fabric with deep folds like carved blocks—an effect obtained by the canny variation of chiaroscuro, and edged with sharply drawn contour lines. ❧ THE next compartment, the first one executed, is the *Cloak Incident* (below) "When the blessed Francis met with a noble but poor knight . . . he immediately undressed and put his clothes on him." The scene takes place in a stony landscape animated by towns perched amid the rocks, constructed with a completely new design of oblique lines in an attempt at perspective. The rocks meet just at the height of the saint's head, which thus constitutes the pivot of the scene, from the figurative point of view as well. This is still a simple composition, or rather a simplified one, formed by two parallel planes, whose most significant element is the observation of nature and reality in the small houses in perspective and the trees with multicolored foliage. Certain details in this episode show very close ties to the biblical stories on the wall's highest tier: the landscape with criss-crossing mountains is the same as in the *Slaying of Abel,* and the trees' dense foli-

age also reminds us of that compartment; the orange clothes that the saint gives away have a sharp, geometric pattern, as in the Stories of Joseph; and the face of the poor knight presents once again, in profile, a "type" that runs through the Stories of Joseph. ❧ *ST. FRANCIS Sees a Building in a Dream* (p. 59) illustrates a chapter of the *Legend* with perfect adherence to the text: "He saw a large splendid palace, with warlike arms marked with the sign of the cross; and when he asked who owned it, from a heavenly voice came the reply that they would eventually belong to him and his disciples." This picture is still tied to the style of the stories on the upper part of the wall. The room in which the saint sleeps is exactly the same as the room in the two Isaac stories, right down to the details of the curtain and the bedspread with sharp pleats. And the very tall Gothic palace, not completely successful in its attempt to be spacious and volumetric, recalls the buildings that rise up behind in the episode *Joseph Recognized by His Brothers.* ❧ A DECISIVE step forward in the representation of architecture and the relationship between figure and architecture appears in the second bay. The first of the three compartments presents the *Crucifix at San Damiano Speaks to St. Francis* (p. 58): "As the blessed Francis prayed before the image of the Crucifix, from the cross came a voice that said three times: 'Go, Francis, repair my house that is being destroyed.'" The church with three

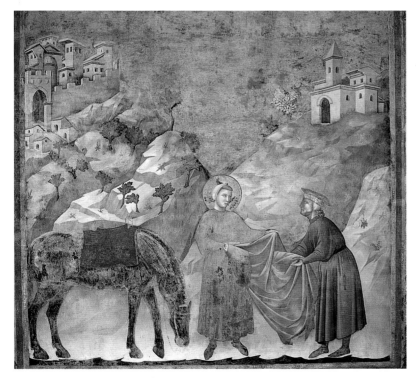

Giotto. CLOAK INCIDENT. *Upper Basilica of San Francesco, Assisi.*

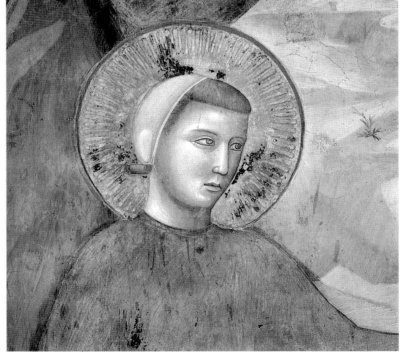

Giotto. Detail of CLOAK INCIDENT. *Upper Basilica of San Francesco, Assisi.*

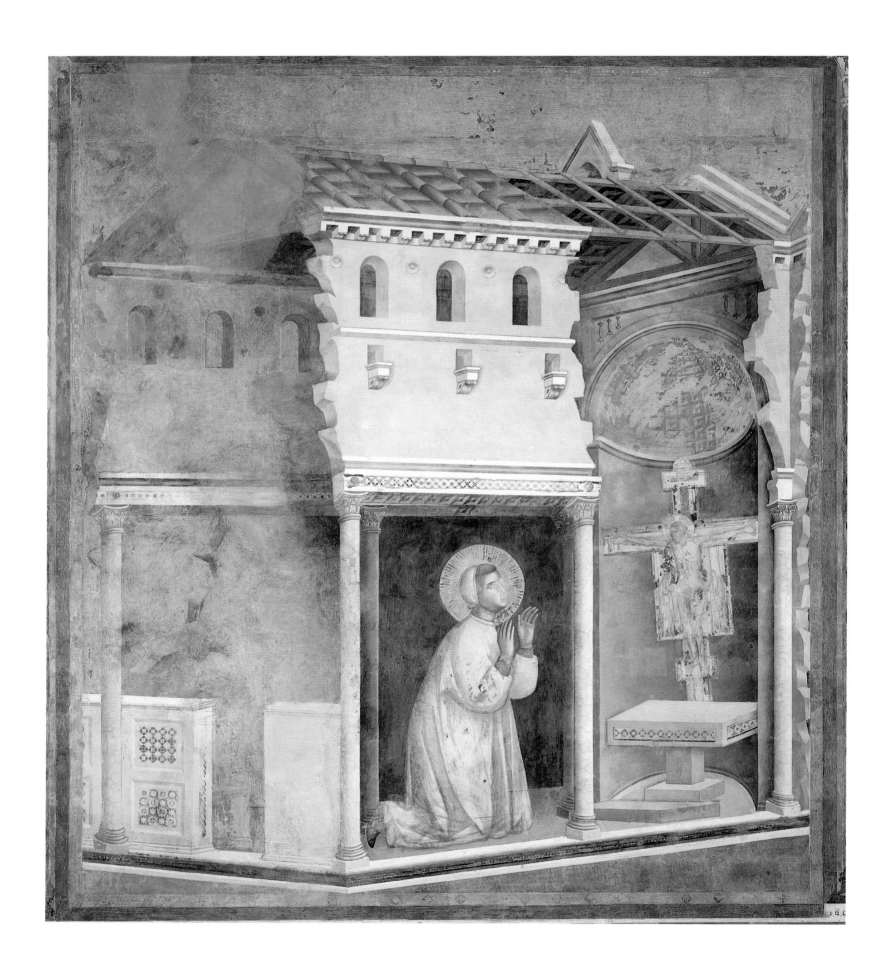

Giotto. CRUCIFIX AT SAN
DAMIANO SPEAKS TO
ST. FRANCIS. *Upper Basilica
of San Francesco, Assisi.*

naves, greatly foreshortened and in ruins, is set on the ground as a slightly oblique, spatial box: the rendering of the interior with the apse and the altar is precise. The crucifix is depicted in accordance with medieval iconography, though the figures of two mourners beside the body of Christ are already stockier than medieval figures. The praying saint, gathered into himself like a block shaped by a neat contour line, is exactly fitted within the edifice; but his clothes, reduced to a red undergarment, still show the pyramidal pleats of their drapery. ❧ IN *St. Francis Renounces His Worldly Possessions* (p. 60) the saint "gave back everything to his father, took off his clothes and renounced his father's wealth and all worldly goods." The episode is set against two tall architectural complexes, very well articulated and precise in their spatial aspect and in the exactly measured effects of the light; the buildings are very beautiful with their pale colors in a warm range of pinks, though still archaic in style. Before them are two groups of persons who are carefully individualized in face and gesture; the central figure of the episode and the one with the greatest dramatic effect is Francis's father, who steps forward in a yellow robe: his strikingly expressive face is one of the most intense in the entire cycle. ❧ THE *Dream of Innocent III* (p. 40) is more complex: "The Pope saw the Lateran basilica already close to collapse; which was supported by a poor man." On the right the spatial box of the Stories of Isaac reappears, enriched by Cosmatesque elements and classical citations, while on the left is the strikingly realistic construction of the porticoed basilica, particularized by the play of Cosmatesque marble and a slender bell tower typical of Roman architecture. The sleeping pope, decked out as for a ceremony, is watched over by two crouching figures, carved like blocks of granite, in symmetrical positions and slightly on the slant, so as to accentuate the place's spaciousness. ❧ THE next bay opens with one of the most mature scenes of the entire cycle: *Franciscan Rule Approved* (p. 61). The scene takes place in a Gothic hall with a roof resting on arches supported, in their turn, by brackets, underlined by a careful play of light that strikes the first bracket to the right and then flows down to illuminate the entire left wall. This severe architectonic structure is set off by a very beautiful and elaborate curtain of French style. The persons, contained within the architecture, are once again in two groups, attentive men with intense faces emphasized by a precise line of neat shadows, wrapped majestically in coarse habits or elegant cloaks. In their midst the pope stands out as a single block wrapped in a mantle; his white stole, which forms a perfect semicircle and then falls over his arm, defines both the volume and the space. The use of color is also very interesting in this picture, playing on different tonalities of browns in the group of monks

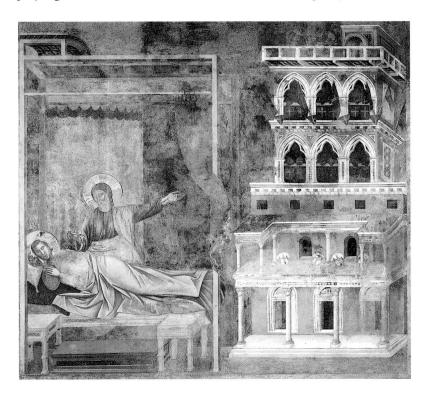

Giotto. ST. FRANCIS SEES A BUILDING IN A DREAM. *Upper Basilica of San Francesco, Assisi.*

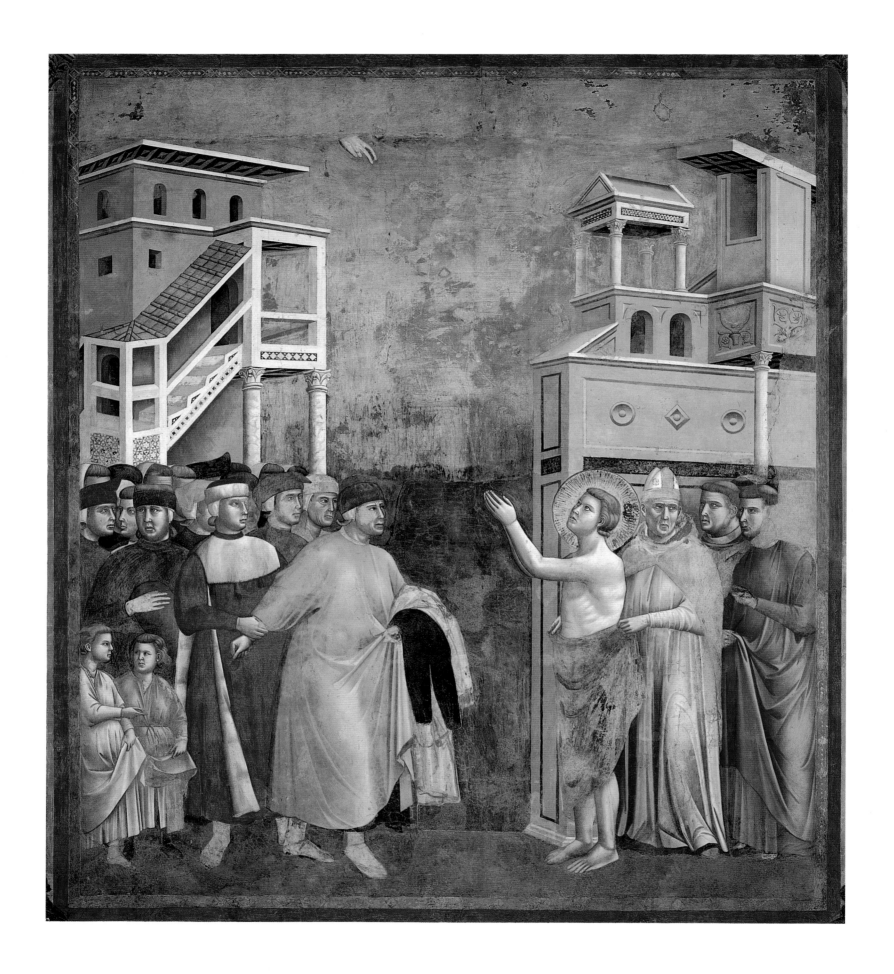

Giotto. ST. FRANCIS RENOUNCES
HIS WORLDLY POSSESSIONS.
*Upper Basilica of San Francesco,
Assisi.*

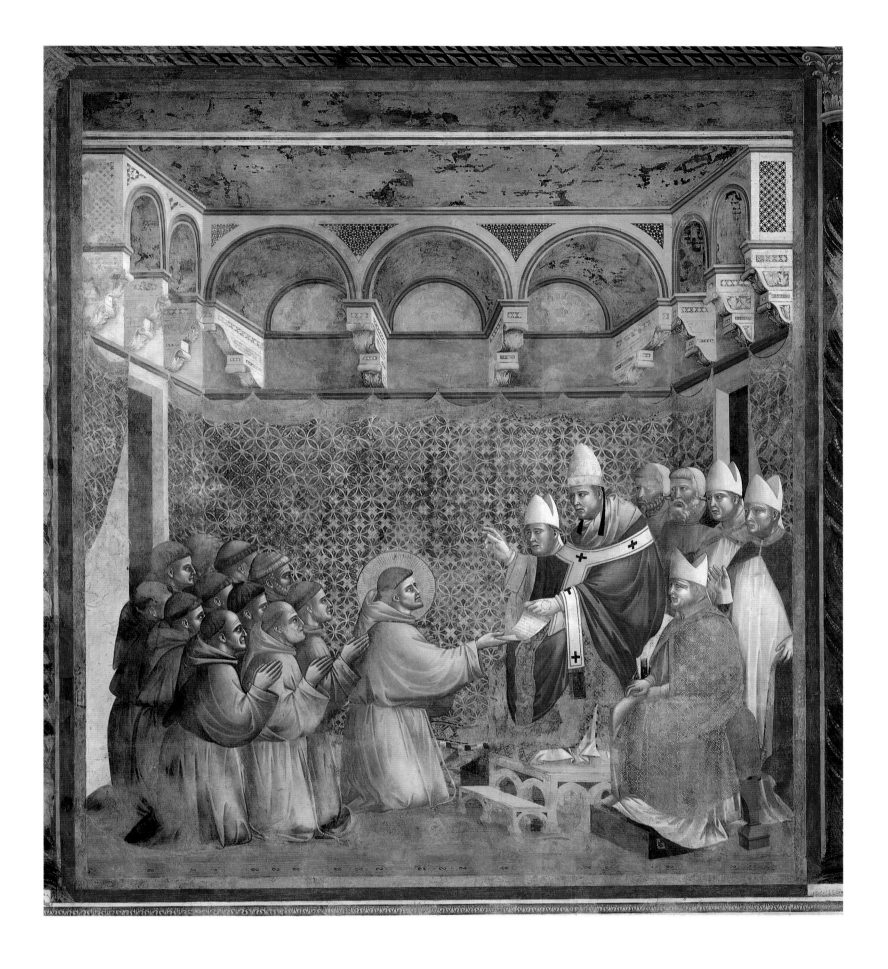

Giotto. FRANCISCAN RULE
APPROVED. *Upper Basilica of
San Francesco, Assisi.*

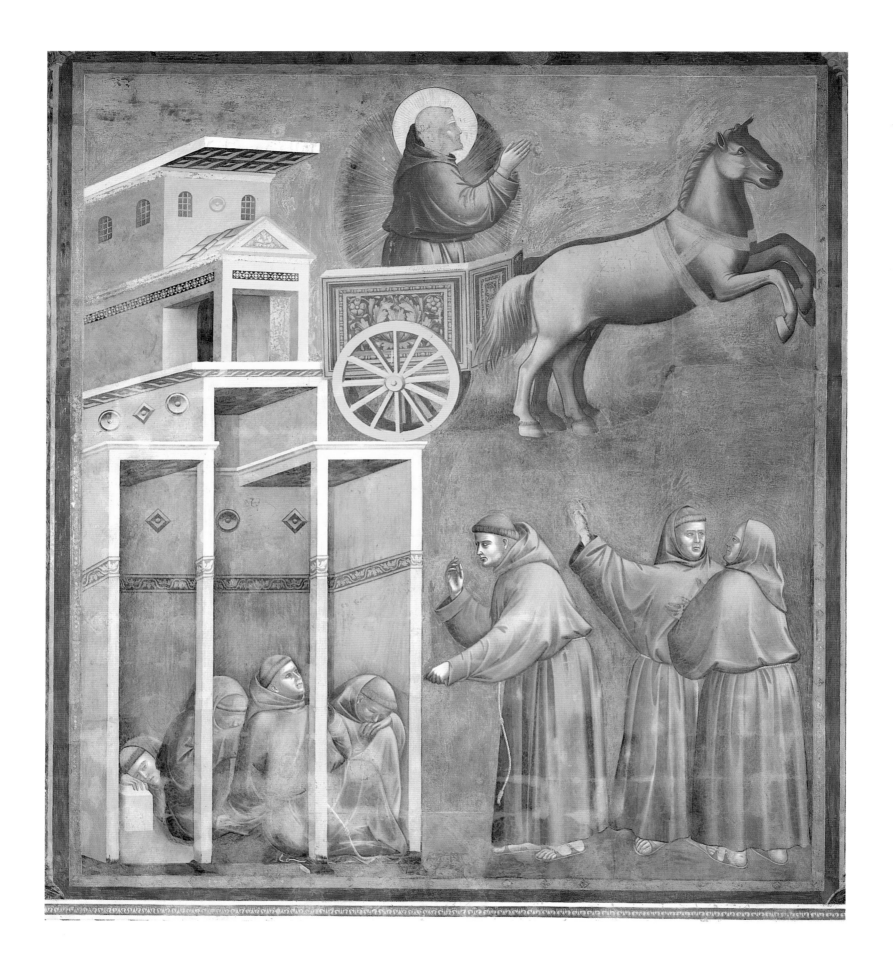

Giotto. VISION OF THE FIERY
CHARIOT. *Upper Basilica of San
Francesco, Assisi.*

and of reds in the group of bishops, against which the green of the platform stands out decisively. ❧ CLASSICAL elements are quite evident in the following scene, the *Vision of the Fiery Chariot* (p. 62): "The blessed Francis [was] praying in a hovel, and his monks were in another hovel . . . and behold, they saw the blessed Francis on a flaming, shining chariot." The building on the left, a cross-section of a church with three naves, is rich in Roman decorative elements; also inspired by Rome is the red chariot decorated with laurel leaves and pulled by two horses—one is almost the shadow of the other—which seem copied from triumphal monuments. The figures of the monks sleeping inside the building are very beautiful, with the powerful impact of masses of stone. And I would like to emphasize the care with which the cords of the habits are drawn, as a prime instance of Giotto's acute attention to reality, even in its less stately aspects. ❧ IN THE next compartment, the *Vision of the Thrones* (p. 66) depicts the vision of Francis's companion who sees "in the sky many thrones, and one more worthy than the others, . . . and heard a voice that said . . . this throne . . . is set aside for the humble Francis." The episode is divided into two zones, not unified by a single vanishing point, thus giving a fragmented compositional impression. ❧ THE *Devils Are Driven Out of Arezzo* (below right) presents a Gothic church on the left and a city encircled by

walls on the right. Giotto depicts the medieval heaping up of houses one on top of the other, and the vivacity of colors; but each of these buildings has a regular, geometric structure and the design of the galleries and windows is spatially very correct, underscored by an exact play of chiaroscuro; thus once again medieval forms are translated into a new language. And there are also new elements, such as the appearance of persons in the city's gates, an interesting spatial contrivance which unifies interior and exterior. The devils are portrayed as huge bats or small monsters, and rendered with acute naturalistic observation and sprightly imagination, a more light-hearted and modern interpretation of the fabulistic medieval world. ❧ THE next two pictures are not at all persuasive from a compositional viewpoint. The *Trial by Fire* (p. 67) in which "the blessed Francis . . . wanted to enter a great fire with the priests of the Sultan of Babylon . . . ," has two interesting edifices with many Cosmatesque elements, though they are not well related to each other, and a very interesting sultan's throne, whose base rests on gilded lions (now barely legible), a sign of royalty. The *Ecstasy* (p. 68) is a very poor episode depicted against a background of too highly colored buildings. ❧ BUT in the *Crib at Greccio* (p. 41) in which "the blessed Francis, in memory of Christ's birth, ordered that they set up a crib . . . [and] a knight saw the child Jesus, instead of the one that

 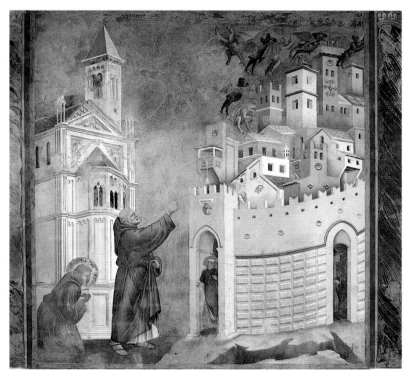

Giotto. Details of VISION OF THE FIERY CHARIOT *(p. 62). Upper Basilica of San Francesco, Assisi.*

Giotto. DEVILS ARE DRIVEN OUT OF AREZZO. *Upper Basilica of San Francesco, Assisi.*

page 64: Giotto. Detail of DEVILS ARE DRIVEN OUT OF AREZZO. *Upper Basilica of San Francesco, Assisi.*

page 65: Giotto and assistants. Detail of CONFIRMATION OF THE STIGMATA *(p. 80). Upper Basilica of San Francesco, Assisi.*

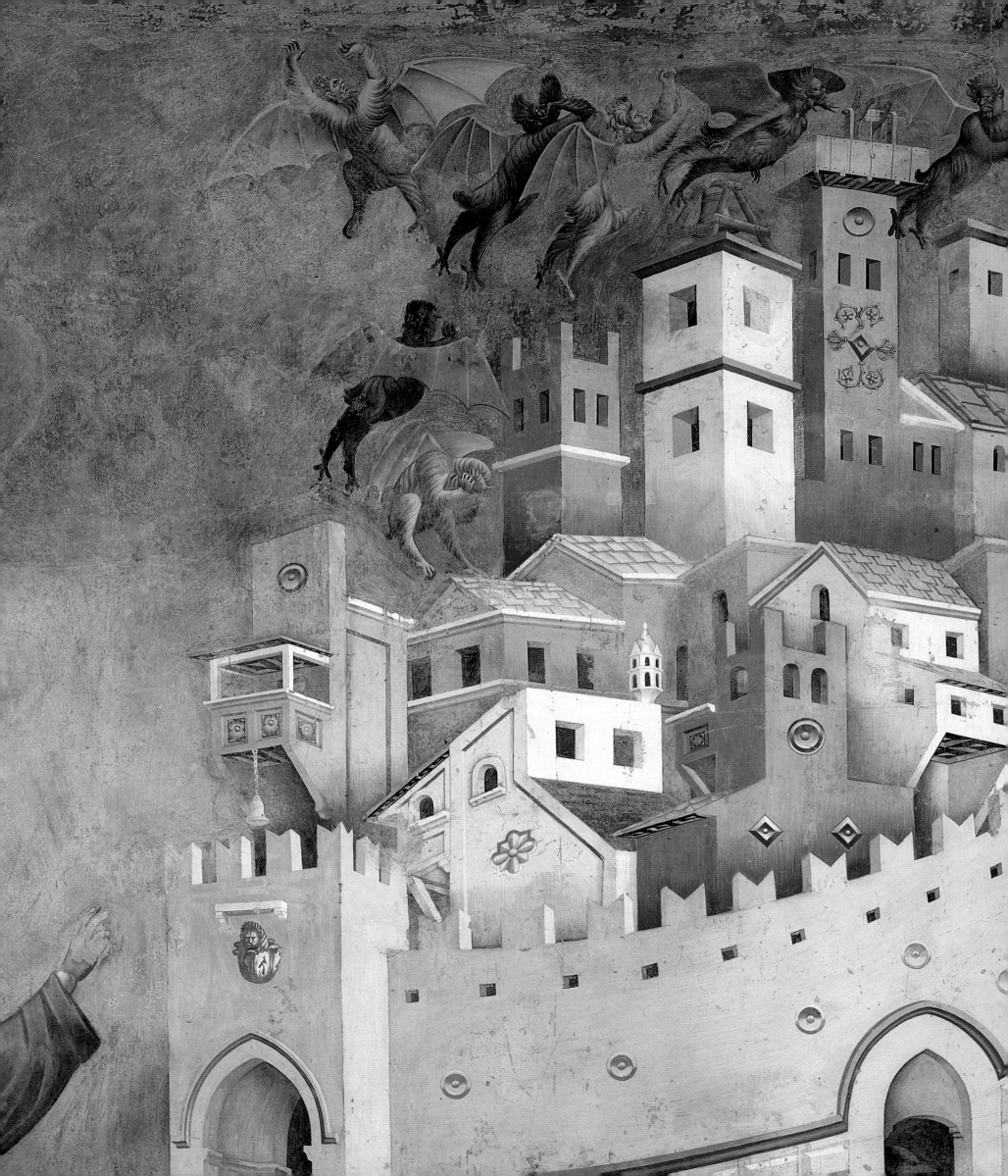

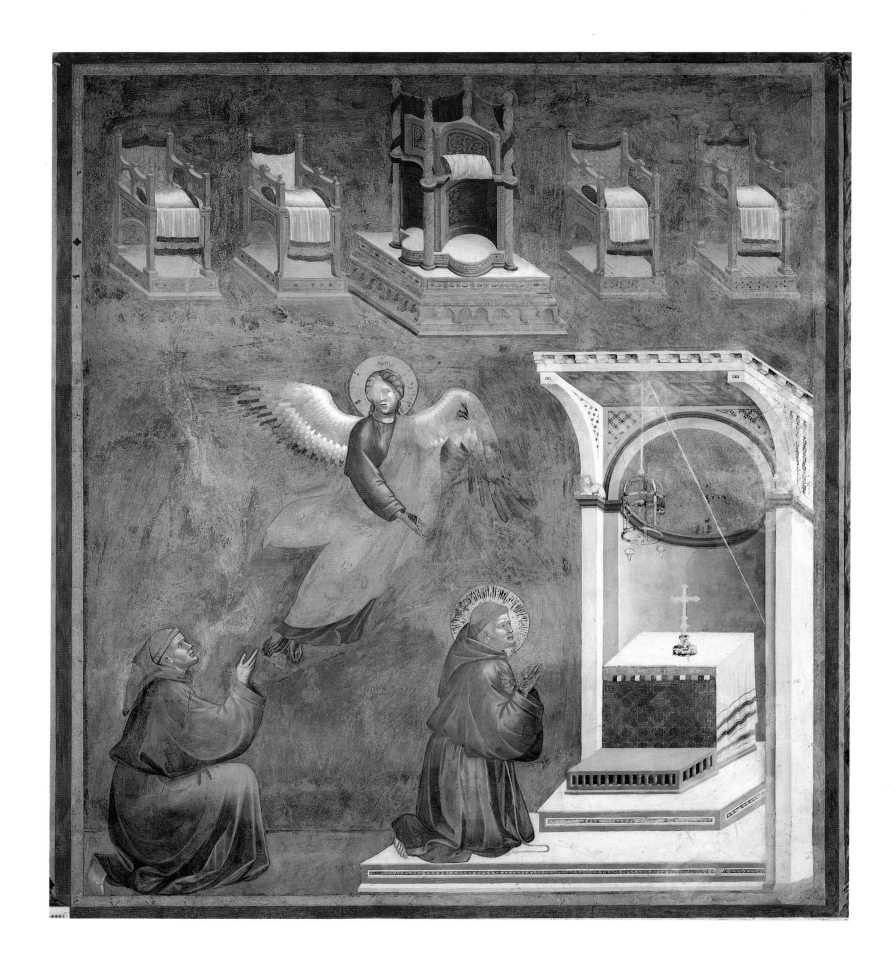

Giotto. VISION OF THE
THRONES. *Upper Basilica of
San Francesco, Assisi.*

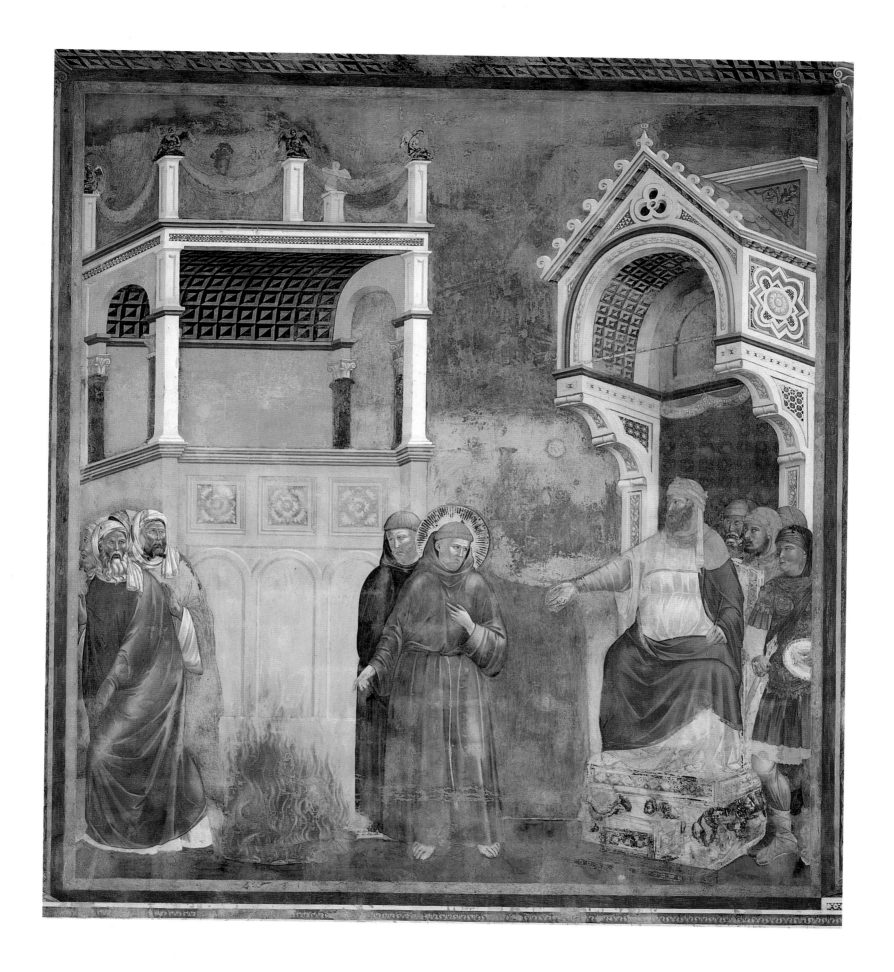

Giotto and assistants. TRIAL BY
FIRE. *Upper Basilica of San
Francesco, Assisi.*

the saint had brought," we see a representation of great compositional maturity. An enclosure, whose framework is drawn with scrupulous precision, separates the presbytery—the site of the action—from the nave; the latter exists, however, as we can see in the perspective play of the pulpit and crucifix that lean towards the interior with a felicitous feeling for space. From the nave itself the women, drawn by curiosity, enter through the door. The scene is enclosed on the right by an Arnolfian canopy and on the left by a stairway ascending to the pulpit. It is packed with a crowd showing extraordinarily vivid faces and greatly expressive postures. As I mentioned before, with this scene Giotto starts expressing himself with a new compositional skill in the creation of space, the treatment of architecture or landscapes, and a more precise relationship between space and figures; possibly there was an interval or break between the first scenes, still closely tied to those of the upper part of the wall, and these, which are certainly more mature and adept. ❧ THE wall of the façade marks a sort of pause; it is decorated with two episodes set in the open countryside, as if to continue, in the fiction of the painting, the vision of what appears beyond the church's portals: the underbrush and woods in which Francis walked. In the *Miracle of the Spring* ("The blessed Francis climbing a hill on the back of a poor man's donkey—and begging for some water for the man who was dying

of thirst, it burst out of a rock . . ."; p. 72), the protagonist is the mountainous landscape, enlivened by trees with beautiful, rich leaves. Gleaming with glancing rays, the rock is ribbed by broad step-like indentations. It is natural to compare this with the *Cloak Incident,* measuring the very great growth in maturity that has taken place here after just a few compartments, in terms of the composition, the landscape-figure relationship, and the effects of chiaroscuro. The persons, humble or grand, are disposed in a stepped arrangement, in keeping with the rock, and the thirsty man looks like a large block of stone set apart by a single decisive stroke that forms a sinuous outline: this is one of the figures that still vividly recalls those of the thirsty in Arnolfo di Cambio's fountain, the Fontana Maggiore, in Perugia. The two friars are talking, and the donkey also seems to participate in this conversation; though we only see half of him, the donkey is a strong presence bursting with life and reality, even in the minute details of his pack-saddle and rope halter. ❧ THIS Franciscan love of animals, which Giotto is so adept at interpreting, reaches its loftiest point, of course, in one of the most poetic chapters of the *Legend, St. Francis Preaches to the Birds* (p. 73). This is how it is told: "The blessed Francis going to Bevagna preached to many birds; and the birds in exultation stretched their necks, spread their wings, opened their beaks, and touched his habit." Here we

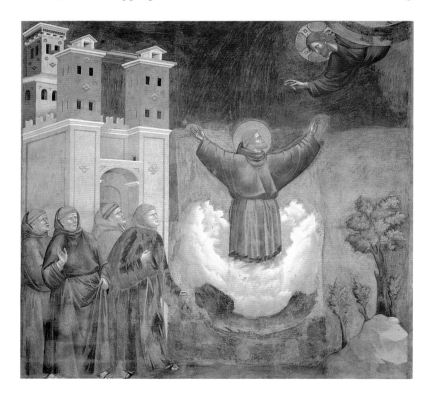

Giotto. ECSTASY. *Upper Basilica of San Francesco, Assisi.*

page 69: Giotto. Detail of CRIB AT GRECCIO *(p. 41). Upper Basilica of San Francesco, Assisi.*

pages 70–71: Giotto. Detail of ST. FRANCIS APPEARS TO THE CHAPTER AT ARLES *(p. 76). Upper Basilica of San Francesco, Assisi.*

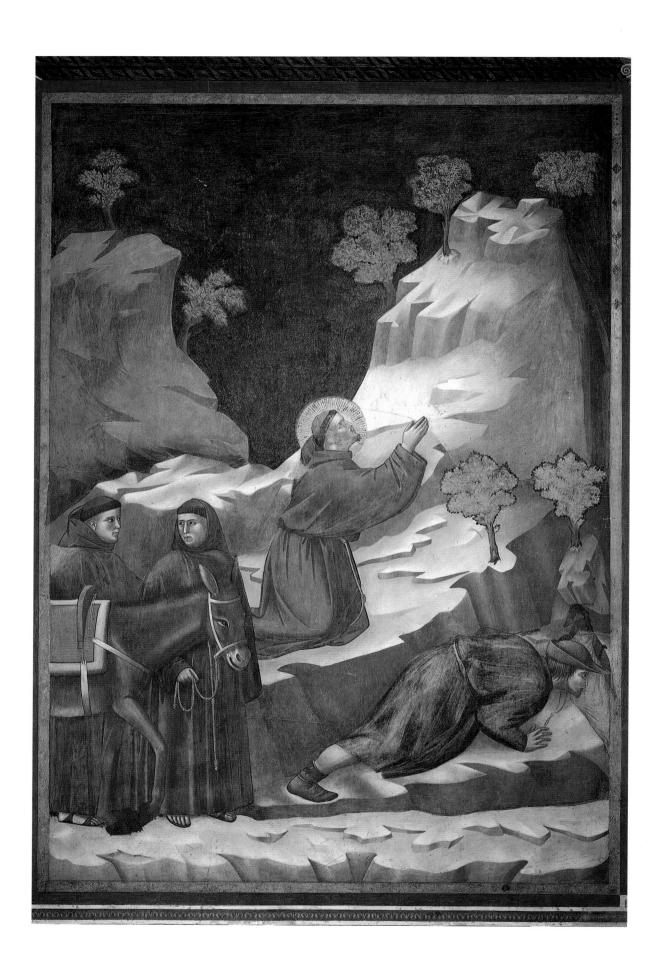

Giotto. MIRACLE OF THE
SPRING. *Upper Basilica of San
Francesco, Assisi.*

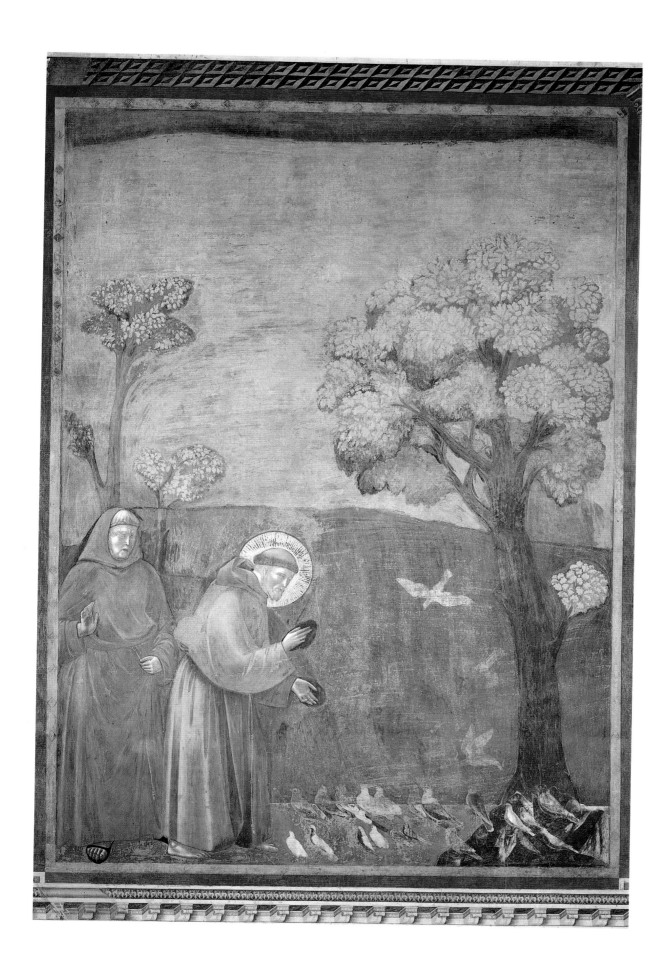

Giotto. ST. FRANCIS PREACHES
TO THE BIRDS. *Upper Basilica of
San Francesco, Assisi.*

see the conversation between the saint and the little birds, who are tiny characters, each one singled out by the color of its plumage and its position. The very simple scene, which seems to take place on a radiant day in late spring, is enclosed by two large, lush trees, painted with loving attention to the trunk, branches, and leaves, which are caressed by brush strokes of light and color. ❧ THE left wall of the nave opens with the narration of the *Death of the Knight of Celano* (below left), the episode in which "the blessed Francis gained salvation for the soul of the Knight of Celano . . . who . . . suddenly breathed out his soul, sleeping in Our Lord." The protagonist of this famous scene seems to be the long table with its everyday objects, rendered, for the first time in modern painting, with realism and minute attention. The crowd of onlookers stands in a semicircle outside the building; their heads form a cluster around the dead man and his wife, creating a very tense dramatic focus. ❧ *ST. FRANCIS Preaches before Honorius III* (p. 42 right) is another of the great chapters in the story of Giotto's treatment of space. The scene is enacted in a Gothic hall roofed with a cross-vault and open in front like a cross-section of a portico; long mullioned windows pierce the walls, and below them hangs a very rich embroidered cloth. The room is drawn in precise perspective, showing the exact distances separating the three arches and vaults, and is a

prelude to the fictive chapels in the Scrovegni Chapel. Within this perfect perspective exercise, which will remain a model for much painting to come, particularly *Christ among the Doctors* and the *Funeral of St. Martin* by Simone Martini, both in the Lower Basilica, the persons are seated in a semicircle, giving a further sense of depth. The scene is unified in color: the tones run from the brown of the religious habits to the red of the dignitaries' robes. Giotto shows extraordinary insight in his analysis of the very attentive faces of the characters, and of their sober yet eloquent gestures. Particularly evocative is the pope, who rests his head on his hand: his face is tense with listening, while his figure is blocked out as a robust sculptural form, carved by the continuous bold outline and emphasized by the firm semicircular motif of the stole that falls in perfect folds across his chest. In the left foreground is the crouching figure of a monk, a pure geometric form, based once again on images created by Arnolfo. ❧ THE episode of *St. Francis Appears to the Chapter at Arles* ("The blessed Anthony preaching in the chapter at Arles . . . the blessed Francis, although corporeally absent, appeared before him . . ."; p. 76) is shown inside a deep Gothic hall: it is a markedly foreshortened perspective box, where the precision of the individual parts of the structure contrasts with the "error" of the ceiling's edge that seems to project beyond the plane of the wall. The monks are disposed

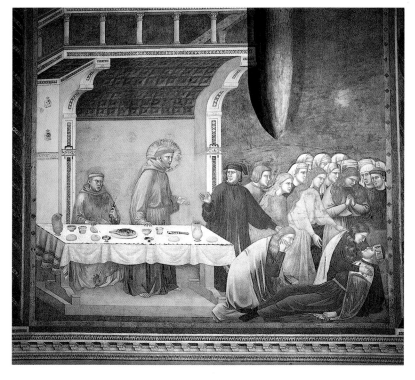

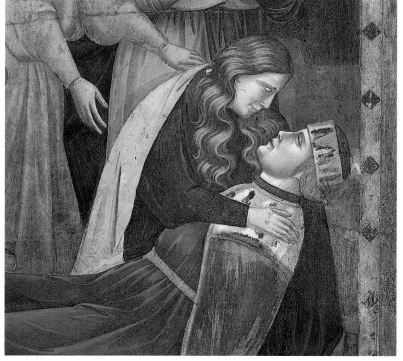

Giotto and assistants. DEATH OF THE KNIGHT OF CELANO. *Upper Basilica of San Francesco, Assisi.*

Giotto and assistants. Detail of DEATH OF THE KNIGHT OF CELANO. *Upper Basilica of San Francesco, Assisi.*

page 75: Giotto. Detail of ST. FRANCIS PREACHES BEFORE HONORIUS III *(p. 42 right). Upper Basilica of San Francesco, Assisi.*

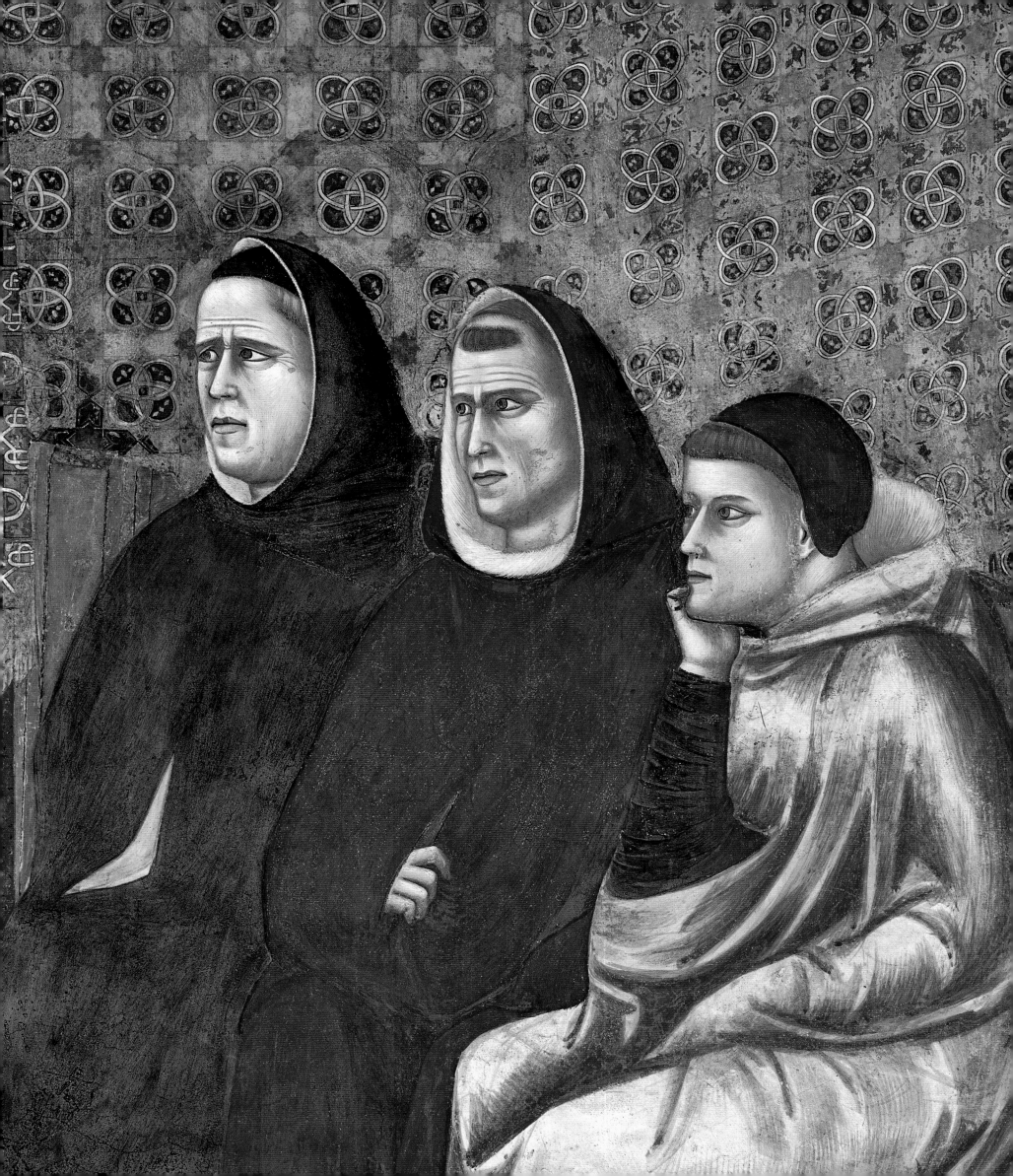

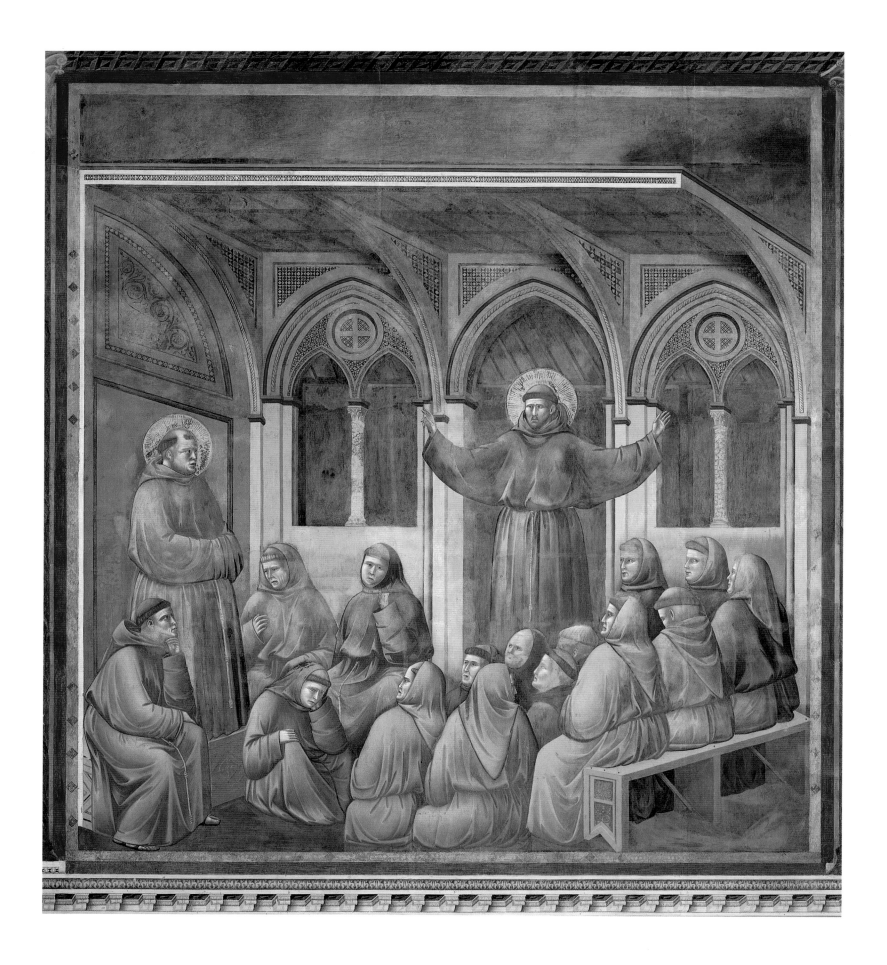

Giotto. ST. FRANCIS APPEARS TO
THE CHAPTER AT ARLES. *Upper
Basilica of San Francesco, Assisi.*

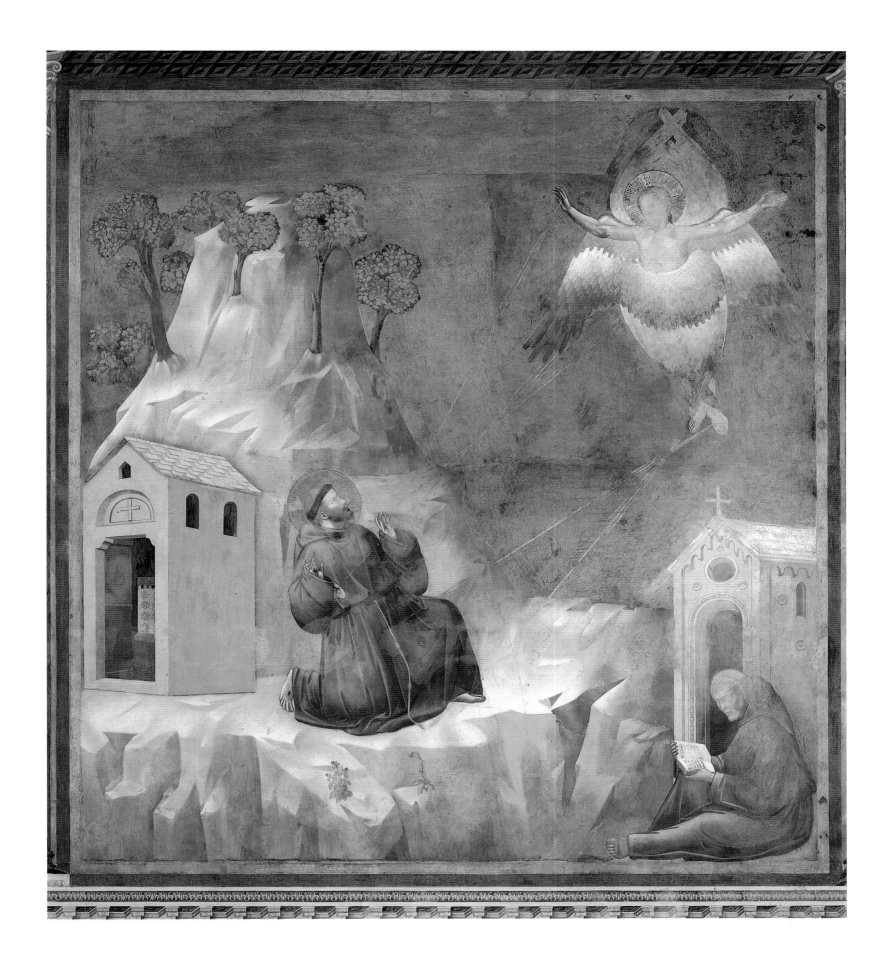

Giotto. STIGMATA. *Upper Basilica of San Francesco, Assisi.*

effectively in the space, grouped around St. Anthony with a striking range of different expressions and nuances of the color brown, all strongly robust figures, like blocks of stone. ❧ THE *Stigmata* (p. 77) follows, set in a rocky nocturnal landscape brightly illuminated by light that looks fluorescent. At the center is the robust figure of the saint, and in the broad, open sky the apparition of a seraphic Christ has a completely original coloristic value, echoed in the pink of the hut at the left, which has an altar cloth hanging inside. ❧ THE *Death of St. Francis* (p. 79) can be divided into two parts, the earthly and the heavenly, even though there are no environmental clues. The dense group of priests and clergymen creates a wall of bodies that encloses the most important and beautiful part of the scene in a semicircle. Alongside the saint's bier his companions, the friars, are crouching on the ground like blocks of stone, each with his particular expression of tenderness and grief. In this group of priests some faces repeat those from the Old and New Testament cycles, such as the two bearers of candles on the left, who seem copied from the Stories of Isaac, confirming the chronological contiguity of the two cycles. ❧ THE *Confirmation of the Stigmata* (p. 80) takes place in a church of which we can see only a beam that serves to enclose the scene. In a play of perspective the Cross, the panels with the crowned Madonna and St. Michael, and two lovely lamps all slant forward towards

the faithful onlookers and thus towards the spectator. Without many changes the scene repeats the episode of the death of the saint, though this one is made slightly more "official" by the presence of two figures in red kneeling before the bier. ❧ IN THE succeeding episode, the *St. Francis Appears to Fra Agostino and the Bishop* (p. 81), the major interest is in the variety of the friars' faces. The setting is new in that the cross-section of the church presents a simplified Gothic structure, with an interesting interplay of spires and rampant arches. ❧ UNFORTUNATELY, the ruinous state of the *Canonization of St. Francis* (p. 86 right) does not permit us to see much of this episode, but the *Poor Clares Mourn the Death of St. Francis* (p. 82) is sufficiently legible. Indeed, this is one of the most animated scenes in the cycle. On the left are gathered the people of Assisi in brightly colored clothes, with heads of equal size clustered together; on the right is a Gothic church ornamented with sculptures and pierced by rose windows. The nuns pour out of the church in a fluttering of veils with the vivacity of an airy flight of brown swallows. Here too there is a feeling of intense rapport, in this case between Francis and Clare. ❧ *ST. FRANCIS Appears to Gregory IX* (p. 87), another ruined episode, presents a patrician space, a cross-section of a rectangular room with a perfectly proportioned coffered ceiling, enriched by a beautiful curtain hanging from the walls and a canopy hanging from a precise

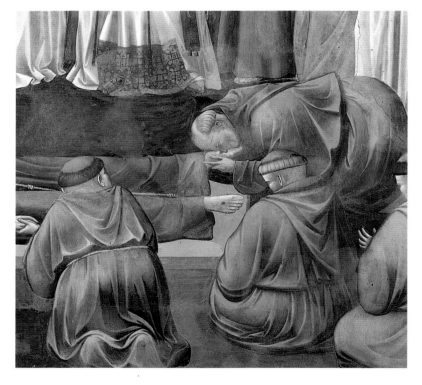

Giotto and assistants. Detail of
DEATH OF ST. FRANCIS *(p. 79).*
Upper Basilica of San Francesco, Assisi.

Giotto and assistants. Detail of
CONFIRMATION OF THE
STIGMATA *(p. 80). Upper Basilica of San Francesco, Assisi.*

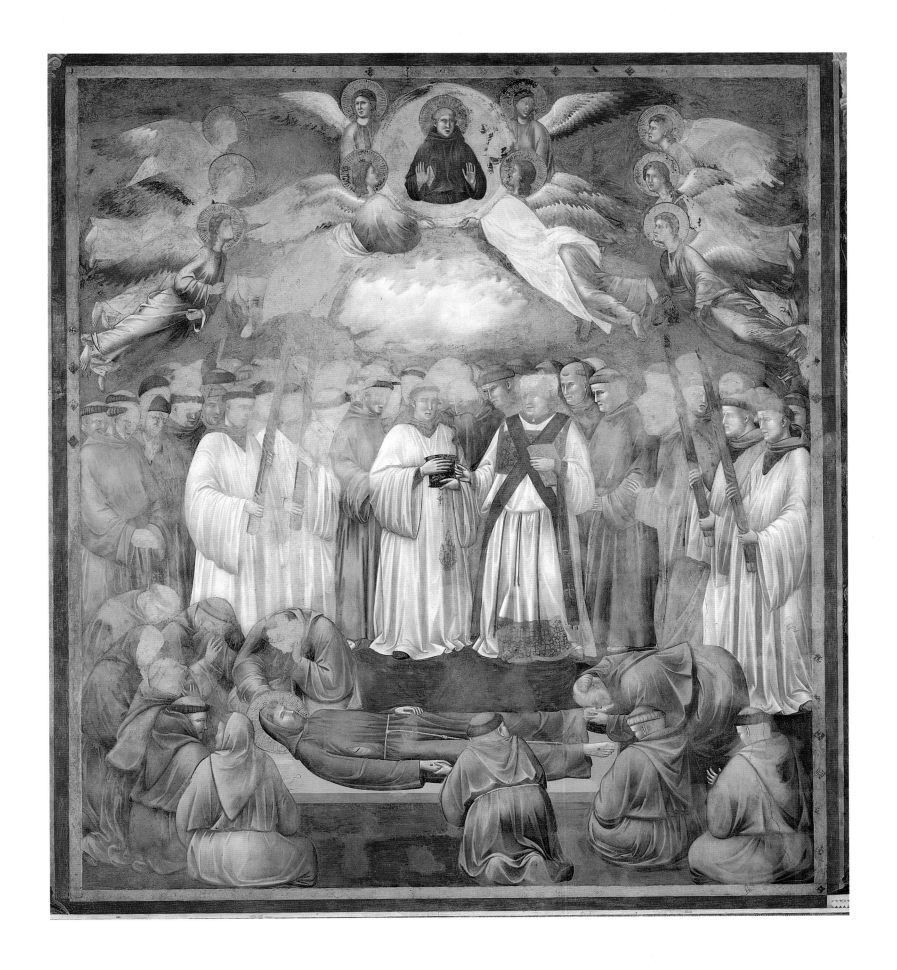

Giotto and assistants. DEATH OF
ST. FRANCIS. *Upper Basilica of
San Francesco, Assisi.*

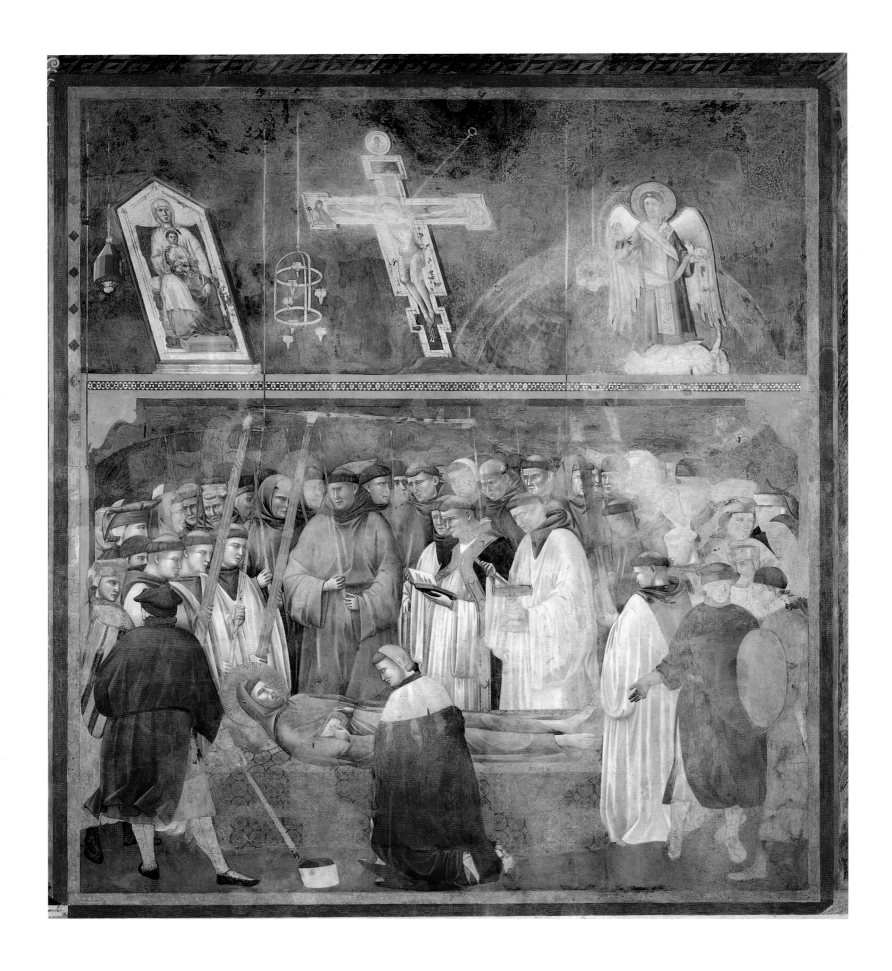

Giotto and assistants.
CONFIRMATION OF THE
STIGMATA. *Upper Basilica of*
San Francesco, Assisi.

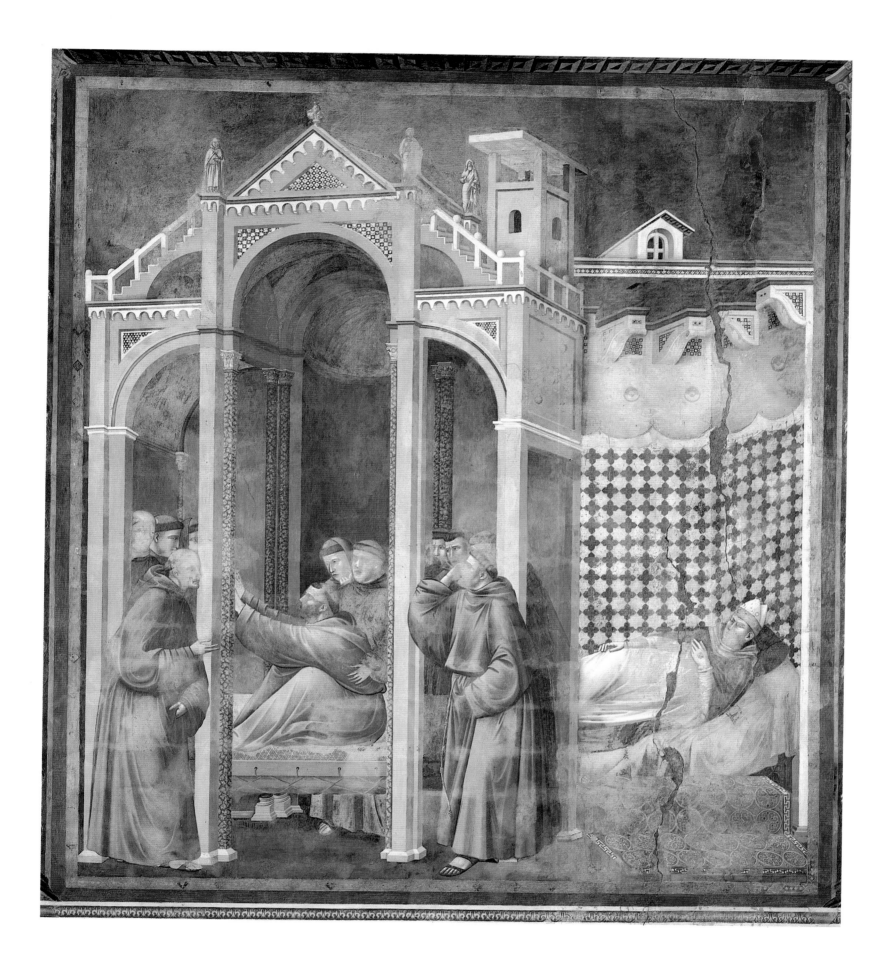

Giotto and assistants. ST. FRANCIS
APPEARS TO FRA AGOSTINO
AND THE BISHOP. *Upper Basilica
of San Francesco, Assisi.*

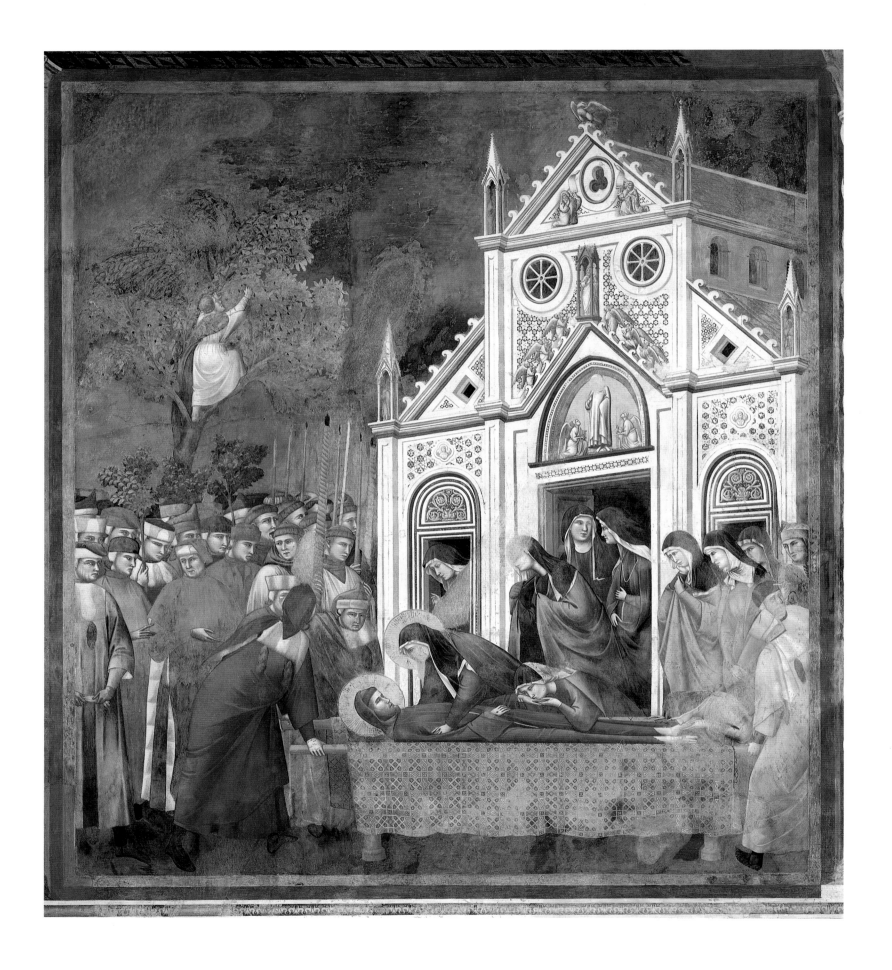

Giotto and assistants. POOR
CLARES MOURN THE DEATH
OF ST. FRANCIS. *Upper Basilica
of San Francesco, Assisi.*

system of cords above the pope's bed. The figures, however, are no more than a repetition, without variation, of those in the *Dream of Innocent III.* ❧ EACH of these last stories in the cycle, beginning with the *Death of St. Francis,* has a repetitive composition in which the space is thronged with people. Certainly the poor condition of the final pictures helps to give a particular sense of heaviness to the scenes. Indeed, one has the impression that the very high tension of certain extraordinary inventions has been lost, not least from the very beautiful *Stigmata;* or rather, this tension is found only in the details. Art historians therefore consider that assistants worked especially in these last episodes, assistants who did not confine themselves to details only. *St. Francis Appears to Gregory IX* (p. 87) repeats some motifs exactly from other episodes, and its beautiful but empty architecture is not commensurate with the undersized figures; other pictures—such as the *Death of St. Francis* or the *Confirmation of the Stigmata*—are designed with too dense a crowd. ❧ THE same problem occurs in a more conspicuous manner in the last three scenes of the cycle: the *Healing of the Wounded Man,* the *Confession of the Woman of Benevento,* and the *Liberation of the Prisoner* (p. 83) are set in fragile and simplified spaces. Despite novel elements such as the representation of Trajan's Column, along which move figures with elongated limbs and sharply pointed profiles, these fres-

coes are certainly not by Giotto. Traditionally attributed to the "Master of Santa Cecilia," the last three compartments of the cycle have been assigned by Previtali (1967)—quite correctly, in my opinion—to an Umbrian painter, the "Master of the Crucifix of Montefalco." ❧ IT IS possible that the overall imagery of these last episodes of the Franciscan Cycle were not even planned by the master, and they may coincide with a sudden unexpected interruption of Giotto's work, such as his departure for Rome in 1297 (or perhaps at the end of 1296) when he was summoned by Pope Boniface VIII. This would reconcile the chronology proposed by Murray (1953) and Bellosi (1985a) with Vasari's assertion that the work started in 1292. With some interruptions, work on the cycle would have proceeded in the presence of the master until 1296, and would have been finished even a little later, with the last bay on the left, by the Master of the Crucifix of Montefalco, precisely as Giovanni da Muro became the head of the Franciscan order. ❧ AT THIS point the problem of Giotto's workshop arises, a shop which seems rather large and varied for such a young painter. In Assisi and in the later series, the overall composition and the single scenes in particular are definitely by Giotto. Assistants intervened in the execution of several different pictures, and their hands are recognizable only in the poor quality of some details, the repetitive design, and

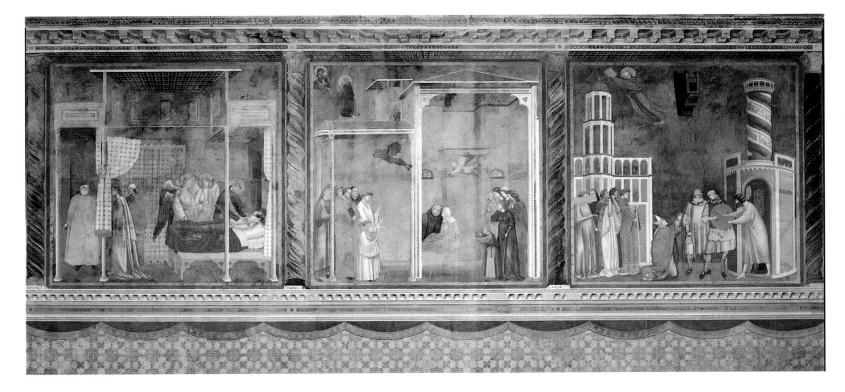

Master of the Crucifix of Montefalco(?). HEALING OF THE WOUNDED MAN, CONFESSION OF THE WOMAN OF BENEVENTO, LIBERATION OF THE PRISONER. *Upper Basilica of San Francesco, Assisi.*

pages 84–85: *Giotto and assistants. Detail of* POOR CLARES MOURN THE DEATH OF ST. FRANCIS *(p. 82). Upper Basilica of San Francesco, Assisi.*

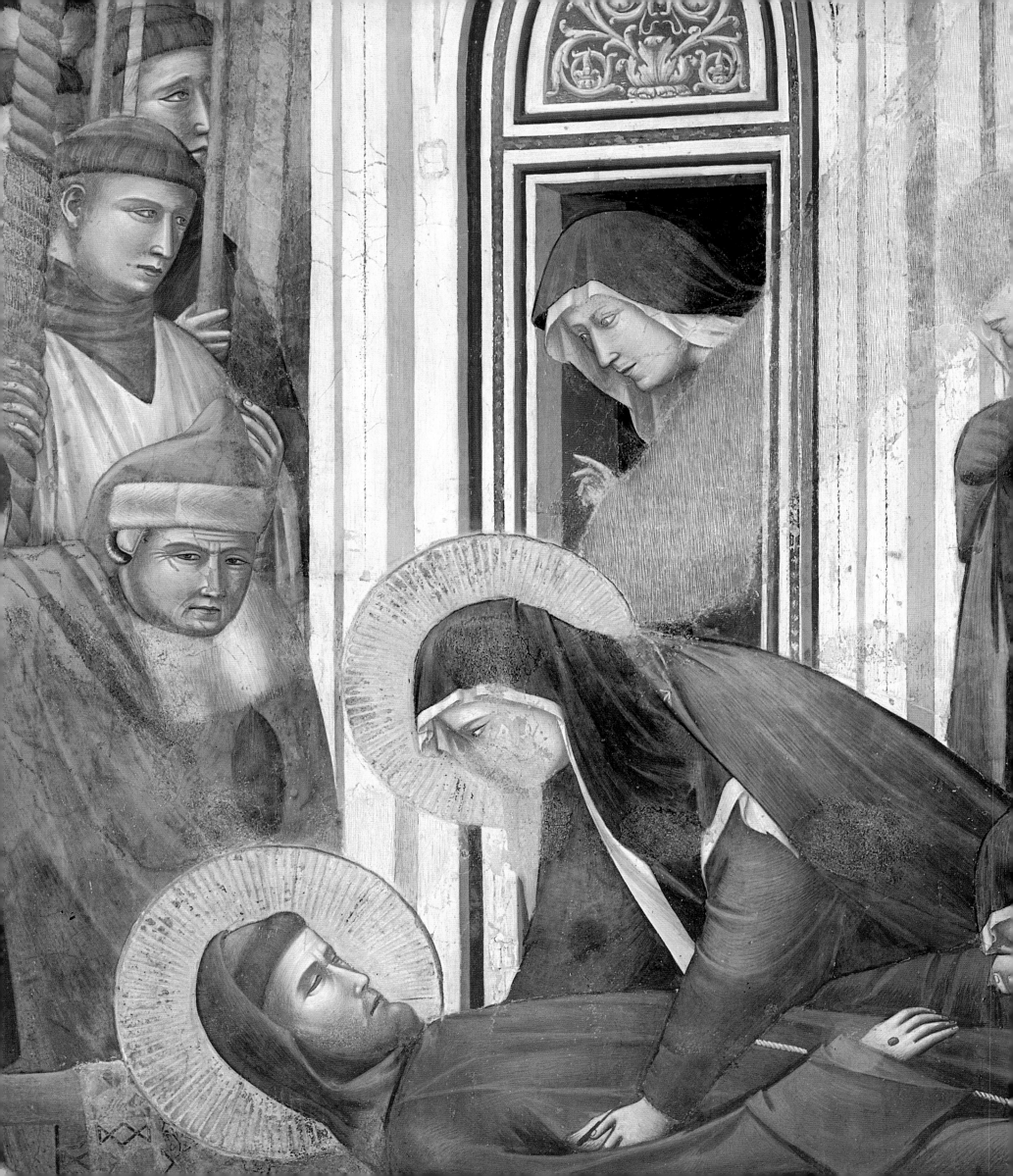

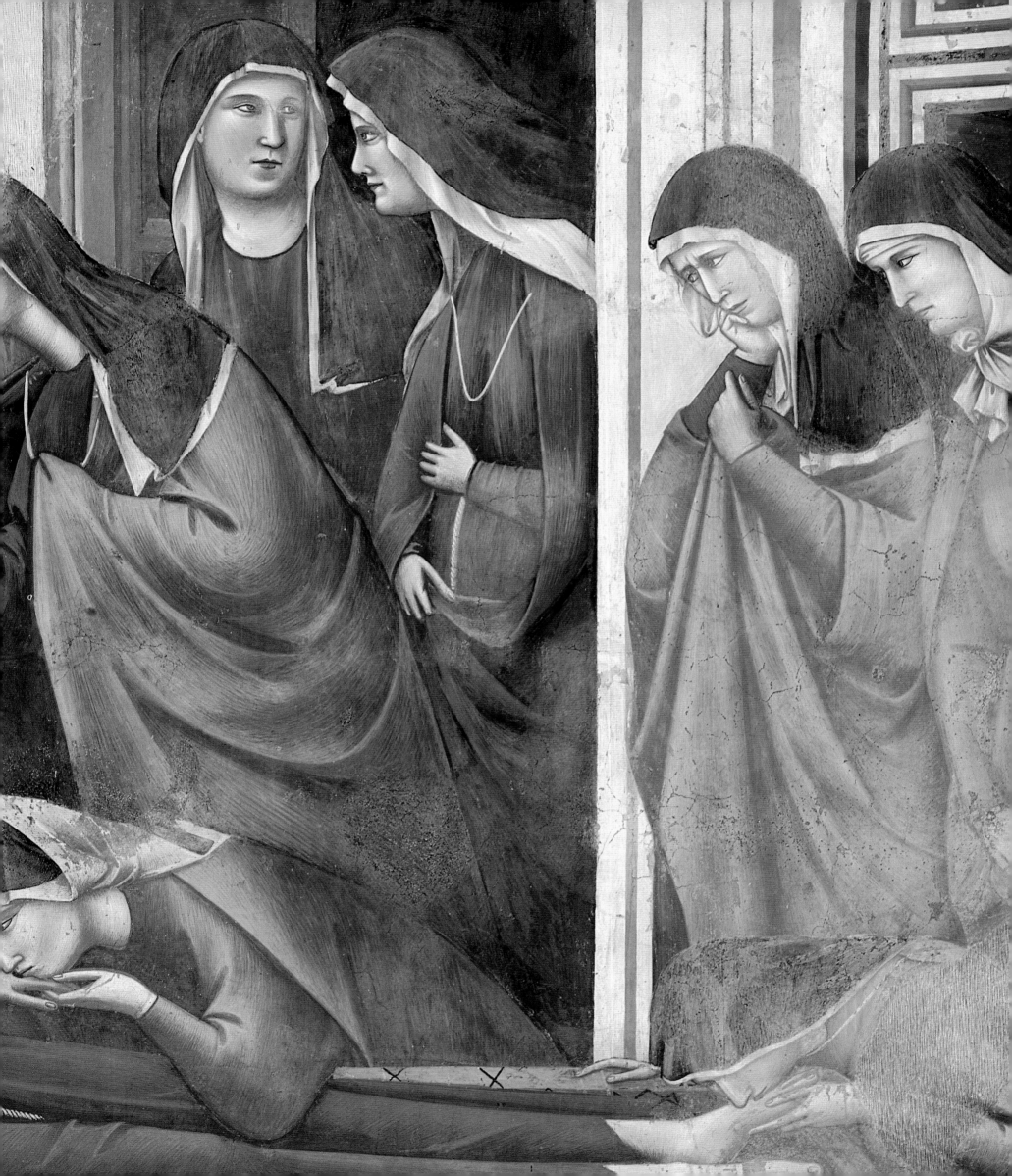

the crudity of the brush strokes. ❧ OBVIOUS differences of hand, which certainly coincide with the presence of an assistant, are visible for example in the two groups of priests and soldiers in the compartment containing the *Trial by Fire* (below left) whose faces are quite different from those of the monks, which are certainly by Giotto. The former group shows some archaic touches that resemble certain faces in the first two bays of the upper tier of the decoration. These faces are not Giottesque, but are rather related to types that run through the Old Testament Cycle in the third and fourth bays, and appear in later episodes of the Franciscan Cycle, in the *Death of St. Francis* and the *Confirmation of the Stigmata.* Yet another, well-defined personality is certainly responsible for the group of women who appear in the door in the *Crib at Greccio,* and the group of onlookers in the *Death of the Knight of Celano,* whose heads form a dense cluster. Interestingly, this type is found again, later, in the upper compartments of the Scrovegni Chapel in Padua, in the episodes dealing with the Marriage of the Virgin, which attest to the continued presence of certain assistants for several years in Giotto's workshop. ❧ BUT it is quite clear that these assistants do not disrupt the unitary conception of the cycle, which stood at the end of the thirteenth century as the loftiest testimony to a completely revolutionary modern language. Here in Assisi, particularly in the Franciscan Cycle, this language is carried "from Greek into Latin," as the fourteenth-century Florentine writer so perceptively declared.

Assistant to Giotto. Detail of
TRIAL BY FIRE *(p. 67). Upper*
Basilica of San Francesco, Assisi.

Workshop of Giotto.
CANONIZATION OF
ST. FRANCIS. *Upper Basilica*
of San Francesco, Assisi.

Workshop of Giotto.
ST. FRANCIS APPEARS TO
GREGORY IX. *Upper Basilica*
of San Francesco, Assisi.

FROM

ASSISI

TO

PADUA

THE FLORENTINE PANELS; PROBLEMS OF DATING

T LEAST SIX OR SEVEN YEARS SEPARATE GIOTTO'S YOUTHFUL WORK IN ASSISI FROM THE PADUAN CYCLE, WHICH WAS COMPLETED BY 1305. DURING THIS VERY IMPORTANT PERIOD, RICH IN EXPERIENCES, HIS LANGUAGE MATURED TO AN EXTRAORDINARY DEPTH. GIOTTO REAPPEARS in Padua in full possession of spatial dynamics and coloristic grace. But there exists very little hard information concerning these years, and the works attributable with certainty to the master are very few. Only Giotto's presence in Florence in 1301 is documented. ❧ VARIOUS reliable sources also tell of the artist's work in Rome for Pope Boniface VIII; this activity, usually dated 1300, on the occasion of the Jubilee, has recently been assigned to 1297 by Maddalo (1983). I believe that this second Roman visit spurred the next phase in the development of the space-volume relationship and of the coloristic revolution in Giotto's language. ❧ AMONG the works that can be assigned to Giotto in this long interval of years, the oldest and the one most closely tied to his work in Assisi is the large *Crucifix* (p. 91) in the church of Santa Maria Novella in Florence. Indeed some of its linguistic elements closely recall the Old and New Testament cycles in the Upper Basilica at Assisi. The crucifix could have been painted in a pause because the biblical stories and the Franciscan Cycle (Salvini, 1983), or during an interruption of the work on the Franciscan Cycle after the first two bays, when Giotto could have returned to Florence and painted the large panel. ❧ THE earliest mention of a crucifix by Giotto in the Dominican church is in the will of Ricuccio, a son of Puccio del Mugnaio, drawn up on June 15, 1312, which leaves a large sum of money so that a lamp will always be kept lit before the crucifix "painted by the distinguished painter called Giotto di Bondone." In the same will, Ricuccio also left money for a lamp to illuminate still another painting, which he himself had commissioned "the distinguished painter called Giotto" to paint in San Domenico in Prato. (Not a trace remains of this painting.) ❧ THIS will is very interesting for several reasons, first because it shows the presence in Florence of an otherwise unknown patron of Giotto, who could perhaps give us some notion of the milieu frequented by the painter in his youth in

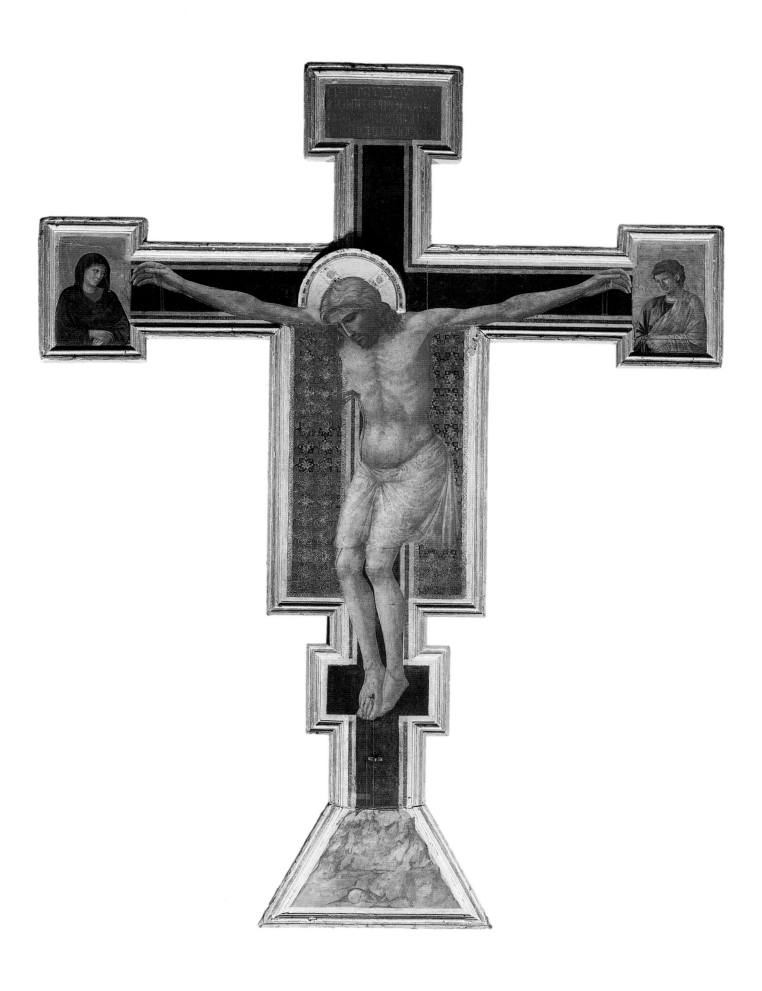

Giotto. CRUCIFIX. *Tempera on panel, 18 ft. 11½ × 6 ft. 7⅞ in. (5.78 × 4.06 m). Santa Maria Novella, Florence.*

pages 92–93: Giotto. Details of CRUCIFIX. *Santa Maria Novella, Florence.*

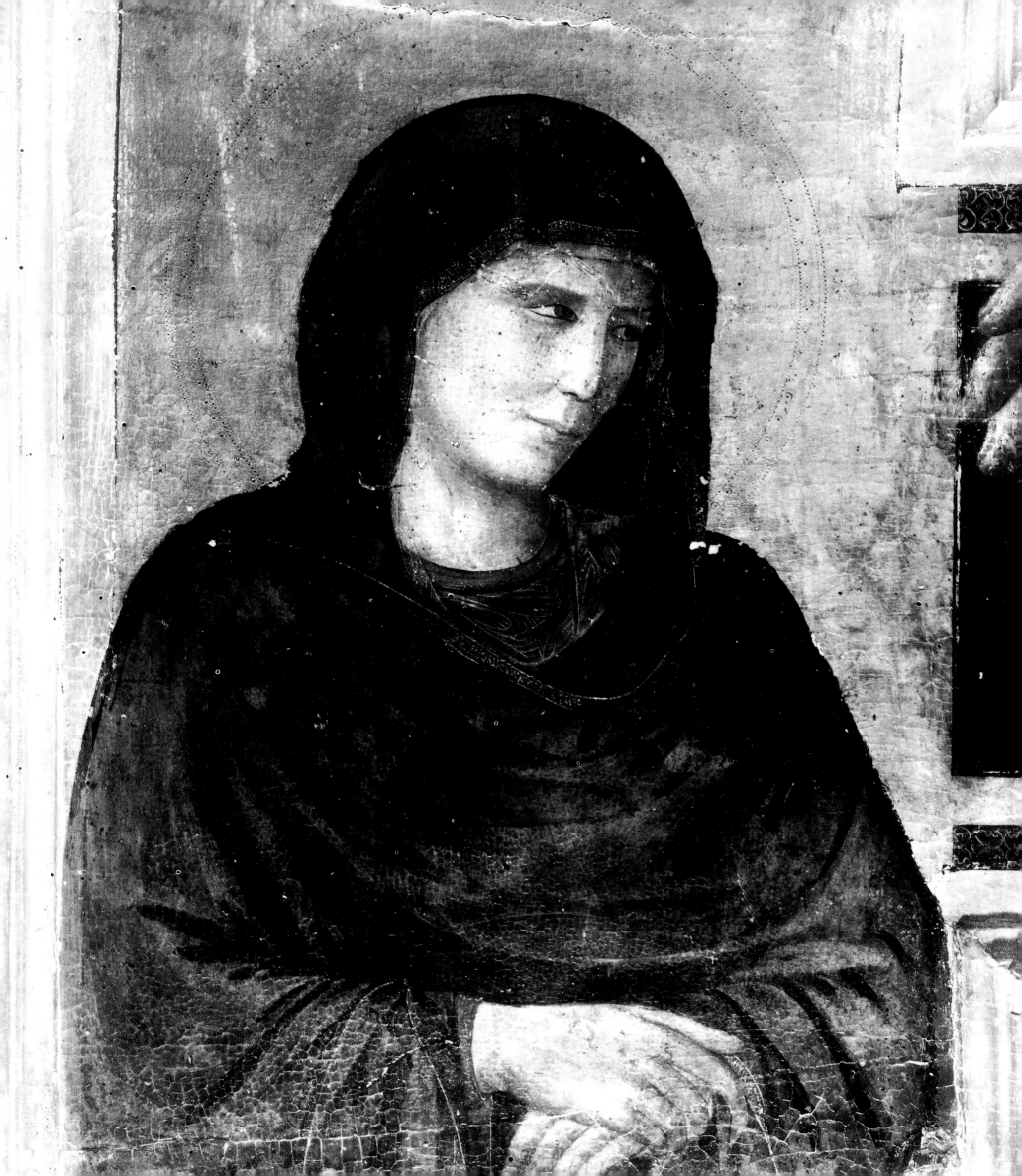

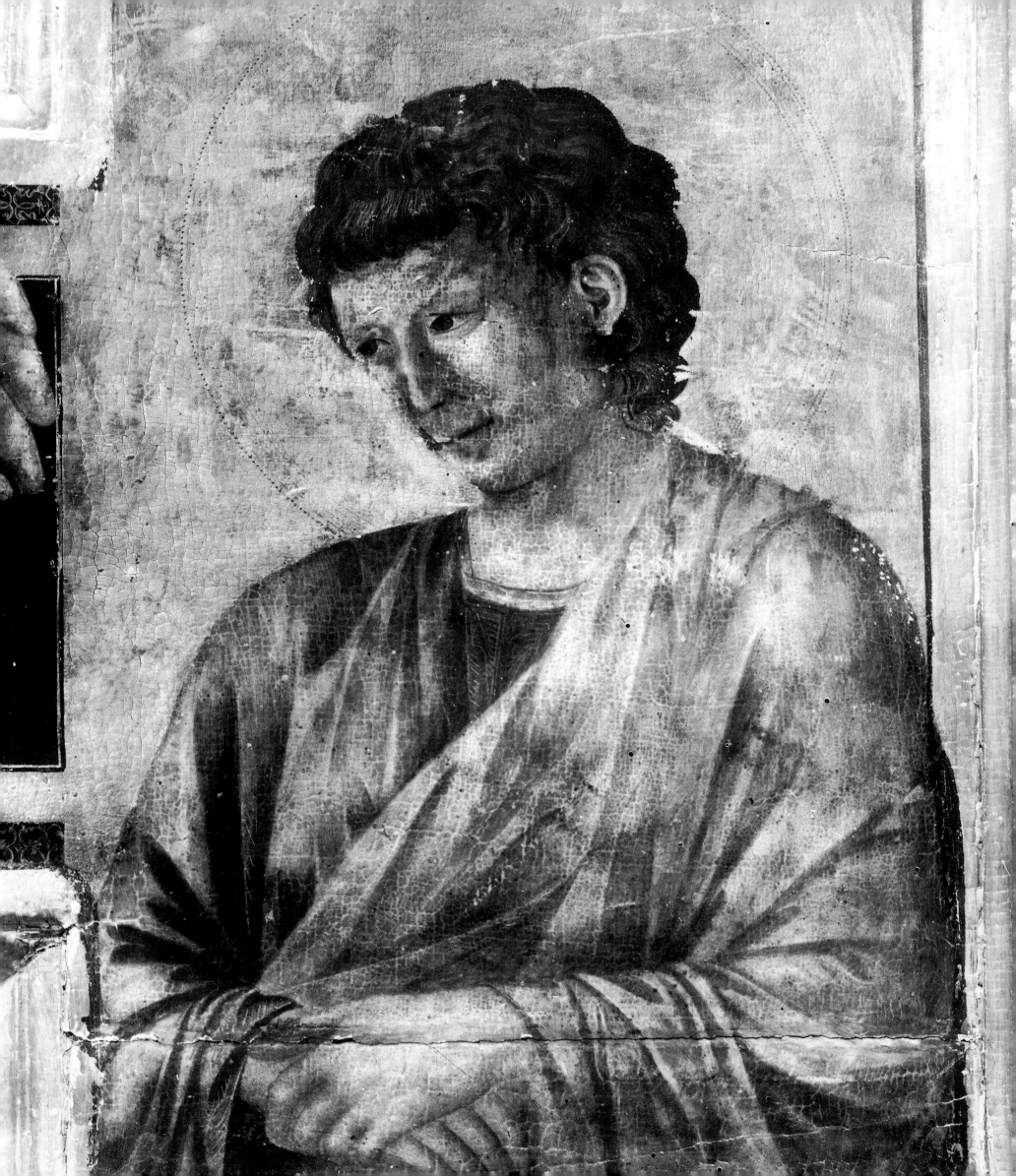

Florence. Second, it underscores the existence of two of Giotto's works for the Dominicans, whom the painter evidently frequented. ❧ RENAISSANCE critics beginning with Ghiberti speak of a Giotto crucifix in the church of Santa Maria Novella in Florence; Vasari says it was executed with the collaboration of a pupil of Giotto's, Puccio Capanna. The grand object was transported from its original location (which is still not completely clear) and placed on the facade wall, where Vasari saw it. In recent times it hung above the door of the sacristy, in poor condition. It appeared in the Giotto exhibition of 1937, and the attribution to Giotto was immediately accepted by Italian scholars (Coletti, Mariani, Salmi) and by the German Oertel. But Offner soon (1939) denied Giotto the work, assigning it to the Master of St. Francis, who is credited with the Franciscan frescoes of the Lower Basilica at Assisi; Meiss later (1960) accepted this view. Scholarly opinion remains divided, with some supporting the Giotto attribution for the *Crucifix,* while Toesca (1929 and 1951), Brandi (1983), and others see the presence of assistants in it. ❧ THE dating is much debated, with suggestions ranging from 1290 to 1300. According to Toesca (1951) and Brandi (1983), the panel should be dated even later, shortly before the Paduan work. Salvini (1952) sees a close relationship between the figures of the mourners and those in the *Deposition* at Assisi. ❧ THE excep-

tionally large work—more than 18 feet high—is extraordinary even from the back, because of the regularity and beauty of the geometric carpentry, similar to the back of the cross depicted in the *Crib at Greccio.* Like other works in this tradition, the cross terminates in three rectangular panels, at the top and at the end of each arm, and in a triangular picture at the foot, which acts as a base; the panel also broadens along with the body, then narrows and broadens out again at the feet. In the highest square panel is an inscription in gold on a red background, written in Hebrew, Greek, and Latin: *JESUS OF NAZARETH KING OF THE JEWS.* Half figures of the Virgin and St. John appear on the lateral panels; at the foot is Mount Golgotha, on which the wood is fitted. Also by tradition, the color of the cross is dark blue. ❧ THE *Crucifix* is an extraordinary work: its inspiration is very poignant religiously and poetically, and yet it is radically revolutionary. Christ's figure is for the first time a human figure. Giotto abandons the typology, typical of the thirteenth century until Cimabue, of a violently curved body crossed by deeply scored lines, with a thorax divided into three distinct sections, and with signs of acute suffering in the face, to replace it with a serene interpretation of the atrocity of the death, almost in anticipation of the resurrection. Christ's limbs are elegantly designed and the form of the body, which curves to the right at the hip, takes on

classical proportion, probably in an echo of the sculpture of Nicola Pisano. The body appears robustly plastic; the arms and legs are modeled by a very soft transition between planes in a skillful chiaroscuro effect created by a ray of light coming from the left; the hands are no longer open, and both hands and arms show, under the taut skin, the pulsing of the veins and swelling of the tendons. But it is the beauty of the head that signals a stupendous and unique revolution. The face is perfect, its delicate lineaments caressed by infinite subtle brush strokes, in the soft play of shadows; the eyes are closed, as if dreaming rather than sunk in the abysmal gloom of death; and the mouth is half-open as in a sigh. The reddish hair falls with great softness over the armpit. This poignant figure arouses powerful religious feeling, not through the old abstraction of a stylized form but in the portrayal of a human being of perfect beauty. ❧ THE figures on the lateral panels are less revolutionary: the Madonna, who evinces the merest hint of a serene sorrow, is wrapped in a dark blue mantle over a dress of a beautiful bright pink. Her very delicate face has classical proportions, perfect in the purity of its lineaments; St. John is enveloped in bright clothes of light blue and pink, deeply furrowed by bold drapery, still exhibiting traces of metallic hues. His face bears a close relation to those in the Joseph episodes and the *Deposition*—the observation is Salvini's (1952)—in the Upper Basilica of Assisi; the Madonna is also still tied to the world of the Assisi frescoes: her perfect, oval face recalls Rebecca's in the Isaac stories, and the clothes and loincloth, with sharp pleats of a Cimabuesque type, are connected to the same pictures. But the Florentine *Crucifix* exhibits absolute iconographic innovation when compared to the higher frescoes of the Upper Basilica of San Francesco, including the *Crucifixion* on the left wall, where Christ is still portrayed in accordance with medieval tradition, conveying suffering in his violently bent body. Furthermore, the Santa Maria Novella *Crucifix* shows a different proportional measurement, in adherence to classical canons. ❧ THANKS to the directors and technicians of the Opificio delle Pietre Dure workshops in Florence, where the painting is now being restored, I have been able to observe at close hand some revolutionary linguistic elements that characterize this crucifix, above all the use of colored shadows. My attention was directed to the fact that, to obtain the dark shadow on the right side of Christ's body, molded by a blast of raking light that comes from the left, Giotto uses quick, broad brush strokes of lacquer. The effect is extremely plastic, but the figure remains immersed in light. An analogous procedure is found in the Madonna's blue mantle, which lets the red coloration gleam through; this colored shadow is very effective. ❧ THE *Crucifix* has another characteristic typical of the

Giotto. Detail of CRUCIFIX *(p. 91). Santa Maria Novella, Florence.*

master throughout the course of his long career: it is designed to be looked at from a precise point of view, in this case from below. In fact, if one looks straight at the majestic panel, the central part of the body appears compressed and almost crushed, while the head and feet seem larger in respect to the other parts; but these proportions are corrected if one reads the painting from below. The ornamental parts of the painting, now more legible thanks to the recent restoration, are still balanced between tradition and innovation; the small ribbon that runs along the vertical arm of the cross simplifies a medieval decorative motif; but in the throat of the frame there is an uninterrupted fuchsia band with Cufic (the earliest written Arabic) characters in silver; Cufic letters, now barely legible, are also incised in the halos around the heads of the Madonna and St. John, and as a background to the inscription on the upper placard-like panel. These are contemporary decorative motifs, which begin to appear in Tuscan painting and sculpture in Florence and Siena at the end of the thirteenth century. Another novelty is the cloth behind the cross, embroidered with gold and silver stars against a wine-colored background: this element was also characteristic of the Gothic world and contrary to the traditional illuminated cloths of Byzantine origin. ❧ I WOULD like to focus attention on a detail that up until now has been missed by critics because it could not be seen in the church and has been visible only since the gigantic panel was brought to the laboratory for restoration: Christ's halo, raised in relief, is encircled by a series of blue glass segments forming flowers with leaves of gold. This absolutely new and unprecedented motif was probably a variant of the precious stones that adorned crucifixes in the medieval tradition before the thirteenth century, and it leads to other considerations. First of all, it confirms what Renaissance sources said regarding Giotto's curiosity about and knowledge of all aspects of figurative language and techniques. What's more, the use of blue and gilded glass was widespread in Tuscany in and around the Pisano workshops, where it was employed to enrich and illuminate the bases of sculptures on pulpits; this motif probably came from France, where extraordinary luminous effects were obtained with blue and gold glass in the Sainte-Chapelle in Paris. It seems to me that these small details can confirm a further link between Giotto, on his return to Florence, and the sculpture of Pisano, which explains the great outburst of human feeling in the definition and modeling of the body of Christ. ❧ THE *Crucifix* presents, as I have said, a new typology for the body of Christ, no longer suffering but almost sleeping; the variety and richness of its ornaments suggest a successful new interpretation of the theme of glory. In a certain sense it is a return to the serene depiction of the glorious Christ

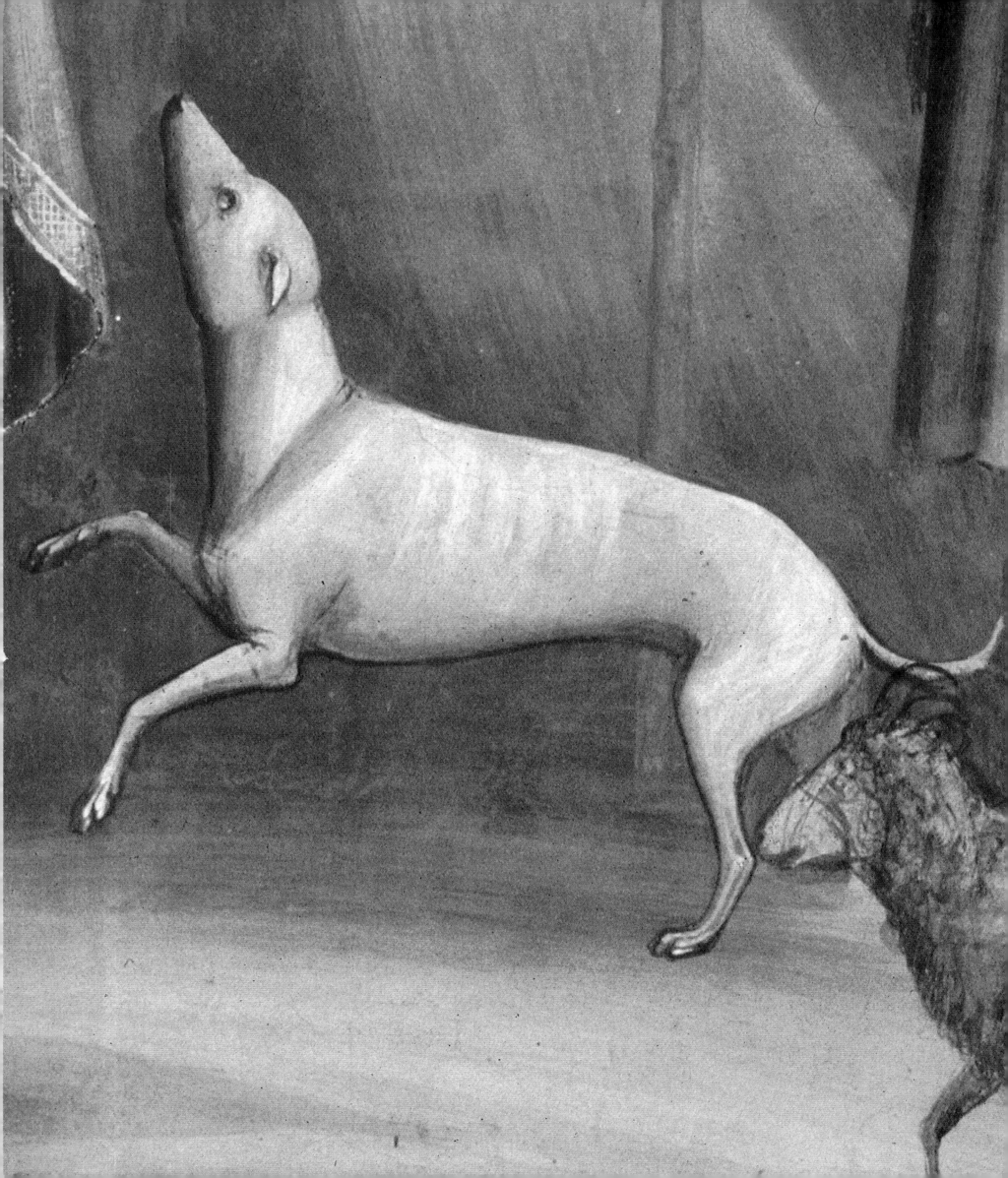

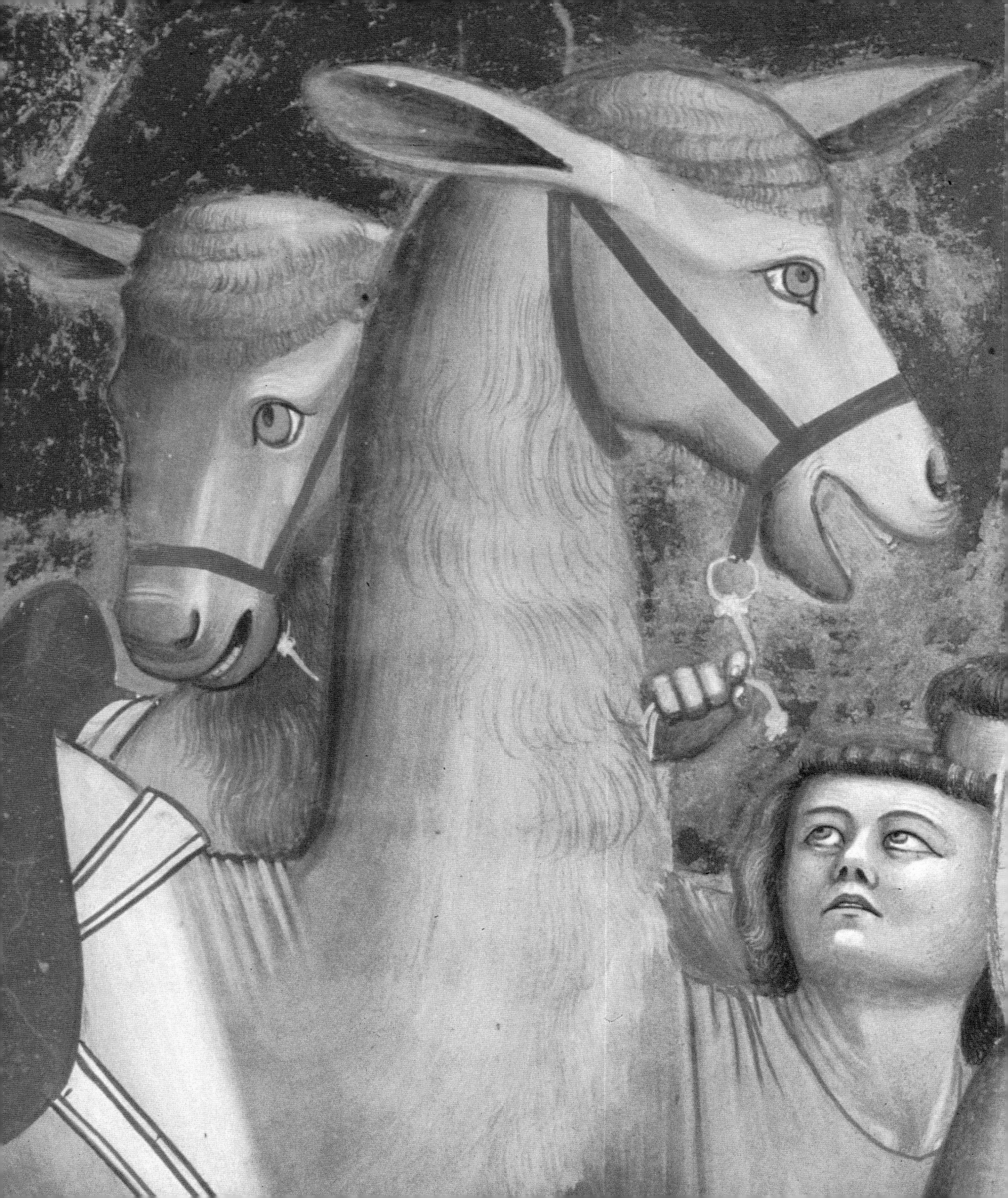

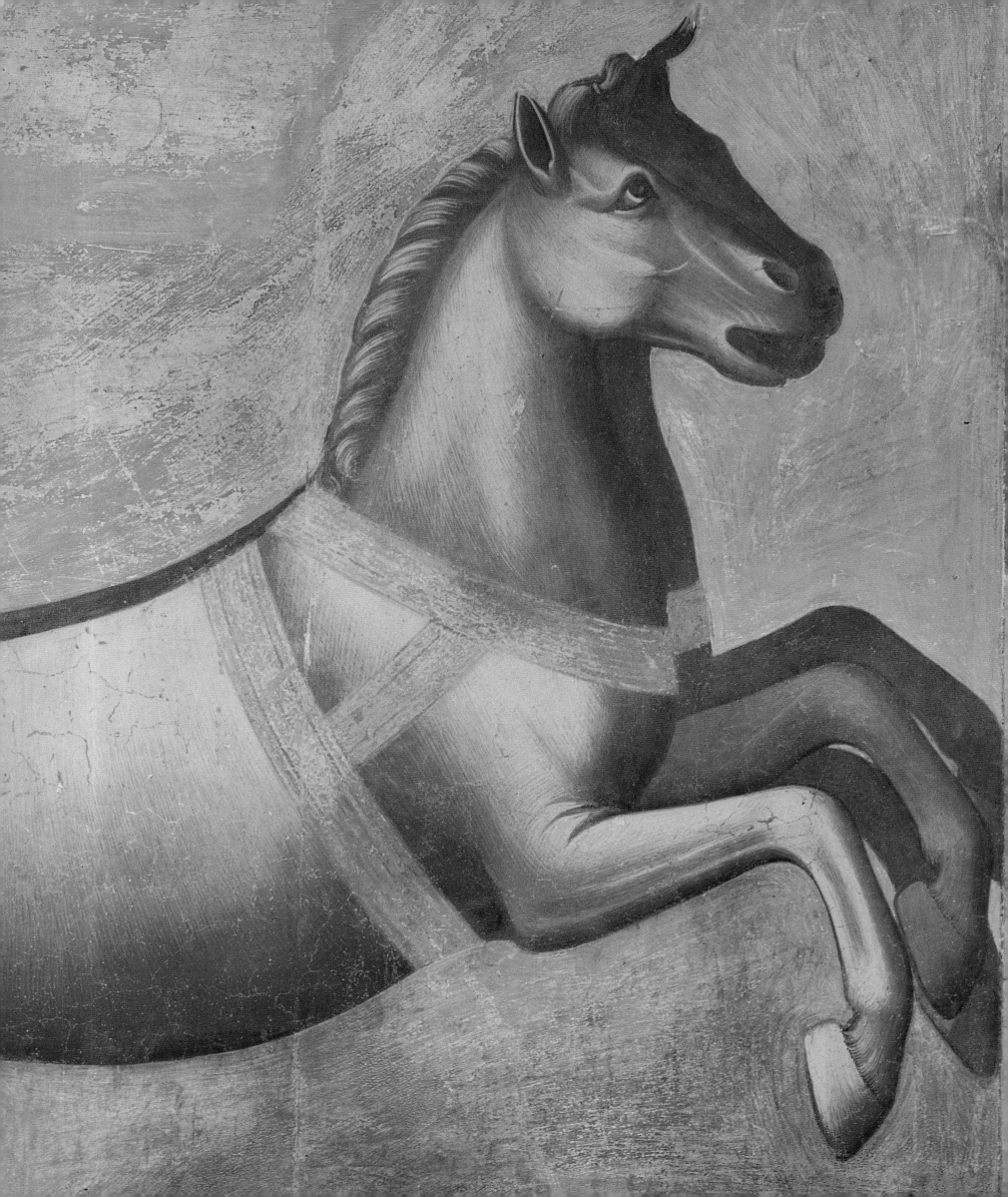

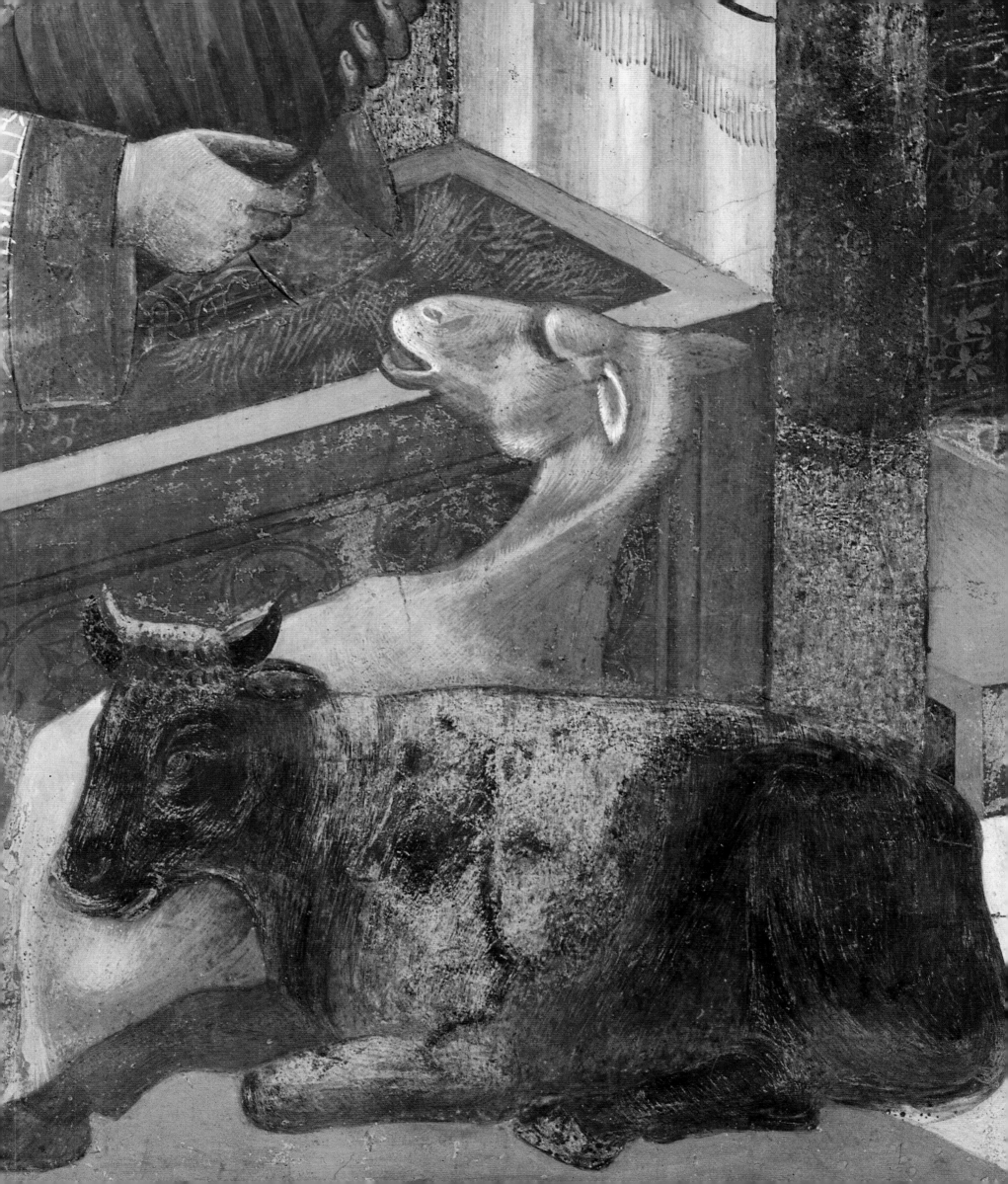

proposed by the Paleo-Christian and high medieval tradition, in contrast to the image of the *Christus patiens,* dear to popular thirteenth-century piety, which was tied to Franciscan religiosity. Giotto therefore not only started a figurative revolution in the Florentine panel but provided a deeper interpretation of newly examined religious and theological matters, an interpretation that he was to propose again in Rimini and Padua. ❧ IN FACT, at the end of the thirteenth and during the first years of the fourteenth century, a debate was going on in religious and theological circles between those who emphasized Christ's humanity, favoring images of his suffering and death, and those—especially the Dominicans—who wanted to return to the more ancient theological tradition that emphasized the divinity of Christ and thus favored images of glory. For the latter group, death and the cross signify not only the moment of suffering, but the concept of resurrection. I think that Giotto's panel, not by chance executed for a Dominican convent, is connected with this new theological and spiritual movement, and reveals a seldom noticed aspect of Giotto's personality. Even in his first works, and then throughout his long and finely articulated artistic career, he was an attentive and sensitive interpreter of the most gripping theological and spiritual problems of his day. ❧ AFTER the decoration of the Upper Basilica of Assisi, Giotto is thought to have painted the *Madonna and Child Enthroned* (p. 106) in the church of San Giorgio alla Costa in Florence. It is presently being restored in the laboratory of Fortezza da Basso. The cuspidated or toothed panel has been mutilated: it was cut on all four sides in the eighteenth century, so that it could be inserted in a baroque altar. Ghiberti was the first to mention a painting by Giotto in the church of San Giorgio; he was followed by other Renaissance historians and scholars. In recent times the panel was, so to speak, rediscovered by Offner (1927), who attributed it to the "Master of Santa Cecilia," and as such it was exhibited in 1937 at the Giotto exhibition. It was attributed to Giotto again by Oertel (1937), followed by Longhi (1948), Salvini (1952), Bauch (1953), Gnudi (1958), and Battisti (1960a). It is now almost unanimously accepted as his work and placed chronologically alongside the Franciscan frescoes of Assisi. ❧ THE Madonna sits on a Cosmatesque throne covered with a very rich cloth that allows us a glimpse of the traditional red cushion; her monumental posture is barely ruffled by a slight tilt of the head and the bend of a knee pushing forward. She is clothed in the traditional colors—the red dress and the (now blackened) blue mantle—but she also wears a *marforium* (tight cap) that is bright red, a color not usual in the tradition. And the blessing Child, seated like his mother in a rigid pose and wearing a costume of white tending to gray, is also

Giotto. MADONNA AND CHILD
ENTHRONED. *Tempera on panel,*
70⅞ × 35⅜ in. (180 × 90 cm)
San Giorgio alla Costa, Florence.

covered by a red mantle. Red also brightens the stoles of the beautiful angels behind the throne, as it does the ribbons in their hair. The vivid red prevails over the blue in this very lively, if not very rich, panel. ❧ RELATED to the better known and more famous Madonnas in Glory by Duccio and Cimabue, this panel exhibits the transition to a new figurative culture: the Madonna's figure now has "natural" proportions and her pose too is natural, while her face, shaped in accordance with classical canons (already seen in the figures on the higher tiers of the Assisi walls) has a unique, vivid expression. Her body is set off by deep drapery and is constructed by a precise chiaroscuro, though her sleeve and the costume of the child still show those sharp folds that one finds in the Assisi frescoes of the upper tier, and in the panels of the Santa Maria Novella *Crucifix*. Still, the panel is very refined in the use of Gothic cloth, and in the presence of the graceful little angels who look out from behind the throne. Again like the *Crucifix,* the panel exhibits a new style, confirming Giotto's new and powerful personality, surpassing the earlier and contemporary tradition with his revolutionary ideas. ❧ INDEED this majestic depiction of the Madonna and Child emphasizes a renewed relationship with the language of Arnolfo. Arnolfo had perhaps already returned to Florence again after his work in the Florentine Duomo, which was begun in 1295. In fact the bond between the panel in San Giorgio alla Costa and the Madonna executed by Arnolfo for the facade of the Duomo (and now preserved in the Museo dell'Opera del Duomo or Cathedral Museum) is very close. The majestic pose is very similar; the static blessing Child, which constitutes an innovation in the depiction of the Madonna in Glory, is completely analogous; and there are also other details, secondary but significant, which confirm this relationship, such as the fall of the clothes in soft fluent waves, leaving the tips of the shoes uncovered. ❧ THUS the painting should be dated after 1295, at the end of Giotto's long youth, but before his second journey to Rome, where he was summoned, as we shall see, by Pope Boniface VIII around 1297, and which marks a new stage in the painter's expressive development.

pages 108–109: Giotto. Details of MADONNA AND CHILD ENTHRONED *(p. 106). San Giorgio alla Costa, Florence.*

ROME, 1297

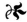

IN A deeply probing and accurate recent study, Maddalo (1983) argues that the date of Giotto's second sojourn in Rome should not be placed in 1300, on the occasion of the Jubilee proclaimed by Pope Boniface VIII. A greatly mutilated fresco of the time, preserved in the Lateran basilica, depicts the pope beneath a canopy, surrounded by deacons and cardinals. This, together with another two depicting the Baptism of Constantine and the foundation of the Lateran basilica, which have been lost, embellished the portico that Boniface VIII had had erected in front of the new palace of the Lateran (1297). The portico was demolished in 1586; of the decoration only the fragment in question was saved, and it had recently been restored. It has been recognized, starting with Muentz (1881), as *Boniface VIII Proclaiming the Jubilee* (p. 111). MADDALO denies that the Lateran fresco can be identified with that proclamation. She asserts that it depicts Boniface VIII taking possession of the Lateran soon after his coronation in 1295, as described in contemporary chronicles. It is known that Boniface had powerful opponents who challenged the legitimacy of his coronation. The spirituals, a faction headed by the Colonna family, waged a particularly harsh struggle, until they were driven out of Rome in 1297. Thus the construction of the portico, called *pulpitum Bonifacii,* initiated in 1297, and the accompanying fresco decoration were devised as a kind of manifesto of the legitimacy of Boniface VIII's election to the papacy, and also as a legitimation of his temporal power. In this exquisitely political key the Giotto portrayal should be read.
ONLY Vasari among Renaissance chroniclers mentions a depiction of Pope Boniface executed by Giotto in San Giovanni in Laterano. The frescoes are recorded by historians of Roman matters and by chroniclers in the fifteenth and sixteenth centuries and attributed indifferently to Cimabue or to Giotto. After restoration in 1952, the fragment has become sufficiently legible to display the splendor of its colors and the classical severity of its composition. Starting with Brandi (1952 and 1956), most scholars have accepted it as Giotto's work. Boskovits (1983) attributes it instead to Cavallini. An overall idea of the fresco in question can be gotten from a watercolor design preserved in the Biblioteca Ambrosiana in Milan and published by Muentz (1881).
THE composition is divided into two zones. Below is a deep portico—the actual site of the fresco—supported by classical

Giotto. BONIFACE VIII
PROCLAIMING THE JUBILEE.
San Giovanni in Laterano, Rome.

white columns, in front of a palace; before and beneath it is a crowd of people on horseback and foot. In the upper part is a central canopy in precise perspective, also supported by classical columns, with a Cosmatesque architrave; underneath, the pope sits between a deacon and a cardinal. At the sides of the canopy appear two groups of church dignitaries. According to Mitchell (1951) the composition was inspired by the Obelisk of the Roman emperor Theodosius in Constantinople, which was indirectly known to Giotto. Vayer (1971) is also interested in the iconographical derivation of the fresco from models of triumphal Roman monuments. ❧ THUS it is a copy of a classical image in a classical milieu; this is of extraordinary importance since it poses once again, with even greater emphasis, the issue of Giotto's relationship with the ancient world. The connection was reinforced by this second contact with Rome when the painter was sufficiently mature; we can see the great results of this assimilation of the classical world in the Paduan frescoes of the Scrovegni Chapel. ❧ AN ANALYSIS of the linguistic data in a strict sense proves that the Roman fragment constitutes a further step in Giotto's linguistic journey. As has already been noted (Brandi, 1983), new solutions to the spatial problem appear in the articulation of several parallel planes and in the canopy drawn with perspective exactitude. The figures are now formed with great fluidity, the drapery is profound, but the surface dilates in a more ample and composed manner. The faces are beautiful. Most striking is the intensity of expression in the portrait of the cardinal on the left, with squinting eyes and heavily scored furrows on his forehead. But in these faces, in comparison to Assisi, a more suffused luminosity softens the trenchancy of the line. ❧ I REGARD this Roman sojourn of Giotto's, just at the end of the century, as very important for comprehending the later development of his language in the more majestic structure of his figures and his changed colors, which grew brighter and were enriched by gilt decorations on the clothes. The results will be seen immediately in the Badia *Polyptych,* and later in the frescoes of the Scrovegni Chapel. In fact Rome in 1297 offered much greater splendor than it had ten years earlier. The decorations of the Lateran basilica and of Santa Maria Maggiore were complete. Pietro Cavallini had executed his commissions at Santa Maria (1291) and Santa Cecilia (1293) in Trastevere, exquisite works caressed by pale, soft colors in pastel shades. The frescoes in the basilica of Sant'Agnese, now in the Pinacoteca Vaticana, were particularly pertinent to the problem of the space-figure relationship and the wise use of chiaroscuro; and Arnolfo had turned toward more measured classical expressions, for example in the canopy in Santa Cecilia (1293). All these works made a

Copy of BONIFACE VIII
PROCLAIMING THE JUBILEE,
from IMMAGINI OSSIA
COPIE DI PITTURE SACRE E
SIMBOLICHE ESISTENTI

IN ROMA DAL GRIMALDI
*(ms. F. inf. 227, f. 3). Watercolor
on paper, 17¾ × 11⅞ in.
(45 × 30 cm). Biblioteca
Ambrosiana, Milan.*

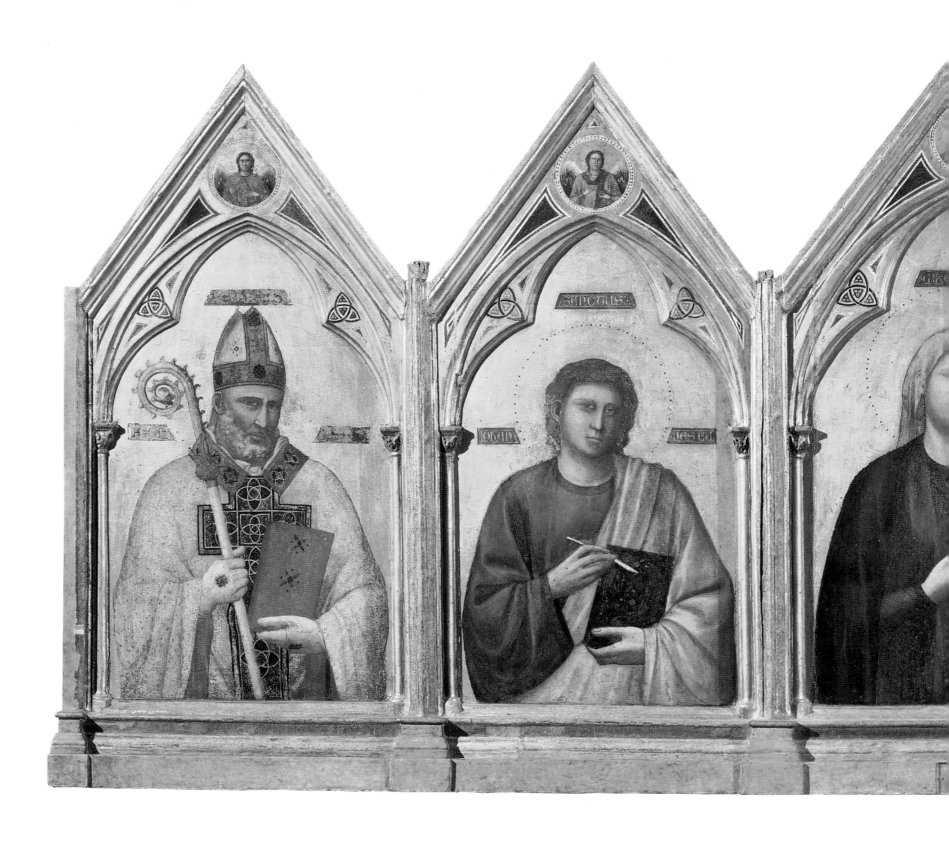

Giotto and assistant. Badia POLYPTYCH. *Galleria degli Uffizi, Florence.*

pages 116–17: Giotto. Details of Badia POLYPTYCH. *Galleria degli Uffizi, Florence.*

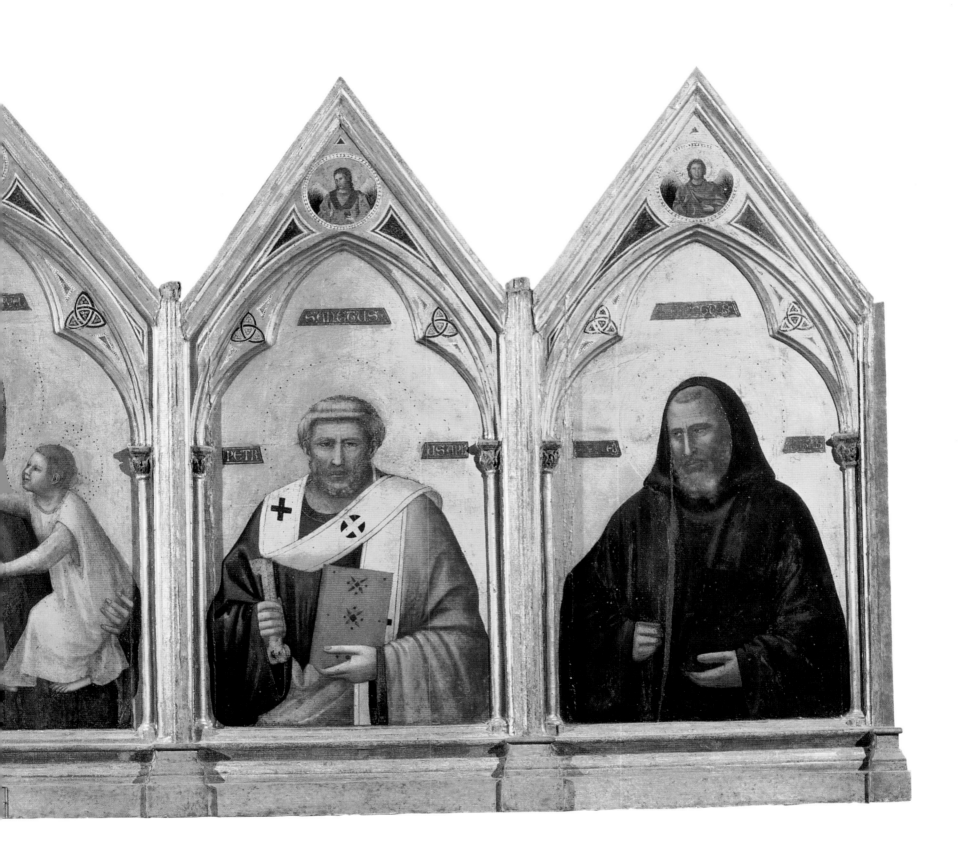

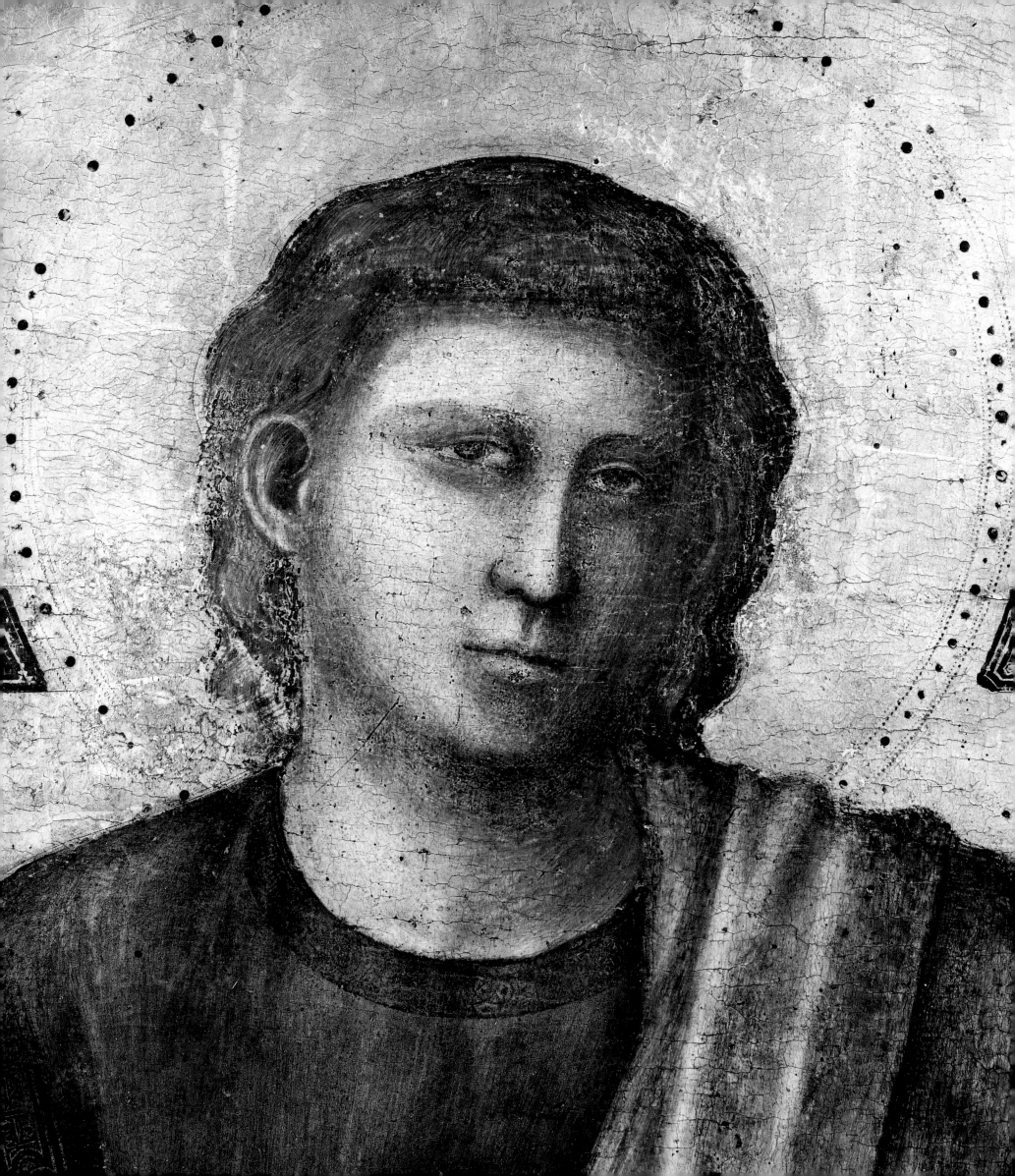

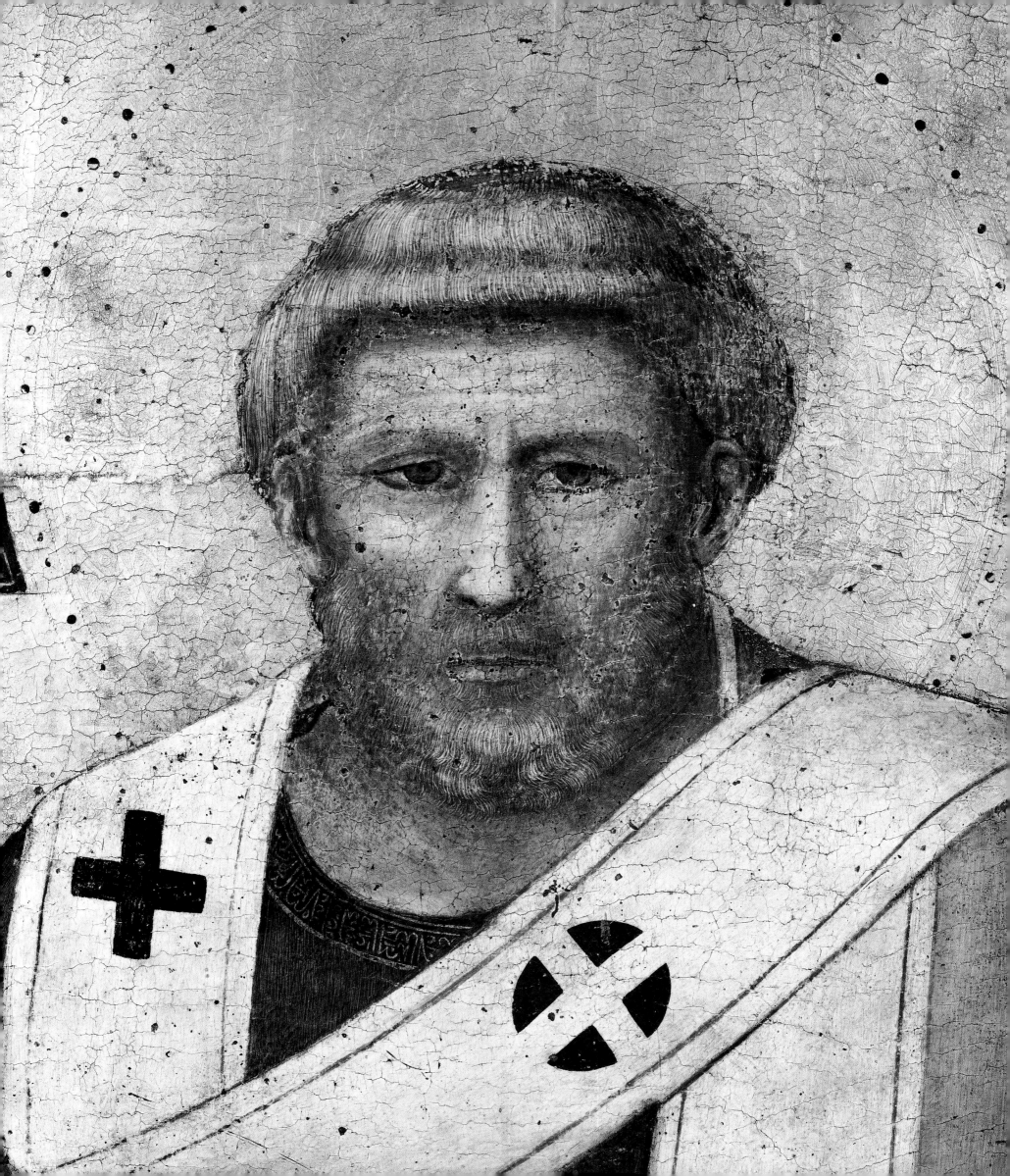

profound impression on the young Giotto, who gained from them a more classical compositional measure and the use of bright color, bursting with light. ❧ RECENTLY a panel has appeared on the market and has been published by Todini (1994) as a work by Giotto during this second Roman sojourn. The painting's whereabouts are unknown and it cannot be seen; so far as one can judge from the photographs, it does not seem to be attributable to Giotto.

RETURN TO FLORENCE

❧ BACK-DATING Giotto's Roman sojourn to before 1300 allows us to posit a greater gap between his works, or at least to imagine the painter's presence in Florence and Rimini before his journey to Padua. Unfortunately very few works remain from this period, and even they have been disputed: the polyptych in the Badia Fiorentina, a Benedictine church, now in the Uffizi Gallery (p. 114); a few tatters of Stories of the Virgin from the same church; and the crucifix in the Tempio Malatestiano at Rimini. In all of these works Giotto's language shows a further maturation of compositional sense and an even greater and more exquisite feeling for color. The forms are more compact and majestic, shaped by a soft and precise play of chiaroscuro, almost as if, as we shall see further on, the renewed contact with the rich and varied figurative Roman world of the last years of the thirteenth century had produced a new monumental solidity in his painting. ❧ THE Badia *Polyptych,* which Procacci (1962) attributes to Giotto and dates around 1301, is a work in five cuspidated compartments. Within the sharp tip of each small frame is a medallion—one depicts the Heavenly Father, and angels appear in the other four. On the large panels are portrayed the Madonna with Child at the center, to the left St. John the Evangelist and St. Nicholas, and to the right St. Peter and St. Benedict. ❧ THE painting, which was found in Santa Croce, has been identified by Procacci (1962) as the painting in the Badia recorded by Renaissance historians, starting with Ghiberti. The attribution of the work to Giotto, originally proposed in modern times by Thode (1885)

Giotto. Detail of Badia POLYPTYCH *(pp. 114–15). Galleria degli Uffizi, Florence.*

and accepted by some critics, was almost unanimously followed after the work was cleaned, even though some suspected the presence of an assistant working alongside the master. Perhaps the assistant was the "Master of San Nicola" who—especially according to Hueck (1983), adopting an opinion of Offner (1930)—might be the painter of the two lateral saints. In fact these slightly slimmer figures have faces with a strong resemblance to the saints of the mural triptych and the window embrasures in the Chapel of San Nicola, and so they could be attributed to that chapel's most skillful painter. ❧ T H E polyptych has an extremely interesting structure, starting with its framing, which seems to repeat the three-lobed cornice inside an acute arch that Giovanni Pisano had invented for his famous pulpit in Pistoia a few years before. But within this accentuated Gothic form the figures in vertical tension dilate with an emphatic plastic sturdiness, like pyramidal blocks; they are set slightly askew, however, so as to give the sensation of penetrating more deeply into the gold background. The chiaroscuro is precise and neat, the light coming from an almost frontal source (a trifle to the left), and this intense luminosity too endows the figures with a composed classical majesty. The faces are meditative and severe, but shaped with an extraordinary delicacy in the shading, and their hands too are precise and delicate, their fingers carefully bent.

The colors are bright and luminous throughout, formed by a modulation of shadow; and certain refined details are very beautiful, such as the Madonna's transparent veil trimmed with gold, and the Child's little pink garment. Brandi (1983) has made an acute observation about St. Peter's cloak: "The consistency of the way the cloak is wrapped around makes it weigh, gives it thickness, gives the sense that it is in a space and not on a surface." Thus at this moment in Florence, Giotto apparently turned his attention to a further reduction of the form within geometric modules, seeking a new monumentality, and to the use of brightened color, caressed by a soft chiaroscuro and enriched by precise ornamentation. ❧ A L M O S T all scholars date the large *Stigmata of St. Francis* (p. 120)—now at the Louvre, where it ended up after the Napoleonic suppression of religious houses—shortly after the Assisi frescoes. But its chronological placement is not so easy, and its close resemblance to the Franciscan Cycle is deceptive. Without accepting Venturoli's (1969) proposal for a late dating, we should certainly allow a few years' gap between the Assisi frescoes and the panel in question. ❧ T H E *Stigmata of St. Francis* decorated the church of San Francesco in Pisa, where it was first reported by Vasari; it hung in one of the chapels in the left transept (Gardner, 1982). Pointed in form, like a facade of the church, it presents the stigmatization at the bottom as a sort of predella,

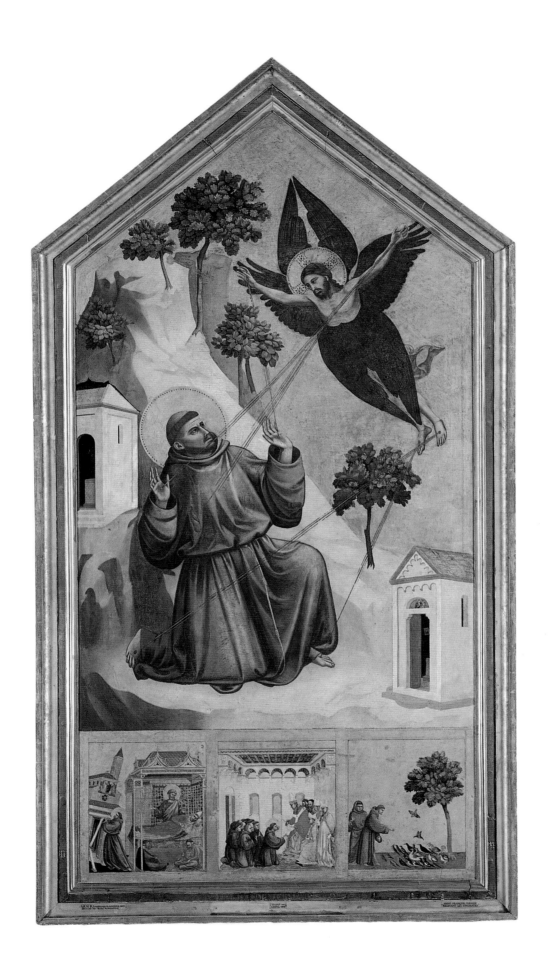

Workshop of Giotto. STIGMATA OF
ST. FRANCIS. *Tempera on panel,*
10 ft. 3½ × 5 ft. 3¾ in. (1.62 ×
3.14 m). Musée du Louvre, Paris.

enclosed by the small engraved frame wherein three compartments depict the *Dream of Innocence III, Franciscan Rule Approved,* and *St. Francis Preaches to the Birds.* All three episodes repeat similar scenes in the Franciscan frescoes at Assisi, down to the details; just as the panel, signed in the border of the frame "opvs jocti florentini," should constitute certain proof of the Giotto autograph of the Assisi frescoes. ❧ THE painting is regarded by most scholars not as an autograph work but as a piece done by Giotto with assistants, or actually executed by Giotto's workshop only. The hard contour line around the saint in ecstasy marks his face too sharply for it to be Giotto's work, and some mistakes in drawing St. Francis's hands and feet and the Seraph Christ, together with the opacity of the color, have led scholars to attribute it to the workshop. The small episodes painted in vivid colors are apparently more successful; but the slender, fragile little figures are not at all in line with the master's autograph. The compositions also exhibit, in comparison to the superb beauty of the original inventions in Assisi, boring workmanship, as in the birds in *St. Francis Preaches,* including a large cock and two ducks, which are disposed in precise rows, all with the same repetitive movement.

RIMINI

❧

❧ RICCOBALDO Ferrarese (c. 1312–13) reports that Giotto worked in the Franciscan church in Rimini. The church was transformed halfway through the sixteenth century by Sigismondo Malatesta into a grand mausoleum for himself and his family, and all the previous frescoes were destroyed. Nevertheless, Giotto's presence in Rimini had quite an impact, affecting above all the development of painting in the Po Valley and the birth of that singular pictorial movement known as the Riminese School. The chronology of Giotto's stay in Rimini is cause for discussion: Should it be placed before or after the artist's time in Padua? ❧ THOUGH the frescoes have been destroyed, a very large *Crucifix* (p. 123) remains in the Tempio Malatestiano—probably present in the same church from the start—which is certainly by Giotto. The panel has been mutilated and is not in a good state of conservation; fragments of the painting on the two horizontal arms indicate that each arm terminated in a polylobed panel,

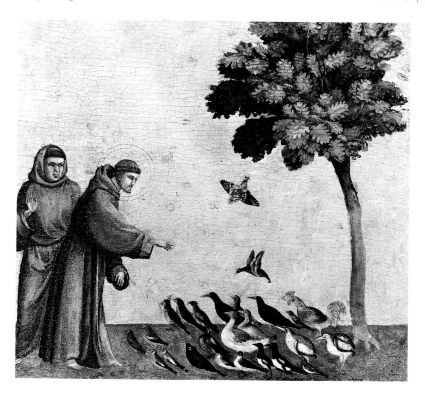

Workshop of Giotto. Detail of the predella, STIGMATA OF ST. FRANCIS *(p. 120). Musée du Louvre, Paris.*

where the figures of the Madonna and St. John stood out against a gold background in small octagonal panels. At the top was the figure of the Eternal Father, also in a polylobed panel; now it is in a private collection, but Zeri actually recognized it (1957) as the cornice for the cross at Rimini. ❧ THE *Crucifix* was exhibited at the show "Riminese Painting of the Fourteenth Century" of 1935 as the work of a "Riminese painter around 1310–15" (Brandi, 1935); later it appeared in the Giotto show of 1937 in Florence as the work of Giotto, and as such is now accepted. The greater problem today is its chronological placement; some scholars put it after Giotto's Paduan experience. ❧ IN COMPARISON to the Santa Maria Novella *Crucifix,* Christ's body here has a more elongated and elegant structure, and the pose is straighter against the wood of the cross. The contour outline is precise and underscores the ribs and torso, darkened by shadow. The arms and legs are thin, perfect in design, and a light shadow emphasizes the musculature and the tendons; the hands are half-closed, and have thin fingers, which seem to be grasping the darkness. The face is beautiful and very sweet, caressed by the shadow of the hair; here too there is no sign of suffering in the closing of the eyes and the sigh of the slightly parted lips. The cross stands out against an elegant carpet, and in the gold background the panel is enriched by semicircular motifs of red and gold, very similar to those in the crucifix in the Museo Civico of Padua. ❧ HOWEVER similar these paintings are, the one in Rimini seems to me to be earlier. The contour line is more incisive, and one can still catch some echoes of Cimabuesque drapery in the loincloth's folds; this work is quite different from the utter softness of the Paduan work. Therefore I maintain that Giotto was in Rimini before Padua. ❧ THAT Giotto was in Rimini first is furthermore proven by his impact on the fascinated painters of the Riminese School. The most affected were, naturally, the masters of the first generation: the painters who decorated the Palazzo dell'Arengo, and the apse and the bell-tower chapel of the church of Sant'Agostino, and the creators of the oldest of the numerous crucifixes scattered in the churches and museums of the Romagna region and the Marches, beginning with the crucifix of Mercatello, dated 1309 (Volpe, 1965). ❧ ALL of these speak a language that leads us back to Giotto's pre-Paduan work. The flow of shapes, not so readily measured as in Padua, is still sometimes frozen in archaic fixity; the drapery is deep, but at times the sharp, scored folds derived from Cimabue reappear, lines that characterize the Assisi frescoes and not those of Padua; the architecture, though articulated and complex, never echoes the perspective simplicity of the Paduan Arena frescoes.

Giotto. Detail of CRUCIFIX *(p. 123). Tempio Malatestiano, Rimini.*

page 123: Giotto. CRUCIFIX. *Tempera on panel, 14 ft. 4 in. × 9 ft. 11¼ in. (4.37 × 3.03 m). Tempio Malatestiano, Rimini.*

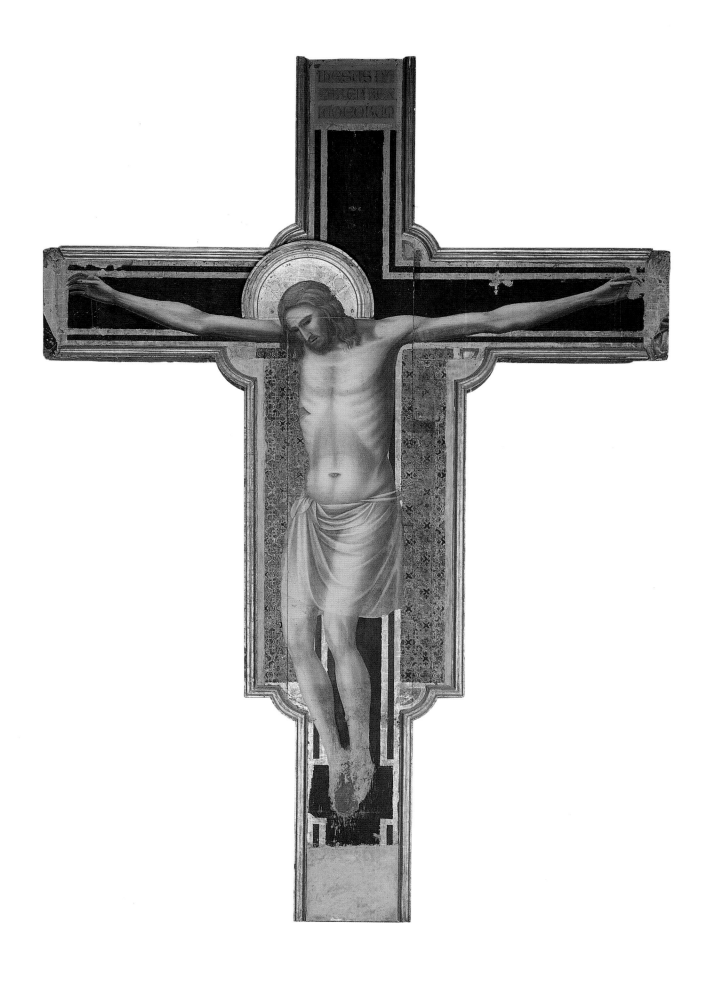

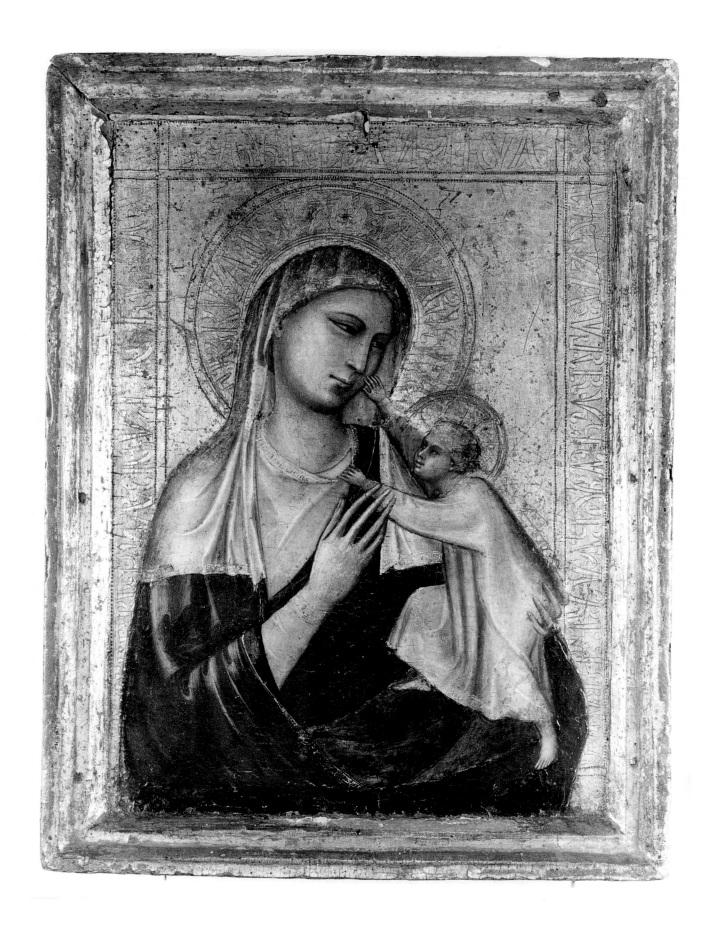

Workshop of Giotto. MADONNA
AND CHILD. *Tempera on
panel, 13 × 9½ in. (33 × 24 cm).
Ashmolean Museum, Oxford.*

CLOSE in style to the Rimini *Crucifix* is the small *Madonna and Child* (p. 124) panel at the Ashmolean Museum in Oxford. The painting, which first Berenson (1932) and then Oertel (1937) found Giottesque, remains a work of uncertain attribution: Volpe (1963) took the strongest stand in calling this delightful little panel a Giotto autograph. Bellosi (1983) and Bonsanti (1985) have agreed, while Bologna (1969) and Brandi (1983) maintain that it is a workshop product. Previtali (1967) assigned it to the Master of San Nicola. The Child's gesture and the pose of the Madonna express an affectionate delicacy. And yet some uncertainties in the drawing, such as the Madonna's oversized hand, and certain persistent archaisms—such as the sharp and compressed folds in the dresses—suggest that this is not by Giotto but by his shop. Moreover, the Madonna's face, so similar to those in later works, including the Magdalen Chapel; the elegance of the transparent veil; the refinement of the halo and frame, enriched by motifs in Cufic letters—all of these features imply a later date.

PADUA

THE WORKS IN THE BASILICA OF SANT'ANTONIO

WE HAVE PRECISE INFORMATION FROM CONTEMPORARIES ABOUT GIOTTO'S ACTIVITY IN PADUA. FRANCESCO DA BARBERINO, IN HIS *COMMENTARI D'AMORE,* WRITTEN AROUND 1310, MENTIONS THE FIGURE OF ANGER PAINTED IN THE SCROVEGNI CHAPEL.

Riccobaldo Ferrarese, in the *Compilatio Chronologica* (c. 1312), interrupts his narration of historic events to speak of Giotto, of whom he says, "How great an artist he was is proved by his work in the church of the minors in Assisi." Moreover, the oldest manuscript to carry the Riccobaldo text, the *Laurenziano,* continues, "And by what he painted in the municipal seat in Padua." ❧ ACCORDING to Ferrarese, the painter's activity in Padua was long and detailed. Giotto worked in three very significant buildings: the basilica of Sant'Antonio (commonly called the Santo), a lively focus of piety and pilgrimages, which grew to be the second most important church of the Franciscan order; the chapel of the Scrovegni palace, and the chapel of the Palazzo della Ragione (the municipal seat). ❧ THE first two works in Padua should certainly be dated to before March 25, 1305. On that day the Scrovegni, or Arena, Chapel was solemnly consecrated, and almost all scholars agree that the fresco decoration was already completed.

To this cycle the fragmentary works in the Santo are tied stylistically. The beginning of the work at the Arena may go back to 1303, and so the frescoes in the Chapter House of the Santo should be dated sometime earlier. Giotto's first sojourn in Padua can therefore be placed chronologically between 1302 and 1305. ❧ I BELIEVE that Giotto came to Padua by passing from convent to convent. He was summoned by the Franciscan monks of the Santo, who wanted to vie with their brothers in Assisi and Rimini by commissioning the most famous and "modern" painter of the time to decorate their church. Only later, while working in the basilica, did Giotto come into contact with Enrico Scrovegni, who commissioned the Arena Chapel. Riccobaldo Ferrarese's testimony that Giotto had worked at the Santo was supported by other illustrious scholars and historians. In his *Commentariolus de laudibus Patavii* (c. 1440), Michele Savonarola said of Giotto, "He decorated our Chapter of Antonio."

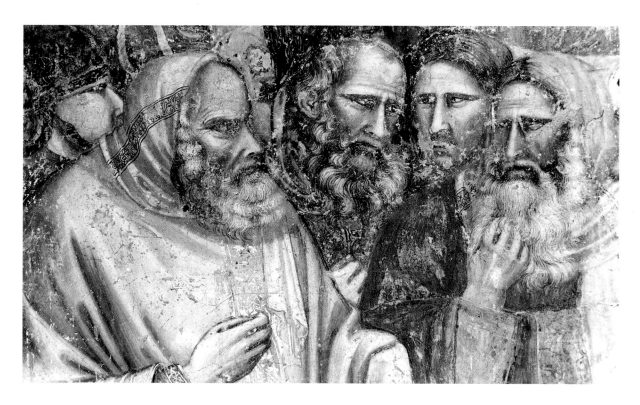

Giotto and the Master of the Chapter House. Detail of CRUCIFIXION. *Chapter House of the Basilica of Sant'Antonio, Padua.*

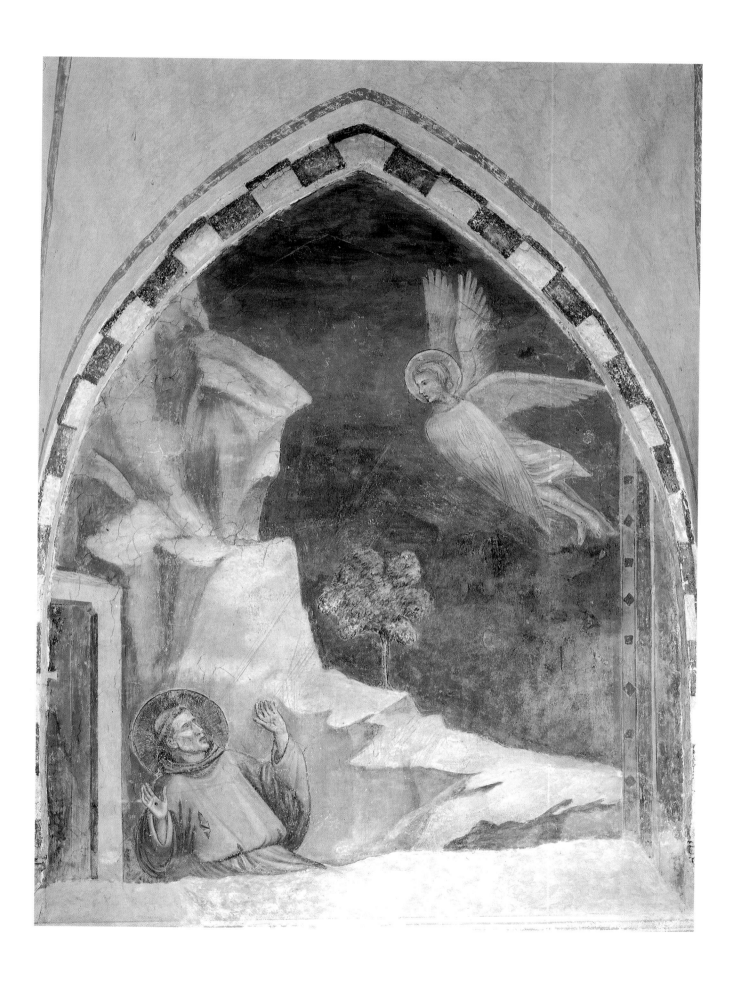

Giotto and the Master of the Chapter House. STIGMATIZATION. *Chapter House of the Basilica of Sant'Antonio, Padua.*

Ghiberti's reference is generic but important: "He painted at Padua in the minor friars." Marcantonio Michiel said, around 1550: "In the Chapter House the Passion fresco was by the hand of the Florentine Giotto"; but Vasari, in the first edition of the *Lives* (1550), attributes to Giotto the decoration of "some chapels" in the basilica, while in the second edition of 1568, he speaks of only one chapel. In 1678 Malvasia reports a beautiful chapel by Giotto in the Santo. And this is the last mention until the nineteenth century. ❧ THE Chapter House underwent various changes over the course of the centuries, so that nothing appeared to remain of the decoration recorded by Renaissance sources. But in 1842 Pietro Selvatico succeeded in finding, under the plaster, fragments of the *Martyrdom of the Franciscans* and of the building beneath: this work immediately seemed to him to be Giottesque. This was the proof that the sources had told the truth! Soon afterwards, the convent's historian, Father Bernardino Gonzati, and his brother, Abbot Lodovico, an amateur painter and restorer, discovered the remains of the fourteenth-century frescoes under the whitewash on the short walls of the hall (Gonzati, 1852). They restored the frescoes, repainting them heavily according to the custom of the time. In 1914 other fragments were tracked down on the long wall, a *Stigmatization* (p. 129) and parts of a *Crucifixion* (p. 128); all these paintings still show unequivocally Giottesque

characteristics. ❧ THE decoration of the Chapter House now presents some stretches of mock marble at the top of the wall, and a wainscot of mock slabs at the wall's base. At the center of the long wall, fragmentary figures of old men and two soldiers' heads are clearly vestiges of a large *Crucifixion;* to the right and left are fragments of a *Martyrdom of the Franciscans,* heavily overpainted, beside the remains of the cross-section of a church. At the sides of the entrance arch of this painted church are two extraordinary, very lively little monochrome figures of the Angel of the Annunication and the Virgin (p. 132), still nearly untouched by repainting, that show skilled and fluent workmanship. More complex are the decorations on the short wall, where a series of mock niches with pointed arches, separated from each other by pillars with floral motifs and constructed with spatial depth, contain Franciscan saints and Old Testament prophets (below): these majestic figures are molded with volumetric plasticity. Above runs a small trompe l'oeil cornice, supported by slightly foreshortened brackets. The solemn and classical composition is set forth in a complex architectonic setting. ❧ THE spatial and architectonic invention is quite new and prompts one to name Giotto as the creator of the niche structures, which emphasize the depth of the figures wrapped in cloaks of dense drapery. The facing of mock marble was later used by Giotto in

page 130: Master of the Chapter House. PROPHET. *Chapter House of the Basilica of Sant'Antonio, Padua.*

Giotto and the Master of the Chapter House. SAINTS AND PROPHETS. *Chapter House of the Basilica of Sant'Antonio, Padua.*

the decoration of the Scrovegni Chapel: this constitutes a new typology, when compared to the Assisi curtains, and is probably derived once again from monuments, both ancient and contemporary, studied by the painter during his second sojourn in Rome. The fall of the cloak folds in the damaged group of priests on the long wall show Giottesque craft, recalling a Louvre panel with the same subject, the *Stigmatization;* while the fragment of the church in cross-section, below the *Martyrdom of the Franciscans,* has the same style as the building that is repeated in the episodes of the Marriage of the Virgin in the Arena Chapel. The decoration as a whole is Giottesque, and many architectonic details—such as the mock-marble plinth of the walls, the cornice of brackets in perspective, the pillars decorated with floral motifs identical to those that encircle the composition of the *Last Judgment*—recall the Scrovegni frescoes. But a certain slackening of compositional rhythm, the solitude of the figures, the placid, almost slow-motion movements, the repetitive, fixed faces characterized by great staring eyes and pointed chins—all of these make me think (so far as the very poor state of conservation permits) that the execution of the pictorial cycle, which Boskovits recently (1990) attributed to Giotto, is owed to a collaborator instead. This artist, whom one could call Master of the Chapter House, can be identified as the author of the decorative bands that divide the ceiling vault of the Scrovegni Chapel, and of some of the high bands and the small quadrilobes in the Stories from the Old Testament on the left wall of the same building. The very close points of resemblance between this cycle and that of the Arena Chapel lead me to think that one was executed soon after the other. ❧ THUS traces of Giotto's presence have been found in the Chapter House of the Santo; but the possibility remains that the painter also worked in the church itself. Many Renaissance historians remark on the chapel or chapels that cannot be those of the apse, whose construction was already finished at the end of the thirteenth century and which were soon completely painted. In any event, over the centuries this whole part of the basilica was subjected to various mishaps that changed its original appearance and destroyed almost every trace of the original decorations. Over the course of the years, the families that had sponsored them disappeared, and the chapels fell into disrepair and became storerooms. Refurbished and "baroquified" during the eighteenth century, the chapels of the apse underwent further rehabilitation toward the end of the nineteenth and the beginning of the twentieth century. It appears obvious, therefore, that in this case too every trace of the fourteenth-century painting must have disappeared. ❧ AND yet the first of the radial chapels toward the right (called the Chapel of the Benedizioni or of Santa

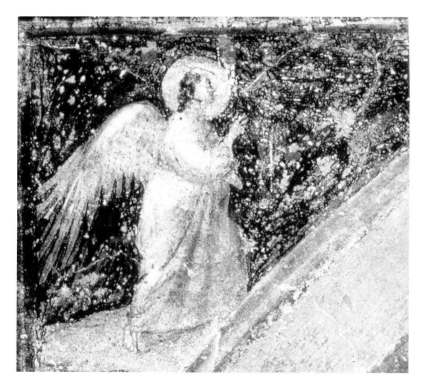

Giotto(?). ANGEL OF THE ANNUNCIATION. *Chapter House of the Basilica of Sant'Antonio, Padua.*

Giotto(?). VIRGIN OF THE ANNUNCIATION. *Chapter House of the Basilica of Sant'Antonio, Padua.*

Caterina or Sant'Angela) clearly shows fourteenth-century—and more precisely Giottesque—characteristics in the decoration of the underside of the arch, formed by eight polylobes containing busts of female saints (p. 133) amid Gothic flora. On closer examination I have been able to determine certainly that the much repainted figures—some with faces half-redone—were originally works of very high quality. The few remaining authentic fragments—the hands, parts of the faces, the trompe l'oeil cornices, the chiaroscuro of the four quadrilobes, and above all the single head that escaped repainting—must be the precious vestiges of the chapel painted by Giotto. It was all repainted in 1925 by the painter Giuseppe Cherubini, who was said to be retracing the fourteenth-century decoration in the vault and in the walls of St. Angela. Information handed down by local eighteenth-century historians and repeated by Gonzati (1852) indicates that the chapel originally belonged to the Scrovegni family, thereby providing important corroboration for the attribution of the few fragments to Giotto, and connecting these frescoes in the Santo with the famous decoration of the Arena Chapel (d'Arcais, 1968 and 1984). ❧ SOME chronology can be obtained from the few remains in the Chapel of Sant'Angela: the only female head that has remained nearly intact, and the legible parts of the others, demonstrate very close ties—in the shapes of the faces, the bending of the hands, and the delicacy of the pastel colors—with the figures in the Arena Chapel. It's easy to see the similarities between the female saints of the underarch and the Madonna receiving the small model of the building in homage in the *Last Judgment* in the Arena Chapel. Thus one can postulate a very close chronological contiguity between the frescoes in the two buildings.

THE SCROVEGNI CHAPEL FRESCOES

❧ THE most important and significant work executed by Giotto in Padua is the decoration of the Scrovegni Chapel, or rather the chapel of Santa Maria della Carità at the Arena (pp. 134–35). Enrico Scrovegni was the son of Reginaldo, a usurer made famous by Dante, who put him in hell (in canto XVII of the *Inferno*); Enrico belonged to one of Padua's richest and most important families,

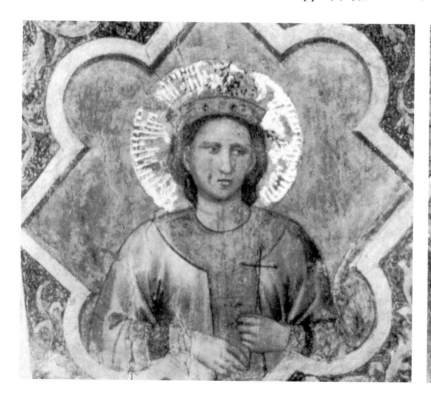

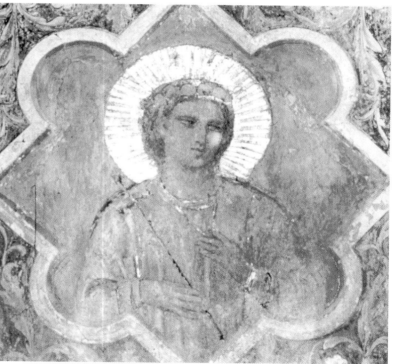

Workshop of Giotto. SAINTS. *Benedizioni Chapel, Basilica of Sant'Antonio, Padua.*

pages 134–35: Interior looking toward entrance wall. Scrovegni Chapel, Padua.

pages 136–37: Vault. Scrovegni Chapel, Padua.

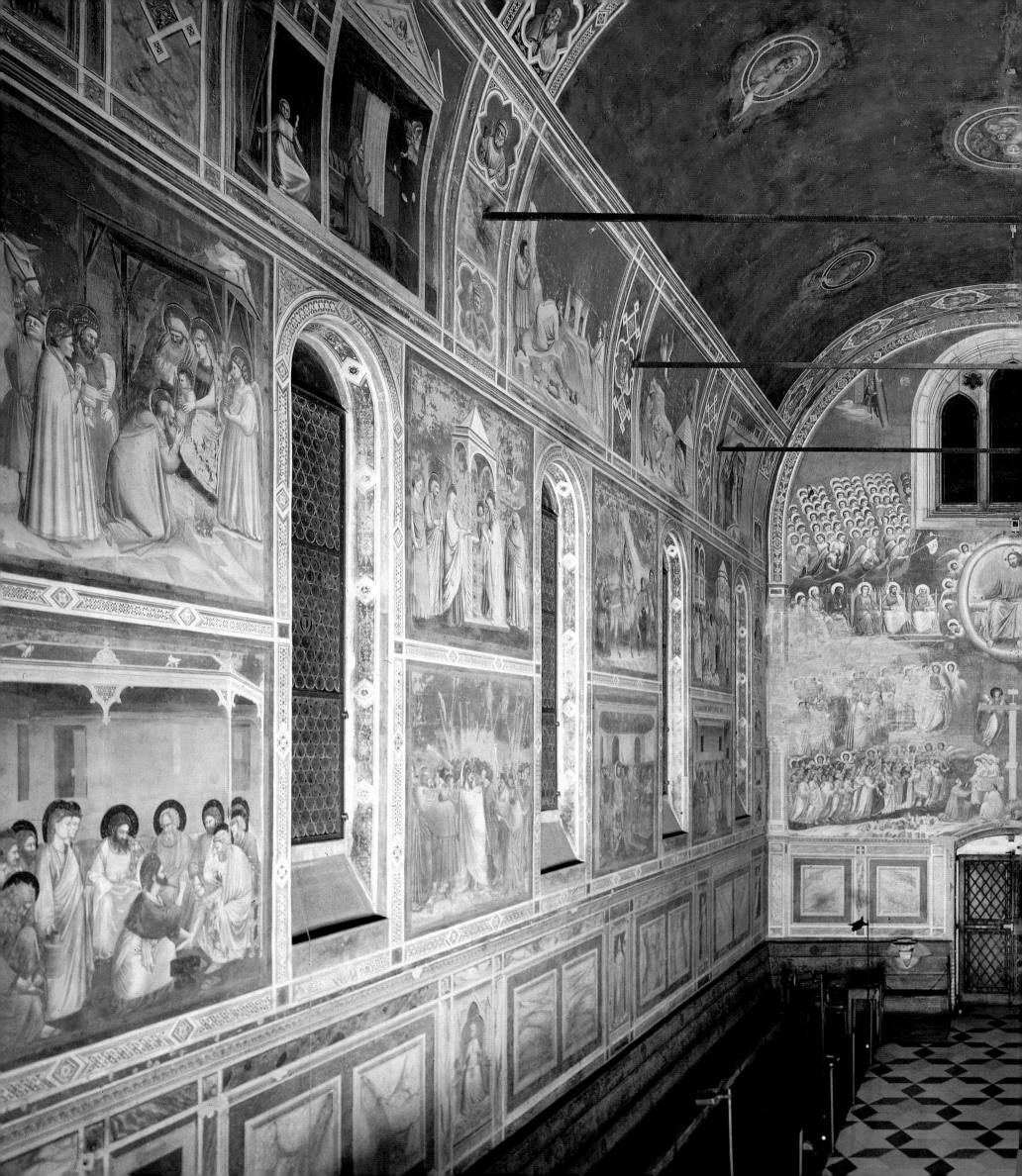

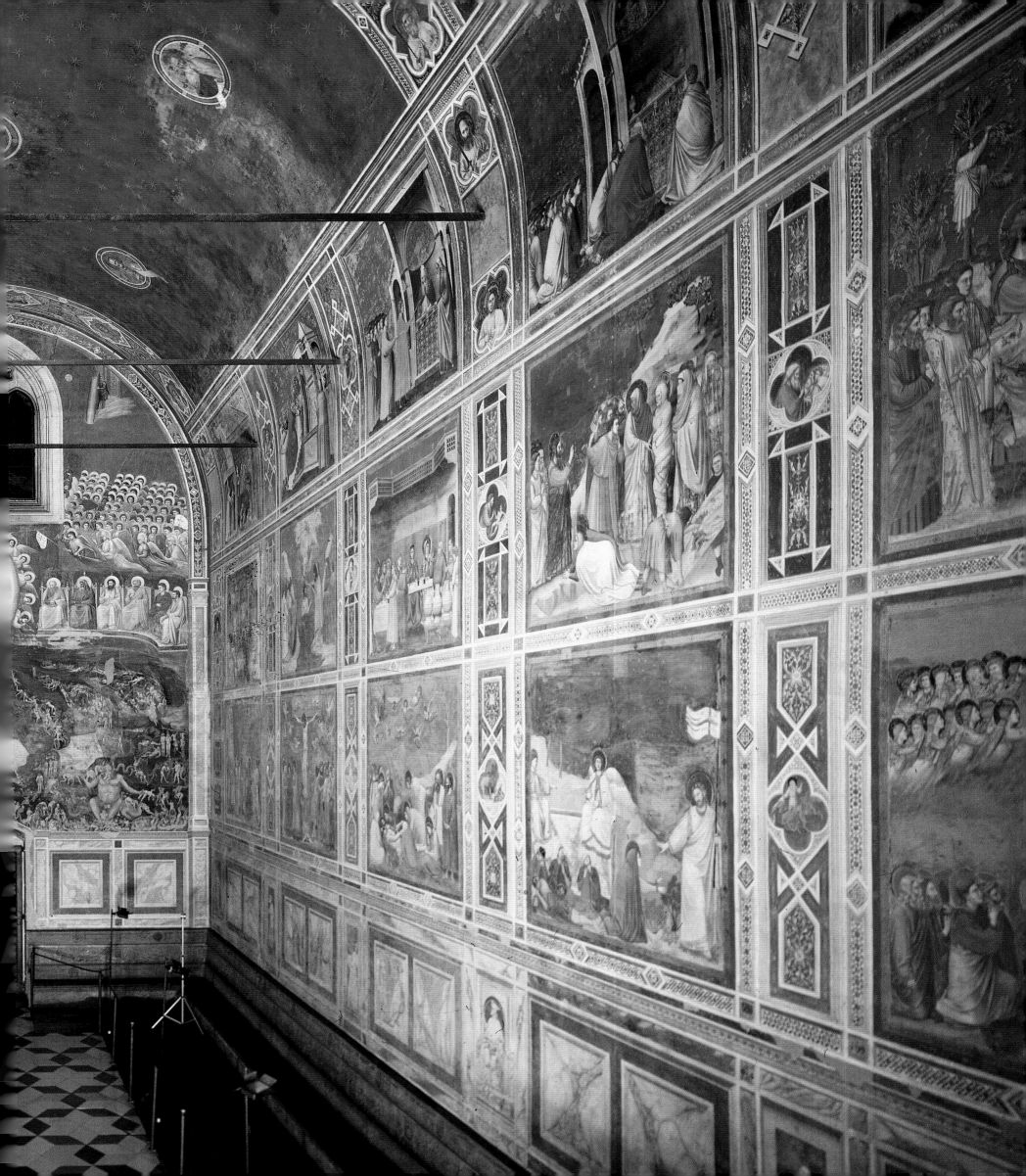

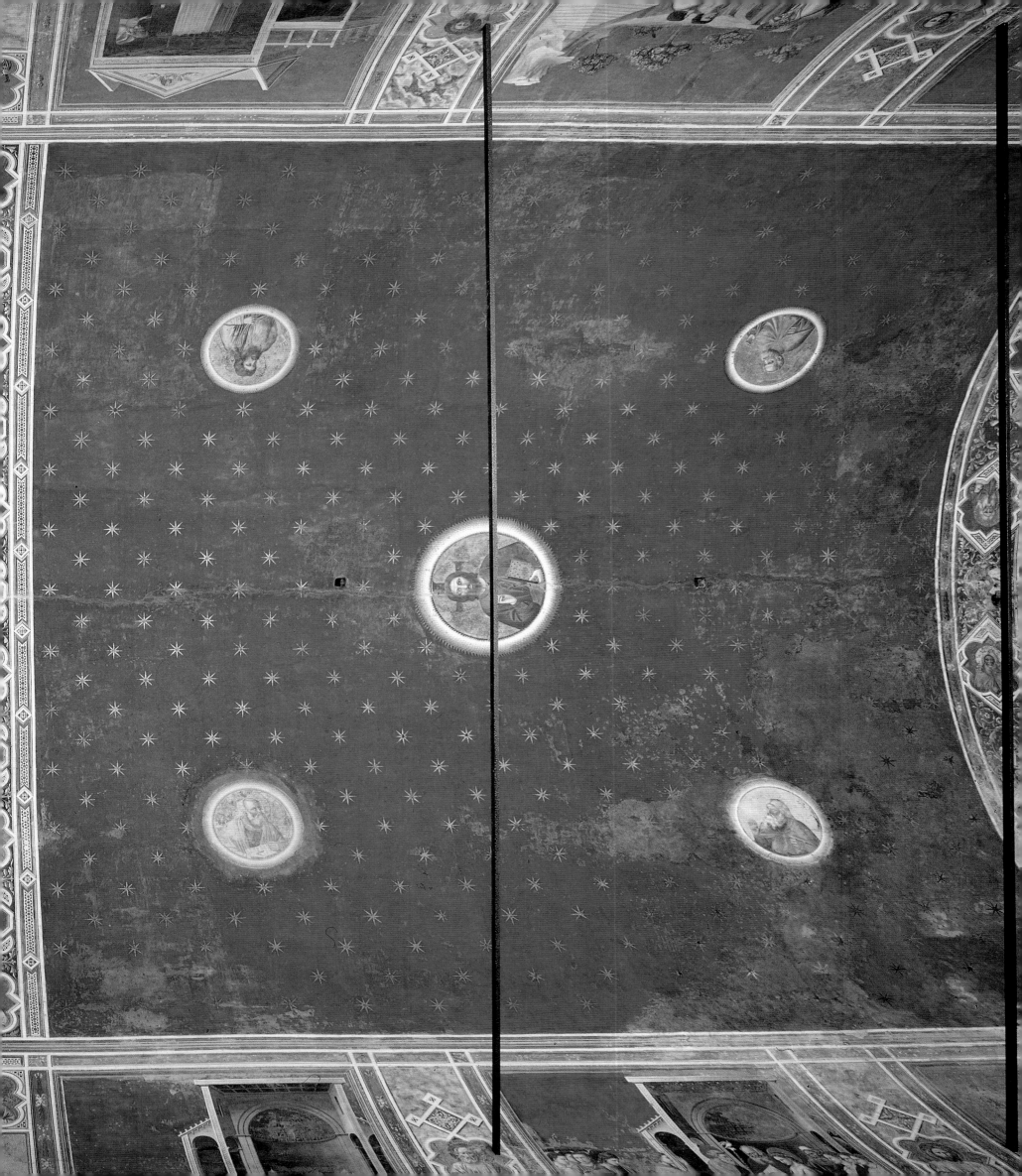

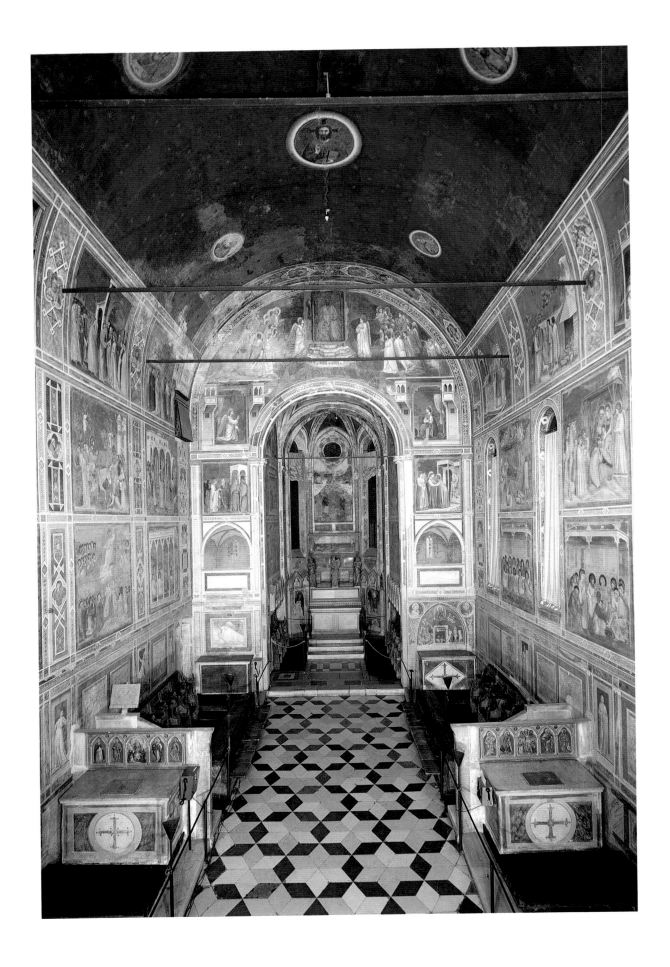

Interior looking toward the apse.
Scrovegni Chapel, Padua.

at a time when the city was very important but was also disrupted by internal conflicts, which would soon bring the Carraresi family to power. ❧ IN 1300 Enrico Scrovegni purchased from a noble Paduan family, the Delsmanini, a vast area including the whole eastern part of the ancient Roman Arena, where a small church had stood at least since 1278, and where every year on March 25 a solemn procession and a mystery play celebrated the holiday of the Annunciation. ❧ ENRICO built a grand palace, and adjacent to it he rebuilt the church in equally grand style, dedicating it to Santa Maria della Carità; according to Scardeone (1560), the dedication was made in expiation of his father's usury. The first stone was laid on March 25, 1303, and exactly two years later, on March 25, the chapel was consecrated and ready again to house the mystery plays, which were enacted again each year, starting in 1306. In almost unanimous agreement—the most significant exception is Gnudi (1958)—scholars concur that the date of the chapel's consecration also marks the conclusion of the decoration of the interior, which was carried out quickly, in little more than a year. ❧ THE chapel is a large shell forming a single nave, twenty-seven feet ten inches (8.5 meters) long and seven feet ten inches (2.4 meters) wide, covered by an ample barrel vault forty-two feet (12.8 meters) high (pp. 136–37). The upper part of the facade is pierced by a trefoil window, and high on the right wall are six single windows. The ample area behind the altar, finished somewhat later, between 1317 and 1320, is covered by a cross-and-bowl-shaped vault with Gothic ribs and lit by a small rose window and two narrow, single windows; it contains the tomb of Enrico Scrovegni and that of his wife. The walls and ceiling of this area were also painted during those same years with fresco decoration by a mediocre Paduan painter with Giottesque leanings. ❧ THOUGH the architecture of the building is quite simple, it has a classical grandeur. This, together with the very close bond between the architecture and the paintings—almost as though the nave had been conceived as a functional part of the frescoes—has led some to surmise (Gioseffi, 1963) that Giotto himself might be the designer of the chapel. ❧ FROM inside it looks like an ample, precious jewel case completely covered with frescoes. The ceiling, bright blue and studded with stars, is edged at the ends by two decorative bands, while a third band divides it into two zones; in the zone toward the altar, Christ and four prophets, among them St. John the Baptist, are portrayed inside medallions; toward the entrance are medallions with the Madonna and the other four prophets. Prophets, patriarchs, and kings from the Old Testament alternate with tiny figures of angels and putti among clusters of flowers, which form the motif of the bands on the ceiling. ❧ THE grand story begins in the

rectangular panel in the lunette above the chancel arch (p. 138), where God the Father, surrounded by his heavenly court, is portrayed sending his messenger to earth; it unfolds in a continuous spiral movement towards the right wall, with Stories of Joachim and Anne in the upper tier opposite those of Mary; with Stories of the Childhood and Public Life of Christ in the middle zone; and with Stories of the Passion, Death, and Resurrection of Christ at the bottom. Separating each episode from the next are decorative bands portraying the Apostles in the top tier; below that, the four Saints; and finally the Evangelists and the Fathers of the Church. On the left wall the episodes of the Stories of Christ alternate with very interesting and abbreviated small portrayals, inside quadrilobes, of episodes and symbols of the Old Testament, which prefigure events in the New Testament; thus the *Raising of Lazarus* is prefigured by the *Creation of Adam,* or the *Ascension* is prefigured by *Elijah in the Flaming Chariot.* ✷ IN ACCORDANCE with medieval iconographic tradition, the entire entrance wall is occupied by a large representation of the Last Judgment. Again in accordance with tradition, it is composed of several tiers focusing on Christ, who sits inside a *mandorla* (an almond-shaped cloud signifying his divinity) with an iridescent oval frame. ✷ THE lower part of the walls presents a plinth in mock marble, where trompe l'oeil marble statues

portray the theological and cardinal Virtues on the right wall, and on the left wall the Vices opposed to them. ✷ THE chapel is thus a great religious poem that begins with the Old Testament and ends with the Last Judgment in a complex iconographic and theological conception. From an iconographical standpoint, the opening Stories of Joachim, Anne, and the Virgin are based on the Apocryphal gospels, but the narration in the other episodes is faithful to the text of the New Testament, just as other parts of the fresco, including the Last Judgment, hold precise references to the Old Testament and the Apocalypse. ✷ BUT this grand sacred drama is almost completely devoid of sacramental connotation; it is transformed into a concrete human drama, where each character, even Christ and the Madonna, is set within the reality of everyday life. Each episode assumes the narrative value of living actuality, rendered in the immediacy of the gestures and postures and in the delicacy or violence of the emotions. The entire story, and the separate scenes in detail, are represented in a concrete period, the time in which Giotto lived, as shown by the introduction of musical instruments typical of the thirteenth century and contemporary clothes alongside the traditional tunics. Characters wear the poor clothes of shepherds, the domestic garments of servants, and the elegant dress of the Magi, decked out like noblemen of the court. The Virgin Mary wears a ceremonial

Giotto. MARRIAGE OF THE VIRGIN. *Scrovegni Chapel, Padua.*

Giotto. ANGEL OF THE ANNUNICATION. *Scrovegni Chapel, Padua.*

white gown in the marriage episodes, and in the Last Judgment she is wrapped in a cloak with squirrel's fur lining. Much of the architecture is Gothic, thirteenth or fourteenth century, with sharply pointed arches, porticoes, and wooden beams, enhanced by curtains, household goods, and objects of common use, which bring the narration into the concrete reality of a specific time and an urban space well known to the faithful who entered the chapel.

THUS Giotto, on the walls of the Scrovegni Chapel, continued and delved more deeply into that process of actualization and "secularization" of the sacred that he had begun on the walls of the basilica of San Francesco, and which was to be one of the constants of the figurative Gothic world for more than a century. Already at the start of the century, the Florentine painter was one of the greatest protagonists of this Gothic language.

WHAT first strikes the visitor about this magnificent pictorial cycle—besides the extraordinary clarity and luminosity of its color—is its sense of quiet equilibrium and classical measure. In comparison with his first work in Assisi and in San Francesco in Rimini (at least from what we can deduce from the later paintings of the Rimini artists who certainly learned from Giotto's works), Giotto experimented in the Scrovegni Chapel with new and simplified compositions that place the decoration on a single plane: this is a new, carefully calibrated relationship between real space and illusory space, suggested by barely perceptible scansions of geometric elements, tiny cornices and bands that burst through the surface of the walls in a shading off of parallel planes. Starting from the base of the walls, the first element is the singular motif of the monochrome plinth (p. 141) of mock slabs of pearl-gray marble framed in the classical bead motif, alternating with rectangular niches in precise perspective. In the niches stand figures of the Virtues and Vices that constitute a proper base of strong architectonic significance; these are in turn surmounted by a thin cornice with consoles painted in perfect perspective, starting from the center of each wall, which seems to support the expanse of wall above. HERE, within narrow decorative bands, and on the highest register in heavier frames of mock marble—similar to the tiles in Nicola Pisano's pulpits—the episodes appear in deep spaces against limpid blue skies. The episodes are separated vertically by decorative bands with Cosmatesque geometric motifs, small lobed panels with figures, and even vegetal elements depicted in depth, with a precise, subtle play of light and shadow indicating the articulation of two or more planes.

Giotto. Detail of plinth decoration.
Scrovegni Chapel, Padua.

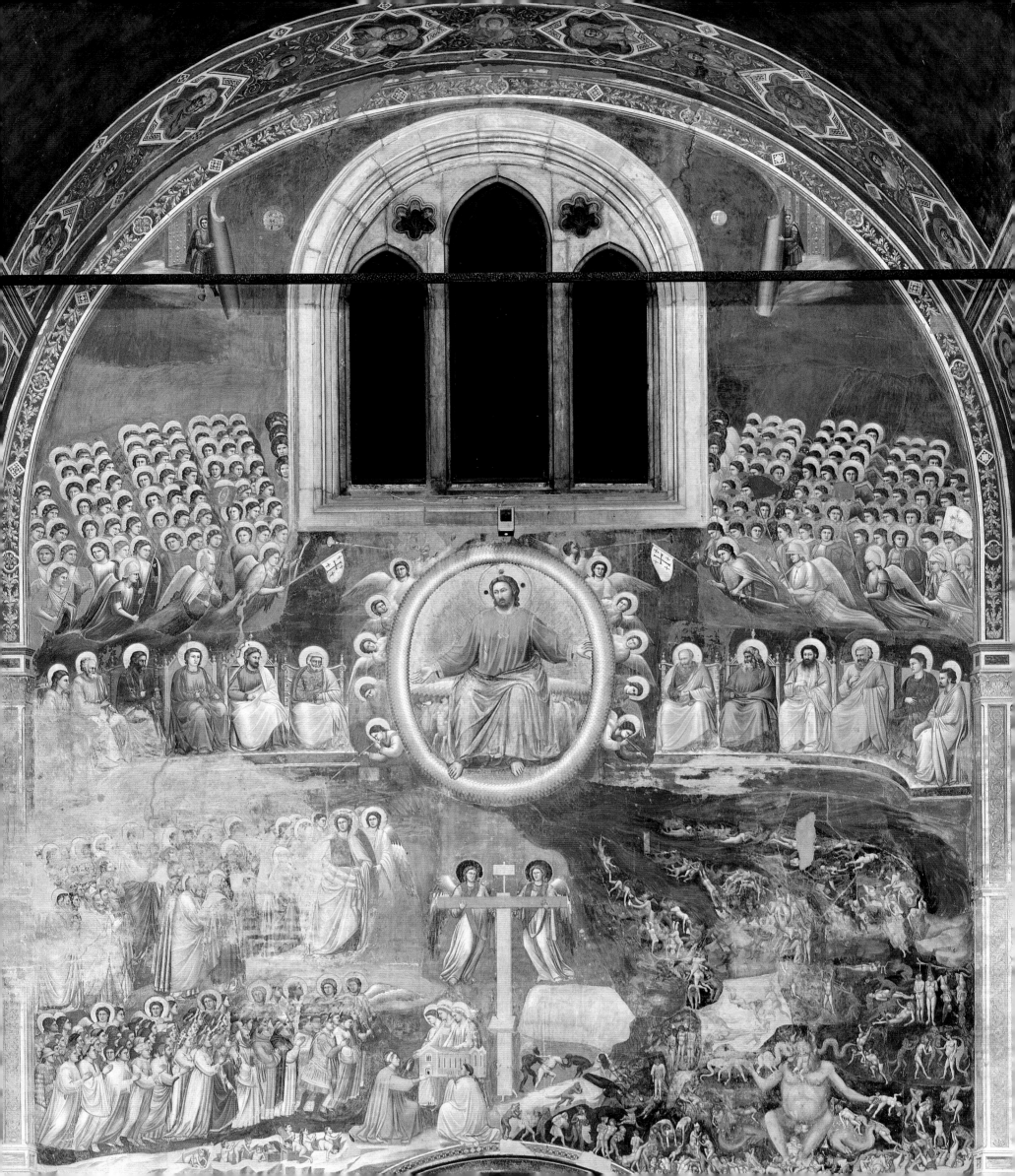

ABOVE the mock-marble plinth on the entrance wall is a large arched area enclosed by thin square columns in perspective, which repeat in paint the real columns that flank the chancel arch leading to the presbytery at the other end of the nave. These painted columns on the entrance wall fling open the vast space where the Last Judgment (p. 142) is depicted. Though still adhering to traditional iconography, this majestic fresco has some interesting modern elements: the pedestal that supports the Apostles' thrones, halfway up the wall, thrusts in a semicircle towards the spectators, defining and measuring the space, which otherwise would be amorphous and undifferentiated; and at the upper edge two angels unroll the scroll of the universe—also semicircular—which seems to embrace the large trefoil window. I would like to call attention to another small but very interesting detail: the cloak of the person who offers the Virgin a small model of the chapel itself, at the very bottom of the picture (p. 146). The garment flows out of the frame, falling over the painted trim. This humorous touch reveals the complexity of the dialectical relationship between the plane of the real wall and the illusory planes in the pictures. The spatial experimentation culminates in the two "choirs," the two empty rooms drawn in perfect perspective at the sides of the chancel arch (p. 147). An ogival arch opens onto each cross-vaulted "choir," at the center of which hang two lanterns in rigorous perspective; on the back wall is an elegant Gothic window with two lights, beyond which one catches a glimpse of the blue sky. THE compartments with the stories are smaller than those in the Franciscan Cycle in Assisi; moreover, they offer a certain compositional homogeneity, actually repeating the same backgrounds almost without variants— this is the case with the three moments of the Marriage of Mary (the *Ceremony of the Rods . . . ,* the *Prayer for the Miracle of the Rods,* and the *Marriage of the Virgin*), or the *Last Supper* (p. 148) and the *Washing of the Feet* (p. 149)—so as to create a calm feeling of order. Moreover, Giotto in Padua abandoned almost entirely the anonymous crowds that filled the spaces of the Assisi compartments in favor of a few figures with specific characteristics, individuated in compositions with a measured equilibrium. One can almost see these simplified compartments as a reply, in painting, to the tiles in Nicola Pisano's pulpits, which were likewise enclosed architectonic modules, and which Giotto probably reexamined during his last Florentine stay. I shall return to the renewed relationship with the great Tuscan sculptor, Giotto's contemporary, because it is without a doubt one of the loftiest sources of inspiration for the innovations in the Paduan pictorial cycle. EXAMINING the separate scenes of the cycle, one gets a more precise spatial sense, especially in the oft-repeated

page 142: Giotto. LAST JUDGMENT. *Scrovegni Chapel, Padua.*

pages 144–45: Giotto. Detail of LAST JUDGMENT *(p. 142). Scrovegni Chapel, Padua.*

page 146: Giotto. Detail of LAST JUDGMENT *(p. 142). Scrovegni Chapel, Padua.*

page 147: Chancel arch and apse. Scrovegni Chapel, Padua.

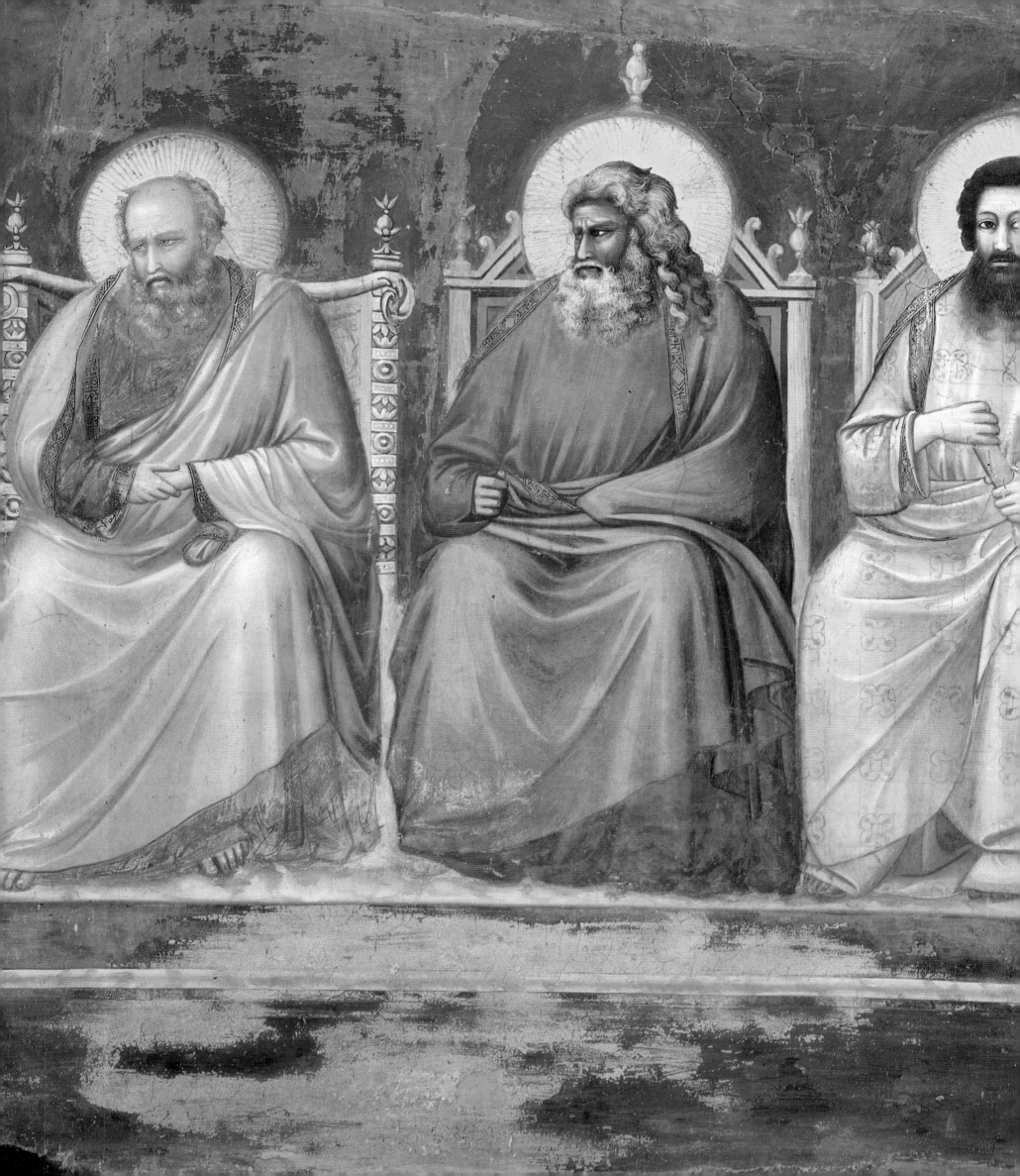

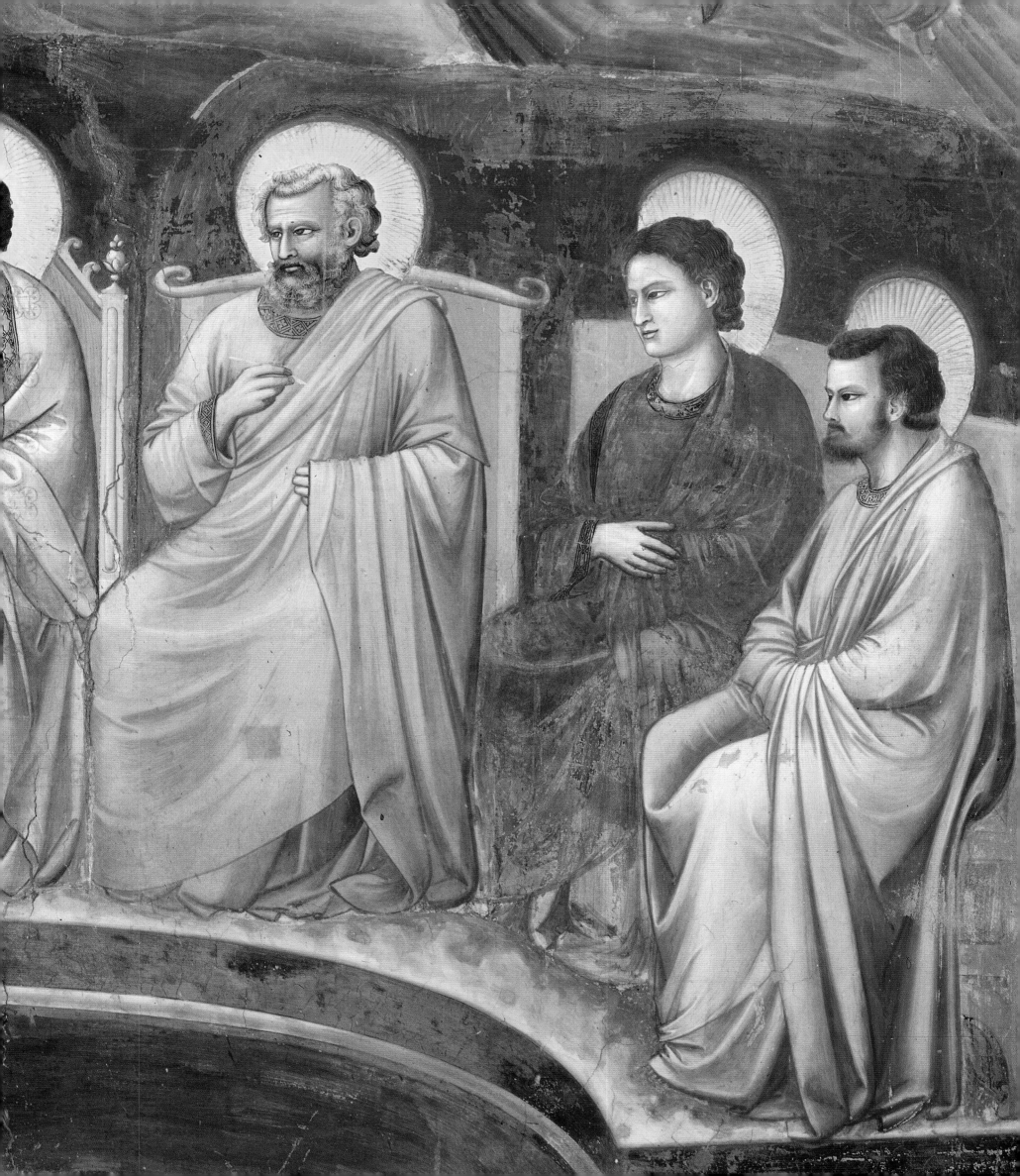

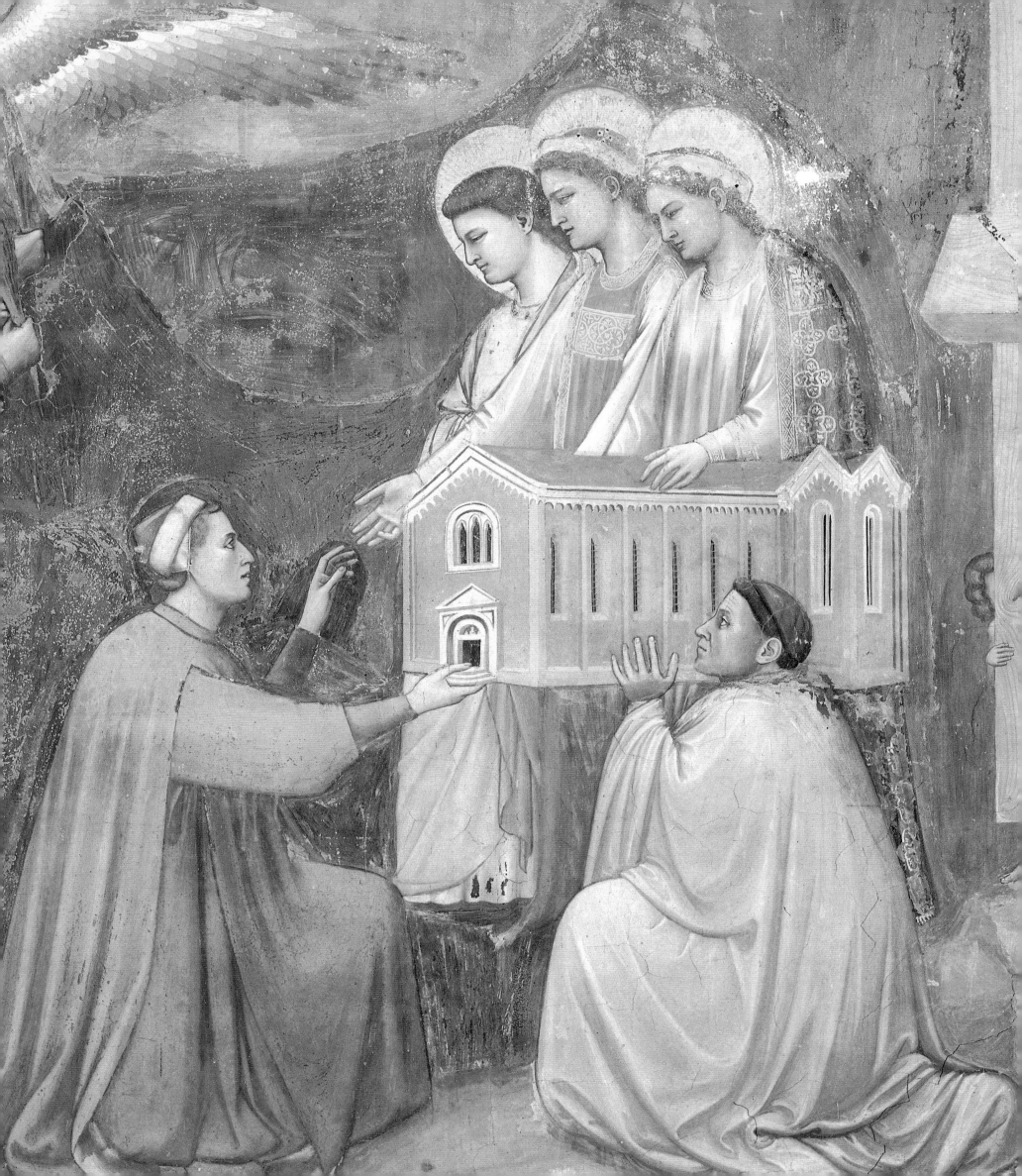

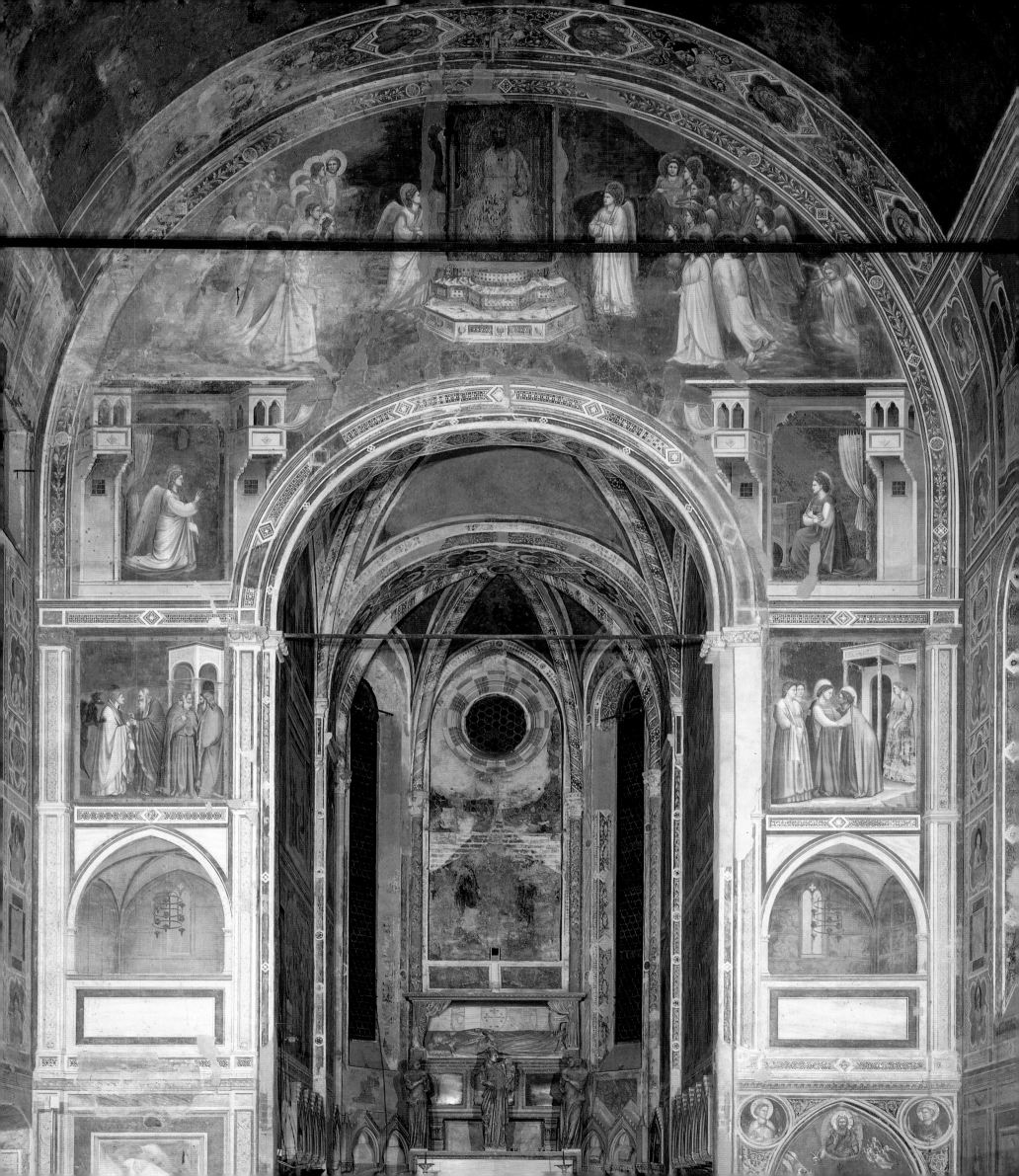

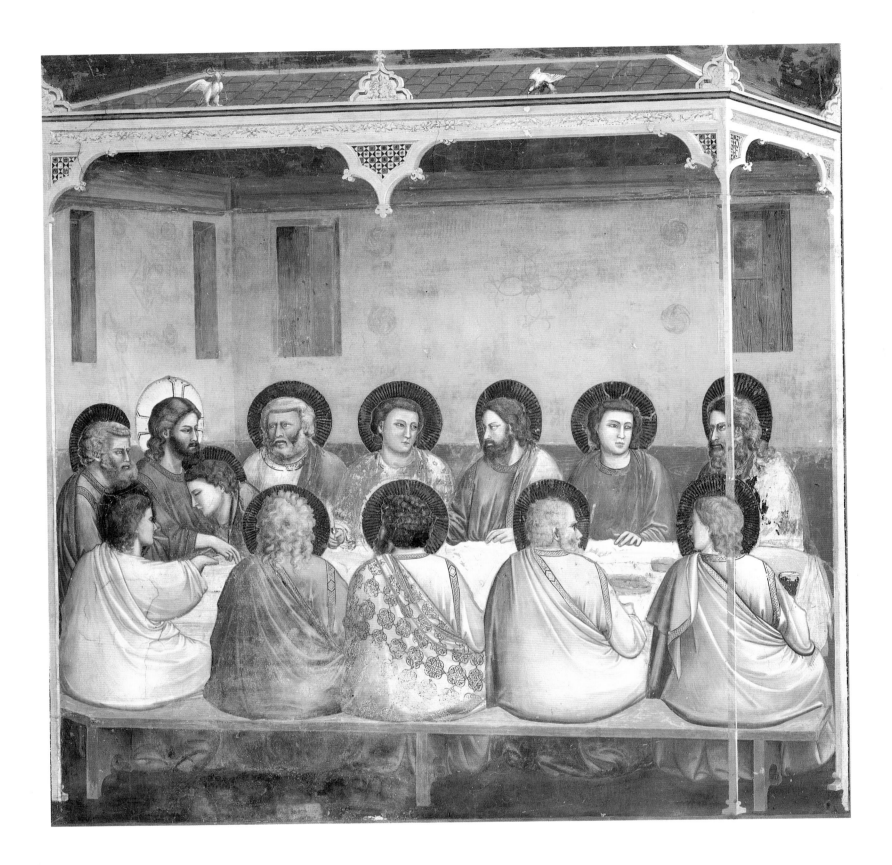

Giotto. LAST SUPPER. *Scrovegni Chapel, Padua.*

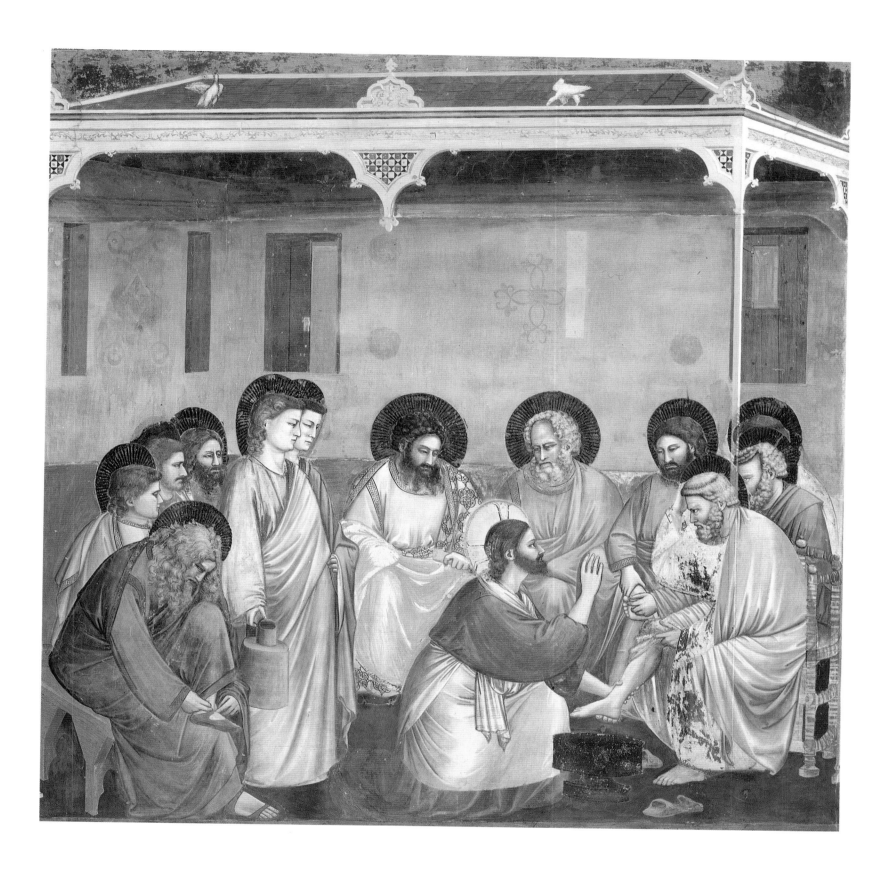

Giotto. WASHING OF THE FEET.
Scrovegni Chapel, Padua.

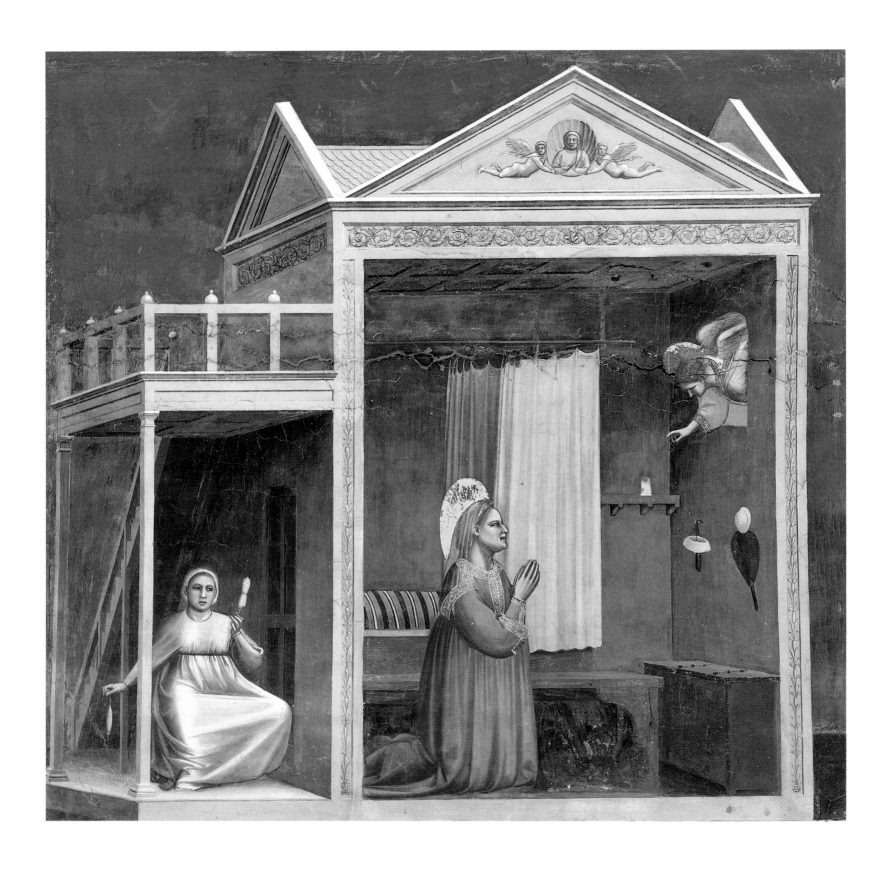

Giotto. ANNUNCIATION TO
ST. ANNE. *Scrovegni Chapel,*
Padua.

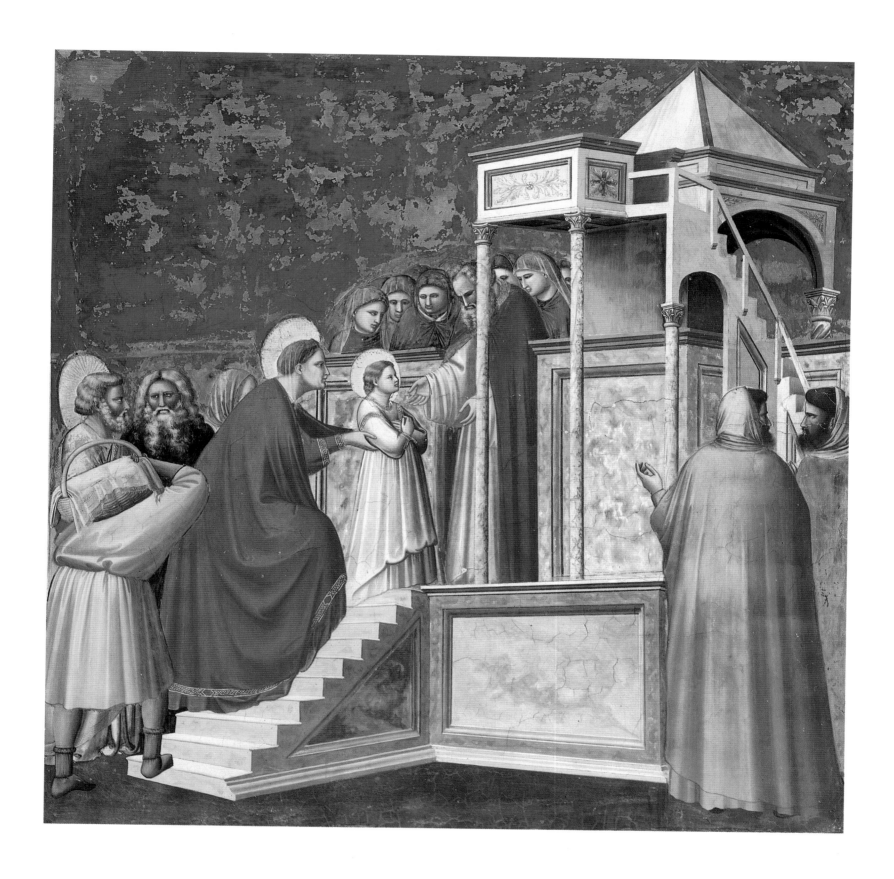

Giotto. PRESENTATION OF
THE VIRGIN IN THE TEMPLE.
Scrovegni Chapel, Padua.

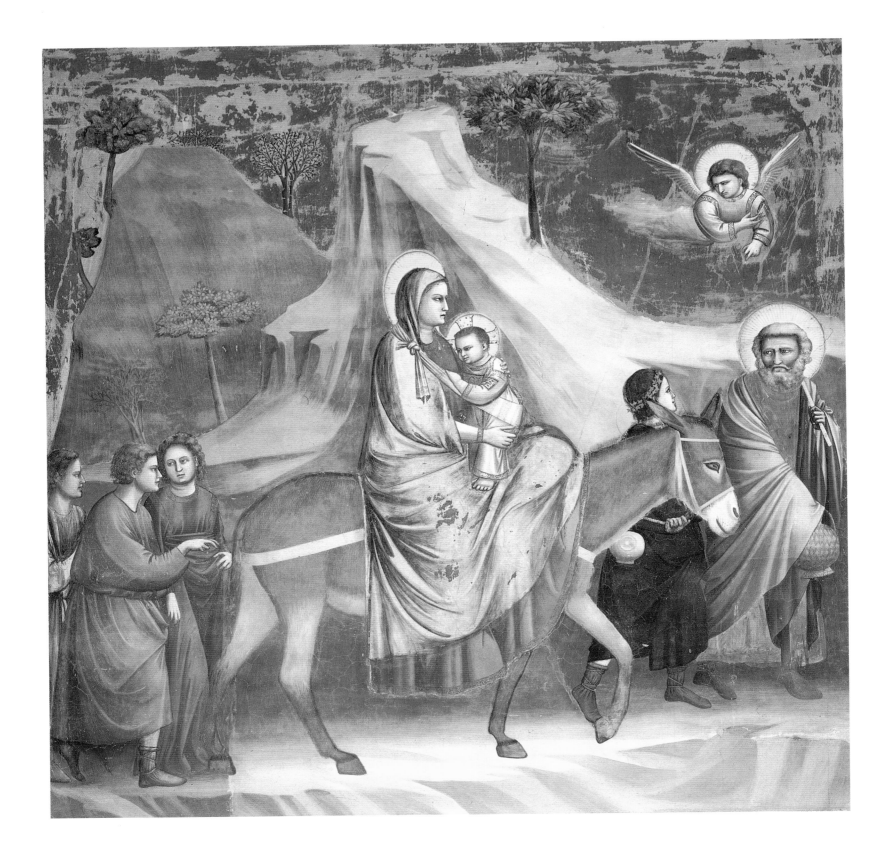

Giotto. FLIGHT INTO EGYPT.
Scrovegni Chapel, Padua.

layout of simple rooms set slightly at an angle, like volumetric boxes, within which the protagonists move with measured proportion. This architecture and these environments are presented with perspective precision in the convergence of the vanishing points, in the positioning of furnishings and objects that articulate the space, and in the subtle play of light and dark, which leaves balustrades and distant frameworks of roofs in shadow. ❧ THESE works show a more precise relationship between figure and environment, especially in landscapes. Thus in the *Flight into Egypt* (p. 152) the mountain reflects the pyramidal form of the Madonna seated on the donkey; in the *Deposition* the diagonal slope of the rock directs the spectator's gaze to the Mother embracing her Son. Furthermore, the compositions no longer make use of symmetrical patterns as in Assisi, but instead shift the fulcrum of the episode laterally, thus accentuating the movement of the entire scene; some examples are the *Presentation of the Virgin in the Temple,* the two episodes of the Marriage of Mary, and the *Resurrection.* ❧ IN PADUA, Giotto's figures are even grander than in previous works, as though they were sculpted from colored granite and set within geometric forms. Look at the bodies of the figures seen from behind, edged by a dry, sharp contour line and yet at the same time softly molded by the carefully measured play of chiaroscuro: look for example at Joachim's imposing bulk,

wrapped in a cloak of delicate pink; the figures of the executioners viewed from the back; the persons crouching, as if they were boulders, like the women seen from behind in the *Deposition* (p. 154). These colored sculptures are like references to the works by Arnolfo di Cambio for the facade of the Florentine Duomo, designed with renewed monumentality and a sense of light, which the painter certainly would have thought about during his most recent Florentine sojourn. ❧ THE ponderous figures are illuminated and shaped by a ray of light that seems to come from the facade: in fact Giotto takes into account the real light that enters from the trefoil window in the entrance wall. This is a very important observation that is part of the subtle, well-reasoned relationship between reality and fiction that we have seen in the entire structure of the decoration. But it should also be said that the painter senses not only the varying intensity of color, when struck by more or less light, but even the quality of color, as we shall see further on: this extraordinarily modern intuition establishes Giotto as one of the great "masters of color," contrary to his characterization by certain critics. There is a fascinating ambivalence, especially in the robust Paduan cycle—robust to the point of violence and geometric to the point of abstraction—but also very refined in the use of color, and very delicate in rendering the variations in chromatic timbres by soft transitions. The delicacy

page 154: Giotto. Detail of
DEPOSITION *(p. 189). Scrovegni Chapel, Padua.*

Giotto. Detail of JOACHIM'S
DREAM. *Scrovegni Chapel, Padua.*

page 155: Giotto. Detail of KISS OF
JUDAS. *Scrovegni Chapel, Padua.*

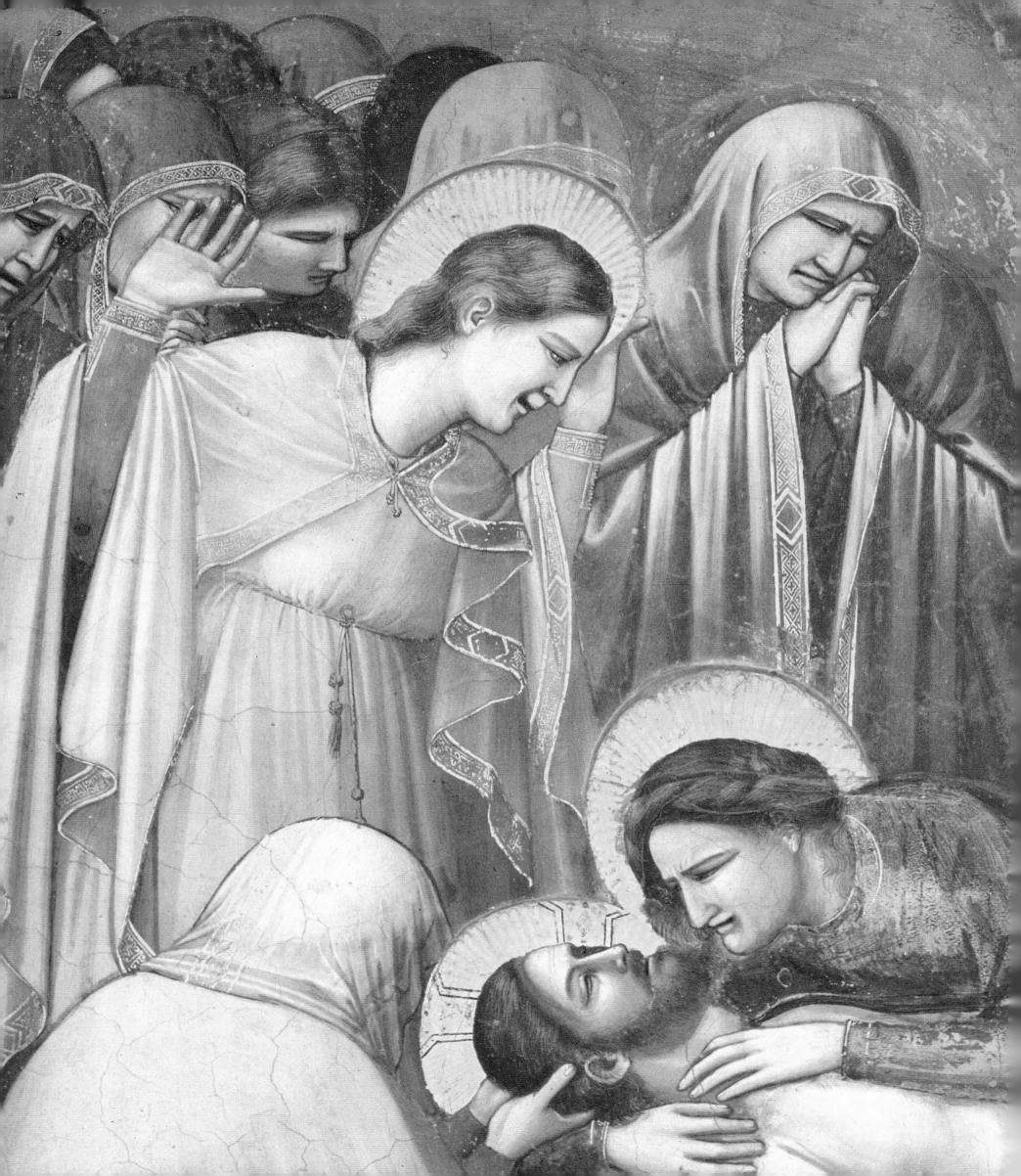

of workmanship can be seen at its best in the faces, which are formed with small, very subtle brush strokes, so as to produce a clear, almost transparent skin color. ❧ FINALLY, the painter paid close attention to foreshortening, which in this cycle assumes a remarkable importance and is charged with consequences for all painting of the fourteenth century and beyond. Examples of this are the head of the boy with the camel in the *Epiphany,* and the sleeping soldiers in the *Resurrection,* who seem a prelude to those of Piero della Francesca. ❧ BUT these heroic persons are also sharply individualized; they are seen with a psychological penetration that analyzes and emphasizes the expressions on their faces, as in a gallery of portraits that have been carefully differentiated, a dynamic series of gestures and poses of strong dramatic significance. From the slow plodding of Joachim, bent over and pensive, and the posture of Anne in the first episodes of the cycle, an absolutely new and modern psychological insight runs through all the stories and reaches a tense dramatic climax in the numerous "conversational" scenes, with extraordinary effects similar to those of Giovanni Pisano who (not by chance, perhaps) is present in the same chapel with his exquisite altar statues. Such scenes include the embrace of Joachim and Anne, the encounter of Mary and Elizabeth, the kiss of Judas, and finally the embrace of the Madonna and her dead Son in the *Deposition.* Much of this vivid visual drama is obtained through the play of hands, the language of gestures and poses, as in the washing of the feet and, in the following picture, St. Peter brusquely cutting an ear off the Roman soldier Malchus (p. 155). Other examples are the very simple, everyday gestures of the onlookers at the *Birth of the Virgin;* or the Evangelist blowing on his pen; or the torturous postures of the henchmen at the Passion, culminating in Caiaphas's impassioned rending of his own garments in response to Christ's "blasphemy"; or the flight of the anguished little angels in the *Crucifixion* and the *Deposition.* Together these prove how much the immediacy and effectiveness of the episodes is owed to this subtly studied mimicry, which indicates Giotto's fresh approach to reality. ❧ THE absolute and dramatic humanity of the Paduan episodes shows the growth of an attitude that one could call open-minded, a further instance of Giotto's growing interest in everyday life. The painter devotes evident attention to so-called secondary characters: suffice it to recall the very vivid figures of shepherds in the Stories of Joachim, the famous wine taster in the *Marriage Feast at Cana* (p. 163), and the woman who turns the spindle in the *Annunciation to St. Anne* (p. 164). Attention to everyday life is also clear in the painter's finely detailed rendering of objects: the architectonic ornamentation of rooms, the curtains hung on rings, the bedcovers, the modest objects in poor houses,

Giotto. Detail of RESURRECTION. *Scrovegni Chapel, Padua.*

page 157: Giotto. Detail of JOACHIM JOINS THE SHEPHERDS. *Scrovegni Chapel, Padua.*

page 158: Giotto. Detail of MEETING AT THE GOLDEN GATE *(p. 171 right). Scrovegni Chapel, Padua.*

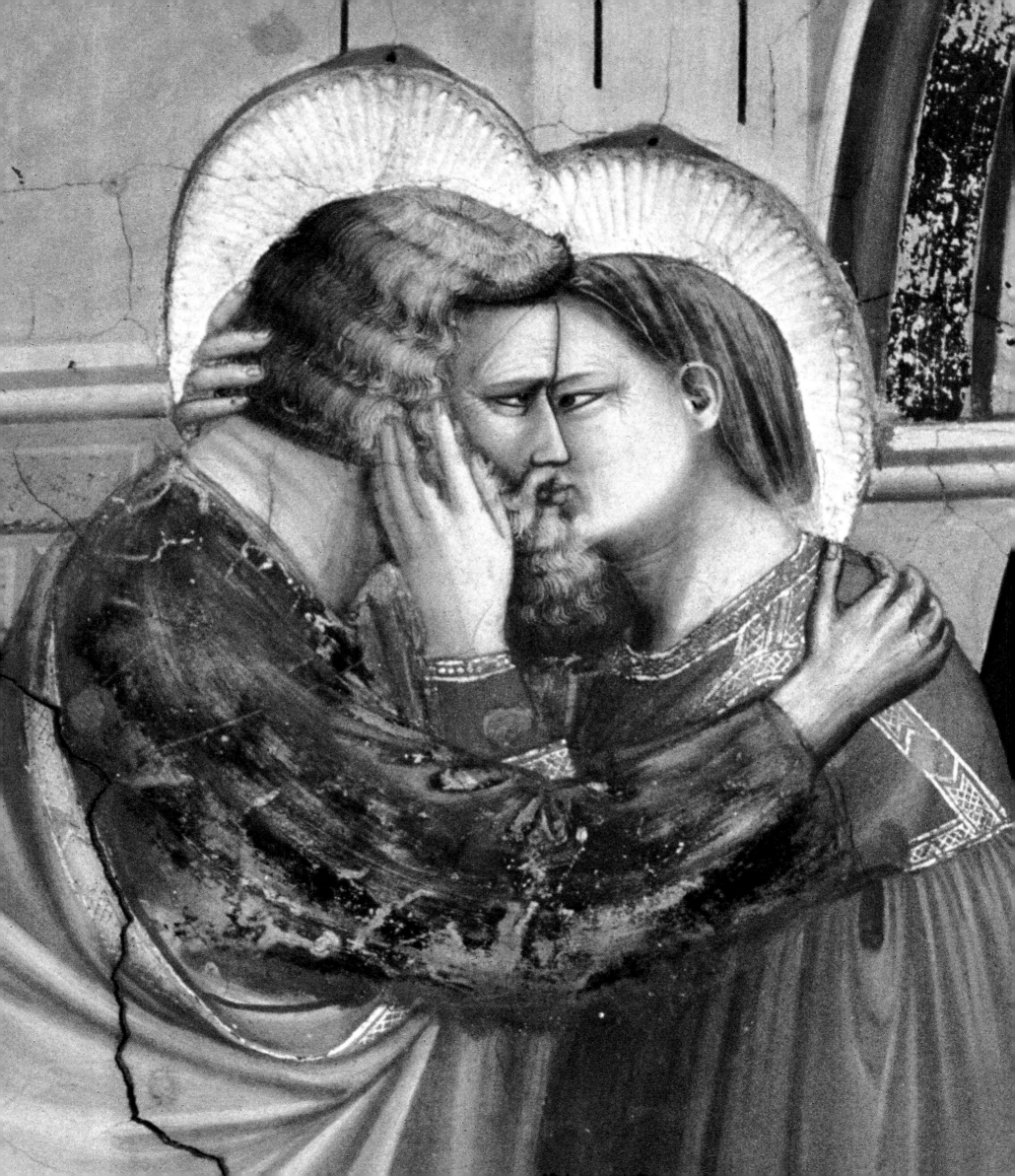

the sandals of the Apostles, and the animals and plants. In painting clothes Giotto focused on the elegant, fashionable ornamentation, or, with poor garments, on the tears and dangling threads.

⁊ THE compositional models of the Paduan stories have the most diverse origins. The first can naturally be traced to immediate pictorial precedents, usually Roman: the *Marriage Feast at Cana* is related to the same episode (by an artist of the Roman school) in the Upper Basilica in Assisi, though only in the disposition of the people. The *Last Judgment* has a whole series of iconographic references of "Byzantine" derivation, starting with the representation on the facade wall of the church of Sant' Angelo in Formis (near Capua), and including certain sections that are drawn literally from the mosaics in the Florentine Baptistery. The rocks with the shrubs and flowers are common elements, spread through all Roman painting and mosaic work of the late thirteenth century. And yet Giotto invents from time to time, enhancing the compositions with more complex motifs, and giving the episodes a contemporary appearance. For example, the shrubs and flowers have clearly been studied from life and also individualized, incorporating the play of light and dark in the thin branches and leaves on the second plane. The earthenware jars of the *Marriage Feast at Cana* in Assisi, clearly a classical echo, are transformed into simple contemporary jars.

⁊ ELSEWHERE the reference is to the Roman architectonic tradition, sometimes with definite Paleo-Christian connections, such as the canopy in *Joachim Is Driven from the Temple* (p. 165), and the enclosure that harks back to the structure of Santa Maria in Cosmedin in Rome. And again contemporary architecture provided the backgrounds of episodes, with elements such as complex porticos, rich single and double windows, and Cosmatesque decorations with colored tessellations. ⁊ REFERENCES to the theater can also be found; certainly the mystery plays, which were actually put on in the Arena, seem to have stimulated Giotto to some undeniably dramatic effects. It has already been observed (Zanocco, 1937) that the curious motif of the angel who appears to Anne through the window is nothing but a transposition, in painting, of a theatrical scene, in which the announcing angel arrives through an opening in the wall. The wings or backdrops, like the canopy used to indicate the temple, might have been suggested by the wings and backdrops of rudimentary stages; likewise, the musicians with contemporary instruments that we see in some of the Paduan paintings were also customary participants in the processions that accompanied the religious dramas.

⁊ AS IN the Assisi church, references to the ancient world are a constant in the Paduan cycle. They are found in the decorative elements of many buildings, such as the pediments and the

Giotto. Detail of ANNUNCIATION TO ST. ANNE *(p. 150). Scrovegni Chapel, Padua.*

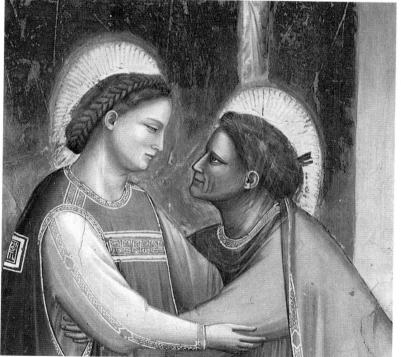

Giotto. Detail of VISITATION. *Scrovegni Chapel, Padua.*

page 160: Giotto. Detail of JOACHIM'S DREAM. *Scrovegni Chapel, Padua.* ⁊ page 161: *Giotto. Detail of ornamental band,* EVANGELIST *(St. Luke?). Scrovegni Chapel, Padua.*

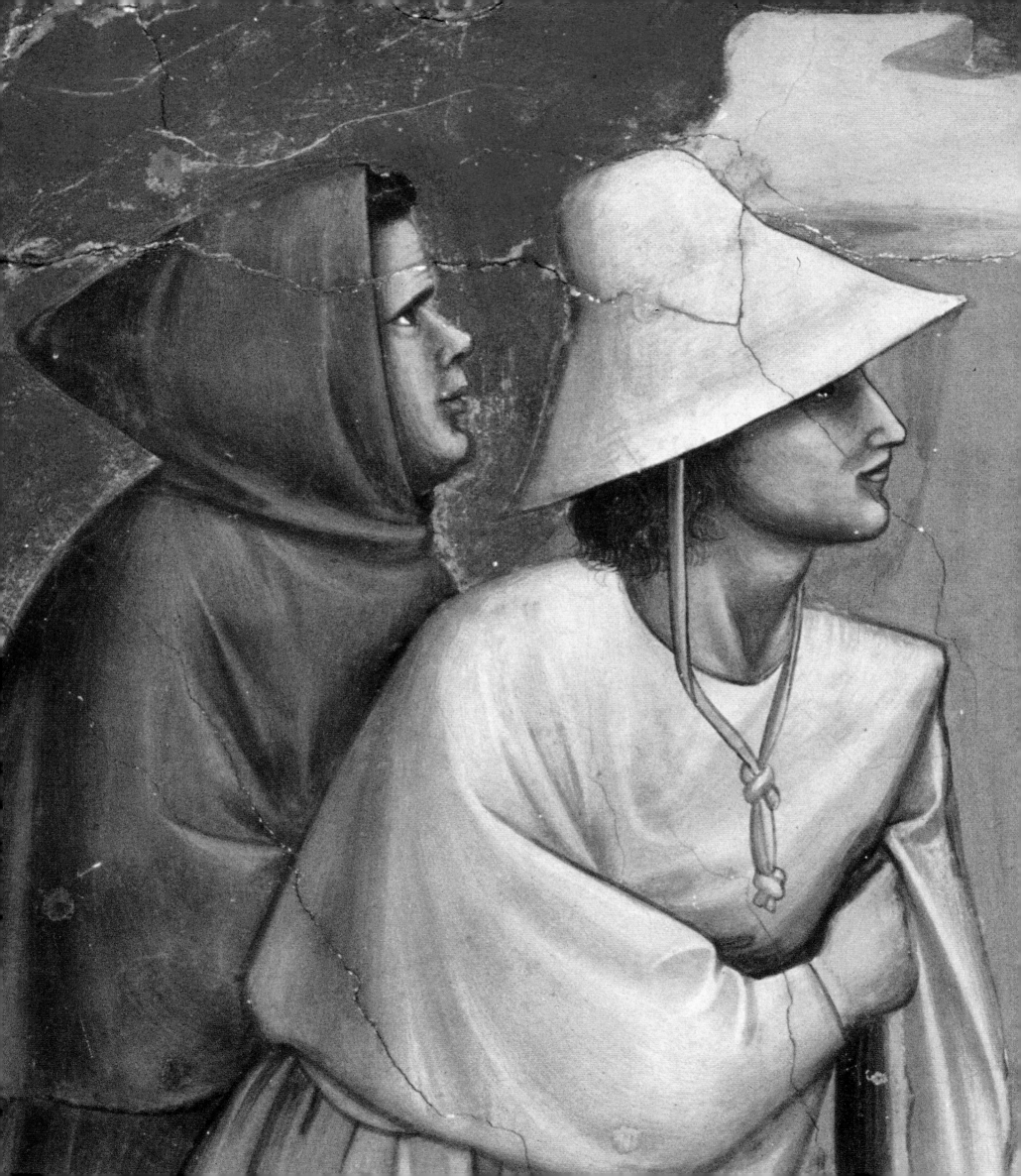

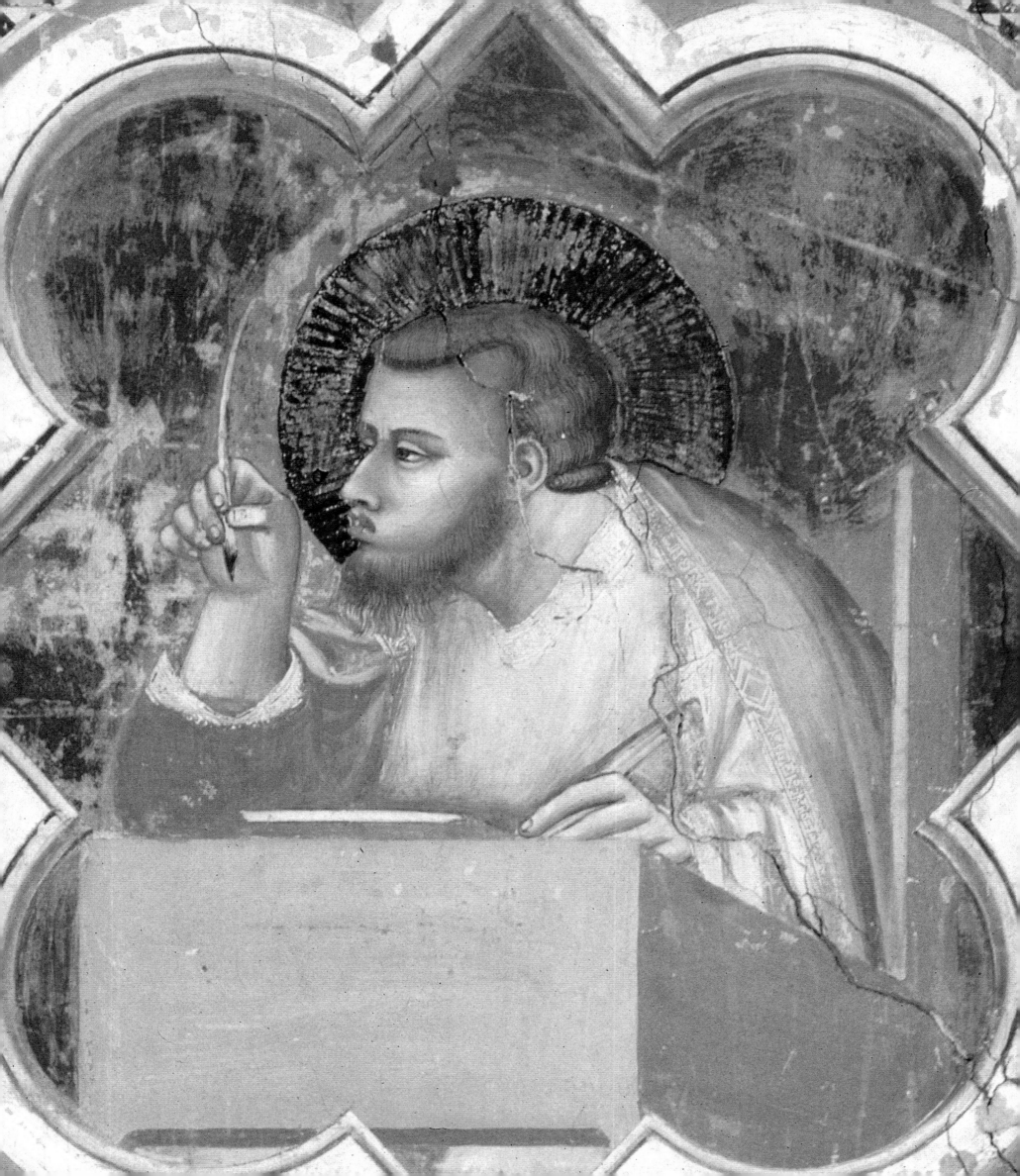

entablatures with clusters of grapes or flowers, and in the clothes, including those of the prophetess Anne and the maidservant in the *Presentation of the Virgin in the Temple.* The episode in which Christ stands before Pilate and also the *Flagellation (Coronation with Thorns)* are set in the courtyard of a Roman palace, with columns, friezes, and ornamentation that exactly echo classical architecture; and indeed Pilate's face seems inspired by the bust of an emperor or a Roman warrior. Finally, the plinth exhibits a whole series of cultivated references ranging from classical and post-classical frescoes to Paleo-Christian and high medieval basilicas, retracing the recovery of the ancient world carried out by Nicola Pisano's workshop. These references are seen in the drawing of the slabs of pale marble, framed in green with the characteristic motif of ovules and beading, and even more in the figures of the Virtues, which seem copied from classical statues: see Hope (p. 167 left), a Winged Victory figure, as well as Charity's costume, and the small figures on the scales of Justice (p. 167 right). One might also consider whether the environment of the Veneto, and Padua in particular, a city so intensely involved in the study and recovery of classicism, further stimulated Giotto's imagination in this direction. ❧ BUT the newest and most extraordinary element of the decoration of the Scrovegni Chapel, in comparison to previous works, both frescoes and panel paintings, is the

color. In this cycle the chromatic choices are always basically bright: starting with the plinth in mock marble of a luminous pearl gray, up through the outdoor episodes that—though set against landscapes of rough rocks—are intensely illuminated, and the indoor architecture of pastel colors: gray, ocher, light green or pink. The figures stand out distinctly in bright-colored clothes, quite often juxtaposed for harmonious effects, such as the symphony of roseate colors in the Stories of Joachim, or of whites in the episodes after the *Resurrection,* or of very bright, precious tones in the cloaks of the Virgin and two saints receiving the small model of the chapel. Dissonances of complementary colors are also created: the green and bright pink of *Joachim Is Driven from the Temple;* the yellows and lilacs of the two priests in the *Presentation of the Virgin in the Temple;* or the yellows and purples in the beautiful scene of the *Flagellation.* Imagination isn't lacking in the sudden flares of color, as in the striped cloth on the walls of the room in the *Marriage Feast at Cana,* or the red cloak of Mary Magdalen among the white clothes of the *Resurrection,* or the choice of a very elegant, rare salmon pink for Christ's tunic in the *Crucifixion.* This jewel-like rendering of fabric was to become characteristic of Gothicism. Black is used here for the first time as a color of extraordinary expressive possibilities: see, for example, the veiled woman in the *Meeting at the Golden Gate,*

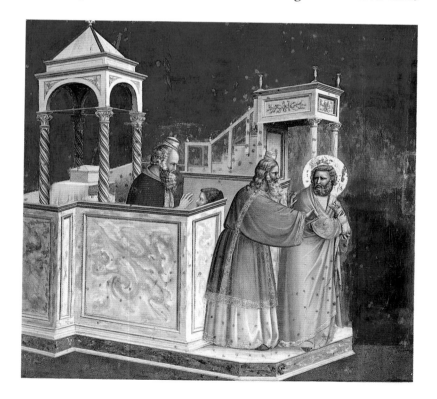

page 162: Giotto. Detail of
BIRTH OF THE VIRGIN
(p. 173 left). Scrovegni Chapel,
Padua. ❧ page 163: Giotto.
Detail of MARRIAGE FEAST

AT CANA (p. 182). Scrovegni
Chapel, Padua. ❧ page 164: Giotto.
Detail of ANNUNCIATION TO
ST. ANNE (p. 150). Scrovegni
Chapel, Padua.

Giotto. JOACHIM IS DRIVEN FROM THE TEMPLE. *Scrovegni Chapel, Padua.*

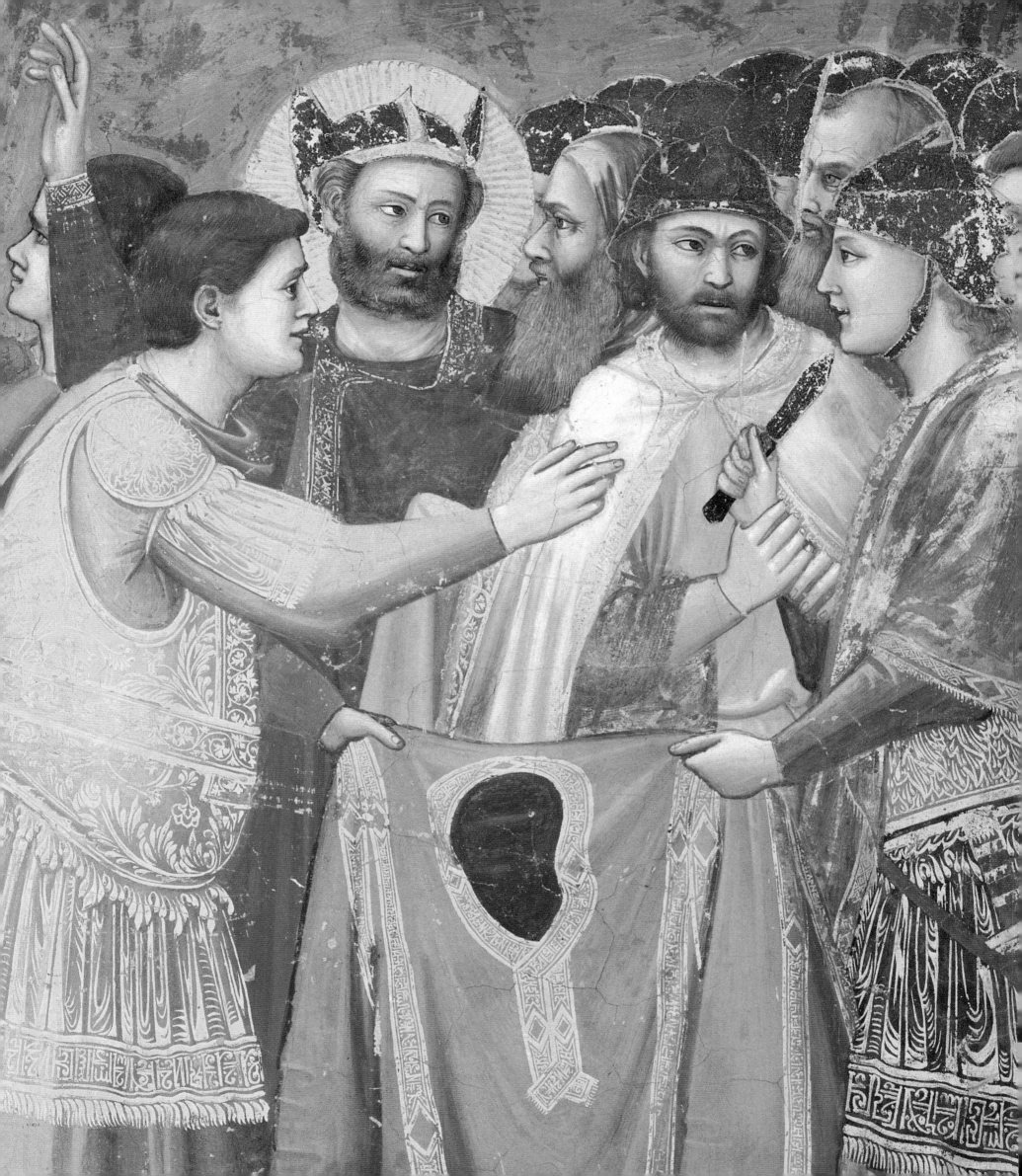

the black henchman in white clothes in the *Flagellation,* and above all the little devil behind Judas—almost his shadow—in *Judas's Betrayal* (below right). ❧ MOREOVER, Giotto experimented, perhaps for the first time, with contemporary colors, with results that were highly important for the local pictorial tradition throughout the fourteenth century and even after, up to Mantegna. He set green alongside red (or bright pink), yellow beside violet (or lilac), and orange next to blue, with effects of extraordinary luminosity. Indeed, he sensed that under the influence of light, chromatic timbres vary not only in intensity but also in quality, and therefore he painted colored shadows: thus the green cloaks have deep red folds, and pink shades off into lilac. *Judas's Betrayal* should be read in this key: the two central figures wear red and green robes, and the two lateral figures yellow and violet, with a double effect of complementary colors, while the pale, cream-colored architecture to the right

is set against the black devil on the left. ❧ I MUST also emphasize the variety and elegance of the hues and transparencies: the play of whites shadowed by pastel tints, as in the angels, dressed in vaporous gauzy veils, who form a ring around the Eternal Father at the summit of the chancel arch; the blue-violet of Martha's veil in the *Deposition;* and the stupendous pink tunic of the maidservant in the *Presentation of the Virgin in the Temple,* which appears to be covered by a transparent silken veil with bluish reflections. ❧ THUS the elegance and luminosity of the colors, accentuated by abundant gilded ornamentation in the halos and the trim of the clothes, distinguish this extraordinary pictorial cycle. Partly because of this chromatic power, the Scrovegni frescoes were to become fundamental texts for the evolution of Paduan Gothic painting; other painters began using it as an example starting in the middle of the fourteenth century.

❧ THE Paduan cycle reproposes in a more urgent manner the problem of Giotto's shop. In Padua the artist was at the height of his maturity and fame: his shop was a big enterprise, with assistants and pupils working at various levels; some were hired on the spot, while others—perhaps the majority—had already collabo-

rated in previous works. ❧ IN ANY event the overall conception and also the details of the decoration, even the secondary ones (such as the bands with lobed panels and geometric and floral elements), were the master's. It is quite possible that the painters had models at their disposal, or cartoons, for the ornamental

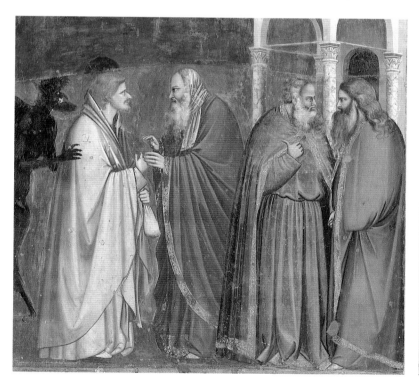 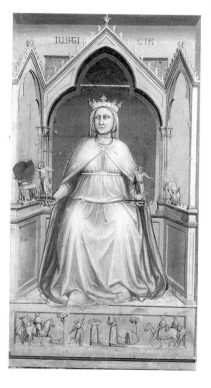

page 166: Giotto. Detail of CRUCIFIXION *(pp. 186–87). Scrovegni Chapel, Padua.*

Giotto. JUDAS'S BETRAYAL. *Scrovegni Chapel, Padua.*

Giotto. HOPE. *Scrovegni Chapel, Padua.*

Giotto. JUSTICE. *Scrovegni Chapel, Padua.*

elements, which were like signature-motifs of the shop, reappearing in various pictorial cycles. Architecture too recurs several times: for example, the cross-section of a building appears three times, in the *Marriage of the Virgin* and the two preceding episodes; Anne's small house acts as a background for the *Annunciation to St. Anne* and the *Birth of the Virgin;* and the room in which the *Last Supper* takes place also appears in the *Washing of the Feet.* ❧ BY ATTENTIVELY going over the pictures on the walls, one can easily pick out the master's work and that of his school. Rarely did Giotto leave to his collaborators whole sections of the decoration, but he did leave them the ornamental bands in the ceiling vault, and those that separate the episodes in the highest tiers. In the vault (p. 168 right) one can recognize a quite identifiable hand, characterized by slightly stiff faces with staring eyes, pointed chins, a certain fussiness in handling thin hair, and slightly darker and rather uniform color. As I said before, I believe this artist is the Master of the Chapter House. I think that the small episodes of the Old Testament on the left wall, characterized by an incisive line and a certain volumetric flattening, should be assigned to the same artist. A different personality is responsible for the figures of the Apostles in the polylobed panels in the highest tier: their faces are less refined. ❧ BUT the division is not always so precise, and not always did the master leave the decorative parts

to his pupils; certainly Giotto painted the Evangelist and the Doctors of the Church in the lower decorative bands. These are figures of intense expression and vividness, especially the stupendous head of the Evangelist who puffs out his cheeks in blowing on his pen to dry the ink: this exquisite observation of reality can only be ascribed to the master. ❧ ALMOST always, however, the assistants' work is mixed with the master's in the same episode, without any logical hierarchy—according to our modern categories—in the division of labor. It could be that Giotto personally painted what pleased him the most. Closer examination of the frescoes proves that the parts that are doubtless his are characterized by an extraordinary finesse of execution: faces whose soft, pallid flesh color is obtained by an infinite series of very subtle strokes; details rendered with amazing freshness and immediacy; surfaces confidently painted within the exact limit of the outline. Where this assurance does not appear, where one does not encounter this finesse and the faces do not appear with vital immediacy—there is the work of pupils. It is striking that the master did not take into account the fact that the upper part of the walls are less visible, and did not therefore leave the work there to his assistants. The robustness of the constructive positioning is joined in the highest parts to a very fine layer of colors and an almost miniaturistic delicacy in the small details, for example in the very beautiful and

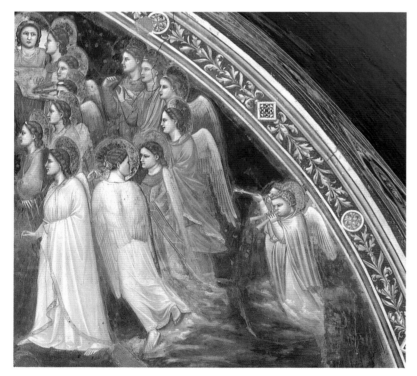

Giotto. Detail of GOD THE FATHER SURROUNDED BY ANGELS *(p. 170). Scrovegni Chapel, Padua.*

Master of the Chapter House. Details of a decorative strip of the vault. Scrovegni Chapel, Padua.

page 169: Giotto. Detail of GOD THE FATHER SURROUNDED BY ANGELS *(p. 170). Scrovegni Chapel, Padua.*

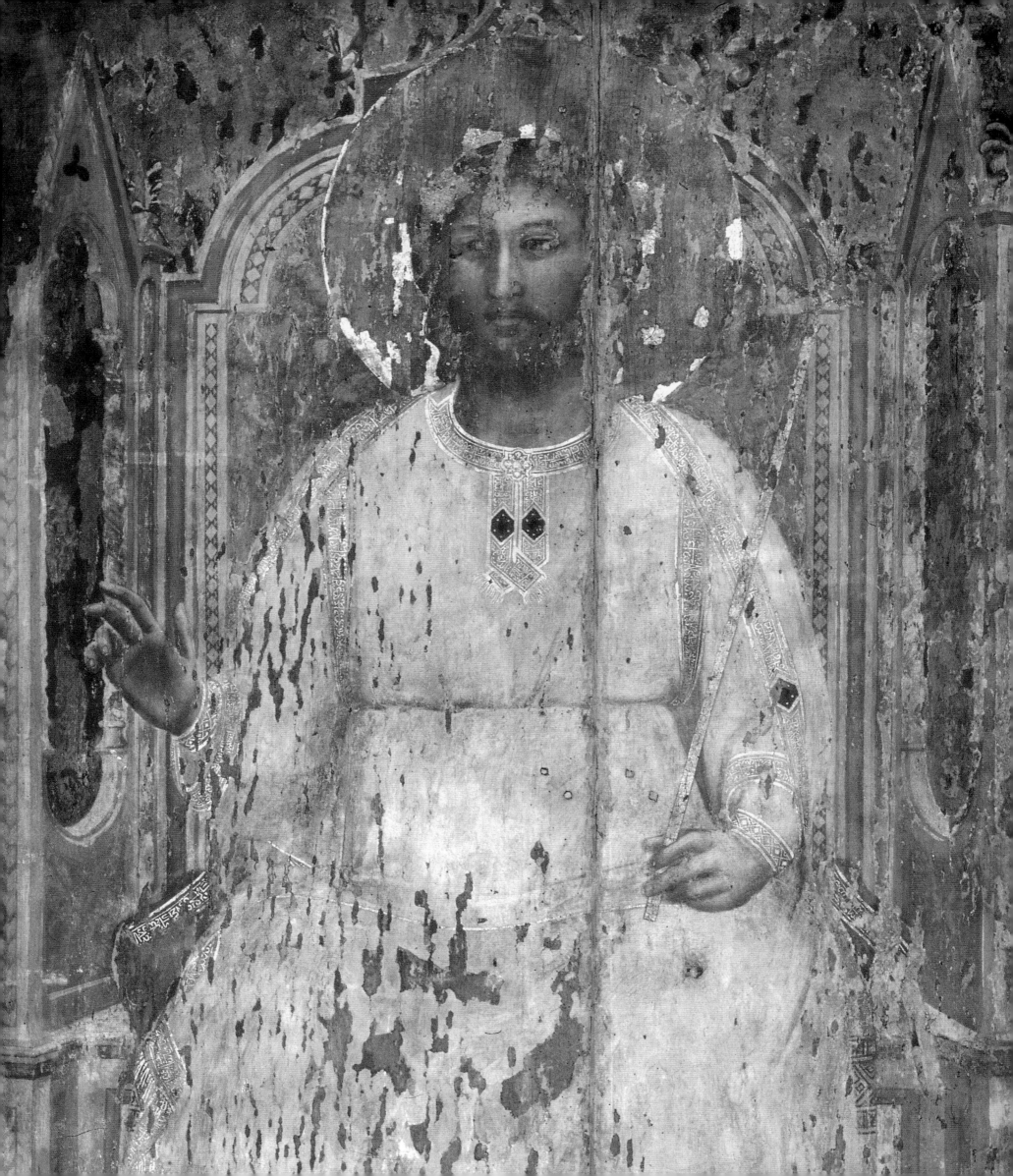

delicate group in the large rectangular lunette in the chancel arch, with the Eternal Father enthroned and surrounded by angels (p. 169)—which I consider a stupendous work by Giotto—and in the Stories of Joachim. It is as if Giotto found it amusing to create art on the highest scaffolds, not visible from below to the naked eye: the shepherds' poor clothes with patches and dangling threads, chiaroscuro grass of startling freshness, the pelts of animals, and above all the extremely passionate faces of the protagonists. I also have the impression that the hand of the master is more present on the right wall than on the left, where the people are repetitive, the composition is stifled within a narrow space, and the faces display the weakest craftsmanship, above all in the *Marriage of the Virgin* and the two preceding episodes. In fact, these three episodes lend themselves to other interesting observations. It has been said that the Paduan cycle favors individuals over crowds, but here again we find groups of figures with repetitive faces and gestures, with some heads showing nothing but hair. These groups have a strong resemblance to some in the Franciscan Cycle at Assisi—such as the friars in *Franciscan Rule Approved*—and to figures from the Stories of Joseph in the highest tiers of the basilica. It is as if there were shop models, still anchored to an archaic conception of composition, or as if these compartments had been completely left to the invention and exe-

cution of one of Giotto's collaborators who had been already active in Assisi. ❧ ANOTHER observation is that Giotto does not favor the protagonists of his episodes: indeed, that was the case in Assisi, where the figure of St. Francis was weaker than the others. He singled out secondary characters and some faces, which could be considered portraits; certainly Giotto himself painted the wine taster in the Scrovegni *Marriage Feast at Cana*, one of the cycle's most modern figures, in an episode that is in fact emblematic of the master-assistant relationship. In this very fine scene one can see that the figures grouped on the right have a striking vivacity and immediacy: the faces of the Madonna and the betrothed couple have vitality and intense emotion attributable solely to the master, whereas the four persons on the left are much weaker and almost insignificant, not only in their faces but also in the generic gestures of their hands. Giotto certainly painted St. Anne, a true portrait of an old woman, and Joachim, and all the poignant faces of old men, executioners, and shepherds. And some almost animate parts of the landscape seem painted by Giotto, such as the dark wound that opens in the stone of Golgotha in the *Crucifixion*, the rocks that look like they were sketched with a chisel in the Stories of Joachim, and the shrubs too—beautiful ornamentation presented as miniatures in the bright pale front leaves and the darker ones in the second

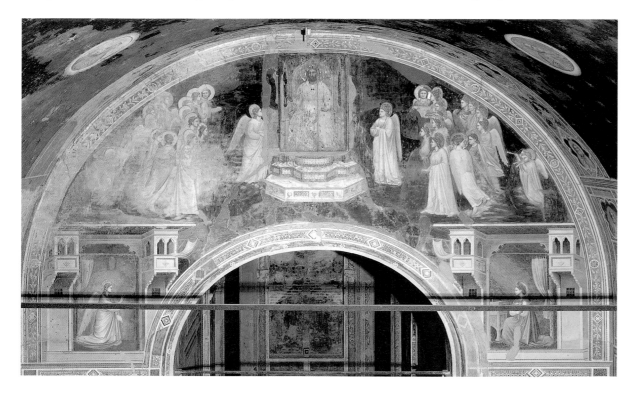

*Upper part of the chancel arch
with* GOD THE FATHER
SURROUNDED BY ANGELS.
Scrovegni Chapel, Padua.

plane. ❧ AND yet it is futile to try to pick out the different hands in this grand composition, breaking it up into fragments and analyzing it with the curious and penetrating eye of the modern critic. Such a collaboration, typical of medieval workshops, does not mar the perfect unity of the decoration, which bears the sign of Giotto's great genius.

❧ PERHAPS now it is worthwhile to review the great poem scene by scene, starting with the depiction of paradise, *God the Father Surrounded by Angels* (p. 170). In a terribly damaged rectangular panel, put up to block an opening at the top of the chancel arch, God the Father in a luminous white robe is seated on a Gothic throne. The chief figure, majestic in his stylized expression and in the fall of his cloak, presents a new iconography for the Heavenly Father and is certainly the product of Giotto's hand and invention. But this figure is only the luminous fulcrum for the graceful figures of the angels, disposed in a semicircle, wearing white robes with pastel reflections and transparencies, soft veils whose lightness we can measure. These angels already seem to be a prelude to the profane transformation that during the fourteenth century will result in winged messengers in courtly postures: just observe the very elegant adornment of white pearls on the hair of one of these spiritual courtiers. Much has been said and written about this panel that disrupts the homogeneous texture of the frescoes, a high door providing access to the presbytery; I believe the only possible solution is the one advanced by Hueck, that the opening was connected with the annual mystery play of the Annunciation on March 25. Opening the small door could release a dove symbolizing the Holy Ghost, which would, by certain mechanical contrivances, fly down to Mary. ❧ LOWER in the chancel arch, the setting becomes quite concrete in the symmetrical two-part depiction of the Annunciation (p. 171 left), placed at the most conspicuous point, because the chapel is in fact dedicated to the Virgin of the Annunciation. The figures kneel in extraordinarily spacious buildings from which two balconies with trefoil openings jut out in a trompe l'oeil effect. The roof, in precise perspective, is also a pedestal for the dance of the angels, and the curtains are a lovely invention, hanging from poles and swaying in the breeze. And while the kneeling angel is a composed and mannered figure, the Virgin embodies a folksy concreteness that sounds the keynote for the entire cycle, an ongoing recovery of earthly values. Enfolded in the ample geometric block of her mantle, Mary appears surprised, in the

Giotto. VIRGIN OF THE ANNUNCIATION. *Scrovegni Chapel, Padua.*

Giotto. MEETING AT THE GOLDEN GATE. *Scrovegni Chapel, Padua.*

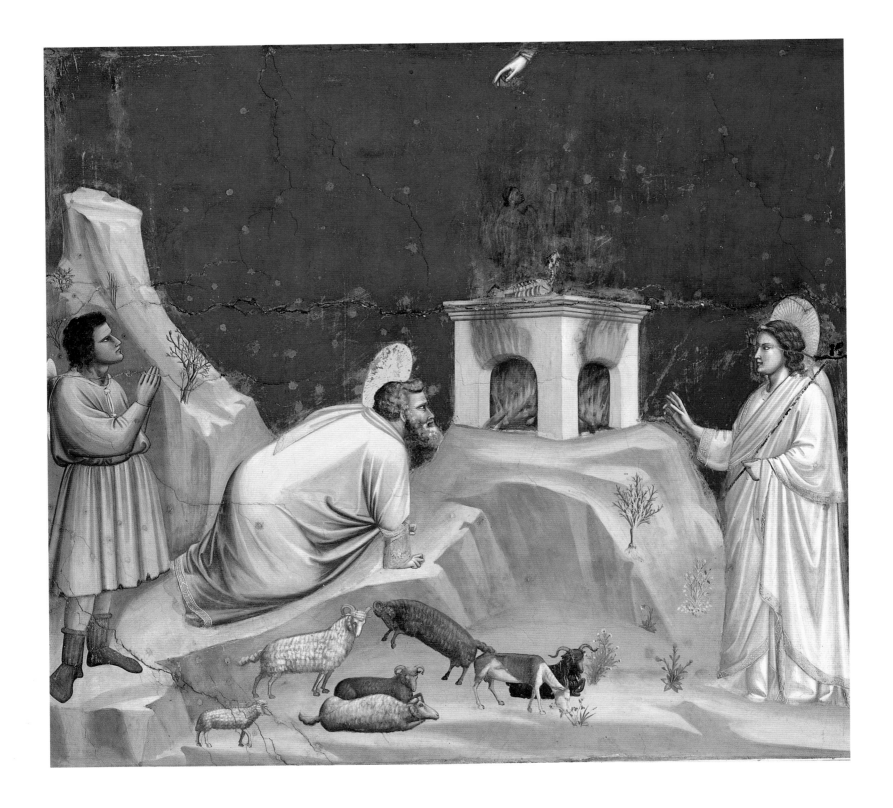

Giotto. SACRIFICE OF JOACHIM.
Scrovegni Chapel, Padua.

instant that she falls to her knees; her intense and perfect countenance and the movement of her arm, not yet completely clasping her breast, are vividly depicted. ❧ THE stories in the upper band are characterized by unusually bright colors; the right wall is dominated by pink in different gradations. The figures are few, very sturdy, with especially poignant faces. In *Joachim Is Driven from the Temple* the architecture repeats the enclosure and canopy of medieval Roman churches—Santa Maria in Cosmedin for example—while the tension of the link between the two old priests, one in pink and the other in bright green, is well expressed by their eyes and the movement of their hands. In Joachim's episodes among the shepherds (*Joachim Joins the Shepherds,* the *Sacrifice of Joachim* [p. 172], and *Joachim's Dream*) the rock of the landscape is the protagonist: very brightly illuminated as though from within, it is scored by sharp, clear-cut furrows and animated by lovely shrubs certainly copied from life, so various are they, and so careful is the rendering of the leaves in shadow and light. The narration begins with Joachim's solemn figure taking a slow step forward, but the shepherds exchanging a quick glance are important. In the two succeeding compartments the figure of Joachim has the violent power of a block of colored marble: in one he is crouching like a dog on its back legs; in the other he is squeezed inside a lopped-off pyramid. Between the

first episode and these last two is the *Annunciation to St. Anne,* which takes place in Anne's small house, as regular as a small classical temple, where the painter dwells on all the objects, from the blanket on the bed to the curtains hanging from rings and the beautiful vermilion-colored trunk. Anne has the same sturdiness as the Virgin in her annunciation, but a delicate sadness suffuses the beautiful face of this mature woman. The maid working the spindle for thread is one of the cycle's striking secondary figures. This sequence of stories closes with the *Meeting at the Golden Gate* (p. 171 right); this is one of the most significant episodes and also the newest of the cycle. The background is a Roman arch—which Gioseffi (1961) identifies as the arch of Augustus in Rimini—but the fulcrum of the scene is shifted to the left, to the stupendous pyramidal block formed by the wedded couple embracing: behind them is the phalanx of maidservants, some partly inside the gate, among them the woman mantled in black, whose meaning has not yet been interpreted. ❧ THE wall opposite offers the *Birth of the Virgin* (below left), again in Anne's small house, now packed with people; though tied to traditional iconography, the episode is enriched by zestful observations of everyday life, such as the maid who touches the nose of the child, and especially the conversation and exchange of gifts across the threshold; the woman inside the room shows only half a face.

Giotto. BIRTH OF THE VIRGIN. *Scrovegni Chapel, Padua.*

Giotto. Detail of WEDDING PROCESSION. *Scrovegni Chapel, Padua.*

pages 174–75: Giotto. Detail of NATIVITY AND APPARITION TO THE SHEPHERDS. *Scrovegni Chapel, Padua.*

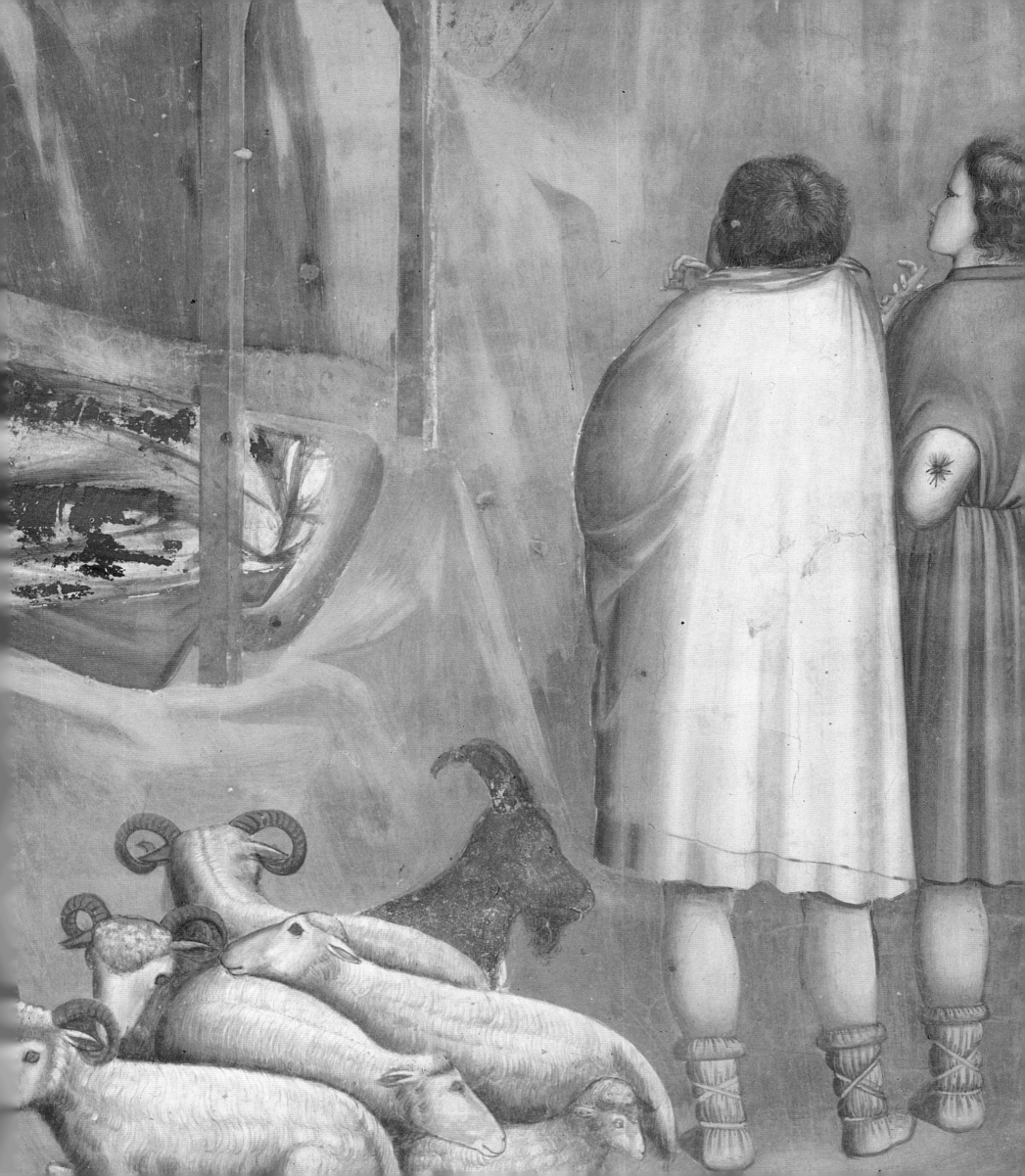

Giotto. EPIPHANY. *Scrovegni*
Chapel, Padua.

Giotto. PRESENTATION IN THE
TEMPLE. *Scrovegni Chapel, Padua.*

Giotto. SLAUGHTER OF
THE INNOCENTS. *Scrovegni
Chapel, Padua.*

The *Presentation of the Virgin in the Temple,* dynamically articulated by the staircase, centers on the granitic figure of Anne, enveloped in a red cloak. But this, and the three repetitive episodes of the Marriage of the Virgin (p. 173 right), crowded with people set against a simple cross-section of a church, all show a certain weakness in both invention and workmanship, leading one to suppose, as we noted above, the presence of an assistant. But Mary's white dress is a very elegant invention, like the three musicians with instruments of the period, a fiddle and two clarinos. ঽ THE *Visitation* to the right of the chancel arch introduces the Stories of Christ's Childhood. This is one of the most intense colloquies of the cycle: the exchange of glances between the two women is reinforced by the affectionate intertwining of their arms, in a very simple and adept composition whose center is the geometric block of the two principal figures. But in this clear-cut and essential scene the painter also pays attention to embroidering with a golden net the braided coif of the woman beneath the portico. The crib in the *Nativity* (pp. 174–75) radiates, perhaps for the first time in the history of art, affection and delicacy; it is crafted of the sweetness of the Madonna's gaze and of the docile animals that seem to participate in the event. The poor hut, perfectly measured in perspective, is surmounted by the happy flight of little angels in song. The next

compartment, the *Epiphany* (p. 176), is composed with a certain solemnity in a symphony of gold and bright colors, and the Magi, particularly the youngest one in an ample white cape with contemporary red shoes, are the first of a long series of courtly characters who will animate this particular scene with their sumptuous and appealing processions throughout the century. ঽ THE scene is very famous because here for the first time a comet with its tail is depicted over the crib instead of the traditional star, with three rays symbolizing the Trinity. This image can be traced to the two comets—one of them the famous Halley's Comet—that crossed the sky in 1301–2. Curious and alert to everyday reality, Giotto observed celestial phenomena too, and with sublime imagination, but also profound religious feeling, he interpreted the words of the evangelist Matthew (2:2)—"We have seen his star arise . . ."—in a completely new way, introducing an innovation in the iconography of the Holy Crib. ঽ THE *Presentation in the Temple* (p. 177) is the central scene on this right wall: the composition has a simplicity that could be called liturgical, against the background of a Paleo-Christian or Romanesque canopy. The figures are bound together in a colloquy that spreads, like wave upon wave, dragging in all the characters—the child Jesus and Simon, and then Simon and Mary—and is echoed by the attention of the others. The prophetess Anne on the far right

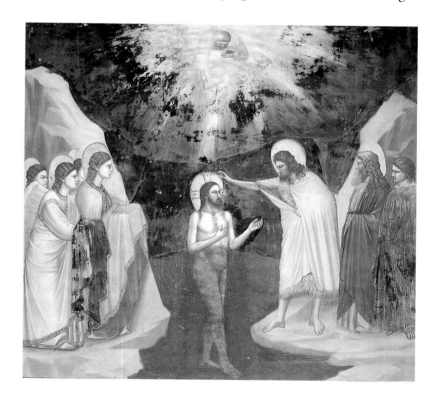

Giotto. BAPTISM OF CHRIST. *Scrovegni Chapel, Padua.*

pages 180–81: Giotto. RAISING OF LAZARUS. *Scrovegni Chapel, Padua.*

is very beautiful, like a sybil (her dress too is sybilline), and has an old, thoughtful face, while the maidservant at the left stands out due to an unusual costume that appears to have a transparent veil with pink and blue reflections. The *Flight into Egypt* (p. 152) is a well-known episode, emblematic for the relationship between environment and persons, seen in the group of the Madonna and Child on the donkey, echoed by the shape of the mountain. But in dialectical contrast with her majestic, almost stylized figure, the painter dwells on a careful description of common, everyday objects beginning with St. Joseph's straw basket. In the *Slaughter of the Innocents* (p. 178), against the background of an octagonal building that recalls the Florentine Baptistery, the cluster of women is powerfully individualized in their expressions of violent sorrow, and they are countered by the executioners with equally violent gestures. ❧ *CHRIST among the Doctors* on the opposite wall is almost lost, but one can sense a very adept perspective spaciousness. The *Baptism of Christ* (p. 179), on the other hand, follows the traditional iconography, leaving little room for the painter's imagination. But the next stories are a succession of vivid strokes of genius, bursting with intensity. The first of these is the famous *Marriage Feast at Cana* (below), set in an elegant room whose walls are covered with striped drapes below a gallery of pierced wood. More than the protagonists in this episode, it is the group

of servants next to the stone pots of wine that catalyzes our attention; extraordinary and full of humor is the figure of the wine taster, whose bulk echoes the form of the stone pots. Once again the details are notable: the tablecloth, the crockery, and the elegant and contemporary clothes of both spouses. The scene is inspired by the same scene in the Upper Basilica at Assisi, by an artist of the Roman school: the proofs of this are the large pots for the wine, echoing classical models, placed so as to close the composition on the right. But the very comparison of the two versions makes us comprehend the revolution in pictorial language created by Giotto in the brief space of a few decades, not only in the spaciousness of the format and the volumetric treatment of the characters, but in this attention to everyday life. ❧ THE *Raising of Lazarus* (pp. 180–81) is once again set in a rocky landscape: the two protagonists do not communicate with each other, but Christ's gesture is observed by a group of onlookers, caught in poses of great amazement and spontaneous immediacy, such as the two dignitaries who cover their noses with veils. The range of colors is unusual: for the first time in these episodes, red umber is used in the green tunic of the young man in the foreground. ❧ LESS interesting from a compositional point of view are the *Triumphal Entry into Jerusalem* and the *Cleansing of the Temple.* But they are enjoyable in their details: the boys climbing the trees in the first scene are a

Giotto. MARRIAGE FEAST AT CANA. *Scrovegni Chapel, Padua.*

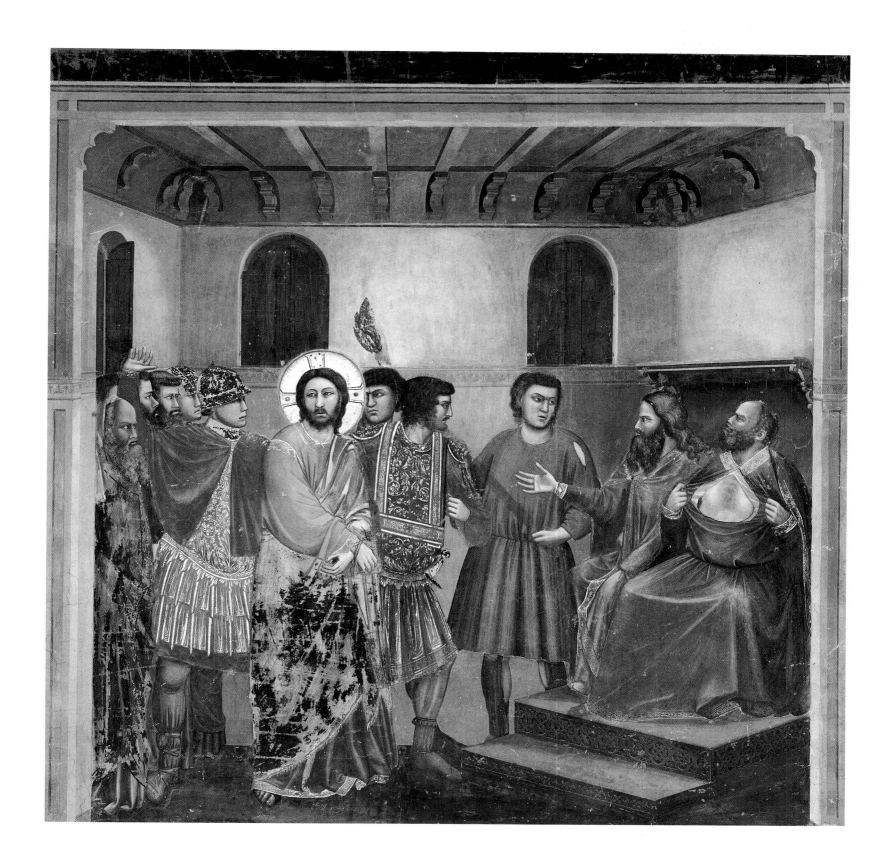

Giotto. JESUS BEFORE CAIAPHAS.
Scrovegni Chapel, Padua.

happy invention, and the temple's deep portico, and the cage in a precise perspective design, almost measuring the space, are interesting. ❧ THE Stories of the Passion have their prelude in the scene of Judas negotiating the betrayal; the intense psychological insight into all of the characters involved makes this an extraordinary episode; and the black devil standing behind Judas, who has the same profile, is one of Giotto's most modern inventions. In the lower band on the right, the same large room appears in the *Last Supper* (p. 148) and the *Washing of the Feet* (p. 149): the architecture is very finely designed with windows half-opened to the sky; the light shadow that condenses under the ceiling is noteworthy. While the first of the two pictures is anchored to a rather static, traditional iconography, the second is animated by simple but vivid gestures, such as the conversation between Jesus and Peter, and is enhanced by everyday objects, including the basin and the sandals. In the middle of the wall is another famous scene: the *Kiss of Judas* (p. 155), focused on the block-like mantle that encloses Judas's tight embrace of Christ. The monumental power of the geometric block is repeated like an echo in the granitic figures of the onlookers with their piercing glares in a space that for the first time lacks all environmental notation and is measured only by the diagonal lines of the torches and spears. The two episodes of the trial then follow: the first more simple, before Caiaphas (p. 183), who rends his clothes, in a room whose depth is measured not only by the vanishing perspective lines of the roof but also by the variations of light along the walls. The second episode, the *Flagellation* (p. 185), is one of the best works of the entire cycle. Giotto sets the scene, with historical fidelity, in a Roman courtyard, illuminated by an intense light that falls from above and leaves in shadow the highest part of the walls: this is a very acute observation in a picture where the study of light and color is carefully calibrated throughout. As Lisner—the scholar who more than any other has studied color in Giotto—has pointed out correctly, the sky through the windows appears black, since the trial takes place at night. The composition is articulated in two groups tied together by the prominent figure of the black-skinned flogger dressed in white, and all the persons are minutely studied and analyzed with the immediacy of portraits: the sweet face of Christ, the grim mugs of the henchmen and torturers, and the face of Pilate, based on the bust of an emperor. But the work can also be placed among the most refined from the coloristic viewpoint: the play of yellows and of violets of different intensities characterizes the group on the left with a stunning effect, while the group on the right, animated by the prevalence of reds, is enclosed by the priest's broad pink mantle with its lilac shadow. On the left wall the miserable state of conservation barely allows

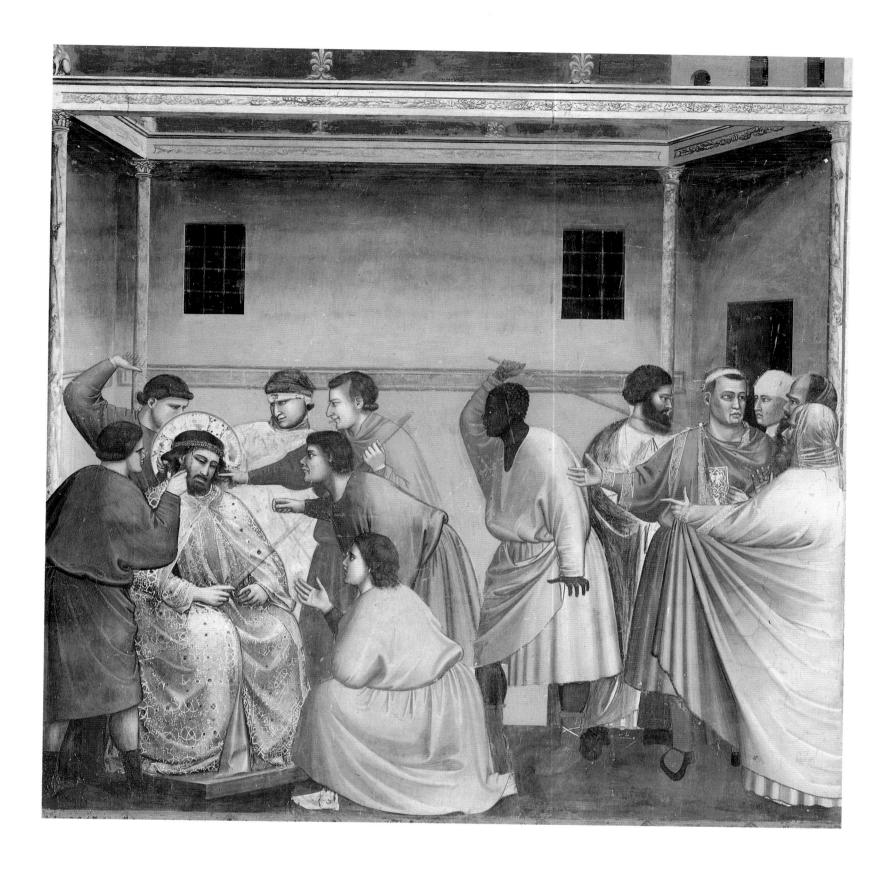

Giotto. FLAGELLATION
(CORONATION WITH THORNS).
Scrovegni Chapel, Padua.

pages 186–87: Giotto.
CRUCIFIXION. *Scrovegni*
Chapel, Padua.

us to read the episode of the *Way of the Cross,* but it should at least be observed that its background is the same city gateway as in the *Entry into Jerusalem.* ❧ THE *Crucifixion* (pp. 186–87) too attains the loftiest heights of expression: the composition is balanced and solemn, against an empty sky, without background structures; the background is occupied, in any event, by the anguished flight of little varicolored angels. The pale body of Christ has elegant proportions, thin and elongated, like a Gothic statue, and his face shows a serene suffering; the group of women with John has a poignantly tragic essence, clustered around the body of the Madonna, who is slumping to the ground. In the group on the right, where all the persons are acutely individualized, Brandi (1983) has stressed the almost animate beauty of Christ's flutteringly empty robe. This episode is novel from many points of view: for the choice of bright and extremely elegant colors—the salmon pink of the robe, Mary Magdalen's violet dress emerging from a green and red robe—and above all for the use of gold in Christ's loincloth, in the angels' halos and clothing, in the cups that collect the blood, in the inscription above the cross, in the hems of the cloaks falling in Gothic cadences, and in the armored breastplates. Giotto transforms the tragic scene into a moment of glory, in a very interesting interpretation of the Christian conception of death and resurrection. ❧ THE *Deposition* (p. 189) is also famous, with its emotional fulcrum shifted down and to the left, to the encounter between the Mother and Son; around the two faces the composition spreads in a semicircle, articulated by the gestures and postures of the mourners. The figures are extraordinarily sturdy, like blocks of stone: the two cloaked figures seen from the back; Martha in her lilac veil; the powerful Madonna, a true image of grief, is as beautiful as Mary Magdalen, in a very delicate posture, and St. John, enveloped in a cloak that falls majestically, who opens his arms to define the space. The cherubs respond to this grief, and nature itself strips the leaves off the tree. The Resurrection and the "Noli me tangere" episode are combined in a single scene in which—as in all the *post mortem* episodes—the color white prevails: the cherubs crowned with golden hair are very beautiful in their delicate spiritual writhing; Mary Magdalen is another of Giotto's grand characters, caught in the vain, trembling gesture of arms and hands thrust forward. Less interesting are the next episodes: the *Ascension* (p. 192), again very traditional, and the *Pentecost* (p. 193). But they are both characterized by a luminous glimmer in the heavily decorated and embroidered clothes and by very beautiful, fine, accurately individualized faces. ❧ THE mock-marble plinth of the walls, which has already been mentioned several times, was intended to emphasize and comment on certain passages in

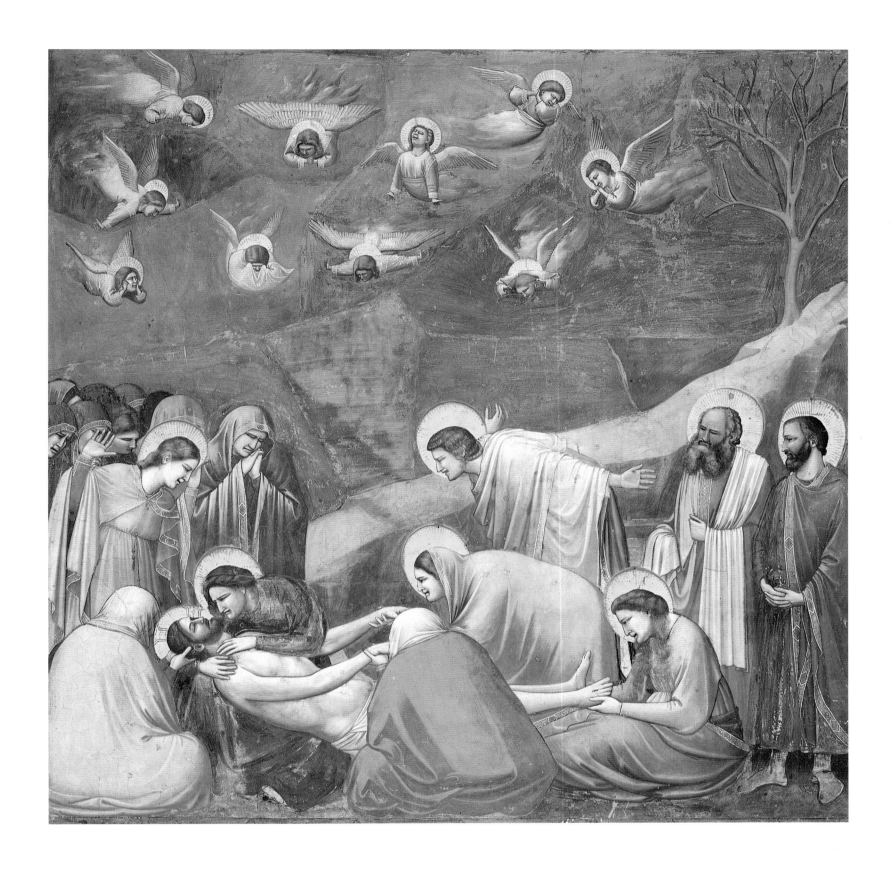

Giotto. DEPOSITION. *Scrovegni Chapel, Padua.*

pages 190–91: Giotto. Detail of DEPOSITION. *Scrovegni Chapel, Padua.*

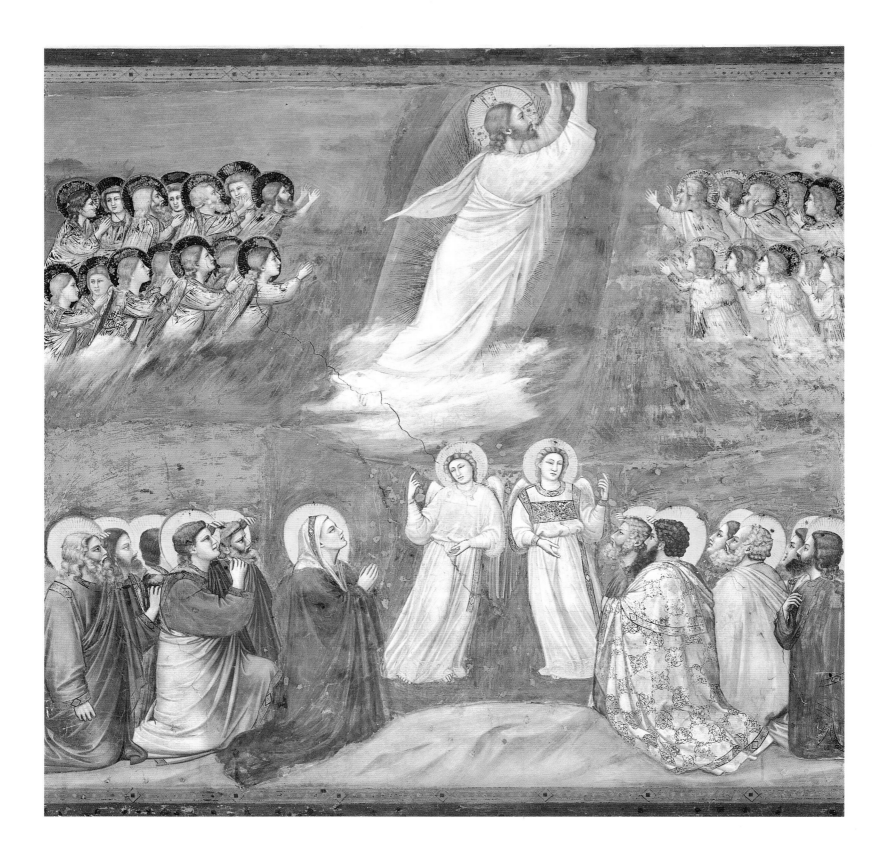

Giotto. ASCENSION. *Scrovegni Chapel, Padua.*

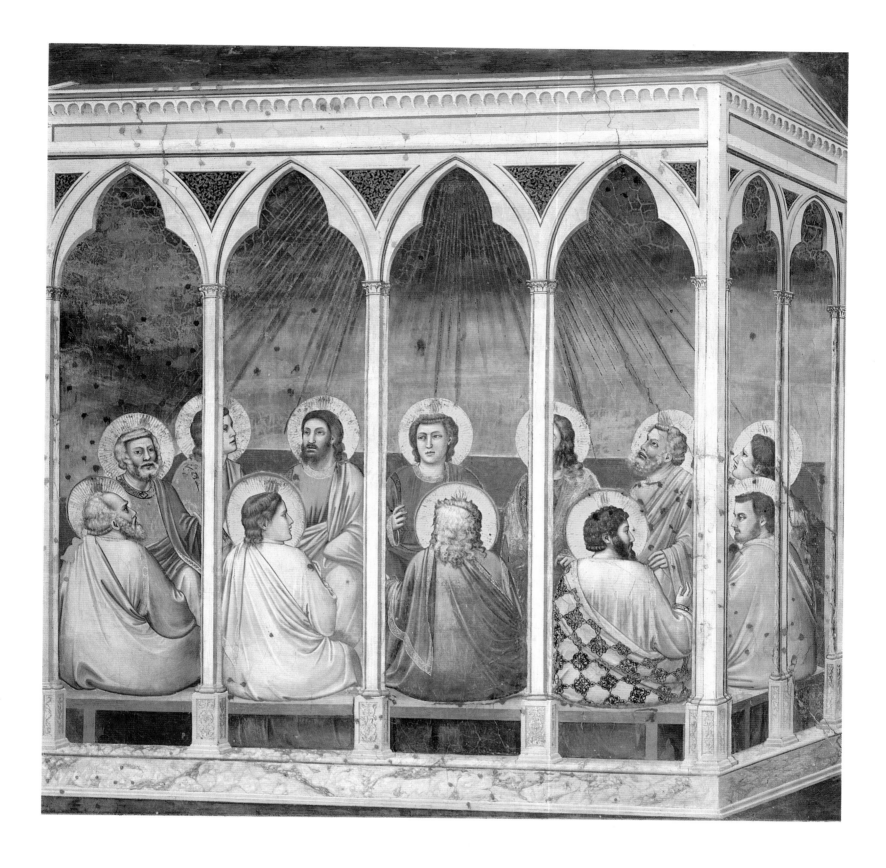

INIVSTITIA

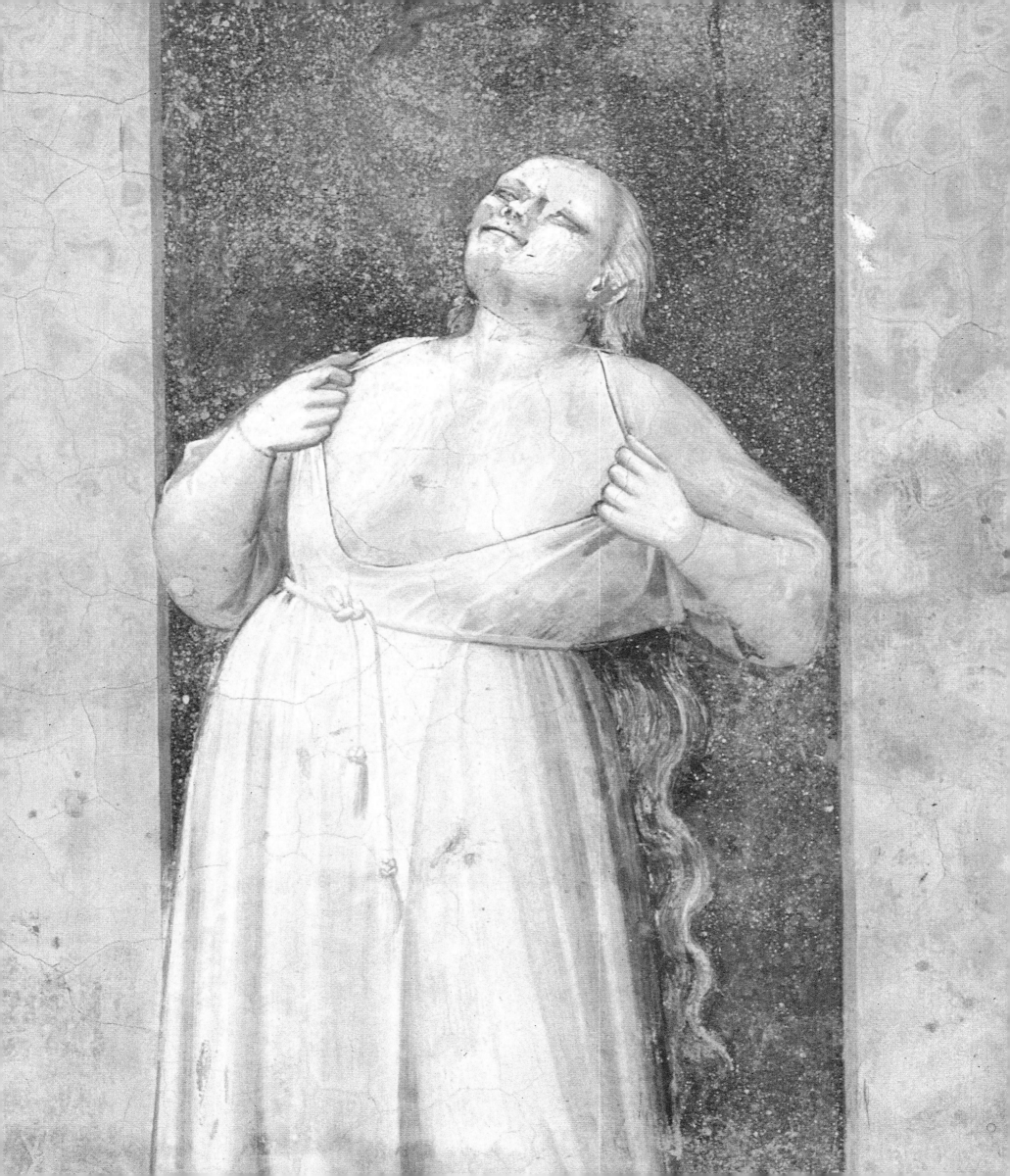

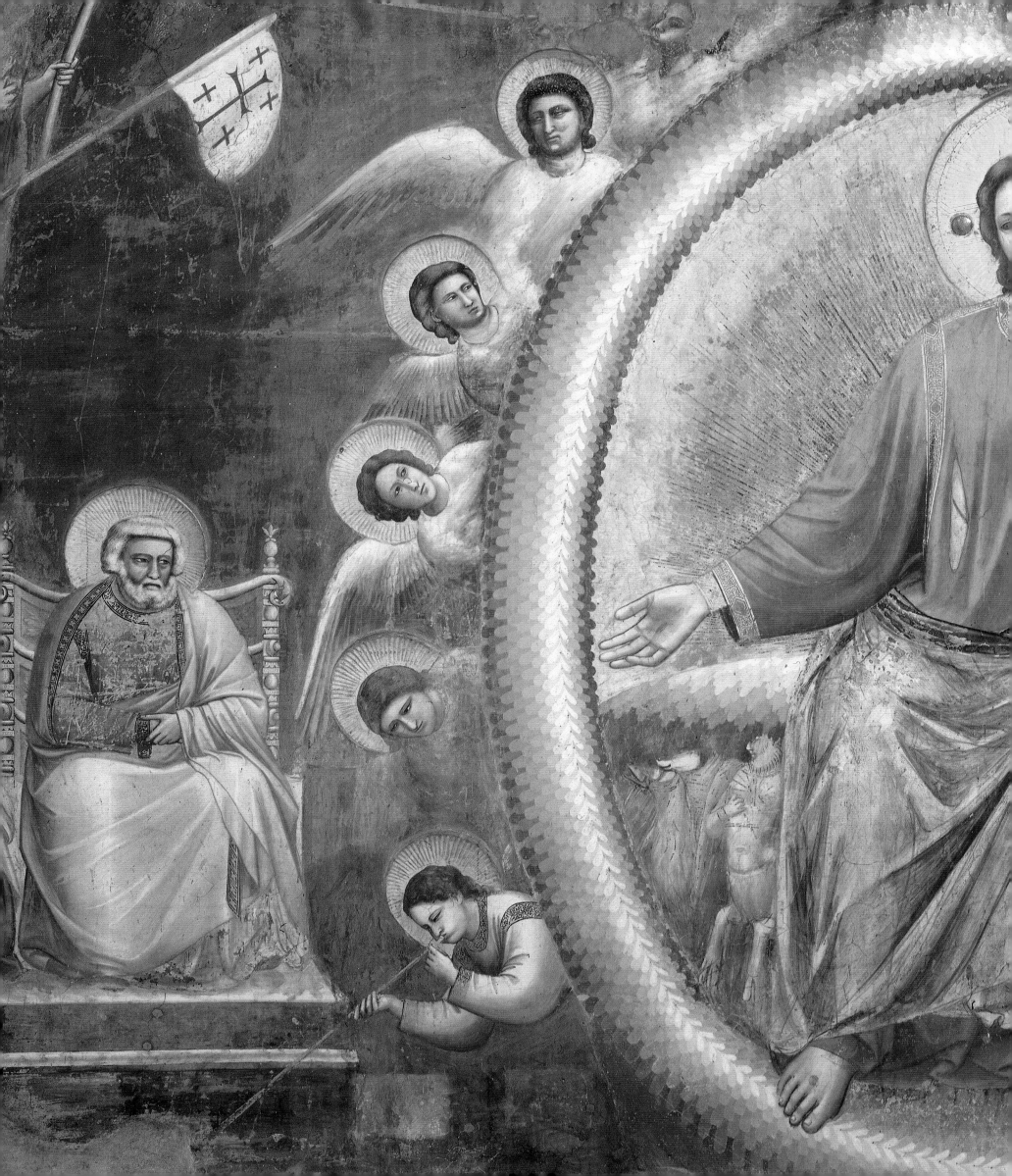

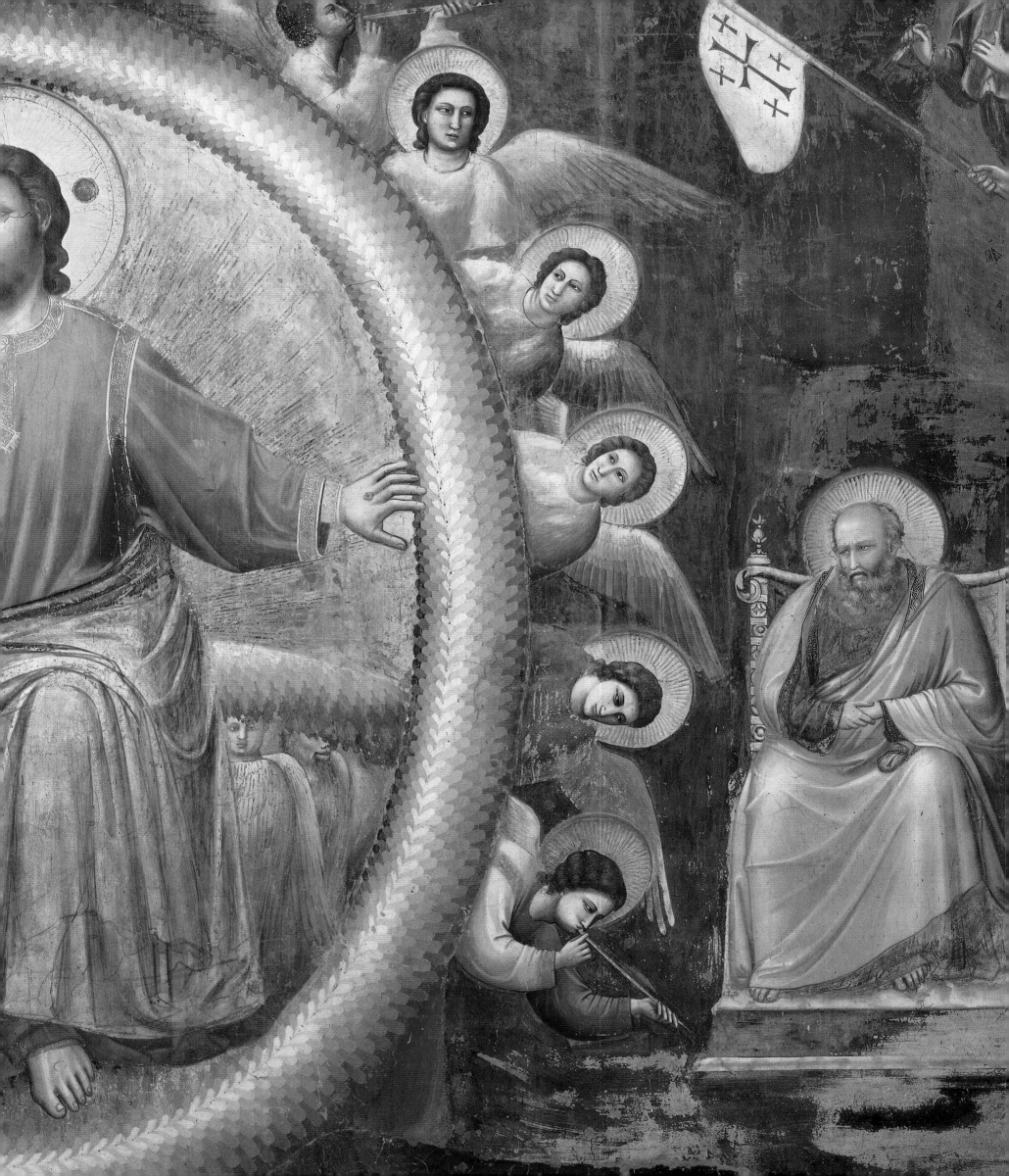

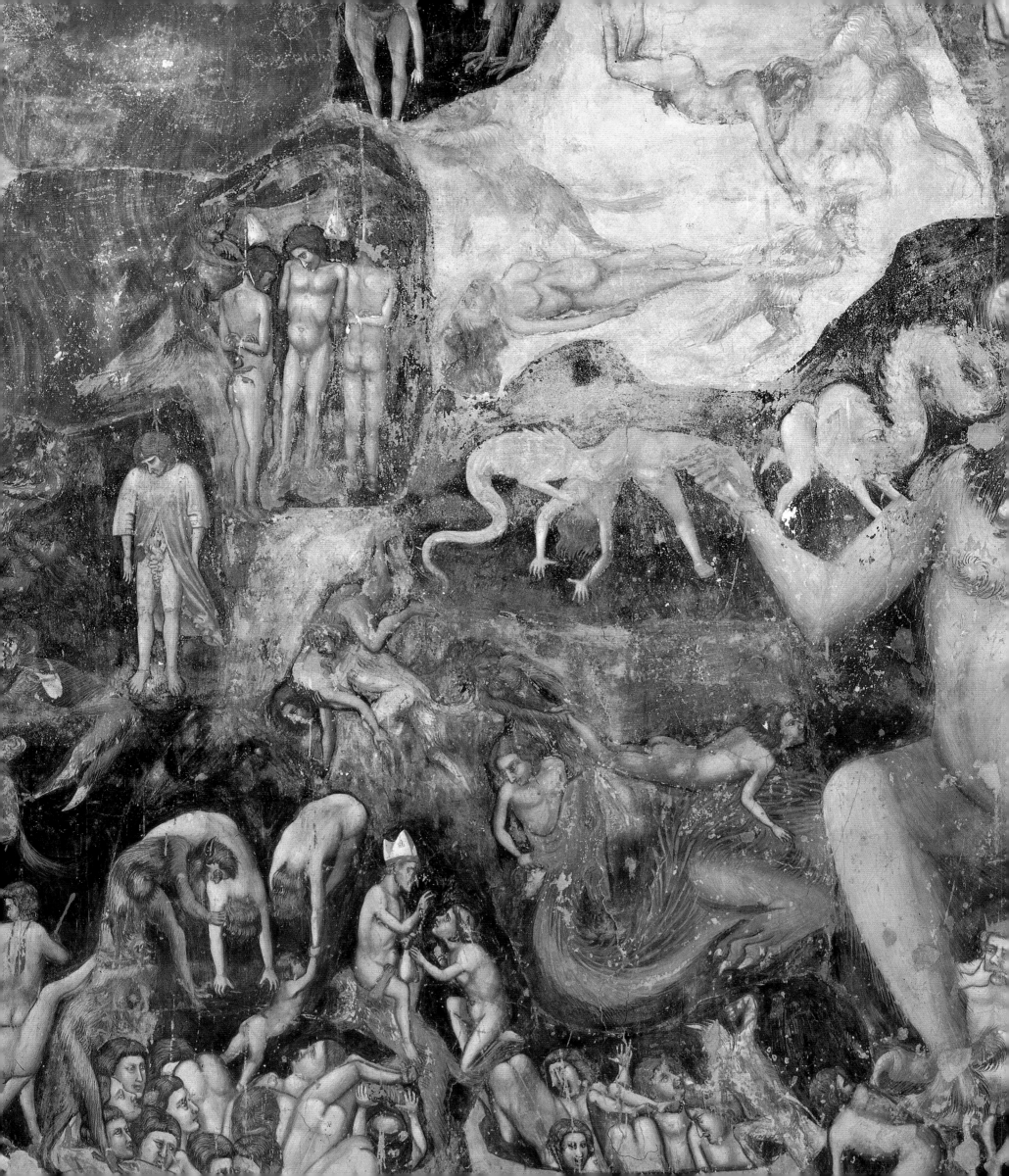

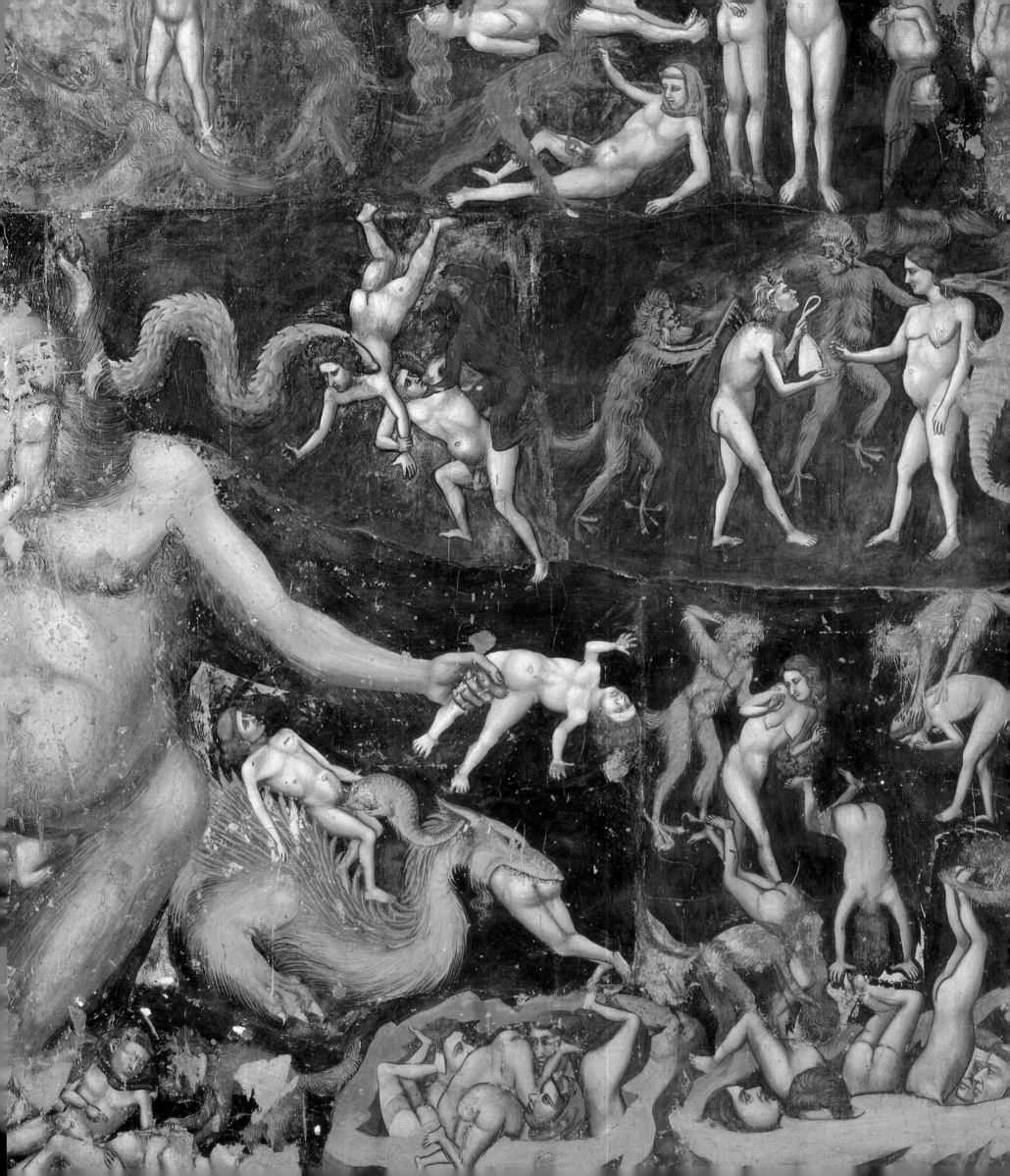

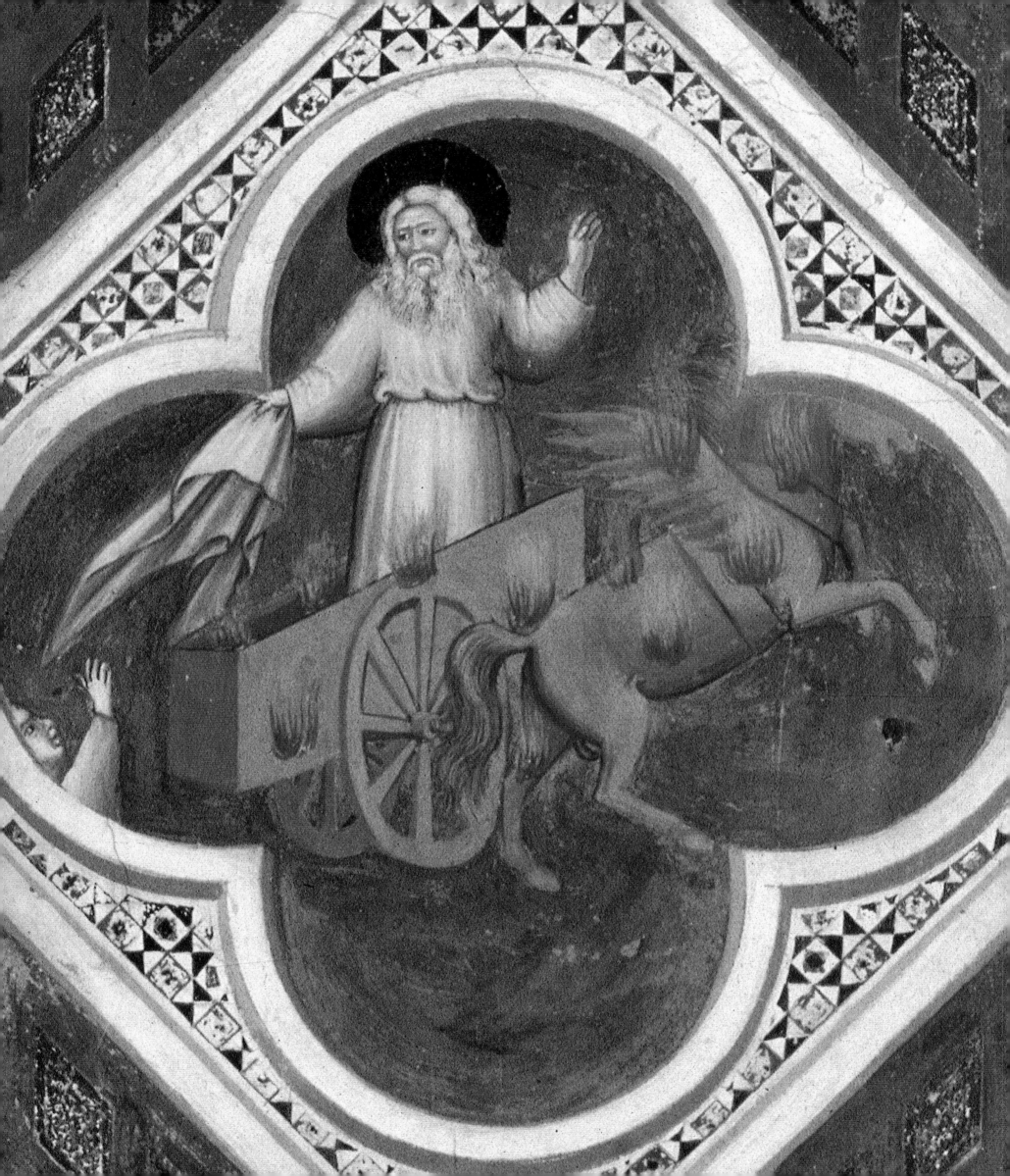

particular. The Virtues, as I said, seem to be copied from classical statues: but they are enhanced with very modern elements, such as jewels—Justice's crown and clasp; Prudence's stool—and other decorative objects (like Charity's lovely pink basket) in a Gothic interpretation of the classical world, reminiscent of Giovanni Pisano. The mock bas-reliefs at the feet of Justice, and of Injustice on the opposite wall, are very effective elements rendered with swift brush strokes, which portray for the first time "the effects of good and bad government." ❧ THE Vices on the facing wall could not be drawn from classical iconography so the figures are less elegant. But they are charged with greater imagination of a lingering medieval flavor: Despair has a little black devil; Envy has donkey's ears, fingernails like claws, and a snake that curls out of her mouth; Injustice is seen against the backdrop of a collapsing city, while the woods at his feet are populated by malefactors; and Anger rends his clothes with a gesture that imitates Caiaphas's. ❧ THE *Last Judgment* is the scene most closely tied to classical iconography. But Giotto introduced some interesting novelties into this model codified by a long history. At the top, two angels unroll the scroll of the universe with the sun and moon. In a *mandorla* Christ the Judge sits on a throne supported by apocalyptic animals, in an interesting commingling of biblical texts (Ezekiel and Revelation), and surrounded by the Apostles. The model for this part of the fresco is certainly the *Last Judgment* by Cavallini in the church of Santa Cecilia in Trastevere, but here the high-backed chairs of the Apostles, all different, are ranged in a semicircle, with an accentuated sense of space. The rows of the blessed, monotone and repetitive, are of rather poor quality in places, just as the angels are weak and were certainly painted by assistants. But at the center Giotto proposes his new ideas, in the cross, usually isolated, which is supported by angels here, and in the fine group in the dedicatory scene. The donors offering a model of the chapel are Enrico Scrovegni, portrayed with exceptional vitality, and a person not yet identified, and the three female figures receiving the model are delicate and very elegant, true ladies of a celestial court. ❧ FROM Christ's throne pours a river of fire that divides into four great flames to form the inferno. This episode is usually neglected by the critics, who assign it to Giotto's workshop; but I believe that the overwhelming drama and violence of the composition in general and the invention of the extremely cruel details of the scene mark it as the work of the master, who is after all a man of the Middle Ages. It is in fact the same medieval imagination that invented those macabre torments for the portrayal of the Vices. The composition and the general scheme do not derive, as is sometimes suggested, from the much more schematic *Last Judgment* in the Cathedral of Torcello

page 202: Master of the Chapter House. Detail of a decorative strip, ELIJAH IN THE FIERY CHARIOT. *Scrovegni Chapel, Padua.*

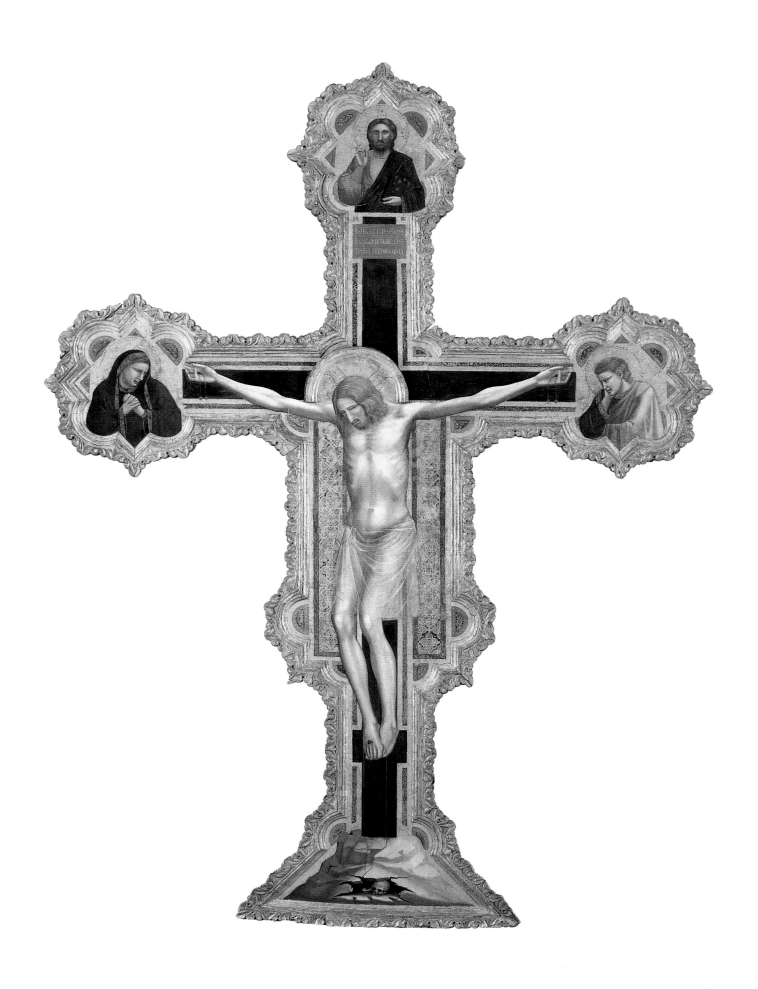

Giotto. CRUCIFIX, *obverse. Tempera
on panel, 87¾ × 64½ in. (223 ×
164 cm). Museo Civico, Padua.*

(Venice), but, as others have noted, from the *Last Judgment* in the Baptistery in Florence. Giotto certainly could not and did not want to avoid that very powerful dramatic model, and so he repeats both the central figure of the demonic, black, flaccid Lucifer with three mouths, writhing with snakes, and many of the terrible torments, such as the damned dangling from skewers, or loaded on the shoulders of devils. But the variety of punishments is even crueler here than in the Florentine Baptistery: they are specified, no longer generic, each suited to the particular guilt of the sinners, who still bear the signs of their earthly roles in a sacred drama that is the visual parallel of Dante's *Inferno*.

WHILE they may not have been executed by the master himself, the small lobed panels containing episodes of the Old Testament in the decorative bands should be noted not only for their iconographic interest but also for the freshness of the abbreviated and synthetic compositions. The lioness who breathes on the lion cubs to revive them is related to all the other animals of the cycle; the fine picture of Elijah (p. 202) ascending on his fiery, precisely foreshortened chariot drawn by a winged horse of clear classical origin is a more elegant variant of the St. Francis who climbs to heaven on the chariot in the stories in the Assisi basilica.

THE CRUCIFIX

THE fine *Crucifix* (p. 204) now preserved in Padua's Museo Civico was an integral part of the decoration of the Scrovegni Chapel. It must have hung in a central position, perhaps above a barrier separating the presbytery from the nave. The work is signed by Giotto and datable to the time when the cycle of frescoes was being painted; it thus constitutes another significant element of the Florentine master's Paduan activity. It was to prove a very important reference point for fourteenth-century painters in the Veneto. THE panel is rather small, especially in comparison to the other crucifixes painted by Giotto and his immediate circle: this one is just under 88 inches (224 centimeters) tall. Painted on two sides, it is set like a precious piece of jewelry in an elegant frame gilded with a leaf motif of Venetian inspiration. THE structure of the *Crucifix* differs from that of the traditional crucifix,

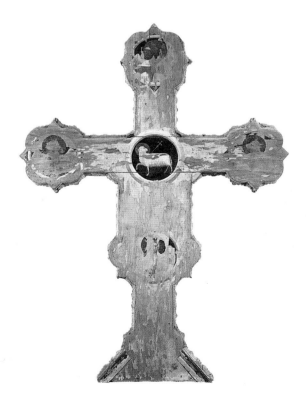

Giotto. CRUCIFIX, *reverse.*
Museo Civico, Padua.

pages 206–207: Giotto. Details
of CRUCIFIX, *obverse (p. 204).*
Museo Civico, Padua.

but not entirely. Like the Rimini *Crucifix,* it has lobed panels on the two arms, presenting the Eternal Father at the top and the Madonna and St. John at the sides, while at the bottom the triangular panel depicting Mount Golgotha acts as the base. Still following tradition, the figure of Christ hangs on a blue cross that stands out against a very rich cloth bearing an arabesque pattern in red, black, and gold. The panel is further embellished with small glittering inserts in vivid red, embroidered with clusters of gold, like enamel or precious stones (below). ❧ THE utterly ruined reverse side (p. 205) presents a system of geometric motifs of various shades of gray—almost in monochrome. Against this background are medallions portraying the Mystical Lamb (at the intersection of the two arms of the cross) and symbols of the Evangelists (in the end panels). Among the Evangelists is a notable face of an angel of perfect classical shape. The panel is painted densely, with a simple red band that runs all around it against a bright background. ❧ IN ITS dimensions and also in the choice of images the rare panel seems to be conceived not as a traditional, large, painted crucifix but rather as an exquisite piece of medieval goldwork. It should be read in the Gothic and very modern key, because of the luminosity of the chromatic range, rendered shrill by the very bright colors of the cloth and the inserts of red lacquer, and because of the delicacy of the workmanship and the expressive force of the emotions it portrays. ❧ THE figure of Christ is long and emaciated, the body thin and tapered, molded gently by light that makes its volume delicate and fragile. The trembling limbs show the swelling of veins and tendons, while a grim shadow thickens under the armpits and in the hollow of hands bent in a spasm of pain. The head is beautiful, slightly bent forward; the eyes, the profile with its thin nose, and the mouth with lips half-opened, as in a sigh, are drawn with subtle, perfect lines; and now, after the recent cleaning, we can see the delicacy of the thin, transparent loincloth. This is a figure of extraordinary spirituality, similar to a Gothic ivory statue, designed with a soft ductile line and soft volume, caressed—more than constructed—by the light. In the lobed panels, the Eternal Father has a traditional rigidity in his face that is still in the Byzantine mode, but the two lateral figures are rendered with accentuated pathos: St. John leans his suffering face against his hand, while the Madonna seems to withdraw into her mantle, clasping her hands in a gesture of charged poignancy. ❧ THE *Crucifix* was noted for the first time in 1864 by Cavalcaselle, who saw it hanging at the back of the apse in the church: he attributed it to Giotto, a judgment accepted by other scholars. It was also explicitly regarded as contemporary with the frescoes of the Scrovegni Chapel—that is, until Sandberg-Vavalà (1929), noting the carpentry and above all

Giotto. Detail of CRUCIFIX, *obverse (p. 204). Museo Civico, Padua.*

the richness of the frame, proposed a later date. This proposal was widely accepted by scholars, beginning with Roberto Longhi (1948), and was refined by Gnudi (1958), who dated the work to 1317. Grossato (1974), and Bellosi (1981), and I myself (1984) have disagreed with this later date, believing that the *Crucifix* was painted at around the same time as the frescoes. ❧ SO I would like to return to the linked problems of chronology and attribution. The date 1317, fixed by Gnudi and later seconded by other scholars, is based on a mistaken reading of a 1317 document in which Enrico Scrovegni announces a large donation to the chapel. This donation was not, as these scholars thought, to provide for ornaments for the chapel itself, including the *Crucifix,* but simply to support the priest who was to celebrate the mass, and to provide oil for the lamps. So there is no reason to posit a second trip by Giotto to Padua in 1317 to paint the *Crucifix.* On the contrary, the work belongs chronologically with the frescoes of the chapel, because its stylistic language is the same. ❧ AS IN the frescoes, the figures in the *Crucifix* stand out against the background with robust plasticity obtained with a precise chiaroscuro. A ray of light coming from the right at once creates and illuminates Mount Golgotha: it is a boulder of great clarity and precision, almost Cubist, which can be found only in the landscapes of the Stories of Joachim and in the *Deposition;* the blood-soaked sloping planes are precisely articulated, and the cave is like a deep wound, affording an accentuated sense of space. The beautiful figure of Christ, tapered like an ivory statue, is identical to that in the *Crucifixion* on the wall: both show the same delicate limbs and the same facial expression, at once serene and enduring. ❧ ST. JOHN'S face repeats that expression, and the majestic folds in his bright pink mantle are touched with chiaroscuro as in the *Deposition.* The spasmodic wringing of the Madonna's hands is one of the significant, characteristic gestures in the chapel's frescoes. ❧ THE accentuated Gothicism of this panel, both in the richness of its ornamentation and in the anguished, very human pathos of the gestures, again recalls Giovanni Pisano, who was mentioned in the discussion of the frescoes. Both of these aspects place this small work among the most interesting innovations in Italian painting of the first years of the fourteenth century.

THE

"SPACIOUS"

GIOTTO

AFTER PADUA

T**HE STAGES IN GIOTTO'S FIRST PADUAN SOJOURN ARE HARD TO PLACE CHRONOLOGICALLY. AN AUTOGRAPH WORK BY THE MASTER CAN BE DATED VERY CLOSE TO THE BEGINNING OF HIS STAY (C. 1302), AND NOT—AS IS GENERALLY MAINTAINED—CLOSE TO OR EVEN BEFORE** 1300. This is the very beautiful panel with the half figure of a Franciscan friar (it does not seem to be St. Francis, since there is no halo), now in the Berenson Collection in Settignano near Florence (p. 213). ❧ THE figure has a monumental stance, which is an elaboration of the saints in the Badia *Polyptych.* But the contour line is very soft, and encloses the person in a series of curves. The very beautiful head is inscribed within a perfect geometric form, in a series of semicircular lines: the profile of the cranium, for example, is echoed by the cut of the hair, and the face is inserted in the curved folds of the hood. The color is extraordinary, particularly the roseate face, formed by very delicate transitions from plane to plane between levels, and the luminous habit, with pinkish reflections, against which the red of the book stands out. ❧ BEAUTIFUL in its classical monumentality, the painting is chiefly characterized by the vivid quality of the perfectly oval face with its acute, profound gaze, almost as if it were a portrait.

Other characteristics are the softness of the figure and the delicate nuances of the color, color that even in brown monotone successfully conveys the sensation of light. These make a later dating of the painting more probable, in contrast to current accepted opinion. ❧ THE head has the power of a portrait: it is clear that Giotto had in mind a real person whom he knew. One wonders whether the painting was conceived as a portrait, or whether it is a saint (it would have to be Anthony) to whom a real person has lent his features. In this case the Berenson panel could be only part of a more complex painting, of which no other trace remains. ❧ THE seven small panels with episodes from the life of Jesus, scattered in various collections, should in my opinion be dated to after Giotto's first stay in Padua, but in any case within the first decade of the fourteenth century. These paintings are the *Epiphany* (p. 214) in the Metropolitan Museum of Art in New York; the *Presentation in the Temple* (p. 215) in the Isabella Stewart

page 213: Giotto. FRANCISCAN SAINT. *Tempera on panel, 21¼ × 15⅜ in. (54 × 39 cm). Berenson Collection, the Harvard University Center, Settignano (Florence).*

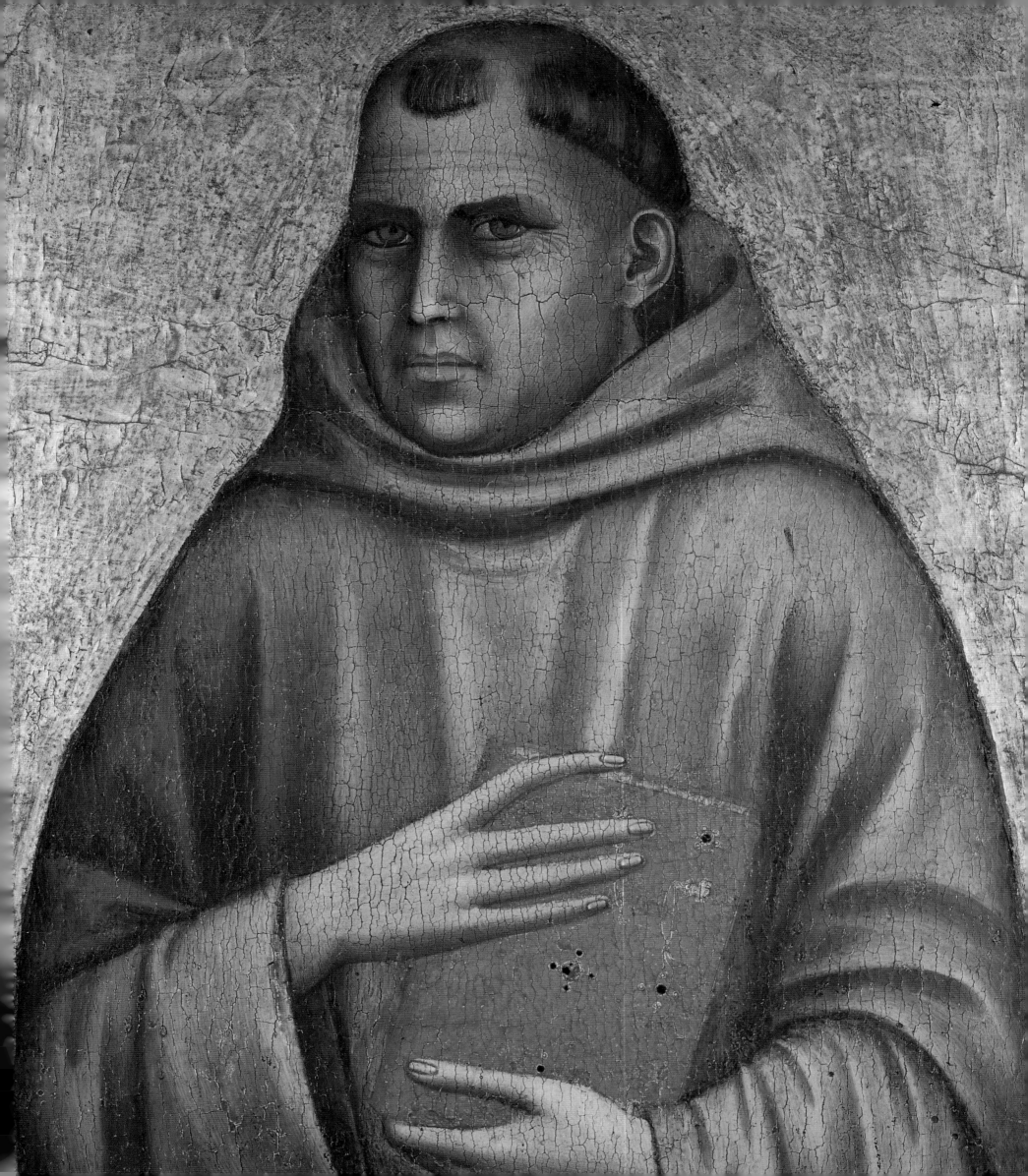

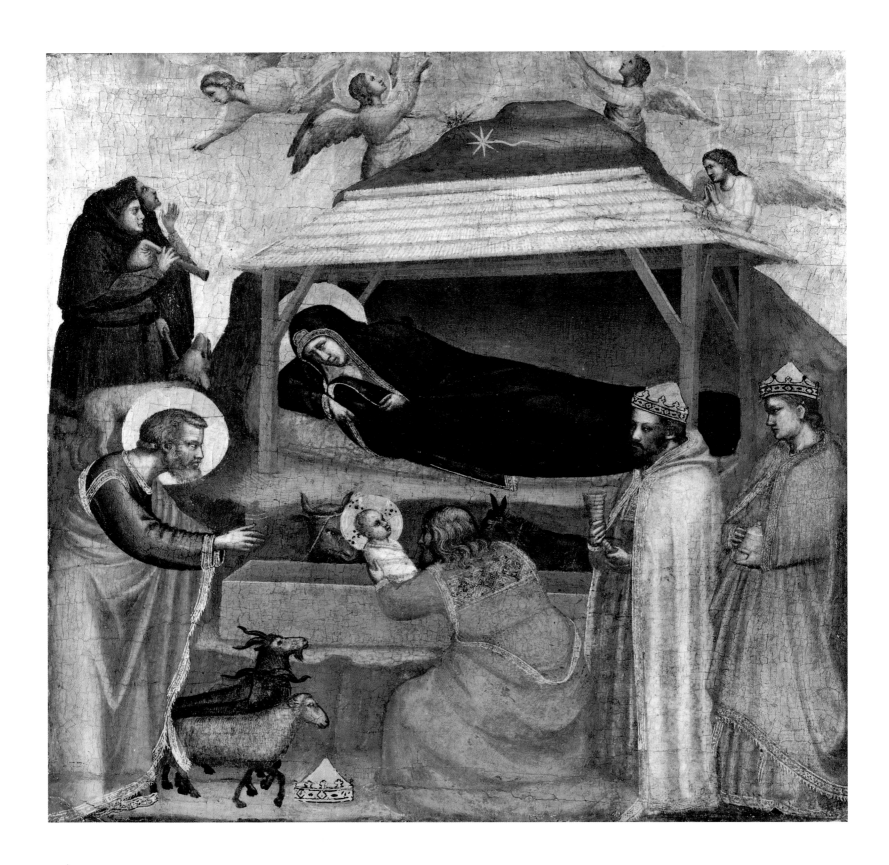

Workshop of Giotto. EPIPHANY.
Tempera on panel, 16⅞ × 17⅜ in.
(43 × 44 cm). Metropolitan Museum
of Art, New York.

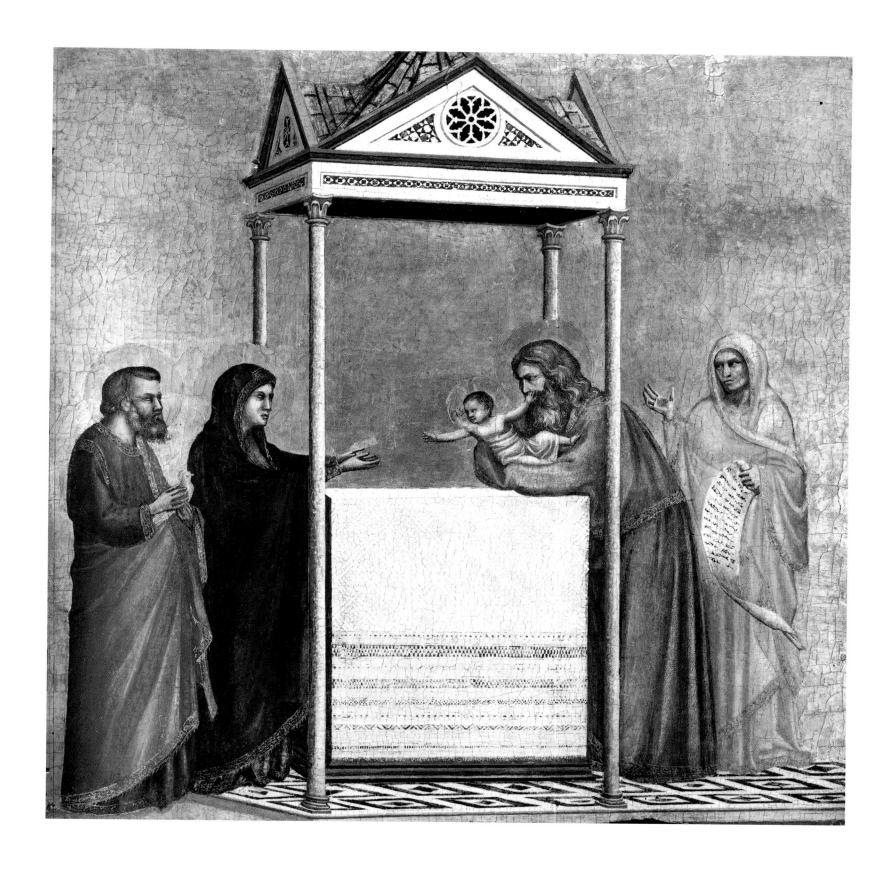

Workshop of Giotto.
PRESENTATION IN THE
TEMPLE. *Tempera on panel, 16⅞ ×
17⅜ in. (43 × 44 cm). Isabella
Stewart Gardner Museum, Boston.*

Gardner Museum in Boston; the *Last Supper* (below left), *Cruci-fixion* (below right), and *Descent to Limbo* (p. 218 left), in the Alte Pinakothek in Munich; the *Deposition* (p. 217), in the Berenson Collection in Settignano; and finally the *Pentecost* (p. 218 right), in the National Gallery in London. The panels have similar dimensions, about 17 inches (44 cm) square, and were cut from the same piece of wood, as examination of the wood grain has shown (Christiansen, 1982; Gordon, 1989; Süre, 1986). They are thought to be parts of a single work, evidently connected with the Franciscans, since St. Francis is pictured kneeling at Christ's feet in the first Munich panel alongside the two donors (a man and a woman). Some critics propose a provenance from the Franciscan church of Santa Croce in Florence, which would include one of "four panels" painted by Giotto; others (Bologna, 1962) suggest a provenance from Borgo San Sepolcro based on Vasari's report: "a panel from the hand of Giotto of small figures, which then was broken into pieces." More recently Gordon (1989) proposed that they came from the church of San Francesco in Rimini. I consider these small paintings to be certainly the product of Giotto's shop, but absolutely not autographs; it is worthwhile dwelling on them, though, because they carry a vast amount of scholarly literature and are still today considered by some to be autograph works by the master, or by Giotto and assistants. They also seem to charac-terize quite well what must have been, quite early on, the production of the Giotto workshop, which repeated, with very small variations, the master's great ideas. ❧ THE workmanship on these small panels is extremely unequal; perhaps the highest points are the *Epiphany* and *Presentation in the Temple*. From an iconographic standpoint they demonstrate a very close derivation from the frescoes of the Scrovegni Chapel: the *Epiphany*, for example, proves to be a "collage" of the two Paduan scenes—the *Nativity and Apparition to the Shepherds* and the *Epiphany*—taking from the former the hut with the reclining Virgin, and from the latter the group of the Magi (shifted from left to right). The *Crucifixion* is obviously nothing but a simplified variation of the fresco in Padua, while the *Presentation in the Temple* is even closer to the model: the protagonists repeat the Paduan episode with great precision in their gestures and postures. In the *Pentecost* the room is simply a small wall-enclosure, and the brackets that support the ceiling carry us back to some architectural elements in Assisi. Finally, the room in the *Last Supper* has a gallery that is a reelaboration of that in the *Marriage Feast at Cana* in Padua, while from the Paduan *Last Supper* is copied the table with the seated Apostles, some of whom are viewed from the back. ❧ I CANNOT see the hand of the master in any of these small panels, because each one is composed with more or less evident misconceptions

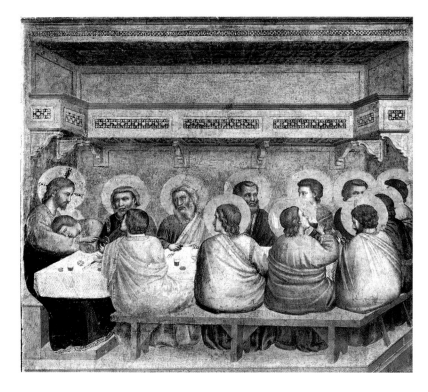

Workshop of Giotto. LAST SUPPER.
Tempera on panel, 16⅞ × 17⅜ in.
(43 × 44 cm). Alte Pinakothek,
Munich.

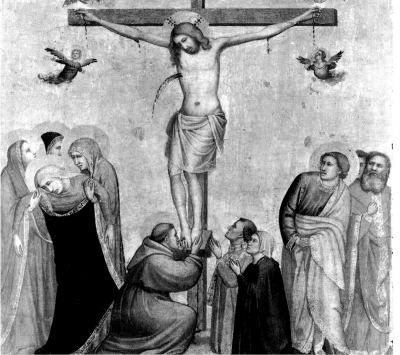

Workshop of Giotto. CRUCIFIXION.
Tempera on panel, 16⅞ × 17⅜ in.
(43 × 44 cm). Alte Pinakothek,
Munich.

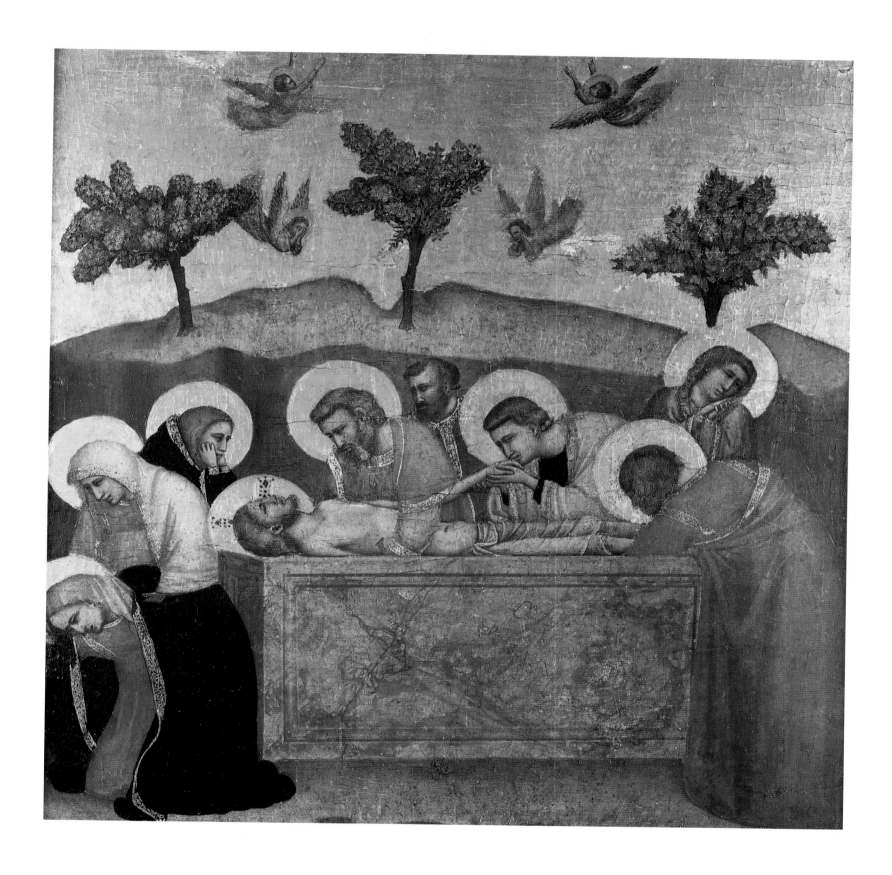

Workshop of Giotto. DEPOSITION.
Tempera on panel, 16⅞ × 17⅜ in.
(43 × 44 cm). Berenson Collection,
the Harvard University Center,
Settignano (Florence).

of Giotto's language. The compositions are always rigidly frontal, and where possible symmetrical, as is clear in the *Presentation in the Temple* and the *Pentecost,* and thus the space gives the sensation of being compressed and deprived of air. The nevertheless lively little figures—with unfortunately repetitive faces—use generic gesticulations and are designed with a dark contour line and enveloped in a drapery that is too uniform. Notice, for example, how the hem of St. John's robe in the *Crucifixion* dangles, and how Christ's head is thrust down between his shoulders in an inharmonious relation to his chest. Furthermore, the painter has not fully understood the significance of Giotto's chiaroscuro, which at some points in these small panels seems to depend on an ill-defined light source. THEREFORE I attribute these panels to Giotto's workshop after, but not long after, 1305. Some of the small figures on the panels, however, display similarities to the people in the frescoes in the right transept of the Lower Basilica in Assisi: work, as I shall discuss further on, by the so-called Relative of Giotto. For example, one of the onlookers in the *Crucifixion* has a bearded face with many affinities to Simeon of the *Presentation in the Temple* in Assisi; and other faces, rather long and with heavily marked lineaments, can be related to the frescoes of the Stories of Christ's Childhood. This proposal indicates that the set of panels might be taken out of the generic category of Giotto's workshop and perhaps attributed to the Relative of Giotto.

THE PROBABLE RETURN TO ASSISI

 THE earliest certain information on Giotto places him in Assisi after his first Paduan stay. This document, unearthed by Martinelli (1973), was drawn up in Assisi on January 4, 1309, and mentions the repayment to an Assisi citizen of a large sum of money borrowed by Palmerino di Guido (presumably an Umbrian painter) in his name and Giotto's. IT CAN reasonably be presumed (as Martinelli does) that the loaned money must have been for some work that the Florentine master performed in Assisi together with Palmerino some years before. It is therefore possible that after Padua, Giotto returned to Assisi with the task

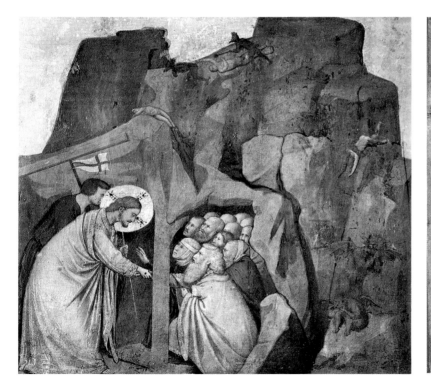

Workshop of Giotto. DESCENT TO LIMBO. *Tempera on panel, 16⅞ × 17⅜ in. (43 × 44 cm). Alte Pinakothek, Munich.*

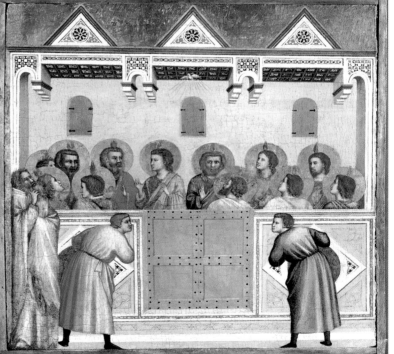

Workshop of Giotto. PENTECOST. *Tempera on panel, 16⅞ × 17⅜ in. (43 × 44 cm). National Gallery, London.*

of painting other frescoes. This trip could coincide with the resumption of the decoration of the Lower Basilica of San Francesco. ❧ AS HAS been well demonstrated by Irene Hueck (1980), in the last years of the thirteenth century the construction of the lateral chapels in this part of the church had begun. In the brief space of a few decades these chapels were all decorated with frescoes. ❧ THE first chapel, belonging to the Orsini family and called the San Nicola Chapel (pp. 220–21), was opened at the end of the right transept in 1294 (Hueck). With a high Gothic cross vault, it opens into the apse in three large two-lighted mullioned windows and presents, in a projecting position behind the altar, the tomb of Giovanni Gaetano Orsini, who died prematurely in 1294, surmounted by an elegant triptych in fresco, where the Madonna and Child and saints Francis and Nicholas are set against a gold background. ❧ THE decoration of the large recess is formed by compartments, with the Stories of St. Nicholas on the lateral walls and a votive fresco on the ceiling depicting Giovanni Gaetano and Cardinal Napoleone Orsini, among other patrons. They are presented by their guardian saints to Jesus, who is standing upright inside a spacious Gothic shrine, and to several saints; busts of other saints occupy the embrasures of the windows. ❧ THE decorative program displays such notable differences of execution that some have posited the presence of a varied group of artists (Toesca, 1951) or different stages in the execution (Previtali, 1967; Bologna, 1969b; Hueck, 1983). I maintain that the decoration, while unitary, might have been produced by a series of different painters, all of them bound to Giotto. One of these painters did the Stories of St. Nicholas and the other compartments on the vaulted ceiling and on the walls. These paintings have a strictly Giottesque quality, with clear references to the characters and architecture in the Franciscan Cycle in the Upper Basilica; but the rather soft and pale-colored figures evoke no memory of the Scrovegni Chapel decoration. This interesting artistic personality, certainly an assistant of Giotto, was dubbed by Previtali (1967) the "Master of San Nicola"; Previtali also recognized his work in the Paduan frescoes. He worked here in the Chapel of San Nicola at an intermediate moment between the Franciscan Cycle and the Paduan paintings: the date most frequently proposed is around 1300, when Cardinal Napoleone Orsini became papal legate for Umbria. ❧ THE newest and most modern parts of the cycle—the triptych in fresco, the busts of the saints in the window embrasures, and the *Annunciation* outside the chapel above the entrance arch—must be attributed to a second artist, more refined and delicate, who uses pale, transparent colors. This is a great master, who moves in a strictly Giottesque orbit; his more subtly linear language, more sensitive

pages 220–21: Right transept and San Nicola Chapel. Lower Basilica of San Francesco, Assisi.

to Gothic values, can be seen in the scrolls and in the fluttering robes of the saints who adorn the windows. (Boskovits, 1971, and Bonsanti, 1983, recognize the hand of Giotto himself, at around 1300, in these busts of the saints.) The three postmortem Franciscan episodes in the lower part of the right transept, by the same team of painters that worked in the chapel, exhibit many derivations from the Paduan frescoes in the Scrovegni Chapel, as can be seen from the faces and particularly in some parts of the *Resuscitation of Suessa,* such as the woman who tears at her hair or the female figure in the foreground, wrapped in a sculptural mantle that falls with geometric modulation. ❧ THE decoration of the San Nicola Chapel, begun perhaps around 1300, would then have been completed after 1305. This first phase of the complex and articulated decoration of the Lower Basilica was allocated to the workshop and school of Giotto. The frescoes of the right transept with the Stories of Christ's Childhood follow, attributed by Previtali (1967) to an artist very close to the head of the school—whom he calls the Relative of Giotto—and dated between 1305 and 1310 (Bonsanti, 1985 argues that it should be shifted to about 1315). Episodes such as the *Crucifixion* attain a very high quality, and they are all characterized by a particularly warm and luminous color and interpreted with an accentuated narrative élan, which dilutes the robust Giottesque syntax in a series of delightful, effective inventions—see for example the palm tree in the *Flight into Egypt,* which bows as the Madonna passes, a scene reported in the Apocrypha. ❧ GIOTTO'S stay in Assisi before 1309 could therefore coincide with the second phase of the decoration of the San Nicola Chapel, or perhaps more likely, with the work on the stories in the right transept, which were at least planned around 1309. In either case Giotto would have been only the conceiver, or inspirer, of the paintings, which were executed by skilled and independent pupils. ❧ THE next stages of the decoration of the Lower Basilica were the Magdalen Chapel and the *vele,* of which we will speak later: in these works one can recognize a certain homogeneity of language, especially in the choices of particularly light chromatic timbres, and in some recurrent faces and character types. It is obvious therefore that the Lower Basilica was executed without excessive time gaps, and that here and in the workshops that succeeded, under Giotto's direction or at least under his inspiration, some of the same artists were always present, most likely Umbrians, among them perhaps the same unknown Palmerino di Guido. Later the Giottesque school was to give way to the Sienese.

GIOTTO'S SECOND PADUAN SOJOURN

SCHOLARS unanimously agree that in 1317 Giotto stayed a second time in Padua, immediately after the completion of the work at the Palazzo della Ragione; I believe that he was in Padua a few years earlier. The local chronicles give two dates, 1306 and 1309; probably the first date refers to the erection of the edifice and the construction of the nave's great keel-like ceiling, and the second to the construction of the two large galleries on the long sides. It is therefore logical to think that the internal decoration of the immense new hall followed immediately; it could also have been done around 1312, as suggested by Portenari (1623). THE fourteenth-century reconstruction and accompanying decoration of the Palazzo della Ragione (commonly called the Great Hall) in Padua came at a moment of great splendor and wealth for the Commune, marked by a surge of building fervor, whose most imposing monuments were the secular Great Hall and the religious basilica of Sant'Antonio. This moment was particularly significant from the cultural point of view as well; the university was an important center for scientists investigating problems of optics and of astrology, among them the extraordinary Pietro d'Abano, medical doctor and astrologist, with whom Giotto probably had close contact. TO RETURN to the decoration of the Palazzo della Ragione: Riccobaldo Ferrarese speaks of it first in his *Compilatio chronologica* (c. 1312), but only in one of the editions of the text. For this reason Gnudi (1957) considered that the passage was a later insertion. Gnudi therefore proposed placing Giotto's second visit to Padua in 1317, but all other evidence leads one to think that he might have returned a few years earlier. FIRST one must establish whether Giotto really worked on the decoration in the Palazzo della Ragione. Another source will be helpful here: as it is Paduan and almost contemporary, it is completely reliable. Giovanni da Nono, a Paduan notary, wrote an interesting small book, a sort of guide to the city, the *Visio Aegidii Regis Patavi,* around 1340–50. In this he imagines that an ancient king, Egidio, sees the future city in a dream and describes it. Of the decoration of the Palazzo della Ragione he says, "In these frescoes shone the twelve celestial signs and the seven planets with their properties, miraculously painted by Giotto, the best of painters; and other golden stars, with their properties, shone in the interior." THIS was an astrological cycle of extreme interest. Later tradition, starting with Michele

*Paduan illuminator of the early
fourteenth century. Astrological
figures, from Michael Scotus,*
LIBER INTRODUCTORIUS
*(ms CLM 10268). Bayerische
Staatsbibliothek, Munich.*

*Paduan illuminator of the early
fourteenth century. Astrological
figures, from Michael Scotus,*
LIBER INTRODUCTORIUS
*(ms CLM 10268). Bayerische
Staatsbibliothek, Munich.*

Savonarola, holds that the inspirer of the subjects painted was the Pietro d'Abano mentioned earlier, author of the *Lucidator,* an important treatise of astrology explaining the influence of the stars on men's temperaments and lives. THAT Giotto was interested in astrological issues, and that he was in contact with Paduan scientists, was evident from his first stay in the Veneto region, when he painted a comet—which had recently been seen—instead of the traditional star in the *Epiphany* in the Scrovegni Chapel. It is thus very probable that there was a close collaboration between the astronomer-astrologist d'Abano and the Florentine painter, and that Giotto embarked on the arduous task of translating d'Abano's complex treatise on the stars' influence into images, as the decoration for the grand ceiling vault, a vault as ample as a starry sky. The close collaboration of these two great men gave birth to marvelous work, from the point of view of iconographic innovation as well. Unfortunately it was visible for little more than a century: in 1420 the ceiling of the Great Hall was destroyed by a fire that canceled every trace of Giotto's decoration. IT IS generally believed that the Giotto paintings were on the highest part of the walls, in place of those now visible, which are traditionally attributed to Giovanni Miretto and to a Ferrarese painter; but an intelligent observation by Jean Sureda (1992; not yet published) advances the idea—which I regard as absolutely acceptable—that the zone painted by Giotto was actually at the summit of the wooden ceiling: this would not have been painted with "buon fresco," therefore, but probably in mixed technique, with a large part of the painting done "a secco," that is, on a dry wall. ACCORDING to da Nono, the iconography of the cycle was vast and complex: not only were the signs of the zodiac themselves depicted but also their "properties"—which probably means the influences that they had on people's temperaments and actions. The seven planets were also depicted, as they are now on the upper part of the walls. ULRIKE Bauer Eberhard has recently (1983) published some miniatures from the Bayerische Staatsbibliothek in Munich (pp. 224 and 225), containing a treatise on astronomy-astrology; Eberhard attributes the manuscript to Padua and the 1430s. A series of very fine watercolors, the miniatures depict constellations and planets in the form of persons, and sometimes animals: the male and female figures have heavy body structures and are fluent, with small heads and elegant gestures; they are depicted with adept chiaroscuro and show an accurate observation of reality. It seems obvious that Giotto's pictures, with their lively imaginativeness and their modern character, were their model. One might reasonably think that the small figures echo the decoration of the Palazzo della Ragione. Stylistically the miniatures exhibit elements not unlike the Giottesque

language of the Scrovegni work, or the *Death of the Virgin* in Berlin (painted soon after) and the Peruzzi *Polyptych*. Thus we can deduce that the cycle in the Palazzo della Ragione should not be dated too late. ❧ ON THE other hand I do not believe that Giotto's second Paduan stay can be dated very far ahead, certainly not after the Peruzzi frescoes. Everything "Giottesque" in and near the Veneto region either exhibits close ties to the work at the Scrovegni Chapel or shows figures of similar plastic power, though they may be slightly more modern: in a word, similar to the small figures in the Munich manuscript. There is absolutely no trace in the Veneto of Giottesque expressions with Gothic elements, or with the small and more graceful figures that characterize the master after his work in the Peruzzi (or Magdalen) Chapel. ❧ SO I would judge that Giotto's Veneto activity concluded within the first decade of the century or soon after. Most likely in those years he even went as far west as Verona, where there is also no trace of a more mature Giotto, different from what can be called the Paduan moment. ❧ I THINK one should focus attention on da Nono's description of the paintings in the Great Hall, dwelling in particular on the words "miraculously painted" and "shone," and on the mention of gold. Certainly the pictures were on a blue background, and they glittered with gold: since the paintings appeared on the wooden vault, they must have been painted mostly on a dry surface and not on "buon (that is, wet) fresco." This would have been a new experiment from the technical point of view, and must be kept in mind in connection with the murals of the Peruzzi Chapel.

THE DECORATION OF THE OGNISSANTI IN FLORENCE

❧ FROM 1311 on we find Giotto in Florence, where his presence was documented for a long period. And in Florence are some of the master's most extraordinary pieces, which form a tight stylistic group certainly executed after the Paduan experience. These include the *Madonna in Glory* (p. 228) in the Uffizi, the *Death of the Virgin* (p. 238) in the Staatliche Museen in Berlin, the Peruzzi

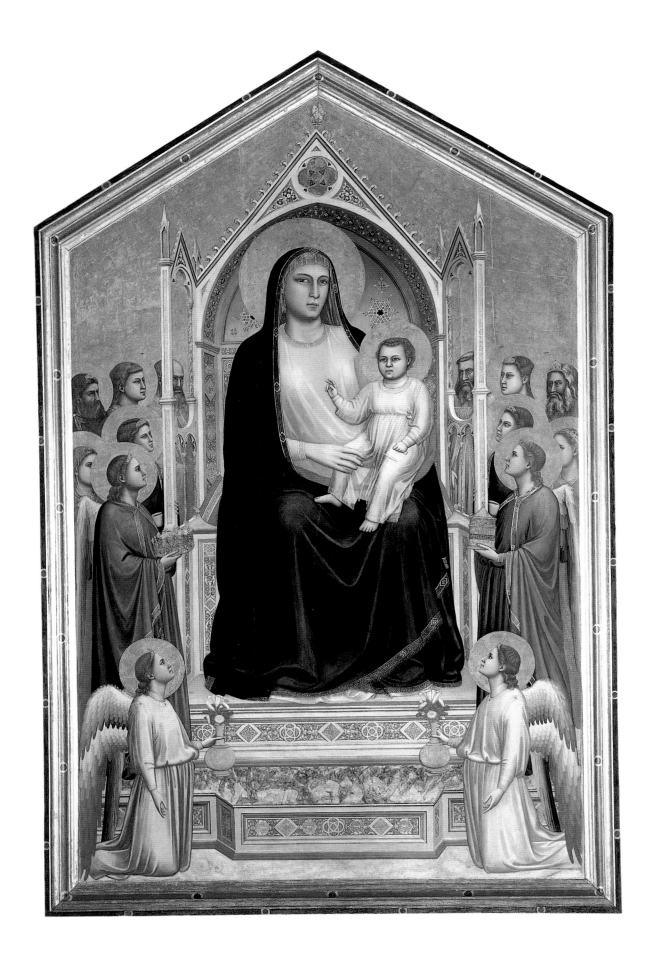

Giotto. MADONNA IN GLORY.
Tempera on panel, 128 × 90⅛ in.
(325 × 204 cm). Galleria degli
Uffizi, Florence.

Polyptych (p. 266) now in Raleigh, North Carolina, and the frescoes in the Peruzzi Chapel (p. 251). ❧ THESE paintings are marked by very similar stylistic elements, so they must be grouped in a very brief span of years. All of them display a sovereign mastery of the spatial problem; Giotto's mastery of space debuted superbly in Padua in the Scrovegni cycle, but here in the Florentine works it shows a harmonious relationship to the figures, with a calmer and more precise geometric measure in the settings. Furthermore, weighty and robust volumes are always built up with a delicate softness in the subtle, modulated play of chiaroscuro, which deepens solemn draperies, almost as a prelude to fifteenth-century painting. The contour line has become more ductile, and the figures take on a greater soft naturalness. ❧ AMONG all the works, the oldest would seem to be the grand *Madonna in Glory* from the church of Ognissanti, now in the Uffizi. It was named as a Giotto painting for the first time by Ghiberti, with the words "a very great panel with Our Lady sitting on a throne with many angels around." In the opinion of some scholars, most recently in an acute essay by Hueck (1992), it must have sat on a partition that divided the church in two lengthwise, on the right-hand side, as an altarpiece, or more likely, above the partition itself but still on the right. In the same group was the panel with the *Death of the Virgin* now in Berlin; the great *Crucifix*, now in a building adjoining the church of Ognissanti; and two other panels of which Vasari speaks, which cannot be traced. ❧ THE *Madonna in Glory* is almost unanimously considered to be Giotto's work; indeed, this is one of the most sublime achievements in his career. However, the discussion has centered and still centers on the dating of the painting, certainly close, according to most modern scholars, to the Paduan frescoes of the Scrovegni Chapel. But some scholars (Longhi, 1951; Toesca, 1951; Previtali, 1967; Bellosi, 1981) set it before the Paduan work, while others (Salvini, 1952; Battisti, 1960a; Gosebruch, 1962; Gioseffi, 1963; Gnudi, 1958; Boskovits, 1988; Peroni, 1992) set it after. ❧ THE grand painting was restored in 1992 by Alfio del Serra; it is now perfectly legible, which allows us a more precise analysis of its stylistic elements, and some details not clearly visible before have emerged and can be useful in resolving or better perceiving the painting's chronology. ❧ THE panel is immense, not only because it is nearly eleven feet (3.4 m) tall but in the architectonic and plastic power that it emanates. The painting is best read, as Peroni rightly suggests (1992), inside the architectonic frame that clasps it, in cuspidal form, like the facade of a Romanesque church. At the center of the composition is the spacious Gothic throne, like a small chapel, bordered in white marble with motifs of red, green, gold, and black, and resting on a step of veined

pages 230–31: Giotto. Details of
MADONNA IN GLORY *(p. 228).*
Galleria degli Uffizi, Florence.

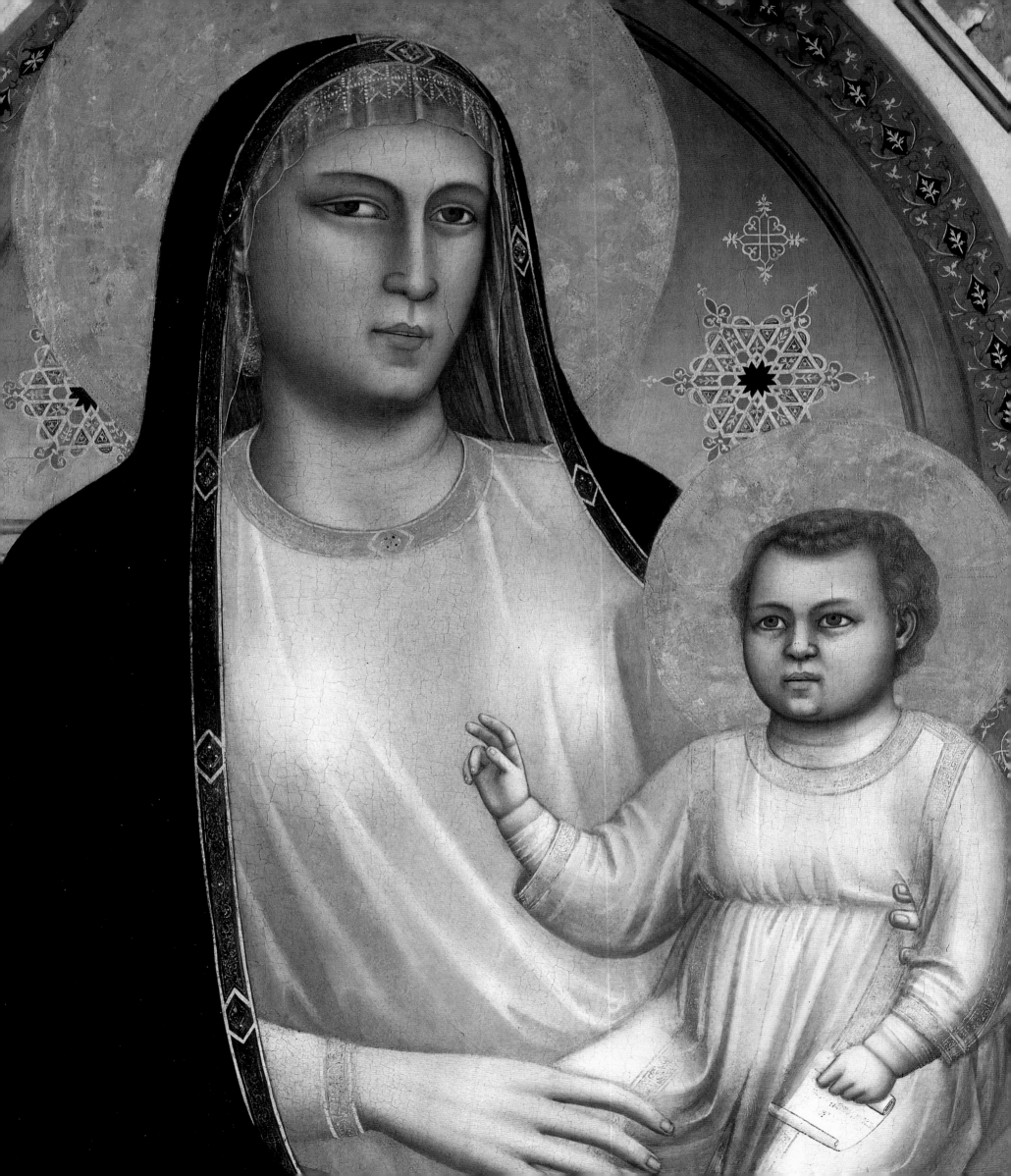

marble. Its apex is slightly off center in respect to that of the panel, so as not to give the sensation of rigidity. The Madonna is turned a bit to the left, and this slight shift gives her figure a kind of rotary movement, counterposed by the Child, who is instead brought forward to close the semicircle. At the foot of the throne and at the sides are the angels and saints, disposed in rigid symmetry and with a strong stylized and sacral accent. Below the gold circles of their haloes appear parts of their robes, wings, and faces. ❧ THIS is therefore a Madonna in Glory in the most pregnant sense of the word, which continues the local tradition, following the painting of the same subject by Duccio, now at the Uffizi, and the two by Cimabue, one now in the Uffizi and the other in the Louvre. Naturally, in this case too, the comparison with the earlier paintings is a comparison between tradition and modernity, or to echo the Renaissance critics, between "Greek and Latin." ❧ ONCE again we see the canons of hierarchical proportion so dear to the Middle Ages: Mary's figure towers above the angels and saints. In Giotto's painting there appears a perfect measurement of space for the architectonic throne, which seems to break through the golden wall and at the same time gives the sensation of coming out of its frame, since its sides seem to thrust forward on a plane closer than the frame. Inside the throne the Madonna is firmly ensconced in a white dress and dark green mantle (which at one time must have been dark blue), and she has a very delicate face—a perfect classical oval—with a static and distant expression. The Child's blessing gesture is equally static; but the Virgin's mantle falls majestically and with exceptional bulk in perfect chiaroscuro, its very deep folds prefiguring Masaccio. ❧ A PRECISE band of light from the right illuminates the two sides of the throne differently, as well as the arch of the apex, which is also adorned with Cosmatesque motifs. With a fine sense of observation, which we have already noted in Padua, the upper part of the throne's back panel is shadowed. The lateral figures, the angels and saints, are designed with a very modern plastic feeling in a rigorous chiaroscuro structure: their faces are modeled with light, skimming shadows, and their absorbed gaze gives the entire work a stylized solemnity. ❧ THE color is wonderful. The luminous clarity of the ensemble is dominated by white, bright red, olive green, and gold; the white of Mary's dress, the point of maximum luminosity in the painting, is echoed by the color of the marble throne. Gold ornaments are scattered profusely on the elegant throne, the robes, and the mantles, and become great circles in the halos, which are repeated in row after row. The red in this particular timbre is heightened by the light and just slightly toned down by the green. The pale robes of the kneeling angels and the robes of the two front angels standing

pages 233–35: Giotto. Details of
MADONNA IN GLORY *(p. 228).*
Galleria degli Uffizi, Florence.

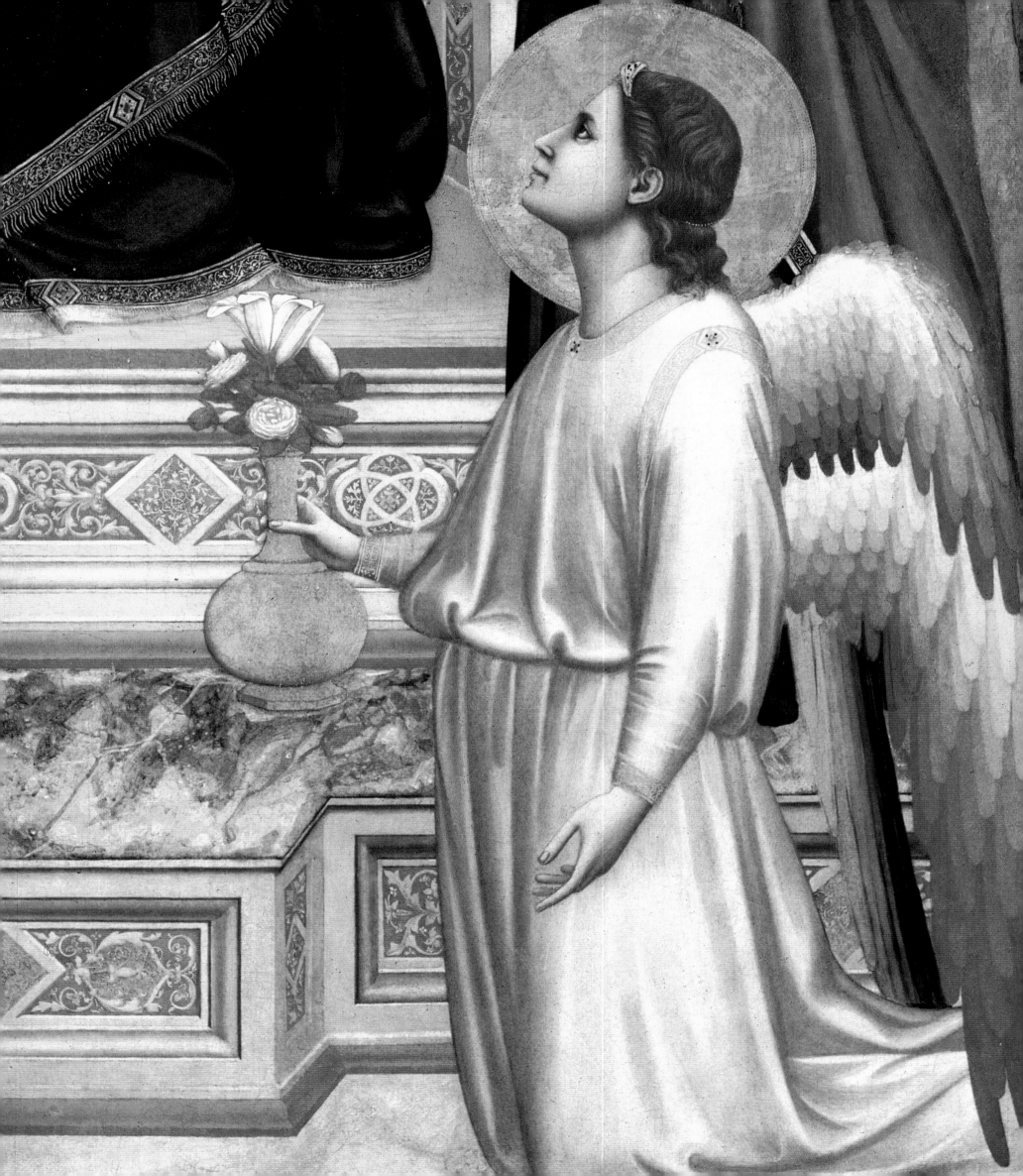

erect are rich in hues and transparencies. The long, elegant, fleshy, and variegated wings are also very beautiful. Lisner, a scholar concerned with the symbolic significance of color, devoted a fascinating essay to this sometimes neglected aspect of Giotto's work on the occasion of the panel's restoration (1992), pointing out how—through particularly vivid and luminous chromatic choices—the painting can be read as a hymn to Mary's virginity, maternity, and royalty. ❧ THIS panel has extraordinary religious feeling and at the same time a vitality and a truth wholly unusual in the tradition of the Madonna in Glory. Observe the attention with which the flowers—the traditional roses and lilies—are painted, and the care with which the wooden platform is rendered and placed beneath the Virgin's feet. Examine too the elegant rendering of the decoration on the throne and the ornamental details of the robes, such as the embroidery on the transparent veil, and the hem of the mantle. ❧ THE painting stands as a direct continuation of the great Paduan creations, whose plastic and spatial discourse it seems to perfect. The bond with the Paduan frescoes is not confined to an analogous spatial and volumetric sensibility but fully recognizable in an examination of its details—for example, the pink vases that the angels offer to the Madonna are very much like the basket of flowers in the *Charity* in the Scrovegni Chapel, and the very elegant border on the Madonna's robe, now clearly legible, presents a motif of volutes of gold leaves, just like the small red-and-black motif on the *Crucifix* now in Padua's Museo Civico. These last are very small clues, but they bolster our certainty that the Florentine panel and the Scrovegni cycle are chronologically contiguous. ❧ BUT in comparison to Padua the treatment of volume here is much softer, obtained with a more nuanced chiaroscuro; the contour line is dissolved in a thin and ductile stroke that wraps the Madonna in a modulated sweep and encloses the angels in delicate outlines, like Gothic statues, capturing them in more natural postures and more fluent gestures. Look, for example, at the gesture of the angels in green, who bend their arms to generate a series of extraordinary folds, like the rays of a sunburst. ❧ THE throne on which the Madonna sits is a much more articulated and richer variant of those in the *Last Judgment* and the *God the Father* in Padua; from the more complex and Gothic armrests the figures of the saints peek out. And the Cosmatesque ornamentation here is even richer and more splendidly colored than in the Paduan architecture, indicating an exquisite Gothic sensibility in the choice of decorative elements too, much more accentuated than in the Padua. ❧ I WOULD like at this point to draw attention to an intelligent observation by Natali (1992) regarding the panel's original position, which prompted some interesting and important singularities in the

composition. According to this scholar, the panel stood to the right of the dividing wall or partition, because it is not painted for a frontal view: but the Madonna's gaze and the placement of the throne clearly presuppose a view from the left. This is very important; it indicates that Giotto considered the spectator's point of view, a consideration that will be developed with extremely effective consequences in the decoration of the Peruzzi Chapel. ❧ THE articles written on the occasion of the presentation of the *Madonna in Glory* after its restoration reiterate and reemphasize the dating of the panel around 1310, and in any case after the Paduan frescoes, which I find fully acceptable. The fresh reading of the panel that is now possible allows a small visual confirmation of this dating—the presence in the marble pavement of the seashells that characterize Paduan marble, which Giotto would have seen during his sojourn in the Veneto. ❧ LINKED to the *Madonna in Glory* is the altar frontal with the *Death of the Virgin*—now in Berlin and originally in the same Ognissanti church—for which a slightly later dating has been proposed (Boskovits, 1988). The panel has an elongated structure with a pointed apex, a rather archaic form. According to the recent reconstruction of the decorative complex of the Ognissanti church, it stood above a lateral altar or above the partition. In accordance with traditional iconography, the Madonna is depicted lying on a sarcophagus, surrounded by angels and saints; behind her stands Christ, holding in his hand her "animula." And yet the composition is marked by innovation: the sarcophagus, a simple wooden coffin with Cosmatesque decorations, is set on a slight oblique in order to define precisely the direction of the space, which is also underscored by the arrangement of the figures in a semicircle, like the movement of a wave that returns repeatedly, row after row. Moreover, the profound compositional maturity of the painting is proven by the close relationship between the structure of the panel and the figures, which is echoed in the massed and stepped gradation of the halos. ❧ ALL the figures emit a majestic grandeur; they are enveloped in mantles that fall in soft, deep folds. The faces are taut and attentive, delicately molded. The color is kept to low tones—in comparison with the pealing tones of the *Madonna in Glory*—and skillfully nuanced by the distribution of the light. ❧ IN COMPARISON to traditional iconography, in which persons are lost in abstract meditation, Giotto in this painting as in his others binds together in vital and attentive colloquy angels and saints, the Madonna and St. Peter. St. John, seen from the back, suddenly kneels with a gesture of particular affection. He is a very poignant figure, by which one can measure the chronological distance between the Scrovegni and the Florentine work: it will

Giotto. DEATH OF THE VIRGIN.
Tempera on panel, 29⅜ × 68¼ in.
(74.7 × 173.4 cm). Staatliche Museen,
Gemäldegalerie, Berlin.

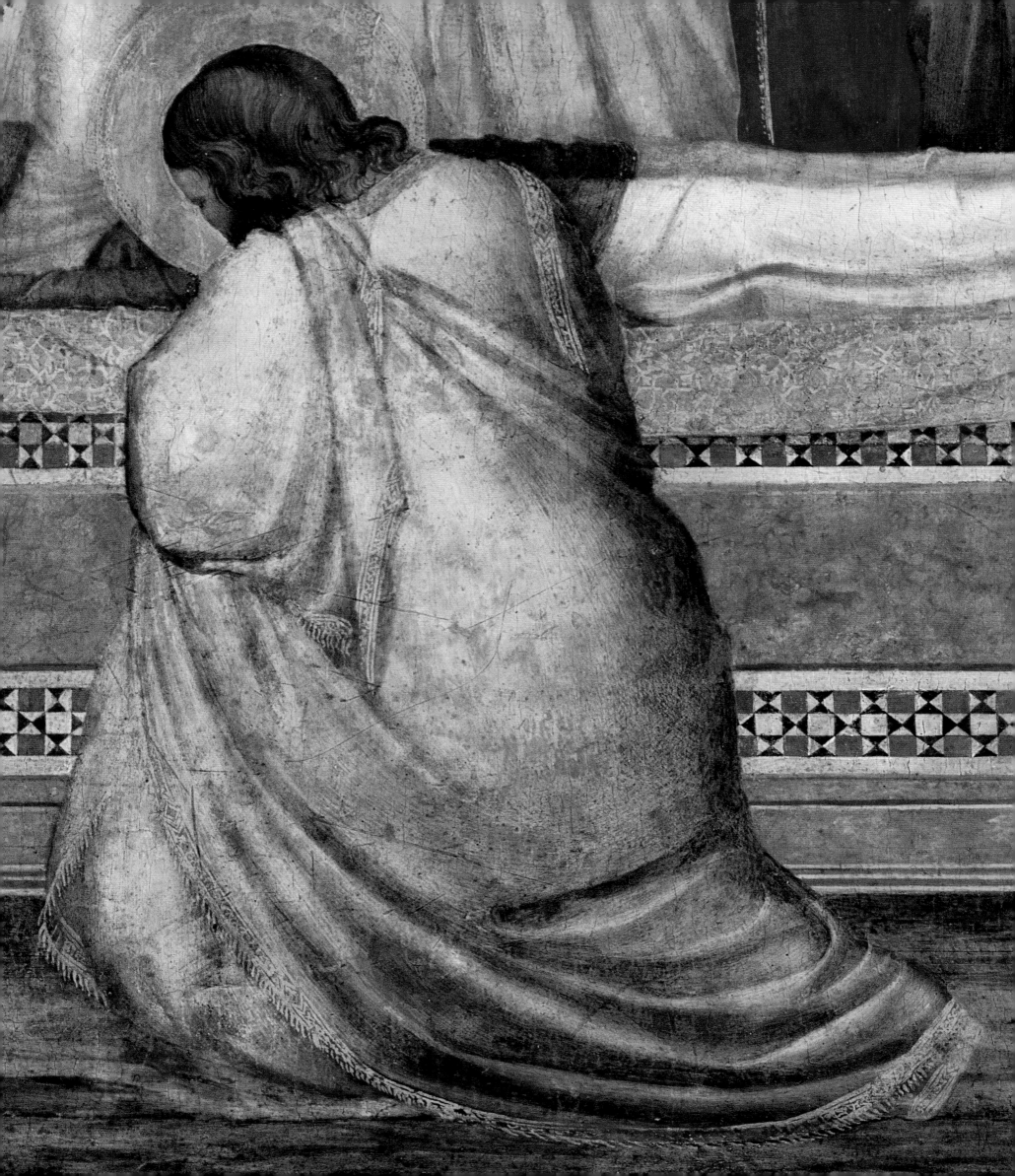

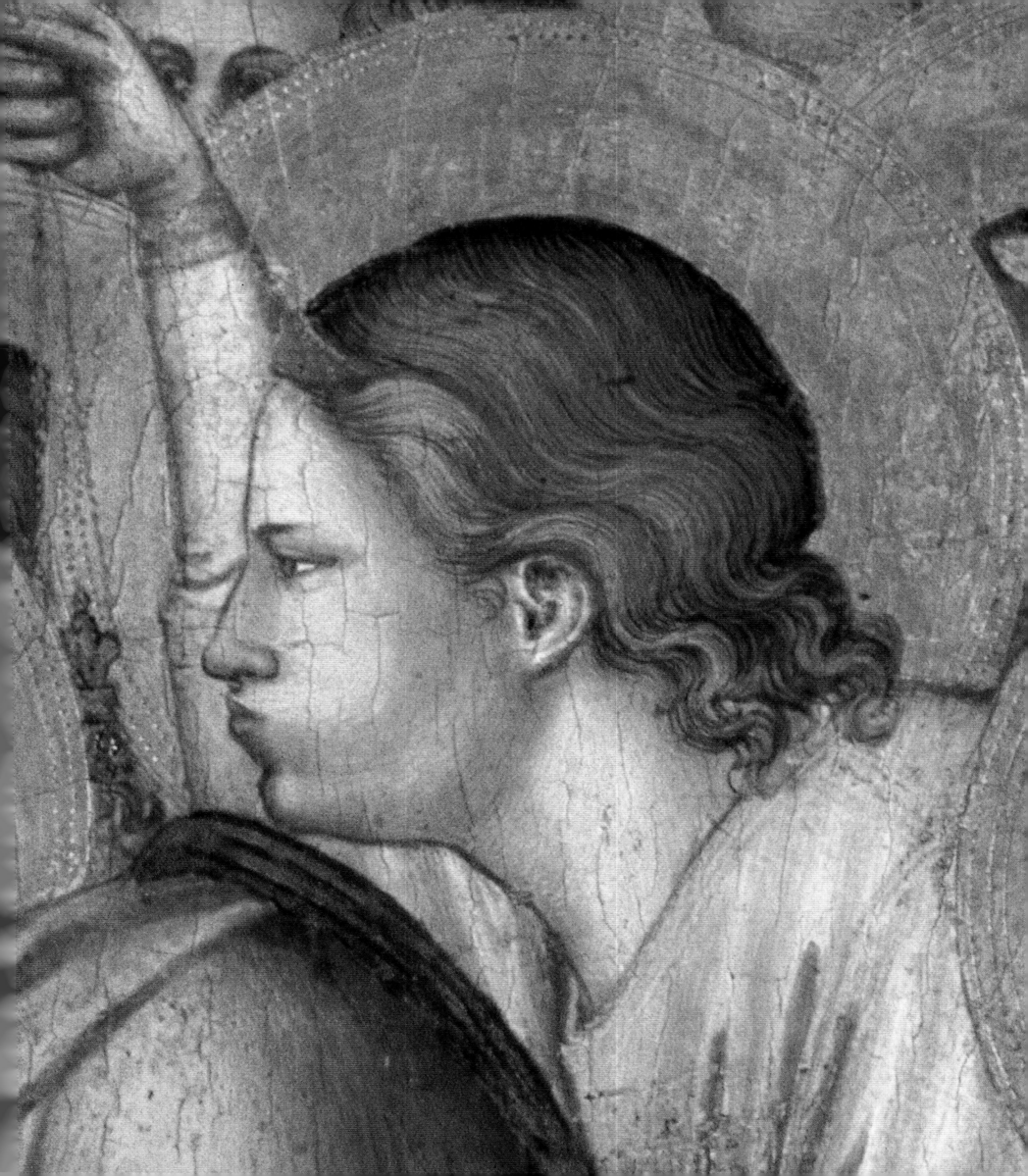

suffice to compare the soft, natural fall of the saint's mantle to the ponderous, granitic crouching figures that populate the Scrovegni frescoes, still constructed with a decisive and cutting contour line. This is sure proof that the Paduan frescoes precede the Ognissanti paintings. ❧ THE stylistic approach is very similar to that of the Uffizi *Madonna in Glory,* though the structure of the persons is perhaps more robust and more solemn, as is the disposition of the figures beside one another, which will also occur in the frescoes of the Peruzzi Chapel. We can therefore posit a slight chronological gap between this painting and the painting in the Uffizi. ❧ IN ANY case, the two panels in the Ognissanti differ from each other in many elements. In comparison to the superb beauty of the Uffizi panel, which pours out gold and splendid colors, the more placid presentation of the Berlin altar frontal offers a more everyday and colloquial atmosphere, which justifies the attribution of at least part of the work to Giotto's workshop. I believe, though, that this is an autograph work; one must consider the diversity of registers that Giotto kept in mind in his painting. In the *Madonna in Glory* a sacred accent prevails that proposes the icon as an object of worship again, in a modern key; while in the Berlin altar frontal it is the

narrative accent that brings it from heaven to earth and helps to give the panel its everyday, almost simple tone. Some "domestic" details here could only be Giotto's inventions: the two angels who raise a cloth, under which the Madonna is stretched out, with such affectionate attention and participation as to appear friends rather than celestial creatures; and the angel who blows on the thurible with a movement wholly earthly and quotidian. These attitudes make the angels seem human in the great concert of human affections that the Berlin panel offers us. ❧ THE great *Crucifix* (p. 243), now in a building adjacent to the church, was part of the work in the Ognissanti; according to Hueck's (1992) reconstruction, it must have stood in a central position above the partition. The panel, a very elegant work from Giotto's workshop or, to be more precise, by the so-called Relative of Giotto, dates from the beginning of the second decade of the fourteenth century or a little later (Bonsanti, 1992). It is characterized by octagonal panels and an elegant leaflike cornice, both elements that appear in the *Crucifix* now in the Museo Civico, Padua; the Paduan work was the model for this one, and the two also confirm, if confirmation is still necessary, the chronological placement of the work in the Ognissanti after that in Padua.

pages 240–41: Giotto. Details of
DEATH OF THE VIRGIN
(p. 238). Staatliche Museen,
Gemäldegalerie, Berlin.

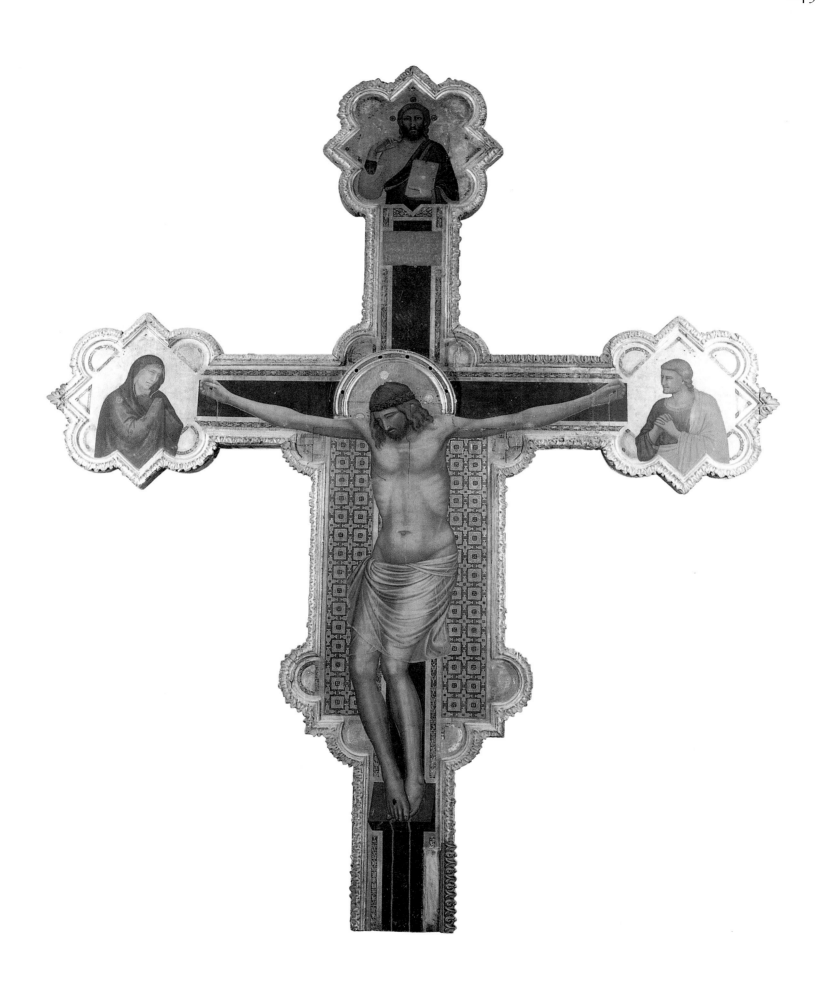

Relative of Giotto. CRUCIFIX.
Tempera on panel, 15 ft. 11 in. ×
10 ft. 1½ in. (4.85 × 3.08 cm).
Ognissanti, Florence.

ROME: THE *NAVICELLA* MOSAIC

IT IS quite probable, and by now accepted almost unanimously by scholars, that Giotto traveled to Rome to create the cartoon for the great mosaic called the *Navicella* on the facade of St. Peter's Basilica. The work was commissioned from him by Cardinal Jacopo Stefaneschi just before December of 1313, when Giotto in Florence engaged a certain Benedetto to recover the household goods he had left in his landlady's house in Rome (see the Documentary Records, p. 370). A detailed reading of this written document and the subtle deductions that derive from it, as well as the careful analysis of the particular historical moment in Rome and the personality of Stefaneschi, are owed to Bologna (1969b), who proposes a dating of 1312–13 for the mosaic.

THAT Giotto executed the celebrated mosaic (or the cartoon for it) can be inferred from the obituary of the cardinal—who died in 1341—which says, "the mosaic by the great painter [Giotto] on the facade of the church represents the moment when Christ held with his right hand St. Peter the Apostle who was drowning in the waves so that he would not succumb." This is therefore a depiction of the episode recounted in Matthew 14:22–33, when Peter, having set out to walk on the water, was seized by fear and held up by Jesus—an episode quite typical of Peter, which alludes to the continual presence of Christ as a support for both the Church and the pope. The mosaic, set in the atrium of St. Peter's Basilica, soon became famous: it is recorded in all documentary sources and inspired many paintings, the oldest of which seems to be a 1320 fresco in the church of St. Peter in Strasbourg. A little later Andrea Bonaiuti quoted from it in the frescoes of the Spanish Chapel in Santa Maria Novella in Florence. Unfortunately it did not have the same good luck in conservation. Detached from the wall in 1610, it was moved and changed several times within a few decades, until during the pontificate of Clement X (1670–76) it was definitively placed in the atrium of the present St. Peter's, facing the central portal. Thus the state of the composition does not permit a correct reading of the text, and the scholars' diverse, discordant opinions are based on the many copies, both drawings and watercolors, which from the fourteenth century until 1610 were made of the famous mosaic.

SO FAR as can be seen in the old drawings (below), and from a reading of the present mosaic, it showed a broad marine landscape bordered in the foreground by the figure of a fisherman on

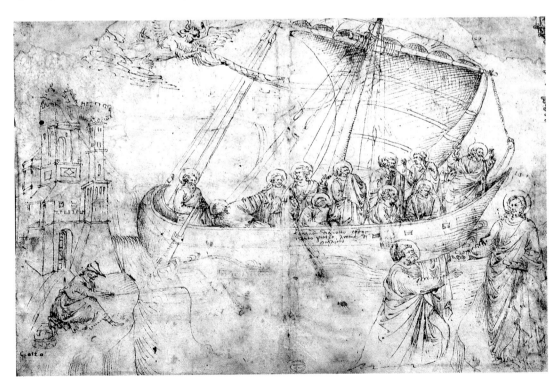

Parri Spinelli (c. 1387–1453). Copy of Giotto's NAVICELLA. *Pen and brown ink on paper, 10¾ × 15¼ in. (27.4 × 38.8 cm). Metropolitan Museum of Art, Hewitt Fund, 1917, New York.*

page 245: Giotto. ANGEL. *Mosaic, diameter: 25¾ in. (65.5 cm). San Pietro Ispano, Boville Ernica (Frosinone).*

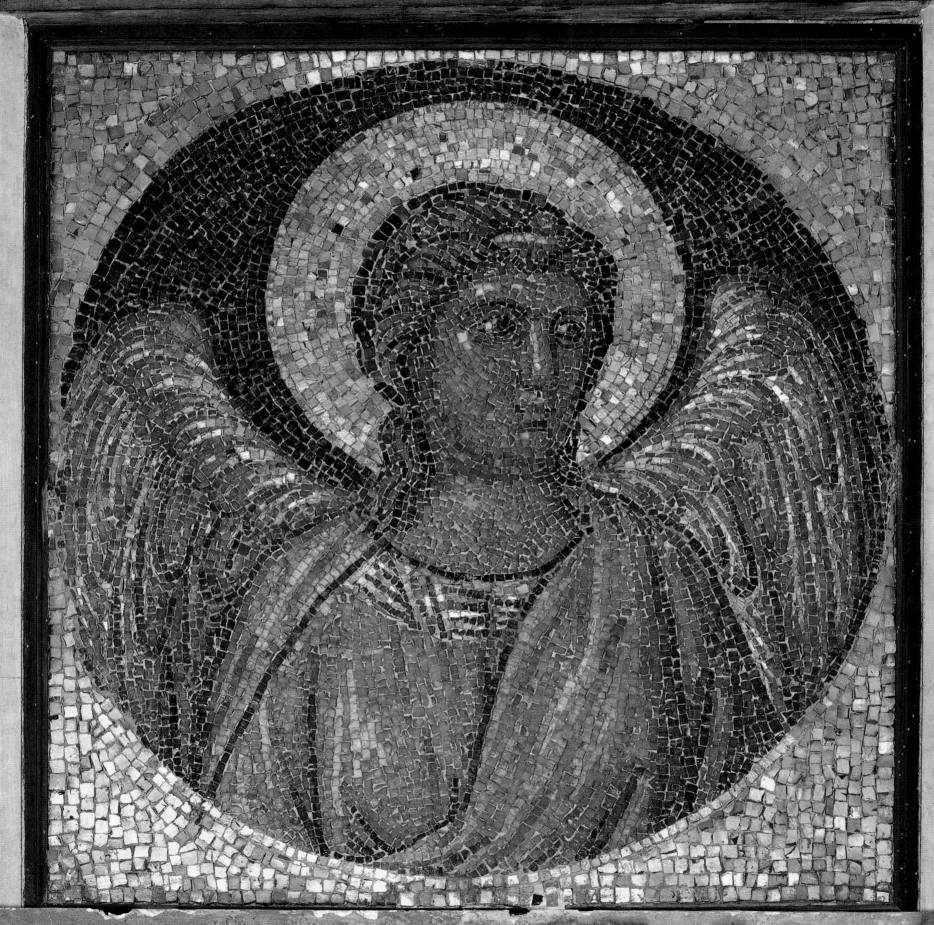

the left and by the kneeling patron on the right, as if by the two wings of a stage. The vast expanse of sea is framed on the left by a watchtower and dominated by a large sailboat in which are seen the Apostles, some sleeping, some maneuvering the sails and pulling the oar. To the right rises the majestic figure of Christ, who is supporting St. Peter. In the upper part of the picture are the winds, pictured according to classical iconography, and, in certain drawings and in the actual mosaic, the four evangelists. A rather inattentive reading has given birth to a series of complicated interpretations of the pictorial text: Battisti (1960a), followed by Bologna (1969b), said that the boat is portrayed with only one oar, alluding to the single power—spiritual—that then governed the Church. In an analysis of the drawings and of the mosaic in its present state, however, we see that only one oar is visible because the other is hidden on the opposite side of the boat; the hands of the Apostle clearly grip not the visible oar, which is in a static position, tightly fixed in its oar lock, but the other oar, whose blade we do not see since it is under the waves and on the other side of the boat. ❧ THE problem of the date of the *Navicella* is one of the most tormented in the Giottesque chronology, complicated by the extensive alterations and restorations the mosaic has been subjected to. I think that the dating of 1312–13 proposed by Bologna is acceptable on the basis of his subtle and acute historical interpretation. This dating would in any event find confirmation in the document of 1313 mentioned before, but stylistic considerations also support it. The great innovation of the composition is the broad expanse of sea against a vast sky. The invention of a space so broad and open, but still with a measure that we can call perspective, is in line with the spatial manipulation that begins in Padua and reaches all the way to the Peruzzi Chapel. This painting also corresponds to the Peruzzi in its plastically constructed figures, at least from what we can imagine on the basis of the paintings and drawings handed down to us. And in the Peruzzi frescoes the marine landscape that represents the island of Patmos goes in this same direction, simply substituting the large boat for the island. ❧ IT HAS been traditionally maintained that in the mosaic were two medallions with angels, one now preserved in the Vatican Grottoes and the other in the church of San Pietro Ispano in Boville Ernica (p. 245). The two heavily restored figures are in any case sufficiently legible, with a plastic, bulky structure and a soft naturalness in the wings that harmoniously clasp the haloes. The color of the two medallions is very beautiful: pale, luminous, chiefly light blue and yellow timbres. Gold is used elegantly: in the fleshy wings it is rendered with a dense and iridescent illumination obtained by mixing strings of gold tiles

with other tiles of reddish brown. As Tomei (1989) points out, this technique was new to late thirteenth-century Roman tradition and presupposes Giotto's presence in the workshop, despite the great skill of the mosaic craftsmen. The head of the angel with staring and heavily underlined eyes in the Vatican Grottoes resembles the face of Lazarus in the Lower Basilica in Assisi and the face of St. Laurence in Chaalis and may indicate a possible dating for the work; while the head of hair, puffed out over the forehead and on the top of the head with ringlets that fall down the neck, is typical of the angels in the Stefaneschi *Polyptych*. Furthermore, the soft rendering of the color, continually varied by subtle nuances, is typical of a rather advanced moment in Giotto's activity, which could well coincide with the painter's certain presence in Rome before December 1313.

WORK FOR THE

FLORENTINE

BANKERS

THE WORK IN SANTA CROCE

SOON AFTER HIS PADUAN WORK GIOTTO BEGAN HIS LONG LABORS IN THE FRANCISCAN CHURCH OF SANTA CROCE IN FLORENCE: THIS ENSEMBLE OF DECORATIVE WORK WAS TO RUN THROUGH THE CENTRAL PART OF THE PAINTER'S ADULT LIFE, UNTIL HIS DEPARTURE FOR NAPLES. ONCE again, therefore, the Florentine master was called to work in a church of the mendicant order, which had by now become very important. This church was not only recently built (construction began in 1294) but new in its architectonic structure; it is attributed to Arnolfo di Cambio, and it quickly became the major museum of early fourteenth-century Florentine painting. ঽৎ THE keen linear severity of the structural elements of this extraordinary church building define a clear, ample, and expanded space, without any concession to ornamentation. The space perfectly balances the verticals of Gothic tradition with horizontals, for besides the flat roof there is a gallery that runs the entire length of the central nave like a cornice above the arches. This severe, precise, and luminous architecture did not grant Giotto the chance to play with the vestiges of Gothic ornamentation, but demanded frescoes—in the close conjunction of architecture and painting that marks the painter's world—of a similar severity of architectonic backgrounds and limpid spatial breadth. ঽৎ GHIBERTI (c. 1450) records that Giotto painted four chapels and four polyptychs in the church of Santa Croce in Florence ("for the minor friars"). Vasari, in the second edition of his *Lives* (1568), states it specifically: "And in S. Croce there are four chapels by the hand of the same, three between the sacristy and the large chapel, and one on the other wall. In the first of the three, which is that of Messer Rodolfo dei Bardi, is the life of St. Francis. . . . In the other, that of the Peruzzi family, there are two stories in the life of St. John the Baptist . . . two stories of St. John the Evangelist." The other two chapels recorded by Vasari are the Giugni Chapel, with Stories of the Apostles, now lost, and the Tosinghi Spinelli Chapel in the left transept, with Stories of the Virgin: in the latter the only surviving thirteenth-century fresco, an *Assumption,* is recorded and generally considered to be by the "Master of Figline." Furthermore, Vasari cites

page 251: Bardi and Peruzzi chapels, Santa Croce, Florence.

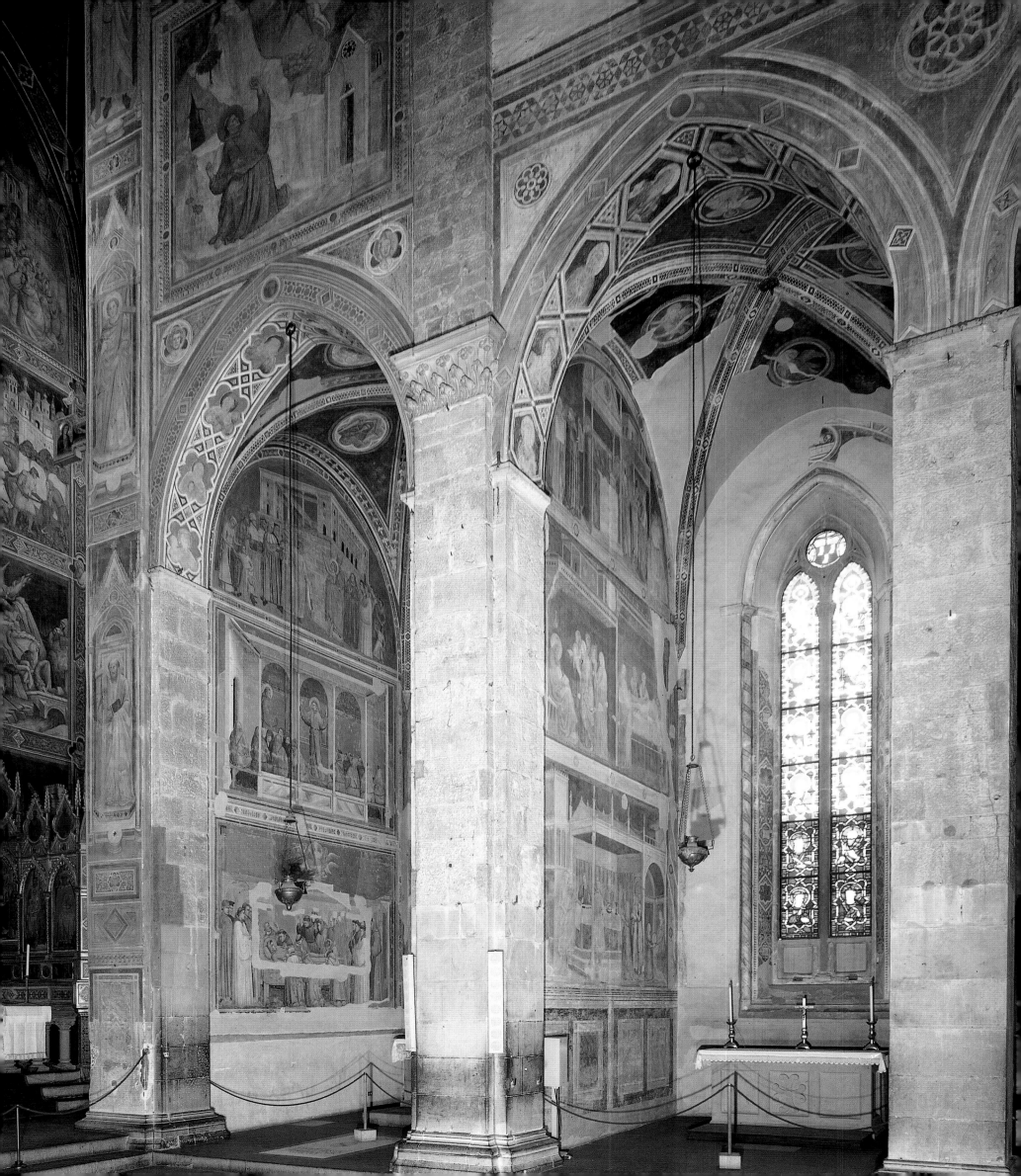

the polyptych of the Baroncelli Chapel, with a detailed description, and records a *Crucifixion,* an *Annunciation,* and other works in the convent's refectory (but these last are by Taddeo Gaddi). ❧ IN THIS Franciscan church the persons commissioning Giotto were among the richest and most powerful members of the new mercantile and banking bourgeoisie in the city of Florence; this does not seem to have influenced the paintings' thematic and iconographic choices, however, which are completely traditional. If anything, the patrons' wealth and position spurred the artist to create paintings, and especially frescoes, insofar as they can be read, of extraordinary quality; these are among the most sublime works in the master's entire career. ❧ ONLY the frescoes of the Peruzzi and Bardi chapels (p. 251) and the polyp-

tych in the Baroncelli Chapel remain of these great creations, which were certainly painted over a period of years. It is possible that the Peruzzi *Polyptych* now in the North Carolina Museum of Art in Raleigh and the *St. John the Baptist in Prison* in the Gemäldegalerie, Dresden, also come from the church of Santa Croce. There is also a theory that the dismembered polyptych scattered among the National Gallery of Art in Washington, the Museo Horne in Florence, and the Musée de la Fondation Jacquemart-André at the Abbaye de Chaalis may have come from Santa Croce. Boskovits (1984) has also recently assigned to Giotto a fragment of a fresco and part of a colored glass window from the chapel in the transept, pieces now in the Museo dell'Opera di Santa Croce.

THE PERUZZI CHAPEL

❧ THE Peruzzi Chapel represents the loftiest peak in Giotto's struggle with the issue of space, a struggle that links the Paduan work in the Scrovegni Chapel, the *Madonna in Glory* in the Uffizi, and the *Death of the Virgin* in Berlin in a single but continually deeper discourse. This discourse centered on the problem of the

space-figure relationship, which for Giotto was in a certain sense already a perspective issue, tied tightly to the problem of the space-light relationship—in other words, chiaroscuro. ❧ THE Peruzzi Chapel is the second in the right transept starting from the chapel in the apse. Its construction was supported by Donato

Peruzzi Chapel, side wall seen at an angle. Santa Croce, Florence.

Peruzzi Chapel, detail of intrados of entrance arch. Santa Croce, Florence.

page 253: Giotto. Detail of decoration of window embrasure. Peruzzi Chapel, Santa Croce, Florence.

Peruzzi, a member of the rich and famous family of Peruzzi bankers, who was still alive in 1299. But we do not know when and by whom the frescoes had been commissioned. ❧ THE chapel's lateral walls are each divided into three horizontal bands, corresponding to three rather elongated compartments: to the left are the three episodes of the life of St. John the Baptist: *Annunciation to Zachary, Birth of John the Baptist,* and *Herod's Feast.* To the right are the Stories of St. John the Evangelist; *St. John the Evangelist on Patmos* at the top, surrounded by motifs from the Apocalypse, the *Raising of Drusiana,* and, below, the *Assumption of St. John the Evangelist.* At the bottom runs a fairly simple base molding in marble. ❧ THE back wall now preserves only fragmentary decorations in the window embrasures, and a tatter with a slaughtered lamb in a roundel above the long window. The *vele* of the ruined ceiling permit us to guess that inside the roundel were the symbols of the evangelists. Furthermore, on the underside of the entrance arch are busts of the prophets inside hexagons. ❧ THE frescoes were whitewashed in the course of the eighteenth century, and memorial tablets and tombs affixed to the walls; uncovered in 1841, the frescoes were "restored," according to the custom of the time, with rather emphatic repainting. They were then cleaned and restored by Tintori in 1958–61, and all the eighteenth-century repainting was eliminated: it was clear that the paintings had suffered great damage even before the whitewashing, probably due to Arno River flooding in the thirteenth and fourteenth centuries. However, their ruinous state is chiefly because the painting was done not on wet plaster but on a dry wall. ❧ THIS issue has given rise to a series of hypotheses, some intelligent, others quite bizarre. Certainly it is surprising to think that Giotto might have used another, more delicate and perishable technique rather than real fresco just for this chapel. Some think that he might have been in a great hurry to finish the work, or perhaps that he did it out of spite because the Peruzzi family had not paid him properly. These hypotheses make no sense, because Giotto always worked very quickly; furthermore, the chapel is rather small, so there are relatively few square meters of wall to be frescoed; it would have required little time to complete the work. It is even less likely that the Peruzzi bankers commissioned Giotto with the decoration of such a prestigious chapel without having the money to pay for it. ❧ IT IS more likely that Giotto wanted to experiment with a new technique, which certainly gave him surprising results. In fact he must have already used a mixed technique in the decoration of the Palazzo della Ragione in Padua—which probably preceded the Peruzzi frescoes—obtaining unquestionably splendid results, and in Rome he took risks with the *Navicella* mosaic, creating

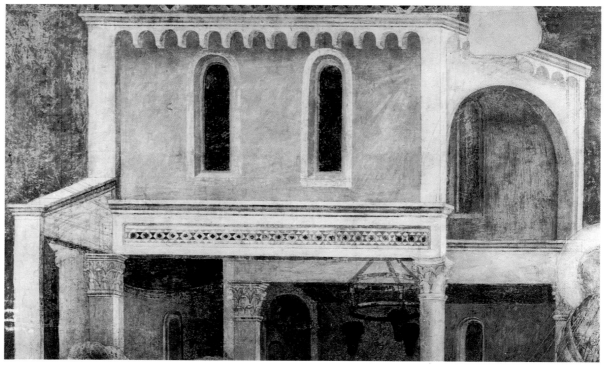

Giotto. Detail of HEROD'S FEAST *(pp. 258–59). Peruzzi Chapel, Santa Croce, Florence.*

Giotto. Detail of ASSUMPTION OF ST. JOHN THE EVANGELIST *(pp. 262–63). Peruzzi Chapel, Santa Croce, Florence.*

effects of unusual luminosity. ❧ THAT Giotto experimented with new techniques to obtain particular effects is also known from Ghiberti's words: "He was very skilled in all art. He was the inventor and discoverer of much doctrine." This passage indicates that the Florentine master developed a continuous inventive capacity, not only from the strictly stylistic point of view. Thus he might have wanted to adopt a mixed technique that would give him extraordinary results, with light and the relationship between light and color in marvelous gradations of chiaroscuro; effects that can barely be discerned today. Even now, in its disintegrated state, the ensemble is superb: think of how beautiful it must have been when it was first displayed. We do know that this decoration was most admired by local artists among all the Florentine works even through the sixteenth century, so much so that Michelangelo himself drew many figures from it. From these very frescoes the major Florentine painters of the early fourteenth century drew their inspiration, beginning with Maso di Banco, who referred to them in the background of his Stories of St. Silvestro, painted in the nearby Bardi Chapel. ❧ EXCEPT for *St. John the Evangelist on Patmos,* which is set in a wonderful broad seascape, the episodes are characterized by deep, adeptly articulated architecture, within or before which moves a crowd of figures in precise proportional relationships. These ample buildings show much more complex observation and reexamination of architectonic reality than do the simple perspective boxes of the Paduan cycle in the Scrovegni Chapel; they display an utterly new ability to think in terms of space. The interiors in the *Birth of John the Baptist* and *Herod's Feast* present two precisely defined rooms, linked by a single vanishing point, which permit the rhythmic scanning of successive events; this effect too will undergo interesting developments in fourteenth-century painting, especially in Padua. The exterior views, such as the *Raising of Drusiana,* present the buildings not as simple backgrounds to suggest a specific place, but—given the structures' robust reality—as protagonists in the episode. ❧ TO AN observer of the frescoes inside the chapel, the deep and spacious buildings appear broadened and almost distended, like paper constructions opened and flattened out on a level plane. The frescoes should really be read from a point of view well outside the chapel itself, the last pilaster of the central nave at the point of conjunction with the transept (p. 252 left). If one stands at that point to view the chapel, and then shifts slightly to the right to better read the frescoes on the left wall, one notices that the architecture—which looks expanded and askew when seen head-on from inside the chapel—is redefined in a perfect measure of space, deep and exactly in perspective. ❧ THE photographs taken from the conjunction of the nave and the transept demonstrate

Giotto. Detail of HEROD'S FEAST *(pp. 258–59). Peruzzi Chapel, Santa Croce, Florence.*

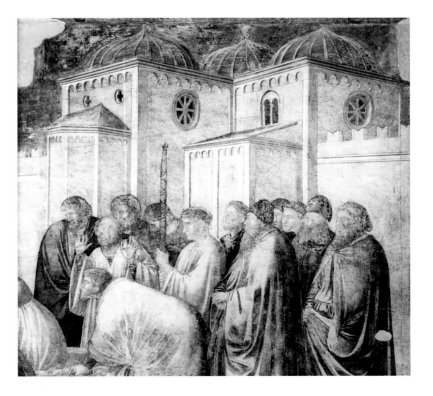

Giotto. Detail of RAISING OF DRUSIANA *(p. 261). Peruzzi Chapel, Santa Croce, Florence.*

this extremely modern idea: Giotto considered not only the objectivity of the wall, at the center of which he placed the focus of the composition, but also the point of view of the spectator. ❧ GIOTTO'S conception is not simply a matter of perspective—because it is not static and geometric—but is absolutely experimental, one might even say dynamic, linked as it is to different points of view. As we have seen, he already considered the spectator in the positioning of the Uffizi *Madonna in Glory,* which requires a precise point of view, slightly to one side rather than frontal. ❧ THIS concept, like the frescoes in the Scrovegni Chapel, leads one to think that Giotto was familiar with the theater. Even quite simple and rudimentary stage sets represent reality, and stage designers necessarily consider the spectator's point of view more than the objectivity of the representation. ❧ IN THIS pictorial cycle the architecture is greatly simplified, reduced to spatial invasions of accentuated classical flavor, with very little ornamentation, measured and essential: this demonstrates a move beyond the Gothic and the reappropriation of a local architectonic tradition, certainly in harmony with the severe, precise structure of the basilica. The decoration of the rooms in these murals, soberly and classically measured in their marble facings or lined at most with striped cloth, makes an interesting contrast to the richness of the cloths on the walls of the rooms in the

Assisi frescoes. The fully rounded arch is used constantly here, and the openings for doors and windows (almost all very simple, single windows) have sharp corners without ornamental moldings. ❧ ON THE left wall the *Annunciation to Zachary* takes place against a background composed of two very simple structures, within and before which the figures move. In this episode the difference between the frontal view and the view from the nave is not sharply marked; yet seen from a distance, the structure on the right takes on greater depth. And from that spot, the painted column to the left of the altar canopy becomes the central point of the entire picture. ❧ THE difference between the two points of view, inside and outside the chapel, is much more marked for the *Birth of John the Baptist.* When seen from the nave, the left wall of the room where Zachary is seated rotates and aligns itself optically with the real pilaster at the entrance to the chapel, while the rooms and galleries assume a more exact measure and spatial depth. An analogous and perhaps even more accentuated effect occurs in *Herod's Feast* (pp. 258–59), where once again the column in front and to the left of the hall becomes the visual fulcrum of the composition, which is marked out in a succession of unusually ample spaces, with pre-Renaissance effects in the deep room where Salome and Herodias stand. ❧ ON THE opposite wall the lunette shows a vast sea, which spreads out in a bird's-eye

Giotto. ANNUNCIATION TO ZACHARY *and* BIRTH OF JOHN THE BAPTIST *seen at an angle. Peruzzi Chapel, Santa Croce, Florence.*

perspective. At the center is the little island where St. John the Evangelist is sleeping (p. 260); one can see that both island and saint are shifted slightly toward the back wall, to allow the viewer from the nave to read the episode more exactly. The various figures that stud the landscape—fantastic, almost shorthand allusions to the Apocalypse—are very beautiful in their classical choice of motifs, such as the reclining form of an elegant woman. The two long scenes on the lower tiers clearly mark the difference between the two points of view, inside and outside the chapel. The *Raising of Drusiana* (p. 261 left) occurs in front of the articulated wall of a medieval city—a city that probably existed, or was constructed of a collection of real elements. Indeed, the architecture of the buildings is perfect and precise: two towers flank the city gate, and there is a church with cupolas, reminiscent of Venetian or Paduan buildings, which in this context perhaps emphasizes more clearly the story's Oriental setting. Seen from the front, the background of the scene looks like the folded paper of a child's toy house; but seen from the nave, the wall and buildings take on a bulky fluidity, becoming spacious architecture again. The same is true of the compartment containing the *Assumption of St. John the Evangelist,* where the cross-section of a church is repeated: it contracts when viewed from the outside, so that the nave in which the crowd is gathered reads as a strong row of columns. ❧ IN THIS extraordinarily vast and embracing space, the figures are grand and imposing, enveloped in robes with deep furrows that seem to anticipate Masaccio's figures. The beauty of the color, rich in new timbres like dark green and light blue, can only be guessed at here and there; but the poor color allows us now to direct our attention to the robustly plastic form of the characters and the adept chiaroscuro work. ❧ THE women attending the birth of St. John the Baptist rise before us, majestic matrons, in the placid and deep drapery of their robes. The two imposing groups in the *Raising of Drusiana* are wrapped in clothes whose folds are thick with shadow, like fifteenth-century sculptures. These figures, like the pyramidal shape of the men at the *Assumption of St. John the Evangelist* (p. 261 right) are all a prelude to the pictorial revolution of the first Florentine Renaissance. ❧ THE chiaroscuro now appears with the immediacy of a first draft, not veiled by color. The effect is mature and modern, because the contour lines seem eroded and nuanced, as in some very powerful "lost" profiles of the women in the *Raising of Drusiana.* ❧ THIS perfectly geometric composition, now reduced to its essentials, does not lack striking and attentive portraits of objects in everyday use. The thoroughly contemporary objects, like the musical instruments and religious objects in the *Annunciation to Zachary* (p. 256 left) and the two painted ceramic

Giotto. HEROD'S FEAST *seen at an angle. Peruzzi Chapel, Santa Croce, Florence.*

pages 258–59: Giotto. HEROD'S FEAST. *Peruzzi Chapel, Santa Croce, Florence.* ❧ *page 260: Giotto. Detail of* ST. JOHN THE EVANGELIST ON PATMOS. *Peruzzi Chapel, Santa Croce, Florence.*

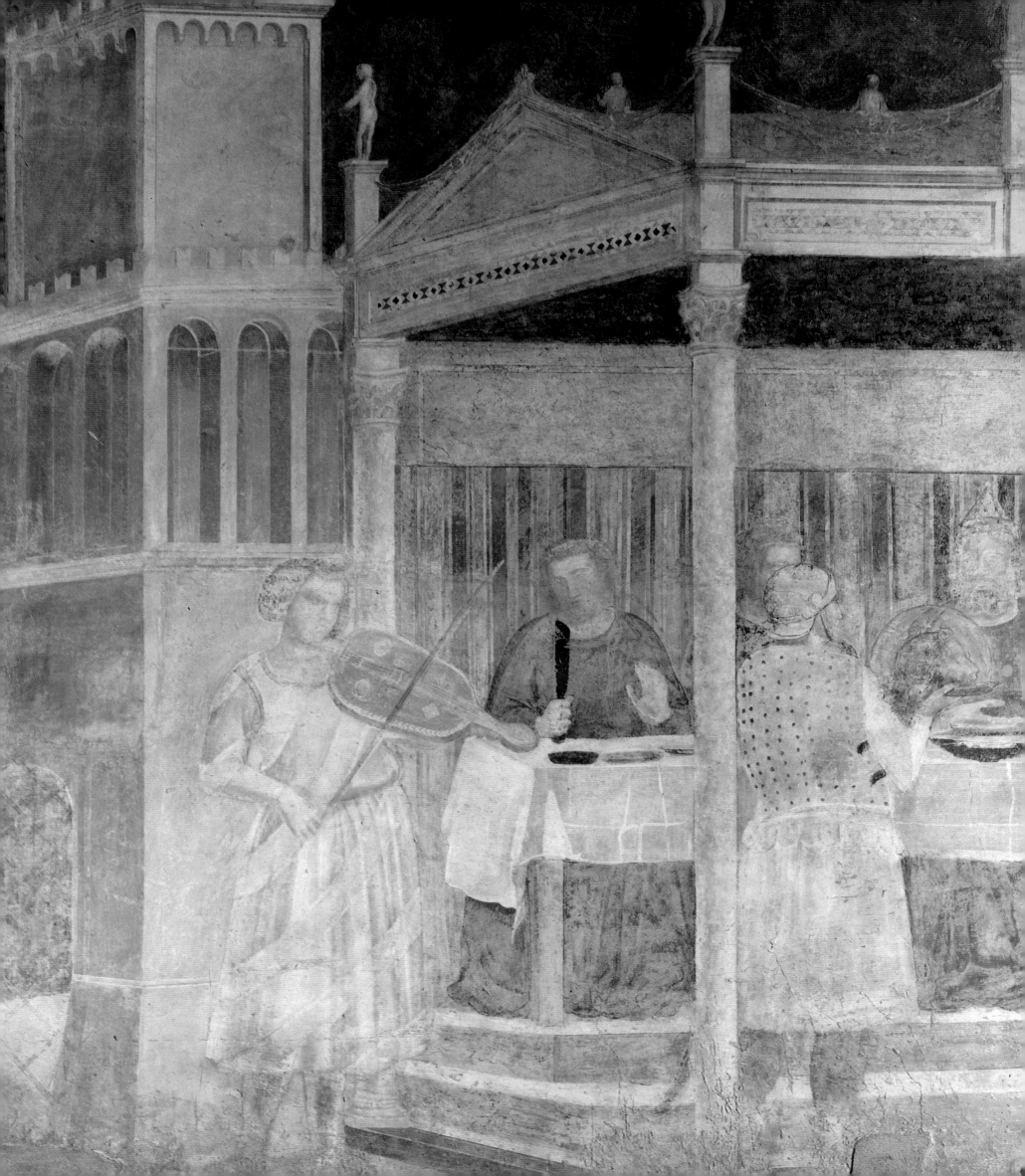

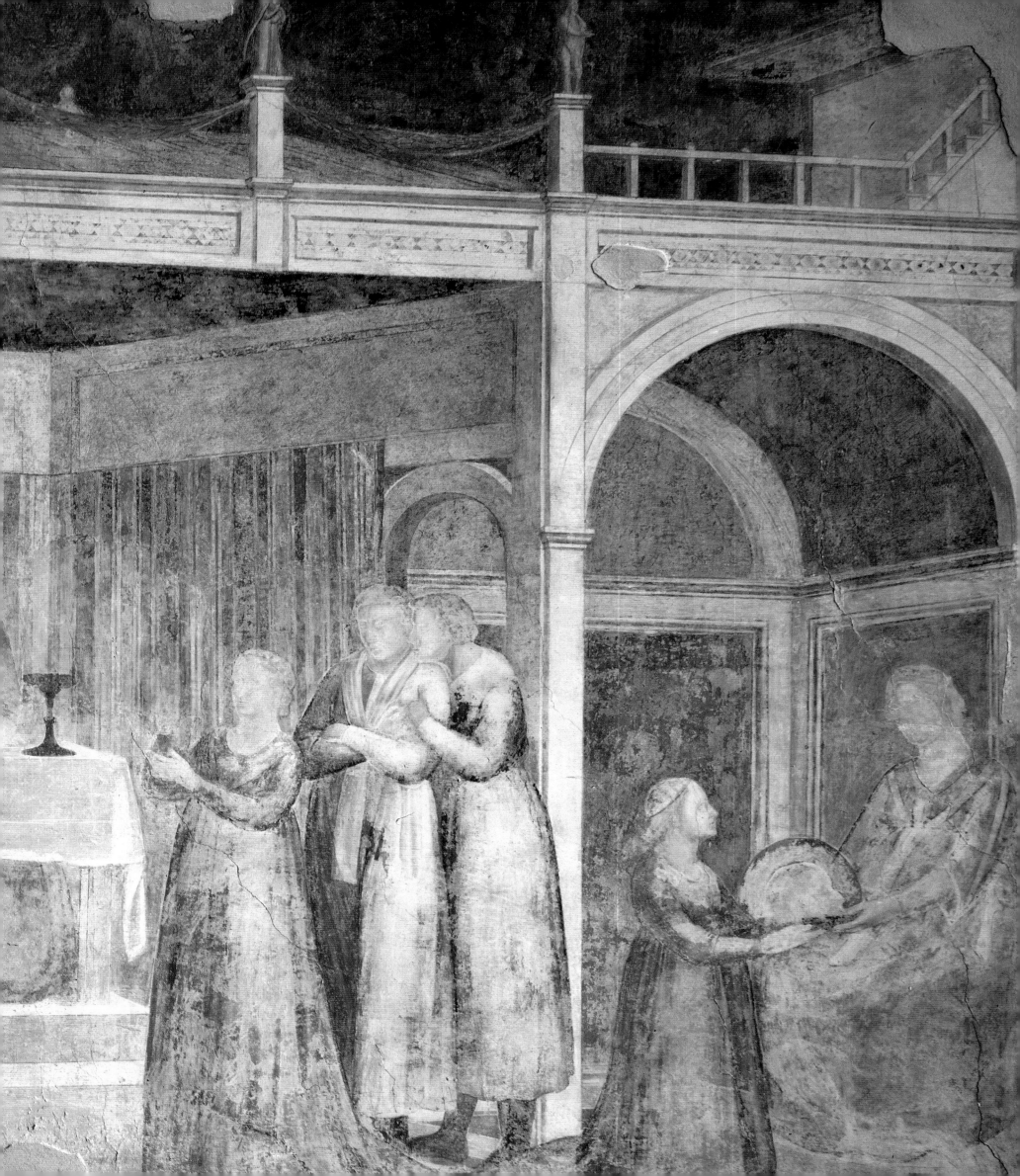

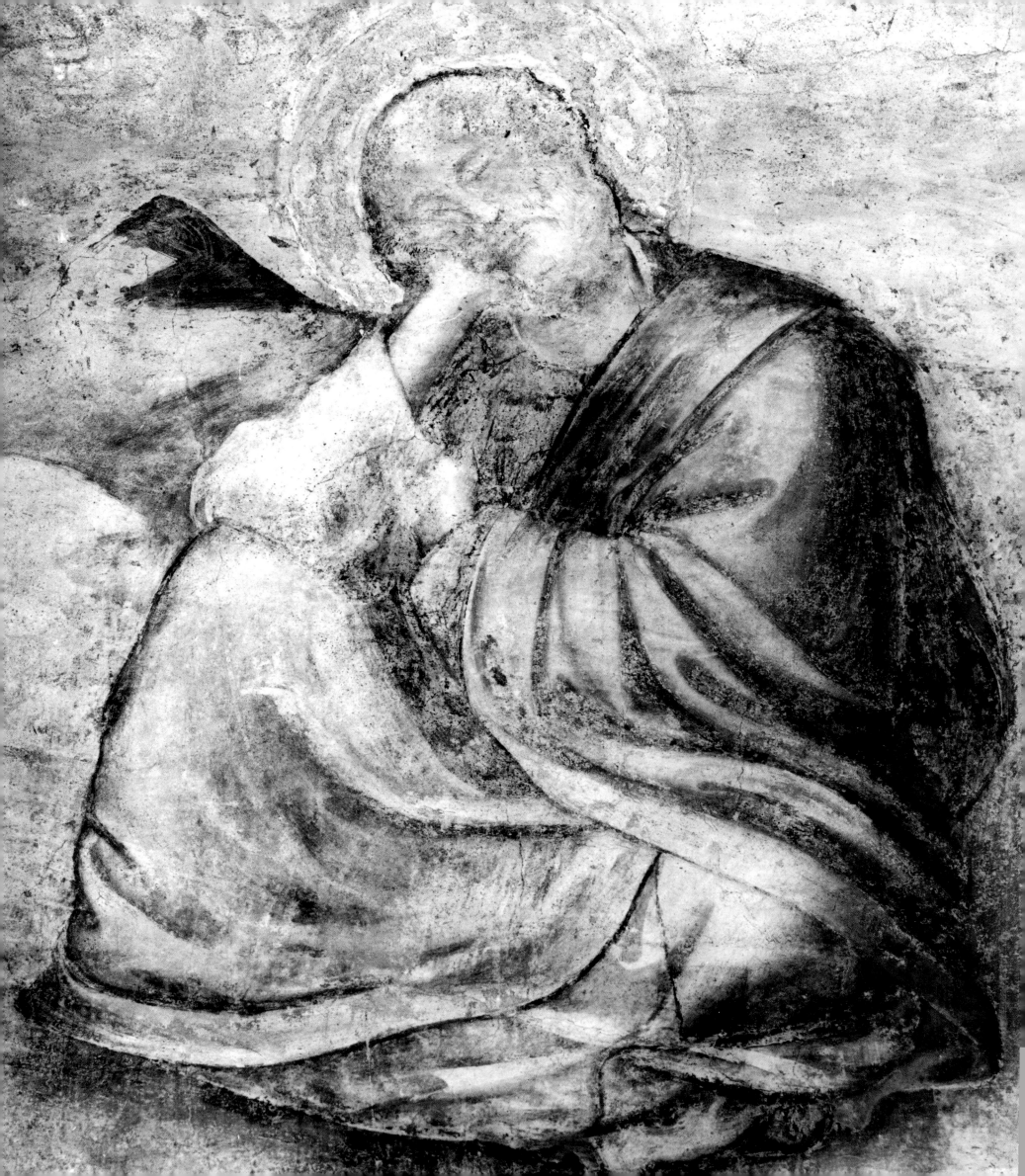

amphoras in the niches dug into the wall in the *Birth of John the Baptist* (p. 256 right), provide wonderful little still-lifes. ❧ THE few allusions to the Paduan work, already noted by several scholars, especially Bologna (1969b)—such as the musician in *Herod's Feast*—again underscore the evolution of Giotto's language in this Florentine cycle toward a greater plasticity and spaciousness. ❧ HERE too, as in all of Giotto's works, the problems of attribution and chronology are still debated. Though almost all scholars now accept that the work is his, opinions vary widely on the date of its execution. A relationship or a temporal contiguity has almost always been sought between the Peruzzi murals and the frescoes in the Bardi Chapel, and that naturally creates interpretive difficulties. Generally it has been—and still is—maintained that the Peruzzi frescoes precede the Bardi murals, though only slightly. Only Borsook and Tintori (1965) hold that the Bardi Chapel is earlier; furthermore, they also argue that the two cycles in the Peruzzi are not contemporary: that the Stories of St. John the Baptist were executed around 1328, and those of St. John the Evangelist after Giotto's return from Naples. ❧ BOLOGNA has recently (1969b) devoted a thoughtful essay to the decoration of the Peruzzi Chapel (and to the Peruzzi *Polyptych*), stressing its high stylistic quality and its central importance in the context of Giotto's development; he maintains that the Peruzzi frescoes

are late, dating after the decoration of the Magdalen Chapel, to about 1317–18. Previtali (1967) had brought them earlier, to around 1310. For Venturoli (1969) the most probable chronological placement is around 1315. Bellosi (1981) places the possible dates between 1310 and 1316, perhaps 1312 exactly. Brandi (1983) regards them as coming after the first document that indicates Giotto was in Florence, in 1313, and certainly after the *Madonna in Glory* from the Ognissanti. In the sequence established in this volume, I believe that the decoration of the Peruzzi Chapel can be dated immediately after Giotto's Roman sojourn in 1313, that is, in 1314 and 1315 when the master's presence in Florence is documented with certainty. ❧ ACCORDING to a hypothesis of Suida's (1931), accepted generally by other scholars, the polyptych now at the North Carolina Museum of Art in Raleigh would seem to have originated from the Peruzzi Chapel. At its center is the blessing Christ and at the sides are the Madonna and saints John the Baptist, John the Evangelist, and Francis; the patrician chapel in Santa Croce is dedicated to the two St. Johns, and its walls are decorated with episodes from the lives of those two saints. Bologna (1969b) regards the polyptych as contemporary with the frescoes and imagines that it had two sides; the only surviving part of the back is the panel with *St. John the Baptist in Prison* (p. 268), of unknown provenance and now at the

Giotto. RAISING OF DRUSIANA *and* ASSUMPTION OF ST. JOHN THE EVANGELIST *seen at an angle. Peruzzi Chapel, Santa Croce, Florence.*

pages 262–63: Giotto. ASSUMPTION OF ST. JOHN THE EVANGELIST. *Peruzzi Chapel, Santa Croce, Florence.*

pages 264–65: Giotto. Details of RAISING OF DRUSIANA. *Peruzzi Chapel, Santa Croce, Florence.*

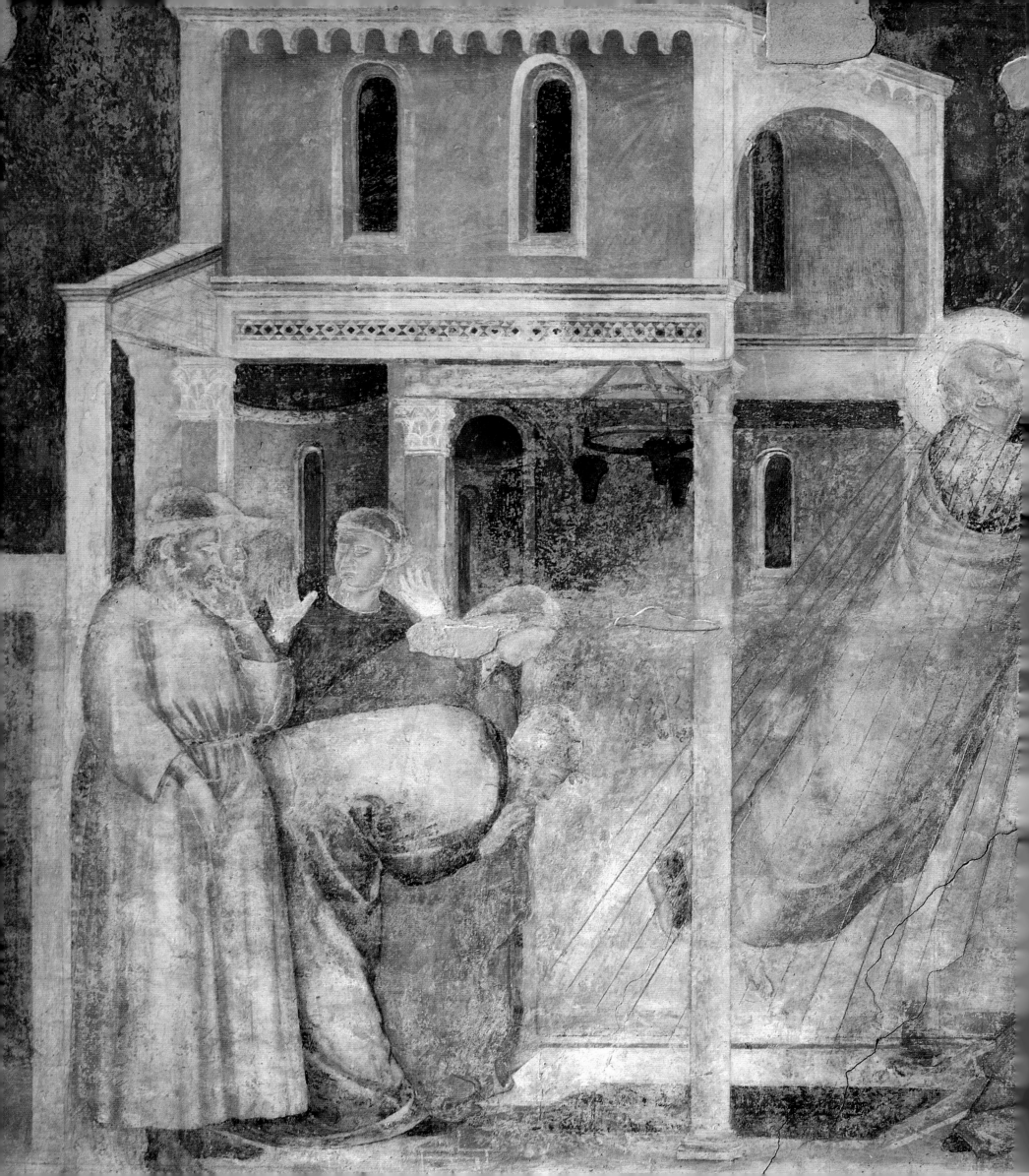

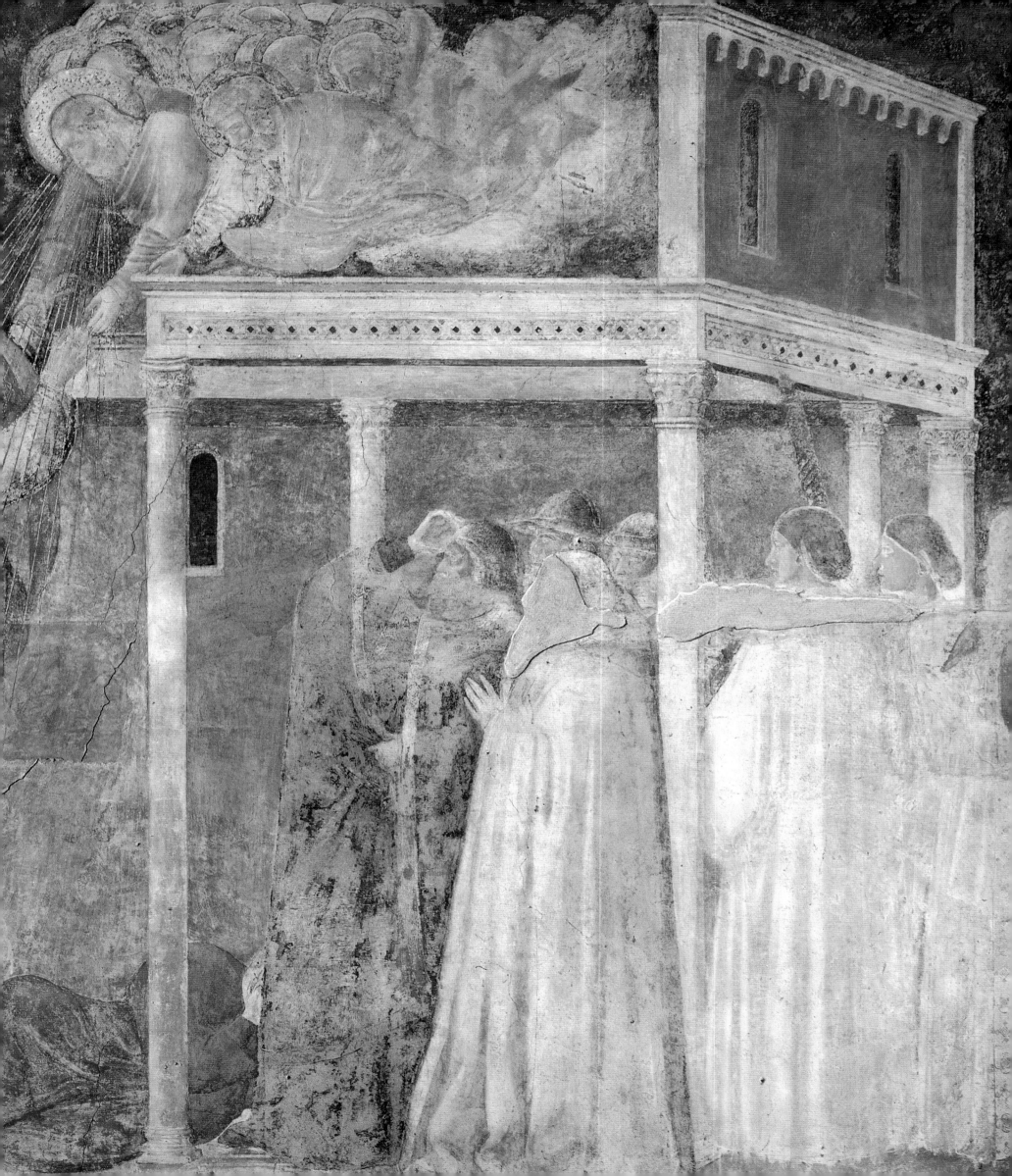

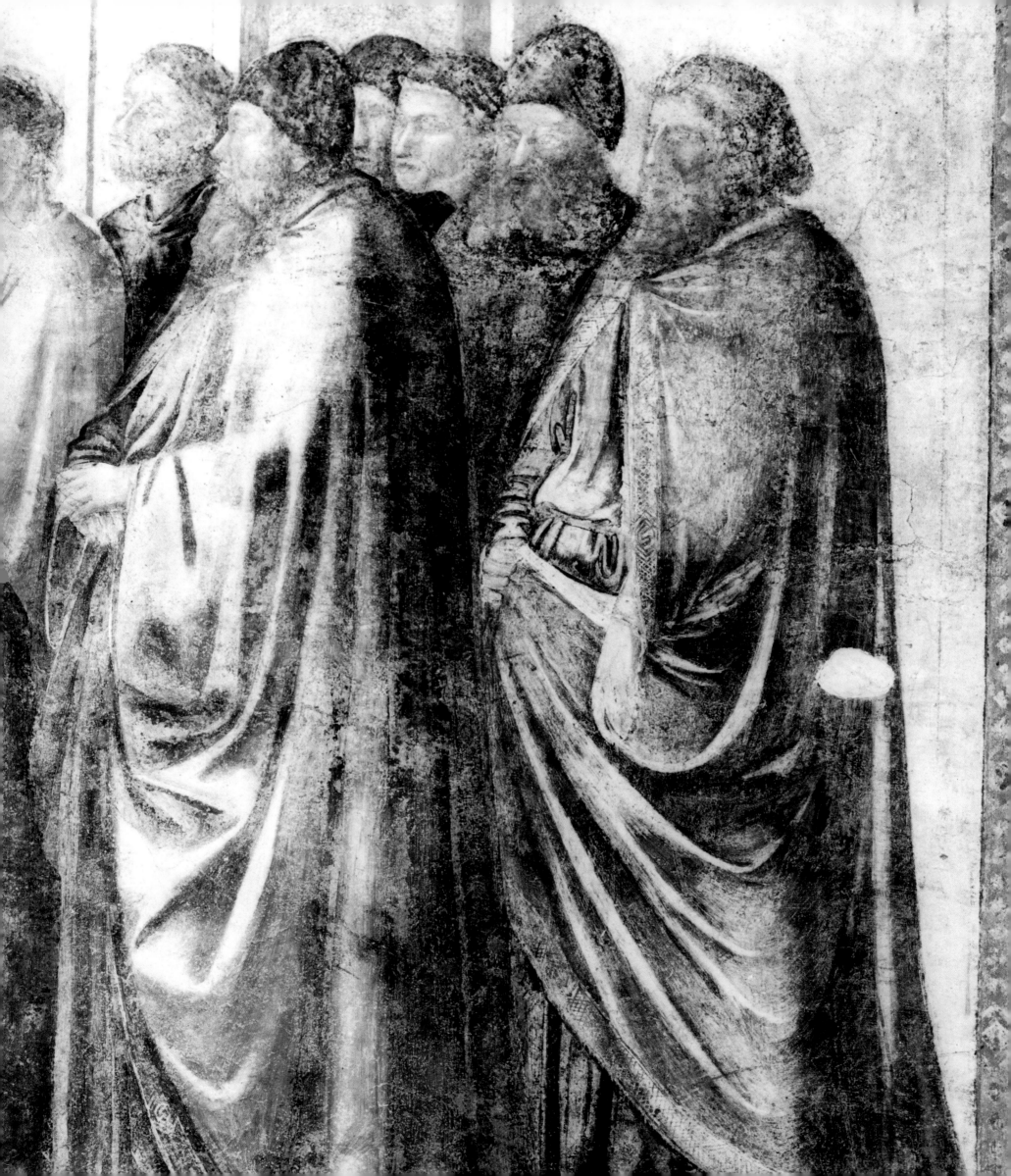

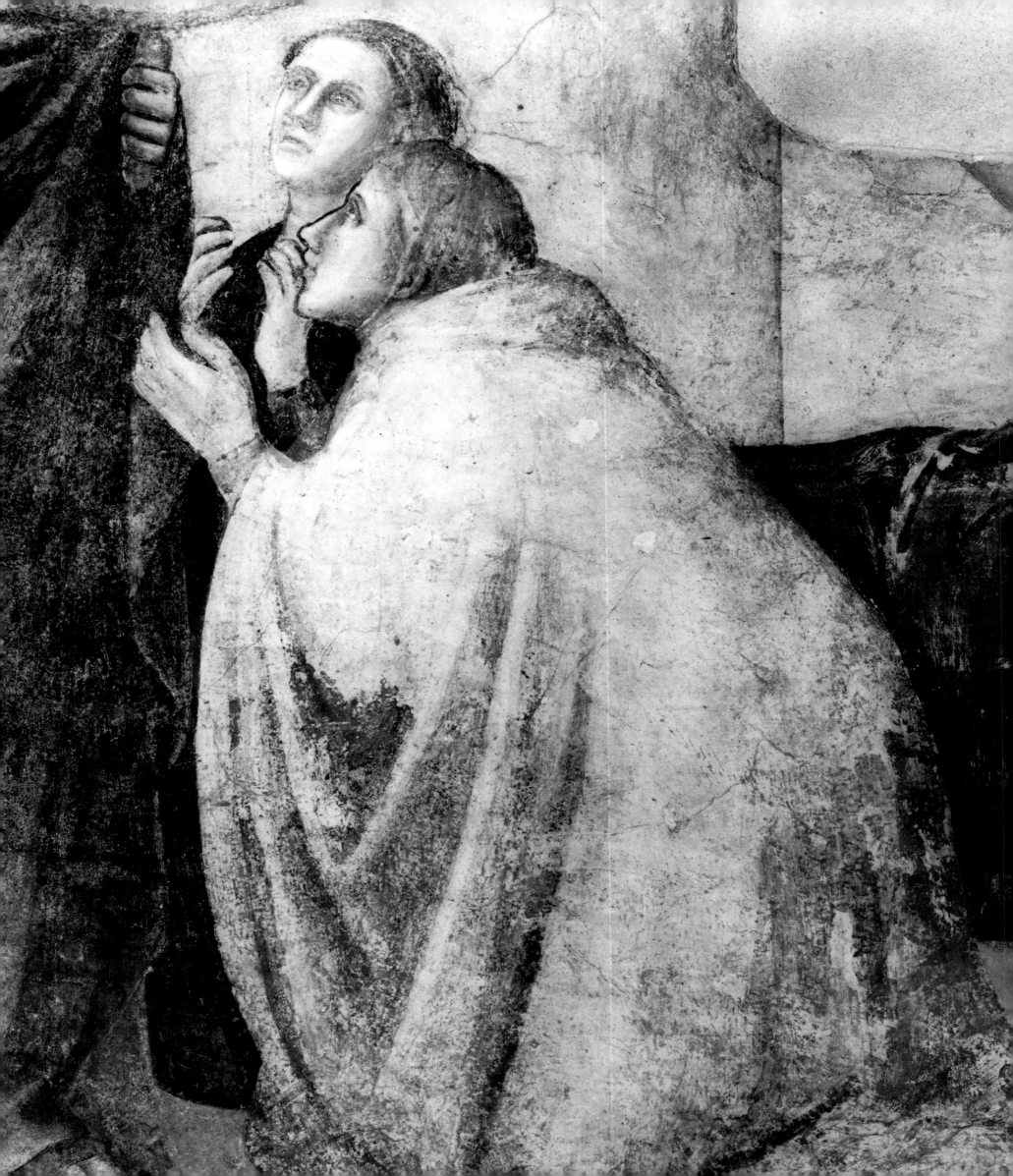

Giotto. Peruzzi POLYPTYCH.
Tempera and gold leaf on panel,
41½ × 98¼ in. (105.4 × 249.6 cm).
North Carolina Museum of Art,
Raleigh.

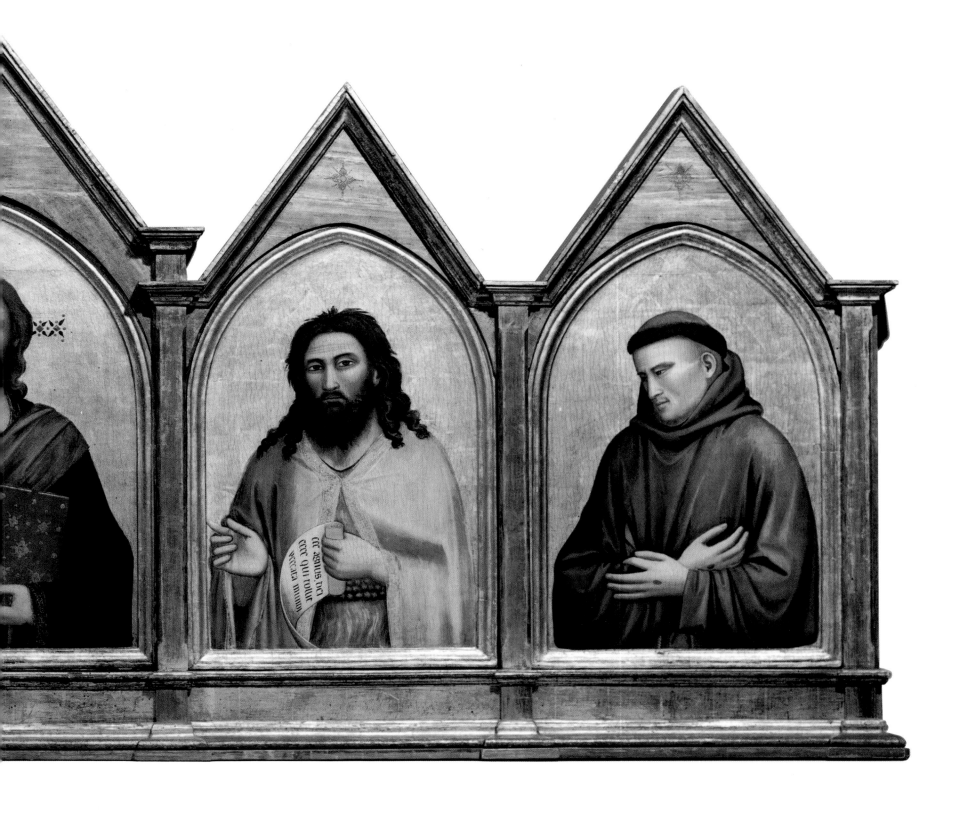

Workshop of Giotto. ST. JOHN THE
BAPTIST IN PRISON. *Tempera
on panel, 23⅜ × 13¾ in. (59.5 ×
35 cm). Gemäldegalerie, Dresden.*

Gemäldegalerie in Dresden. ❧ THE polyptych has five panels framed by broad pointed arches that create a precise architectonic dimension in an extensive space. Inside the arched frame, which creates a sort of loggia, the majestic, grave figures appear: they form a pyramidal structure and are slightly shifted on the diagonal, as though to penetrate inside the gold background and precisely indicate the space. The figures are certainly Giottesque in the grandeur of their forms, constructed with a soft chiaroscuro. Equally Giottesque are the delicate transitions from one plane to another; the sweet expressions, especially the intense faces of Christ and the Madonna; the fine ornaments and details of the clothes, such as the Madonna's thin, transparent veil; and the exquisite clarity of the luminous colors. ❧ THIS work, almost austere in the severe solidity of its figures, fixed in profound, intent expressions, is extremely significant for Giotto's figurative evolution. It clearly belongs to the Peruzzi moment, when the master was particularly concerned with architectonic and volumetric problems, which he resolved with a special sensitivity to color softened by the light. The Dresden panel is weaker, though, especially in its architectural format; so weak that it should be considered a product of the workshop. ❧ THE dating of the polyptych, which was certainly executed in part by assistants, is very close to that of the frescoes of the Peruzzi Chapel. It repeats the ample majesty of their forms and the classical precision of the line, thus confirming, also from a stylistic point of view as well, the hypothesis of its provenance from that chapel.

COLOR

THE MAGDALEN CHAPEL IN ASSISI

⟡

THAT GIOTTO CREATED THE DECORATION OF THE MAGDALEN CHAPEL (P. 273) IN THE LOWER BASILICA OF SAN FRANCESCO IN ASSISI IS A RATHER RECENTLY ESTABLISHED FACT; GNUDI'S (1958) DISCOVERY OF THIS RECEIVED DECISIVE CONFIRMATION AFTER THE 1967 RESTORATION (ROTONDI, 1968).

⟡ MOST scholars believe that this work closely follows the Scrovegni Chapel—of which it repeats two episodes—usually because of the Assisi document that has Giotto present in the Umbrian city before January 1309. But Bologna (1969) and Venturoli (1969b) put the Magdalen Chapel work after the *Navicella* mosaic. I agree with these datings, though I consider this Assisi cycle later than the Peruzzi Chapel (as Venturoli has also suggested), for it constitutes the start of a different and further phase in Giotto's artistic journey, when he pays more attention to the issues of light and color and seeks a more intimate and profound expressiveness, greater psychological insight, and more easy naturalness, as well as delving more profoundly into religious and theological themes. ⟡ IF THESE frescoes can be dated to that interval of years between 1315 and 1318 during which Giotto is not documented as being in Florence, they are in line and in consonance with the highest Sienese painting—that of the late Duccio and the young Simone Martini, who were concerned precisely with the problem of color. But there is also a close kinship with Giovanni Pisano's last sculptures and those of his best disciples, who twine small, very elegant figures against their backgrounds. Giotto, without renouncing the heroic form of man plastically constructed by chiaroscuro nor the space studied with great attention to its relation to figures, as well as in its intrinsic expressive possibility, demonstrates once again his concern with the new figurative problems that engaged the artists' world. His style and language were more and more Gothic, with northern European inflections, and more geared to the realization of refinements in an almost courtly key. Here too Giotto moved with the authority and skill of a protagonist. ⟡ IN THE final stages of Giotto's artistic journey he showed an astounding ability to change his expressive register; by turns solemnly stylized, affectionately discursive, severely narrative, and delicately profane. This is even

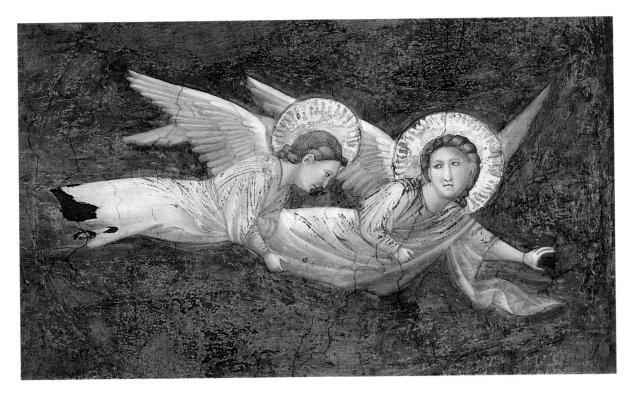

Giotto. Detail of NOLI ME TANGERE *(p. 288). Magdalen Chapel, Lower Basilica of San Francesco, Assisi.*

page 273: Magdalen Chapel. Lower Basilica of San Francesco, Assisi.

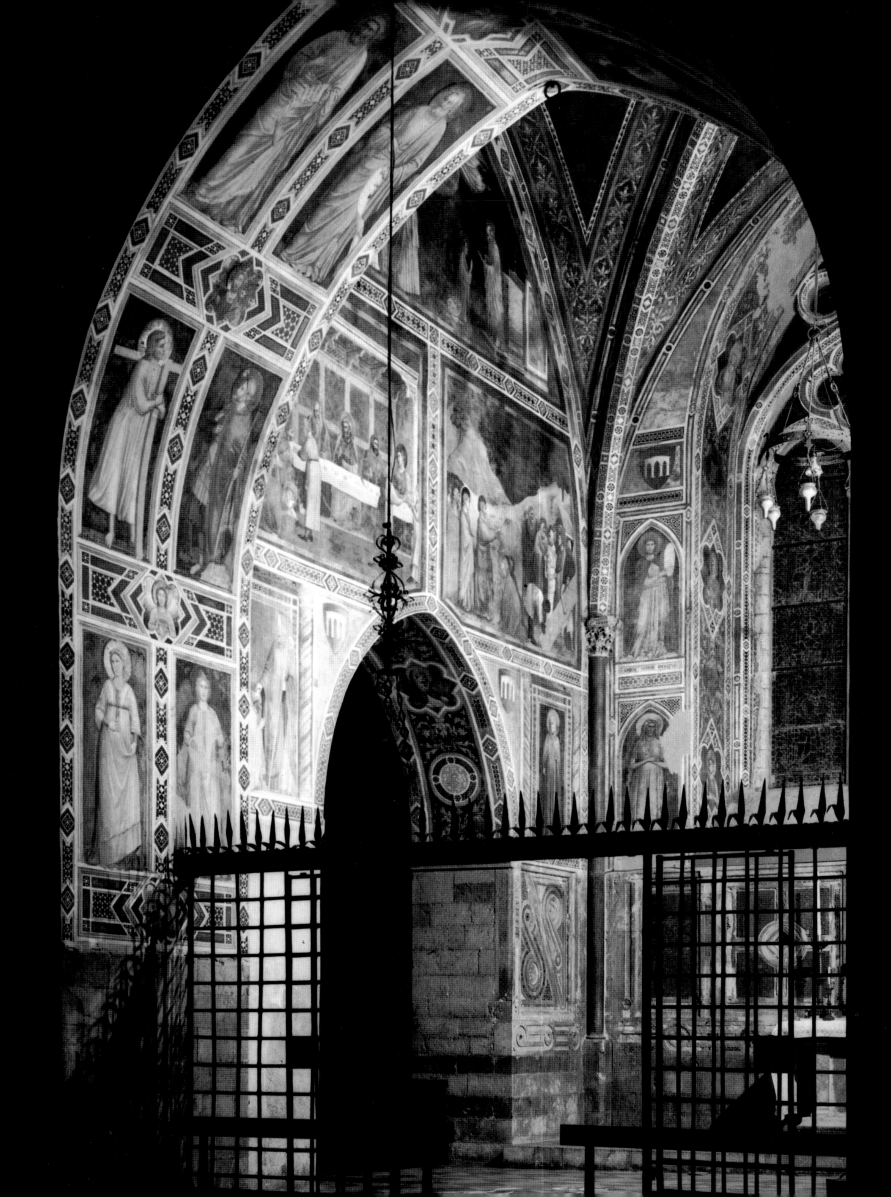

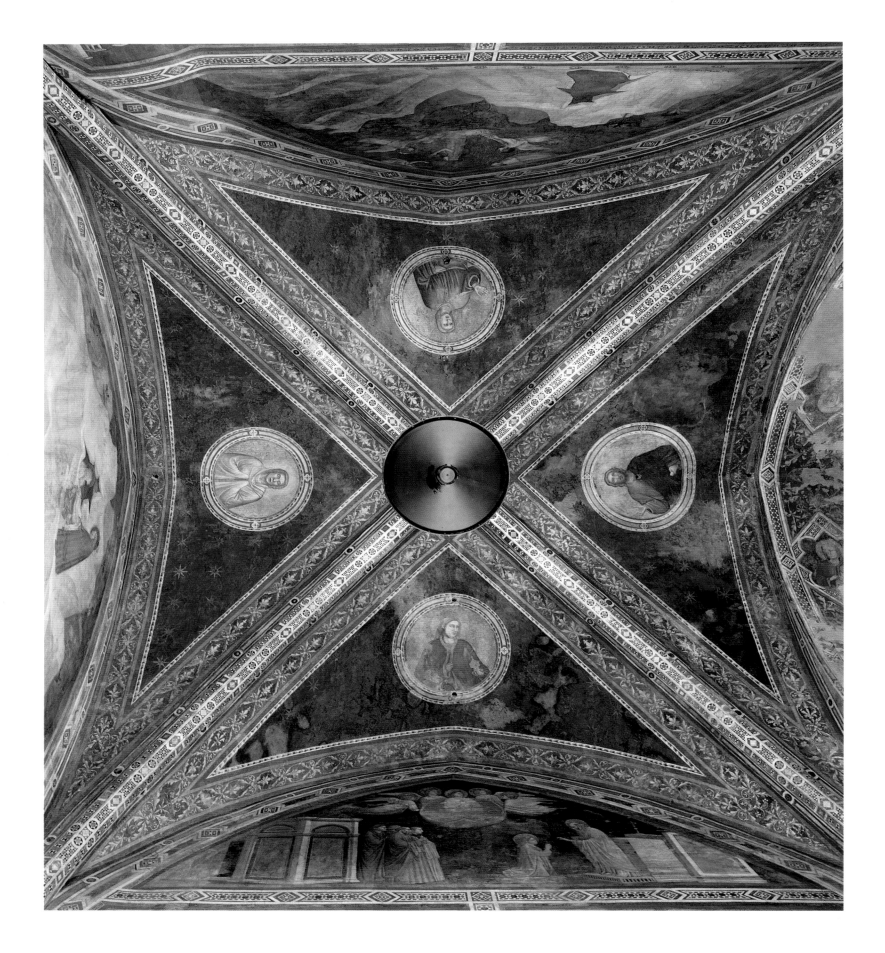

Clockwise from top:
MARY MAGDALEN, LAZARUS,
ST. MARTHA, *and* CHRIST THE
REDEEMER. *Vault of the Magdalen
Chapel, Lower Basilica of San
Francesco, Assisi.*

more apparent than in the previous period, though he maintained his constant search for an ever more luminous color. ❧ THE Magdalen Chapel is the last in the nave to the right when facing the transept. The decoration was commissioned by the Franciscan Teobaldo Pontano, who had become the bishop of Assisi in 1314 (or 1296: the dates are disputed) and died in 1329. ❧ COVERED by a cross vault with pointed arches, it has a high marble base with Cosmatesque motifs, above which the frescoes appear, and it opens on a large stained-glass window with images relating to Mary Magdalen. The *vele* of the vault are blue according to custom, and at their center are medallions with half figures of Jesus, Mary Magdalen, Martha, and Lazarus (p. 274). The painting also covers the four walls, the underarch of the entrance, and the window embrasures: the major scenes represent episodes in the life of St. Mary Magdalen taken from Jacopo da Varagine's *Legenda aurea.* ❧ ABOVE the entrance arch is a large lunette with *Mary Magdalen Receives a Habit from the Hands of Zosimo the Hermit* (p. 295); on the right wall is the large lunette with *Mary Magdalen and Angels* (pp. 278–79); in the middle tier are the *Noli me tangere* (p. 288 left); and the *Arrival of Mary Magdalen in Marseilles* (pp. 286–87). Flanking the arch opening onto the adjacent chapel is *Mary Magdalen and Bishop Pontano Clad in Franciscan Habits* (p. 288 right) on one side, and a half figure of a saint or

prophet, each framed by a kind of gallery supported by twisted columns and against a Cosmatesque cornice. On the opposite side are *Mary Magdalen Receives Communion* (pp. 284–85), *Supper in the House of the Pharisee* (pp. 298–99), and the *Raising of Lazarus* (pp. 300–301). Lower down again are two figures inside a gallery supported by twisted columns: on one side is *St. Rufino and Bishop Pontano,* and on the other is a Franciscan saint. On the rear wall, alongside the window, are four female figures of saints: Mary, the sister of Moses; St. Mary the Egyptian; St. Helen; and an elderly martyred saint. In the window embrasures are eight half figures of saints, and under the entrance arch are depicted saints in couples: Peter, Matthew, Longinus Cireneo(?), David, and Augustine—all of them repentant sinners—can be recognized, and there are four female saints, as yet not identified but probably also repentant. Figures in the lobed medallions also appear in the arches communicating with the two adjacent chapels. ❧ THIS is a complex iconography that, beyond the narration of the saint's life, proposes two other interesting correlated themes: conversion and penitence, shown by the depiction of the grand converts, and female sanctity, as evidenced by the numerous figures of women. ❧ THE worship of Mary Magdalen flourished in Europe just after the year 1000, as is testified by some famous and admirable church edifices, such as Saint Magdalen of Vézeley. After a long

Side wall, Magdalen Chapel. Lower Basilica of San Francesco, Assisi.

Giotto. ST. RUFINO AND BISHOP PONTANO. *Magdalen Chapel, Lower Basilica of San Francesco, Assisi.*

Giotto and assistants. Detail of decorative strip. Magdalen Chapel, Lower Basilica of San Francesco, Assisi.

period of silence the Franciscans resumed the worship, recognizing a kind of spiritual kinship between the Magdalen and St. Francis: this explains her prominence in the Franciscan basilica and the emphasis given her by the commissioner of the chapel, who was of this order. The chapel in Assisi holds the most complex and the most complete of the numerous celebrative portrayals of the grand convert. ❧ THE frescoes in the chapel offer some novelties, starting with the sequence of events: with a stroke of genius from the painter—who for this reason alone can only be Giotto—the story unfolds in an inverted direction, that is, from the bottom toward the top. To put it more plainly, the early stories of the saint's life as a hermit are in the bottom register, and the three episodes after her landing in Marseilles are in the lunettes (Previtali, 1967). An almost spiritual bond seems to exist between the saint and the sky of the *vele,* so expressive of these moments of ecstasy and mystical colloquy. ❧ FROM a purely figurative point of view, what strikes one most in the Magdalen Chapel is the expanded sense of space, visible above all in the grand, far-reaching landscapes. But to accomplish this the background almost spills onto the surface, projected forward in a bird's-eye view, so that the rocks and sea are the protagonists of many episodes. A second element is the extraordinary light and the bright colors of the frescoes, based on warm chromatic timbres, with

pink and red prevailing: color and light are essential components of these singular paintings. The rocks are intensely illuminated, in a desert brought to life by a clear and silvery lunar light that expands the space even more, with a mystical sense of the void. ❧ THE very poetic episodes of *Magdalen and Angels* and *Mary Magdalen Receives a Habit from the Hands of Zosimo the Hermit* should be read in this key. Both have an incredible narrative freshness, with figures that seem to vanish into the grandeur of the rocky hills with their bright reflections against a sky crossed by flying angelic figures. The third lunette, with the *Magdalen Receives Communion,* has architecture reduced to very simple, abbreviated huts—also highly colored; and at the center towers the radiant figure of the saint being carried to heaven on a beautiful boat. ❧ A SENSATION of complete spatial openness is communicated by the episode of the *Arrival of Mary Magdalen in Marseilles,* one of the most innovative in all of Giotto's art. It depicts the saint's arrival at Marseilles together with four companions, and on the left is portrayed a very poetic miracle wrought by the Magdalen. A merchant had been forced to abandon his pregnant and seriously ill wife on an island; on his return he lands on the island expecting to find the corpses of his wife and child, but thanks to the saint's intercession they are alive and well. (He has at times been wrongly interpreted as the figure of a

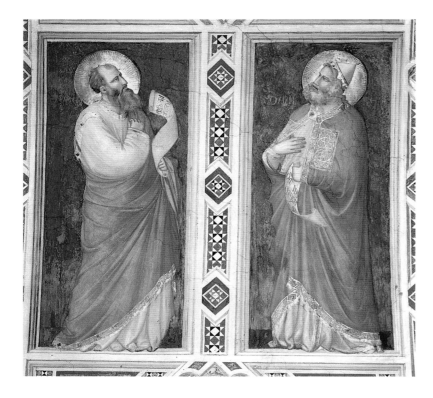

above and page 277: Assistant to Giotto. Details of entrance arch, ST. PAUL AND DAVID. ❧ *pages 278–79: Giotto.* MARY MAGDALEN AND ANGELS. ❧ *page 280: Giotto. Detail of*

MARY MAGDALEN AND ANGELS *(pp. 278–79).* ❧ *page 281: Giotto. Detail of* MARY MAGDALEN RECEIVES A HABIT FROM THE HANDS OF ZOSIMO THE HERMIT *(pp. 282–83).*

❧ *pages 282–83: Giotto.* MARY MAGDALEN RECEIVES A HABIT FROM THE HANDS OF ZOSIMO THE HERMIT. ❧ *pages 284–85: Giotto and assistants.* MARY MAGDALEN RECEIVES

COMMUNION. ❧ *pages 286–87: Giotto.* ARRIVAL OF MARY MAGDALEN IN MARSEILLES.

ALL: *Magdalen Chapel, Lower Basilica of San Francesco, Assisi.*

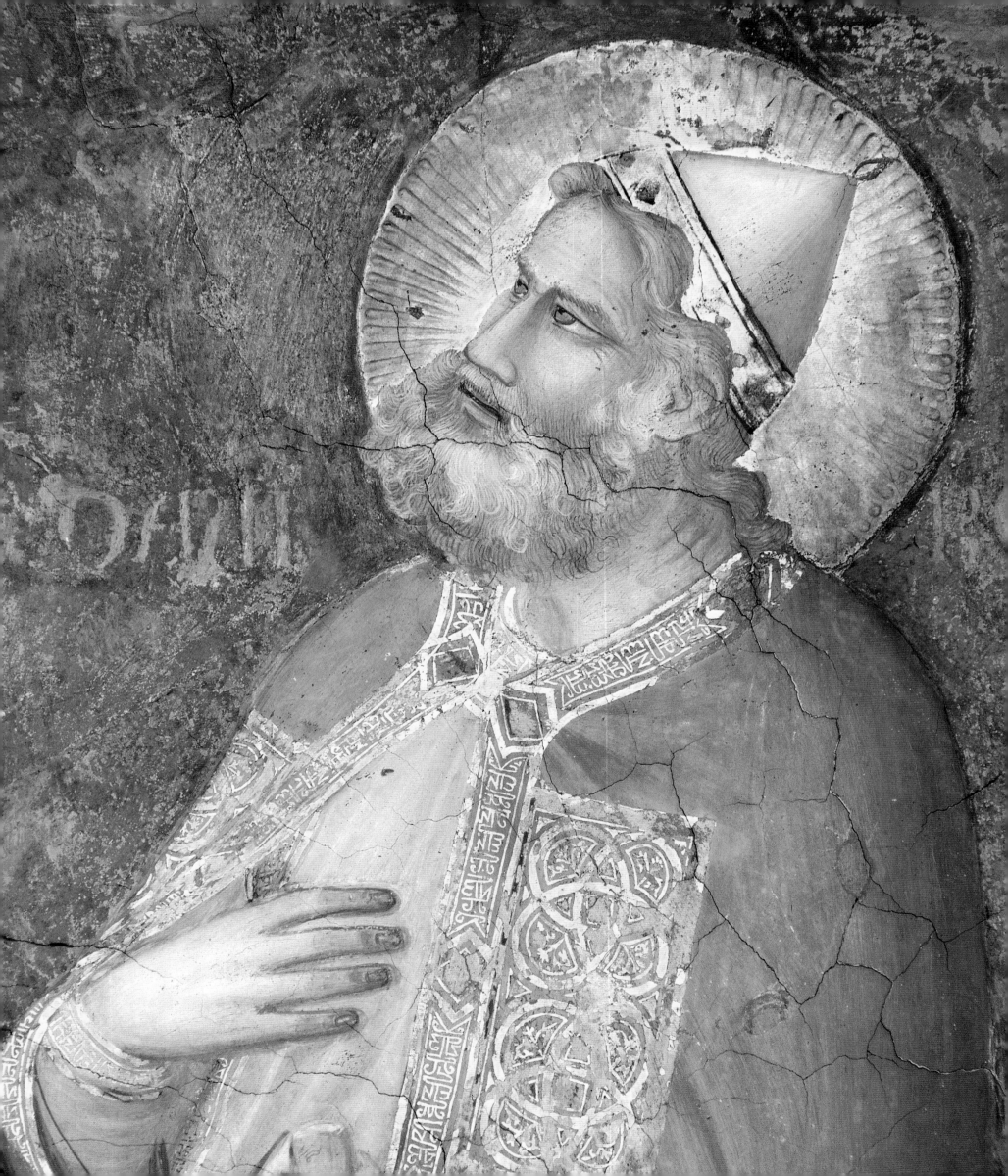

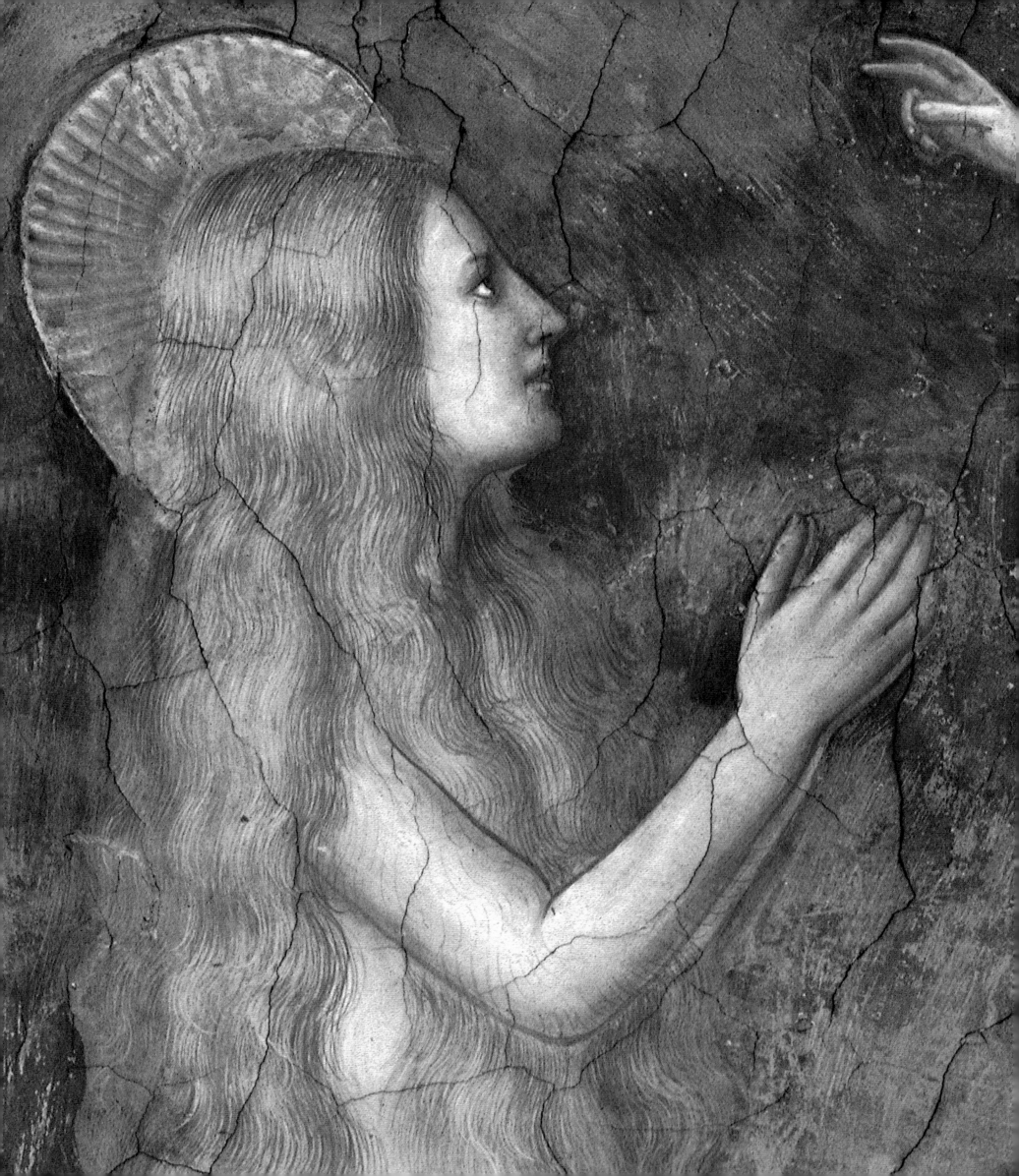

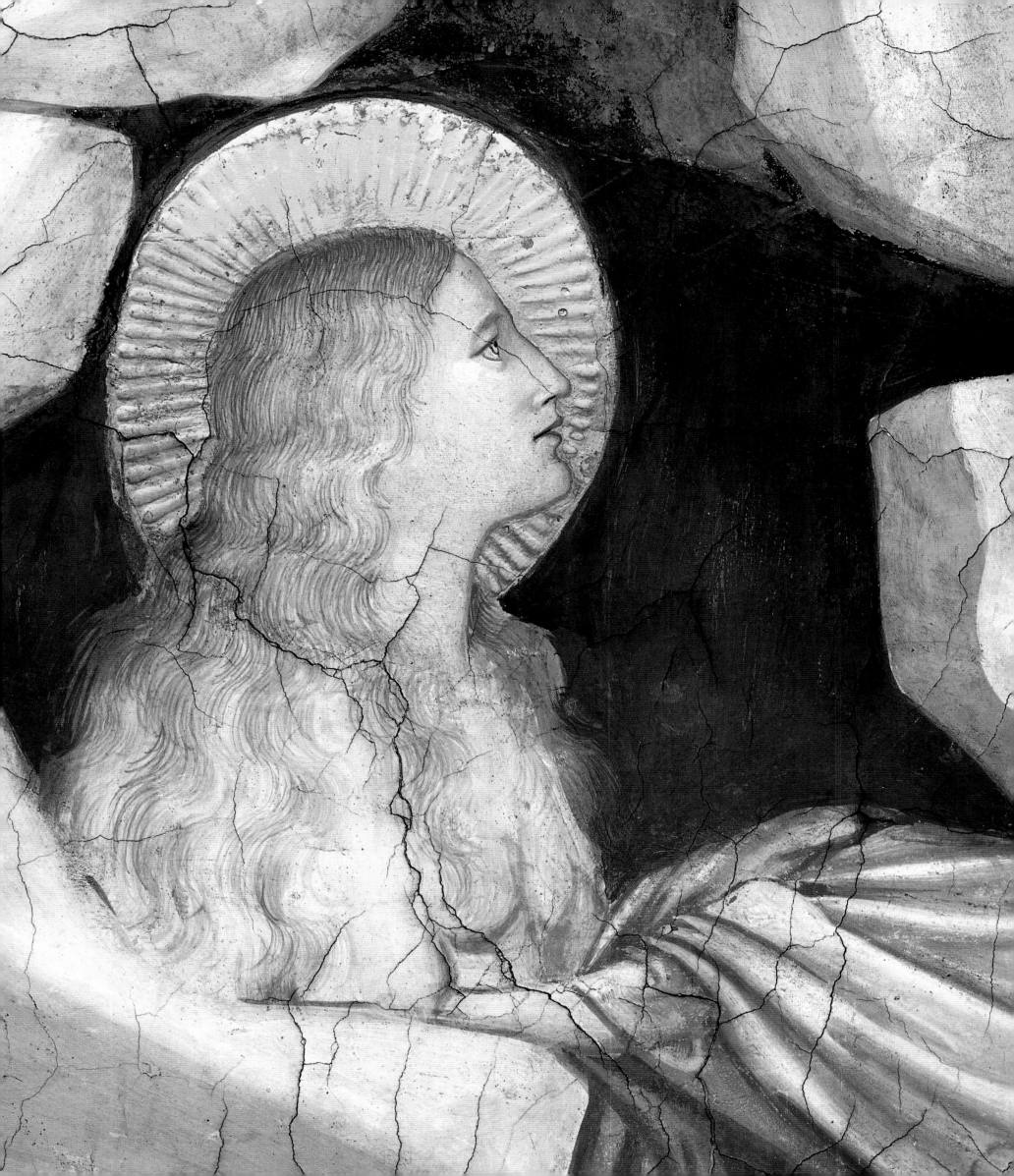

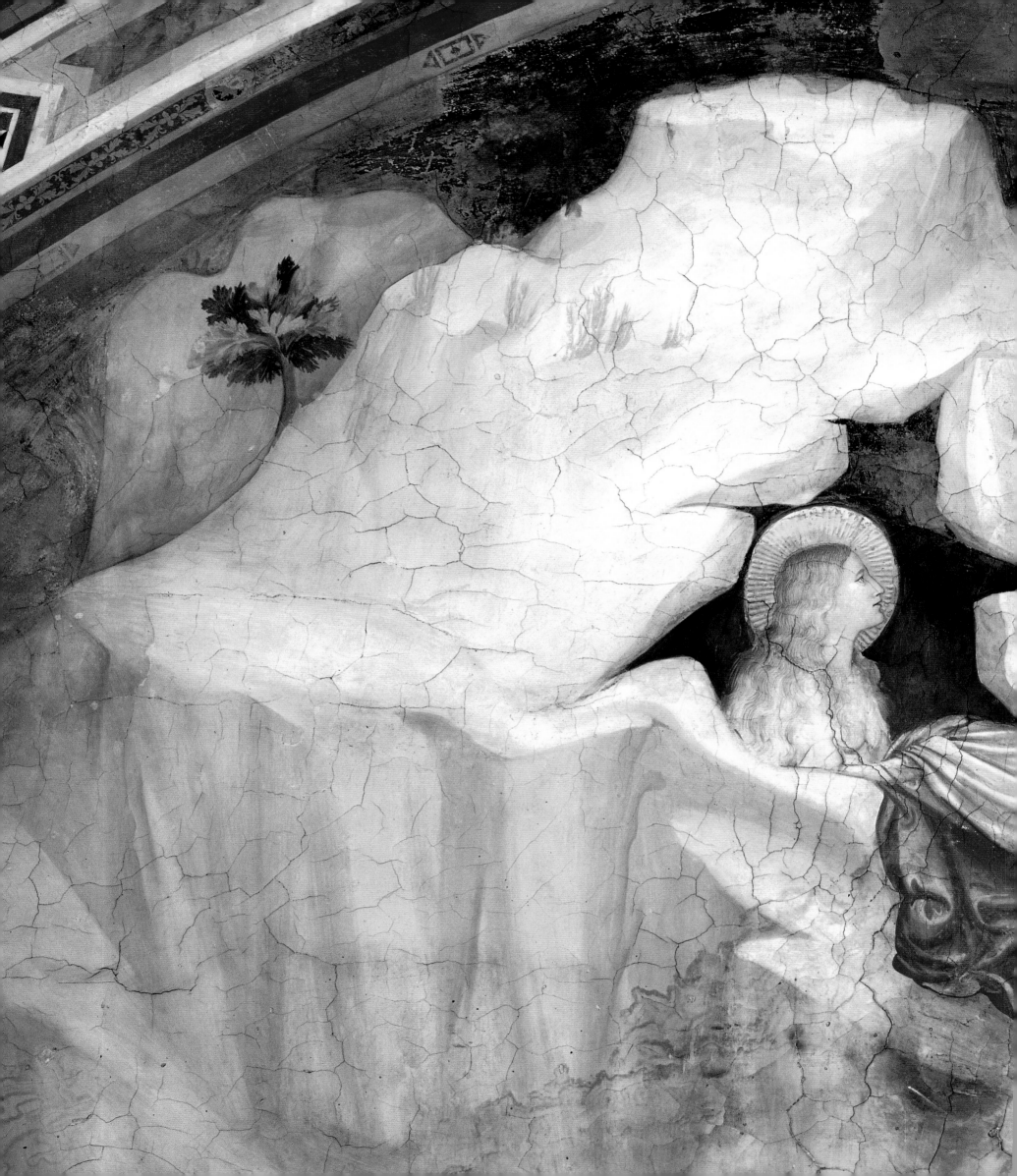

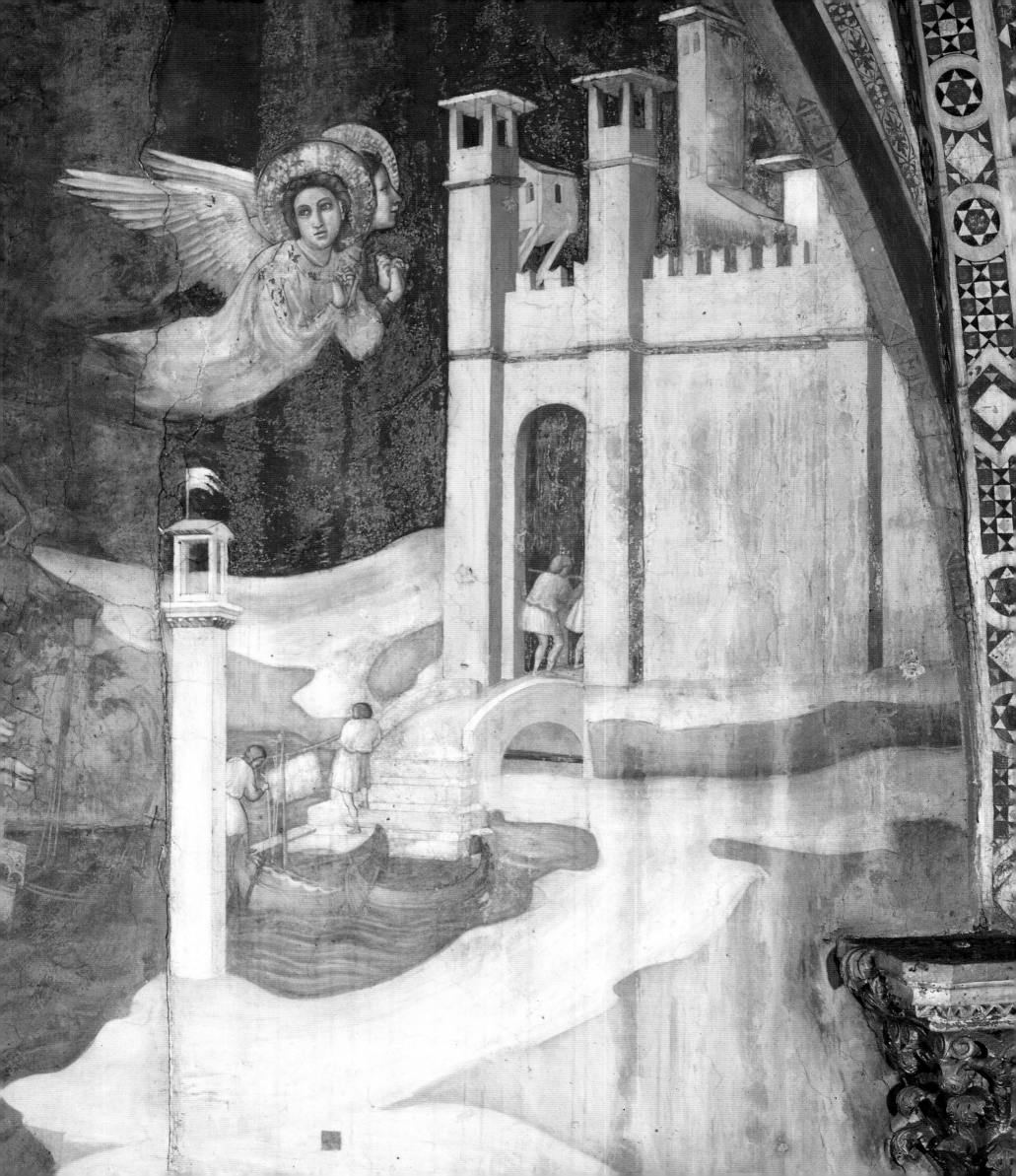

fisherman taken from the *Navicella* mosaic, but, as can easily be seen since the restoration, he is a little man stepping ashore from his boat.) The scene sets before us an enormous expanse of green sea, which reaches almost to the edge of the frame, in a bird's-eye view bordered on the right by a poetic view of the port with small boats, a foundering sailboat, and little people busy at their work, and on the left by a white rock: the expanse of water is animated only by the islet and the boat with the fugitives. This seascape was to influence Ambrogio Lorenzetti's equally poetic seascapes. ❧ WITHIN these settings, and against the simple, abbreviated architecture, the people are smaller, with less bulky and more slender structures, and move with greater agility. See, for example, the *Supper in the House of the Pharisee,* where the protagonist is the back of a small building with colored marble facing. ❧ THIS feature is even more evident if one compares the *Raising of Lazarus* in Padua, where the figures stand out and the mountain behind rises just enough to define the space as a kind of backdrop to this scene. Here the rock, colored as in Duccio's *Madonna in Glory,* is closed toward the top of the frame by the crossing of two mountains that contain and embrace the episode, which moves like a bas-relief. ❧ AN ANALOGOUS comparison can be made between the *Resurrection* in Padua, which is graduated in depth by the arrangement of the figures and by the audacious foreshortened view of the soldiers in the foreground, and the *Noli me tangere* in the Magdalen Chapel in Assisi, rhythmically marked off by the elegant little figures against the incandescent rock, which gathers in the entire scene and projects it forward. This picture should be read for its color, for its very simple but greatly expressive chromatic selection. The rock is illuminated in streaks by the raking light of dawn, the tomb is of pink marble, and Christ and the angels are robed in white; the interjection of Magdalen's dark red mantle is like a shrill cry. A profusion of gold is everywhere. In this scene the expression of emotion is enormous and yet restrained: the Magdalen's head and arm are thrust forward to touch the divine Master, but Jesus fends her off with an equally delicate gesture of his arm and hand. He appears in a ray of golden light, elegant in his figure and his face with its subtle and elongated features, recalling the characters being brought to life in those years by the very young Simone Martini. ❧ A RED flame ignites the Magdalen's soft dress of silk and gauze as she holds Pontano by the hand; the figures are set inside an elegant little structure between two twisted columns, in a white frame with red and gold motifs, before a precious slab of blue mock marble. The Magdalen is a solemn and robust figure, but the softness of the contour line and the fluidity of the robe's folds give her a slender appearance; her form should be read in a

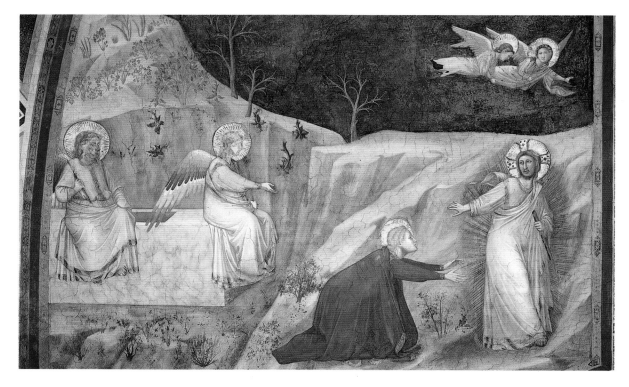

Giotto. NOLI ME TANGERE. *Magdalen Chapel, Lower Basilica of San Francesco, Assisi.*

Giotto. MARY MAGDALEN AND BISHOP PONTANO CLAD IN FRANCISCAN HABITS. *Magdalen Chapel, Lower Basilica of San Francesco, Assisi.*

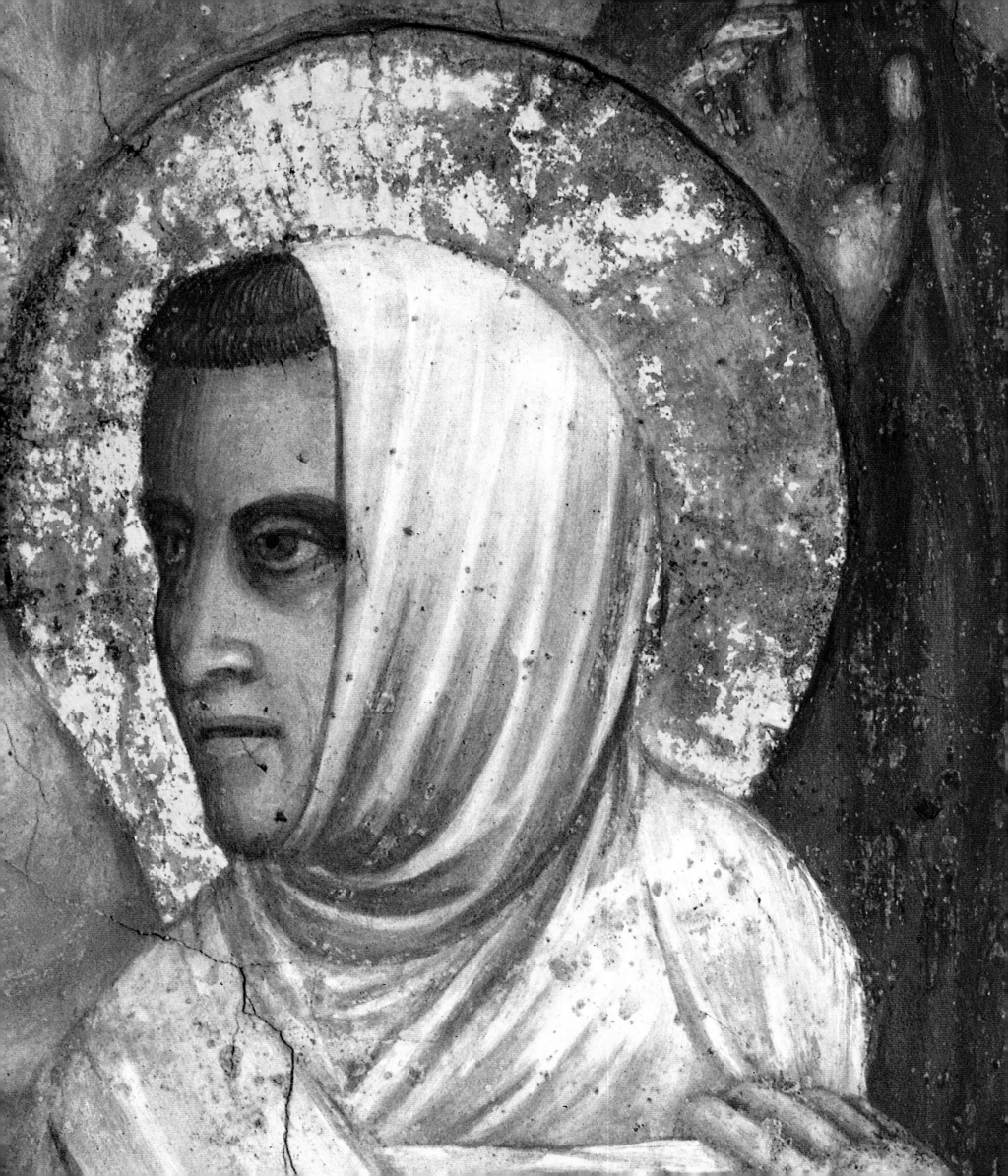

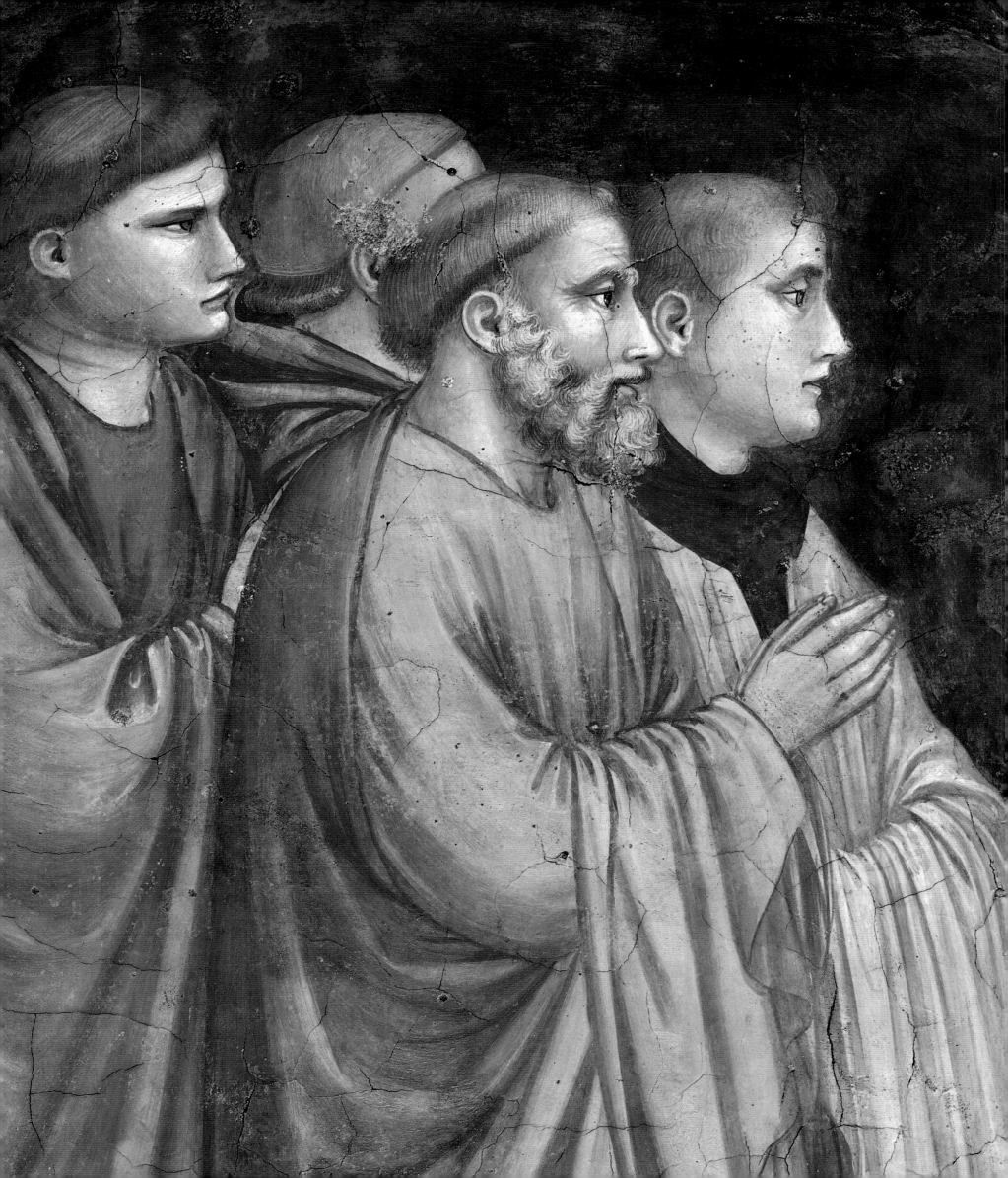

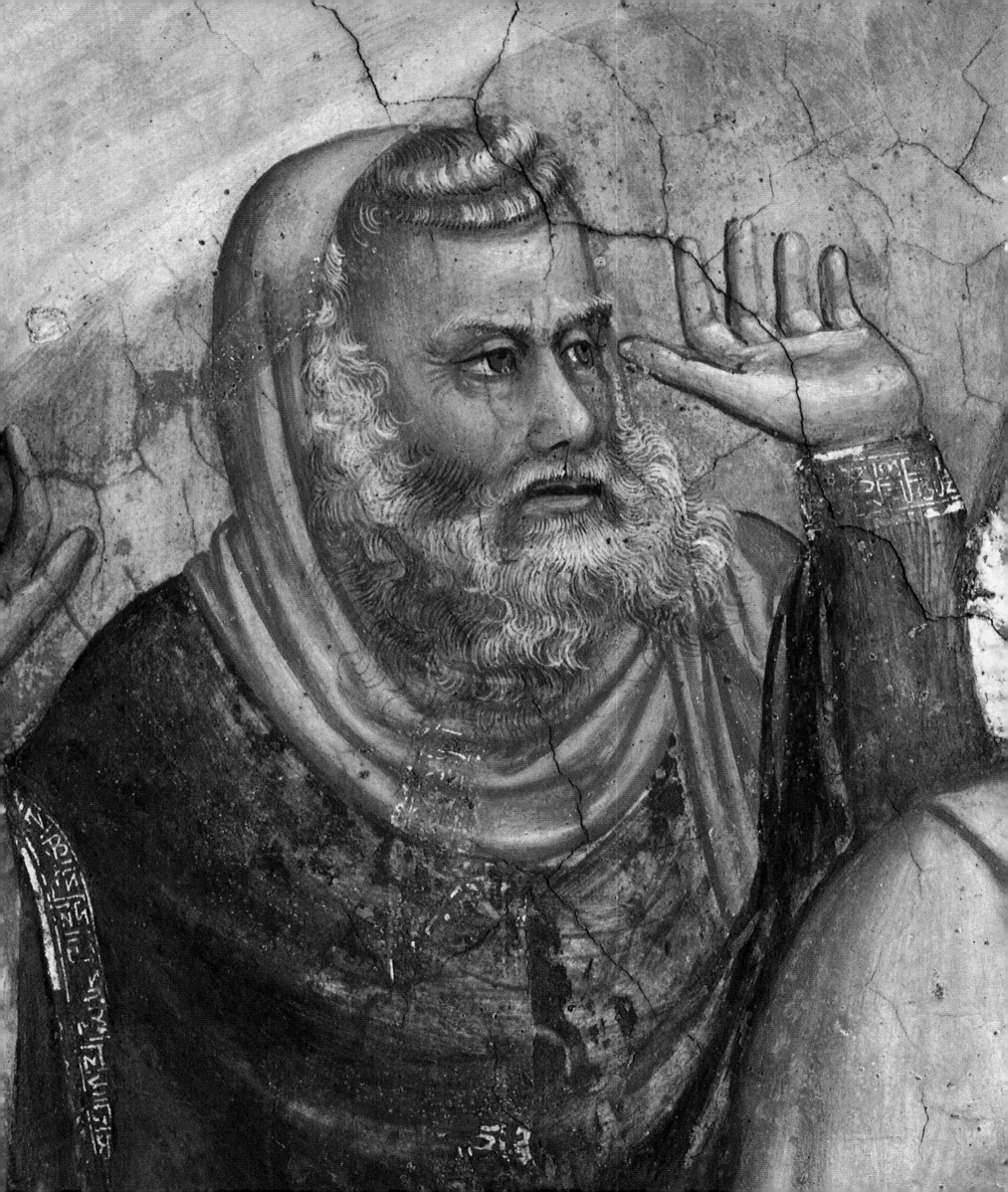

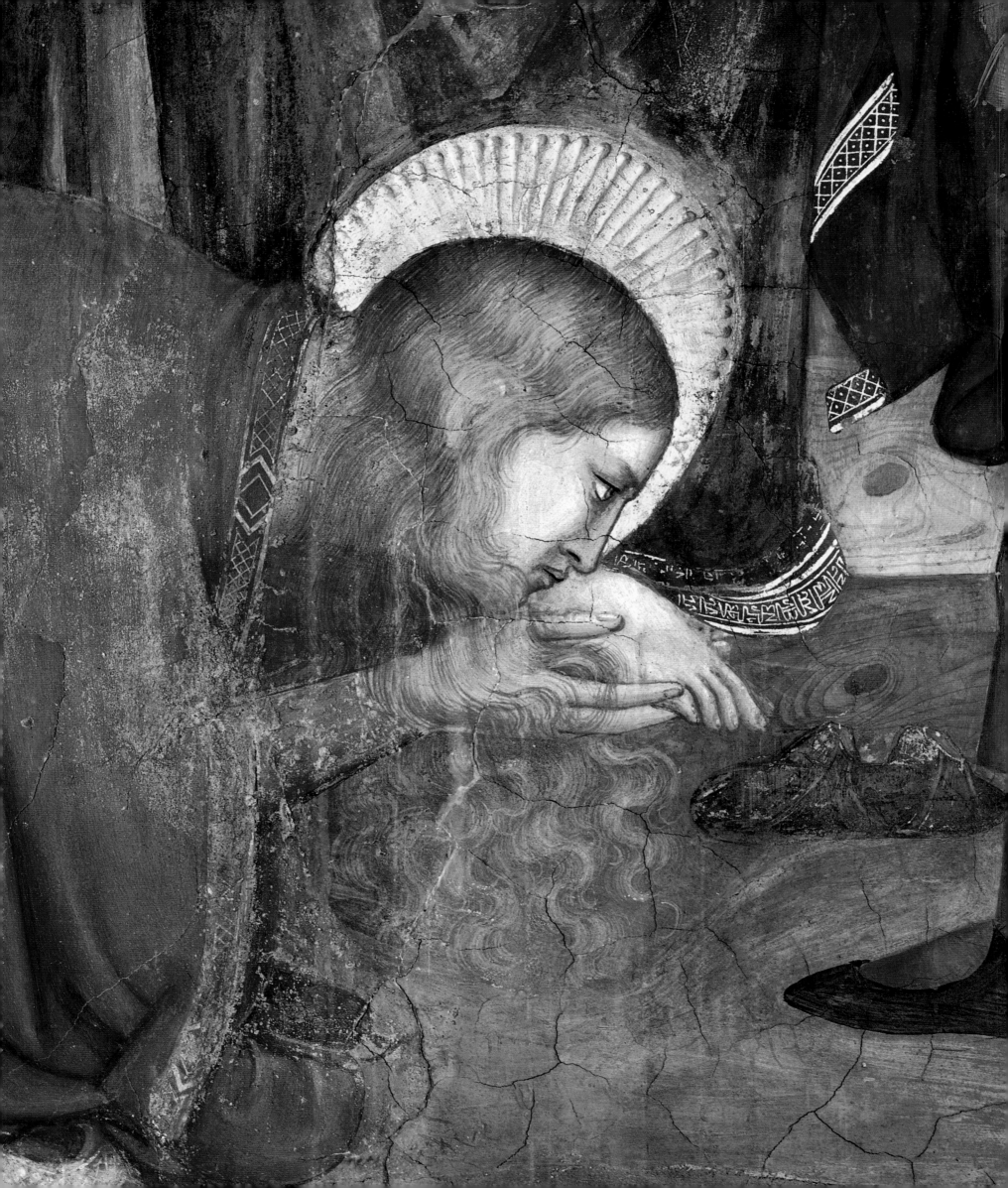

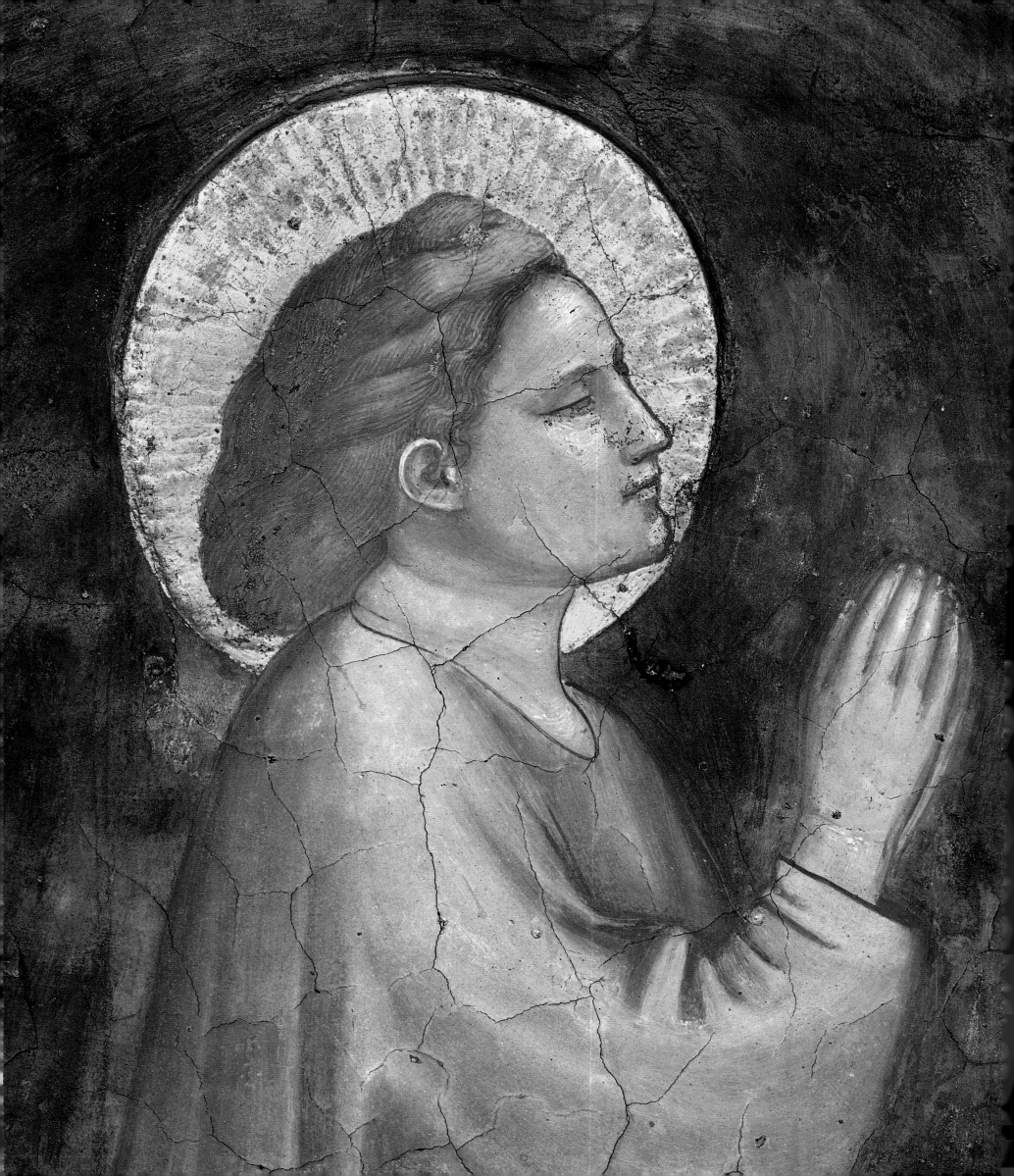

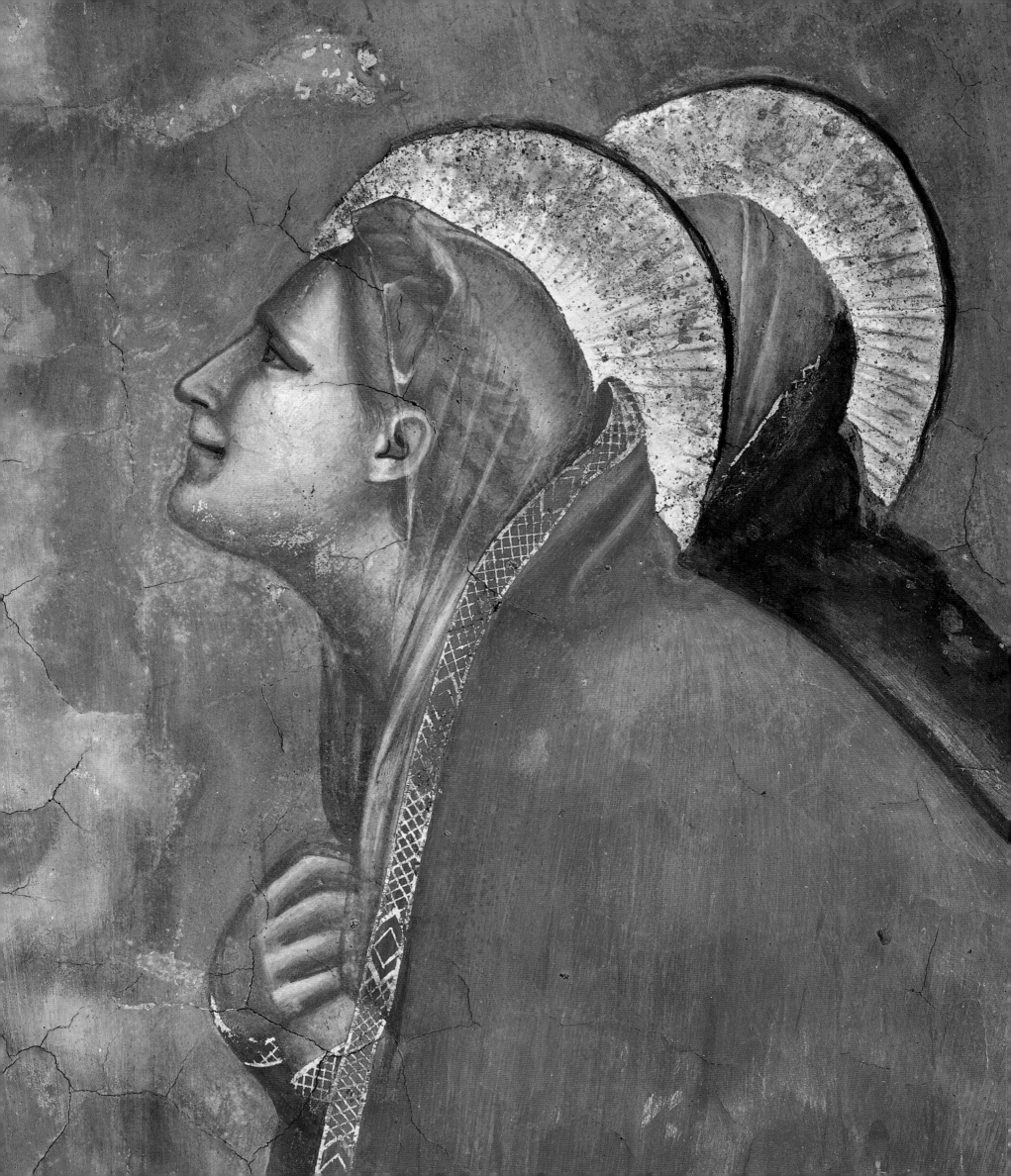

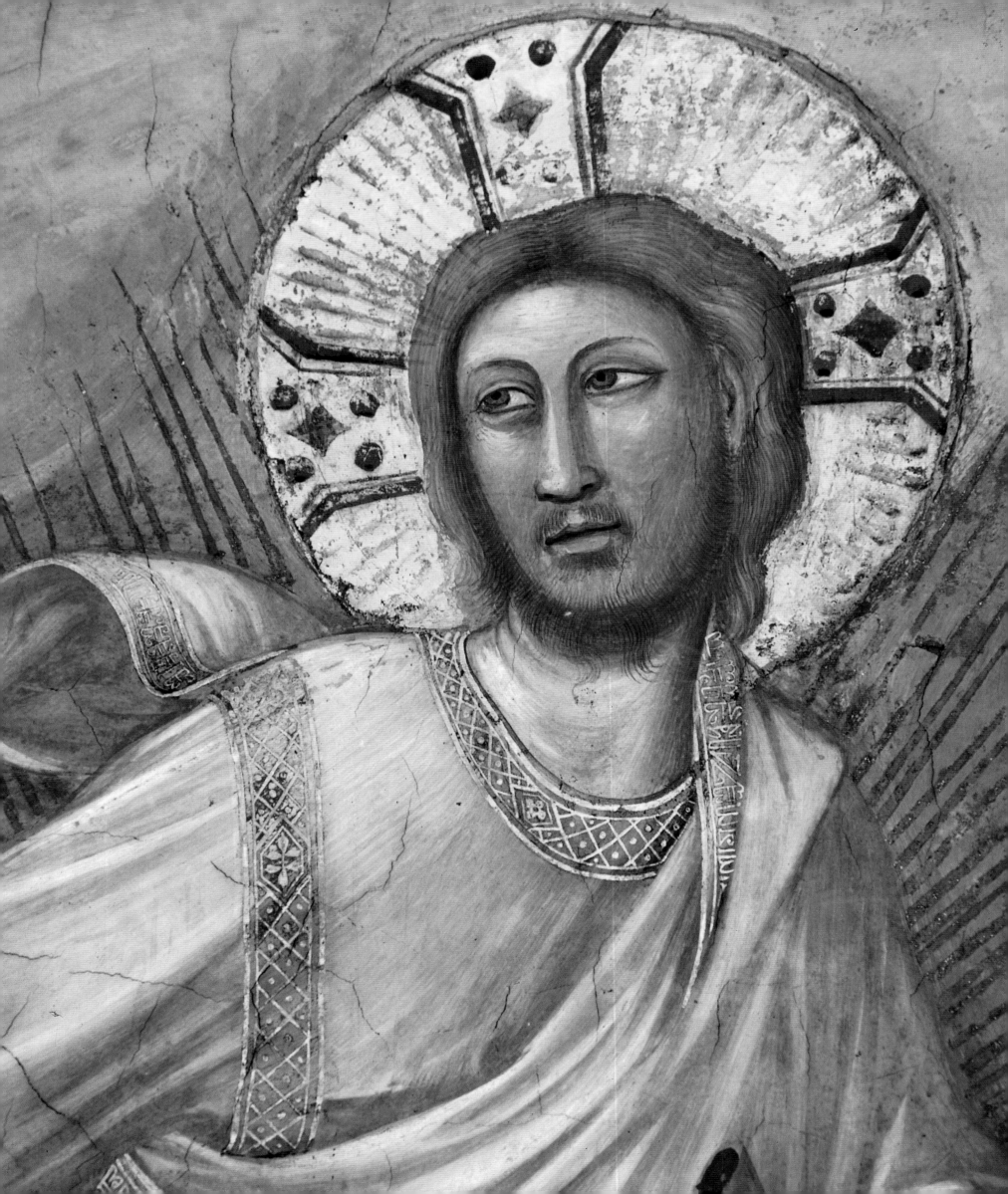

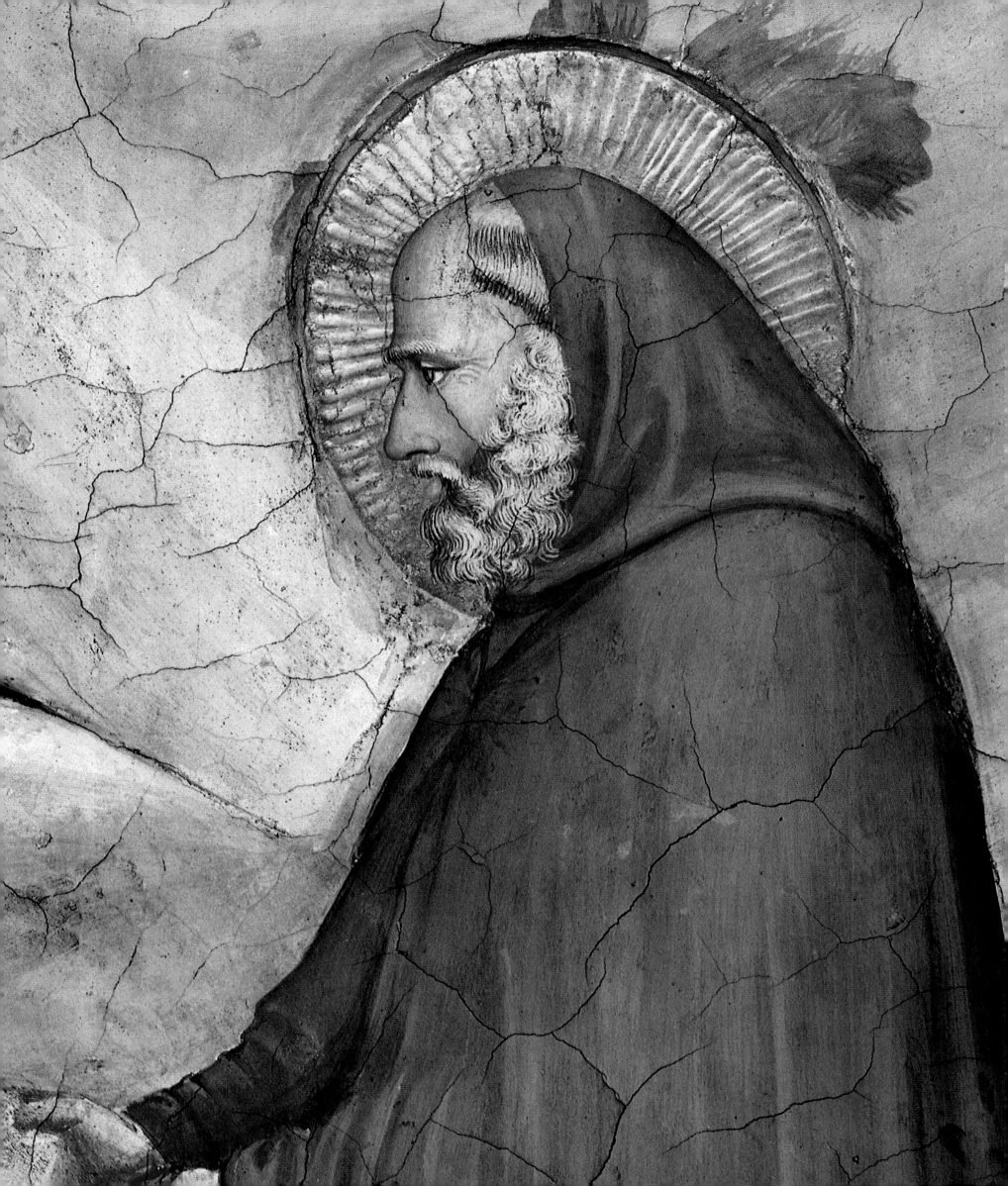

Gothic key also because of the slight sway of her elongated body and her small head, which has almond-shaped eyes in the French style. ❧ ST. RUFINO has an extremely delicate face and the slight nod of his head is almost a reference to Giovanni Pisano. His light green clothes are contained by a serpentine contour line that lightens his pyramidal shape. In the medallions on the ceiling appear the half figures of Christ and the saints: the Magdalen is again wearing a red robe, but Martha has a jewel-like violet dress, and Lazarus, wrapped in his shroud, is shown with a haggard, ghostly face: this marvelous invention reveals Giotto's fervid and extraordinary imagination. ❧ THIS cycle is full of innovative effects, and at the same time rich in theological and spiritual significance and affectionate attention to each person. In the *Noli me tangere,* for example, which is thick with gold, the hands and faces of the angels seated on the tomb are not painted but carved in gilded stucco. This is an effective and extraordinarily fresh depiction, already noted by Rotondi (1968), of the words spoken by Matthew the Evangelist, who described how the angel looked to the women: "His countenance was like lightning, and his raiment white as snow" (Matthew 28:3). ❧ FURTHERMORE, the idea of having the Magdalen, this pilgrim saint, ascend to heaven in a small boat supported by angels is exquisite. Giotto must have loved the Magdalen; in the *Magdalen Receives Communion* the saint, in a red robe, wears her blond hair gathered at the neck in a chignon that doesn't hide the hair but gathers it in a soft and luminous bun. This is a rare naturalistic observation, an homage to a beautiful woman who used her hair, of which the Bible speaks, as a weapon of seduction. ❧ THESE details denote an unusual imagination and an acute observation of reality; I believe that there can be no doubt about Giotto's authorship of this cycle of frescoes. But Giotto did not work alone here: though based on Giotto's design, the unquestionably elegant figures in the intrados of the entrance arch, all in bright clothes with warm reflections, are not by his hand, nor are those in the embrasure of the large window, nor probably even those on the back wall. Other artists painted some of the characters in the *Magdalen Receives Communion,* the *Raising of Lazarus* (certainly an assistant did the group on the left), and the entire compartment containing the *Supper in the House of the Pharisee.* In this cycle in any case it is possible to recognize and identify the assistants, as Previtali (1967) has very accurately done. The first is the so-called Master of the *Vele,* the painter responsible for the *vele* in the Lower Basilica's central vault, which are characterized by bright colors and faces with great staring eyes. A second painter, who also worked in the *vele,* paints persons with large faces scored by a dark contour line; and a third paints tiny figures with thin limbs. ❧ AT THIS

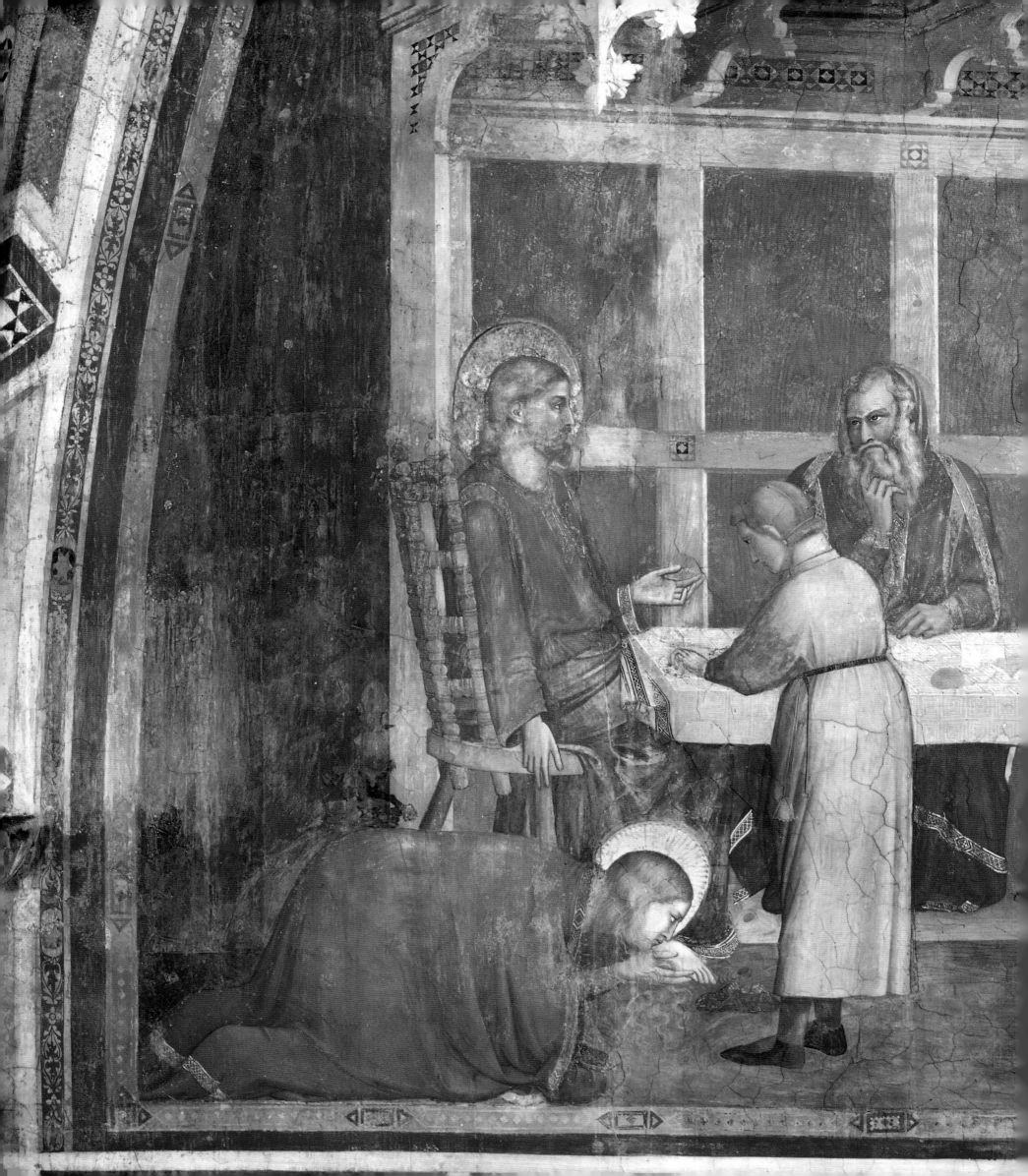

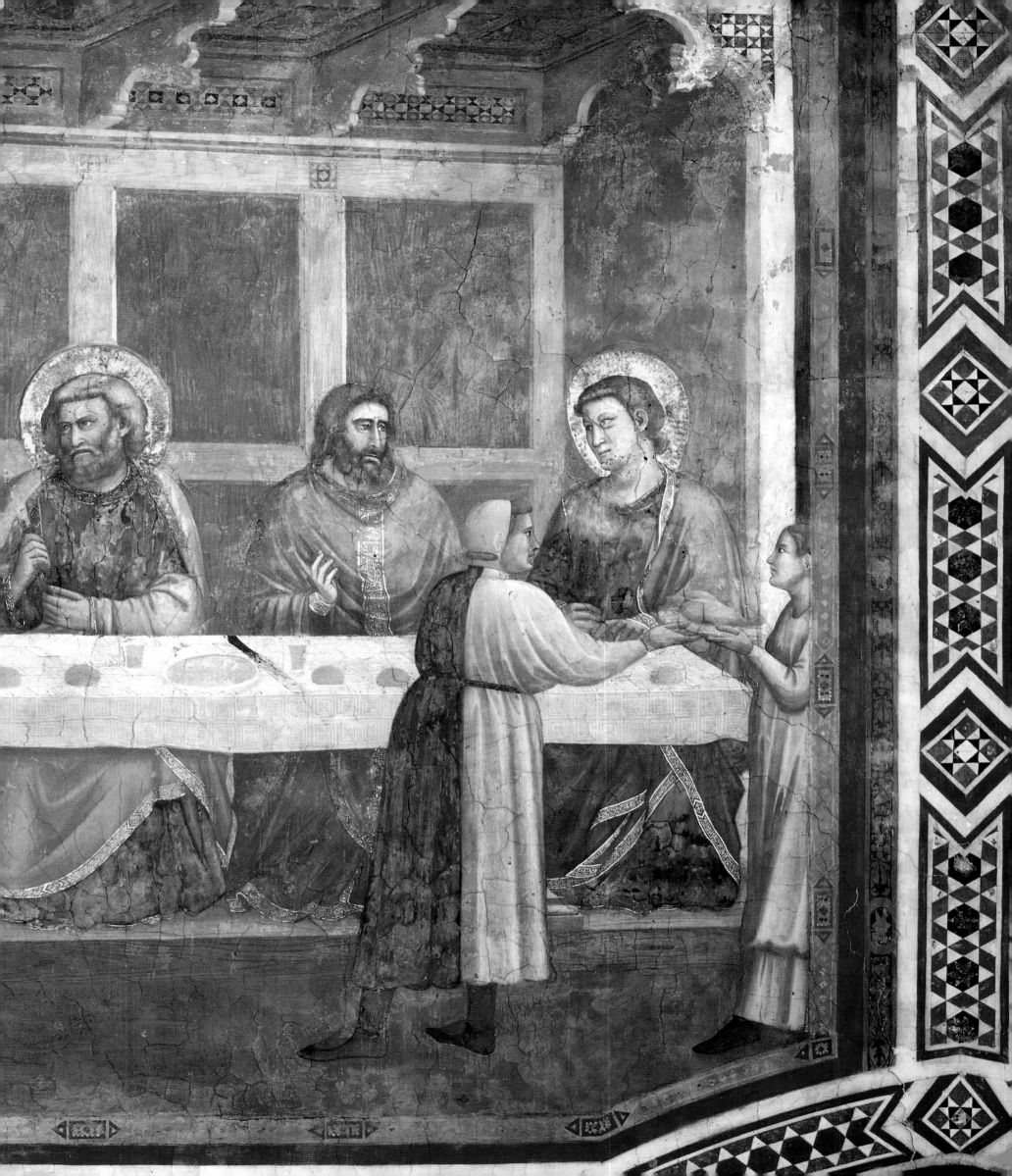

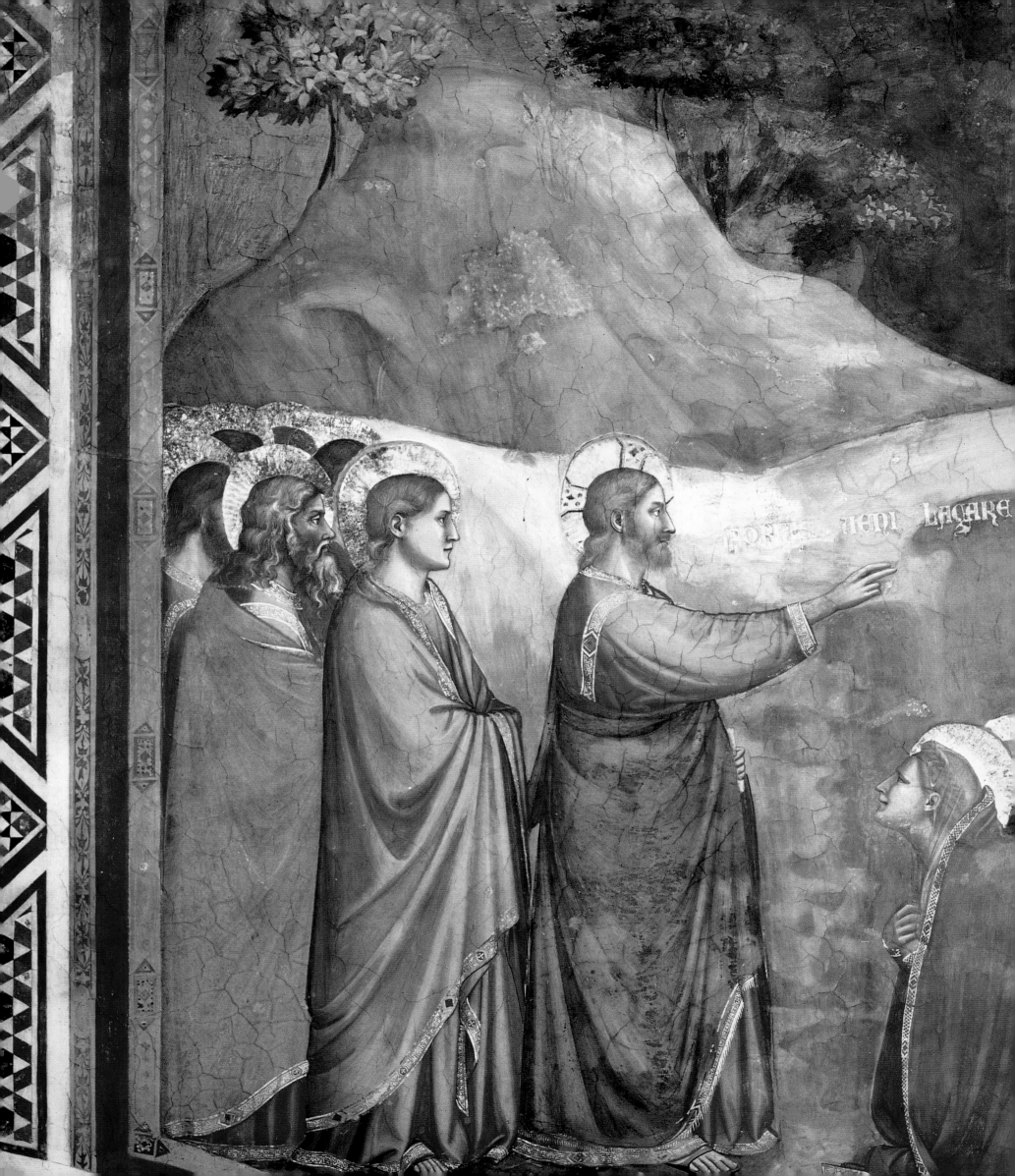

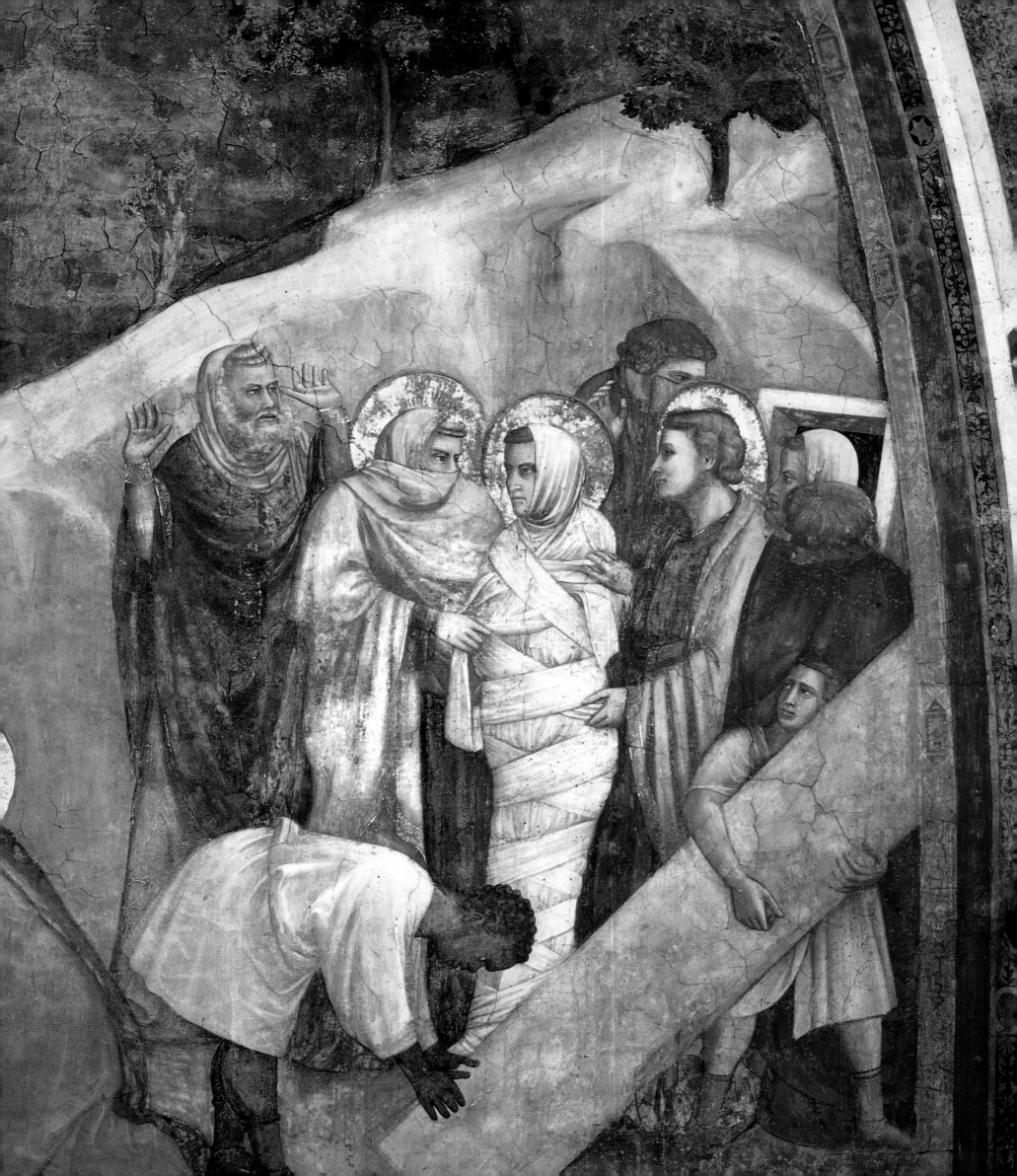

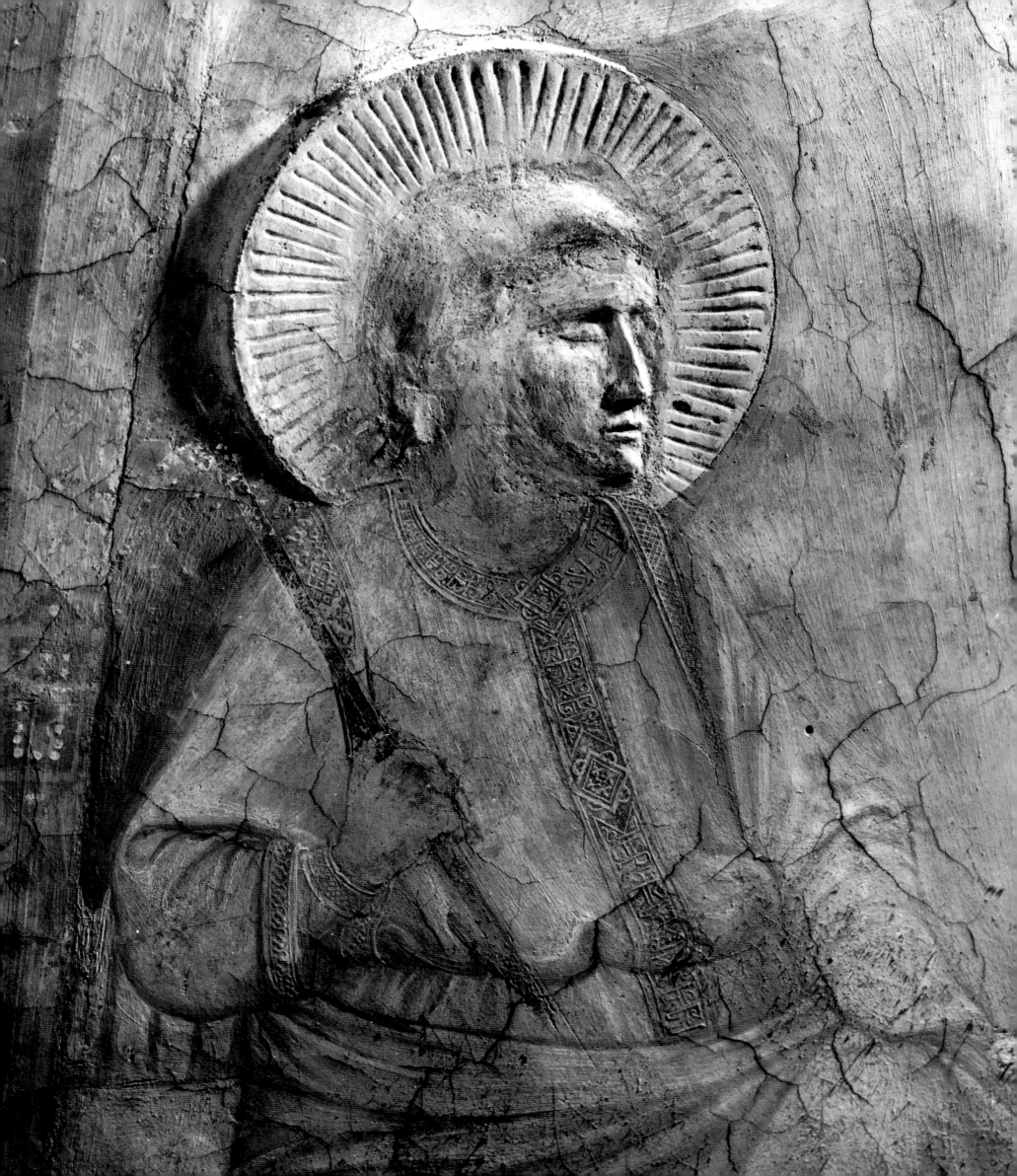

moment in Giotto's career his shop was very large and active and included interesting artistic personalities, who would work on their own soon after. Among the assistants some were certainly Umbrian, perhaps even from the city of Assisi. In the part of the decorations of the Lower Basilica done by the "Giottesque" assistants, one can sense at base a tacit unity of language, a repetition of typologies and colors that relates the different parts to one another and establishes a general tone for the entire work: from the San Nicola Chapel to the right transept, to the Magdalen Chapel, and to the *vele* of the central bay. These analogies and resemblances are due not only to a common Giottesque derivation but also to the presence of the same painters in all the various parts of the work. ❧ THE Magdalen cycle therefore marks an important moment in the evolution of Giotto's activity and language in a more modern Gothic direction; but it is also a central moment in the decoration of the Lower Basilica, inaugurating the luminous painting that one can find again in the frescoes of the central vault and in small passages attributed to Puccio Capanna. It also influenced the Sienese painters Pietro Lorenzetti and Simone Martini. Indeed, here begins the path of that "painting so fused and united" of which Vasari speaks, which was to characterize the most modern painting of the fourteenth century (Volpe, 1984).

GIOTTO'S PUPILS IN ASSISI: THE *VELE*

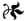

❧ THE succeeding moment in the decoration of the Lower Basilica is marked by the work on the *vele* of the vault at the conjunction of the nave and the transept; this vault soars above St. Francis's tomb (p. 304 left), the focal point of the basilica and its entire convent. ❧ THE *vele* (p. 304 right) describe the Franciscan Virtues: poverty, chastity, obedience, and the glory of the Saint in complicated allegories. The scenes are set against a gold background, which transforms the vault into the cover of a gigantic and precious reliquary. The compositions are absolutely symmetrical, with a strong sacral tone; the figures cluster around the principal nucleus in slightly rigid and repetitive poses, but they are characterized by an intense luminosity in the pale, transparent colors of their clothes and the precious quality of the fine ornaments, which stand out against the gold background. The entire

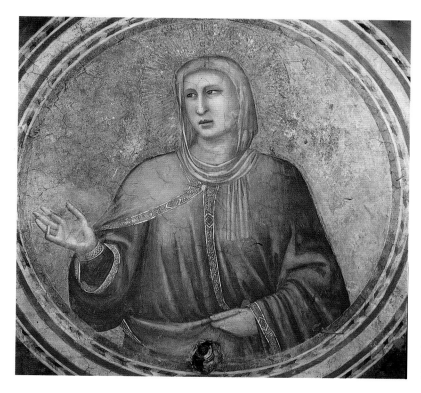

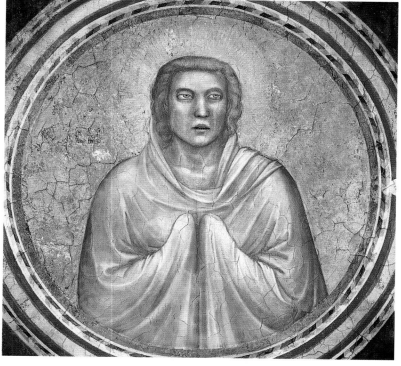

pages 298–99: Assistant to Giotto. SUPPER IN THE HOUSE OF THE PHARISEE. *❧ pages 300–301: Giotto and assistant.* RAISING OF LAZARUS.

❧ page 302: Giotto. Detail of NOLI ME TANGERE *(p. 288).*

ALL: *Magdalen Chapel, Lower Basilica of San Francesco, Assisi.*

Giotto. ST. MARTHA. *Magdalen Chapel, Lower Basilica of San Francesco, Assisi.*

Giotto. LAZARUS. *Magdalen Chapel, Lower Basilica of San Francesco, Assisi.*

complex, which has been attributed to Giotto by some, could have been conceived, or perhaps only suggested, by the master. But the realization of the scenes is certainly not by Giotto: they are dense with figures in a monotonously repetitive string of faces and great staring, inexpressive eyes; the characters and their poses are inert within their light clothes. AND yet the decoration emanates a subtle evocative power in the intense light of the pale colors, enriched by delicate nuances, and in the complex doctrine of the allegorical depictions. Scholars almost unanimously agree that the frescoes should be assigned to one painter, the Master of the *Vele,* who seems to have been one of Giotto's assistants in the decoration of the Magdalen Chapel and was helped in his turn by other artists already active in the preceding cycles of the Lower Basilica. THE chronology of the complex has been much debated: it could have been executed before 1319, when the city of Assisi was disrupted by the ferocious war there between the Guelphs and Ghibellines, which lasted for two years and left it impoverished. As is clearly evident in an examination of the plas-

ter, the paintings precede those in the left transept by Pietro Lorenzetti, for which a dating before 1320 seems valid (Cavalcaselle, 1885, recently reasserted by Volpe, 1965b, 1990). Thus the interesting proposal put forward by Gosebruch (1958), followed by Gnudi (1959) and Bologna (1969a), of connecting the vault frescoes with the year 1334—when Cardinal Stefaneschi became the protector of the Franciscan order—would appear out of the question. IN ANY case, though not by Giotto's hand, the *vele* reflect an interesting phase of his late painting. This phase was characterized by bright, radiant colors, by a reduction in size of the figures, and by compositions that recapture archaic and stylized elements, flattening spaces and expanding the figures on the surface. SCHOLARS stress the close compositional analogy, in its severe symmetry and the innovation of its spatial treatment, between the *vele* paintings in Assisi and the two late polyptychs—the Stefaneschi, preserved in the Pinacoteca Vaticana, and the Baroncelli, in the chapel of that name in Santa Croce in Florence.

Vault over the tomb of St. Francis. Lower Basilica of San Francesco, Assisi.

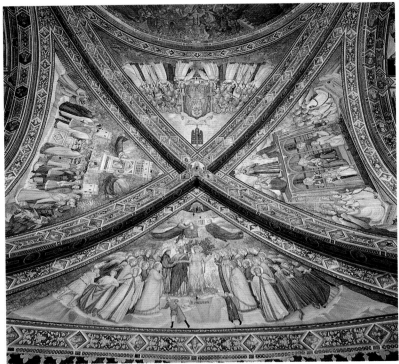

Master of the Vele, FRANCISCAN VIRTUES. *Lower Basilica of San Francesco, Assisi.*

FURTHER WORKS FOR CARDINAL STEFANESCHI

❧

❧ THE Stefaneschi *Polyptych* (pp. 306–7) in the Pinacoteca Vaticana stood on the central high altar of St. Peter's basilica in Rome and was commissioned from Giotto by Cardinal Jacopo Stefaneschi. The cardinal had also commissioned Giotto, probably at the same time, to do the entire decoration of the tribune of the basilica, which depicted (according to Vasari) five episodes from the life of Christ; these were destroyed in the sixteenth-century reconstruction of the church. Perhaps a brief trace of these can be seen in the two beautiful fragments of saints' heads with thin, delicate lineaments, recalling figures by Simone Martini, now in a private collection in Assisi. ❧ THE painting is two-sided, and each face has three compartments, of which the central one is slightly broader; the three compartments also include a predella. The cuspidated panels, now set in a modern frame, have very accentuated vertical points enclosing sharply pointed trilobed arches. ❧ THE front of the polyptych has simpler decoration on the pillars framing each panel with their Cosmatesque motifs. The central panel shows St. Peter enthroned in sumptuous white papal vestments with a red robe, attended by two blond angels in clothes with pink reflections, and by the two patrons, Cardinal Stefaneschi and Celestine V with a halo, each presented by their guardian saints. St. George presents Stefaneschi (the titular head of the church of San Giorgio in Velabro), and St. Celestine presents the pope. Peter's very plain throne with Cosmatesque decorations, almost a repetition of the more ancient papal thrones, rests on a beautiful pavement with pink-and-white marble inlays. The two lateral panels of the polyptych, shaped like a double window surmounted by a rose window, show two pairs of saints, with prophets and angels in the pointed arches above. Of the predella only the central part remains, with three figures of saints inside an engraved frame. ❧ THE back (p. 310) is more complex: in the center panel Christ sits immobile in blue clothes inside a very tall chapel-like throne, encircled by angels; and at his feet kneels the figure of the work's patron on a sumptuous Oriental carpet. In the left panel is the *Crucifixion of St. Peter* (p. 312): the scene is symmetrically constructed and framed laterally by two white structures, a narrow pyramid and the so-called Meta Romuli, indicating that the site is Rome and the Vatican. Above, St. Peter is carried to heaven in a blue mandorla borne by angels, while two angels in flight also surround the cross. The perfect

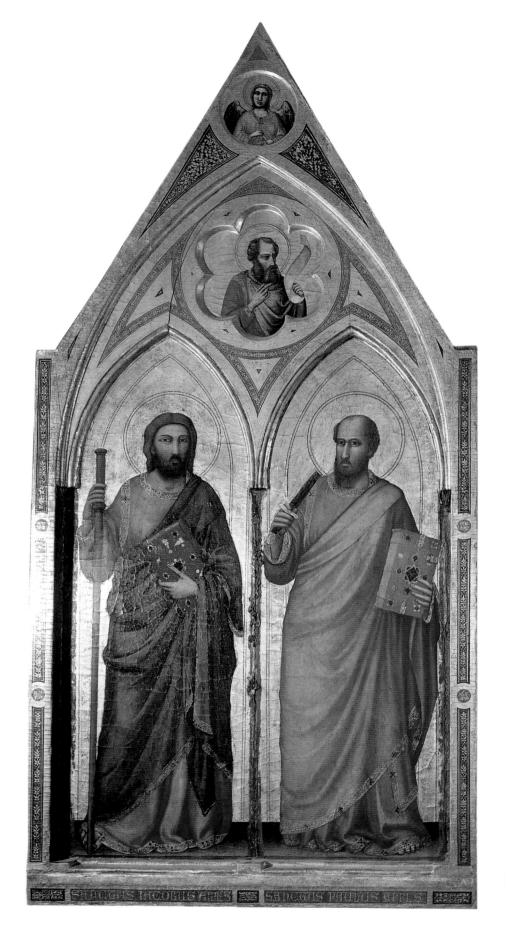

Giotto and assistants. Stefaneschi
POLYPTYCH, *obverse. Tempera*
on panel, 70⅛ × 99⅛ in. (178 ×
252 cm), overall. Pinacoteca
Vaticana, Vatican City.

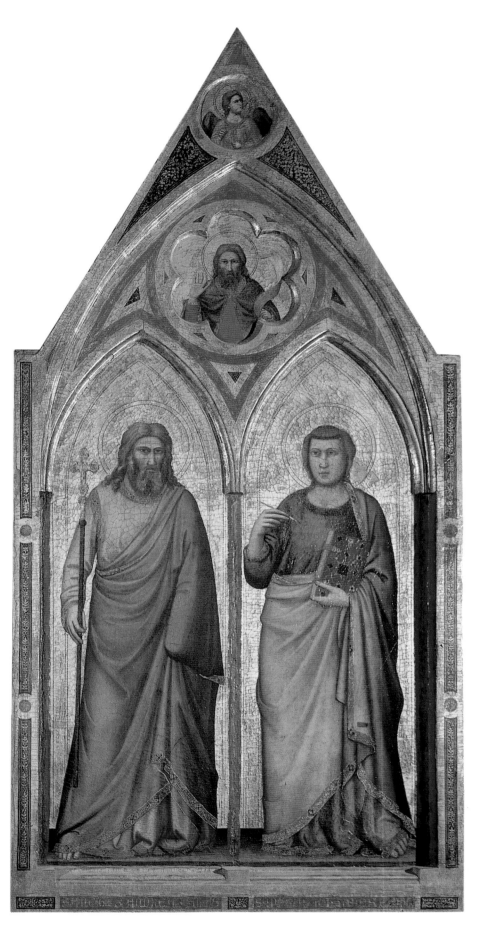

symmetry of the composition is repeated in the two facing groups of the faithful, many of them women with dresses in bright colors, painted in lively contrasting pinks and greens. The panel on the right is the *Beheading of St. Paul* (p. 313): the scene takes place against the background of a schematic landscape, formed by two large rocky masses descending in a gentle, curvilinear profile and enriched by intensely green trees and a small red tower, which encloses the scene, clustering the figures in the foreground. The two groups are composed so as to follow the fall of the rocks and linked by the body of the saint in bright pink; the onlookers are painted in bright and effective colors, red and dark green; on the summit of the hill at the left Plautilla lifts her hands to receive St. Paul's blood-streaked cloth, while the saint himself appears in a *mandorla* supported by angels, and in the depths of the sky fly two little angels in blue veils. ❧ THE central part of the predella shows the Madonna in a classical throne with a curved backrest, meditatively withdrawn and wrapped in a blue mantle; on the side are two angels in pink with very beautiful censers, and saints Peter and John. In the pillars that divide the three compartments are little figures of the prophets, while in the three pointed arches are three medallions with the Eternal Father and two prophets; small medallions with heads of the saints also appear in the lobes of trilobed arches. ❧ THE scholarly literature on the polyptych is vast (see in this regard Volbach's index of 1979): the first mention is by Ghiberti, who writes, "and of his hand he painted the chapel and the panel in St. Peter's in Rome"; the information is repeated by Vasari. But only Grimaldi in the seventeenth century, while describing St. Peter's basilica, mentions the name of the commissioner, Cardinal Jacopo Stefaneschi, taken from the *Liber benefactorum* (kept in St. Peter's Chapter Archive): for the year of the cardinal's death, 1343, there is written, "he donated the panel painted by the hand of Giotto over the holy altar of the same basilica; the panel cost 800 gold florins." Although almost all scholars agree with the identification of the polyptych mentioned by Grimaldi with the one now in the Pinacoteca Vaticana, many have divergent opinions concerning the autograph of the painting and its chronological placement. The first scholar who attributed the work to Giotto's workshop was Rintelen (1912), and his opinion was adopted with different nuances by various scholars, such as Toesca (1929), Offner (1939), Berenson (1937), Gnudi (1958), and recently Brandi (1983). For Previtali (1967) this is a work by Giotto and his assistants, among them Taddeo Gaddi and the Relative of Giotto. But Gosebruch (1958), Gioseffi (1971), Bologna (1969a), Gardner (1974), Bellosi (1981), and Bandera Bistoletti (1990) insist on Giotto's autograph. With the single exception of Gardner (1974), who argues that the

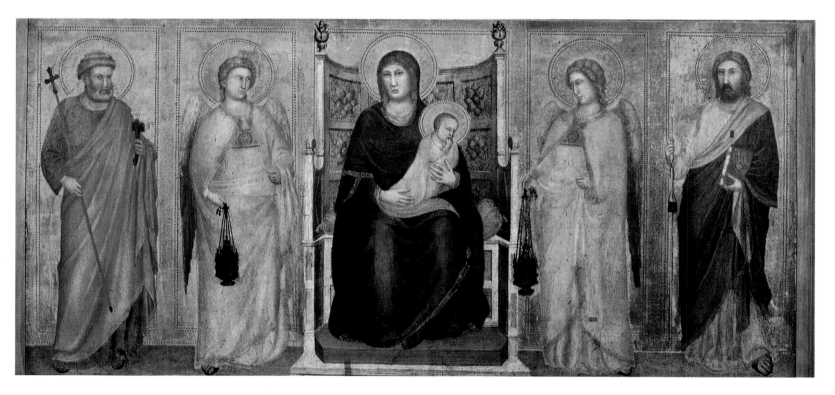

Giotto and assistants. Detail of Stefaneschi POLYPTYCH, *reverse of the predella (p. 310). Pinacoteca Vaticana, Vatican City.*

polyptych was made before the Scrovegni Chapel, scholars consider it a late work; Gnudi and Bologna say it was painted by Giotto during his stay in Naples. ❧ SINCE Celestine V is depicted with the halo of a saint, the polyptych could not be dated before 1313, the year of his beatification. But many elements of the style lead me to accept 1320, the date proposed by Grimaldi (1619), which the historian says he read on the frame of the painting itself. The painting was from the start much admired and celebrated, so much so that copies were immediately made of it; among the most interesting are the *Crucifixion of St. Peter* in the Museo Horne in Florence, and the *Beheading of St. Paul* in the Van Marle collection, both Florentine works from the early fourteenth century. ❧ THE painting proposes archaic and at the same time very modern elements, which can cause a certain confusion. The very form of the polyptych is extraordinarily modern, as can be seen in the little model of it being offered to St. Peter by the cardinal. It is a consummately Gothic triptych, articulated in its structure like a small building or reliquary: the model exhibits the system of pediments, spires, and spikes that crowned and embellished the grand object. But the individual panels also have an architectonic layout, in the cornices with trilobed arches and in the subdivision of windows in the lateral panels with figures of saints, the small rose windows inside the

pointed arches, and the strength of the pillars adorned with tiny figures like the portals of a cathedral. Moreover, in comparison to the linear simplicity of Florentine paintings, the decorative and figurative richness, as profuse as in a reliquary, is new. See the tiny heads that adorn the lobes of the frame, and the alternating blue and red pillars in Cosmatesque style on the verso. Precious objects, such as the beautiful tiles in the pavement, the Oriental carpet, and the golden censer, are even more numerous. ❧ THE glorification of St. Peter and thus of the papacy could not find a more sumptuous and modern image than in the frescoed tribune. And perhaps it is the sacramental aspect of the images that induces the painter to present a structure that appears archaic in its rigid symmetry above all. The light is frontal, and thus petrifies the figures in an intense, diffuse glare—bereft of the usual chiaroscuro—almost a repetition of sacred Byzantine images. The figures of the saints in the wings are majestic, enveloped in deep draperies without sharp folds, as in the Peruzzi frescoes, and particularly in the figures beneath the entrance arch to the Magdalen Chapel in Assisi. ❧ IF THE compositions on the front display a characteristic compression of the space, as though the figures were thrust forward—look at the tight perspective of St. Peter's pavement, which elevates the figure of the saint and brings it out—the verso accentuates some of these elements. The throne here is

Giotto and assistants. Detail of Stefaneschi POLYPTYCH, *obverse (pp. 306–307), with Cardinal Stefaneschi offering a model of the polyptych to St. Peter. Pinacoteca Vaticana, Vatican City.*

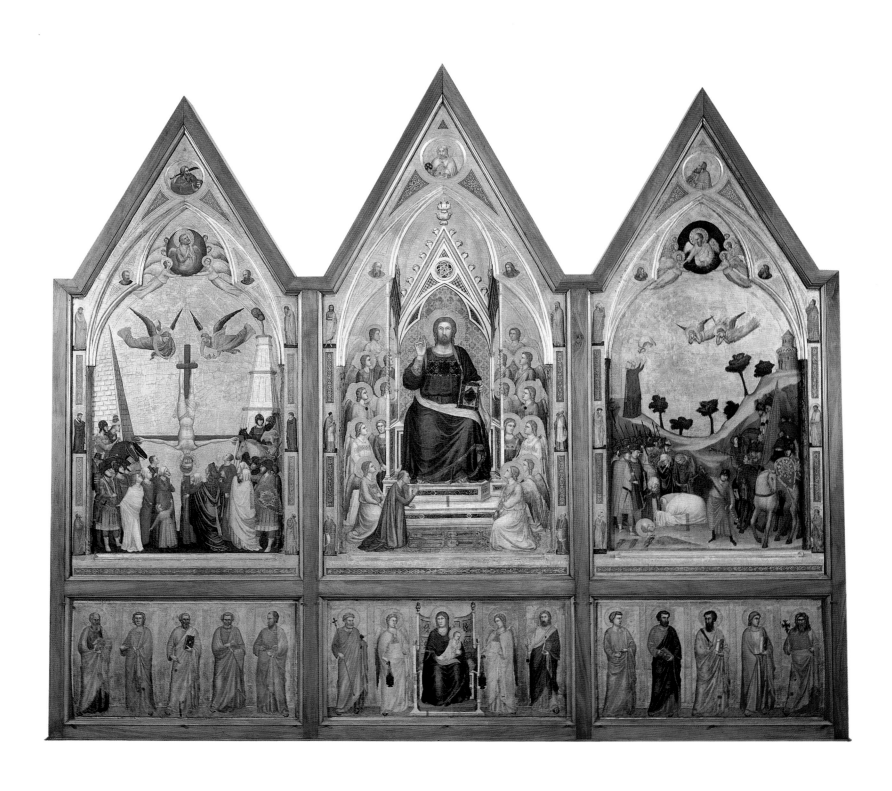

Giotto and assistants. Stefaneschi
POLYPTYCH, *reverse. Pinacoteca*
Vaticana, Vatican City.

very tall, but not particularly deep, and it is backed by a precious cloth arabesqued in gold; the elongated figure of Christ is also projected forward in a static, stylized pose, wrapped—almost bandaged—in soft rather than sharp drapery, almost lacking in body. The angels are arranged one next to the other until they go beyond the curve of the frame; the effect, while certainly not naturalistic, is extraordinarily effective from the liturgical standpoint: it is a return to the Madonna in Glory style of the late thirteenth century. ❧ AN ANALOGOUS sacral effect is achieved in the figures of the saints in the lateral panels and in the predella, and particularly in the beautiful figure of the Madonna, enclosed in her blue robe like an Oriental icon. ❧ BY CONTRAST, the climate in the scenes from the martyrdoms of St. Peter and St. Paul in the lateral panels of the verso is completely different and very original. The episodes are handled with a singularly fresh narrative ease, translating the highly dramatic moments into lively little scenes, where the protagonist is the crowd of those "tiny figures" of which Vasari speaks when discussing Giotto's late works. The *Crucifixion of St. Peter* is wedged between two white structures. The horizontal arms of the cross seem to rest on these structures, and they cut the composition in two: the two angels flying above in absolutely symmetrical positions shut off the earthly space like curtains, while higher still

St. Peter is transported to heaven by multicolored angels. In this episode too the spatial compression is absolute: the gold background is closed, and the ensemble of white constructions and the cross form a backdrop parallel to the foreground where the people move. All these figures are quite beautiful, particularly because of the choice of colors, some of them very new, like the intense green, dear to the taste of the "international Gothic," worn by the woman seen from the back, traversed by a long pink tassel that dangles from her hood. ❧ EVEN fresher is the *Beheading of St. Paul* in a landscape studded with dark trees, where once again the protagonist is the crowd, caught in attitudes of grief, lit up by vivid colors: the red of the executioner, the pink of the saint's mantle, and the blue of the two little flying angels. The horses, who deserve a place among Giotto's more careful depictions of animals, are also vivid. Very new and full of poetry is the portrayal of Plautilla, standing tall on the hill, who receives the saint's blood-streaked cloth with an affectionate gesture. The saint in glory continues to feel earthly emotions and leans out of the mandorla in a singular colloquy with the woman who, on her side, manages to carry on a dialogue with heaven. ❧ THE polyptych is an extraordinary work from the coloristic standpoint, with its choice of rare and precious tones and its lively juxtapositions, especially in the lateral back panels. The front is

page 312: Giotto and assistants. Stefaneschi POLYPTYCH *(p. 310), detail of reverse,* CRUCIFIXION OF ST. PETER. *Pinacoteca Vaticana, Vatican City.*

page 313: Giotto and assistants. Stefaneschi POLYPTYCH *(p. 310), detail of reverse,* BEHEADING OF ST. PAUL. *Pinacoteca Vaticana, Vatican City.*

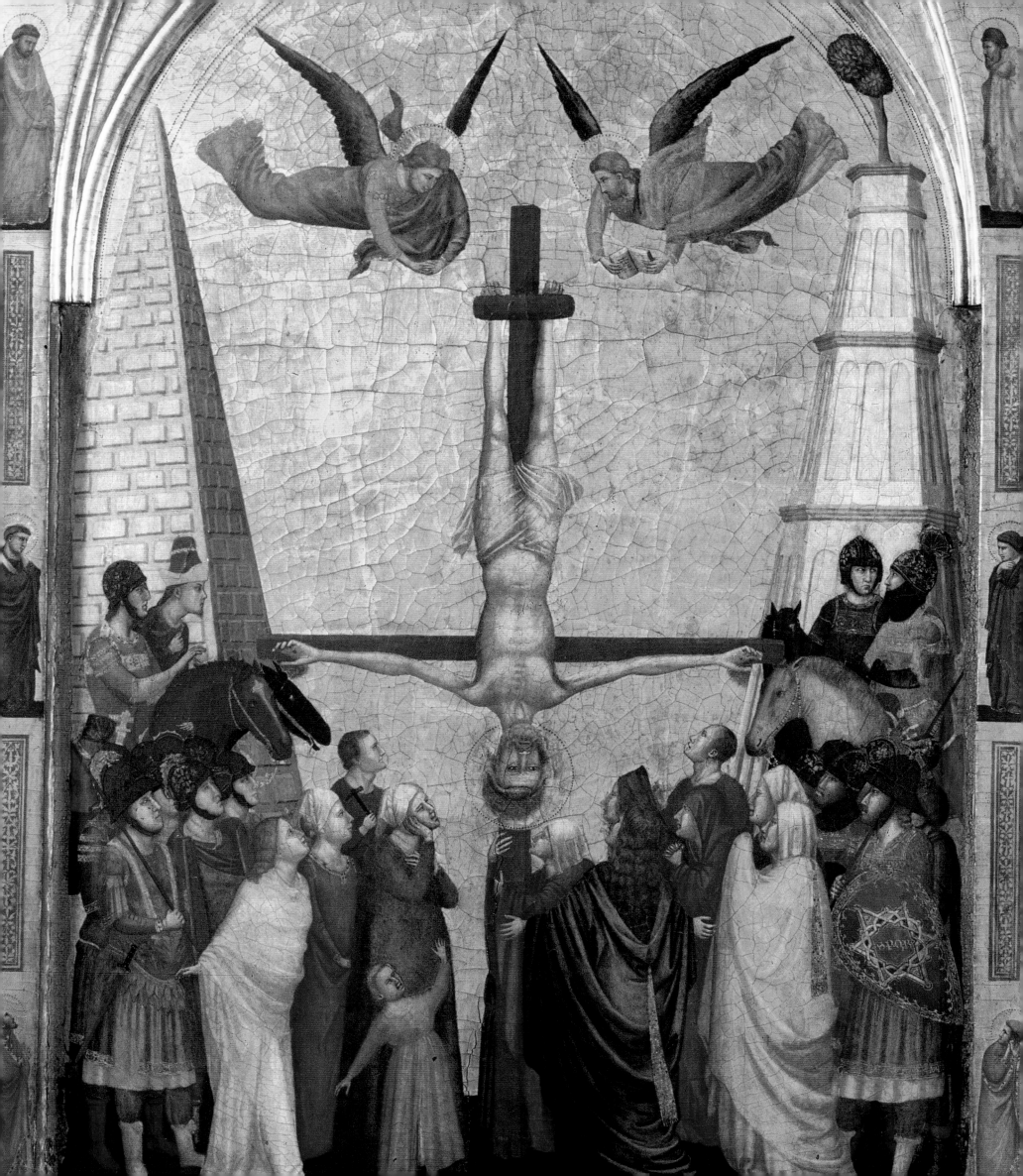

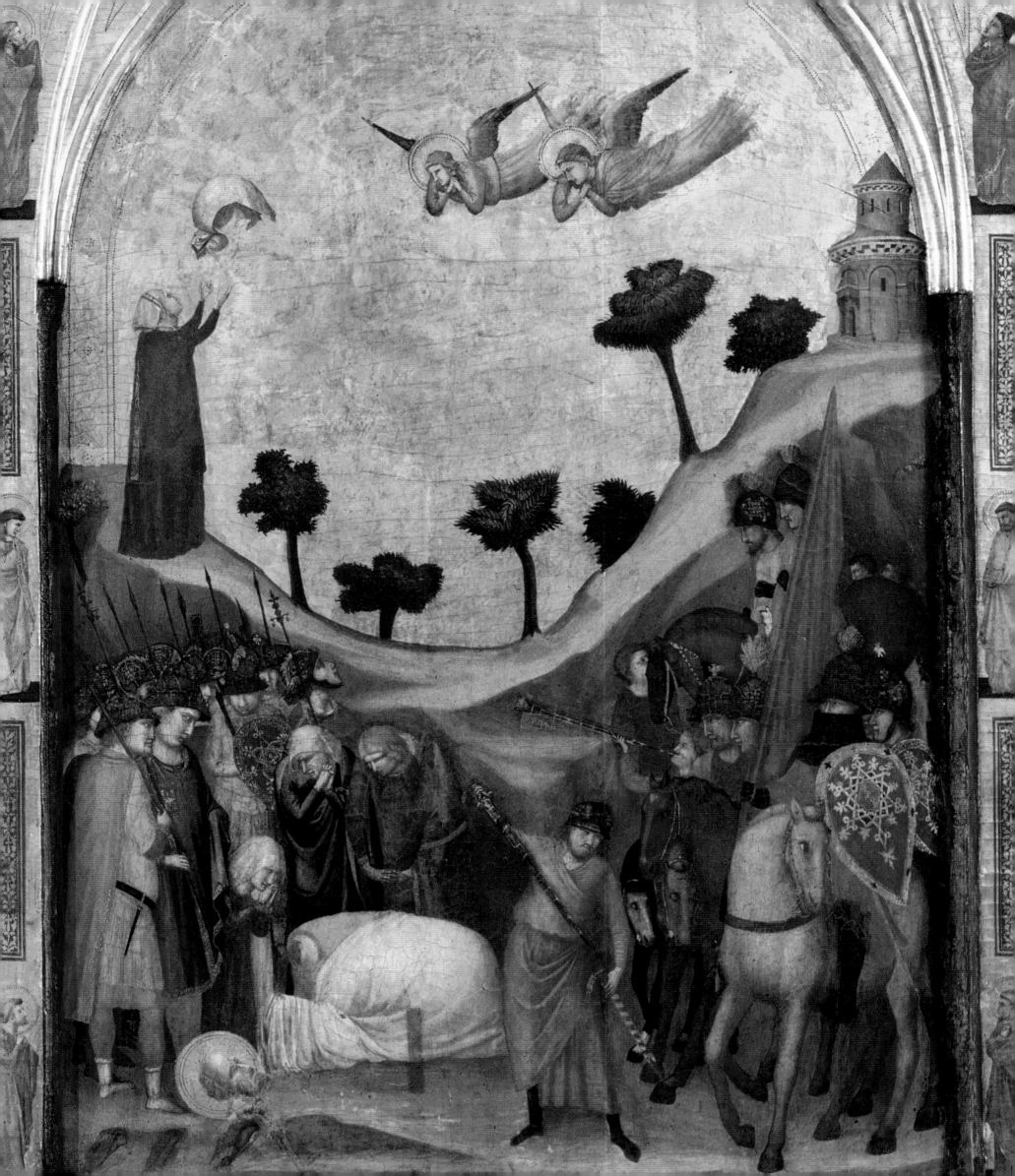

dominated by radiant white—of St. Peter's clothes and the throne—accompanied by red: white and red alternate throughout the panel right down to the tile pavement, alongside the warm tones of pink and yellow. On the back, however, the figure of Christ is completely in blue (the color of divine majesty) against a very rich carpet flecked with gold. Around him the angels offer tender nuances of bright colors—to liken them to flower petals is not empty rhetoric—and the harmony of blue and violet in Cardinal Stefaneschi's robe is wonderful. All are very precious and, by now, Gothic colors, which recall Sienese work and justify putting this great painting at a much later date. ❧ A GOOD number of scholars do not consider the polyptych one of the master's autograph works, but the product of his workshop. They do not want to admit as his certain naive, rough spots in the delineation of some figures, such as the two saints borne to heaven in mandorlas, and a certain rigidity, chiefly in the figures of the saints in the lateral medallions and in the predella. But the work's masterly conception can only have been by Giotto: at once poetry and architecture, beginning with the gorgeous grandeur of the frame, which is also a Giottesque invention of great celebrative significance for the papacy, and continuing with images from the Old Testament, the Apostles, Christ, and the Madonna. Figuratively the sumptuous and precious panel presents a series of elements of great pictorial value, such as the thrones in perspective set high on the pavement and the choice of very modern colors, in some of which can be read symbolic and liturgical meanings. Besides, the narrative is complete, and the decorative schemes are saturated with delightful discoveries that could only have been conceived by Giotto's acute mind. Such new ideas as the small busts of saints that peek out from sections of the polylobes on the verso frame, and the mock rose windows on the front side— again with saint's busts alongside the roundels in the pointed arches—are images of unprecedented richness. The small figure of St. John the Baptist in the frame, looking not at Christ but straight ahead, and the figure of St. Paul issuing from his mandorla carry deep emotion, but are also profound interpretations of the sacred texts. ❧ THIS polyptych reaffirms Giotto's typical ability to adapt to different situations and to the different meanings the work must assume. In this case, an image of strong sacramental and symbolic significance determines some choices that are apparently archaic in tone, which recapture the Paleo-Christian tradition and even refer to Byzantine art. The exaggeration of "hierarchical proportion" in the central panel on each side was certainly suggested to Giotto by the Roman curia, which left the artist free only in the delightful, fascinating invention of the two lateral images. ❧ IN ANY event some spatial aspects of

this polyptych can, I think, be connected to Giotto's new experiences and knowledge since working on the Magdalen Chapel. Speaking of the Bardi Chapel, Brandi (1983) maintains that Giotto's contact with the young Ambrogio Lorenzetti may have provoked some changes in the artist's spatial sensibility and in his feeling for color. This reverses the current critical opinion, which instead puts the Sienese painter in debt to the elderly master. It seems to me that Brandi's acute suggestion applies even more to the Stefaneschi *Polyptych,* especially on examination of the two central panels, with the tile pavement and the carpet in accentuated perspective. Moreover, the choice of jewel-like and refined colors of rare timbres—such as the violet of the cardinal's robe, which harmonizes with the blue of his gown; Christ's intense, luminous blue robe, standing out against golden arabesques; and perhaps even the profusion of gold ornamentation—certainly points to Giotto having further contact at this time with Sienese painting, and especially with Simone Martini, who was active in the San Martino Chapel in Assisi just when the Florentine painter was busy with the decoration of the Magdalen. ❧ DESPITE some extraordinary coloristic innovations and the very modern sequence of the two stories in the lateral panels, which would suggest a late dating, I believe that one should accept the 1320 date based on Grimaldi's (1619) information, which I consider well founded.

It should be placed after the frescoes of the Magdalen Chapel; and the figures of the saints and Apostles in the wings and on the predella of the polyptych can find some points of contact with the saints of the underarch in the chapel itself, just as some roughnesses in design in the decorative parts of the Roman painting have a correlation in the marked and incisive drawings of some figures in the Assisi decoration. Certainly the same assistants were present in the two complexes. In the Stefaneschi *Polyptych,* however, as in the Baroncelli later, especially in the elongated figures of the predella with their heavy lineaments, appears the work of another assistant whom I believe can be identified as the very young Taddeo Gaddi, as Donati (1966) and later Previtali (1967) have perceptively suggested. ❧ BUT above all the Stefaneschi *Polyptych* has, as the scholars have often stressed, many aspects that show a great affinity with the depictions in the cross vault of the central transept of the Lower Basilica in Assisi: the same centrality, the same symmetrical arrangement of the compositions, and, in the *St. Francis in Glory* (below), the same "hierarchical proportion." These elements all reassert the contiguity of the two works and lead one to think of the Assisi *vele* as an idea of Giotto's, while on the other hand they point again to the presence of the Master of the *Vele* among Giotto's assistants in the execution of the great Roman painting.

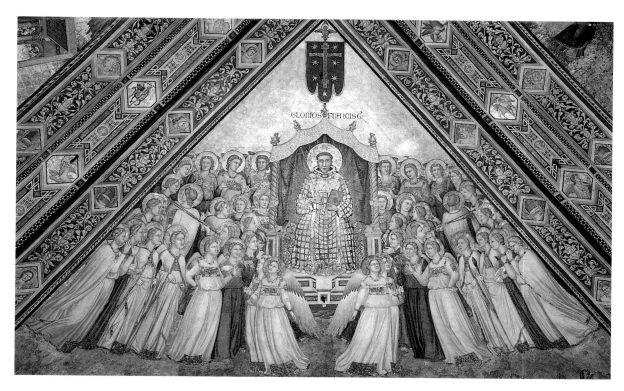

Master of the Vele. ST. FRANCIS IN GLORY. *Lower Basilica of San Francesco, Assisi.*

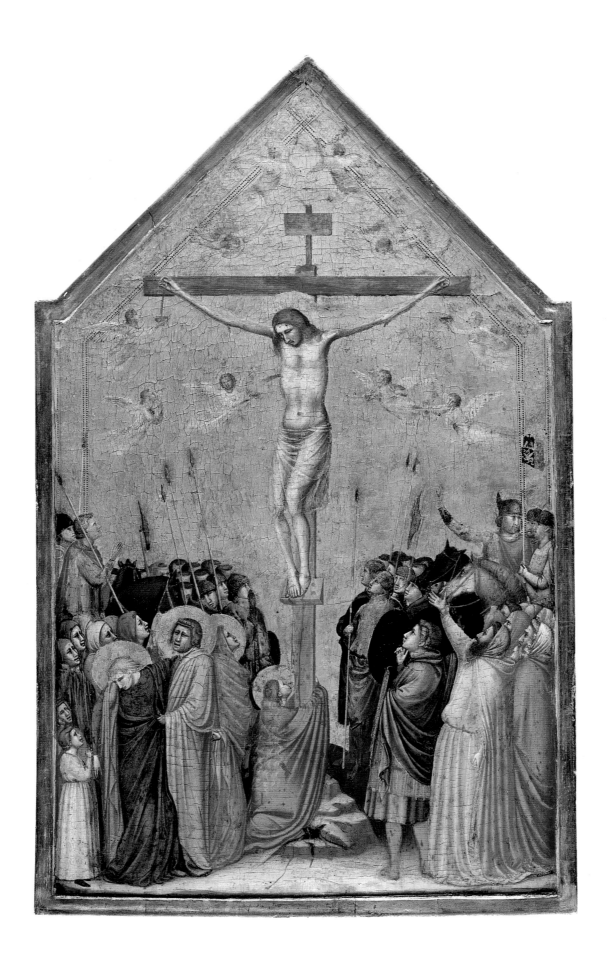

Sphere of Giotto. CRUCIFIXION.
Tempera on panel, 22⅞ × 13 in.
(58 × 33 cm). Staatliche Museen,
Gemäldegalerie, Berlin.

THE *CRUCIFIXION* IN BERLIN AND THE STRASBOURG-WILDENSTEIN *DIPTYCH*

❧

SCHOLARS have connected two works with the Stefaneschi *Polyptych,* attributing them variously to Giotto, to his workshop, to the Master of the *Vele,* and to the Relative of Giotto. One is the *Crucifixion* (p. 316) in Berlin, and the other is the diptych formed by the *Crucifixion* (below left) in Strasbourg and the *Madonna and Child Enthroned Surrounded by Saints and Virtues* (below right) formerly in the Wildenstein Collection in New York. ❧ BOSKOVITS (1988) has devoted a detailed note to the Berlin *Crucifixion,* attributing the panel to Giotto himself at a moment quite close to that of the Stefaneschi *Polyptych,* that is, around 1320. The painting is fascinating in its choice of bright chromatic timbres, enlivened by the use of complementary colors and of colored shadows, and for the narrative verve of the two groups gathered at the foot of the cross, who seem to thrust out of the confines of the engraved frame. The figures are captured with an accentuated fluency in their gestures; their expressions are poignant, and they are enveloped in clothes that are softly molded; even softer and more delicate is the figure of Christ, with thin limbs, hanging from a long wooden bar. Even if not an auto-graph work by the master—and indeed it has some elements typical of the art of the Po Valley (Donati, 1966, also discovered some Riminese aspects)—still this panel was certainly produced in a tightly Giottesque orbit. ❧ THE Strasbourg-Wildenstein *Diptych* also has very delicate craftsmanship. Its close ties to the *Crucifixion*—in its chromatic choices and in the soft plasticity of the figures—should be noticed, as well as its links with the Berlin painting and the stories of saints Peter and Paul in the Stefaneschi *Polyptych;* the severe expression of the enthroned Madonna has a great resemblance to the Virgin of the Roman polyptych's predella. This work too should therefore be considered to come from Giotto's circle; but most scholars believe it was executed, all or in part, by a pupil, perhaps (Previtali, 1967) the Relative of Giotto. The three panels, dated to the third decade of the century or just a bit before, confirm the "point of style" (seeking delicate coloristic effects) of Giottesque language at the moment of the Stefaneschi *Polyptych;* they bear witness to his students' and assistants' immediate reception of the master's extraordinarily modern sensibility.

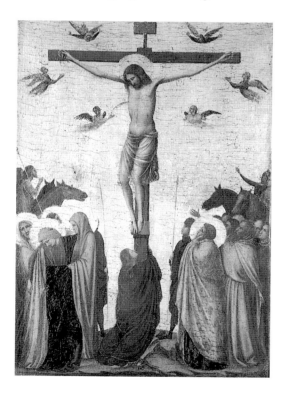

Sphere of Giotto (Relative of Giotto?).
CRUCIFIXION. *Tempera on panel, 15⅜ × 10¼ in. (39 × 26 cm). Musées de la Ville de Strasbourg, France.*

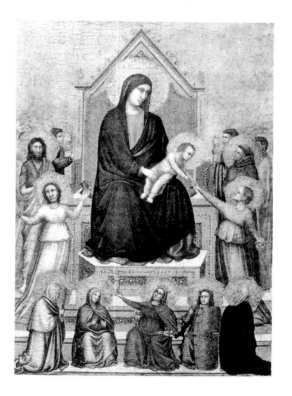

Sphere of Giotto (Relative of Giotto?).
MADONNA AND CHILD ENTHRONED SURROUNDED BY SAINTS AND VIRTUES. *Tempera on panel, 13⅝ × 10 in. (34.5 × 25.5 cm). Formerly Wildenstein Collection, New York.*

LATE

FLORENTINE

ACTIVITY

THE HORNE-WASHINGTON-CHAALIS *POLYPTYCH*

T HE FRESCOES IN THE BARDI CHAPEL IN SANTA CROCE, I BELIEVE, PRECEDE THE DISMEMBERED AND FRAGMENTARY POLYPTYCH THAT ALSO APPARENTLY COMES FROM THE SAME FRANCISCAN CHURCH. THE POLYPTYCH WAS ORIGINALLY COMPOSED OF FIVE PANELS, OF WHICH ONLY four now remain: the *Madonna and Child* (p. 321) at the National Gallery of Art in Washington, the *St. Stephen* (p. 324) at the Museo Horne in Florence, and the *St. John the Evangelist* (p. 322) and the *St. Laurence* (p. 323) at the Musée de la Fondation Jacquemart-André at the Abbaye de Chaalis in Senlis, France. THE very strong resemblance between St. Stephen's face, oval in the French style with almond-shaped eyes, and the physiognomies in the Franciscan Cycle in the Bardi Chapel, and the resemblance of the Madonna's face to that of St. Clare in the same Santa Croce complex, have always made me think that there was a close chronological contiguity between the polyptych and the Florentine frescoes. But the two figures in Chaalis show references to an earlier moment. St. John's plastic robustness is sharply accentuated, as in Giotto's early work, and his face has a more ancient shape; while St. Laurence, with his sunken cheeks and wide, staring eyes—his almost suffering expression—displays obvious connections with typical figures in the Magdalen Chapel, such as St. Lazarus. In all four parts the splendor of the colors with their rare, jewel-like timbres seems to echo the effects of the Stefaneschi *Polyptych*. I believe, therefore, that the Washington-Horne-Chaalis complex should be dated closer to 1320 than 1325. THE panels of the polyptych are all extraordinarily beautiful, using a language of particular refinement, especially in the selection and harmony of the colors and in the sumptuous decorations, starting with the gold background trimmed by an engraved frame and enriched by arabesque halos, each different from the next. A singular atmosphere of dreaminess and silence pervades the works, which can recall the sacramental fixity of the figures in the Stefaneschi *Polyptych*. The theme of colloquy and the relationship between people is gone from these scenes: the Child stares at the rose, and the Madonna has a distant gaze. So do St. Stephen and St. John; while the expressive intensity of

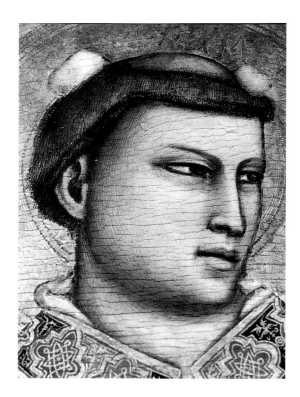

Giotto. Detail of ST. STEPHEN
(p. 324). Museo Horne, Florence.

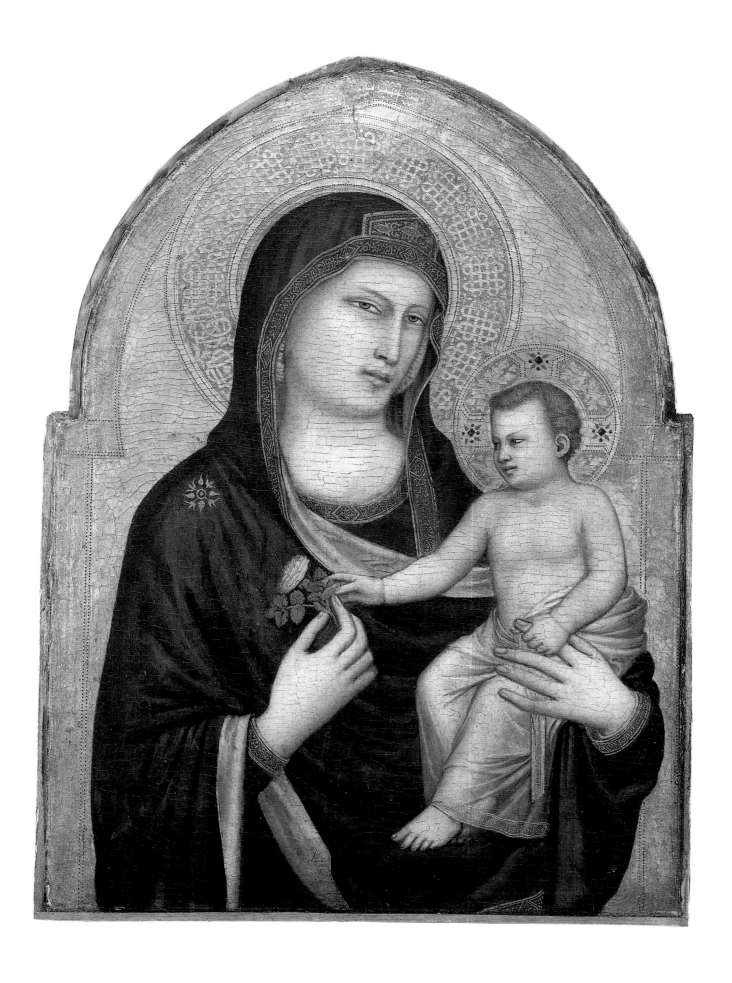

Giotto. MADONNA AND CHILD.
*Tempera on panel, 33⅝ × 24⅜ in.
(85.5 × 62 cm). National Gallery
of Art, Washington, D.C.*

page 322: Giotto. ST. JOHN THE
EVANGELIST. *Tempera on panel,
31⅞ × 21⅝ in. (81 × 55 cm).
Musée Jacquemart-André, Abbaye
de Chaalis, Senlis, France.*

page 323: Giotto. ST. LAURENCE.
*Tempera on panel, 31⅞ × 21⅝ in.
(81 × 55 cm). Musée Jacquemart-
André, Abbaye de Chaalis,
Senlis, France.*

St. Laurence's great staring eyes, fixed and deeply sunken in an elongated oval, recall the St. Lazarus in the Magdalen Chapel, thus binding together distant and apparently different complexes. ❧ AN EXAMINATION of the individual panels reveals the superb beauty of the painting and the modernity of certain effects. The Madonna is majestic in the drapery of her greenish blue veil, which spreads out over the plane. Her face is very sweet, created with soft gradations of color that cast the faintest of shadows on her fine features. The Virgin presents some elements of Byzantine iconography: she wears a star on her shoulder and a *marforium,* which also adds a warmer tone around her face. The inside of her robe is a burnished green, resembling precious silken cloth, and its border is extremely rich; she also wears a hint of pink on her head. The naturalness of her face and hands—and of the white rose edged with red—is extraordinary. ❧ THE panel with St. Stephen is a balance of colors prefiguring the effects of the most elegant of courtly painters. His white gown has a slight hint of lilac, but in the shadow of his bent arm it becomes a burnished metal, reflecting a crepuscular light from its border, which is embroidered with dark red. The vermilion book, with golden star motifs, elevates and ignites the entire composition, which is enlivened by very fine nuances of white and gold. ❧ THE two saints in the Chaalis panels are also impressive in their rare chromatic harmonies. St. John wears a light blue garment and a rosy robe softly nuanced toward a very pale pink; these colors can be found in the Stefaneschi *Polyptych* and later in the Baroncelli *Polyptych,* but they are made luminous here by a ray of light coming from the right to softly caress the figures. St. Laurence fills the entire width of the panel with his intensely red dalmatic; it makes an elegant contrast to the green—or rather, different nuances of greens—and gold of the ornamentation. The small pointed arches of these two panels present small figures of angels in magenta robes decorated with very rich borders, figures of a rare refinement that seem to prefigure the rare chromatic timbres of Flemish painting of the early fifteenth century. ❧ CERTAINLY a Giotto autograph, the polyptych is yet another typical Florentine altarpiece in five compartments. Markedly architectonic in its carpentry, the structure is transformed into a sumptuous celebration of color with a strikingly modern richness and a variety of nuances and iridescences, placing the Florentine painter among the great colorists of the early years of the fourteenth century in Italy.

Giotto. ST. STEPHEN. *Tempera on panel, 33⅛ × 21¼ in. (84 × 54 cm). Museo Horne, Florence.*

THE DECORATION OF THE BARDI CHAPEL

❧ THE decoration of the Bardi Chapel in Florence's Santa Croce constitutes the last, most accomplished decorative complex of Giotto's career now extant. ❧ THIS is the first chapel to the right of the presbytery; narrow and tall like the Peruzzi, it is, again like the Peruzzi, illuminated from the flat rear wall by a tall single window. It is dedicated to St. Francis, whose life is illustrated in seven episodes. The visitor is greeted by a compartment above the entrance arch with the *Stigmatization of St. Francis.* Inside the chapel on the rear wall were four Franciscan saints, of which only St. Louis of Toulouse, St. Clare, and St. Elizabeth of Hungary remain. On the side walls the Franciscan episodes read alternatively left and right and from top to bottom: the two large lunettes of the highest tier are *St. Francis Renounces His Possessions* (p. 327) on the left, and *Franciscan Rule Approved* (p. 329) on the right; in the middle tier to the left, *St. Francis Appears to the Chapter at Arles* (p. 330 left) on the left and the *Trial by Fire* (p. 330 right) at the right; at the bottom are the *Confirmation of the Stigmata* (pp. 334–35) and *St. Francis Appears to Fra Agostino and the Bishop* (p. 337). In the vault are medallions containing the Franciscan virtues, and in the window embrasures are some beautiful fragmentary borders with fleshy foliage. ❧ THE cycle of frescoes was whitewashed in the course of the eighteenth century; it was brought back to light in 1852 and restored according to the custom of the period, especially in areas that had suffered from the insertion of plaques or tombs. In 1937 the episode of the *Stigmatization of St. Francis* was cleaned, and between 1958 and 1959 the frescoes were cleaned by Tintori. Because the fashion at that time was to remove every trace of repainting, the pictures are now full of gaps; this allows one to enjoy the details in their extraordinary original appearance, but not to read the complexity of the composition in its entirety. Furthermore, the surface color has been partly lost, so that unfortunately the frescoes appear somewhat faded. ❧ ASSIGNED to Giotto by the oldest sources, starting with Ghiberti, they are also considered to be his by modern scholars, with the sole exception of Oertel (1943–44), who assigned them to a pupil, perhaps Maso di Banco. ❧ COMPARISON with the analogous pictures in the Upper Basilica at Assisi brings into focus the very great difference between the painter's first works and his extraordinary and always fresh later language. The *Stigmatization of St. Francis* is the episode

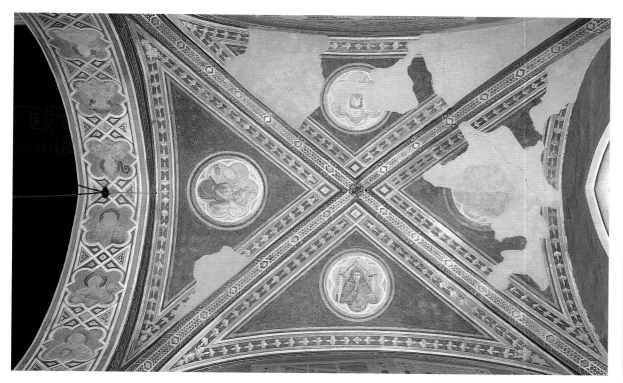

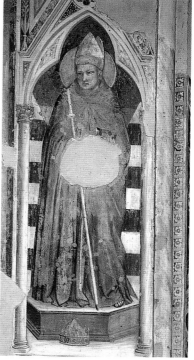

Vault. Bardi Chapel, Santa Croce, Florence.

Giotto. ST. LOUIS OF TOULOUSE. *Bardi Chapel, Santa Croce, Florence.*

closest to the Assisi cycle: it has the same insertion in a rocky landscape framed on the right by a small church, and the saint and the seraphic Christ are apparently the same. But the mountain rises up behind St. Francis, closing the space and projecting the figures forward. And the kneeling figure, who in Assisi was seen at a three-quarter angle, accentuating the background—with the play of diagonals—to create an embryonic perspective system, is presented here from the front. But this St. Francis spins, using the kneeler as a pivot, and flings his arms open in an unusually broad gesture while thrusting them forward. The effect of this movement is accentuated for anyone approaching the chapel, so that the saint appears more frontal and flat, or less so, depending on the spectator's viewpoint. Thus the space is not fixed and objective but is once again created by movement, an effect that we will also find elsewhere in this cycle. ❧ *ST. FRANCIS Renounces His Possessions* echoes the composition of the analogous Assisi episode, with the figures divided into two separate and quite distinct groups; and it repeats certain details, such as the gestures of Francis's companions and the father's face. This face is actually identical, but in Florence it is simpler and is treated with more tenderness. While at Assisi the composition is articulated against two wings that visually echo the two counterposed groups, here a large building set on an angle unifies the composi-tion without creating gaps. Brandi (1983) has noted that, despite the apparent perspective rendering of the edifice, the string-course lines of the two walls are in fact exactly parallel, so as to project the building forward, closing off the background and becoming a backdrop of color behind the people. The range of their gestures, poses, and expressions acquires a rhythm and a special natural quality, threading the people together in a narrative continuum that recalls a bas-relief. They are rendered in tender, pale colors, kept to low tones: grays matched by the pink of the building, against which the red worn by the person next to St. Francis stands out. ❧ IN THIS, as in the succeeding pictures, the fig-ures are small and clustered together in strongly articulated groups within the vast architectonic spaces, which take on a strong em-phasis in the composition. These are no longer the statuary blocks of the earlier work but a linked series of gestures and figures in a crowd, not an anonymous throng but one formed of carefully individualized persons. In each scene, and in the single figures of the saints on the rear wall, the characters have a plasticity and a volume that is still substantially robust, emphasized by their heavy, soft clothes; yet the softness of the chiaroscuro is enriched by light, rounding out the figures as though they were carved in ivory. Furthermore, the rather small faces—on elongated bodies made delicate by the tenuous passages between planes—seem to

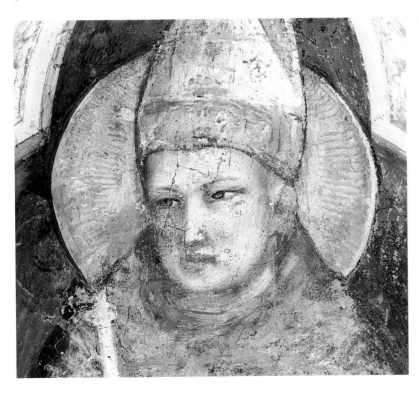

Giotto. Detail of ST. LOUIS OF TOULOUSE *(p. 325 right). Bardi Chapel, Santa Croce, Florence.*

Giotto. ST. CLARE. *Bardi Chapel, Santa Croce, Florence.*

Giotto. Detail of decorative strip in a window embrasure. Bardi Chapel, Santa Croce, Florence.

be constructed exclusively from the barely perceptible vibration of light and shadow, and all are characterized by small almond-shaped eyes in the French style. ❧ HERE Giotto has arrived at the peak of a process that consists in the thinning down of the figure, which nevertheless maintains intact its plastic robustness. This process was already underway in the decoration of the Magdalen Chapel, and can be seen in the polyptychs the artist created from about 1315 to 1330. ❧ SO ONCE again Giotto's development must be seen in the context of the figurative culture of Florence just before 1320. And once again the important relationship is with Tuscan sculpture after Giovanni Pisano, particularly the series of bas-reliefs composed with an accentuated narrative and characterized by thin, elegant little figures and by persons with French-style faces: those of Giovanni di Balduccio and, more importantly, of Tino di Camaino. And again, as Brandi (1983) cogently suggested—reversing the relationship that scholars have commonly accepted—the influence of the young Ambrogio Lorenzetti is felt in terms of an expanded feeling for space that thrusts the composition forward, in a perspective from a closer point of view. ❧ IN THE front lunette, *Franciscan Rule Approved* is set inside a very simple building: a cross-section of a church with three naves and a coffered ceiling. The perspective box is precise but not deep, even though the design of the coffered ceiling is intended to indicate the vanishing point exactly, while the compartments on the rear wall have a geometric, pre-Renaissance simplification. The building appears almost symmetrical, with a barely perceptible divergence to accommodate the visitor viewing the painting from outside the chapel itself. The simplified space is reduced to essential structural lines, without even the richness of cloths, carpets, high-backed chairs, or thrones. The decoration consists solely of marble facings, barely legible today, which in the past were rich in colors and must have given a further classical flavor to the building. This compositional linearity—which goes beyond the Gothic in the creation of a pure space and essential lines—is the same found in St. Peter's very simple throne in the Stefaneschi *Polyptych,* and, even before that, in the tight dimensions of the architecture in the backgrounds of the Magdalen Chapel in Assisi. The colors are kept to pale tones and jewel-like harmonies: the white architecture is given a precious quality with the lightest touches of pink shading, while the lateral naves present neutral light blue backgrounds. The figures of the friars have that incredible variety of browns that marks the entire chapel: they throb softly with life, each one captured as in a delicate snapshot despite the apparent monotone. An example of the debt that Giotto unquestionably owed to Simone Martini, especially in his work in Assisi, is the high-backed chair on which the bishop is

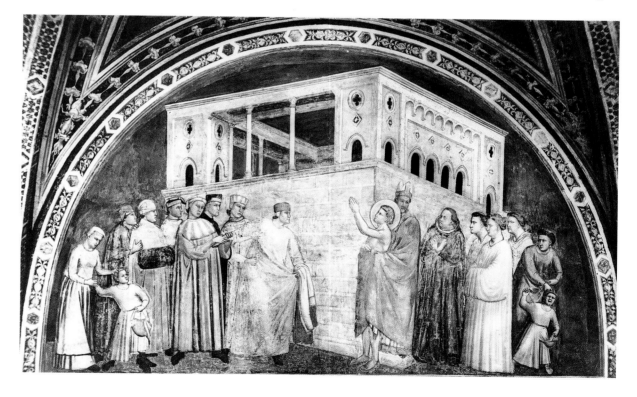

Giotto. ST. FRANCIS RENOUNCES HIS POSSESSIONS. *Bardi Chapel, Santa Croce, Florence.*

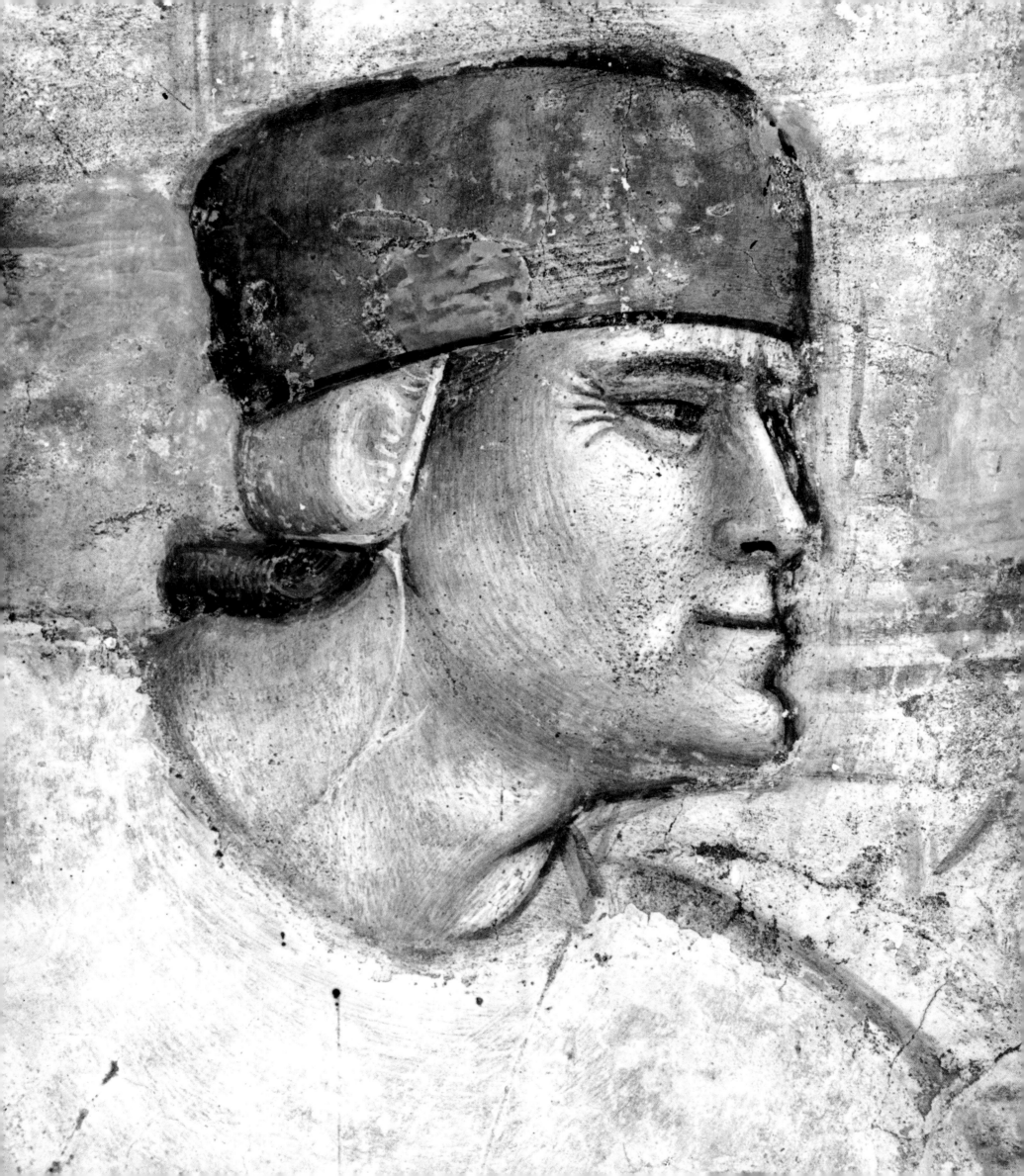

seated, copied from the emperor's chair in one of the episodes in the San Martino Chapel in the basilica of San Francesco. ❧ IN THE middle tier on the left is *St. Francis Appears to the Chapter at Arles.* The architecture that contains the friars is simple and fragile: a cloister with very thin columns, roofed with pink tiles, is depicted in cross-section; deeper in, the wall opens in three ample, rounded arches where the tops of the heads of other friars appear; a single uniform pavement binds the two sections; and the rear wall is covered with very simple geometrical decorations. The strong light coming from the right—notionally from the window of the chapel's rear wall—illuminates the stark white of the thin columns and enlivens the left wall with a narrow band of brightness. This too is a very knowing composition, from the precise linear prominence of the door that opens in the small wall to the lively effect of a dark color set off against a bright one. The thin columns fall exactly at the edge of the pilasters separating the rear arches, as if to emphasize the structure in brighter colors. The composition is based on low, dim colors in which pale grays prevail, but the light that filters through gives the atmosphere consistency by adding a slightly darker shadow under the slope of the roof. The pink of the tiles and the orange of the pavement stand out against the white and gray. The small figures of the friars, varied by the shadings of grays and browns and cap-

tured with a vivid attention to their features, mark off the space with great precision in this perspective exercise. ❧ THE *Trial by Fire* seems to be a luxurious variant of the scene on the opposite wall: this one too has a perfectly symmetrical composition. At the center is an austere Cosmatesque throne adorned with a splendid gilded cloth on which the sultan sits in a white vestment and red robe. If it weren't for the turban and long black beard, which unequivocally identify the man as Muslim, the shape of his robe and the majesty of its folds could suggest a Roman emperor. And indeed the palms and the other very simple, severe ornaments of the marble enclosure bring us back to the classical world, a source of constant inspiration for Giotto. Among all the episodes of the cycle, this one presents the greatest variety of colors: the background is covered by a uniform cloth of a very tender, luminous green bordered with gold at top and bottom. On this colored space the hues of the tunics and the red of the flames and of the sultan's robe are prominent. The left side of the composition is a succession of very modern coloristic innovations: the dark-faced dignitary has a brilliantly luminous white robe, recalling the black henchman dressed in white who wielded the whip in the *Flagellation* in Padua; but here the robe descends in soft folds as if it is light cloth, and with a naturalness that is wholly modern. Over the white robes of the other figures shine warm colors,

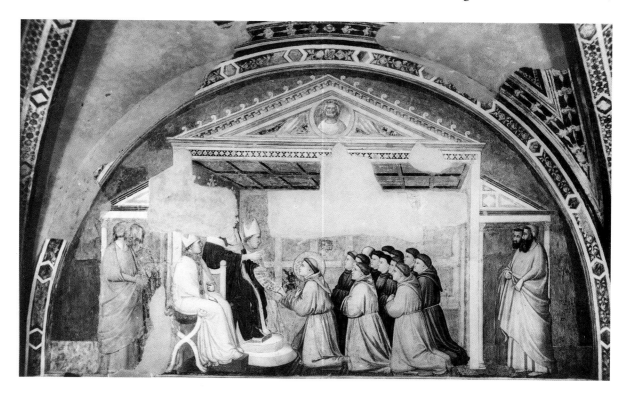

page 328: Giotto. Detail of ST. FRANCIS RENOUNCES HIS POSSESSIONS *(p. 327). Bardi Chapel, Santa Croce, Florence.*

Giotto. FRANCISCAN RULE APPROVED. *Bardi Chapel, Santa Croce, Florence.*

such as the orange mantle of the first—an extraordinary splash of color that ignites the entire wall—and the purplish one next to him. ❧ THE two bottom scenes have the community of friars as protagonists. The *Confirmation of the Stigmata* is set against a low stone wall that opens on a broad expanse of sky. The countryside is totally absent, and the space is confined by a very simple architectonic element: a mock courtyard or cloister, once bracketed by two short walls with a small shrine above the entrance door. The recent restoration, which removed the nineteenth-century repainting to reveal the original appearance of the work, leaves us to guess at the shallow spatiality of the image, which unrolls like a bas-relief. But the beauty of the colors remains: the pink marked by the white marble slab, against which the tunics stand out in a broad variation of browns, from the white of the two friars in the foreground to the maroon of the two figures in the central group. The facing episode, *St. Francis Appears to Fra Agostino and the Bishop,* offers an even more fragile simplicity, with a linear Cosmatesque cornice marking the edges of the picture; the depth of the room was once emphasized by the roof's now illegible coffers and by a sort of Cosmatesque balcony separating the two simultaneous episodes. Here too color is the protagonist: the green spreads over the background and forms a counterpoint to the rich shades of the tunics, which are them-

selves as light as apparitions. The faded ocher of the wooden bed on the left shades into the golden yellow of the bishop's bed, while the wine-colored platform harmonizes with the clothes of the two servants, in faded, spent colors. ❧ THOUGH the color—its tender and delicate harmonies, quite the opposite of shrill—strikes one most in the Bardi cycle, one should also notice a new factor: the frank and summary construction of the images and particularly of the faces, eliminating the contour line. Shadows erode the planes, creating superbly eloquent and expressive hands and outlining eyes and mouths, as in the two notable friars seen in foreshortened perspective, with a disconcerting modernity of language: the old friar of the *Confirmation of the Stigmata,* with his hand raised, and the young friar who appears behind the curtain. But all the frescoes display a renewed ability to make the friars' faces expressive, each one as marvelously individualized as a portrait, giving the cycle a special, very modern note of truth. ❧ THE Franciscan Cycle in the Bardi Chapel has a long scholarly history, going all the way back to Ghiberti. It is by now solidly attributed to Giotto. But the problem is the chronological placement of this cycle; the only certain *post quem* date is 1317, since the cycle depicts St. Louis of Toulouse, who was canonized that year. Furthermore, some scholars have tied the Peruzzi and Bardi chapels together closely in a chronological

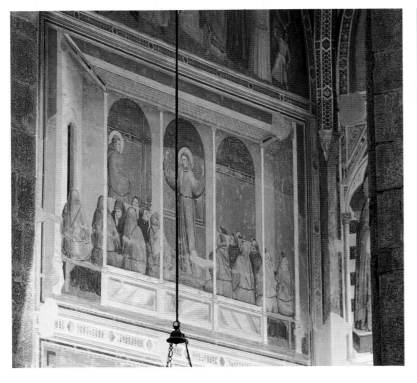

Giotto. ST. FRANCIS APPEARS TO THE CHAPTER AT ARLES *seen from an angle. Bardi Chapel, Santa Croce, Florence.*

Giotto. TRIAL BY FIRE *seen from an angle. Bardi Chapel, Santa Croce, Florence.*

page 331: Giotto. Detail of ST. FRANCIS APPEARS TO THE CHAPTER AT ARLES. *Bardi Chapel, Santa Croce, Florence.*

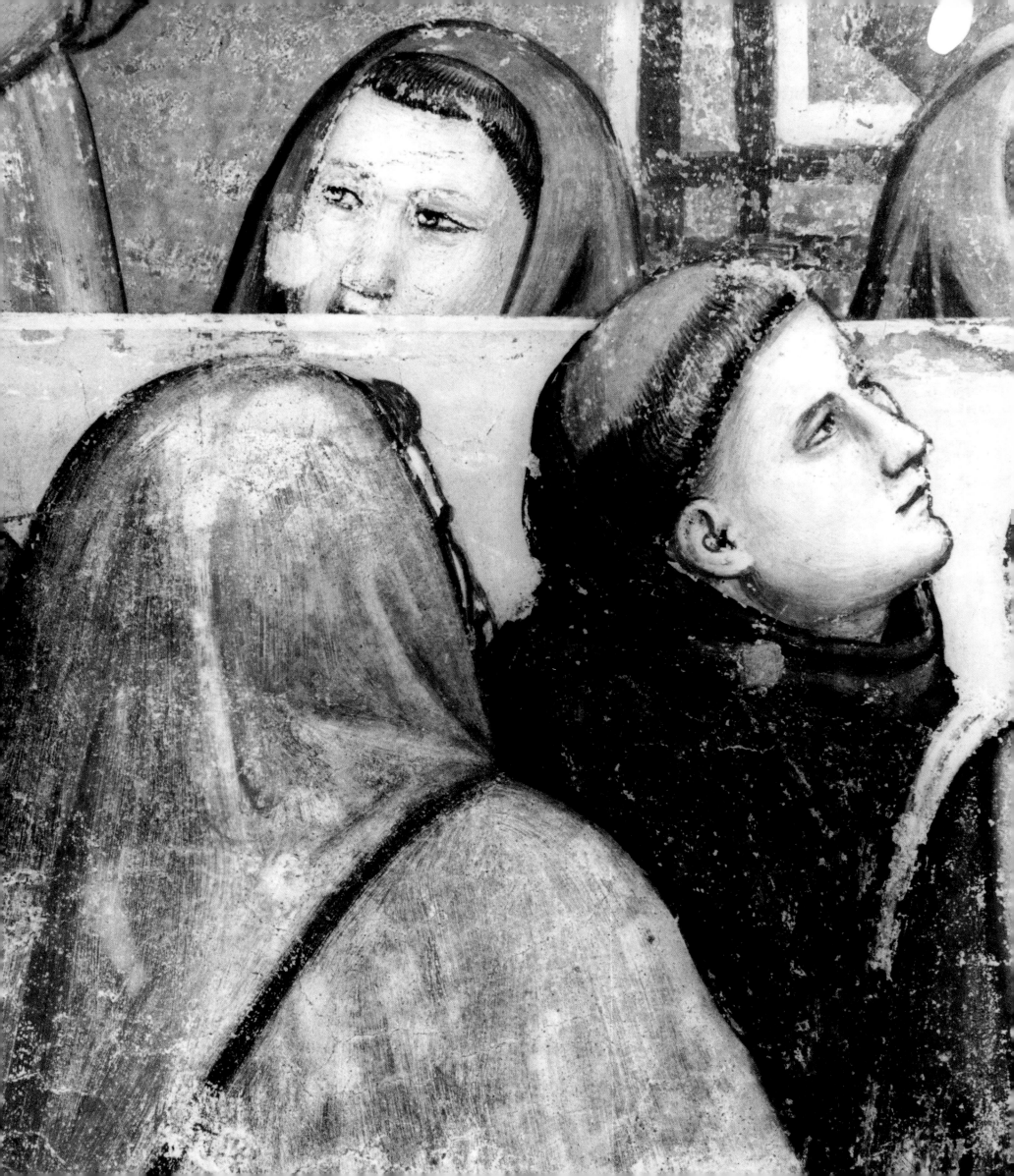

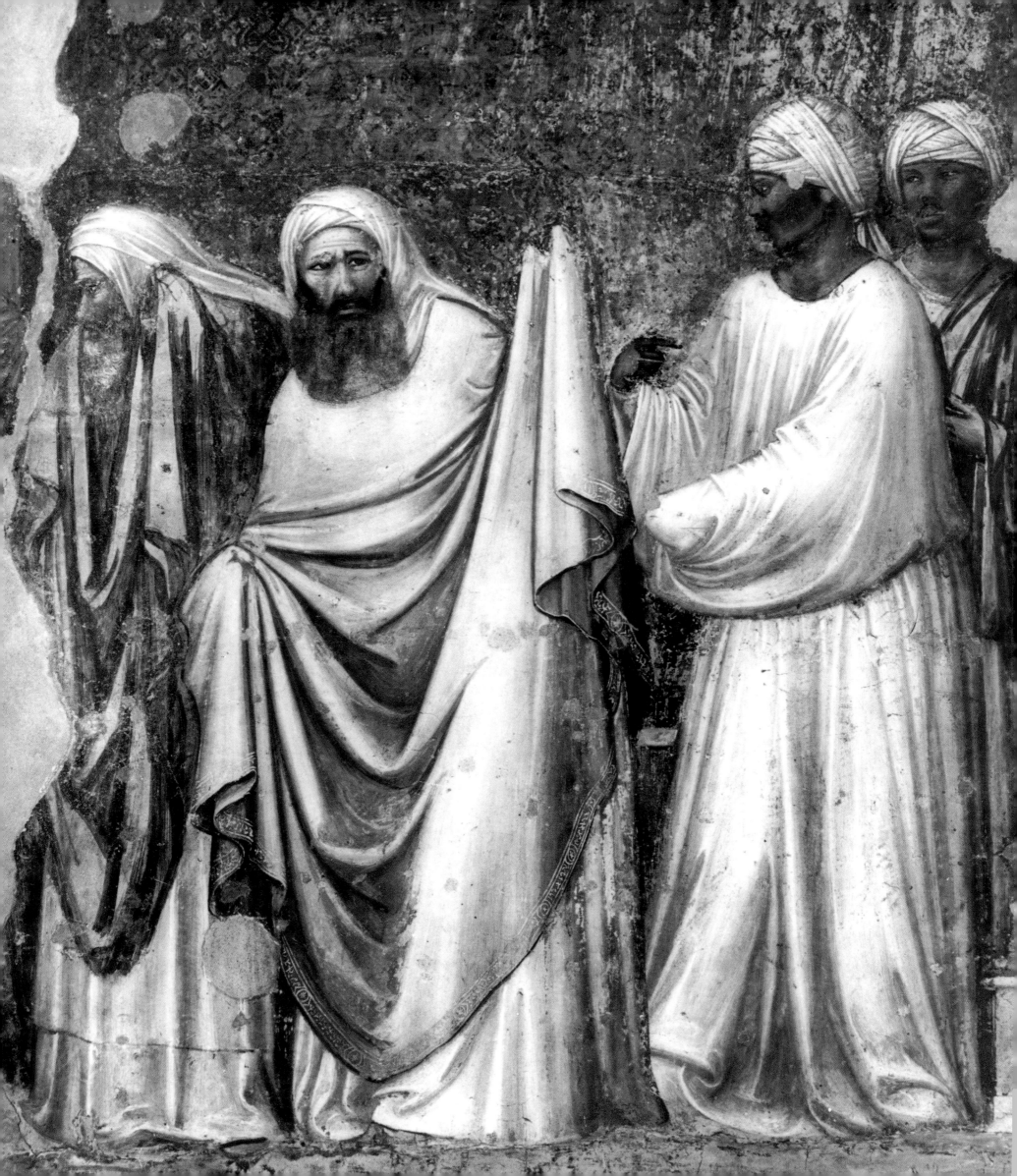

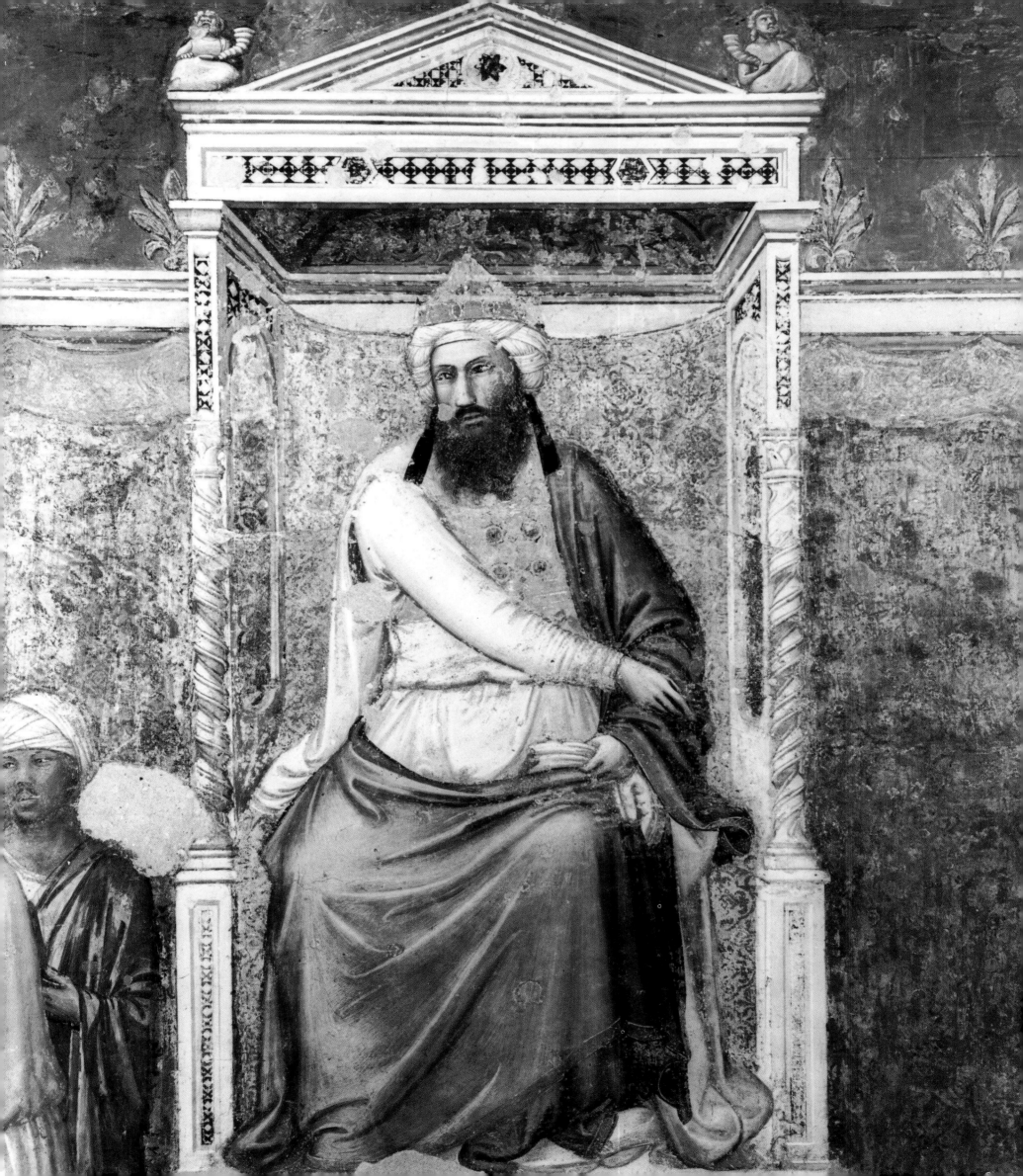

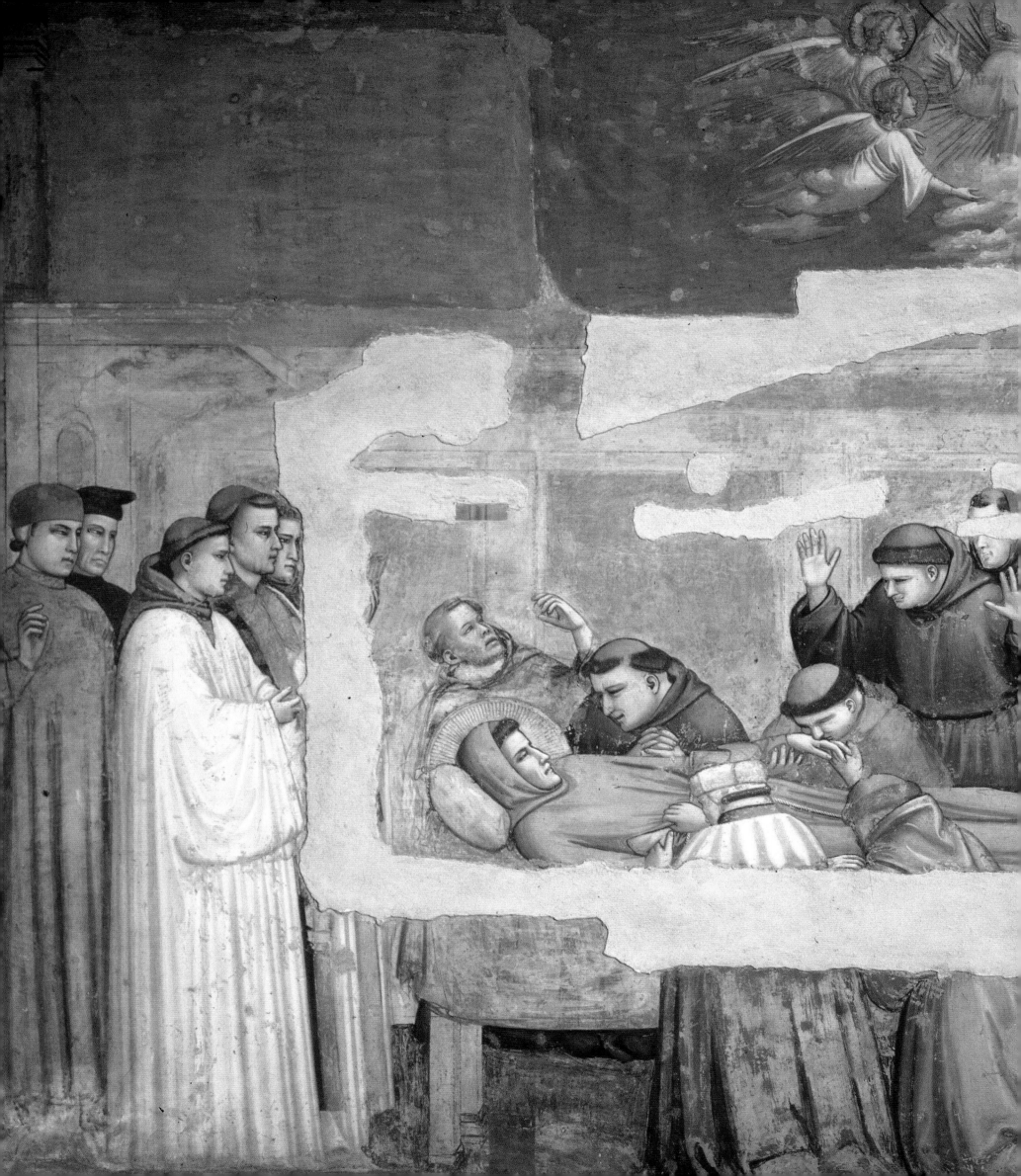

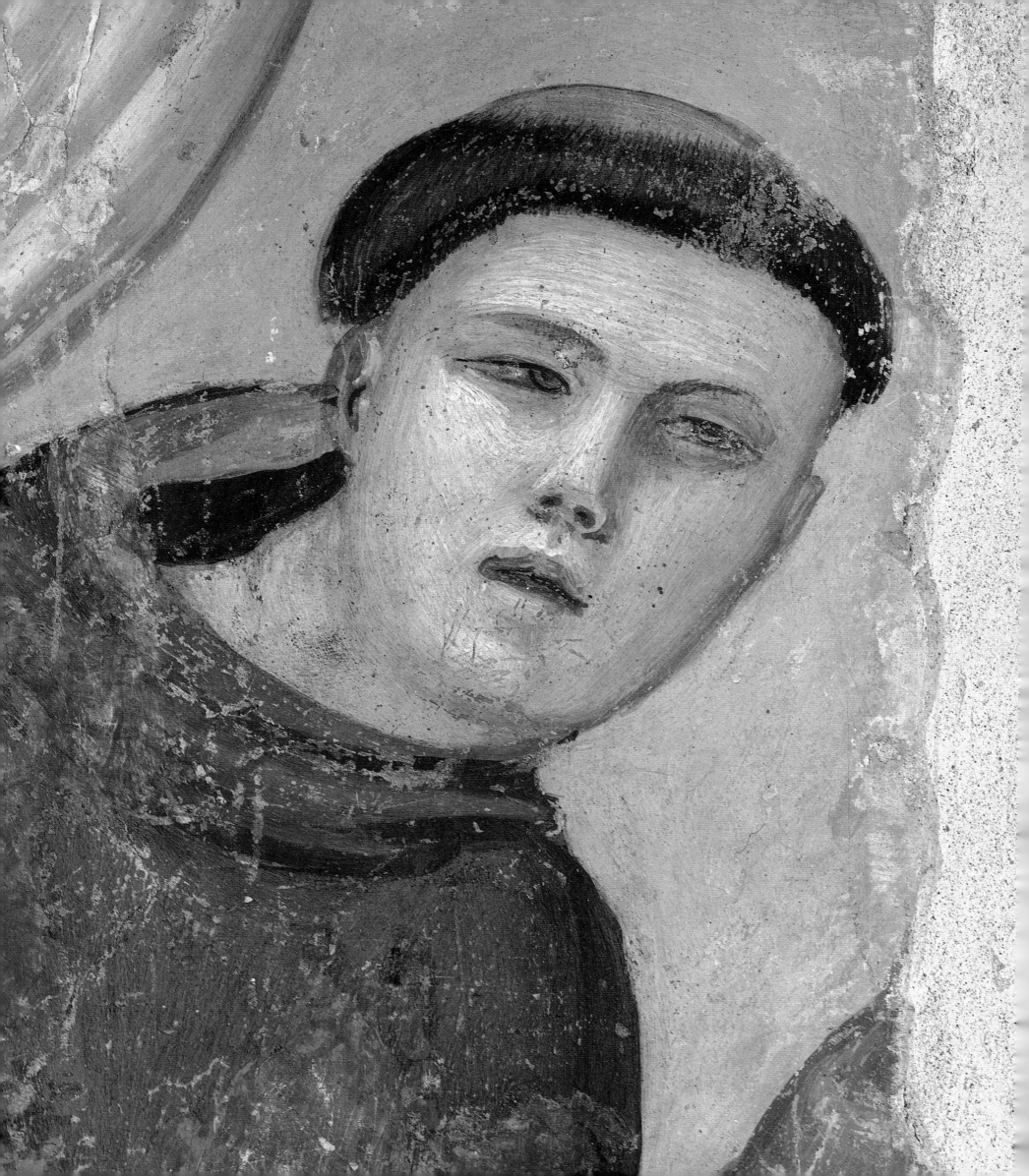

sequence, blurring the issue completely. With the exception of Tintori and Borsook (1965), scholars generally think that the Bardi Chapel came after the Peruzzi. ✤ SO FAR, our analysis of the development of Giotto's language leads me to regard this cycle as very late, falling at the end of Giotto's involutional period. In this period he reduced the space, brought the composition forward on one plane, diminished the size of the figures, and used very elegant methods of applying colors, with a sort of summary painting that eliminates contour lines and creates by means of color alone: almost tonal painting. ✤ THERE are moreover close affinities, discovered in particular by Bologna (1969a), between the heads in the Bardi frescoes and certain details of the decoration in Castel Nuovo in Naples, which are certainly dated around 1328–30. This confirms the very late dating of the Bardi decoration—just before Giotto's departure for Naples—as around 1325, according to the best documented scholars (Bologna, 1969a; Bellosi, 1981; Brandi, 1983; Bandera Bistoletti, 1989).

THE BARONCELLI *POLYPTYCH*

✤

✤ THE polyptych showing the Coronation of the Virgin and Saints (pp. 338–39) in the church of Santa Croce in Florence belongs to a late moment in Giotto's activity. ✤ THE painting, signed "OPUS MAGISTRI JOCTI," hangs in the Baroncelli Chapel, which is decorated with frescoes by Taddeo Gaddi concerning the life of Mary and decorated, as the plaque attached to one of the pilasters says, in 1327 (Borsook, 1962; Donati, 1966). Thus the painting could have been executed in that year, before Giotto's journey to Naples in 1328. Such a dating fits quite well with the characteristics of a work closely related to the Stefaneschi *Polyptych;* in a certain sense, it seems like an evolution of that triptych. ✤ VASARI clearly indicates that the polyptych is Giotto's work: he gives an exact description of it, mentioning that the upper part of the frame and the cherubs carved between the arches are from the fifteenth century. So the large work was modified from the early years of its existence, and the panels, which now have a sharp arch, were probably encapsulated in a pedimental structure. The point of the central panel, shorn to set the polyptych inside its

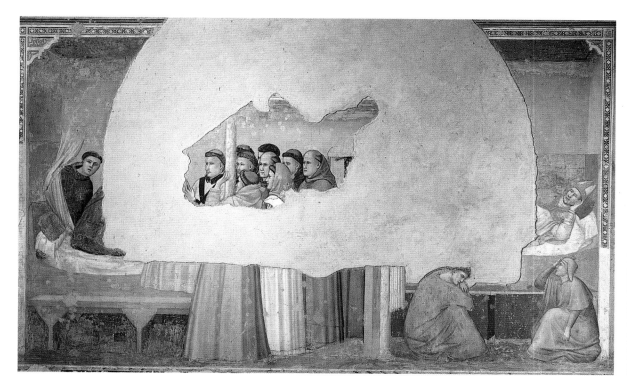

pages 332–33: Giotto. Details of TRIAL BY FIRE *(p. 330 right).*

pages 334–35: Giotto. CONFIRMA-TION OF THE STIGMATA.

page 336: Giotto. Detail of ST. FRANCIS APPEARS TO FRA AGOSTINO AND THE BISHOP.

Giotto. ST. FRANCIS APPEARS TO FRA AGOSTINO AND THE BISHOP.

Giotto. Detail of ST. FRANCIS APPEARS TO FRA AGOSTINO AND THE BISHOP.

ALL: *Bardi Chapel, Santa Croce, Florence.*

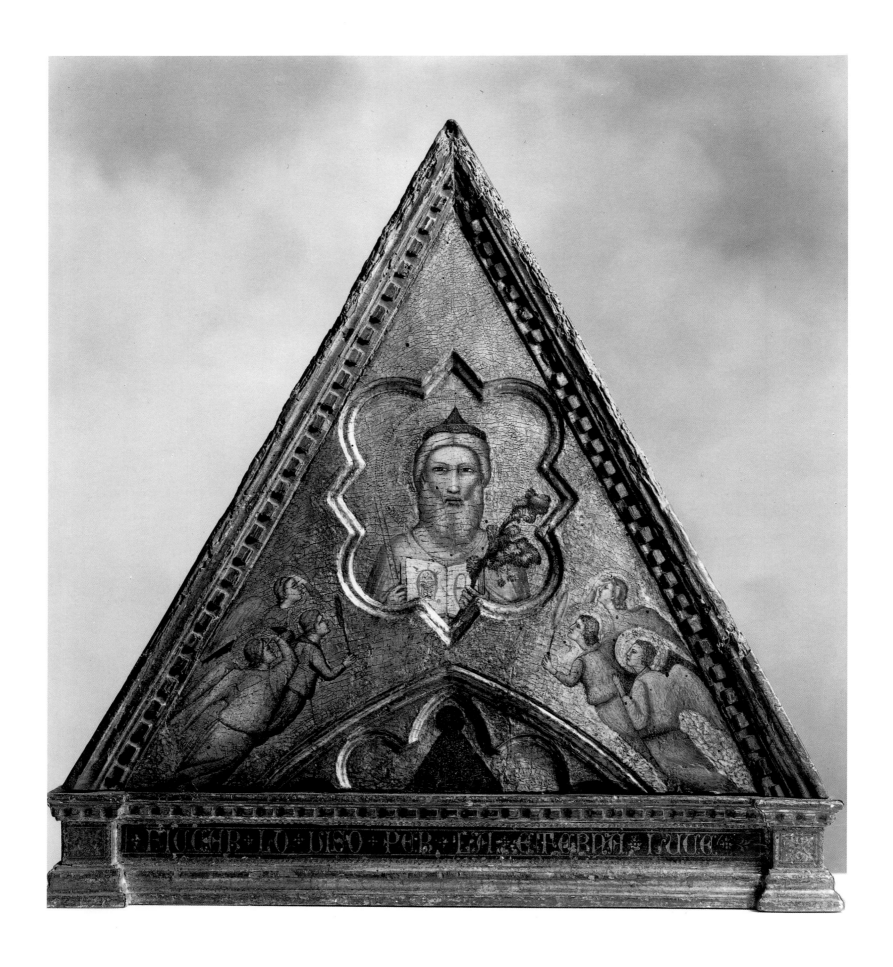

pages 338–39: Giotto and assistants.
Baroncelli POLYPTYCH. *Tempera*
on panel, 72⅞ × 127⅛ in. (185 ×
323 cm). Santa Croce, Florence.

Giotto. GOD THE FATHER AND
ANGELS. *Tempera on panel, 23 ×*
30 in. (58.4 × 76.2 cm). San Diego
Museum of Art.

rectangular Renaissance frame, has been identified by Zeri (1957) as the fragment with *God the Father and Angels* (p. 340) now at the San Diego Museum of Art in California. ❧ A RECENT restoration has reinstated the fourteenth-century structure of the painting, made up of five panels with sharply arched and lobed frames. The predella, certainly by an assistant of Giotto's, probably Taddeo Gaddi (Zeri, 1957), is subdivided into five rectangular parts with hexagons flanked by elegant spirals of acanthus leaves. Inside each hexagon is a small lobed medallion: the central one shows the head of Christ, and at the sides are the heads of a sainted bishop, St. John the Baptist, St. Francis, and St. Onofrio, each against a gold background. ❧ IN THE center panel of the polyptych, on a simple pointed throne of pale marble embellished with a green cloth hanging, is the Coronation of the Virgin. Christ and the Madonna are both dressed in white, over which is thrown a luxurious pink mantle embroidered with gold; Mary also wears a light wimple, in accordance with royal fashion. Below them are two angels in bright blue and two in green with yellow highlights. ❧ THE side panels, which mirror each other by pairs in a symmetry of both composition and color, form a great choir of saints and angels in a single space like a loggia, formed by the subdivisions of the frame. The airy figures are crowded one on top of another, right to the edge of the panel;

lower down are the angels playing instruments, and above them are rows of male and female saints in a paradisiacal succession of halos in a shallow space seen from a bird's-eye view. The painting is illuminated by a frontal light that reduces the chiaroscuro and thus also the volume of the figures: they become almost devoid of weight, as befits the inhabitants of heaven. ❧ THE invention is beautiful, especially for such a difficult theme, which can easily be monotonous. But Giotto makes it lively by transforming it into a fantasy of tender colors, with bright and intensely luminous chromatic timbres, beginning with the Virgin's and Christ's pink mantles embroidered with gold; these colors are absolutely new to the iconographical tradition, and they transport the scene into a benign atmosphere. The angels and saints of the side panels, in their flowing clothes, display an exquisite range of bright and burning tints, like a garden in flower, where blue tones prevail with pinks, all drenched in reflections and nuanced hues. A final, very effective idea is the transformation of the angelic ranks into musicians in a paradisiacal concert, concentrating on their absolutely contemporary instruments in an elegant, courtly atmosphere that is at once heavenly and earthly. ❧ THE polyptych does not show equal skill in craftsmanship throughout. The central panel is more spacious, and its figures are elongated, with small, graceful heads and long eyes in the French manner, typical

Assistant of Giotto (Taddeo Gaddi?). Detail of the predella, Baroncelli POLYPTYCH *(pp. 338–39). Santa Croce, Florence.*

page 342: Giotto. Detail of Baroncelli POLYPTYCH *(pp. 338–39). Santa Croce, Florence.*

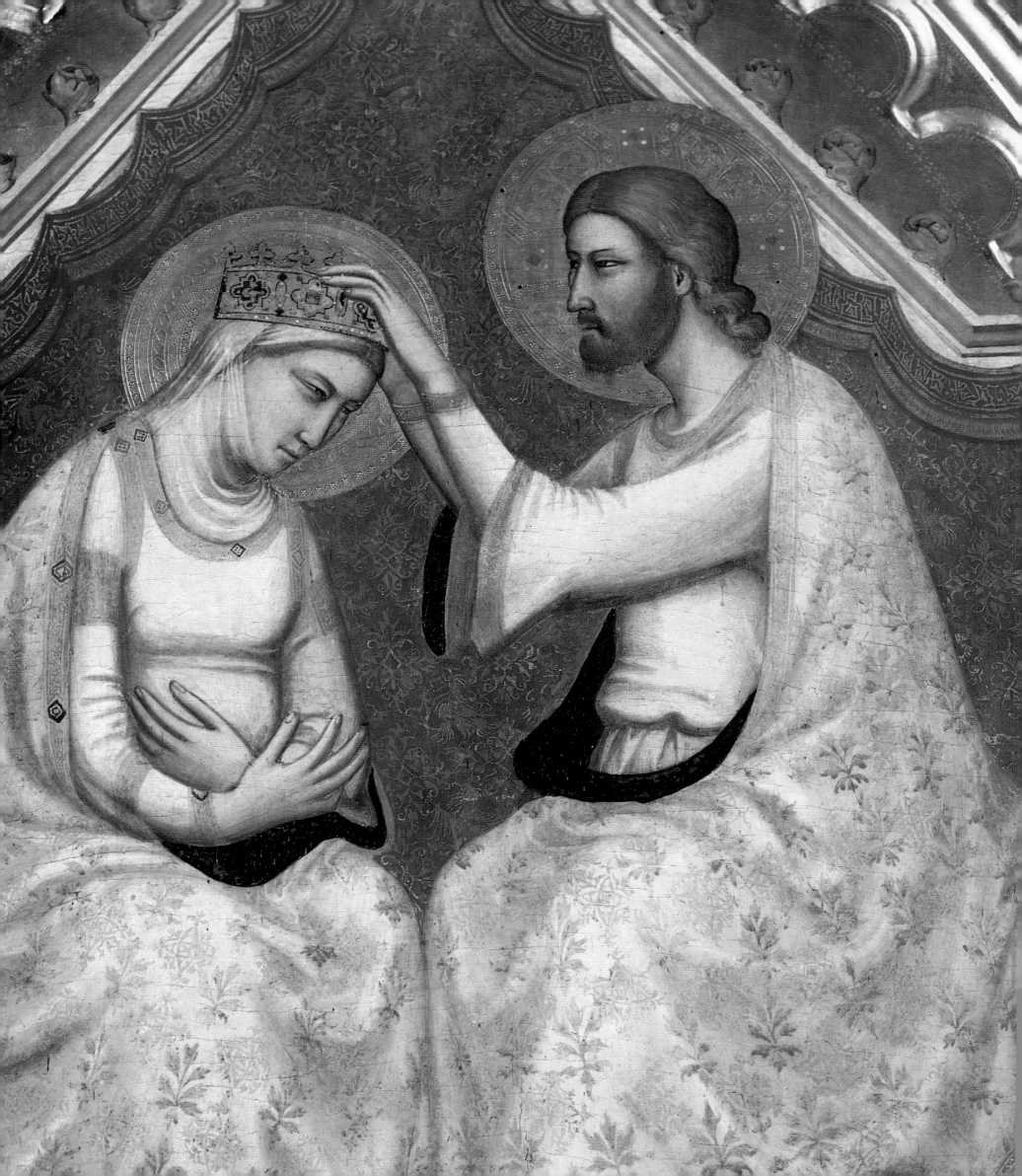

of Giotto's late works. The composition here is absolutely harmonious, with Christ and the Madonna both enveloped in nontraditional pale pink mantles embroidered with gold, seated on a very simple throne covered with a dark green cloth in a lovely chromatic contrast; below, the semicircle of kneeling angels wear robes with golden reflections, and their wings too are woven with gold. I believe that this panel should be attributed to Giotto, such is the subtlety of its compositional equilibrium. The picture is reduced to its essential elements and based particularly on elegant chromatic relations, some of which are utterly new: look, for example, at how the two angels in the first row echo in a lower tone the green color of the cloth on the throne, and how the pink of the mantles sinks into the darker hue of the pavement. Even late in life Giotto had an extraordinary capacity for renewal and freshness, and also for approaching the most modern themes, a constant in his language. ❧ THE side panels, however, present some chunkier figures, stuffed into their mantles and inharmoniously constructed, with faces too large for their bodies—for example, the first musician angel in pink on the left panel. The figures closely resemble those in the Assisi *vele*. The selection of beautiful colors here does not have the calibrated finesse of the central *Coronation of the Virgin*. It is clear that assistants worked on parts, if not all, of the side panels, assistants including—as has often been proposed—the Master of the *Vele*. ❧ BUT the effect of the whole is new and bright, showing Giotto in the last phase of his long career as a painter intent on creating color as much as form. ❧ THE work was certainly important for the Florentine painting that immediately followed it, and particularly for the artists who drew a new sense of color from the master's last inventions. It was copied by Bernardo Daddi in the polyptych in the Galleria dell'Accademia in Florence, and Giovanni da Milano was soon using it as inspiration for the great mural he did in the Florentine church of Ognissanti, which repeats the rows of saints that crowd the unlimited space of heaven with their multicolored robes.

Assistant of Giotto (Taddeo Gaddi?).
Detail of the predella, Baroncelli
POLYPTYCH *(pp. 338–39). Santa*
Croce, Florence.

Giotto and the Noble Courts

GIOTTO IN NAPLES

✺

IN DECEMBER 1328 GIOTTO WAS IN NAPLES IN THE SERVICE OF KING ROBERT OF ANJOU. THIS PROVED TO BE A LONG STAY, DOCUMENTED UNTIL DECEMBER 1333, DURING WHICH THE PAINTER EXECUTED NUMEROUS WORKS THAT WERE ALSO DOCUMENTED AND DESCRIBED BY LOCAL sources, though unfortunately almost all the works are now lost. ❧ DURING his stay in the Mediterranean city the Florentine artist had a very interesting and new position: he received a regular stipend, as well as reimbursement for the expenses of his workshop, which included the maintenance of numerous assistants and errand boys. If we add that on January 20, 1330, the king named Giotto "a painter familiar and faithful to ourselves" in consideration of services rendered, we realize how profoundly his status had changed: Giotto had become a court painter. ❧ THE artist had already had commissions from men of great prestige—Pope Boniface VII, followed by Cardinal Stefaneschi— but these were always works for public buildings such as the great Roman basilicas. The Anjou commission, however, constituted a significant change for the artist and certainly for his painting as well. ❧ IN 1895 Schlosser clarified the role that the city-states played in Italy, especially in northern Italy: starting from the end of the thirteenth century, they established a completely special artistic language characteristic of their closed milieux, which were particularly refined and elegant. One of the most important Italian courts was that of Naples, where the Anjou kings, Charles and then his son Robert, provided an extraordinary stimulus to arts and letters, enriching the city with very modern monuments, paintings, and sculptures. While Charles seems bound to French culture by the Gothic designs of the buildings he erected and his predilection for knightly literature, Robert liked to surround himself with literary men and humanists, many of them Florentines, and his reign established one of the most important intellectual circles of that proto-humanism which was one of the characteristics of Italian courts at the dawn of the Renaissance. ❧ THE felicitous flowering of the figurative arts under the Anjou dynasty has recently been brought to light by Bologna (1969a) and by Leone de Castris (1986), who point out the role of

patrons in the formation of a language of literature and humanistic studies. Bologna and de Castris have also shown the close financial and cultural ties between Naples and Florence since 1326 and 1327, when the Tuscan city had sought the protection of the Anjous by soliciting help from Charles, the Duke of Calabria, against Castruccio Castracani. Also according to Bologna, Charles had very good relations in Florence with the Franciscans of Santa Croce and even with Giotto, who Vasari tells us had painted his portrait in the Palazzo della Signoria. But perhaps more interesting is the information concerning the presence of a powerful and growing bank owned by the Florentine Bardi family in Naples and the presence of Florentine businessmen (among them the father of Giovanni Boccaccio, who actually held a post in the Merchants' Guild), not to mention the many literary men and humanists from whom Petrarch emerged. The figurative arts were also represented: Tino di Camaino, a Sienese, was called to Naples in 1324–25 in his capacity as architect and sculptor, and he was later commissioned to do the royal family's tomb in the new Gothic-style church of the Franciscan convent of Santa Chiara. THUS Giotto's arrival in Naples was not due solely to his fame as a painter and to King Robert's desire to have near him the greatest artist in Italy at that moment: it was part of that dense and growing network of relations between the two cities that was imparting a special, modern character to the culture, both figurative and otherwise, of the Anjou realm. Among the artists of the court Giotto naturally had a position of particular resonance at that moment of the greatest efflorescence of the arts, as construction continued on new churches and monasteries and on Castel Nuovo, the seat of the Anjou court. FOR Giotto the courtly setting perhaps brought contact with artists from different backgrounds, of which the most significant would be Tino di Camaino. But particularly it meant an artistic choice of renewed elegance and an approach to a completely new and modern thematic iconography that was precociously humanistic. FROM the numerous documents dealing with Giotto's activity in Naples, we know that he was busy in Castel Nuovo, the king's residence. The documents mention payment for frescoes in two chapels: the Palatine Chapel and the Secret Chapel, where the Florentine painter had to continue the paintings of Montano d'Arezzo. GIOTTO'S Neapolitan paintings are also recorded, though imprecisely, by old sources, both local and Florentine. The most interesting of these, since it is almost contemporary, is the *Raccolta di sonetti* (Collection of Sonnets) by an anonymous author, written around 1350, which describes the illustrious men painted by Giotto in Castel Nuovo. Another important mention is that made by Petrarch in his 1358 *Itinerarium Syriacum* of the decoration of

the royal chapel. Ghiberti records a "hall of King Robert's famous men"; Billi (c. 1530) also records the decoration in Santa Chiara and in the Incoronata. The Neapolitan historian Pietro Sumonte, writing a letter in 1524 to Marcantonio Michiel with news about art and artists in Naples, is more precise: he attributes the decoration in the Incoronata to Giotto's disciples; says that the chapel in Castel Nuovo was completely frescoed with scenes from the Old and New Testaments; and says that the church of Santa Chiara, whose convent held some panel paintings, was also covered with frescoes. Vasari (1568) reports that in the church of Santa Chiara some chapels were painted with scenes from the Old and New Testaments and with the Apocalypse. Only a few tatters of these numerous and significant works by the Florentine master still exist. វ IT IS probable that Giotto was summoned to Naples in connection with the decoration of the church of Santa Chiara, which was in a sense the temple of the Anjou dynasty. Completed in 1330, the church was the site of some of the most modern Anjou mausoleums sculpted by Tino di Camaino. វ OF THIS vast work there are today a few fragments that reveal indubitably Giottesque language. But the fragmentary condition of the paintings and their relatively poor state of conservation does not allow us to specify whether this is an autograph work of the master, or by the hand of some

pupil. In the last years of his activity Giotto had a very large workshop, which could be regarded as a kind of business enterprise, of which, as a Neapolitan document says, he was the "protho-magister." Master painters, other painters, and ordinary laborers worked there. It is therefore difficult, in a situation of precarious legibility, to distinguish whether a given work was painted by the master's hand or by an assistant: this problem is characteristic of all Giotto's production, and especially of the late works. វ UNKNOWN to the oldest sources and rediscovered only during restoration after World War II, the *Crucifixion* found in a hall of the convent of Santa Chiara has a very interesting composition. The vast fresco creates a great false opening in the wall, bordered at the bottom by a Cosmatesque skirting and at the top by an equally Cosmatesque architrave supporting brackets in perspective; at the sides are two pilasters with square bases, also drawn in precise foreshortening. Beyond this "opening" the composition is spread out against a great blue sky, broad and empty, deeply evocative, where the persons are disposed symmetrically. The cross is thin and thrust aloft, and its long horizontal arm traverses almost the entire width of the compartment; the figure of Christ is delicate and very fine, surrounded by slender angels arranged symmetrically so as to give the impression of a painting that expands across the surface. Below, three figures—

the Madonna, the Magdalen, and St. John—are isolated from each other. They are long, slender figures, but at the same time they are fleshily robust, their faces rendered essentially but charged with a powerful expressivity. The range of colors is very delicate: among them one notices the pallor of Christ's body and the luminous pink and orange of the garments of St. John and the Madonna. This is an unquestionably Giottesque painting. Its atmosphere of absence and the void, its projection onto the surface of figures like the flattened and symmetrical angels that form a fan around Christ, and its elimination of all spatial notation all reflect the consequences of the master's late language. But I prefer not to judge it necessarily a work by Giotto himself. ₰ MORE strictly Giottesque are the remains of a large *Deposition* (pp. 349–50) in the nuns' choir of the same convent of Santa Chiara. (Bologna, 1969a, argues that at least the fragmentary figure of the old bearded man is by Giotto.) These parts of wonderful faces are rendered with a style based on the bare essentials, even more accentuated than the *Crucifixion* in the convent, and with very poignant expressions of grief. They are extremely modern faces: the line marking the contour is by now completely eliminated, and the shape is built up only by means of chromatic gradations. The male head is executed with brush strokes that are very fine and soft and with an expression of emotional intensity so strong as to leave no doubt that Giotto was the author of the fragment. But the almost Cubist female heads too are painted in a completely essential fashion by means of a decisive play of shadows emphasizing the features, repeating a stylistic element already present in the Magdalen Chapel (in the profile of the saint in *Noli me tangere*). This, together with the grief-stricken angels in anguished flight, who descend with perfect foreshortened wings, and the very delicate naked body on the cross, all seem to indicate the presence of the master in the entire work. ₰ ONE of the walls of the same choir presents a curious and interesting decoration: a series of very fragmentary painted choir-stalls, elegantly designed and in perfect perspective. These were exactly copied from the real stalls (as can be seen from a photograph depicting the original Gothic choir before the destruction caused by World War II), and they seem to continue the series of stalls, with that capacity to integrate real and fictive space, real and fictive architecture, that is a constant in Giotto's speech, starting with the two fictive "choirs" drawn in perfect perspective at the sides of the chancel arch in Padua (Conti, 1972; Leone de Castris, 1986). So the complex of the nuns' choir in the church of Santa Chiara was doubtless frescoed by Giotto's shop, certainly under his direction and probably also with his direct participation in certain more elegant passages. ₰ PROBABLY Giotto was also

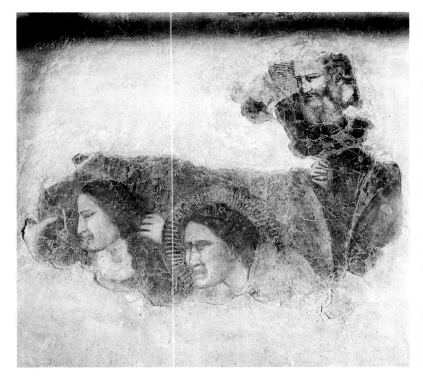

Giotto(?). Detail of DEPOSITION.
Nuns' Choir, Santa Chiara, Naples.

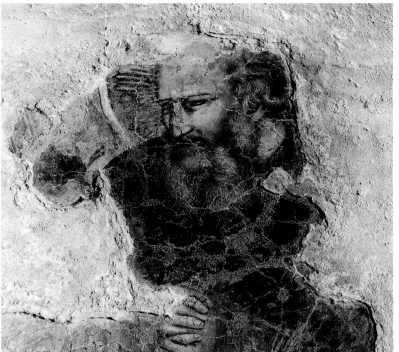

Giotto(?). Detail of DEPOSITION.
Nuns' Choir, Santa Chiara, Naples.

running the workshop at Castel Nuovo at the same time, as is shown by the first payment that he received, in February 1329, which refers to work in the Palatine Chapel (also called the Maggiore or Santa Barbara Chapel) and in another called the Secret Chapel. ❧ THE Palatine, a chapel with a single, very high nave adjacent to the body of the palace, was dedicated to the Madonna of the Assumption and was completely decorated with frescoes depicting episodes from the Old and New Testaments; the sources also record an altarpiece, unfortunately lost, that could have depicted a *Death of the Virgin* and a *Coronation.* ❧ THE chapel was redone together with the entire palace in 1470 by Ferrante d'Aragona, and all the frescoes were lost except for the embrasures of the seven high windows, each decorated with a different ornamental band. The bands offer a rich variety of motifs, simple Cosmatesque decorations alternating with fleshy clusters of acanthus leaves among which are fantastically shaped medallions with portrait busts. ❧ THE work on these friezes is particularly elegant, rendered with naturalistic verve accentuated by a precise play of chiaroscuro. A completely new element is a pre-Renaissance cluster of fruit—oranges, limes, and lemons from the Mediterranean—tied together with a ribbon: this decoration certainly comes from classical antiquity, but its "realistic" observations also bear witness to Giotto's increasing interest in natural truth. The most

interesting aspect of the friezes is the series of heads (p. 351), some with halos, others in the Oriental style, still others wearing the hood that was fashionable at that time. These depictions were evidently a running commentary on the episodes depicted on the walls. They are splendid heads, showing the collaboration of many different hands but almost all graphically characterized as portraits by the emphasis on features and expressions and the vivid hairstyles. Everywhere else the marginal parts of Giottesque pictorial cycles were done by assistants, and this is also true of the Palatine Chapel in Naples. But here the painting is particularly beautiful, indicating the artistic talent of Giotto's collaborators in Naples. Scholars have concentrated on these fragments, especially recently, trying to identify exactly who the painters were. On the basis of Salmi's (1943–46) intuition, they have identified one of them as Maso di Banco, who would have been here at the start, while another quite recognizable personality would have been the Neapolitan painter Roberto Oderisi. ❧ WHEN between 1453 and 1457 the Castello was altered by the order of Alfonso I d'Aragon, the decorations in the Secret Chapel and those in the hall of "famous men" or Great Hall were completely lost. But a sufficiently detailed description of the Great Hall can be found in the collection of sonnets written around 1350 to illustrate the frescoes. According to the sonnets the hall was decorated with nine figures of illustrious

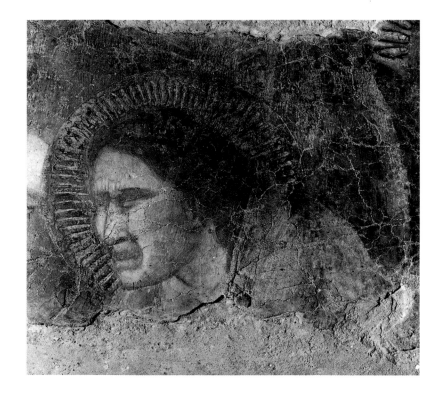

Giotto(?). Detail of DEPOSITION.
Nuns' Choir, Santa Chiara, Naples.

men, some accompanied by women: Alexander the Great, Solomon, Hector accompanied by Penthesilea, Aeneas, Achilles accompanied by Polyxena, Paris, Hercules, Samson, and Caesar. ❧ THE theme was certainly not new: medieval tradition, and French tradition in particular, had often proposed the portrayal of the so-called *neuf Preux*—that is, the nine valiant men, chosen from the three great cultures: Hebrew, Classical, and Christian—and went on to reaffirm certain modern heroes. But in the Castel Nuovo Great Hall are depicted heroes of the classical world only, in line with the humanistic ideas that were beginning to circulate in Naples during the 1330s. This is the first example of this subject, which was to have a great future in Italian painting, especially during the Renaissance; perhaps it directly inspired Petrarch, who certainly knew the frescoes, in writing his *De viris illustribus.* ❧ THIS is not the first time that Giotto used a secular theme: the Paduan frescoes have an astrological cycle, whose iconographical invention, at least in part, must have been Giotto's own. But the work in Naples was a completely new subject in regard to preceding tradition, a response to the stimuli and suggestions of modern culture reclaiming the classical world. Giotto took on this modern culture, strewing his paintings with figurative elements absorbed from Roman culture during the course of his long activity. ❧ NOT only are these very important frescoes lost but unfortunately there is not even a visual record of them. They may have offered, alongside the figures of heroes, a portrait of the ruler of Naples. Leone de Castris (1986) offers an interesting proposal: that in the Great Hall there might have been King Robert himself, surrounded by the Virtues, just as he appears in a miniature by Cristoforo Orimina in the *Bibbia di Nicolò Alife* (Library of the University of Louvain, France) done about a decade later.

GIOTTO AND THE VISCONTIS

❧

❧ GIOTTO returned to Florence in 1334, where on April 12 he was nominated with a public decree "magister et gubernator" (chief and governor) of works in Santa Reparata (later the Duomo) and architect of the city's walls and fortifications. Renaissance sources, starting with Villani, chronicle Giotto's stay in Milan too, following his return from Naples; the Florentine writes,

Assistants of Giotto. Details of friezes.
Palatine or Santa Barbara Chapel,
Castel Nuovo, Naples.

"The Master Giotto, having returned from Milan, where our commune sent him in the service of the lord of Milan, passed from this life." This was not therefore a long stay, and must be set at about 1335 or 1336. This information was also reported by Ghiberti, who does not specify the date of the journey but notes that Giotto had painted "a worldly glory" in Milan. The Florentine master painted decorations in the palace of Azzone Visconti, but these were unfortunately destroyed very soon after by his successor, Galeazzo II, so no trace remains of Giotto's paintings there. ❧ THERE cannot, however, be any doubt about Giotto's late stay in Milan, if for no other reason than the clear echoes of Giotto's late language in frescoes in that city. The *Crucifixion* in the church of San Gottardo in Corte, and the very soft fresco fragments in the church of Santa Maria in Brera, are unmistakably influenced by his work. ❧ DESPITE Ghiberti's information, it is not known with precision where and what Giotto painted in Milan for the Viscontis. We know that Azzone had built his palace in the area of the present Palazzo Reale. The Milanese chronicler Galvano Fiamma, writing around 1342, gives a detailed description of it, since he could admire it in all its splendor. The palace had many rooms and was decorated with "marvelous paintings." Furthermore, "at the side . . . is a truly glorious great hall, with paintings in honor of his glory . . . there are painted the illustri-

ous princes of the gentile world, such as Aeneas, Attila, Hector, Hercules, and many others. There is only one Christian among them—Charlemagne—and Azzone Visconti. And these figures are depicted in gold, azure, and enamel with such beauty and subtle art that no better can be found in all the world." Scholars generally agree that the paintings in question are precisely those that Giotto executed in the Visconti palace. ❧ FOR a second time, therefore, Giotto worked in a court, and for a second time he dealt with a secular theme, celebrating the ruling lord. And once again one is struck by his capacity for continuous renewal, which characterized the Florentine painter through the last years of his life. ❧ IN MILAN he painted a cycle with a secular subject and strong classical connotations, depicting pagan heroes. Unlike the work in Naples, it was embellished by portraits of Charlemagne and Azzone Visconti: significant presences, confirming the celebrative purpose of the frescoes. But alongside the heroes is depicted Glory, or Vainglory, according to Ghiberti: this adds a moralizing note to the celebrative one. I believe that for this image too Giotto must have sought iconographic inspiration in the classical world. And I agree with Creighton Gilbert's (1977) proposal that the Milanese fresco with a worldly Glory could have been the inspiration for the authors of the frontispiece on two manuscripts (lat 6069F and lat 6069I in the Bibliothèque

Nationale in Paris) of Petrarch's *De viris illustribus,* which emanated from an anticlerical circle; the manuscripts show the figure of Glory advancing in a triumphal Roman chariot surrounded by cupids playing trumpets. Here again Giotto appears as a leader, developing a theme and an iconography characteristic of the courtly world, but in an exquisitely classical key, in the spirit and fashion of the Italian fourteenth century. ❧ BUT court art was also a particularly refined and elegant language. Galvano Fiamma's description of the Great Hall in the Visconti palace speaks of gold, blue, and enamels: precious materials were used, but also special procedures to obtain elegant jewel-like effects—paintings gleaming with light and color, enriched by enamels—of a clearly Gothic flavor. Thus Giotto again proves to be an extraordinary inventor and innovator in this special field. In his long artistic career we have already seen him experiment with mixed techniques, as in the use of small colored and gilded pieces of glass in the halo of the *Crucifix* in Santa Maria Novella; we have seen his attention to details, allowed by an uncommon knowledge of the so-called "minor arts," as evidenced in the display of cloth and the abundance of decorative borders. Here, at the end of his journey, he seems ready to try other, richer, more elegant techniques and particularly luxurious materials. This matched the taste of the courts, and in particular, perhaps, the Visconti court, which was always alert to fashions from France. ❧ THE chroniclers' descriptions of the decorations in Castel Nuovo and the Visconti palace show Giotto in the court environments in which he was summoned to work, open to the newest and most fertile stimuli for the continued development of the arts in Italy, in two apparently opposed fields. Both fields—the recovery of the classical world and the elegant use of costly techniques and materials—are characteristic of the magnificent world of the first Italian city-states. The Florentine master was even ready to play the role of inventor and protagonist in the context of fourteenth-century Italian painting. ❧ BUT there is probably no truth to the information from old sources that Giotto went to the papal court of Avignon at the summons of Benedict XII. No element of the pictorial culture of Avignon during the middle years of the century recalls the artist's language.

page 354: Workshop of Giotto.
Bologna POLYPTYCH. *Tempera*
on panel, 35⅞ × 133⅞ in.
(91 × 340 cm). Pinacoteca
Nazionale, Bologna.

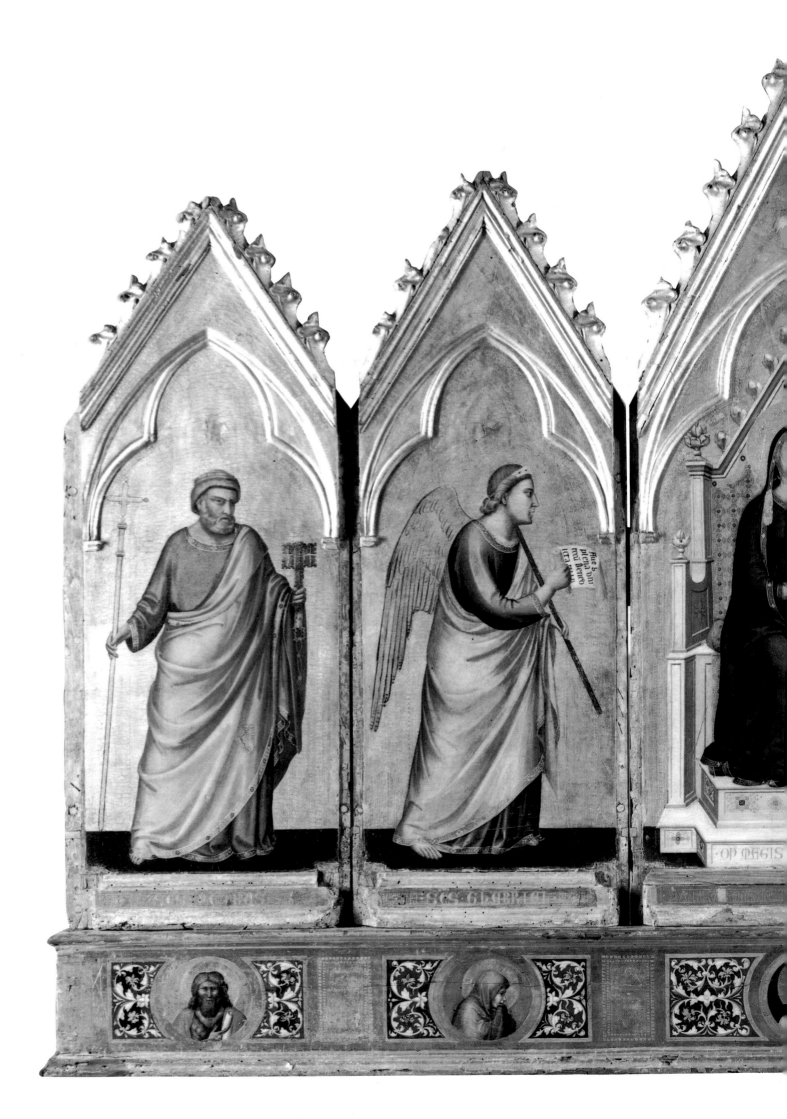

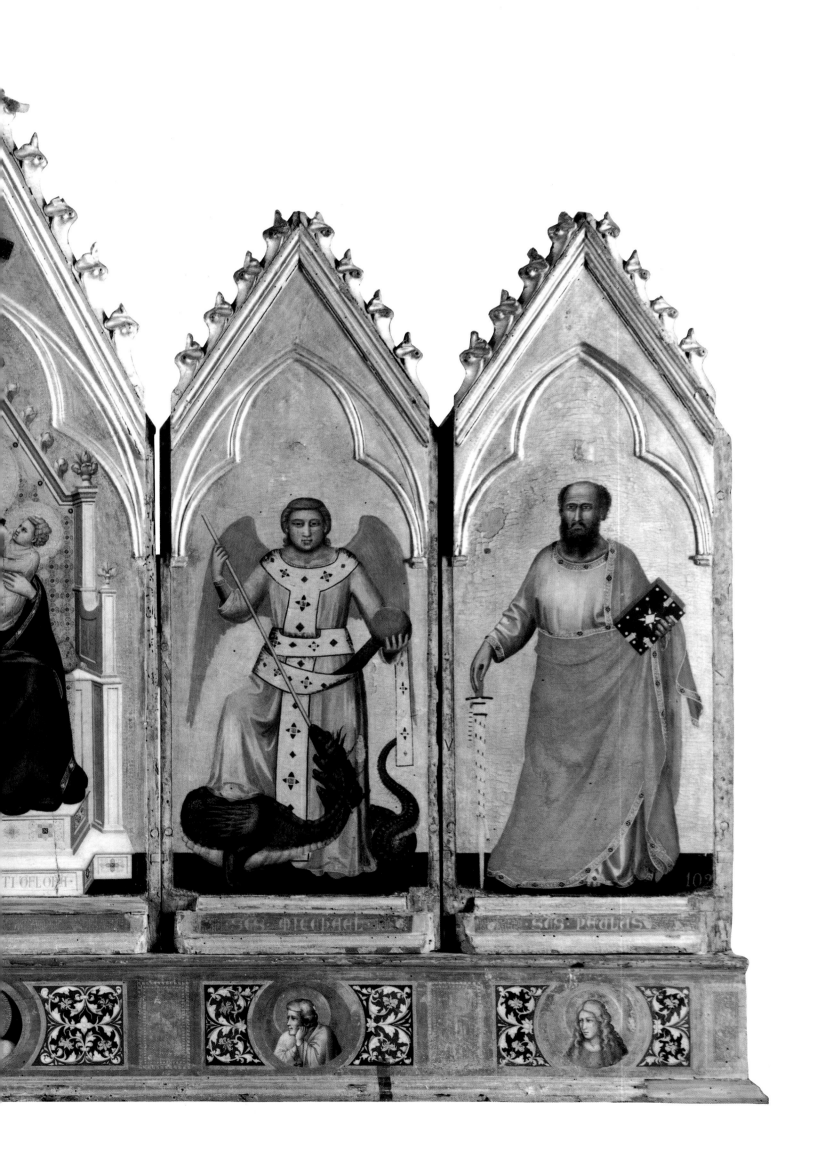

SCS MICCHAEL SCS PETLAS

THE BOLOGNA *POLYPTYCH*

ON GIOTTO'S return to Florence after the Neapolitan sojourn, the artist's large shop certainly did not stop producing panel paintings among other things. THE polyptych (pp. 354–55) preserved in the Pinacoteca Nazionale in Bologna should be placed after his return from Naples, perhaps before the journey to Milan. It came from the church of Santa Maria degli Angeli in Bologna, which was built by Gera Pepoli on his return from exile in 1328. Thus the work cannot be dated before that year. Broken up in 1808 as a result of the Napoleonic suppression, the painting was put together again in its present state in 1894. THE polyptych is formed of five panels framed within pointed trilobed arches, terminating in greatly accentuated vertical pediments. The panels portray the Madonna enthroned with Child at the center, and on the left St. Peter and the archangel Gabriel; on the right are the archangel Michael and St. Paul. The predella, which seems a severe architectonic base, presents elegant floral ornamentations of gold against blue or green backgrounds framing medallions containing small heads: at the center is the dead Christ, flanked by the Madonna and St. John with John the Baptist and Mary Magdalen beyond them. The work is signed in full—"OPUS MAGISTRI IOCTI DE FLORENTIA S.C."—yet its authorship is nevertheless also one of the most debated. ALL the figures have a certain harshness, and a generic quality of composition, betrayed by, for instance, the inertia of the postures: St. Paul, for example, seems to be leaning wearily on his sword, and the archangel Michael pushes forward a knee awkwardly, as though stiffened by his symmetrical and rigid wings, which look almost metallic. Also not very moving is the Child's affectionate gesture, which the Madonna, her face enveloped in a gauze wimple, does not look at. The figure of Gabriel, seen in profile, is singular, as though copied from an Annunciation scene but without the slightest connection with any person in the painting. Certainly the polyptych came out of the master's shop, and the master himself may have proposed a few compositional and coloristic solutions. But the long figures with rather small heads, while tied to Giotto's late language, are distanced from it by their more generic postures and the imprecise study of light. MUCH more interesting is the play of colors, which reflects the painter's last experiments in the use of a bright palette and rare nuances— the lilac reflections on archangel Michael's red robe, the yellow

reflections on St. Paul's green garment, or the flaring red of archangel Michael's wings. This taste for color is captured even more in the predella, where the heads are set against highly colored backgrounds like the vivid red behind Christ, the Madonna, and St. John, or the pale green behind the John the Baptist and the Magdalen, who wear red clothes in a lively, luminous juxtaposition of complementary colors. ❧ THIS polyptych was of particular importance for painting in Bologna during the years when the city began to develop a more distinct personality; one need only consider the tradition of the vernacular that a very few years later, in 1345, will give us Vitale da Bologna's *Madonna* (today at Bologna's Museo Davia Bargellini). ❧ GHIBERTI records as Giotto's work the decoration in the Podestà Chapel in the Bargello palace in Florence, where mutilated and ruined depictions of the *Last Judgment* and the Stories of Mary Magdalen can be seen. An inscription states that these paintings were commissioned under the mayoralty of Fidesmino da Varano; that is, between 1333 and 1337. The frescoes imitate and repeat Giottesque motifs, particularly Paduan, but they must be entirely assigned to Giotto's workshop because of the general compositional design, which is devoid of new and original ideas. ❧ SO WITH the Bologna *Polyptych* we come to the end of the known journey of the Florentine master, a journey that lasted almost fifty years and was fundamental and decisive for the history of Italian, and thus European, painting. Giotto moved through the many stages of a fascinating progress, from the first conquest of space and volume, to research into the problems of color and light, to the last extremely refined and intimate luministic creations. ❧ GIOTTO'S journey is intermingled with those of the major Italian painters and sculptors, especially with Simone Martini, Ambrogio Lorenzetti, Arnolfo di Cambio, and Giovanni Pisano; this reciprocity furnishes a key to the continuously renewed vitality of Giotto's art. ❧ IN THE history of Italian painting in the fourteenth century Giotto's role was that of a revolutionary innovator, master of generations of artists. His lofty poetic also inspired the great Florentine protagonists of the early Renaissance, starting with Masaccio, who certainly remembered the figures in the Peruzzi Chapel for his own powerful characters. ❧ WHEREVER the Florentine master opened his shop, a school sprang up that absorbed and gradually developed his characteristics. From Rimini to Padua, from Assisi to Florence, and finally to Lombardy; some of these Giottesque painters were less faithful to the master's style, but all traced certain fundamental elements back to the master: the renewed "Latinity" of the space-volume relationship and the tenderness of color revealed by the light.

GIOTTO

THE

ARCHITECT

ON APRIL 12, 1334, GIOTTO WAS NAMED BY THE COMMUNE OF FLORENCE "MAGISTER ET GUBERNATOR" OF THE WORK OF SANTA REPARATA—THAT IS, THE DUOMO—AND ARCHITECT OF FLORENTINE WALLS AND FORTIFICATIONS, A POSITION HE WOULD HOLD UNTIL HIS death. The Florentine master, versatile like all medieval artists, might have tried his hand even earlier in construction, if we can credit fourteenth-century sources that say he was the designer of certain challenging buildings. Furthermore, Vasari called him a "sculptor and architect," not just a painter. ❧ GIOTTO'S activity in the field of architecture was certainly suited to his sensibility and talent as an artist; he was always interested in the problems of space, as we have seen from his work as a painter, and in the formulation of architectonic backgrounds of ever greater precision. The considerable importance of the buildings commissioned by the Commune from the artist on his return from Naples would seem to confirm his continuous, though marginal, attention to architectonic problems. ❧ STRANGELY, however, critical attention to this aspect of Giotto's activity has been recent and limited: it was set in motion by a Longhi essay in 1952 with the significant title *Giotto spazioso* (The Spacious Giotto). Soon after, in 1963, Gioseffi published an important book, *Giotto archi-tetto* (Giotto the Architect), reconstructing the activity of the Florentine master in architecture, starting with an examination of the paintings, in which the artist's spatial feeling, equivalent to an "architectonic sense," is strikingly evident. The critic then proposed that Giotto designed some buildings, first of all the Scrovegni Chapel in Padua, a hypothesis already advanced by local Paduan scholars, such as Selvatico (1839). The Paduan chapel presents a very simple structure—just one nave covered by a vast barrel vault and with an ample triumphal arch—so that there would be no need to consider Giotto, if not to stress the spacious sense of openness and breadth of the main section of the church and the classical measure of its proportions, not to mention the majesty of the vault echoed by the triumphal arch. This sense of openness and breathing space is quite similar to the architecture painted on the walls of that same building. But it is the close bond between environment and painting, as if the building had been intended as a grand receptacle for the frescoes, which most

strongly supports Gioseffi's hypothesis. The material and construction of the building are for the most part typical of the local tradition, from which Giotto did not want to distance himself. The large triple window in the facade, however, owes more to Tuscan influences; thus one can presume that Giotto suggested at least this important element, the source of illumination for the interior painting. In any event, this proposed attribution does not qualify the artist for the title of great architect. ❧ VASARI assigns to a much more mature Giotto the design for the tomb of Bishop Tarlati in the cathedral at Arezzo (p. 364), executed in 1330 by the Sienese sculptors Giovanni and Agnolo di Ventura. This is certainly a very original work: the sarcophagus is surmounted by a canopy with a fully rounded arch in exquisitely classical taste, resting on thin elegant pillars. The wall under the sarcophagus is adorned with a bas-relief composed of four bands of small sculpted slabs, completely new elements in the fourteenth-century tomb tradition that could indicate at least a suggestion from the great master, not only in the sequence of pictures in relief, as in a pictorial decoration, but perhaps even more in the majestic and classical measure of the fully rounded arch in precise perspective, which seems a proper prelude to the Florentine Renaissance tombs. ❧ BUT it is the only document of 1334 that gives us the certainty that in the last years of his life, at the end of his long and varied activity, Giotto dedicated himself to the work of building for the city of Florence. ❧ PERHAPS the first work constructed in Florence under Giotto's direction was the Carraia bridge (p. 367), unfortunately destroyed during World War II. In 1333 the old medieval bridge was swept away by a flood of the Arno; it is possible, as Brandi (1983) suggests, that Giotto was called home from Naples specifically for the reconstruction of this important link in the city's system of communication. In any case it was completed and inaugurated in 1337, as Giovanni Villani says. A highly modern construction, the bridge's technical perfection culminates in the hyperbolic curve of its roadbed and the inspiration of the low arches that grow bigger toward the middle— a realization of an idea that the master had already hypothesized when he painted the small bridge in front of the portal in the *Meeting at the Golden Gate* in Padua. Gioseffi (1963) emphasizes the linear severity and simplicity of the structure, which make it a revolutionary work in the field of medieval civil architecture and which could have been suggested by analogous solutions of the classical age, such as the Roman bridge at Rimini, certainly well known to Giotto. ❧ LOCAL tradition, confirmed by the 1334 document, assigns to Giotto the construction, or better the design of the bell tower of the Florentine Duomo (p. 365), which is generally called the Campanile di Giotto. The foundations of the

pages 362–63: Exterior of the Scrovegni Chapel, Padua.

Giovanni and Agnolo di Ventura.
Tomb of Bishop Tarlati (1330).
Cathedral, Arezzo.

Bell tower, Florence.

construction were laid on July 18, 1334; according to Billi (c. 1530), the master directed the construction "up to the first carvings"; Ghiberti thinks the sculptures of the lower part of the monument should be attributed to him also. ❧ THIS building is absolutely new and singular: it rests on a square base and is anchored at the corners by four robust octagonal pillars (below). In comparison to the traditional structure of bell towers with sharply pointed corners, this Florentine bell tower takes on a significantly new form, almost a gigantic sculpture set on the ground. The idea of enclosing the composition within thin pillars had been in Giotto's mind since the Scrovegni Chapel; and the importance that he always gives to the borders and frames of his paintings, it seems to me, can be an interpretative clue also for the base of this construction, where the volume is not left free but curbed and measured. At the same time the motif of octagonals, perhaps inspired by Neapolitan architecture (Gioseffi, 1963), impresses on the construction a kind of rotary motion quite visible if one looks at the bell tower not from the front but on an angle. ❧ COMPLETELY covered with colored marble of white, pink, and green, the bell tower not only repeats a long local tradition but perfectly integrates it with the piazza, between the Duomo, whose facade project stipulated a similar outer covering, and the Baptistery, encrusted with slabs of white and green marble. ❧ WITHOUT question the

base is attributable to Giotto; it rests on a step, perhaps built later, due to the sagging of the ground (Gioseffi). The base is formed of a series of marble skirtings in dark green and pink with Cosmatesque motifs in the same colors. In the central part of each wall seven vertical pink panels framed in white contain at their center a hexagon with a bas-relief; above is a thin frame whose small brackets alternate with small Cosmatesque white mosaics on pink or green backgrounds. A similar interplay of marble is in the corner turrets. The repetition of the base, which repeats with greater lightness the original typology higher up, is owed to Andrea Pisano. ❧ WHAT should be emphasized about Giotto's structure is the geometric firmness of the design, the use of brackets, which repeat in reality those painted above the pedestal in the Scrovegni Chapel, and the hexagons inserted in the rectangular bands, which recall (the observation is again Gioseffi's) the painted borders in several fresco cycles, thus indicating a very close continuity between the pictorial and architectonic languages. ❧ THE complex iconographic program, which one reads in two rows of stone tiles as a bas-relief, is the exquisite work of Andrea Pisano. It depicts in the lower zone the life of man from his creation to the development of civilization through the arts and sciences; and in the upper zone the planets, which influence the virtues, the liberal arts, and the sacraments that discipline and sanctify

Giotto, Andrea Pisano, and Francesco Talenti. Base of the bell tower, Florence.

man. This was in all probability devised by Giotto, who was not unaccustomed to tackling encyclopedic medieval summae such as the astrological cycle he painted in Padua's Palazzo della Ragione. For this very beautiful invention, more pictorial than architectonic, the reference is to the plinth in the Scrovegni Chapel composed of pale mock marble with mock painted statues. This was a constant typology conceived first in painting; here the monochrome figures are substituted by real reliefs. ❧ BUT in the choice of pale colors and pink marble new to the local construction tradition, one encounters the same chromatic sensibility that char-acterizes the decoration of the Bardi Chapel in Santa Croce, where the plane closes behind the figures, offering the same shadings of bright and luminous colors and the same use of facings in alternating tints. It is notable that Giotto in his most important work as an architect should have stressed the pictorial effect more than the spatial one, in accord with his late paintings. ❧ THIS extraordinary and unique architecture, begun by the great Florentine artist, was completed by Andrea Pisano and Francesco Talenti: Giotto died on January 8, 1337, and was buried with great honors in Santa Reparata under the auspices of the Commune.

Carraia bridge, Florence, before its destruction in 1944.

APPENDIXES

DOCUMENTARY RECORDS

1309 Assisi, January 4: Palmerino di Guido repays a loan in his and Giotto's names. *(Bevagna, Municipal Archives, busta 14 c, fascicolo E, foglio 13v. Notary Iohannes Alberti de Assisio. Published in V. Martinelli, 1973.)*

1311 Florence, December 23: Giotto stands surety for a loan. *(Florence, State Archives: Protocollo di ser Arrigo di Benintendi, A. 937, foglio 129. Published in L. Chiappelli, 1923.)*

1312 Florence, September 4: Giotto rents a loom to Bartolo di Rinuccio. *(Florence, State Archives: Protocollo di ser Lapo di Gianni di Ricevuto da Firenze, foglio 88. Published in R. Davidsohn, 1901, vol. 3.)*

1313 Florence, December 8: Giotto names Benedetto son of Pace to act as his agent to recover the belongings he left in Rome in the home of Filipa di Rieti, where he had resided. *(Florence, State Archives: Protocollo di Giovanni di Gino da Calenzano, G. 393, foglio 34. Published in L. Chiappelli, 1923.)*

1314 Florence, March 28: Giotto names Giovanni di Rosticio and Filippo di Bencino as his proxies. *(Florence, State Archives: Protocollo di Giovanni di Gino da Calenzano, G. 393, foglio 82. Published in L. Chiappelli, 1923.)*

1314 Florence, April 15: Giotto names as his proxies ser Donato di Gherardo, ser Bene di ser Riccobene, ser Giovanni di Ciaio, and ser Pagno di ser Bonaffede. *(Florence, State Archives: Protocollo di Giovanni di Gino da Calenzano, G. 393, foglio 100. Published in L. Chiappelli, 1923.)*

1314 Florence, September 14: Legal action by Giotto as guarantor of a loan. *(Florence, State Archives: Protocollo di Giovanni di Gino da Calenzano, G. 393, I, foglio 174. Published in R. Davidsohn, 1908, vol. 4, part 3.)*

1315 Florence, October 2: Legal dispute between Giotto and ser Grimaldo over certain holdings of land. *(Florence, State Archives: Archivio dell'Ospedale di Santa Maria Nuova, Protocollo di ser Lando d'Ubaldino di Compagno da Pesciola, carta 28. Published in G. Baccini, 1900.)*

1318 Florence, September 15: Giotto emancipates his son Francesco. *(Florence, State Archives: Protocollo di ser Francesco di Pagno di Vespignano. Published in I. B. Supino, 1920, vol. 3, p. 317.)*

1320 Florence, October 16: Giotto names as his proxy ser Lorenzo di Ubertuccio. *(Florence, State Archives: Protocollo di ser Lando d'Ubaldino di Compagno da Pesciola, L. 38. Published in L. Chiappelli, 1923.)*

1321 Florence, December 4: Giotto leases two plots of land to ser Buto son of Gardino. *(Florence, State Archives: Protocollo di ser Lando d'Ubaldino di Compagno da Pesciola, 1318–26, carta 101. Published in I. B. Supino, 1920, vol. 3, p. 317.)*

1321 Colle di Vespignano: Guerrazio son of Andrea di Colle sells Giotto a piece of land for the price of 45 "small florins." *(Florence, State Archives: Protocollo di ser Francesco di Boninsegna da Vespignano, registro F 481. Published in I. B. Supino, 1920, vol. 3, p. 317.)*

1322 Colle di Vespignano, January 14: Giotto acquires holdings in Colle di Vespignano. *(Florence, State Archives: Protocollo di ser Francesco di Boninsegna da Vespignano, 1316–27. Published in G. Baccini, 1892.)*

1325 Florence, November 10: Giotto stands surety for a loan. *(Florence, State Archives: Protocollo di ser Francesco di Boninsegna da Vespignano, 1321–33. Published in I. B. Supino, 1920, vol. 3, p. 318.)*

1326 Florence, February 17: Giotto promises to give his daughter Chiara in marriage to Zuccherino di Coppino. *(Florence, State Archives: Protocollo di ser Francesco di Boninsegna da Vespignano, carta 211. Published in G. Baccini, 1892.)*

1326 Colle di Vespignano, May 12: Giotto stipulates the dowry for his daughter Chiara. *(Florence, State Archives: Protocollo di ser Francesco di Boninsegna da Vespignano, carta 225v. Published in G. Baccini, 1892.)*

1327 Florence: Together with several other painters, Giotto becomes a member of the guild of doctors and apothecaries. *(Information published in R. Mather Graves, 1936.)*

1328 Naples, December 8: Giotto is paid by the king's treasurer. *(Naples, State Archives: Cancelleria Angioina, registro 1328 B. Published in R. Filangieri, 1936.)*

1329 Naples, August 5: Giotto receives a payment. *(Naples, State Archives: Cancelleria Angioina, registro 285, foglio 213. Published in R. Filangieri, 1936.)*

1330 Naples, January 2: Giotto receives a payment. *(Naples, State Archives: Cancelleria Angioina, registro 285, foglio 213. Published in R. Filangieri, 1936.)*

1330 Naples, January 20: King Robert decrees that Giotto is "a painter familiar and faithful to ourselves." *(Naples, State Archives: Cancelleria Angioina, registro 1329 A, foglio 20. Published in R. Filangieri, 1936.)*

1331 Naples, May 20: King Robert gives a receipt to the royal treasurer for expenses incurred for various paintings by Giotto in Castel Nuovo. *(Naples, State Archives: Cancelleria Angioina, registro 285, foglio 213. Published in R. Filangieri, 1936, pp. 319–22.)*

1332 Naples, February: Giotto receives a payment for the frescoes in the "Secret Chapel" and the Palatine Chapel in Castel Nuovo. *(Naples, State Archives: Cancelleria Angioina, registro 286, foglio 228. Published in R. Filangieri, 1936.)*

1332 Naples, March 16: Donation from King Robert to Giotto. *(Naples, State Archives: Cancelleria Angioina, registro 287, foglio 227. Published in R. Filangieri, 1936.)*

1332 Naples, April 28: King Robert grants Giotto an annual pension. *(Naples, State Archives: Cancelleria Angioina, registro 286, foglio 74. Published in R. Filangieri, 1936.)*

1332–33 Naples: Giotto has several quarrels with Giovanni da Pozzuoli. *(Naples, State Archives: Cancelleria Angioina, registro 1332–33, foglio 39v. Published in R. Filangieri, 1936.)*

1333 Naples, July 1: Giotto receives a payment. *(Naples, State Archives: Cancelleria Angioina, registro 284, foglio 18, and registro 287, foglio 213. Published in R. Filangieri, 1936.)*

1333 Naples, December 6: Giotto receives a payment. *(Naples, State Archives: Cancelleria Angioina, registro 281, foglio 159v; registro 286, foglios 228 and 240v; registro 293, foglio 392. Published in R. Filangieri, 1936.)*

1334 Florence, April 12: Giotto is named master builder for the construction of Santa Reparata (the Duomo) and chief of public works for the Commune of Florence. *(Florence, State Archives: Archivio delle Riformagioni di Firenze. Provvisioni, filza 27. Published in G. Gaye, 1839.)*

1334 Florence, July 18: Laying of the foundation for the bell tower of Santa Reparata. *(Reported by G. Villani, c. 1340, book 11, chapter 12.)*

1334 Florence, November 29: Giotto acts as witness to a document drawn up in the Bargello palace. *(Published in C. Baccini, 1892.)*

1335 Florence, September 15: Giotto is in Florence. *(Reported by F. Baldinucci, 1681, vol. 1, p. 51.)*

1337 Florence, January 8: Giotto dies and is buried in Santa Reparata at the expense of the Commune and "with great honors." *(Reported by G. Villani, c. 1340, book 11, chapter 12.)*

THE UPPER BASILICA OF SAN FRANCESCO, ASSISI: KEY TO THE FRESCOES

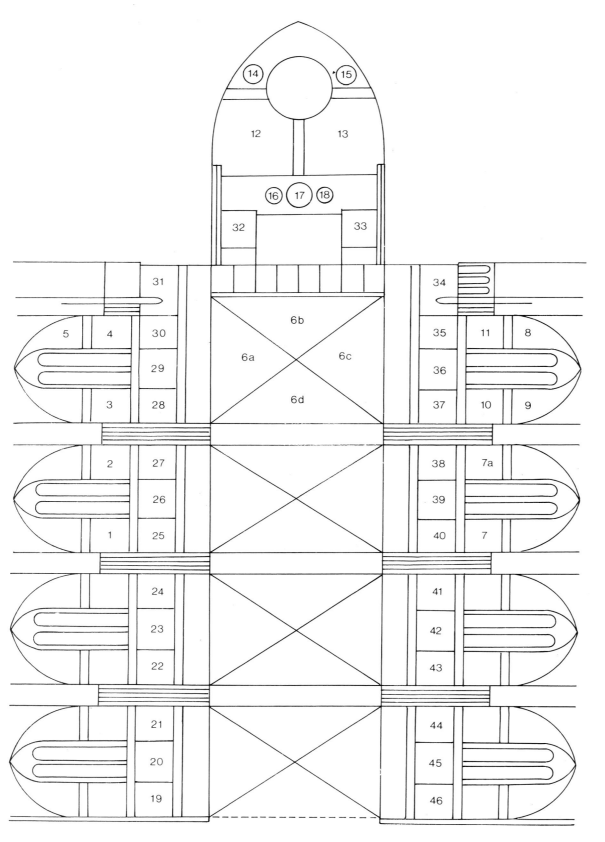

OLD TESTAMENT CYCLE

1 Jacob Receives the Blessing of the First-Born
2 Isaac Rejects Esau
3 Joseph Is Thrown into the Pit (Joseph Is Sold by His Brethren)
4 Cup Found in Benjamin's Pack
5 Slaying of Abel
6 Doctors of the Church and Saints: (a) St. Ambrose (b) St. Jerome (c) St. Augustine (d) St. Gregory the Great

NEW TESTAMENT CYCLE

7 Way of the Cross
7a Crucifixion
8 Baptism of Christ
9 Christ among the Doctors
10 Deposition
11 Resurrection of Christ
12 Pentecost
13 Ascension
14 St. Paul
15 St. Peter
16 Angel
17 Madonna with Child
18 Angel

FRANCISCAN CYCLE

19 Man in the Street Pays Homage to St. Francis
20 Cloak Incident
21 St. Francis Sees a Building in a Dream
22 Crucifix at San Damiano Speaks to St. Francis
23 St. Francis Renounces His Worldly Possessions
24 Dream of Innocent III
25 Franciscan Rule Approved
26 Vision of the Fiery Chariot
27 Vision of the Thrones
28 Devils Are Driven Out of Arezzo
29 Trial by Fire
30 Ecstasy
31 Crib at Greccio
32 Miracle of the Spring
33 St. Francis Preaches to the Birds
34 Death of the Knight of Celano
35 St. Francis Preaches before Honorius III
36 St. Francis Appears to the Chapter at Arles
37 Stigmata
38 Death of St. Francis
39 St. Francis Appears to Fra Agostino and the Bishop
40 Confirmation of the Stigmata
41 Poor Clares Mourn the Death of St. Francis
42 Canonization of St. Francis
43 St. Francis Appears to Gregory IX
44 Healing of the Wounded Man
45 Confession of the Woman of Benevento
46 Liberation of the Prisoner

THE SCROVEGNI CHAPEL, PADUA: KEY TO THE FRESCOES

1 God the Father Surrounded by Angels
a "choirs"

LIFE OF JOACHIM

2 Joachim Is Driven from the Temple
3 Joachim Joins the Shepherds
4 Annunciation to St. Anne
5 Sacrifice of Joachim
6 Joachim's Dream
7 Meeting at the Golden Gate

LIFE OF THE VIRGIN

8 Birth of the Virgin
9 Presentation of the Virgin in
 the Temple
10 Ceremony of the Rods
11 Prayer for the Miracle of the Rods
12 Marriage of the Virgin
13 Wedding Procession
14a Angel of the Annunciation
14b Virgin of the Annunciation

LIFE OF CHRIST

15 Visitation
16 Nativity and Apparition to
 the Shepherds
17 Epiphany
18 Presentation in the Temple
19 Flight into Egypt
20 Slaughter of the Innocents
21 Christ among the Doctors
22 Baptism of Christ
23 Marriage Feast at Cana
24 Raising of Lazarus
25 Triumphal Entry into Jerusalem
26 Cleansing of the Temple
27 Judas's Betrayal
28 Last Supper
29 Washing of the Feet
30 Kiss of Judas
31 Jesus before Caiaphas
32 The Flagellation (Coronation
 with Thorns)
33 Way of the Cross
34 Crucifixion
35 Deposition
36 Resurrection
37 Ascension
38 Pentecost
39 Last Judgment
40 Virtues:
 (a) Prudence (b) Fortitude
 (c) Temperance (d) Justice (e) Faith
 (f) Charity (g) Hope
41 Vices:
 (a) Folly (b) Inconstancy (c) Anger
 (d) Injustice (e) Infidelity (f) Envy
 (g) Despair

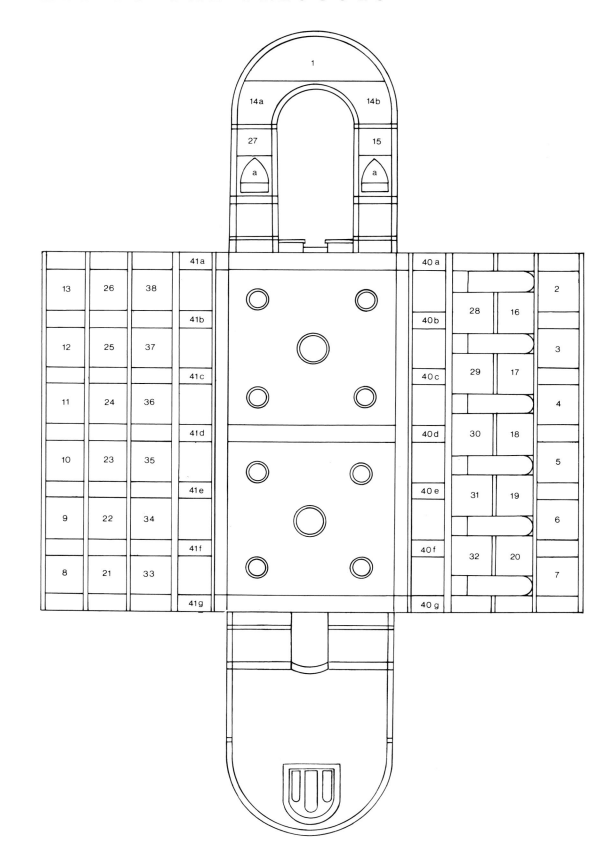

BIBLIOGRAPHY

❧

The number of books on Giotto is vast. For works published prior to 1969, please refer to R. Salvini's *Giotto. Bibliografia* (Rome, 1938), and C. De Benedictis's *Giotto. Bibliografia* (Rome, 1973). Works published before 1969 and cited in the text are listed below, together with a selection of titles published since 1969.

C. 1310 Francesco da Barberino. *I documenti d'amore di Francesco da Barberino (Liber Documentorum amoris),* ed. F. Egidi. Rome, 1905.

C. 1312–13 Riccobaldo Ferrarese. *Compilatio Chronologica,* in *Rerum Italicarum Scriptores,* book 9, ed. L. A. Muratori. Milan, 1726.

C. 1333–34 *L'Ottimo Commento della Divina Commedia,* ed. A. Torri. Pisa, 1828.

C. 1340 G. Villani. *Cronica.* In *Biblioteca Classici italiani,* book 11. Trieste, 1852.

C. 1340–50 Giovanni da Nono. *Visio Aegidii Regis Patavi,* from *La cronaca di Giovanni da Nono,* ed. G. Fabris. In *Bollettino del Museo Civico di Padova,* n. s., 8 (1938).

C. 1342 Gualvanei de la Flamma ord. praed. *Opusculum de Rebus gestis ab Azone, Luchino et Johanne, Vicecomitibus, ab anno MCCCXXVIII usque ad annum MCCCXLII.* In *Rerum Italicarum Scriptores,* book 12, part 4a, ed. C. Castiglioni. Bologna, 1938.

1358 F. Petrarca. *Itinerarium Syriacum,* in G. Lumbroso, *Memorie del buon tempo antico.* Turin, 1889.

1373 A. Pucci. *Il Centiloquio che contiene la Cronica di Giovanni Villani in terza rima.* In *Delizie degli Eruditi toscani,* vols. 3 and 4. Florence, 1772–1773.

C. 1388–95 F. Sacchetti. *Il Trecento novelle.*

C. 1390 C. Cennini. *Il libro dell'arte,* ed. D. V. Thomson. New Haven, Conn., 1932.

C. 1400 F. Villani. *Le vite di uomini illustri fiorentini con le annotazioni del Conte Gianmaria Mazzucchelli.* Venice, 1747.

C. 1400 F. Villani. *De origine civitatis Florentiae et einsdem famosis civibus,* ed. G. C. Galletti. Florence, 1847.

C. 1440 M. Savonarola. *Commentariolus de laudibus Patavii.* In *Rerum Italicarum Scriptores,* book 24, ed. L. A. Muratori. Milan, 1738.

C. 1450 L. Ghiberti. *I Commentari,* ed. J. von Schlosser. Berlin, 1912.

1524 P. Sumonte. Lettera a Marcantonio Michiel. In F. Nicolini, *L'arte napoletana del Rinascimento e la lettera di Pietro Sumonte a Marcantonio Michiel.* Naples, 1925.

C. 1530 A. Billi. *Il libro di Antonio Billi in due copie nella Biblioteca Nazionale di Firenze,* ed. C. De Fabriczy. In *Archivio Storico Italiano* 7 (1891): 295–368.

1550 and 1568 G. Vasari. *Le Vite de' più eccelenti pittori,* ed. R. Bettarini and P. Barocchi, text and commentary with comparison of the two editions. Florence, 1966–67.

1560 B. Scardeone. *De Antiquitate urbis Patavii.* Basel, Switzerland.

1598 A. Riccoboni. *De Gymnasio Patavino commantariorum libri.* Padua.

1619 G. Grimaldi. *Descrizione della Basilica di san Pietro in Vaticano,* Codice Barberini Latino 2733, ed. R. Niggl. Vatican City, 1972.

1623 A. Portenari. *Della felicità di Padova.* Padua.

1678 C. C. Malvasia. *Felsina pittrice. Vite dei Pittori bolognesi.* Bologna.

1681 F. Baldinucci. *Notizie de' Professori del Disegno da Cimabue in qua.* Florence.

1754–61 G. Richa. *Notizie istoriche delle chiese fiorentine. . . .* Florence.

1792 L. Lanzi. *Storia Pittorica dell' Italia inferiore.* Florence; 2nd edition, unabridged, Bassano del Grappa, Italy, 1795–96.

1821 W. K. Witte. "Der Sacro Convento in Assisi," in *Kunstblatt,* pp. 166–67.

1827 C. F. von Rumohr. *Italienische Forschungen.* Berlin-Stettin.

1839 G. Gaye. *Carteggio inedito d'artisti,* book 1. Florence.

1839 P. Selvatico. "L'oratorio dell' Annunziata nell'Arena di Padova e i freschi di Giotto in essa dipinti." In *Scritti d'arte,* Florence, 1939, pp. 215–28.

1852 B. Gonzati. *La Basilica di sant' Antonio di Padova,* vol. 1. Padua.

1864 J. A. Crowe and G. B. Cavalcaselle. *A New History of Painting in Italy,* vols. 1 and 2. London.

1869 J. A. Crowe and G. B. Cavalcaselle. *Geschichte der italienischen Malerei,* vol. 1. Leipzig.

1875 J. A. Crowe and G. B. Cavalcaselle. *Storia della pittura italiana dal secolo II al secolo XVI,* vol. 1. Florence.

1881 E. Muentz. "Etudes sur l'histoire des arts à Rome pendant le Moyen Age. I, Boniface VIII et Giotto." In *Mélange d'Archéologie et d'Histoire* (Ecole française de Rome) 1: 111–37.

1885 J. A. Crowe and G. B. Cavalcaselle. *Storia della Pittura in Italia,* second edition, vols. 1 and 3. Florence.

1885 K. Frey. "Studien zu Giotto." In *Jahrbuch der preussischen Kunstsammlungen* 6: 107–40.

1885 H. Thode. *Franz von Assisi und die Anfaenge der Kunst der Renaissance in Italien.* Berlin.

1886 K. Frey. "Studien zu Giotto." In *Jahrbuch der preussischen Kunstsammlungen* 7: 101–18.

1892 G. Baccini. "Dove è nato Giotto?" In *Messaggero del Mugello,* nos. 42, 44, 45.

1894 A. Tolomei. *La cappella degli Scrovegni di Padova.* In A. Tolomei, *Scritti vari.* Padua.

1895 J. von Schlosser. "Ein veronesisches Bilderbuch und die Hoefische Kunst des XIV Jahrhunderts." In *Jahrbuch der Kunsthistorischen Sammlungen,* 16: 144–230.

1896 B. Berenson. *The Florentine Painters of the Renaissance.* New York and London.

1899 H. Thode. *Giotto.* Leipzig.

1899 M. G. Zimmermann. *Giotto und die Kunst Italiens im Mittelalter,* vol. 1. Leipzig.

1900 G. Baccini. In "Messaggero del Mugello," no. 37.

1900 G. De Blasis. "Immagini di uomini famosi in una sala di Castelnuovo attribuite a Giotto." In *Napoli nobilissima* 9: 65–67.

1901 R. Davidsohn. *Forschungen zur Geschichte von Florenz.* Berlin.

1901 R. Fry. "Giotto." In *Monthly Review.*

1902 F. M. Perkins. *Giotto.* London.

1903 J. A. Crowe and G. B. Cavalcaselle. *A History of Painting in Italy,* vol. 2. London.

1904 P. Toesca. "Gli antichi affreschi di Santa Maria Maggiore." In *L'Arte* 7: 312–17.

1906 O. Sirén. *Giotto.* Stockholm.

1907 A. Venturi. *Storia dell'arte Italiana,* vol. 5, *La Pittura del Trecento e le sue origini.* Milan.

1908 J. A. Crowe and G. B. Cavalcaselle. *A History of Painting in Italy,* vol. 3. London.

1908 R. Davidsohn. *Forschungen zur Geschichte von Florenz,* vols. 3 and 4. Berlin.

1912 F. Rintelen. *Giotto und die Giotto-Apokryphen.* Munich.

1917 O. Sirén. *Giotto and Some of His Followers.* Cambridge, Mass.

1920 I. B. Supino. *Giotto.* Florence.

1922 L. Venturi. "La 'Navicella' di Giotto." In *L'Arte* 25: 49–69.

1923 L. Chiappelli. "Nuovi documenti su Giotto." In *L'Arte* 26: 132–36.

1923–24 A. Moschetti. "Di nuovo su 'questioni cronologiche giottesche.'" In "Atti e memorie dell'Accademia patavina di Scienze Lettere e Arti," Cl. Sc. M., pp. 125–34.

1924 R. van Marle. *The Development of the Italian Schools of Painting,* vol. 3. The Hague.

1924–25 S. Pichon. "Gli affreschi di Giotto al Santo a Padova." In *Bollettino d'Arte,* 2nd series, 18: 26–32.

1926 B. Kleinschmidt. *Die Basilika S. Francesco in Assisi.* Berlin.

1927 P. Toesca. *Storia dell'arte Italiana,* book 2, *Il Medioevo.* Turin.

1929 E. Sandberg-Vavalà. *La Croce dipinta italiana e l'iconografia della passione*. Verona.

1929 P. Toesca. *La pittura fiorentina del Trecento*. Verona.

1930 R. Offner. *A Critical and Historical Corpus of Florentine Painting*, sec. III, vol. 2, 1. Berlin.

1930–31 R. Longhi. "Progressi nella reintegrazione d'un polittico di Giotto." In *Dedalo* 11: 285–91.

1931 W. Suida. "A Giotto Altarpiece." In *The Burlington Magazine* 59: 188–93.

1932 B. Berenson. *Italian Pictures of the Renaissance*. Oxford.

1934 R. Filangieri. *Castel Nuovo reggia angioina ed aragonese di Napoli*. Naples.

1935 C. Brandi. *La pittura riminese del Trecento*, exhibition catalog. Rimini.

1936 R. Filangieri. "Rassegna critica delle fonti per la storia di Castel Nuovo." In *Archivio Storico per le Provincie Napoletane*, pp. 251–323.

1936 R. Mather Graves. "Nuove informazioni relative alle matricole di Giotto, Gaddi di Zanobi Gaddi, B. Daddi, A. Lorenzetti, T. Gaddi ed altri pittori nell'arte dei Medici e Speziali di Florence." In *L'Arte*, n. s., 7: 50–64.

1937 *Mostra giottesca—Catalogo*. Bergamo.

1937A L. Coletti. "Nota sugli esordi di Giotto." In *La Critica d'Arte* 2: 124–30.

1937B L. Coletti. "Note giottesche: il Crocifisso di Rimini." In *Bollettino d'Arte*, 3rd series, 30: 350–61.

1937 V. Mariani. *Giotto*. Rome.

1937 R. Oertel. "Giotto-Ausstellung in Florenz." In *Zeitschrift für Kunstgeschichte* 6: 218–38.

1937A M. Salmi. "Le origini dell'arte di Giotto." In *Rivista d'Arte* 19: 193–220.

1937B M. Salmi. "La Mostra giottesca." In *Emporium* 43: 349–62.

1937 R. Zanocco. "L'Annunciazione all'Arena di Padova." In *Rivista d'Arte* 19 (nos. 3–4): 370–73.

1937–38 L. Coletti. "La Mostra giottesca." In *Bollettino d'Arte*, 3rd series, 31: 49–72.

1938 R. Salvini. *Giotto. Bibliografia.* Rome.

1938 E. Sandberg-Vavalà. "Giotto's Workshop." In *The Burlington Magazine*, pp. 151–54.

1938–39 C. Brandi. "Giotto." in *Le Arti*, folder 1, pp. 5–21; folder 2, pp. 116–31.

1939 R. Offner. "Giotto, non Giotto." In *The Burlington Magazine*, 74: 259 ff., and 75: 96–113.

1940 W. and E. Paatz. *Die Kirchen von Florenz*, vol. 1. Frankfurt.

1941 T. Hetzer. *Giotto, seine Stellung inder Europäischen Kunst*. Frankfurt.

1941 W. Paeseler. "Giottos Navicella und ihr spätantikes Vorbild." In *Römisches Jahrbuch für Kunstgeschichte* 5: 51–162.

1941 P. Toesca. *Giotto*. Turin.

1943 G. Sinibaldi and G. Brunetti. *Pittura italiana del Duecento e del Trecento. Catalogo della Mostra Giottesca di Firenze del 1937*. Florence.

1943–44 R. Oertel. "Wende der Giotto-Forschungen." In *Zeitschrift für Kunstgeschichte* 11: 1–27.

1943–46 M. Salmi. "Contributi fiorentini alla storia dell'arte. I, Maso di Banco a Napoli." In "Atti dell'Accademia fiorentina di scienze morali 'la Colombaia,'" pp. 415–32.

1946 R. Pallucchini. *Capolavori dei musei veneti*. Venice.

1947–48 W. Braunfels. "Giotto's Campanile." In *Das Munster* 1: 193–210.

1948 R. Longhi. "Giudizio sul Duecento." In *Proporzioni* 2: 5–54.

1949 L. Coletti. *Gli affreschi della Basilica di Assisi*. Bergamo.

1951 R. Longhi. "Stefano Fiorentino." In *Paragone*, no. 13, pp. 24–26.

1951 R. Longhi. "Giotto spazioso." In *Paragone*, no. 31, pp. 18–24.

1951 C. Mitchell. "The Lateran Fresco of Bonifacio VIII." In *Journal of the Warburg and Courtauld Institutes* 14: 1–6.

1951 R. Salvini. *Tutta la pittura di Giotto*. Milan.

1951 P. Toesca. *Storia dell'arte italiana*, vol. 2, *Il Trecento*. Turin.

1952 C. Brandi. "The Restoration of the St. John Lateran Fresco." In *The Burlington Magazine* 94: 218.

1953 P. Murray. "Notes on Some Early Giotto Sources." In *Journal of the Warburg and Courtauld Institutes* 16: 58–80.

1956 C. Brandi. "Giotto recuperato a S. Giovanni in Laterano." In *Scritti di Storia dell'arte in onore di Lionello Venturi*, pp. 55–85. Rome.

1956 M. R. Fischer. "Assisi, Padua, and the Boy in the Tree." In *Art Bulletin*, pp. 47–52.

1956 M. Laclotte. *De Giotto à Bellini, Les primitifs italiens dans les Musées de France*. Paris.

1956 R. Offner. *A Critical and Historical Corpus of Florentine Painting*, vol. 6, sec. 3. Glückstadt, Germany.

1956 J. White. "The Date of 'The Legend of St. Francis' at Assisi." In *The Burlington Magazine* 98: 344–51.

1957 C. Gnudi. "Il passo di Riccobaldo Ferrarese relativo a Giotto e il problema della sua autenticità." In *Scritti in onore di W. Suida*, pp. 26–30. London.

1957 L. Grossato. *Il Museo civico di Padova*. Venice.

1957 U. Schlegel. "Zum Bildprogramm der Arena-Kapelle." In *Zeitschrift für Kunstgeschichte* 20: 125–46.

1957 J. White. *The Birth and Rebirth of Pictorial Space*. London.

1957 F. Zeri. "Due appunti su Giotto." In *Paragone*, no. 85, pp. 75–87.

1958 C. Gnudi. *Giotto*. Milan.

1958 M. Gosebruch. Giottos römischer Stefaneschi-Altar und die Fresken des sog. 'Maestro delle Vele' in der Unterkirche S. Francesco zu Assisi." In *Kunstchronik* 11: 288–91.

1960A E. Battisti. *Giotto*. Geneva.

1960B E. Battisti. *Rinascimento e Barocco*. Turin.

1960 M. Meiss. *Giotto and Assisi*. New York.

1960 A. Smart. "The S. Cecilia Master and His School at Assisi." In *The Burlington Magazine* I: 405–413; II: 431–37.

1961 D. Gioseffi. "Lo svolgimento del linguaggio giottesco da Assisi a Padova: il soggiorno riminese e la componente ravennate." In *Arte Veneta* 15: 11–24.

1961 M. Gosebruch. "Giotto Stefaneschi Altarwerk aus St. Peter in Rom." In *Miscellanea Bibliothecae Hertzianae zu Ehren von Leo Bruhns, Franz Grof Wolf Metternich, Ludwig Schudt*, pp. 104–130. Munich, Germany.

1961 R. Longhi. "Un dossale italiano a St. Jean-Cap-Ferrat." In *Paragone*, no. 141, 11–19.

1962 F. Bologna. *La pittura italiana delle origini*. Rome and Dresden.

1962 E. Borsook. "Notizie su due Cappelle in Santa Croce a Florence." In *Rivista d'Arte*, pp. 89–107.

1962 M. Gosebruch. *Giotto und die Entwicklung des neuzeitlichen Kunstbewusstseins*. Cologne.

1962 M. von Nagy. *Die Wandbilder der Scrovegni-Kapelle zu Padua: Giottos Verhältnis zu seinen Quellen.* Bern and Munich.

1962 U. Procacci. "La tavola di Giotto dell'altar maggiore della chiesa di Badia fiorentina." In *Scritti di Storia dell'arte in onore di Mario Salmi*, vol. 2, pp. 9–45. Rome.

1962 L. Tintori and M. Meiss. *The Painting of the Life of St. Francis in Assisi*. New York.

1963 B. Berenson. *Italian Pictures of the Renaissance. Florentine School.* London.

1963 D. Gioseffi. *Giotto architetto*. Milan.

1963 R. Longhi. "In traccia di alcuni anonimi trecentisti." In *Paragone*, no. 167, pp. 3–16.

1963 C. Volpe. "Un momento di Giotto e il 'Maestro di Vicchio di Rimaggio.'" In *Paragone*, no. 157, pp. 6–14.

1964 G. Previtali. *La fortuna dei Primitivi. Dal Vasari ai neoclassici*. Turin.

1965 C. Gilbert. "The Sequence of Execution in the Arena Chapel." In *Essays in Honor of Walter Friedlaender*, pp. 80–86. New York.

1965 A. M. Romanini. "Giotto a Padova e il Trecento architettonico padano veneto." In *Bollettino del Centro Internazionale di Studi di Architettura A. Palladio*, pp. 264–79.

1965 L. Tintori and E. Borsook. *Giotto. The Peruzzi Chapel*. New York.

1965A C. Volpe. *La pittura riminese del Trecento*. Milan.

1965B C. Volpe. *Pietro Lorenzetti ad Assisi*. Milan and Geneva.

1966 P. P. Donati. *Taddeo Gaddi*. Florence.

1966 G. Matthiae. *Pittura Romana del Medioevo*, vol. 2, *Secoli XI–XIV*. Rome.

1966 I. Toesca. "Una croce dipinta Romana." In *Bollettino d'Arte* 51: 27–32.

1966 J. White. *Art and Architecture in Italy 1250–1400*, Harmondsworth, England.

1967 *Giotto e il Mugello, nel VII centenario della nascita di Giotto*. Florence.

1967 P. Dal Poggetto. *Omaggio a Giotto*, exhibition catalog. Florence.

1967 B. Klesse. *Seidenstoffe in der Italieniscen Malerei*. Bern.

1967 G. Previtali. *Giotto e la sua bottega*. Milan.

1967 F. Zeri. "Early Italian Pictures in the Kress Collection." In *The Burlington Magazine* 109.

1968 F. d'Arcais. "Affreschi giotteschi nella Basilica del Santo a Padova." In *Critica d'Arte* 15: 23–24.

1968 C. Gilbert. "L'ordine cronologico degli affreschi Bardi e Peruzzi." In *Bollettino d'Arte* 53 (5th series): 192–97.

1968 P. Rotondi. "Giotto nella Cappella della Maddalena in Assisi." In *L'Arte*, no. 1, pp. 75–97.

1969 *Giotto e i giotteschi in Assisi*. Rome.

1969A F. Bologna. *I pittori alla corte angioina di Napoli, 1266–1414, e un riesame dell'arte nell'età federiciana*. Rome.

1969B F. Bologna. *Novità su Giotto. Giotto al tempo della Cappella Peruzzi*. Turin.

1969 G. A. Cicognani. "Giotto e san Francesco." In *Giotto e i giotteschi . . .*, pp. 1–4.

1969 G. Fallani. "L'arte religiosa di Giotto." In *Giotto e i giotteschi . . .*, pp. 5–13.

1969 J. Gardner. "The Influence of Popes' and Cardinals' Patronage on the Introduction of the Gothic Style into Rome." Ph.D. diss., Courtauld Institute, London.

1969 M. Gosebruch. "Gli affreschi di Giotto nel braccio destro del transetto e nelle Vele centrali della chiesa inferiore di San Francesco." In *Giotto e i giotteschi . . .*, pp. 129–98.

1969 G. Marchini. "Le vetrate della Basilica di San Francesco." In *Giotto e i giotteschi . . .*, pp. 271–99.

1969 V. Mariani. "Giotto nel ciclo della 'Vita di San Francesco.'" In *Giotto e i giotteschi . . .*, pp. 61–89.

1969 E. Pagliani. "Note sul restauro degli affreschi giotteschi nella chiesa inferiore di San Francesco." In *Giotto e i giotteschi . . .*, pp. 199–209.

1969 G. Palumbo. Introduction to *Giotto e i giotteschi . . .*, pp. xi–xvi.

1969 G. Previtali. "Le cappelle di san Nicola e di Santa Maria Maddalena nella chiesa inferiore di san Francesco." In *Giotto e i giotteschi . . .*, pp. 93–127.

1969 C. L. Ragghianti. "Percorso di Giotto." In *La Critica d'Arte*, nos. 101–2, pp. 3–80.

1969 A. M. Romanini. *Arnolfo di Cambio e lo "stil nuovo" del gotico italiano*. Milan.

1969 P. Sarpellini. "Di alcuri pittori giotteschi nella città e nel territorio di Assisi." In *Giotto e i giotteschi . . .*, pp. 210–70.

1969 J. H. Stubblebine, ed. *Giotto: the Arena Chapel Frescoes*. London.

1969 P. Venturoli. "Giotto." In *Storia dell'arte*, nos. 1–2, pp. 143–58.

1969 L. Vertova. "I Tatti." In *Antichità Viva* 8: 64–73.

1969 C. Volpe. "La formazione di Giotto nella cultura di Assisi." In *Giotto e i giotteschi . . .*, pp. 15–59.

1970 *Giotto di Bondone*. Constance, Germany.

1970 W. Euler. "Die Architektur bei Giotto als Umgebung des Menschen." In *Giotto di Bondone*, pp. 243–49.

1970 M. Gosebruch. "Figur und Gestus in der Kunst des Giotto." In *Giotto di Bondone*, pp. 7–25.

1970 W. Messerer. "Giotto Verhaeltnis zu Arnolfo di Cambio." In *Giotto di Bondone*, pp. 209–17.

1970 R. Salvini. "Bemerkungen ueber Giottos Fruehwerk in Assisi." In *Giotto di Bondone*, pp. 169–83.

1970 F. Schmersahl. "Die Architektur in Giottos Bildern, Betracht von einem Architekten." In *Giotto di Bondone*, pp. 253–70.

1970 O. Von Simson. "Über Giottos Einzelgestalten." In *Giotto di Bondone*, pp. 229–35.

1971 *Giotto e il suo tempo, Atti del Congresso internazionale per la celebrazione del VII centenario della nascita di Giotto* (1967). Rome.

1971 M. Alpatov. "Giotto. Tradition, Creatio, reforme." In *Giotto e il suo tempo . . .*, pp. 331–43.

1971 K. Bauch. "Giotto und die Portraetkunst." In *Giotto e il suo tempo . . .*, pp. 299–309.

1971 M. Baxandall. *Giotto and the Orators*. Oxford.

1971 A. Bertini. "Per la conoscenza dei medaglioni che accompagnano le Storie della Vita di Gesù nella Cappella degli Scrovegni." In *Giotto e il suo tempo . . .*, pp. 143–47.

1971 F. Bologna. "Un'opera di Giotto nella Gemäldegalerie di Dresda e il problema del politico della Cappella Peruzzi." In *Giotto e il suo tempo . . .*, pp. 265–98.

1971 M. Boskovits. "Nuovi studi su Giotto ad Assisi." In *Paragone*, no. 261, pp. 34–56.

1971 C. Brandi. "Sulla cronologia degli affreschi della Chiesa Superiore di Assisi." In *Giotto e il suo tempo . . .*, pp. 61–66.

1971 H. M. Davis. "Gravity in the Painting of Giotto." In *Giotto e il suo tempo . . .*, pp. 367–82.

1971 J. Gardner. "The Decoration of the Baroncelli Chapel in Santa Croce." In *Zeitschrift für Kunstgeschichte* 34 (no. 2): 89–114.

1971 D. Gioseffi. "Il politico Stefaneschi nella storia della prospettiva." In *Giotto e il suo tempo . . .*, pp. 221–31.

1971 C. Gnudi. "Sugli inizi di Giotto e i suoi rapporti col mondo antico." In *Giotto e il suo tempo . . .*, pp. 3–23.

1971 M. Gosebruch. "Sulla necessità di colmare la lacuna tra Padova e le Cappelle di santa Croce nella biografia artistica di Giotto." In *Giotto e il suo tempo . . .*, pp. 233–51.

1971 L. Grassi. "Il concetto di 'moderno' in rapporto a Giotto nella riflessione del pensiero critico del Trecento." In *Giotto e il suo tempo . . .*, pp. 419–27.

1971 H. W. Kruft. "Giotto e l'antico." in *Giotto e il suo tempo . . .*, pp. 169–76.

1971 G. L. Luzzato. "Giotto: da primitivo a classico nel giudizio critico degli ultimi anni." In *Giotto e il suo tempo . . .*, pp. 319–30.

1971 G. Marchini. "Il giottesco Giovanni di Bonino." In *Giotto e il suo tempo . . .*, pp. 67–77.

1971 V. Martinelli. "Contributo alla conoscenza dell'ultimo Giotto." In *Giotto e il suo tempo . . .*, pp. 383–99.

1971 M. Meiss. "Alesso d'Andrea." In *Giotto e il suo tempo . . .*, pp. 401–18.

1971 R. Meoli Toulmin. "L'ornamento nella pittura di Giotto con particolare riferimento alla Cappella degli Scrovegni." In *Giotto e il suo tempo . . .*, pp. 177–89.

1971 C. Mitchell. "The Imagery of the Upper Church at Assisi." In *Giotto e il suo tempo . . .*, pp. 113–34.

1971 G. Morozzi. "La casa di Vespignano." In *Giotto e il suo tempo . . .*, pp. 345–48.

1971 P. Murray. "On the Date of Giotto's Birth." In *Giotto e il suo tempo . . .*, pp. 25–34.

1971 W. Paeseler. "Cavallini e Giotto: aspetti cronologici." In *Giotto e il suo tempo . . .*, pp. 35–44.

1971 A. Parronchi. "Una Crocifissione duccesca." In *Giotto e il suo tempo . . .*, pp. 311–18.

1971 J. Pesina. "Quelques éléments d'illusion spatiale dans le cycle d'Assise et leur echo dans la peinture politique de Bohème." In *Giotto e il suo tempo . . .*, pp. 105–11.

1971 A. Prandi. "Spunti per lo studio della prospettiva di Giotto." In *Giotto e il suo tempo . . .*, pp. 149–59.

1971 U. Procacci. "Bonaccorso di Cino e gli affreschi della chiesa del Tau a Pistoia." In *Giotto e il suo tempo . . .*, pp. 349–66.

1971 A. Prosdocimi. "Osservazioni sulla partitura delle scene affrescate da Giotto nella Cappella degli Scrovegni." In *Giotto e il suo tempo . . .*, pp. 135–42.

1971 R. Salvini. "Giotto e Rimini." In *Giotto e il suo tempo . . .*, pp. 93–103.

1971 U. Schlegel. "Un collaboratore di Giotto a Padova. Osservazioni sul Maestro di Figline." In *Giotto e il suo tempo . . .*, pp. 161–67.

1971A A. Smart. "Quasi tutta la parte di sotto." In *Giotto e il suo tempo . . .*, pp. 79–91.

1971B A. Smart. *The Assisi Problem and the Art of Giotto.* Oxford.

1971 F. Valcanover. "Le cause del rapido deterioramento degli affreschi della Cappella degli Scrovegni negli ultimi venti anni." In *Giotto e il suo tempo . . .*, pp. 191–96.

1971 L. Vayer. "L'affresco del giubileo e la tradizione della pittura monumentale Romena." In *Giotto e il suo tempo . . .*, pp. 45–59.

1971 C. Volpe. "Sulla Croce di san Felice in Piazza e la cronologia dei Crocifissi giotteschi." In *Giotto e il suo tempo . . .*, pp. 253–63.

1971 W. Weidlé. "Giotto et Byzance." In *Giotto e il suo tempo . . .*, pp. 197–219.

1972A C. Bellinati. "Il giudizio universale nella Cappella di Giotto all'Arena." In *Patavium*, pp. 34–38.

1972B C. Bellinati. "Tipologia e arte nei medaglioni della Cappella di Giotto all'Arena." In *Padova e la sua provincia* 18 (no. 5): 7–10.

1972 A. Conti. "Pittori in S. Croce (1295–1341)." In "Annali della Scuola Normale Superiore di Pisa. Classe di Lettere e Filosofia," pp. 247–63.

1972 A. M. Romanini. "Nuove tracce per il rapporto Giotto-Arnolfo in san Gottardo a Milan." In *Studi in onore di Roberto Pane*, pp. 149–81. Naples.

1973 C. De Benedictis. *Giotto. Bibliografia.* Rome.

1973 J. Gardner. "Pope Nicholas IV and the Decoration of Santa Maria Maggiore." In *Zeitschrift für Kunstgeschichte* 36: 1–50.

1973 I. Hueck. "Zu Enrico Scrovegnis Veränderungen der Arenakapelle." In *Mitteilungen des Kunsthistorischen Institutes in Florenz*, no. 17, pp. 277–94.

1973 V. Martinelli. "Un documento per Giotto ad Assisi." In *Storia dell' Arte*, no. 19, pp. 193–208.

1973 D. Redig De Campos. "Restauro del Trittico Stefaneschi di Giotto." In *Mitteilungen des Kunsthistorischen Institutes in Florenz*, no. 17, pp. 325–46.

1974 J. Gardner. "The Stefaneschi Altarpiece: a Reconsideration." In *Journal of the Warburg and Courtauld Institutes* 57: 57–103.

1974 L. Grossato, ed. *Da Giotto al Mantegna*, exhibition catalog. Padua and Milan.

1974 G. Previtali. *Giotto e la sua bottega*, second edition. Milan.

1975 C. Bellinati. "La Cappella degli Scrovegni." In *Padova, Basiliche e Chiese.* Vicenza, Italy.

1975 M. Boskovits. "Una scheda e qualche suggerimento per un catalogo dei dipinti ai Tatti." In *Antichità viva* 14 (no. 2): 9–21.

1975 H. M. Thomas. "Der Erlösungsgedanke in theologischen Programm der Arenakapelle." In *Franziskanische Studien*, no. 57.

1976 M. Boskovits. *Cimabue e i precursori di Giotto.* Florence.

1977A L. Bellosi. "La sala dei Notai, Martino da Perugia e un antequem per il problema di Assisi." In *Per Maria Cionini Visani*, pp. 22–25. Turin.

1977B L. Bellosi. "Moda e cronologia: gli affreschi della basilica inferiore di Assisi." In *Prospettiva*, no. 10, pp. 21–31.

1977 H. Belting. *Die Obere Kirche von san Francesco in Assisi. Ihre Dekoration als Aufgabe und die Genese einer neuen Wandmalerei.* Berlin.

1977 C. Gilbert. "The Fresco by Giotto in Milan." In *Arte Lombarda*, nos. 47–48, pp. 31–72.

1977A I. Hueck. "Das Datum des Necrologs für Kardinal Jacopo Stefaneschi in Martyrologium der Vatikanischer Basilika." In *Mitteilungen des Kunsthistorischen Institutes in Florenz* 21: 219–20.

1977B I. Hueck. "Giotto und die Proportion." In *Festschrift Wolfgang Braunfels*, pp. 143–55, Tübingen, Germany.

1977 F. R. Pesenti. "Maestri arnolfiani ad Assisi." In *Studi di Storia delle arti*, pp. 43–53.

1978 A. Caleca. "A proposito del rapporto Cimabue-Giotto." In *Critica d'Arte* 43: 157–59.

1979 W. F. Volbach. *I dipinti dal secolo X fino a Giotto*, Catalogo della Pinacoteca Vaticana, vol. 1. Vatican City.

1980A L. Bellosi. "La barba di San Francesco. Nuove proposte per il problema Assisi." In *Prospettiva*, no. 22.

1980B L. Bellosi. "La rappresentazione dello spazio." In *Storia dell'arte*, vol. 4, part 1. Turin.

1980 A. Conti. "Un Crocifisso nella bottega di Giotto." In *Prospettiva*, no. 20, pp. 47–56.

1980 L. C. Schwartz. "The Fresco Decoration of the Magdalen Chapel in the Basilica of St. Francis at Assisi." Ph.D. diss., Indiana University.

1980 F. Todini. "Una nuova traccia per Giotto ad Assisi." In *Storia dell' arte*, nos. 38–40, pp. 125–29.

1980 F. Todini and B. Zanardi. *La Pinacoteca Comunale di Assisi.* Florence.

1981 L. Bellosi. *Giotto.* Florence.

1982 K. Christiansen. "Fourteenth-Century Italian Altarpieces." In *The Metropolitan Museum of Art Bulletin* 40 (no. 1): 53–55.

1982 J. Gardner. "The Louvre Stigmatization and the Problem of the Narrative Altarpiece." In *Zeitschrift für Kunstgeschichte* 45: 217–48.

1982 V. Herzener. "Giottos Grabmal für Enrico Scrovegni." In *Muenchener Jahrbuch der bildenden Kuns* 33: 39–66.

1982 P. Scarpellini. *Commentario a Lodovico da Pietralunga, Descrizione della Basilica di San Francesco ad Assisi e di altri santuari di Assisi.* Treviso, Italy.

1983 *Roma anno 1300—Atti della IV Settimana di Studi di Storia dell'arte medievale dell'Università di Roma La Sapienza (1980)*, ed. A. M. Romanini. Rome.

1983 U. Bauer Eberhard. *Der Liber Introductorius des Michael Scotus in der Abschritt CLM. 10268 der Bayerischen Staatsbibliothek München.* Munich, Germany.

1983 L. Bellosi. "La decorazione della basilica superiore e la pittura Romena di fine Duecento." In *Roma anno 1300 . . .*, pp. 127–39.

1983 H. Belting. "Assisi e Roma, Risultati, problemi, prospettive." In *Roma anno 1300 . . .*, pp. 93–101.

1983 G. Bonsanti. "Giotto nella Cappella di san Nicola." In *Roma anno 1300 . . .*, pp. 199–209.

1983A M. Boskovits. "Celebrazioni dell'VIII Centenario della nascita di san Francesco. Studi recenti sulla Basilica di Assisi." In *Arte Cristiana* 71: 203–14.

1983B M. Boskovits. "Proposte (e conferme) per Pietro Cavallini." In *Roma anno 1300 . . .*, pp. 297–329.

1983 C. Brandi. *Giotto.* Milan.

1983 I. Hueck. "Il cardinale Napoleone Orsini e la cappella di S. Nicola nella basilica francescana ad Assisi." In *Roma anno 1300 . . .*, pp. 187–98.

1983 S. Maddalo. "Bonifacio VIII e Jacopo Stefaneschi. Ipotesi di lettura dell'affresco della loggia lateranense." In *Studi Romani* 31: 129–50.

1983 R. Salvini. "Noterelle su Giotto a Roma." In *Roma anno 1300 . . .*, pp. 175–85.

1983 C. Volpe. "Il lungo percorso del 'dipingere dolcissimo e tanto unito.'" In *Storia dell'arte italiana*, vol. 5, part 2. Turin.

1984A F. d'Arcais. "La presenza di Giotto al Santo." In AA. VV., *Le pitture del Santo a Padova.* Vicenza, Italy.

1984B F. d'Arcais. "La Croce giottesca del Museo Civico di Padova." In *Bollettino del Museo Civico di Padova* 73: 65–82.

1984 M. Boskovits. "Una vetrata e un frammento d'affresco di Giotto nel Museo di Santa Croce." In *Scritti di Storia dell'Arte in onore di Federico Zeri*, Milan, pp. 39–45.

1984 I. Hueck. "Ein Dokument zur Magdalenenkapelle der Franziskuskirche von Assisi." In *Scritti di Storia dell'arte in onore di Roberto Salvini*, Florence, pp. 191–96.

1984 H. Tanaka. "Giotto and the Influence of the Mongols and the Chinese on His Art." In *Art History* 6: 1–38.

1985 F. d'Arcais. Review of U. Bauer, "Der Liber Introductorius des Michael Scotus in der Abschritt CLM. 10268 der Bayerischen Staatsbibliothek München, München 1983." In *Bollettino del Museo Civico di Padova* 74: 269–74.

1985A L. Bellosi. *La pecora di Giotto.* Turin.

1985B L. Bellosi. "Su alcuni disegni italiani tra la fine del Due e la metà del Quattrocento." In *Bollettino d'Arte* 70 (no. 30): 1–48.

1985 G. Bonsanti. *Giotto.* Padua.

1985 M. M. Donato. "Gli eroi Romani tra storia ed exemplum. I primi cicli umanistici di uomini famosi." In *Memoria dell'antico nell'arte italiana,* ed. S. Settis, book 2. Turin.

1985 M. Lisner. "Farbgebung und Farbikonographie in Giottos Arenafresken." In *Mitteilungen des Kunsthistorischen Institutes in Florenz* 29: 1–75.

1985 J. Poeschke. *Die Kirche san Francesco in Assisi und ihre Wandmalerei.* Munich.

1985 J. Stubblebine. *Assisi and the Rise of a Vernacular Art.* New York.

1985 H. M. Thomas. "Gedanken zu Bildkonzeption, Ikonographie und Kunstleriscer Darstellung Giottos in Padua." In *Bollettino del Museo Civico di Padova* 74: 53–66.

1985 F. Todini. "Pittura del Duecento e del Trecento in Umbria e il cantiere di Assisi." In *La pittura in Italia, Le origini.* Milan.

1985–86 C. Bellinati. "Iconologia e iconografia dell'affresco 'Incontro alla Porta Aurea' nella Cappella di Giotto all'Arena." In *Atti e Mem. dell'Accademia patavina di Scienze, Lettere e Arti,* 98 (no. 3): 75–79.

1986 *Capolavori e restauri,* catalog for the exhibition in Florence (1986–87), prepared by B. Santi. Florence.

1986 I. Hueck. "Die Kapellen der Basilika San Francesco in Assisi: die Autraggeber und die Franziskaner." In *Patronage and Public in the Trecento,* Proceedings of the Lambrecht Symposium. Abtei St. Lambrecht, Styria, Austria, July 1984, pp. 81–104. Florence.

1986 P. Leone de Castris. *Arte di corte nella Napoli Angioina.* Naples.

1986 C. Süre. "'Wirken Sie, was Sie vermoegen.' Die Entwerbung italienischer Gemaelde in der Korrispondenz mit der Kunstgenten." In *Ihm, welcher der Andacht Tempel Bant.* Munich.

1986 H. M. Thomas. "La Cappella degli Scrovegni: Linee iconografiche degli affreschi di Giotto e aspetti problematici di alcuni studi attuali." In *Ateneo Veneto* 24 (no. 173): 291–304.

1987 D. Gioseffi. "Marginalia giotteschi." In *Antichità viva* 26 (nos. 5–6): 12–19.

1987 A. M. Romanini. "Gli occhi di Isacco. Classicismo e curiosità scientifica tra Arnolfo e Giotto." In *Arte Medievale* 2 (nos. 1–2): 1–56.

1987A H. M. Thomas. "Uno sguardo all'iconografia degli affreschi di Giotto." In *Padova e il suo territorio,* no. 7, pp. 14–17.

1987B H. M. Thomas. "La missione di Gabriele nell'affresco di Giotto della Cappella degli Scrovegni a Padova." In *Bollettino del Museo Civico di Padova,* no. 76, pp. 99–111.

1988 M. Boskovits. *Gemäldegalerie Berlin. Fruehe italienische Malerei.* Berlin.

1988 F. Gandolfo. "Aggiornamento scientifico e bibliografia." In G. Matthiae, ed., *Pittura Romana del Medioevo,* vol. 2. Rome.

1989 *Fragmenta picta. Affreschi e mosaici staccati del Medioevo Romano,* catalog for the exhibition in Rome. Rome.

1989 *Da Giotto al Tardogotico,* catalog for the exhibition in Padua. Rome.

1989 S. Bandera Bistoletti. *Giotto.* Florence.

1989 L. Bellosi. *Giotto ad Assisi.* Assisi.

1989 D. Gordon. "A Dossal by Giotto and His Workshop: Some Problems of Attribution, Provenance and Patronage." In *The Burlington Magazine* (August): 524–31.

1989 A. M. Romanini. "Arnolfo alle origini di Giotto: l'enigma del Maestro di Isacco." In *Storia dell'arte,* no. 65, pp. 5–26.

1989 D. Russo. "Entre Christ et Marie. La Magdaleine dans l'art italien." In *Marie Madeleine dans la mystique, les arts et les lettres.* Paris.

1989 H. Tanaka. "Oriental Scripts in the Painting of Giotto's Period." In *Gazette des Beaux-Arts* 113 (May–June): 214–26.

1989 F. Todini. *La pittura in Umbria dal Duecento al primo Cinquecento.* Milan.

1989 A. Tomei. *I due Angeli della Navicella di Giotto in Fragmenta picta.* Catalog for an exhibition in Rome, 1992, pp. 153–61.

1990 M. Boskovits. "Insegnare per immagini: dipinti e sculture nelle sale capitolari." In *Arte cristiana* 78 (folders 737 and 738): 123–42.

1990 H. Koeren-Jausen. *Die Erettung Petri aus der Fluten: Die Navicella Giottos und die Bildtradition von Mt. 14, 22–23.* Cologne, Germany.

1990 M. Lisner. "Die Apostelfarben in Giottos Arenafresken Farbgebrung und Farbikonographie." In *Zeitschrift für Kunstgeschichte,* no. 55, H. 3, pp. 309–75.

1990 A. Tomei. *Jacobus Torriti pictor.* Rome.

1991 *Rome nel Duecento. L'arte nella città dei papi da Innocenzo III a Bonifacio VIII.* A. M. Romanini, ed. Rome.

1991 J. Gardner. "Giotto: First of the Moderns or Last of the Ancients?" In *Wiener Jahrbuch für Kunstgeschichte,* no. 44, pp. 63–78.

1991 C. Gilbert. *Poets Seeing Artists' Work. Instances in the Italian Renaissance.* Florence.

1991 A. T. Hankey. "Riccobaldo of Ferrara and Giotto." In *Journal of the Warburg and Courtauld Institutes* 44: 44.

1991 J. Thomann. "Pietro d'Abano on Giotto." In *Journal of the Warburg and Courtauld Institutes* 44: 239–41.

1992 U. Bazzotti, ed. *Indizii di castigato disegno, di vivaci colori. Gli affreschi trecenteschi della Cappella Bonacolsi.* Mantua, Italy.

1992 *La Croce giottesca di san Felice in Piazza. Storia e restauro.* M. Scudieri, ed. Venice.

1992 *La "Madonna d'Ognissanti" di Giotto restaurata.* Florence.

1992 F. Aceto. "Pittori e documenti della Napoli Angioina: aggiunte ed espunzioni." In *Prospettiva,* no. 67.

1992 G. Basile. *Giotto. La Cappella degli Scrovegni.* Milan.

1992 G. Bonsanti. "La bottega di Giotto e la croce di San Felice." In *La croce Giottesca di San Felice in Piazza,* pp. 53–90. Venice.

1992 A. Cecchi. "La 'Madonna d'Ognissanti' dalla chiesa al museo: vicende espositive e di conservazione." In *La "Madonna d'Ognissanti". . . ,* pp. 69–74.

1992 I. Hueck. "Le opere di Giotto per la chiesa di Ognissanti." In *La "Madonna d'Ognissanti". . . ,* pp. 37–50.

1992 M. Lisner. "Significati e iconografia del colore nella 'Madonna d'Ognissanti.'" In *La "Madonna d'Ognissanti". . . ,* pp. 57–68.

1992 A. Natali. "Lo spazio illusivo." In *La "Madonna d'Ognissanti". . . ,* pp. 51–56.

1992 A. Peroni. "La 'Maestà' di Ognissanti rivisitata dopo il restauro." In *La "Madonna d'Ognissanti". . . ,* pp. 17–36.

1992 A. Petrioli Tofani. Preface to *La "Madonna d'Ognissanti". . .*

1992 A. M. Spiazzi. "Padova." In *La pittura nel Veneto. Il Trecento.* Milan.

1992 H. M. Thomas. "Note sulla cappella di Giotto a Padova." In *Ateneo Veneto,* no. 179, pp. 283–306.

1992 F. Todini. "Un'opera Romana di Giotto." In *Studi di Storia dell'arte,* vol. 3, 1992 (published 1993), pp. 9–44.

1993 A. Busignani. *Giotto.* Preface by U. Baldini. Florence.

1993 A. Conti. "Giotto e la pittura italiana nella prima metà del Trecento." In *L'arte medioevale in Italia e nell'Occidente europeo,* L. Castelfranchi Vegas, ed., Milan.

1993 G. Previtali. *Giotto e la sua bottega,* 3rd edition, ed. A. Conti. Milan.

1994 A. Parronchi. *Pietro Cavallini.* Florence.

INDEX OF NAMES

INDEX OF WORKS BY SITE

❧

PHOTOGRAPHY CREDITS

The photographers and the sources of photographic material other than those indicated in the captions are as follows:

Fabbrica di San Pietro in Vaticano, Photographic Archive, Vatican City
Alinari, Florence
Ashmolean Museum, Oxford
Bayerische Staatsgemäldesammlungen, Munich
Bayerische Staatsbibliothek, Munich
Berenson Collection, Villa I Tatti, Settignano (Florence)
Biblioteca Ambrosiana, Milan
Bildarchiv Preussischer, Kulturbesitz, Berlin
Photo Bulloz, Paris
Elio Ciol, Casarsa della Delizia (Pordenone)
Isabella Stewart Gardner Museum, Boston
Istituto Centrale del Restauro, Rome
Kunsthistorisches Institut in Florenz, Florence
Foto Lufin, Padua
The Metropolitan Museum of Art, New York
Musées de la Ville de Strasbourg, Strasbourg
Musei Vaticani, Vatican City
The National Gallery, London
National Gallery of Art, Washington
Nazario Fotografia, Forlì
North Carolina Museum of Art, Raleigh
Nicolo Orsi Battaglini, Florence
Réunion des Musées Nationaux, Paris
San Diego Museum of Art
Scala Istituto Fotografico Editoriale, Antella (Florence)
Soprintendenza per i Beni Artistici e Storici, Florence
Soprintendenza per i Beni Artistici e Storici, Naples
Soprintendenza per i Beni Artistici e Storici, Rome
Staatliche Kunstsammlungen, Dresden
Staatliche Museen Preussischer Kulturbesitz, Berlin
Studio Fotografico Quattrone, Florence

The publishers would also like to thank the following institutions and individuals: the Musei Civici di Padova (Padua); the Abbaye de Chaalis (Senlis, France); The President and Fellows of Harvard College di Firenze (Florence); Msgr. Andrea Baiocchi of the Bishop's Curia of the Tempio Malatestiano (Rimini); Christine Speroni of the Musées de la Ville de Strasbourg; Caterina Pileggi of the Istituto Centrale del Restauro, Rome; and Grazia Visintainer of the Kunsthistorisches Institut in Florenz (Florence).

All photographic inquiries should be addressed to Federico Motta Editore, via C. B. Castiglioni 7, 20156 Milan, Italy.